The Look of the Book

The Look of the Book

MANUSCRIPT

PRODUCTION

IN SHIRAZ,

1303–1452

ELAINE WRIGHT

Occasional Papers, New Series, Volume 3

FREER GALLERY OF ART

Smithsonian Institution, Washington, D.C.

in association with

UNIVERSITY OF WASHINGTON PRESS,

Seattle

CHESTER BEATTY LIBRARY, Dublin

*Published with the generous assistance
of the Hagop Kevorkian Fund.
Additional support was provided by the
Chester Beatty Library, Dublin, the Barakat Trust,
and the Mellon Publication Endowment
of the Freer Gallery of Art*

Freer Gallery of Art Occasional Papers
Original Series, 1947–1971
Interim Series, 1998–2002
New Series, 2003–

Freer Gallery of Art
P.O. Box 37012, MRC 707
Washington DC 20013
http://asia.si.edu

University of Washington Press
PO Box 50096, Seattle, WA 98145
www.washington.edu/uwpress

Chester Beatty Library
Dublin Castle
Dublin 2, Ireland
www.cbl.ie

Library of Congress Cataloging-in-Publication Data
Wright, Elaine Julia.
The look of the book : manuscript production in
Shiraz, 1303–1452 / Elaine Wright.
 pages cm
Includes bibliographical references and index.
ISBN 978-0-295-99191-7 (cloth : alk. paper)
1. Manuscripts–Iran–Shiraz. 2. Illumination of books
and manuscripts, Iranian–Iran–Shiraz–History–to
1500. 3. Miniature painting, Iranian–Iran–Shiraz–
History–to 1500. 4. Calligraphy, Persian–Iran–
Shiraz–History–to 1500. 5. Bookbinding–Iran–
Shiraz–History–to 1500. I. Title.
Z106.5.I7W75 2012
091.0955′72—dc23
2011049619

The paper used in this publication is acid-free and
meets the minimum requirements of American
National Standard for Information Sciences—
Permanence of Paper for Printed Library Materials,
ANSI Z39.48–1984.∞

In memory of Agnes Kirkness (Tarr) Wright, 1898–1997

CONTENTS

A manuscript is the physical realization of an intricate, but not always conscious, decision-making process involving patrons, calligraphers, artists, and craftsmen. Each decision, whether made by one or several of these individuals, is conditioned by specific cultural, social, political, technical, and personal factors. Although the question of decisions made is not addressed directly, it nevertheless forms the basis of this study. It is because of the specific decisions made that the manuscripts of any given period or place take on the form and appearance that they do: hence the title of this study, *The Look of the Book*.

The aim of this study is quite simply to examine the "look" of the book, specifically the evolution of manuscripts produced in the city of Shiraz in southern Iran in the period of Injuid, Muzaffarid, and Timurid rule, from the early fourteenth century until 1452. However, the reader must be warned not to expect a comprehensive examination of manuscript production throughout these years. Instead, the study identifies and focuses on specific periods of change (and even these are not necessarily dealt with comprehensively). The main periods identified are the late 1350s and 1360s; the years from about 1409 to 1415, when Iskandar Sultan served as governor of Shiraz (and Isfahan); and 1435–45, the decade following the death of Ibrahim Sultan. A fourth period of more restricted change occurred in the years following 1340, during what is here identified as the late Injuid era. During each of these periods, the appearance of the book, and thus certain aspects of book production *per se*, underwent both major and minor changes. Some of these changes had a major impact on production throughout Iran and those centers of book production that followed the Iranian model; others were limited to Shiraz as well as having a limited impact chronologically.

Despite its focus on specific chronological periods, the study functions more broadly than do most studies of Islamic manuscripts, and it particularly differs from the majority of such studies in two key ways. First, the book is treated as a complete entity: illumination, codicology, illustration, calligraphy, and bookbinding are all examined, and, more important, these various components of the book are considered in relation to each other. Most studies tend to focus on

just one area of book production at a time, although a few other studies taking a broader view of their subject have been published.[1] While the more usual focused approach admittedly offers greater opportunity for in-depth analysis, the holistic approach as taken here, which focuses on the interaction among the various components of the book (specifically how changes in one area relate to or force changes in other areas), produces a broader picture of the actual and overall process of book production. Second, a large percentage of the manuscripts included in this study are illuminated but do not include any illustrations at all. The whole corpus of Islamic manuscripts produced at any one period can be imagined as forming a pyramid: at the base is the vast majority of manuscripts, those that are devoid of any type of decoration at all or that include only a few simple, perhaps mathematical or medical, diagrams, necessary to elucidate the text.[2] Filling the middle section of the pyramid is a smaller group of manuscripts, those that are illuminated but not illustrated. At the pinnacle are those few manuscripts adorned with both illuminations and illustrations. It is this small, latter group, the tip of the iceberg only so to speak, on which art-historical attention has traditionally been lavished, a situation that can be attributed to the predominant role that figurative painting has always played in manuscript studies and the resulting high profile of certain illustrated manuscripts. However, by enlarging the corpus of manuscripts to include both this upper tier and the middle tier of the "manuscript pyramid," a more complete picture of manuscript production emerges.[3]

This study is also somewhat unusual in its focus on manuscripts produced in Shiraz, because, in terms of Persian painting of the fourteenth and fifteenth centuries, greater notice tends to be given to the (usually court-produced) manuscripts of Tabriz, Baghdad, and Herat, cities that served as capitals for the Il-Khanid, Jalayirid, and Timurid dynasties. Shiraz manuscripts are often overlooked, largely because, with the exception of manuscripts produced for the Timurid prince Iskandar Sultan (who served as governor of Shiraz in the early years of the fifteenth century), they were often made to be sold commercially, and even those that were not usually employ rather simple and straightforward paintings, ones generally deemed less visually appealing than those found in court manuscripts of other centers.[4]

The present study examines manuscript production during the time that the Injuid, Muzaffarid, and Timurid dynasties controlled Shiraz, a period that stretches from the establishment of the Injuids in Shiraz in 703/1303[5] to 856/1452, the year in which the Qara Qoyunlu Turcomans replaced the Timurids as rulers of Shi-

raz.[6] However, as a broadly comparative approach to the material is taken, the chronological (and geographical) range of the study is at times much greater. Although the study focuses on specific chronological periods, the material is more easily comprehended when presented thematically, and so the first five chapters deal with illumination, codicology, illustration, calligraphy, and bookbinding. The order in which the chapters are presented was determined in recognition of the need to establish both a visual and a chronological framework in the reader's mind. For each chapter, and even for each section of each chapter, the corpus of manuscripts from which the information presented was gleaned varies considerably (and was generally dependent upon the condition of the manuscripts sourced). However, the overall corpus is large, and as many of the manuscripts have never been published before, such a framework is required to assist the reader (even the specialist) in mentally organizing the material so that a specific group of manuscripts can be easily and quickly called to mind as necessary. It is the discussion of illumination that best creates this framework, and so the first chapter is that on illumination. In the analysis of the codicological features of the manuscripts, several points discussed are pertinent for the understanding of later aspects of the study; thus, the codicological analysis forms the second chapter. The order of the remaining three chapters was more randomly determined. Although bookbinding is technically an aspect of codicology, it is here treated separately.[7] The sixth chapter presents a chronological overview of the findings of the preceding five chapters.

As noted previously, the study, and hence each individual chapter, is not intended to be comprehensive, chronologically or otherwise. Rather, the study identifies and explores specific points of time most crucial for comprehending the history and process of manuscript production in Shiraz, in particular, and Iran, in general—an approach that has resulted in chapters of uneven length. The first chapter is much longer and much more comprehensive than the others, in part because illumination has been so little studied that it is not possible simply to refer the reader to published studies or to assume the reader is acquainted, more or less, with any particular style or period of illumination. (And for this reason, this chapter is also more heavily illustrated than are other chapters.) Because illumination has been largely neglected, the study of it proved to be very rewarding, offering many insights into the world of manuscript production. In contrast to the comprehensiveness of the first chapter, the fourth chapter—one of the shortest in the study—discusses calligraphy in the fourteenth century only,

for at the time of writing no significant developments in calligraphy in the first half of the fifteenth century have been discerned. Two other chapters also require special note. To a great extent the chapter on illustration takes the form of a case study of a particular manuscript—Ibrahim Sultan's *Shahnama*—and it is in relation to this manuscript that aspects of figurative painting in general, as well as those more specifically characteristic of painting in Shiraz, are discussed. The chapter on bookbinding presented special problems because so few manuscripts have retained their original bindings. Consequently, the discussion that evolved is somewhat more general than that in the preceding chapters, and it deals almost as extensively with non-Shiraz bindings as it does with those made in Shiraz.

As is obvious from the previous sentence, a few matters of terminology need to be clarified. "Shiraz style" and even "Shiraz" are used in reference not only to the city itself but also to those regions that would have been considered part of the cultural sphere of the city, namely, the surrounding province of Fars and also, at times, the cities of Isfahan and Yazd. Manuscripts that are illuminated or illustrated in a Shiraz style but are known definitely to have been produced in other centers, such as Samarqand, are generally excluded from the study. It should also be noted that when the term "other production centers" is used, it is meant to refer only to other centers within Iran, unless specifically stated otherwise. Likewise "non-Shiraz" is used to refer to manuscripts produced in, or styles associated with, these other Iranian production centers, while the terms "Iran/Iranian" and "Persia/Persian" are used in relation to the boundaries of Iran as they existed in the years covered by the study and therefore apply to manuscripts produced in Herat and Baghdad, as well as in those areas that constitute modern-day Iran.

In chapter 3 a distinction is made between figurative paintings that actually illustrate a text and ones such as frontispieces that do not relate in any way to the actual text of the manuscript and that therefore cannot be referred to as "illustrations."[8] Because of this distinction—and because "painting" is a general term that encompasses both illustration and illumination—it has sometimes been necessary to use the terms "figurative-frontispiece" and "figurative-painting" to clarify exactly what type of painting is meant. Also, "text-frontispiece" refers to a (usually) double-page frontispiece enclosing the beginning lines of a section of the text and consisting of linked upper and lower, inscribed panels. "Non-text-frontispiece," on the other hand, refers to a single- or double-page frontispiece that is devoid of any portion of the actual text, although it may include inscrip-

tions (perhaps stating the title of the manuscript or the name of the author or the person for whom the manuscript was made).

Because of the mass of material dealt with, references to sources in which any particular manuscript is discussed, or its paintings reproduced, are not comprehensive. Furthermore, in the text, notes, and tables, the manuscripts are, for the sake of brevity, most often identified only by prefix (usually the name of the city in which the manuscript is currently located or an abbreviated form of the collection name) and inventory number; more complete entries, listing title and date at least, are given in appendix 5. Of the mass of manuscripts consulted for the study and on which the statistical analyses are based, only those manuscripts actually referred to in the text and notes are included in appendix 5. Certain textual sources, known to the author solely through secondary sources, are referred to in the notes only.

Transliterations are based on Persian orthography and pronunciation, according to the system used in the *International Journal of Middle East Studies*. However, titles of works in Arabic are generally transliterated as such, as are titles, such as *Kalila wa dimna*, that are typically given in Arabic though the text may be in Persian. Names of individuals, however, are presented according to Persian pronunciation, even if the name is Arabic in form, such as that of Qivam al-Din al-Kitab. A few words and names, such as "Qara Qoyunlu" and "beg," are presented in their common transliterated form, even though it does not follow the *IJMES* model. In addition, the names of the letters of the Persian alphabet, as used in chapter 4, follow the model of Thackston (1993). Diacriticals, vowel markings, and most other orthographic marks—except for *ayn* and *hamza*—have not been included in the transliterations.

This study grew out of my doctoral research at the Oriental Institute of Oxford University, under the supervision of Julian Raby, now director of the Freer Gallery of Art and the Arthur M. Sackler Gallery, Washington, D.C., and I must first and foremost thank Julian for his continued support and for so kindly offering to publish *The Look of the Book* as part of the Freer Gallery of Art Occasional Papers.

I am greatly indebted to the Hagop Kevorkian Fund for its generous financial support of the publication of this book, and also to the Chester Beatty Library—Fionnuala Croke, director; Michael Ryan, former director; and the board of trustees—which also provided financial assistance. Further support was kindly provided by the Mellon Publications Endowment of the Freer Gallery of Art and the Barakat Trust.

For their contributions to the publication of this volume, I am grateful to the following individuals at the Freer Gallery of Art and the Arthur M. Sackler Gallery: Nancy Micklewright, Massumeh Farhad, Louise Cort, Jane Lusaka, and Betsy Kohut; and Ann Hofstra Grogg for her careful editing of the text. At the University of Washington Press: Jacqueline Ettinger, Marilyn Trueblood, Pamela Canell, Alice Herbig, Rachael Levay, and designer Richard Hendel. Other individuals to whom I am indebted are, in the U.K.: Robert Hillenbrand, University of Edinburgh; Charles Melville, Cambridge University; Nahla Nassar, Nasser D. Khalili Collection of Islamic Art, London; Eleanor Sims, London; Chrysanthe Constantouris, Victoria and Albert Museum; Auste Mickunaite, British Library; Yani Petsopoulos and Sylvia Segal, Alexandria Press, London; James Allan, Teresa Fitzherbert, and Oliver Watson, The Oriental Institute, Oxford University; John Gurney and Faraneh Alavi, formerly of Oxford University; Doris Nicholson, formerly of the Bodleian Library, Oxford; elsewhere in Europe: Maria Queiroz Ribeiro, Gulbenkian Museum, Lisbon; Olga Vasilyeva, National Library of Russia, St. Petersburg; Norbert Ludwig, Bildagentur für Kunst, Kultur und Geschichte, Berlin; in the Middle East and Central Asia: Bernard O'Kane, American University in Cairo; Khalid Ali, Museum of Islamic Art, Doha; Sue Koukji, Dar al-Athar al-Islamiyyah, Kuwait; Filiz Çağman, former director of the Top-

kapi Palace, Istanbul, and Ayşe Erdoğu, deputy director, Zeynep Çelik Atbas, and Esra Müyesseroğlu of the same institution; Nazan Ölçer, Sakıp Sabancı Museum; Şule Aksoy, formerly of the Turkish and Islamic Arts Museum, Istanbul, and Yeliz Çetindag of the same institution; Francis Richard, French Institute for Central Asian Studies, Tashkent; and in North America: Sergei Tourkin, McGill University; Linda Komaroff, Los Angeles County Museum of Art; Abolala Soudavar, Houston; Shreve Simpson, Baltimore; Tom James, Oriental Institute Museum, University of Chicago; and Mike Schwartz, Princeton University Press. And last, but by no means least, thanks are due to Sinead Ward and Frances Narkiewicz, both of the Chester Beatty Library, for their assistance with all matters concerning photography of the Chester Beatty Library folios.

Financial support for my original research was provided by a number of organizations and institutions, and I would like to take this opportunity to thank each of them once again: the Social Sciences and Humanities Research Council of Canada; The Barakat Trust; Oxford University (Overseas Research Student Fund and the Graduate Studies Committee); The British Institute of Persian Studies; The Oriental Institute, Oxford University; The Arnold, Bryce and Read Fund, Oxford University; The British Institute of Archaeology in Ankara; The World of Islam Festival Trust; and St. Antony's College (The Raymond Carr Fund), Oxford.

Aga Khan	Collection of the late Prince Sadruddin Aga Khan, Geneva
Bayezit	Bayezit Library, Istanbul (former Millet Library Collection)
Berenson	Berenson Collection, I Tatti, Florence
Berlin-MIK	bpk / Museum für Islamische Kunst, Staatliche Museen zu Berlin
Berlin-SB	Staatsbibliothek, Preussischer Kulturbesitz, Berlin
BL	British Library, London
BL-IOL	British Library, India Office Library Collections, London
BM	British Museum, Department of Oriental Antiquities, London
BN	Bibliothèque nationale de France, Paris
BOD	Bodleian Library, Oxford
Cairo	Dar al-Kutub, Cairo
CBL	Chester Beatty Library, Dublin
Christie's	Christie's Sale Catalogues, London
CUL	Cambridge University Library
Detroit	Detroit Institute of Arts
EUL	Edinburgh University Library
FITZ	Fitzwilliam Museum, Cambridge
Florence	Biblioteca Nazionale Centrale, Florence
Freer	Freer Gallery of Art, Smithsonian Institution, Washington, D.C.
Georgian	Institute of Manuscripts of the Georgian Academy of Sciences
Gulistan	Gulistan Palace Library, Tehran
IAM	Istanbul Archaeology Museum
IUL	Istanbul University Library
JRL	John Rylands Library, Manchester
Keir	Keir Collection, London
Khalili	Nasser D. Khalili Collection of Islamic Art, London
Krauss	(former) Collection of Hans P. Krauss
Kuwait	Dar al-Athar al-Islamiyyah, Kuwait
Leiden	University Library, Leiden
Lisbon	Calouste Gulbenkian Foundation, Lisbon
Majlis	Majlis Library, Tehran

Malek	Malek Library, Tehran
Mashhad	Mashhad Shrine Library
MET	Metropolitan Museum of Art, New York
Morgan	Pierpont Morgan Library, New York
Munich	Bayerische Staatsbibliothek, Munich
Pars	Pars Museum, Shiraz
Punjab	Punjab University Library, Lahore
Qatar	Museum of Islamic Art, Doha, Qatar
RAS	Royal Asiatic Society, London
Sackler	Arthur M. Sackler Gallery, Smithsonian Institution, Washington, D.C.
Sam Fogg	Islamic Manuscripts, Catalogue 22, London 2000
Sotheby's	Sotheby's Sale Catalogues, London
StP-HM	St. Petersburg, Hermitage Museum
StP-IOS	St. Petersburg, Institute for Oriental Studies, Russian Academy of Sciences
StP-RNL	St. Petersburg, Russian National Library
Suleymaniye	Suleymaniye Library, Istanbul
Tashkent	al-Biruni Institute for Oriental Studies, Academy of Sciences of the Republic of Uzbekistan, Tashkent
Tbilisi	Museum of Fine Arts, Tbilisi, Georgia
TIEM	Türk ve İslam Eserleri Müzesi, Istanbul
TS	Topkapi Saray Library, Istanbul
TUL	Tehran University Central Library
Vienna	Nationalbibliothek, Vienna
WL	Wellcome Library, London

The Look of the Book

is the style of this period that has come to be recognized generally as "the" Injuid style. By comparison, illuminations of the late period are stylistically diverse and therefore do not form an immediately recognizable group.

Early Injuid Illumination

Early Injuid manuscripts from a cohesive group, employing distinct types and styles of illuminations.[4] Especially recognizable is the program of illuminations (namely, the combination of illumination types) used to introduce a manuscript: typically a single-page frontispiece (figs. 1–2) is followed by a double-page frontispiece (fig. 3). The single-page frontispiece consists of a sunburst-like roundel, or *shamsa*, placed between upper and lower panels with rounded ends. Sometimes the panels are joined by a thin frame (in which case the ends of the panels are squared) and the corners of the enclosed space are filled with quarter-circle medallions (fig. 4). The *shamsa* is usually, but not always, formed through the geometrical interlacing of thin white bands, with the spaces between the bands filled with lotuses, palmettes, or bits of arabesque incorporating palmettes and often in the form of small medallions. Any of these same elements, or a windmill-type motif, might also be placed conspicuously at either end of the two panels that border the *shamsa*. The lotuses are always large, consisting of a single blossom set on a short stem. The remaining space of the panels is usually inscribed with the title of the manuscript and the name of the author. A petal-like border forms the outer edge of both the *shamsa* and the panels, although a simpler, more leaf-like version is sometimes used for the panels (see fig. 1);[5] less frequently the panels are surrounded by a segmented, mainly white band (see fig. 2).

The predominantly gold palette of these frontispieces clearly arises from a conservative adherence to an older, "all-gold" tradition, one that prevailed in the field of Qur'an illumination from the late eighth and ninth centuries through to the late twelfth century, at least. As in this older tradition, in these Injuid illuminations most forms are delineated only by fine black outlines, by the contrasting of two tones of gold, and by the use of the natural color of the unpainted page. Touches of color are used mainly in the leaf or petal borders: alternating tones of a rusty orange, bluish gray, and olive green or, occasionally, more vibrant and purer hues of red, blue, and green;[6] sometimes a deep red is used to highlight an otherwise all gold palette. In almost all cases, however, each petal of the border is delineated by a thick gold contour.

A manuscript copied by Yahya ibn Muhammad ibn Yahya al-Dudi in 708/1308

The Look of the Book

Illumination

P ainting has long been the prime focus of art historians studying Islamic manuscripts, but it is painting in terms of figurative illustration, not illumination (nonfigurative decoration) that has commanded their almost exclusive attention. Nevertheless, as the only permissible means of adorning the Qur'an (other than, of course, the art of the calligrapher), illumination plays an important role in Islamic art. It is, moreover, an area of study that can prove highly rewarding, especially for periods for which figurative material is relatively sparse, as is the case with the fourteenth century, the period with which this chapter begins.

THE ILLUMINATION AND PATRONAGE
OF INJUID MANUSCRIPTS

One of the earliest existing copies of the *Shahnama*—the epic account of the pre-Islamic kings and heroes of Iran—is dated 741/1341 and bears an illuminated frontispiece inscribed with a dedication to Hajji Qivam al-Dawla va al-Din Hasan, who served as vizier to the Injuid rulers of Shiraz.[1] The manuscript includes 101 paintings, executed in a rather simple but highly distinctive style. In 1936, on the basis of the dedication to Qivam al-Din, Ivan Stchoukine attributed to Shiraz all manuscripts employing a similar style.[2]

One manuscript of this group is a slightly earlier *Shahnama*, dated 731/1330 (TS H. 1479). In 1983, Norah Titley published the illuminated *shamsa*-frontispiece of this manuscript (fig. 1), which at last brought about widespread recognition of an Injuid illumination style and in turn led to the attribution to Shiraz of all unillustrated manuscripts illuminated in the same style.[3] However, although these two Injuid *Shahnama*s, dated 731/1330 and 741/1341, are illustrated in the same style, their illumination styles are not totally congruous because manuscripts produced in Shiraz during the period of Injuid rule can, in fact, on the basis of illumination style, be divided into two groups: those that pre-date 740/1340 and those produced between 740/1340 and the end of Injuid rule in Shiraz in 754/1353. Illuminations of the early period are stylistically both coherent and conservative, and it

is the style of this period that has come to be recognized generally as "the" Injuid style. By comparison, illuminations of the late period are stylistically diverse and therefore do not form an immediately recognizable group.

Early Injuid Illumination

Early Injuid manuscripts from a cohesive group, employing distinct types and styles of illuminations.[4] Especially recognizable is the program of illuminations (namely, the combination of illumination types) used to introduce a manuscript: typically a single-page frontispiece (figs. 1–2) is followed by a double-page frontispiece (fig. 3). The single-page frontispiece consists of a sunburst-like roundel, or *shamsa*, placed between upper and lower panels with rounded ends. Sometimes the panels are joined by a thin frame (in which case the ends of the panels are squared) and the corners of the enclosed space are filled with quarter-circle medallions (fig. 4). The *shamsa* is usually, but not always, formed through the geometrical interlacing of thin white bands, with the spaces between the bands filled with lotuses, palmettes, or bits of arabesque incorporating palmettes and often in the form of small medallions. Any of these same elements, or a windmill-type motif, might also be placed conspicuously at either end of the two panels that border the *shamsa*. The lotuses are always large, consisting of a single blossom set on a short stem. The remaining space of the panels is usually inscribed with the title of the manuscript and the name of the author. A petal-like border forms the outer edge of both the *shamsa* and the panels, although a simpler, more leaf-like version is sometimes used for the panels (see fig. 1);[5] less frequently the panels are surrounded by a segmented, mainly white band (see fig. 2).

The predominantly gold palette of these frontispieces clearly arises from a conservative adherence to an older, "all-gold" tradition, one that prevailed in the field of Qur'an illumination from the late eighth and ninth centuries through to the late twelfth century, at least. As in this older tradition, in these Injuid illuminations most forms are delineated only by fine black outlines, by the contrasting of two tones of gold, and by the use of the natural color of the unpainted page. Touches of color are used mainly in the leaf or petal borders: alternating tones of a rusty orange, bluish gray, and olive green or, occasionally, more vibrant and purer hues of red, blue, and green;[6] sometimes a deep red is used to highlight an otherwise all gold palette. In almost all cases, however, each petal of the border is delineated by a thick gold contour.

A manuscript copied by Yahya ibn Muhammad ibn Yahya al-Dudi in 708/1308

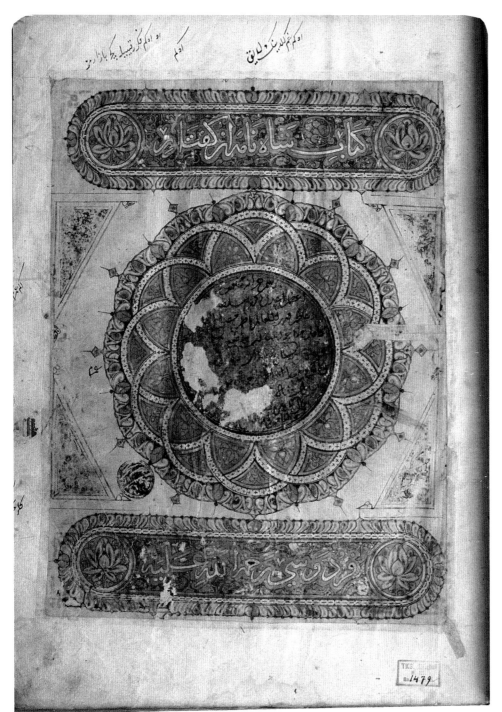

1. Single-page *shamsa*-frontispiece, *Shahnama*, 731/1330, 37.7 x 29.3 cm (folio). Topkapi Saray Library, Istanbul, H. 1479, f. 1a. Photograph by author.

2. Single-page *shamsa*-
frontispiece, *Athar al-bilad*,
729/1329, 34 x 23.1 cm (folio).
© The British Library Board,
Or. 3623, f. 2a.

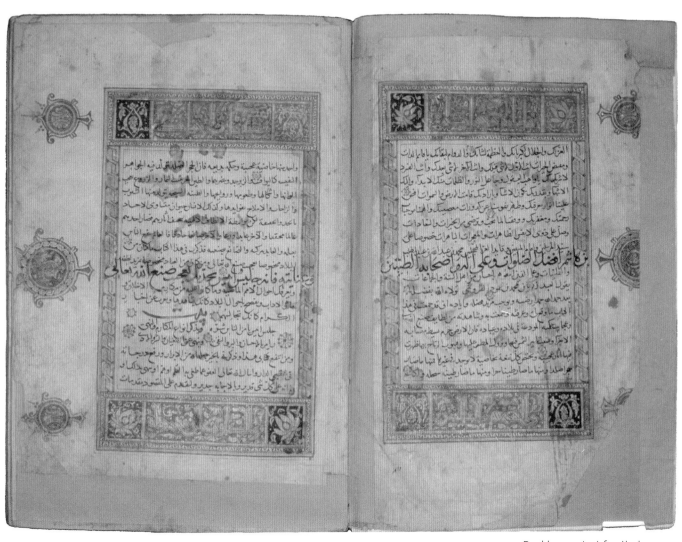

3. Double-page text-frontispiece,
Athar al-bilad, 729/1329, 34 x 23.1 cm
(folio). © The British Library Board,
Or. 3623, ff. 2b–3b.

4. Single-page *shamsa*-frontispiece, *Javami' al-hikayat*, 732/1332, 36.3 x 23.5 cm (folio). © The British Library Board, Or. 2676, f. 4a.

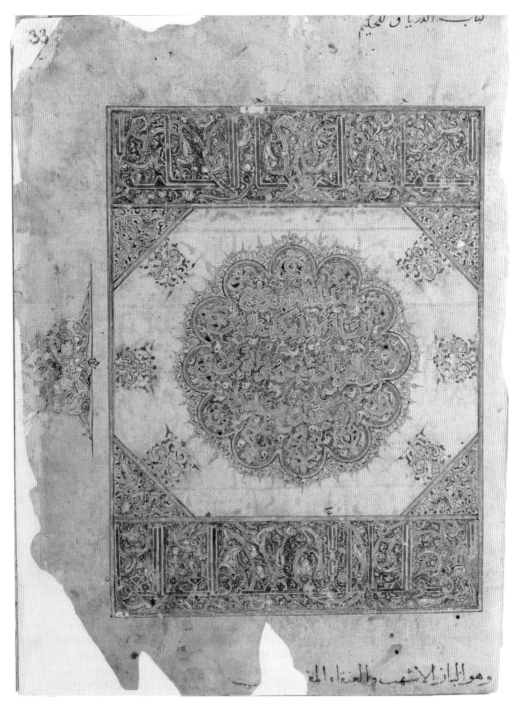

5. One half of a double-page frontispiece, *Kitab al-diryaq*, 595/1199, 36.5 x 27.5 cm (folio). Bibliothèque nationale de France, Arabe 2964.

(BN Pers. 14) may be the earliest extant single-page frontispiece of this type dating to the period of Injuid rule,[7] but at least two dated, pre-Injuid examples exist, in manuscripts dated 672/1274 and 681/1282.[8] These all surely evolve from illuminations such as those in the well-known copy of the *Kitab al-diryaq* (BN Arabe 2964), dated 595/1199 and generally attributed to northern Iraq. The illuminations of this manuscript include a double-page frontispiece, each half of which consists of a multilobed roundel framed by a petal or leaf border and set between linked upper and lower panels (fig. 5).[9] An *ansa* occupies the outer margin of each of the two facing folios. Although red, blue, and green pigments are used, the overall impression is of a predominantly gold palette, with the color of the unpainted page being used to great effect. Therefore, in terms of overall type (*shamsa* set between panels), palette (predominantly gold), and motif (petal border), this double-page frontispiece is a clear precursor to the single-page *shamsa*-frontispiece of early Injuid manuscripts.

Following the *shamsa*-frontispiece is a double-page frontispiece surrounding the beginning of the text of the manuscript (see fig. 3). This text-frontispiece, too, is a specific type, and it is one that will continue to be used in the late Injuid era. It consists of upper and lower panels linked (usually) by wide bands of gold strapwork,[10] and here, too, a gold lotus or a palmette motif is set at either end of each panel, most often against a ground of deep forest green or dark blue. A small roundel or else a stylized palmette motif protrudes from the exterior edge of each panel, and placed midway between the two roundels is a larger, stylized palmette[11] or, more often, an ornate palmette-arabesque element in the form of a triangular *ansa* (fig. 6); often these *ansas* have not survived, but evidence of their former existence can invariably be detected.[12]

Decorated colophons appear in most of these manuscripts, highlighting the documentary information provided, usually the name of the calligrapher and the date when the copying of the text was completed. Typically, double red lines demarcate a more or less (inverted) triangular space, in which the colophon text is written; the (often truncated) triangular spaces on either side of the text area are filled with lotuses and palmettes, either all in gold or in gold on green or dark blue grounds, but, overall, in terms of decoration, colophons form a less uniform group than do either of the two types of frontispiece (fig. 7).

In many manuscripts, the complete program of illumination consists only of the two introductory frontispieces and the colophon. In other manuscripts, however, illuminations are also used to mark internal divisions of the text. Thus, the

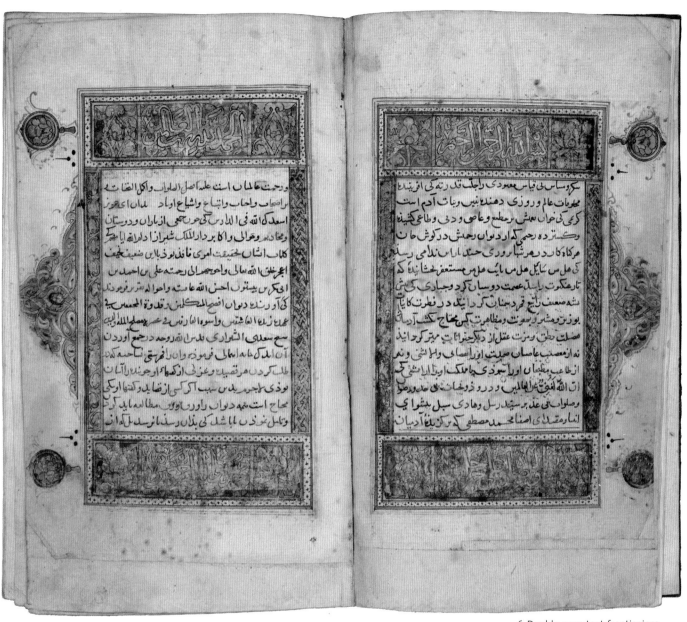

6. Double-page text-frontispiece, *Kulliyyat* of Sa'di, n.d., but mid-fourteenth century, 28.6 x 17 cm (folio). © The Trustees of the Chester Beatty Library, Dublin, Per 113, ff. 2b–3a.

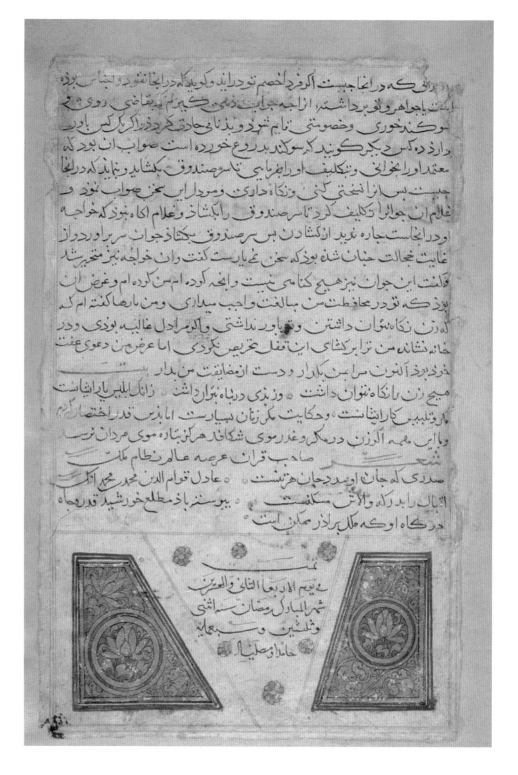

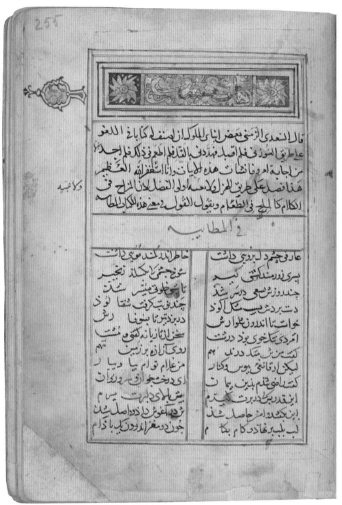

8. Folio with heading, *Kulliyyat* of Sa'di, early fourteenth century,
25.5 x 16.9 cm (folio). © The Trustees of the Chester Beatty Library,
Dublin, Per 109, f. 255a.

9. Folio with heading, *Kulliyyat* of Sa'di, early fourteenth century,
24.5 x 16.9 cm (folio). © The Trustees of the Chester Beatty Library,
Dublin, Per 109, f. 8b.

13

program of illumination generally reflects the formal structure of the text itself. For example, in copies of the *Shahnama*, the poem is always preceded by a prose preface. In the 731/1330 *Shahnama* (TS H. 1479), a single-page *shamsa*-frontispiece (f. 1a; see fig. 1), followed, as one would expect, by a double-page text-frontispiece (ff. 1b–2a), marks the start of the manuscript and therefore the start of the prose preface. The end of the preface is, in turn, marked by a double-page figurative-painting with an illuminated border (ff. 4b–5a), which is immediately followed by another double-page text-frontispiece containing the first couplets of the poem (ff. 5b–6a). In another manuscript, a copy of *Javami' al-hikayat* and *Lavami' al-rivayat* of Muhammad 'Awfi, dated 717/1317 (BN Supp. pers. 95), the text is divided into four major sections. Again, the standard introductory program of a single-page *shamsa*-frontispiece (f. 1a) and a double-page text-frontispiece (ff. 1b–2a) introduces the first section of the text. Each of the next two major sections of the text is also introduced by a double-page text-frontispiece (ff. 149b–50a and 202b–03a), with the final section introduced by two headings (one at the bottom of f. 243b, with an inscription announcing the start of the fourth section, and one at the top of f. 244a, inscribed with the *basmala*). Generally, headings mark less important internal divisions, or, as in the final section of this manuscript, they may be used in place of internal frontispieces, often depending on the wealth or taste of the patron. Whatever the case, headings tend to be almost identical to the upper and lower panels of text-frontispieces (figs. 8–9).

Il-Khanid Illumination

In western Iran, the region controlled by the Il-Khanid sultans (r. 1258–1335), artists employed more varied types and programs of illumination than did their early Injuid contemporaries. For example, in the so-called Anonymous Baghdad Qur'an, a widely dispersed thirty-part manuscript produced in the first decade of the fourteenth century, each *juz'* (section) was introduced by two double-page frontispieces, one a non-text-frontispiece (fig. 10), the other a text-frontispiece. Another manuscript—this time a single-volume Qur'an dated 702/1303—begins with three double-pages of illumination (one consisting of a central roundel and upper and lower inscribed panels; one an arrangement of more than thirty small, lobed cartouches each containing the name of God; and a text-frontispiece).[13] However, in a thirty-part Qur'an dated 733/1334, each *juz'* begins with only a double-page text-frontispiece (fig. 11), while each of the sections of the well-known thirty-part Qur'an made in Maragha, in northwest Iran, in 738/1338,

10. One half of a double-page frontispiece, the Anonymous Baghdad Qur'an, 701–07/1302–08, 49.7 x 35.5 cm (folio).
© The Trustees of the Chester Beatty Library, Dublin, Is 1614.2.

11. Double-page frontispiece,
Qur'an, 734/1334, 35.5 x 26 cm
(folio). © The Trustees of the
Chester Beatty Library, Dublin,
Is 1469a, ff. 1b–2a.

begins with a single, freestanding *shamsa* followed by a double-page text-frontispiece (figs. 12–13).[14] The evidence of these two later Qur'ans suggests a possible move in the 1330s to slightly simpler programs of introductory illumination. In each of these manuscripts, and as is usual in all decorated copies of the Qur'an, each *sura* (chapter) is introduced by an illuminated heading.

The introductory illumination programs used in all other types of Il-Khanid manuscripts, from the late thirteenth century to at least 1340, are often, but not always, much simpler than those used for copies of the Qur'an. A single heading, a single- or a double-page frontispiece, or a combination of these might be used, but if a manuscript begins with a *shamsa*, it is almost certainly followed by a single heading at the top of the next page; the *shamsa* is usually freestanding (with no bordering panels),[15] but it may also be set within an elaborate rectangle, as it is in two extravagantly decorated copies of *al-Majmu'a* of Rashid al-Din.[16]

The style of these various types of Il-Khanid illumination also differs from that used in early Injuid manuscripts. Immediately noticeable is the more varied and usually brighter palette (see figs. 10–13). For example, a leaf (not petal) border is also used in Il-Khanid illumination, but one that is distinctly different from that used in Injuid manuscripts: always, either the whole border consists of leaves in shades of blue (see fig. 13), each outlined in gold, or a brilliant combination of two-toned red and green leaves—likewise outlined in gold—is used.[17] A second striking feature of Il-Khanid illumination is the ubiquitous use of the palmette-arabesque. Clearly a favorite of Il-Khanid artists, there are in fact several frontispieces that consist of little else than this single motif and a structure to contain its spiraling energy (see fig. 10). Although in early Injuid illumination, the palmette-arabesque is at times a prominent element of the double-page text-frontispiece, it never plays more than a minor role in the *shamsa*-frontispiece (see figs. 2–4 and 6). Likewise, bands of gold strapwork are a major element in many Il-Khanid illuminations but are accorded a limited role only in early Injuid illuminations (compare figs. 10 and 3).

Despite the use of common features, the work of Injuid and Il-Khanid illu-

12. *Shamsa*, Qur'an, 738/1338, Maragha, 31.5 x 23 cm (folio). © The Trustees of the Chester Beatty Library, Dublin, Is 1470, f. 1a.

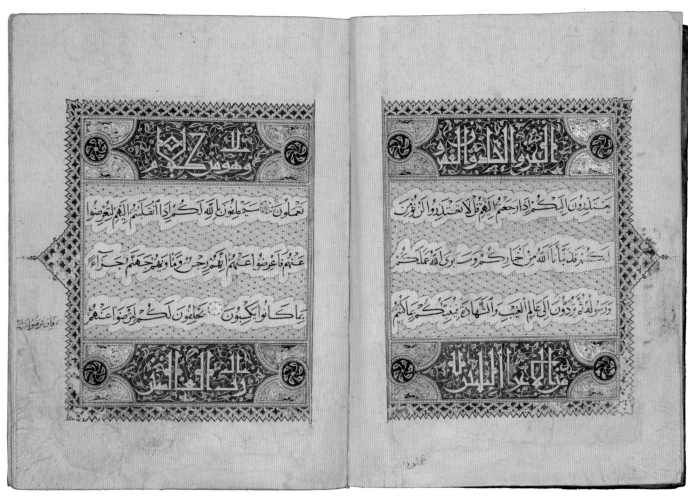

13. Double-page text-frontispiece,
Qur'an, 738/1338, Maragha,
31.5 x 23 cm (folio). © The Trustees
of the Chester Beatty Library,
Dublin, Is 1470, ff. 1b–2a.

minators clearly differs in their emphasis on, and combination of, certain traits. Moreover, while Il-Khanid illuminations may well be an identifiable group, they nevertheless employ a more diverse range of types and programs than are found in early Injuid manuscripts.

Late Injuid Illumination

In contrast to the stylistic homogeneity of the first phase of Injuid illumination, late Injuid illuminations—those produced after 1340—are stylistically diverse. What unites them is their characteristic use, in varying degrees, of Il-Khanid traits.

Three of the known, decorated manuscripts from this period are dated, one of which is the only Injuid manuscript that actually states that it was copied in Shiraz (Pars 456). Dated 745–46/1344–46 and signed by the calligrapher Yahya al-Jamali al-Sufi, the manuscript—a Qur'an—was made for Tashi Khatun, the mother of Abu Ishaq, ruler of Shiraz from 744/late 1343 to 754/1353.[18] It is illuminated in a style distinct from that of the early period: a brightly colored palmette-arabesque border and an extensive use of wide bands of gold strapwork are its main decorative features, each of which is characteristic of Il-Khanid illumination (fig. 14).[19] Yahya's signature in this manuscript suggests that Tabriz, capital to the Il-Khanid sultans throughout much of dynasty's rule, was indeed the source of these new traits, because it is known that Yahya worked first in Tabriz for the Il-Khanid warlord Amir Chupan Sulduz (d. 728/1328), then in Shiraz for the Injus, and finally for their successors, the Muzaffarids. The exact circumstances under which he made his way to Shiraz are not known, although it has been suggested that after the downfall of the Il-Khanids Yahya may have ended up working for the grandson of Chupan Sulduz, Pir Husayn, who was in Shiraz for various periods of time from 740/1339; after the final expulsion of the Chupanids from the city, he would probably have been taken into the employ of Abu Ishaq.[20] The visual evidence of the Yahya Qur'an therefore suggests that by the early 1340s artists as well as calligraphers had moved from Tabriz and were working in Shiraz. Yahya surely was just one individual in a much larger migration, the ultimate cause of which was the dissolution of Il-Khanid rule in western Iran and the ensuing political and social chaos.[21]

Also exhibiting Il-Khanid traits is a copy of *Tarjuma-i ihya'-i ʿulum al-din*, a Persian translation of al-Ghazali's great work on theology, dated 744/1344 (TS H. 231). The manuscript opens with what is in fact a typical early Injuid type of single-page frontispiece (fig. 15), but here the usual gold palette is offset by an

14. One half of a double-page frontispiece marking the beginning of *juz'* 11, Qur'an, 745–46/1344–46, 50 x 36 cm (folio). Pars Museum, Shiraz, no. 456 (folio number unknown). Reproduced courtesy of Alexandria Press, from David James, *Qur'ans of the Mamluks* (1988), fig. 115.

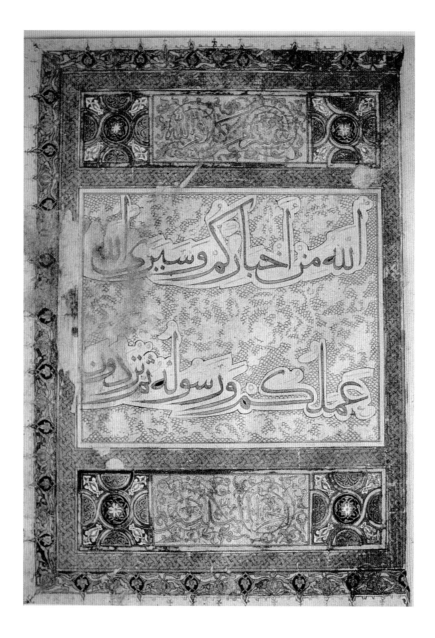

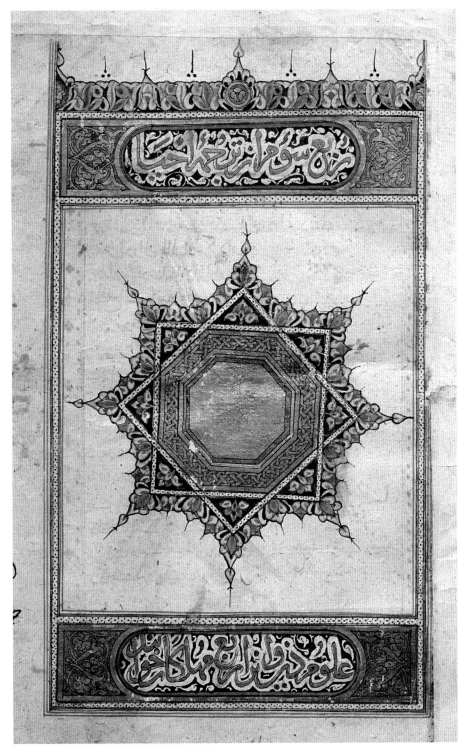

15. Single-page *shamsa*-frontispiece, *Tarjuma-i ihya-i 'ulum al-din*, 744/1344, 35.6 x 24.2 cm (folio). Topkapi Saray Library, Istanbul, H. 231, f. 1a. Photograph by author.

16a. One half of a double-page frontispiece, *Shahnama*, 741/1341, Shiraz, 36 x 27.7 cm (folio). Arthur M. Sackler Gallery, Smithsonian Institution, Washington, D.C.: Purchase—Smithsonian Unrestricted Trust Funds, Smithsonian Collections Acquisition Program, and Dr. Arthur M. Sackler, S1986.111a.

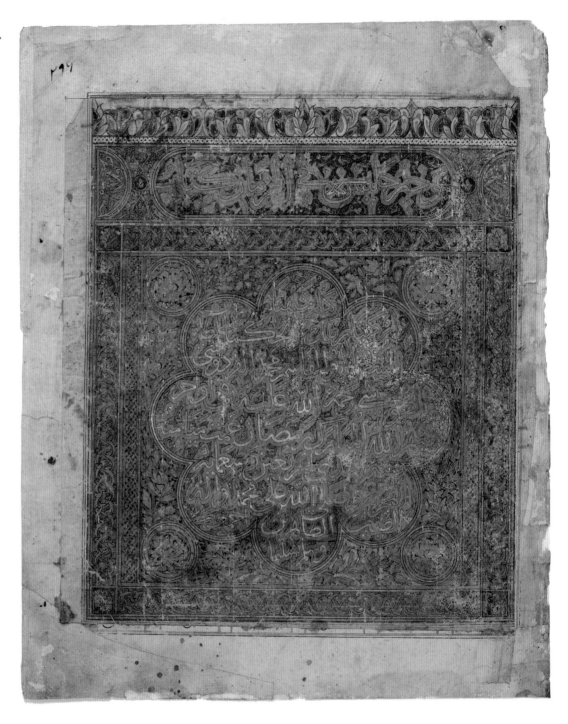

unexpected abundance of blue and green, indicative, it would seem, of the influence of the brighter palette of Il-Khanid illumination.

The last of the three dated late Injuid manuscripts is the dispersed Qivam al-Din *Shahnama* of 741/1341. In this manuscript, the single-page *shamsa*-frontispiece typical of the early Injuid era has evolved into a double-page frontispiece, in this case one that marks the end of the prose preface (fig. 16a).[22] Each half of the frontispiece consists of a square, in the center of which is a large, lobed roundel that is not freestanding—and therefore not a true *shamsa*—but is instead completely integrated into the surrounding space of the frontispiece. The roundel is so large it almost completely fills the central square, which is boldly delineated by wide bands of palmette-arabesque and strapwork. A small roundel is placed in each corner of the square, and any remaining space around the central roundel is completely filled with blossoms and leaves. The two halves of the frontispiece are not identical, and on the right-hand page a typical early Injuid leaf border sits immediately above the upper band of palmette-arabesque and the central roundel; then, above the leaf border, are the last five lines of the preface. However, on the left-hand page there are no lines of text and the leaf border sits above an illuminated panel. Another manuscript, a copy of the *Kulliyyat* of Saʿdi in the Chester Beatty Library (CBL Per 113; fig. 17), also employs a double-page frontispiece of this same basic type. The manuscript is undated, and, although its inclusion of a double-page "*shamsa*"-frontispiece suggests it is contemporary with the 1341 *Shahnama*, it does not employ any Il-Khanid traits; it is therefore better classified as transitional between the early and late periods of Injuid illumination.[23]

In the frontispiece of the 741/1341 *Shahnama*, the gold blossoms and leaves that surround the lobed roundel are set against a darker gold ground and are delineated by a fine black contour that thickens noticeably at the tip of each petal or leaf (fig. 16b). The decoration of many early Injuid manuscripts includes gold florals on a gold ground delineated by a black contour, but only in the *Shahnama* does this specific technique of black-tipping appear. However, it does appear in a painting entitled "Sindukht Becomes Aware of Rudaba's Actions" (Sackler S1986.102), one of the dispersed folios from the Great Mongol *Shahnama*, attributed to Tabriz in about 1335. That it does suggests that knowledge of this painting technique, ultimately of Chinese origin, may have reached Shiraz via a Tabriz artist.[24] Moreover, two illustrations from the 741/1341 *Shahnama* (CBL Per 110.4 and Sackler S1986.99a) are painted in the contemporary style of Tabriz and recall

16b. Detail of fig. 16a.

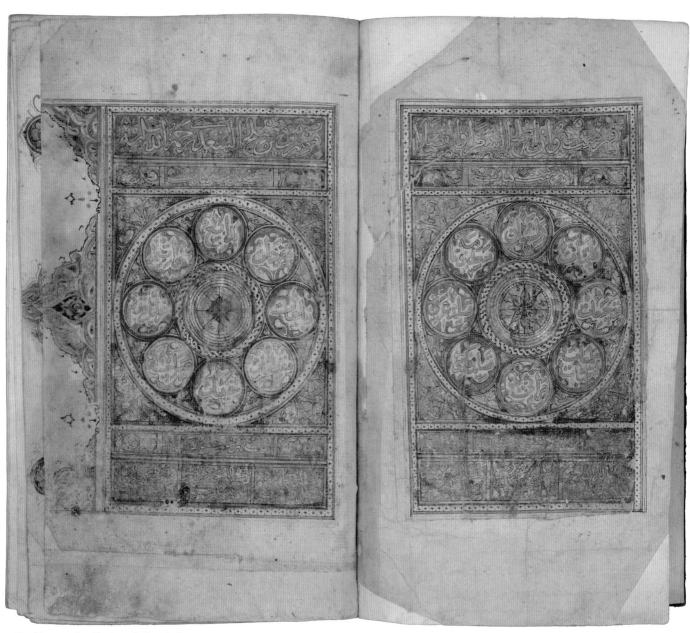

17. Double-page frontispiece, *Kulliyyat* of
Sa'di, n.d., but mid-fourteenth century,
28.6 x 17 cm (folio). © The Trustees of the
Chester Beatty Library, Dublin, Per 113,
ff. 1b–2a.

those of the Great Mongol *Shahnama*. All others in the 741/1341 manuscript are in the typical Injuid style. The Il-Khanid-style illustrations are usually denounced as fakes or, at the very least, as later additions to the 741/1341 manuscript. However, no evidence exists to support this allegation other than the incongruity of employing two such diverse styles in one manuscript. It is therefore likely that the paintings are indeed contemporary with the 741/1341 manuscript, painted by an artist who had fled Tabriz.[25]

The Il-Khanid traits present in the three manuscripts dated in the 1340s make it possible to attribute three undated manuscripts with extensive Il-Khanid traits to this same decade, or perhaps to the early 1350s. These three manuscripts are certain of the remaining parts of a thirty-part Qur'an now divided between the Nasser D. Khalili Collection of Islamic Art in London (QUR182; figs. 18–19) and the Pars Museum in Shiraz (no. 417); a single-volume Qur'an, also part of the Khalili Collection (QUR242); and the so-called Stephens *Shahnama*, now on long-term loan to the Arthur M. Sackler Gallery (LTS1998.1.1.1–94; figs. 20–21). In fact, greater Il-Khanid influence is evident in each of these three manuscripts than in any of the three dated ones.

The Qur'an that is now divided between the Khalili Collection and the Pars Museum was copied for Fars Malik Khatun, sister of Abu Ishaq. The endowment notice at the beginning of each part states that the manuscript was to be kept in her house until her death, then placed at the head of her tomb, although it has been suggested that as the manuscript was still unfinished at the time of her death, it is unlikely that her wish was ever carried out.[26] Each endowment notice is in the form of a single-page frontispiece (see fig. 18) of the same basic type as those in the 1341 *Shahnama* and the Chester Beatty *Kulliyyat* of Sa'di. A frontispiece of the same type is also used in the Stephens *Shahnama* (see fig. 20).[27] In the latter manuscript and in the Qur'an, the central, lobed roundel, or "*shamsa*," is again thoroughly integrated into the surrounding space of the frontispiece, yet as single-page frontispieces (bordered by both upper and lower panels) they more closely follow the tradition of the early Injuid era. The placing of blossoms at either end of the tripartite panels of both these and the text-frontispieces (see figs. 19 and 21), and the actual types of blossoms used (some of which can be read as derivations of the lotus), further link these illuminations to those of the early Injuid era. In the Qur'an, the blossoms are large, painted in gold, and placed against a dark ground, either deep blue or burgundy, parallels for which are found in both Il-Khanid and Injuid illustrations as well as in the illuminations of earlier Persian

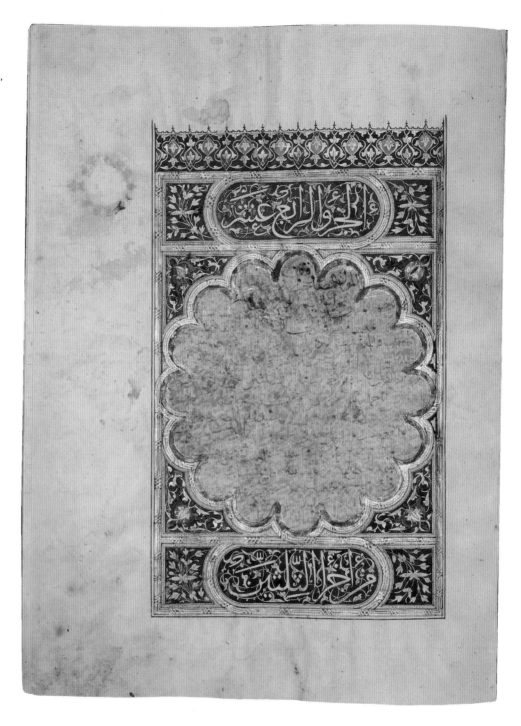

18. Single-page frontispiece, Qur'an, probably 1340s, 42.4 x 30.9 cm (folio). Nasser D. Khalili Collection of Islamic Art, QUR182, f. 26a. © Nour Foundation. Courtesy of the Khalili Family Trust.

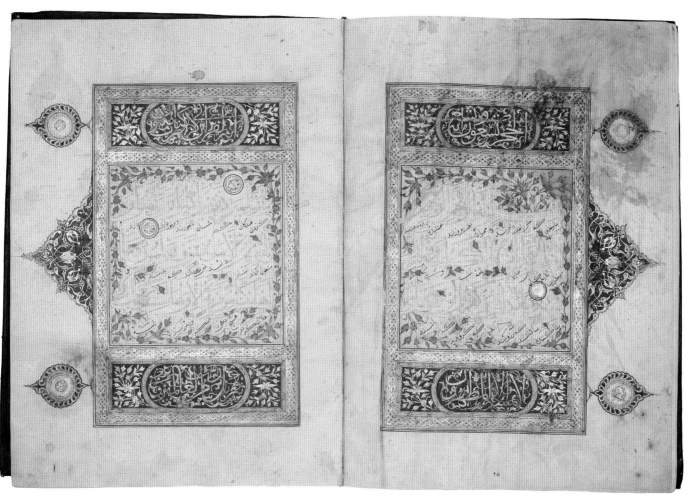

19. Double-page text-frontispiece, Qur'an, probably 1340s, 42.4 x 30.9 cm (folio). Nasser D. Khalili Collection of Islamic Art, QUR182, ff. 26b–27a. © Nour Foundation. Courtesy of the Khalili Family Trust.

20. Single-page frontispiece marking the start of the second half of the poem, Stephens *Shahnama*, n.d., but late 1340s to early 1350s, 29.1 x 20.2 cm (folio). Lent by Mr. and Mrs. Farhad Ebrahimi; Courtesy of the Arthur M. Sackler Gallery, Smithsonian Institution, Washington, D.C., LTS1998.1.1.70a.

21. One half of a double-page text-frontispiece marking the start of the prose preface, Stephens *Shahnama*, n.d., but late 1340s to early 1350s, 29.1 x 20.2 cm (folio). Lent by Mr. and Mrs. Farhad Ebrahimi; Courtesy of the Arthur M. Sackler Gallery, Smithsonian Institution, Washington, D.C., LTS1998.1.1.8a.

and non-Persian manuscripts.[28] Strictly Il-Khanid influence is clearly evident in the increased use of the palmette-arabesque: in particular, now an arabesque (not leaf or petal) border sits atop the upper edge of each single-page frontispiece (see figs. 18 and 20).[29] When the petal border is retained, as on the small marginal roundels of the text-frontispieces, it is the type and coloring characteristic of Il-Khanid, not early Injuid, manuscripts (see figs. 19 and 21), and indeed the overall palette of these illuminations with their varied range of colors is certainly Il-Khanid. Il-Khanid influence is also apparent in the greater use of strapwork, in particular in the Fars Malik Khatun Qur'an, where it is no longer used merely to link the panels of the frontispieces, but rather it totally surrounds them, functioning as the superstructure of the whole composition.

Although the Fars Malik Khatun Qur'an was copied for an Injuid princess, it does not actually state that it was copied in Shiraz. It is in fact of a much higher quality, in terms of the draftsmanship, paper, and pigments, than any of the early Injuid manuscripts, and its high quality, along with its obvious Il-Khanid-influenced illumination style, might well tempt one to think that the manuscript had been made to order for the princess in another center, probably Tabriz. But the Yahya Qur'an leaves no doubt that Il-Khanid traits were being employed extensively in Shiraz manuscripts in the late Injuid period. Moreover, the Stephens *Shahnama*, which exhibits the same Il-Khanid traits as the Fars Malik Khatun and Yahya Qur'ans and which is adorned with illuminations equally as fine as those of the former manuscript, can be placed firmly in Shiraz on the basis of its illustration style—an often denigrated style, in which prevail highly stylized forms, at times executed in an uncertain hand (and particularly so in the Stephens manuscript) and favoring a palette of deep red and ocher. There can therefore be little doubt that the Fars Malik Khatun Qur'an was made in the city in which its patron lived, though there is equally little doubt that included among those who produced it were artists and craftsmen who had once worked in the Il-Khanid capital of Tabriz.[30]

The Evidence of Injuid and Il-Khanid Metalwork
The documentary evidence of the Qur'an copied by Yahya al-Sufi (Pars 456) and the visual evidence of this and other late Injuid manuscripts suggest that by the early 1340s artists and calligraphers from Tabriz had moved to Shiraz. Contemporary metalwork indicates that it was not only the arts of the book that were affected by the influx into the city of those fleeing the turmoil following

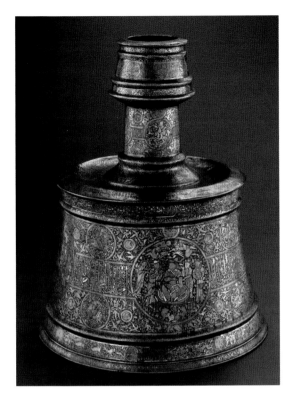

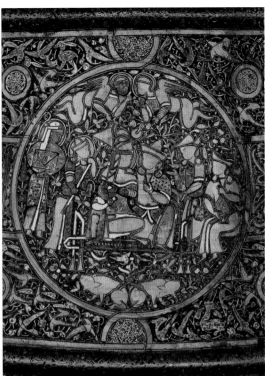

22a. Inlaid brass candlestick inscribed with the name of Abu Ishaq, n.d., but 1343–53, 34.2 cm (height). Museum of Islamic Art, Doha, Qatar, MW.122.1999.

22b. Detail of Abu Ishaq's candlestick (fig. 22a), showing ruler and consort enthroned together.

the breakdown of Il-Khanid rule. As with manuscripts such as the Khalili Qur'an made for Fars Malik Khatun (QUR182), certain metalwork objects of the 1340s are of a much higher quality than other contemporary pieces made in Shiraz. In particular, a candlestick that bears the name of Abu Ishaq Inju (figs. 22a–b), but neither a date nor the name of the place it was made, is technically superior to the mass of bowls attributed to Shiraz and most often decorated with roundels depicting figures in small pointed caps who stand on either side of a seated figure or are engaged in hunting (fig. 23).[31] These bowls are normally attributed to Shiraz because some bear inscriptions that refer to the "Inheritor of the Kingdom of Solomon," a title used by the rulers of Fars, who incorrectly regarded Pasargadae and Persepolis as Solomonic sites and to which they made pilgrimages.[32] The bowls are not dated, but they are usually assigned dates from the late 1330s to about the start of the third quarter of the fourteenth century.[33] Although they can vary greatly in quality, they are generally inferior to Abu Ishaq's candlestick. Writing in 1987, before the Fars Malik Khatun Qur'an had been identified, James Allan explained this discrepancy in quality by attributing production of the candlestick to Baghdad, presuming that it was made on order of the Injuid ruler because work

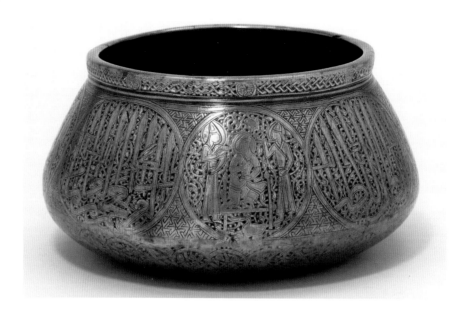

of such quality was unavailable in Shiraz.[34] But the realization that high-quality manuscripts such as the Fars Malik Khatun Qur'an were being produced in Shiraz during the reign of Abu Ishaq now makes it possible to accept that high-quality metalwork, too, was available locally.

The imagery of the candlestick also differs from that used on the bowls, and in some ways it relates more closely to Il-Khanid imagery. There are, for example, correspondences between the imagery of the candlestick and a composite vessel known as the Nisan Tasi, parts of which (the basin, globular support, and pedestal) are inscribed with the name of the Il-Khanid ruler Abu Sa'id (r. 716–36/1316–35): the frieze of running animals around the base of the candlestick and the band of palmette-arabesque motifs (each set in its own diamond- or triangular-shaped space) that runs around the upper edge of the body—and which also appear on a bowl in Brussels that is inscribed with Abu Ishaq's name—are similar to motifs used on the basin of the Nisan Tasi.[35] However, these motifs are not used on the large group of bowls attributed to Shiraz on the basis of references to the Kingdom of Solomon. The frieze of animals, especially, harks back to the metalwork tradition of the thirteenth century and the early decades of the fourteenth and is found on Persian, Mesopotamian, and Syro-Egyptian pieces, including a bowl dated 705/1305 that may be a product of Shiraz, for it is signed by an artist named 'Abd al-Qadir ibn 'Abd al-Khaliq Shirazi.[36] Nevertheless, the evidence of the Il-

Khanid portions of the Nisan Tasi suggests that these motifs continued to be used in Tabriz at a time when new and very different types of imagery were being used in Shiraz for the mass of bowls generally produced about the mid-fourteenth century. The appearance of Nisan Tasi–type imagery on Abu Ishaq's candlestick can therefore be credited to Il-Khanid artists working in Shiraz. Furthermore, that the flying duck motif that is so prevalent a feature of the candlestick is also used on a bowl dated 738/1338 and which is probably a product of Shiraz, for it is inscribed "Inheritor of the Kingdom of Solomon," suggests that Tabriz metalworkers were in Shiraz by 1338.[37]

A further piece of metalwork pertinent to this discussion is an undated tray now in the Museum of Fine Arts in Tbilisi (no. 48/1). As noted by Linda Komaroff, there is a close similarity between the imagery of the tray and an illustration from a copy of the *Jami' al-tavarikh* thought to have been produced about 1330 and now preserved in an album in Istanbul (TS H. 2153, f. 148b).[38] Komaroff comments in particular on the "spatially expanded compositions" of Il-Khanid painting, a trait reflected in the scene of an enthroned couple surrounded by a great assortment of retainers and courtiers that is depicted on both the tray and the album folio. But the album folio is clearly a product of a Tabriz atelier, while the inscription on the tray, which refers to the "Inheritor of the Kingdom of Solomon," allows it to be attributed to Shiraz. From parallels evident between manuscript illustration and the imagery on metalwork, Komaroff concludes that both illustrators and metalworkers worked from models, or they copied from earlier drawings, and that they presumably at times used the same models.[39] She assumes that the model for the tray was either an actual copy of the *Jami' al-tavarikh* sent to the vassal Injuids prior to 1325 (at which date they became independent of their former Il-Khanid overlords) or that folios of a dispersed manuscript ended up in Shiraz following the downfall of Il-Khanid power in 1335.[40] She mentions only rather incidentally, in a note, that perhaps the artist of the tray might at one time have worked in Tabriz, where he would have had access to Il-Khanid paintings and drawings.[41] However, in light of other evidence discussed here it would seem that this suggestion is indeed closer to the true explanation for the imagery of the tray. And although manuscripts and other goods from the former Il-Khanid capital surely would have reached Shiraz, Il-Khanid influence undoubtedly was often much more direct and occurred as a result of actual artists and craftsmen from Tabriz working in Shiraz. Metalworkers clearly were among those who went in search of new centers of employment following the dissolution of Il-Khanid rule.

Issues of Patronage

A change in patronage also distinguishes manuscripts produced in the late Injuid period from those of the early period. Of the traits that can be cited as evidence of this change, none are either evenly or consistently employed in all manuscripts, yet taken as whole they make explicit the contrast between the two groups of manuscripts.

The first of these traits can be summed up as the overall higher quality of late Injuid manuscripts in comparison with those of the early Injuid period and refers to the quality of the materials used, the skill of the artists, and the quantity of decoration. The higher quality of the Fars Malik Khatun Qur'an (and also the Abu Ishaq candlestick) has already been commented upon. The quality of the illuminations in the late Injuid Stephens *Shahnama* is certainly equal to those in the Khalili Qur'an, but as noted previously the *Shahnama* rather surprisingly employs the often denigrated early Injuid illustration style. The quality of the illuminations of the dispersed *Shahnama* of 741/1341 does not quite match that of either of these latter two manuscripts, but, like the Stephens *Shahnama*, it employs a more elaborate illumination program than is typical of early Injuid manuscripts, and in particular it begins, not with a single-, but rather a double-page *shamsa*-frontispiece.[42] The manuscript—made for one of the ruler's viziers—also has a greater number of illustrations than either of the two early Injuid *Shahnama*s. The move to a new level of patronage that these changes seem to suggest can be explained as a probable—though not exclusive—division between public and private markets, a division for which further evidence is suggested by the treatment of the *shamsas* (or central roundels) of these manuscripts.

In both the 741/1341 *Shahnama* and the Fars Malik Khatun Qur'an, the importance of the *"shamsa"* inscription is proclaimed by the amount of space it occupies (in each case nearly half of the whole frontispiece) and by the use of an elaborate outlined script set against a decorated ground (see figs. 16 and 18). The double-page frontispiece of the 741/1341 manuscript states the title, the name of the patron, and the date, while the single-page versions in the Fars Malik Khatun Qur'an each function as a *vaqfiyya*, detailing the princess's donation of the manuscript. In sharp contrast to these two examples is the small gold space that forms the center of several other Injuid *shamsas* (see figs. 2, 4, and 15). The title and name of the author usually appears in the two panels that border the *shamsa*, so the central space presumably was intended for a dedication to the owner. The small size of the space, however, signals the presumed insignificance of the in-

tended dedication and thereby of any owner it might name. But, in fact, the dedications were probably never added, for most of the *shamsa* centers are now blank or have later, hastily written inscriptions.[43] It would seem, therefore, that these manuscripts were not made to order but perhaps were instead commercial products, made to be bought—and later inscribed—by individuals wealthy enough to purchase a decorated manuscript in the market, yet not so wealthy as to be able to commission one of their own design. With the exception of the 744/1344 manuscript (TS H. 231; see fig. 15), these all are part of the early Injuid group.[44]

This is not to say, however, that all early Injuid manuscripts were made for commercial sale. The 731/1330 *Shahnama* (TS H. 1479; see fig. 1) now has a later inscription, but Zeki Togan claims that it once bore a dedication to Ghiyath al-Din Muhammad, the Il-Khanid vizier and son of Rashid al-Din, who died in 736/1336.[45] Unfortunately, there is no way of verifying this claim. Royal, or at least courtly, patronage might also appear to be indicated by the iconography of the double-page frontispiece (with illuminated border) in each of the four Injuid *Shahnama*s (of which two are early Injuid and two are late Injuid). In three of these manuscripts, the folio on the left portrays a ruler enthroned and surrounded by various combinations of princes, musicians, servants, and other courtiers, while the folio on the right depicts a royal hunt. In the 731/1330 *Shahnama*, the iconography of the double-page painting is more unusual and may portray the presentation of gifts to a ruler or other high official on the occasion of Nawruz.[46] However, while royal imagery as used in these double-page paintings is well-suited to the *Shahnama*, it is not restricted to copies of the *Shahnama*, nor does it necessarily indicate royal patronage. Richard Ettinghausen noted that royal imagery is used in the frontispiece of several thirteenth- and fourteenth-century manuscripts that cannot be attributed to royal patronage and suggested that these manuscripts might instead merely be works copying a royal archetype.[47] In other words, by the thirteenth century, the portrayal in frontispieces of rulers enthroned or engaged in royal pastimes such as the hunt, and perhaps even the depiction of more specific events such as the Nawruz ceremony, had passed beyond the sphere of the court to serve as standard frontispiece iconography in both court and noncourt manuscripts. The royal iconography of a frontispiece therefore should not on its own be taken as evidence of royal patronage.[48]

The evidence for the early Injuid period weighs more heavily in favor of commercial production with perhaps just one manuscript—the 731/1330 *Shahnama*—a product of court patronage. However, in the late Injuid period, court—and

specifically royal—patronage is not in doubt and is more extensive. Manuscripts were commissioned by an Injuid vizier and by the sister and mother of the ruler Abu Ishaq, who himself commissioned at least three surviving pieces of metalwork[49] and who can, perhaps, be associated with two manuscripts, though neither actually bears his name. These two manuscripts are a copy of *Mu'nis al-ahrar*, produced in Isfahan and dated 741/1341 (Kuwait LNS 9 MS), and the undated Stephens *Shahnama*. In the double-page frontispiece included in each, a ruler is shown enthroned with his consort, a scene also depicted on Abu Ishaq's candlestick (see fig. 22b) and on the Tbilisi tray. The portrayal of an enthroned couple is rare in Islamic art as a whole, yet a surprising twenty-six such depictions, including two on metalwork, are known from the fourteenth century. Including those previously discussed, they are:

SMALL, SQUARE ENTHRONEMENTS (TABRIZ)
1. Berlin-SB Diez A folio 71, s. 41 no. 4, s. 42 no. 4, s. 42 no. 6, s. 45 no. 4, s. 46 no. 6, and s. 63 no. 1 (six paintings)[50]
2. Berlin-SB Diez A folio 71, s. 63 nos. 2–3 and 5–7 (five paintings)[51]
3. Tashkent 1620, ff. 109a ("Ogedei Khan and His Wife") and 193a ("Hulagu Khan and His Wife"), *Tarikh-i ghazani* (vol. 1 of *Jami' al-tavarikh*) (two paintings)[52]

SINGLE-PAGE ENTHRONEMENTS (TABRIZ)
4. Berlin-SB Diez A folio 70, s. 22[53]
5. Berlin-SB Diez A folio 71, s. 48[54]
6. Berlin-SB Diez A folio 71, s. 52[55]

DOUBLE-PAGE ENTHRONEMENTS (TABRIZ)
7. Berlin-SB Diez A folio 70, s. 10 (one half of a double-page composition with s. 5)[56]
8. Berlin-SB Diez A folio 70, s. 21 (one half of a double-page composition with s. 11)[57]
9. Berlin-SB Diez A folio 70, s. 23 (one half of a double-page composition with s. 20)[58]
10. TS H. 2153, f. 23b (presumably one half of what was once a double-page composition)[59]

11. TS H. 2153, f. 148b (presumably one half of what was once a double-page composition)[60]

12. Rampur, Reza Library no. 1820, ff. 154b–55a, "The Enthronement of Timur Khan and His Consort," *Tarikh-i ghazani* [61]

OTHER ENTHRONEMENTS

13. Tbilisi 48/1, inlaid brass tray, first half of the fourteenth century, Fars[62]

14. Qatar MW.122.1999, candlestick with the name of Abu Ishaq Inju (see figs. 22a–b)

15. Kuwait LNS 9 MS, *Mu'nis al-ahrar*, f. 2a, Isfahan, 741/1341 (fig. 24)

16. Sackler LTS1998.1.1.3a, Stephens *Shahnama*, f. 3a, n.d., but late 1340s, early 1350s (fig. 25)

Of the twenty-two paintings listed above as numbers 1 to 12, only numbers 3 and 12 remain in their original manuscripts, undated copies of *Tarikh-i ghazani*.[63] All others are today preserved in albums in Berlin and Istanbul. Most of these album paintings can be attributed to Tabriz in about the 1330s,[64] and, as Karin Rührdanz has shown, they, too, were probably made to illustrate copies of *Tarikh-i ghazani*, a history of the Mongols and the first volume of Rashid al-Din's *Jami' al-tavarikh*.[65] As discussed in the next paragraph, these paintings are of three types.

The eleven paintings listed above as numbers 1 and 2 are small, the largest being 65 millimeters square; the two paintings in the Tashkent manuscript, listed together as number 3, are slightly larger.[66] Each depicts a ruler and his consort alone, seated on a throne or only on cushions. The figures, in particular those listed as numbers 1 and 2, are large, filling the whole space of the painting, with hand gestures that indicate lively conversation. The text of *Tarikh-i ghazani* includes a three-part account of each ruler, the first part of which consists of genealogical tables that were illustrated by these small, square paintings.[67] Double-page enthronements of the khan and khatun (numbers 7–12), with the royal household arranged before the throne in a standard format, introduced the second part of each account; they might also have been used within the body of the text of any especially long passages. Particular announcements, feasts, or receptions given by the ruler and reported in the second and third parts of the account were illustrated by large, single-page enthronements of the ruler and consort (numbers 4–6).[68] Thus, each of these three types of paintings, depicting

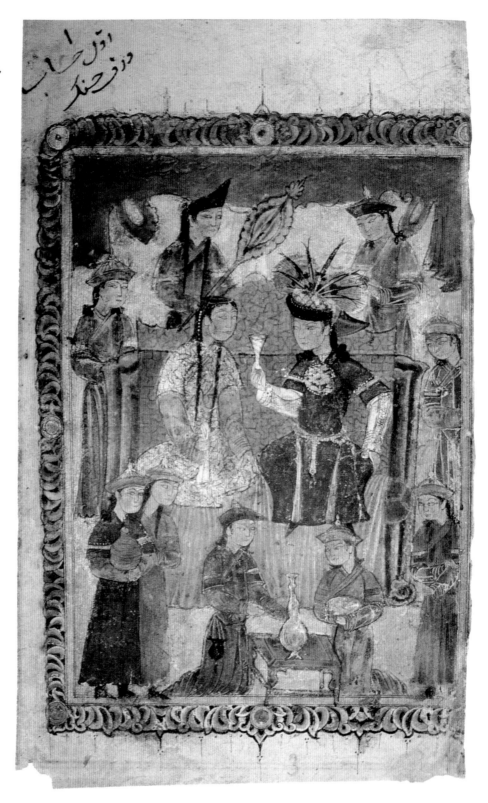

24. One half of a double-page frontispiece, *Mu'nis al-ahrar*, 741/1341, Isfahan, 26.8 x 18.4 cm (folio). Dar al-Athar al-Islamiyyah, Kuwait, LNS 9 MS, f. 2a.

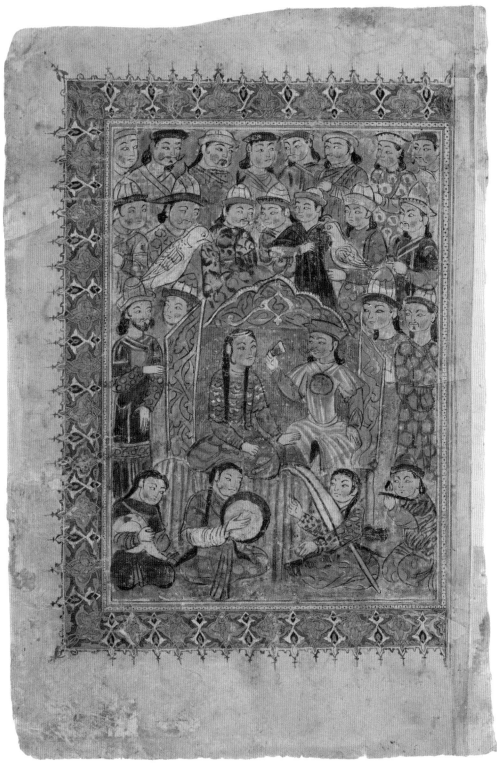

25. One half of a double-page
frontispiece, Stephens *Shahnama*,
n.d., but late 1340s to early 1350s,
29.1 x 20.2 cm (folio). Lent by
Mr. and Mrs. Farhad Ebrahimi;
Courtesy of the Arthur M. Sackler
Gallery, Smithsonian Institution,
Washington, D.C., LTS1998.1.1.3a.

an enthroned couple and attributable to Tabriz, served a specific function within a specific text.[69]

Extracted from this original context, the depiction of an enthroned couple, as on the Tbilisi tray and Abu Ishaq's candlestick and as in the Stephens *Shahnama* and the *Mu'nis al-ahrar* manuscripts, takes on a special significance. This is especially true considering that the function of the Tabriz paintings surely was known to the artists who created these four other depictions, whether they were familiar with the original Tabriz examples from Il-Khanid copies of the *Jami' al-tavarikh* sent from the capital to Shiraz or knew of them firsthand, as artists once employed in Tabriz themselves.

On the Tbilisi tray, the woman is placed on the right. With the exception of just one, or possibly two, of the small genealogy paintings,[70] this same arrangement is used on each of the *Tarikh-i ghazani* depictions of an enthroned couple listed above as numbers 1–12. Komaroff has drawn parallels between the tray, which can be attributed to Fars on the basis of its inscriptions, and one of the *Jami' al-tavarikh* paintings (number 11 above), suggesting that the tray's imagery derives from Il-Khanid painting in Tabriz in about 1330. It is therefore not surprising that the seating arrangement of the couple on the tray follows that of the *Jami' al-tavarikh* paintings. However, on the candlestick, in the Stephens *Shahnama*, and in the *Mu'nis al-ahrar* manuscript, the seating arrangement is reversed, with the woman placed on the left (see figs. 22b and 24–25).[71]

Both the candlestick and the Stephens *Shahnama* can be attributed to Shiraz during the period of Abu Ishaq's rule. The portrayals of the couple on the candlestick and in the *Shahnama* painting are quite different, nor does either relate closely to the *Jami' al-tavarikh* paintings. In terms of the overall composition—and especially the depiction of the couple—the *Shahnama* frontispiece does, however, relate closely to that of the *Mu'nis al-ahrar*. In the *Shahnama*, a much more distant view of the scene is depicted and the supporting cast of attendants and other courtiers is much greater, but the basic arrangement of figures is similar in both compositions, as is the type of throne around which they are dispersed. It is in fact not at all difficult to envisage the reduction of the *Shahnama* composition into that of the *Mu'nis al-ahrar* (or, alternatively, the expansion of the *Mu'nis al-ahrar* composition into that of the *Shahnama*). The relationship between the two sets of enthroned figures is equally obvious. In both scenes the woman wears her hair in long dark plaits with what appears to be only a small, transparent circle of cloth covering her head. In each, her hands are in roughly the same position,

both held low, close to or resting on her lap, not held high and gesturing as in the *Tarikh-i ghazani* examples. The two men wear different hats, but their gestures are identical, with one hand placed firmly on one knee and the other held high and holding a cup or glass, a position similar to that of several of the male rulers in the album paintings and in the Rampur manuscript.

The Tbilisi tray, the candlestick, the Stephens *Shahnama* painting, and the *Mu'nis al-ahrar* painting are therefore linked through the depiction on each of an enthroned couple in a context other than that of the *Tarikh-i ghazani* section of the *Jami' al-tavarikh*.[72] The candlestick, *Shahnama*, and *Mu'nis al-ahrar* are further linked by the placement of the woman on the left, an arrangement almost unknown in other works of the fourteenth century. The candlestick was made for (and presumably by order of) Abu Ishaq; the patron of the *Shahnama* is not known, although it, too, can be attributed to Shiraz during the time of Abu Ishaq's rule and therefore can be at least indirectly associated with him. The link between the two Shiraz objects (the candlestick and the *Shahnama*) and the *Mu'nis al-ahrar* manuscript is the parallel imagery of the two paintings. This parallel imagery suggests that the *Mu'nis al-ahrar* manuscript, too, should be associated with Shiraz and Abu Ishaq.

The *Mu'nis al-ahrar* manuscript is dated 741/1341. Muhammad ibn Badr al-Din was both the poet and compiler of the text and the calligrapher of the manuscript. In the text he speaks of the state of Isfahan at the time of composing his poems, and he notes that following the death of the Il-Khanid sultan Abu Sa'id, in 736/1335, the city fell into a state of turmoil, transforming his once-contented life in Isfahan into one of relative sorrow. He also comments that at the time he was writing, the turmoil had been ongoing for "more or less" five years, which, as A. H. Morton points out, suggests that Ibn Badr must have copied the manuscript only shortly after he had finished composing and compiling the text. From this Morton has in turn concluded that it is likely that Ibn Badr was still living in Isfahan when he copied the manuscript and also that this state of civic upheaval obviously affected patronage of the arts, for the manuscript was produced on the initiative of Ibn Badr alone, acting on the encouragement of "friends and wise notables."[73]

The manuscript opens with a single-page *shamsa*-frontispiece, a variation of the Injuid type, illuminated in an unusual mix of styles: a brilliantly colored, but otherwise Injuid-type, petal border is used on both the *shamsa* and the upper and lower panels, and the latter are filled with gold florals set against a deep blue

ground (fig. 26).[74] Only one other manuscript employing the same mix of styles is known, namely, a copy of Juvayni's *Tarikh-i jahan-gushay* (BN Supp. pers. 1375) that, although undated, can be attributed to Shiraz sometime after 1362.[75] Following the *shamsa*-frontispiece is the double-page painting consisting of an enthroned couple on the left (see fig. 24) and a hunt scene in three registers on the right, although the latter is damaged and only the bottom register—depicting a mounted prince thrusting his sword into a lion—is now complete.[76] The tall, sharply peaked mountains that form the backdrop of the hunt scene are thickly outlined in gold; these are high-quality versions of the spiked peaks seen in Injuid paintings, suggesting that at least this half of the frontispiece could be roughly contemporary with the copying of the text.[77] The painting of the enthroned couple has also suffered damage, for it appears to have been repainted at some stage, but, although one can only guess when and to what extent, there is no reason to suspect that the original composition has been altered in any way. However, considering the specific function of depictions of enthroned couples, the painting surely could not be the product of Ibn Badr's own initiative. It seems, therefore, that he may have copied the text in 1341 but then left the manuscript to be decorated once a suitable recipient or patron was found. Perhaps this was Abu Ishaq.

The manuscript was copied not long before Pir Husayn appointed Abu Ishaq governor of Isfahan, in 742/1341–42. How much time Abu Ishaq actually spent in the city itself is not clear, because it is recorded that in that same year he joined Malik Ashraf in Tabriz, subsequently accompanying him on his campaign into Fars in 743/1342 and then gaining control of Shiraz in 744/late 1343.[78] The manuscript could have been collected by Abu Ishaq and eventually taken to Shiraz with him, or a disheartened Ibn Badr may have himself moved to Shiraz eager to benefit from the patronage of the new Injuid ruler and his family. There the manuscript may eventually have been completed, the composition of the frontispiece being based on that of the *Shahnama*. (Alternatively, the manuscript may have been completed in Isfahan after Abu Ishaq's move there in 1353.)

The simple, mistaken reversal of a pattern during the copying process could well explain the new arrangement for depictions of enthroned couples—with the woman, not the male ruler, seated on the left. But even if so, it was an error that was apparently willingly and intentionally repeated. However, much more important than the question of how the reversal of figures came about is the significance of established imagery being utilized in new contexts (namely, on the Abu Ishaq candlestick and in a copy of the *Shahnama* and a copy of *Mu'nis al-ahrar*)

26. Single-page *shamsa*-frontispiece, *Mu'nis al-ahrar*, 741/1341, Isfahan, 26.8 x 18.4 cm (folio). Dar al-Athar al-Islamiyyah, Kuwait, LNS 9 MS, f. 1a.

and the transference of the dynastic function imbued in that imagery. As will be explained more fully later, Abu Ishaq was the first of the Injuids to see himself as a ruler in his own right, fully independent of the Il-Khanids. In light of this, the imagery on the candlestick and in the two manuscripts was undoubtedly intended to portray Abu Ishaq himself and his consort[79]—an intentional usurping of Il-Khanid imagery to proclaim Injuid dynastic heritage that correlates perfectly

with Abu Ishaq's other endeavors to establish his autonomy. All three images may therefore be attributed to Abu Ishaq, with depictions of an enthroned couple in a context other than that of the *Tarikh-i ghazani* and in which the woman is seated on the left seen as idiosyncratic of his patronage.[80]

The period of Abu Ishaq's rule is also notable for a change in the type of texts that were copied, for the late period—in comparison with the early period—is characterized by a greater production of religious works, specifically copies of the Qur'an: the group of early Injuid manuscripts includes two treatises on theology, one geographical and three historical texts, two copies of the *Shahnama*, and one copy each of *Kalila wa dimna* and the *Kulliyyat* of Sa'di; the group of late Injuid manuscripts includes four copies of the Qur'an,[81] one treatise on theology,[82] the *Mu'nis al-ahrar* anthology of poetry, and again there are two copies of the *Shahnama*. The commissioning of copies of the Qur'an in the late Injuid period can be seen in the broader light of the patronage of religious works in general at that time. For example, the Qur'an copied by Yahya al-Jamali (Pars 456) states that it was copied during the reign of Abu Ishaq. James believes that this statement should not be taken as indicating that the ruler was the patron, but rather that it is much more likely that it was his mother, Tashi Khatun, who commissioned the manuscript, for an endowment notice in the manuscript states that she bequeathed it to the tomb complex of Shah-i Chiragh (Shah-i Chiragh being the name by which Ahmad ibn Musa, the brother of Imam Riza, was known locally). But her patronage was not limited to manuscripts, because between 1344 and 1349 she commissioned major renovations to be carried out at the tomb of this saint to whom she is said to have been especially devoted.[83] The renovations included the addition of both a *madrasa* and a *zawiyya* to provide for Qur'an readers to read continuously at the saint's tomb and for sustenance for the pilgrims who visited.[84]

Fars Malik Khatun, Abu Ishaq's sister, commissioned the large and beautiful thirty-part Qur'an, the remains of which are now divided between the Pars Museum and the Khalili Collection. And she may have been responsible for another two copies of the Qur'an at least (Khalili QUR242 and Pars 427), for James has suggested that all three might well have been illuminated by the same artist.[85] Like Tashi Khatun, she was a patron of architecture, too, and is known to have commissioned the building of a mausoleum over the tomb of a local saint, 'Ali ibn Bazghash, and was responsible for the construction of several other buildings at the same site.[86] Abu Ishaq himself was also a patron of religious architecture. Within the open courtyard of the Jami 'Atiq Mosque in Shiraz is a rectangular

structure, a *khuda-khane* or *bayt al-mushaf*, in which copies of the Qur'an were preserved and possibly also produced. The construction of this building had long been attributed to Abu Ishaq because one of its corner towers bears the date 752/1351. However, Eugenio Galdieri has suggested that it actually predates Abu Ishaq and that the date refers to renovations carried out under orders of the Injuid ruler. Nevertheless, it is significant that Abu Ishaq desired to preserve this particular building in which perhaps were stored copies of the Qur'an commissioned by various members of his family.[87]

Thus, the early and late Injuid periods are distinguished from each other not only by a change in illumination style but also by a change in patronage, for while commercial production seems to have been predominant in the early period (with possibly just one court manuscript known), in the late period court and specifically royal patronage flourished. And a most important aspect of this new, royal patronage is the commissioning of copies of the Qur'an, which appears to have been paralleled by the patronage of religious buildings. An attempt must now be made to understand further the context in which these changes occurred.

Abu Ishaq, under whose reign the changes largely took place, was praised as a generous and eager patron of the arts, and renowned poets such as Khwaju Kirmani and Hafiz benefited from his patronage.[88] Ibn Battuta recorded that Abu Ishaq wished to be compared to the "king of India"—Muhammad Shah ibn Tughluq (r. 724–52/1324–51)—who was acclaimed for his generous gift giving to all those who came to his court, but, although the Injuid ruler was indeed "generous and of eminent merit," Ibn Battuta says his munificence in no way equaled that of the Tughluqid sultan.[89] Abu Ishaq may have tried to emulate other rulers as well, and the royal patronage characteristic of the late Injuid era perhaps was fostered by the desire to do so, not only on his part but by other members of his family also. The Injus had begun as vassals of the Il-Khanids, who would undoubtedly have served in some capacity as models of kingship for them. They would surely have been well aware of the patronage of the arts—specifically of large, sumptuous copies of the Qur'an[90] and illustrated copies of the *Jami' al-tavarikh*—during the early years of the fourteenth century on the part of the Il-Khanid sultans and members of their court. Less is known of manuscript production in western Iran in later years, but the large-format Great Mongol *Shahnama*, with its extensive illustration program, is thought to have been produced in the 1330s in Tabriz, perhaps for the vizier Ghiyath al-Din ibn Rashid al-Din. Artistic patronage as a requisite to rule was thus a concept with which Abu Ishaq not only would have been familiar

but which he would likely have consciously decided to embody, and his actual presence in Tabriz, the former Il-Khanid capital, in 742/1341–42, less than two years before he assumed control of Shiraz, was therefore surely a significant factor in shaping the patterns of patronage of the late Injuid era. More to the point, many of the Il-Khanid artists and craftsmen who were eventually to move to Shiraz may have been encouraged to do so as a result of personal or merely indirect contact with Abu Ishaq during his sojourn in the city.

The rise in, or move to, royal patronage may be directly related to Abu Ishaq's concept of himself as ruler. Although the Injus were in almost every respect independent rulers of Fars by 725/1325, they continued to rule in the name of the Il-Khanid sultan or, after the death of Abu Saʿid, in the name of one of the many Il-Khanids put forth as mere puppet khans. Abu Ishaq was the first of the Injus to conduct himself in the manner of a fully autonomous ruler: upon taking control of Shiraz in 744/late 1343, he soon appropriated the twin rights of the *khutba* and *sikka* in his own name. Evidence of the speed with which he achieved the latter is provided by the earliest extant coin bearing his name, dated 745.[91] He was the first Injuid ruler to claim these dual rights of sovereignty, and Kutubi states that by doing so Abu Ishaq "rose from the rank of amir to [that of] sultan" and thereby established his position as the true sultan of Fars.[92] His expressed desire to equal the generosity of the sultan of Delhi and his presumed attempt to emulate the artistic patronage of the Il-Khanid sultans thus can be seen as a facet of this more forthright proclamation of kingship.

Although none of the manuscripts of the late Injuid era bear the name of Abu Ishaq, many can be attributed to him, or are at least indirectly associated with him, and all are nevertheless a reflection of the political climate of his period of rule. The highly conservative illumination style of the early Injuid era was totally transformed in the 1340s as a result of the dispersal of artists following the downfall of Il-Khanid rule. Undoubtedly encouraged by the political chaos of his time, Abu Ishaq made the final, symbolic break from the Il-Khanids, a break his predecessors had not seen fit to make and one that may well have stimulated a flourishing of court and specifically royal patronage, two features of which were the patronage of religious manuscripts and buildings and the production of images of enthroned couples, specifically those, in contrast to similar images produced in Tabriz, in which the woman is seated on the left.

27. Folio with heading, *Sahih* of al-Bukhari, 758–60/1357–58, 32 x 24.7 cm (folio). The Art and History Collection: Courtesy of the Arthur M. Sackler Gallery, Smithsonian Institution: LTS2003.1.20.3, f. 1b

THE *SAHIH* OF THE VIZIER QUTBUDDIN SULAYMANSHAH

In the Art and History Collection of the Arthur M. Sackler Gallery is a four-volume copy of the *Sahih* of al-Bukhari (LTS2003.1.20.3).[93] The style of the illuminations in this manuscript would seem to base it firmly in the late Injuid era, for it employs a bright and varied palette and the predominant motif used throughout is the palmette-arabesque (fig. 27). Moreover, on some of the colophon folios, sprays of blossoms and leaves have been painted in colored washes between the lines of text, just as on the text-frontispieces in the sections of the Fars Malik Khatun Qur'an that were illuminated in the late Injuid era (see fig. 19). Also, the florals in one of the headings relate closely to those used in the marginals of the other

Khalili Qur'an, QUR242.[94] The manuscript is not, however, a product of the late Injuid era, because it bears three dates—758/1357, 759/1358, and 760/1358—and thus was copied following the demise of Injuid control of the city, in the early years of Muzaffarid rule. Moreover, its calligrapher, Sayin Mashaza al-Isfahani, states that it was copied for the vizier Qutbuddin Sulaymanshah, "in the capital city of Shiraz." Thus, although it is dated more than a decade later than the Qur'an copied by Yahya al-Jamali al-Sufi (Pars 456), this manuscript provides further indisputable evidence that illuminations in the style of the Il-Khanid capital were produced in Shiraz and that the style continued to be used in the early years of Muzaffarid rule.

A CHANGE IN AESTHETICS: ILLUMINATED MUZAFFARID MANUSCRIPTS

In the second half of the fourteenth century, during the reign of the Muzaffarid dynasty (754–95/1353–93), the illumination style of Shiraz underwent a startling metamorphosis: the large and bold, well-spaced elements of the Injuid era were transformed into dense mats of minute and intricate forms. The result was illuminations comprising an overwhelming mass of detail for the eye to behold and for the mind to comprehend. It was, however, much more than a simple change in the size of motifs, for an overall change in aesthetic had in fact occurred, and although illustrated most strikingly in the illuminations of Shiraz, it was a change not restricted either to Shiraz or to manuscript illumination. Indeed, the move to a new aesthetic was one of the most dramatic occurrences in the visual arts of the fourteenth century, but in order to understand more fully how the aesthetic was altered—and thereby how the illumination style of Muzaffarid and Timurid Shiraz was formed—the specific changes that occurred need to be detailed and, as much as possible, their evolution analyzed. Fars metalwork will again be considered, because it provides evidence of contemporaneous closely related changes in other media produced by Shiraz craftsmen. Similar, though less obviously related, changes also occurred in manuscript illustration, discussion of which will be saved for the following chapter.

The Illumination of the Fars Malik Khatun Qur'an
The overall difference in aesthetic, as well as the specific differences in motif and palette, between the illuminations of the Injuid and Muzaffarid eras is con-

veniently illustrated in a single manuscript—the Qur'an of Fars Malik Khatun (Khalili QUR181–82 and Pars 417). The complete manuscript was probably copied sometime in the 1340s, and some parts of it were illuminated at that same time (see figs. 18–19). The decoration of certain other parts was not, however, completed until the 1370s, at the behest of the Muzaffarid vizier Turan Shah (fig. 28). Thus, the manuscript contains both late Injuid and Muzaffarid illuminations.[95]

Two of the four parts in the Khalili Collection have Muzaffarid illuminations (QUR181), and each part opens with a double-page text-frontispiece only; unlike their late Injuid-illuminated counterparts (QUR182), there is no preceding single-page *shamsa*-frontispiece. The late Injuid and Muzaffarid text-frontispieces are the same in terms of type, but they differ greatly in style. The gold floral sprays in the upper and lower panels of the Injuid frontispiece are large and consist of a variety of clearly defined, well-differentiated types, all elements of which are carefully outlined (see fig. 19). By comparison, masses of tiny and comparatively poorly defined gold leaves and colored blossoms—none of which are outlined— are used in the Muzaffarid frontispieces (see fig. 28). In some, the leaves are three-toothed (but sometimes more clearly tri-lobed) with the monotony of gold leaves broken only by a few poorly defined colored dots intended to portray buds and the odd lotus-type blossom in gold (a distinctive butterfly-like, five-part blossom, composed of a roughly triangular central petal, two long lateral petals, and two short, downward-turning sepals). In others, the leaves have what can be described as multitoothed or serrated contours, and the colored blossoms are more clearly defined, consisting of long lotus-type petals, or they are colored variations of the multitoothed leaves. The vegetation, whatever type of leaves or blossoms it comprises, is most often clearly arranged in sprays, as it is in late Injuid frontispieces, but unlike the latter the Muzaffarid leaves and blossoms are always tiny and densely applied. Floral-arabesques, usually in the form of scrolling vines, are also used but only in cartouches, where they serve as a ground for script.

The use of blossoms that can be understood as forms derived ultimately from the lotus is the norm in Muzaffarid illuminations, especially from about 1370 onward. At first this use might seem a harking back to the pervasive use of the lotus in early Injuid illuminations. However, it may instead be that the influx of Il-Khanid-type florals that occurred during the late Injuid era never fully supplanted the earlier penchant for the lotus in Shiraz, and so those of the Muzaffarid era are the result of a "natural"—and uninterrupted—evolution of early Injuid types. Evidence that this might be the case is provided by the florals carved on the

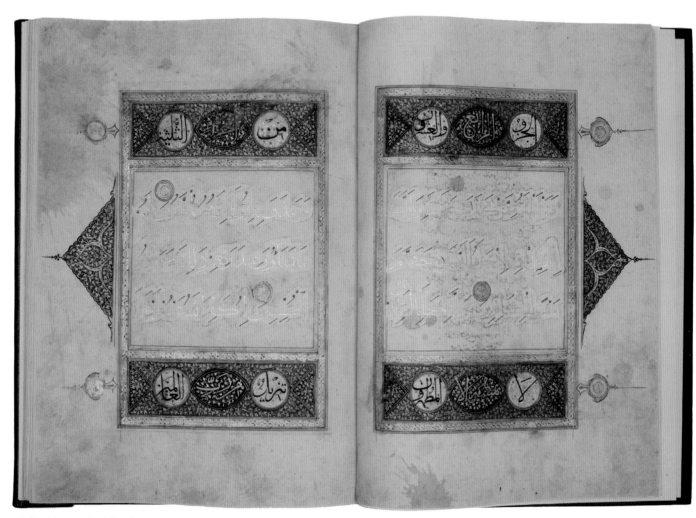

28. Double-page text-frontispiece,
Qur'an, illumination 1370s, 42.8 x
30.9 cm (folio). Nasser D. Khalili
Collection of Islamic Art, QUR181,
f. 1b. © Nour Foundation. Courtesy
of the Khalili Family Trust.

exterior of the *khuda-khane* in Shiraz, restored by Abu Ishaq in 752/1351. There are both "ordinary" Injuid-type lotuses and "lotus-derivatives" with long thin petals, none of which are identical to the blossoms of the Muzaffarid era but some of which are types that can well be considered precursors to those that first appear in illuminations of the late 1350s and the 1360s.

In this new, Muzaffarid blue-and-gold style, as seen in the Fars Malik Khatun Qur'an, there is typically a much greater division of the surface plane: in addition to the multitude of tiny leaves, several roundels and full- or half-cartouches divide the upper and lower panels of each frontispiece, while only a single large cartouche is used in each panel of an Injuid frontispiece (compare figs. 19 and 28). And, although the cartouches in figure 28 have even contours, in most other examples of the style the division of space is made even more intricate through the use of cartouches with irregular, or baroque, contours.[96] Moreover, in late Injuid illuminations the contour of each cartouche and roundel is defined by a thick and very noticeable band, but not so in Muzaffarid examples, wherein a much finer, more narrow (usually gold) contour band is used, thus creating a less severe division between the cartouche (or roundel) itself and the space surrounding it. Individual floral motifs rarely overlap one another in either illumination style, yet in Muzaffarid illuminations there is an increased illusion of depth because smaller motifs are inherently perceived as more distant from the surface plane than are larger ones (compare figs. 19 and 28). The resulting impression is that the larger elements—the roundels and cartouches—float above a distant sea of blue and gold.

The vibrant, varied palette introduced during the late Injuid era disappeared in favor of a more limited palette in which blue and gold are predominant—primarily gold florals on a blue ground. A blue-and-gold palette had been a popular choice for Il-Khanid illuminations, but overall they more often employ a broad palette, frequently incorporating bright contrasts of color. The Il-Khanid use of blue and gold—especially in manuscripts such as the so-called Hamadan Qur'an, produced for the Il-Khanid sultan Uljaytu, in the city of Hamadan, in 713/1313 (Cairo 72)[97]—might well seem to foreshadow the predominance of this color scheme in illuminations of the later fourteenth century. Nevertheless, it is in the illuminations of Muzaffarid Shiraz that blue first played a consistently prominent role, and it was surely that role—not its much lesser role in earlier, Il-Khanid illuminations—that should be credited as ultimately responsible for the position of blue as the single most important color in the illuminations of the Timurids, Turcomans, and Safavids.

The incorporation of the color of the unpainted page is another feature of both the illuminations of the Hamadan Qur'an and those of the Muzaffarids. In the former, the unpainted page often serves as the ground for geometric patterns, creating the impression of negative, or empty, space existing behind—and thus beyond—the painted pattern of the surface plane. However, in Muzaffarid illuminations, the color of the unpainted page is a more integral part of the palette, wherein it most often serves as a ground for gold floral sprays or arabesques. Muzaffarid illuminations also make considerable use of black, as does the Hamadan Qur'an, most notably as a ground for cartouches. All other colors are used sparingly in the Muzaffarid style, with touches of green or orange to indicate buds being most common.

Clearly, two apparently contrasting forces were responsible for the change in aesthetic that took place. One was the simplification and diminution of certain elements, such as the type and form of vegetation, the palette, and the use of un-outlined forms. The other was that some aspects of the style were actually made more intricate, namely, cartouches and the division of the surface plane. The result was a complete altering of the visual impact and overall aesthetic of Shiraz illuminations.

The Development of the Muzaffarid Style

Four manuscripts enable the evolution of the Muzaffarid style to be traced. Three of these have already been considered, if only briefly, as they are illuminated in the late Injuid style; the fourth is from the earliest years of Muzaffarid rule in Shiraz. The manuscripts are: the parts of the Fars Malik Khatun Qur'an illuminated in the late Injuid style (QUR182), the second undated Khalili Qur'an (QUR242), the Stephens *Shahnama* (Sackler LTS1998.1.1.1), and a copy of the *Khamsa* of Amir Khusraw Dihlavi, dated 756/1355 (Tashkent 2179).

Certain features of each of the first three manuscripts and all features of the fourth can be designated as transitional and as precursors to the Muzaffarid style. For example, a marginal in one of the parts of the Fars Malik Khatun Qur'an with late Injuid illuminations consists of gold vegetation of the types and bold size used elsewhere in the manuscript (fig. 29).[98] The type of leaf used has been limited to one that can be described as three-toothed, one of the precise types referred to earlier and the one that is most characteristic of Muzaffarid illuminations. Moreover, each leaf and petal has been tipped with red pigment, likewise a common trait of the Muzaffarid era. Similar leaves—though often minus the red

tips—are also included in one of the many types of marginals in Khalili QUR242 (fig. 30), the blossoms and buds of which relate specifically to those used in Muzaffarid illuminations of the 1360s. Of greatest interest however is the placement, in both QUR182 and QUR242, of the gold vegetation of the marginals against a deep blue ground, which is of course the defining trait of Muzaffarid illuminations. Therefore, despite being portrayed in the aesthetic of the Injuid era, these marginals foretell the style of the following era. This is especially clear when the marginal of QUR182 is compared to one of the marginals from QUR181, the sections of this same Qur'an that were illuminated in the Muzaffarid era (see figs. 29 and 31).

The illuminations in the late Injuid Stephens *Shahnama* are closely akin to the Injuid illuminations of the Fars Malik Khatun Qur'an. However (and although not evident from the folios reproduced here), the palette of the Stephens manuscript is overall more exclusively blue and gold and thus has moved a step beyond the broad and bright palette introduced to Shiraz under Il-Khanid influence. The change suggests that the undated Stephens manuscript may be of a later date than the Fars Malik Khatun Qur'an. Yet the relative abundance of crimson and black in some of the illuminations of the Stephens manuscript is unknown in the Muzaffarid era, and the palette can therefore be designated as transitional between that of the late Injuid and Muzaffarid eras.

In 754/1353, the Muzaffarids expelled Abu Ishaq from Shiraz, and Mubariz al-Din Muzaffar became the new ruler of the region. Despite being described by the early fifteenth-century author Kutubi as a patron of learning, he is said to have been a stern and harsh individual, renowned for having closed all wineshops and one whose rule over the city was a bitter contrast to what the poet Hafiz remembered as the halcyon days of Abu Ishaq.[99] The earliest decorated manuscript to have survived from this new era appears to be a *Khamsa* of Amir Khusraw Dihlavi, dated 756/1355 and made for an unnamed patron (Tashkent 2179);[100] it is illuminated with a single-page frontispiece (fig. 32) and five headings.[101] Considering the manuscript is dated just two years after the establishment of Muzaffarid rule in Shiraz, it is not surprising that, in terms of type, the frontispiece relates to those of the late Injuid era and hence to those of the early Injuid era as well; however, in terms of style, it is much closer to illuminations of the Muzaffarid period. A palette of gold and blue prevails, although black, in particular, is also used. The triangular cornerpieces of the frontispiece are actually sections of a cloud-collar pattern— and three of its five headings employ a baroque-edged cartouche—heralding the

29. Marginal, Qur'an, probably 1340s, 42.4 x 30.9 cm (folio). Nasser D. Khalili Collection of Islamic Art, QUR182, f. 41a. © Nour Foundation. Courtesy of the Khalili Family Trust.

30. Marginal, Qur'an, probably 1340s, 42.4 x 30.9 cm (folio). Nasser D. Khalili Collection of Islamic Art, QUR242, f. 30a. © Nour Foundation. Courtesy of the Khalili Family Trust.

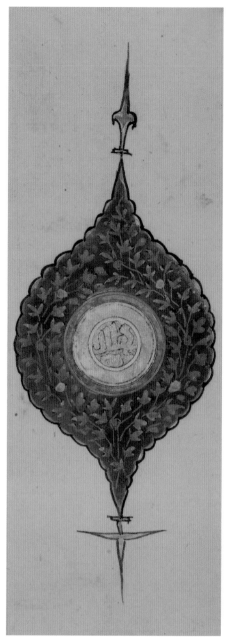

31. Marginal, Qur'an, 1370s, 42.8 x 30.9 cm (folio). Nasser D. Khalili Collection of Islamic Art, QUR181, f. 2b. © Nour Foundation. Courtesy of the Khalili Family Trust.

predominant use of baroque-edged cartouches in the Muzaffarid era. The florals that fill both these corner-pieces and the center of the *shamsa* (as well as one of its headings) are the same carefully rendered types common to Muzaffarid manuscripts of the late 1350s and 1360s (which will be discussed shortly), some of which were also used in the marginals of Khalili QUR242 (see fig. 30); they are also proportionately smaller and more densely applied than in any earlier manuscript. By 1355 the aesthetic had unquestionably begun to change, clearly distinguishing this frontis-piece from all illuminations of the preceding era.[102]

It was not, however, a change that was to be con-fined either to Shiraz or to the production of illu-minations. As stated previously, this move to a new aesthetic was in fact one of the most dramatic occur-rences in the visual arts of the fourteenth century, and one that is first evident in the illuminations of Shiraz. Illustrations produced in the third quarter of the four-teenth century, both in Shiraz and in Baghdad, tend to employ the new aesthetic. However, it was not until the period of Timurid domination of Herat that the new aesthetic was consistently employed for illumina-tions produced in centers other than Shiraz, because, on the whole, Jalayirid illuminations (to be discussed below) employ the earlier, Il-Khanid–Injuid aesthetic. Thus, the defining aesthetic of all fifteenth-century and later Iranian illuminations and illustrations can be traced to developments that took place in Shiraz in the mid-fourteenth century.

32. Single-page frontispiece, *Khamsa* of Amir Khusraw Dihlavi, 756/1355, 29.5 x 19.5 cm (folio). al-Biruni Institute for Oriental Studies, Academy of Sciences of the Republic of Uzbekistan, Tashkent, no. 2179, f. 1a.

Manuscripts of the Late 1350s and 1360s

The earliest example of the fully developed form of the new Muzaffarid style appears in a manuscript dated 759/1358, one of a group of eight manuscripts, the rest of which date between 763/1362 and 769/1367 (figs. 33–35). The illumination of these manuscripts is truly exquisite. In certain aspects, however, these illumi-nations differ from most later examples of the style. In particular, gold strapwork frames are a feature of several of the headings but are rarely seen in Muzaffarid

33. Heading, *Khamsa* of Nizami, 766-67/1365, 26.5 x 16.5 cm (folio). Bodleian Library, University of Oxford, Ouseley 275, f. 52b.

34. Heading, *Khamsa* of Nizami, 767/1366, 22.8 x 15.6 cm (folio). Bibliothèque nationale de France, Supp. pers. 580, f. 291b.

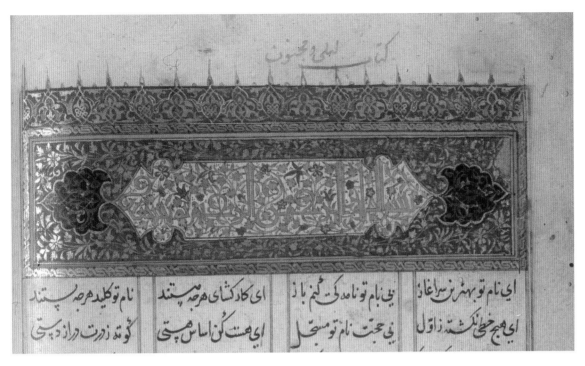

كتاب ليلى والمجنون

| اي نام تو بهترين سراغاز | يي نام تو نامدى كنم باز | اى كار گشاى هر صد هستند | نام تو كليد هر صد هستند |
| اى هيچ خط نگشته زاول | يي حجت نام تو مسجل | اى هست كن اساس هستى | گو ته زدرت دراز دستى |

35. Heading, *Khamsa* of Nizami, 766–67/1365, 26.5 x 16.5 cm (folio). Bodleian Library, University of Oxford, Ouseley 274, f. 133b.

illuminations after about 1370. Also, the florals used tend to be unusually well delineated and highly differentiated: in addition to the long-petaled lotus types mentioned previously, small (usually five- or six-petaled) rosettes are also common, as are buds, some still tightly closed, others already partially opened, and, with their long petals, having a somewhat tulip-like appearance. These specific blossoms are often more brightly colored than will be usual later on. Of particular note is the use of a distinctive, usually two-toned turquoise, a color also typical of Muzaffarid illustrations, where it is often used for blades of grass, arranged in tufts and dispersed across the ground (fig. 36). In illuminations, this turquoise color is frequently used in conjunction with blossoms and buds that are what now appears as a slightly purplish brown color. Florals in these colors may be arranged in sprays, but they also may spring forth from a rather thick gold arabesque vine, heavily laden with lush gold leaves, set against an unpainted ground and serving as the ground of an inscribed cartouche (see fig. 35). This particular type of arabesque will continue throughout the years as a sort of substrain of the blue-and-gold floral style, one that is used infrequently though often prominently, freed from its earlier, subsidiary role as a ground for inscriptions (fig. 37).[103] An arabesque is also used as a border along the upper edge of headings, but it is a palmette-arabesque and notably one that is unoutlined (see fig. 33). This is one of two types of borders used for these headings, both of which remain a feature of Muzaffarid illuminations; a lotus-and-bud pattern constitutes the other type of border (see fig. 34).[104] The rays that extend from both types of upper border are short, unadorned strokes.

Another notable trait of several of the illuminations of these manuscripts is the pricking or punching of the gold to catch the light.[105] These are the earliest examples of what became a common practice in later years, both in Shiraz and other centers as well. Also of particular interest is what might be termed a "playing with space," namely a tendency to cut off forms in unusual ways, which makes it appear that the various elements of a heading (or frontispiece) have been laid one atop the other (such as the small gold triangular forms in figure 33), thereby increasing dramatically the illusion of spatial depth. This is in fact a characteristic feature of the blue-and-gold floral style throughout its history. In these manuscripts, too, is seen the introduction of a narrow band of gold and an exterior line of blue ink as the standard textblock frame for all fine manuscripts, as well as the use of gold for column dividers.[106] Previously, two red lines were usual for both the textblock frame (sometimes used in conjunction with an exterior line of blue) and column

36. "The Persians Capture
Bihisht," *Shahnama*, 772/1371,
26 x 16 cm (folio). Topkapi Saray
Library, Istanbul, H. 1511, f. 128b.
Photograph by author.

37. Double-page frontispiece,
Kulliyyat of Sa'di, 852/1448, 19.9 x
12.7 cm (folio). © The Trustees of
the Chester Beatty Library, Dublin,
Per 275, ff. 1b–2a.

dividers, with the more elegant blue-and-gold frame used only for the very finest manuscripts, in particular, copies of the Qur'an.[107]

As will become increasingly evident, this group of manuscripts is of critical importance. They were, however, produced at a rather confused period when control of Shiraz switched from the hands of Mubariz al-Din to his son Shah Shuja', then to another son, Shah Mahmud, and then back to Shah Shuja' again. As a result, it is not clear for whom they were produced, or if indeed they are products of royal patronage. But based on the high quality of their decoration, a royal origin is highly plausible, and, in fact, one of the manuscripts, a copy of *Miftah al-khaza'in* (BOD Marsh 491)—a Persian work based on Dioscorides' *De Materia Medica*—has a royal connection because it was compiled, translated, and copied by 'Ali ibn al-Husayn al-Ansari (called Hajji Zayn al-'Attar), who for sixteen years served as the personal physician of Shah Shuja'.[108] There is, however, no indication that it was either produced at the behest of the sultan or intended as a gift for him, though it is dated 769/1367 and therefore was produced at a time when Shah Shuja' was definitely in control of Shiraz.

Of the other seven manuscripts in this group, the earliest is a copy of the *Divan* of Zahir Faryabi (IUL FY 496/1), dated Jumada I 759/April 1358 and thus produced at a time when Mubariz al-Din was in control of Shiraz.[109] Mubariz al-Din's position as head of the Muzaffarid dynasty ended in Ramazan 759/August 1358 when, while on campaign, he was captured, blinded, and deposed by Shah Shuja'. (Mubariz al-Din did not die, however, until 765/1363–64.) Shortly, Shah Shuja' took control of Shiraz and remained in control until 765/1364. During these years two copies of the *Khamsa* of Nizami were produced, one dated 763/1362 (BN Supp. pers. 1817) and the other dated both 764/1362 and 765/1363 (Berlin-SB Minutoli 35).[110] In 765, Shah Shuja' was driven out of Shiraz by his brother Shah Mahmud (with the help of the Jalayirid Sultan Uvays), and three other manuscripts were produced during the two years that Shah Mahmud then held the city: a third copy of the *Khamsa* of Nizami, dated 766–67/1365 (BOD Ouseley 274–75; see figs. 33 and 35);[111] a copy of *Tarjuma-i mawlud-i mustafa*, Kazaruni's biography of the Prophet as translated into Persian by his son, dated 766/1365 (BOD Pers. d. 31);[112] and a Qur'an dated 767/1365 (Sam Fogg cat. no. 15).[113] In 767/1366, Shah Shuja' managed to regain control of the city from his brother, and a fourth copy of the *Khamsa* of Nizami is dated just one month after that event (BN Supp. pers. 580; see fig. 34).[114] If these manuscripts were indeed produced in

a court atelier, then it seems that the considerable political upheavals of the time exerted little effect on its functioning.

An alternative to royal patronage is, however, patronage at the vizierial level. As Abolala Soudavar has noted in his discussion of the *Sahih* of al-Bukhari manuscript (Sackler LTS2003.1.20.3; see fig. 27), viziers often maintained their positions despite changes in rulers or even of dynasties, as did Qutbuddin Sulaymanshah, who served as vizier under three successive Muzaffarid rulers—Mubariz al-Din, Shah Shujaʿ, and Shah Mahmud (and then Shah Shujaʿ again). Patronage at this level apparently could sometimes proceed relatively unimpeded by a change in ruler and any concomitant political turmoil, for the production of the *Sahih*, carried out at Qutbuddin's behest, spanned the reigns of both Mubariz al-Din and Shah Shujaʿ, with the dates given in the manuscript's colophons covering the years 758–60/1357–58.[115] The rather long period of time that it took to copy the manuscript may have been required because of the manuscript's considerable length (a total of 766 folios), or work on the manuscript might indeed have been slowed or even temporarily interrupted because of the political situation in Shiraz. Nevertheless, manuscript patronage by high court officials clearly could continue despite the internecine fighting of the ruling family, and perhaps the court atelier itself could function for some time—continuing to work on existing projects—relatively unaffected by those disputes.

The Decoration of Contemporary Metalwork

The increased division of space and the incorporation of smaller, more detailed motifs that resulted in an overall change in aesthetic in illuminations were paralleled in the decoration of metalwork. Komaroff has proposed a direct relationship between manuscript illustration and the decoration of metalwork, suggesting that the artists responsible for each medium worked from the same models, though the metalwork artist would have more frequently excerpted only portions of, or individual figures from, larger compositional models.[116] During the course of the fourteenth century, the spatial complexity of painting increased as figures were depicted in ever more developed environments, both natural and architectural. As Komaroff notes, this change can be related to modifications in the decoration of metalwork bowls (and other objects) of Fars. On some, figures are set against a ground of palmette-arabesque scrolls (see fig. 23). On others, oversized blossoms and leaves on long stems form a more realistic ground for mounted or enthroned figures (fig. 38) and presumably were introduced to increase the

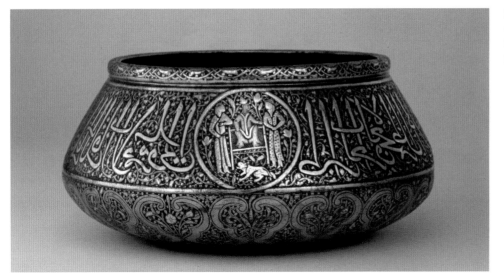

spatial depth of the figural compositions in an attempt to emulate the more complete natural environments being portrayed in contemporary painting.[117] Bowls decorated in this manner may therefore be later than those in which a scrolling palmette-arabesque serves as the main ground decoration for figures.[118] This latter type of decoration usually prevails on bowls decorated with, alternately, large oblong cartouches containing inscriptions and roundels enclosing large figures enthroned or hunting (see fig. 23).[119] By comparison, the decorative surface of some other bowls is divided more thoroughly, both horizontally and vertically, and thus comprises smaller, more numerous, separate compartments (fig. 39).[120] This greater division of the decorative surface seems to be contemporary with, but is not exclusively tied to, the increased use of the alternate type of ground decoration for figures, namely, long-stemmed floral motifs. It is therefore more precise to say that bowls characterized by a greater and more prominent emphasis on (stemmed) floral and vegetal motifs and/or a more extensive division of the decorative surface (see figs. 38–39) are generally later in date than those in which figures are placed against a scrolling, palmette-arabesque ground and/or there is a bold and rather simple division of the decorative surface (see fig. 23). A greater division of the decorative surface should, however, be considered a surer sign of a later date than the use of the long-stemmed floral ground.

Certain early fourteenth-century objects with highly compartmentalized surfaces, such as a bucket in the Hermitage Museum, dated 733/1333 and bearing a reference to the Injuid ruler Sharaf al-Din Mahmud, and an undated casket in the

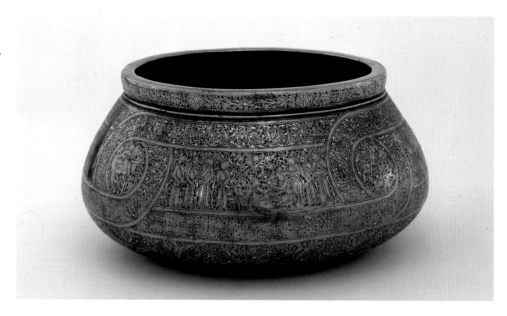

Victoria and Albert Museum (attributed to "western Iran or Fars"), might seem to contradict these statements.[121] However, these objects form a group distinct from the mass of Fars bowls under discussion here. Their decorative schemes are characterized by an extensive and prominent use of astrological personifications, a spoked-wheel or swastika-like motif (enclosed individually within small circles or used as an all-over ground pattern), a ground pattern of what can be described as an interlocking "T" or "I" motif, and circles containing a large hexagonal motif (either a six-pointed star[122] or a "blossom" composed of six interlaced and roughly triangular-shaped petals); less ubiquitous is the use of confronting pairs of birds. As such, these objects remain closely related to the thirteenth-century metalworking traditions of Iran, the Jazira, and Syria.[123] Although few dated objects have survived, it seems that the disappearance of objects with this type of decoration coincides more or less with the appearance of the mass of Fars bowls first produced in about the late 1330s and the decorative surface of which is divided, initially, by a few large cartouches only. The various decorative motifs listed above (with the exception of the astrological personifications) do appear on these bowls also, but in a greatly reduced capacity, treated merely as small, secondary motifs at best (as is the spoked-wheel motif in figure 23). Therefore, it appears (admittedly somewhat confusingly) that while certain early fourteenth-century objects closely tied to the tradition of the previous century may have a highly compartmentalized surface, under the Injuids there developed a taste

for objects, mostly bowls, the decorative surfaces of which were divided by only a few large cartouches. Eventually, however, and in conjunction with changes in manuscript illumination and illustration (to be discussed below), this taste gave way to a preference for bowls that again had highly compartmentalized decorative schemes.

At the same time as the move to grounds of long-stemmed floral decoration and a greater division of the decorative surface was taking place, figural representation in metalwork decreased: figures played a less prominent role, being both smaller and generally less frequent, giving way to an emphasis on abstract geometrical, but mainly vegetal and floral, decoration (compare figs. 23 and 39).[124] This move from figurative to nonfigurative decoration seems to have been at least partially (though not solely) due, suggests Komaroff, to "the metalworker's inability to compete, so to speak, with [more spatially complex compositions of] the painter."[125] Thus, in an initial attempt to keep up with changes in book illustration, grounds of long-stemmed blossoms were introduced, but the concurrent move to a more divided decorative surface made the rendering of figures more difficult, and so figural decoration was eventually rejected altogether.[126]

Few pieces of fourteenth-century metalwork are dated, making it difficult to propose even a relative chronology for the production of these bowls. Komaroff's comparisons with manuscript illustration, however, in conjunction with the parallels that can be drawn with manuscript illumination, would now seem to make it possible to do so. Moreover, that a candlestick of the second decorative type (i.e., with a greatly divided surface) is dated 761/1360 and signed "the work of the slave, the most lowly Muhammad ibn Rafi' al-Din Shirazi" (fig. 40)[127] suggests that the move to a new aesthetic in metalwork and in manuscript illumination occurred simultaneously. Furthermore, floral motifs—both long- and short-stemmed (including lotus blossoms)—prevail on the candlestick, though geometric motifs are also used, thus supporting the supposition that the move to an increased use of floral motifs and a greater division of the decorative surface occurred hand in hand.

The floral types used on this candlestick are, however, those of both the early and late Injuid eras. Types related more specifically to those used in Muzaffarid il-

40. Inlaid brass candlestick, fourteenth century, 1360, 29 cm (height). Museum of Islamic Art, Cairo, no. 15066. Reproduced by permission of Oxford University Press, from Arthur Upham Pope and Phyllis Ackerman, eds., *A Survey of Persian Art: From Prehistoric Times to the Present* (1939), vol. 6, pl. 1371.

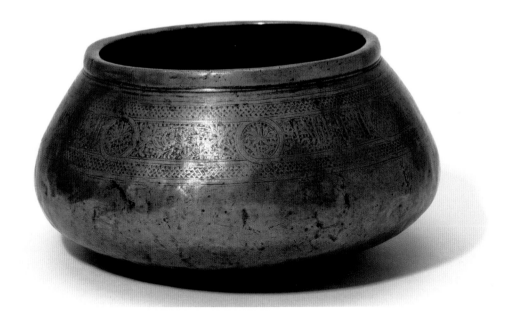

luminations decorate an undated bowl that belongs to a decorative class quite different from the mass of Fars bowls discussed above (fig. 41). On this and similar bowls, only the top half of the body is decorated, the bottom half and underside of the bowl being left plain. The decorated surface of these bowls is divided into a number of small sections: a central band, bordered on either side by a narrower band, comprises a number of small roundels, each separated from its neighbor by long spaces usually filled, alternately, with a geometric pattern or inscription.[128] However, the spaces between the roundels in the example reproduced here contain, alternately, inscriptions and florals. Among the floral types depicted are a lotus with long, thin petals and also the distinctive butterfly-like lotus-derivative mentioned previously and first used in illuminations in the Muzaffarid manuscripts of the 1360s.[129] Although the florals themselves are comparatively large, the decoration of the bowl as a whole is more detailed and more intricate than is the decoration of bowls such as that reproduced here as figure 23. Despite differences in the specific types of motif used, all bowls decorated in the basic manner of figure 41 can be classified as forming a single group. Thus, the fact that one such bowl with geometric decoration is dated 760/1359[130] permits us to assign the floral bowl to this same period. The combined evidence of the candlestick and this

bowl therefore substantiates the evidence of manuscript illumination and suggests a media-wide transformation of the prevailing aesthetic of the visual arts in the late 1350s and 1360s.

The Impetus for Change

From the ninth century, the arts of China played an important role in shaping the style and technique of various artistic media in the Middle East, though the influence that Chinese art exerted waxed and waned over the years. However, with the establishment of Mongol rule in Iran in the mid-thirteenth century, it was inevitable that the impact of China—then also under Mongol rule—on the art of Iran would be both renewed and strengthened.[131] The decorative motifs employed, the actual painting technique used, and the Il-Khanid artist's conception of space were all first altered during the late thirteenth century and first half of the fourteenth century as a result of political and cultural links with China. For example, late thirteenth-century tiles from Takht-i Sulayman, the summer residence in the mountains of Azerbaijan of the Il-Khanid sultan Abaqa Khan (r. 1265–82), are decorated with dragons and lotuses derived ultimately from Chinese art, presumably imported textiles.[132] Textiles decorated with gold blossoms—mainly lotuses on dark grounds—are depicted in the illustrations of the Great Mongol *Shahnama* of about 1335, and presumably these were also painted in imitation of Chinese textiles. Inspired, perhaps, by imported items of furniture, or less directly by imported paintings, the artists of the *Jami' al-tavarikh*, dated 714/1314–15 (Khalili MSS727), depicted Chinese-style thrones with dragon-headed finials and intricately cusped legs and backs. The technique of painting with washes, used in the *Jami' al-tavarikh* paintings and other contemporary manuscripts, likewise can be traced to China. But it was the Chinese conception of space that had the greatest and most enduring impact on Persian art. Various paintings from the early years of the fourteenth century are spatially more complex than the typically shallow compositions of the time.[133] It is, however, in the Great Mongol *Shahnama* that a concentrated interest in the depiction of space is first visible.[134]

The evidence of Muzaffarid illuminations suggests that following this first wave of Chinese influence, which took place in the late thirteenth century and first half of the fourteenth century, a second, renewed wave occurred in the late 1350s and 1360s, though no historical sources actually suggest this course of events. With the fall of the Mongol Yuan dynasty in China in 1368, trade with China slowed

considerably. The new Ming emperor, Hung-wu (r. 1368–98), actively discouraged foreign trade, and in 1371 an official edict was issued prohibiting maritime trade with foreign countries, though overland trade seems to have continued.[135] Thus it was in the years immediately preceding this edict that the arts of China came to exert a new impact on the arts of Iran.

Three types of Chinese wares imported into Iran seem to have been responsible for the changes in Shiraz illumination that eventually resulted in the Muzaffarid style: textiles, blue-and-white ceramics, and lacquerware. Both textiles and blue-and-white ceramics were often decorated with the cloud-collar motif. It has been suggested that cloud collars may have been worn by the Khitans, a people from Mongolia who, taking the dynastic name Liao, ruled North China from 907 to 1125.[136] Although the motif is most closely associated with China, of the textiles using the motif that have been discussed by James C. Y. Watt and Anne E. Wardell, all are assigned to Central Asia, with one dated to the eleventh–twelfth centuries and two others said to be of the thirteenth century or earlier.[137] Considering the easy portability of textiles and the incursions into Iran by the Mongols beginning in the early thirteenth century, the motif may well have been known, at least in northern Iran, by this early date, if not much sooner. The cloud-collar motif was also frequently used to decorate blue-and-white ceramics, specifically the shoulders of a type of storage jar known as *guan* and vases known as *meiping*.[138] Although its introduction into Iran through this medium presumably occurred later, because the production of blue-and-white did not begin in China before the end of the first quarter of the fourteenth century, the cloud-collar motif was also used on other, earlier ceramics that might well have made their way to Iran before, or in the very early years of, the fourteenth century.[139]

Early fourteenth-century paintings include depictions of furniture with intricately cusped legs and backs, suggestive of the deeply in-cut contour of the cloud-collar motif, yet one of the earliest, obvious uses of the motif in Iran is in the frontispiece to the copy of the poems of Amir Khusraw Dihlavi, dated 756/1355 (Tashkent 2179; see fig. 32). As noted previously, the main decorative element of the frontispiece is a *shamsa* set in a rectangular space, the corners of which each contain a quarter (or two half-lobes) of a complete cloud collar. A close parallel for this frontispiece occurs on the inside of the vault of an ivan in the tomb of the Muzaffarid amir Shams al-Din Muhammad, in Yazd, dated to 767/1365.[140] There the cloud-collar motif is more obvious because both full- and half-lobes are por-

trayed. The painting is effaced, but it seems that at least some of the blossoms that fill the cusped lobes are the same types used in contemporary Muzaffarid illuminations, as are some of the ones in the frontispiece of the Amir Khusraw Dihlavi manuscript.

The deeply in-cut contour, which use of the cloud-collar motif creates, is with one exception new in illumination and a sharp contrast to the solid, even contours typical of the Injuid era.[141] Many, if not most, of the irregular, indented contours of cartouches as used in Muzaffarid illuminations of the 1360s are derivatives of the cloud-collar motif, although that they are is usually not immediately apparent. In many examples, it becomes clear only if one considers, not the cartouche itself, but rather the space surrounding it—in other words, what appears more or less as negative, not positive, space (see figs. 33–35). The "negative" space can then be easily read as portions of the cloud-collar motif. The contour of some cartouches is much smoother and only mildly indented, but even these forms can often be understood as ultimately derived from the cloud collar, if one again considers the background space rather than the cartouche itself.[142]

The importation of Chinese lacquer may also have affected the development of the Muzaffarid illumination style, although no exact parallels between the two media exist. Of the several types of lacquer produced, it is *qiangjin* (incised gold) wares that are of interest here, in particular a group of sutra boxes preserved in various temples in Japan (fig. 42). Of the seven boxes known to John Figgess in the mid-1960s, two bear inscriptions printed in black lacquer with a wooden stamp on the inside of the lid and stating "second year of Yen-yu," which corresponds to 1315; one also states that it was made in Hangzhou. A third box has an inscription, written with a brush in red lacquer, that states "Casket for the sutra Saishoo-kyo [belonging to] the Jodo-ji [temple] at Onomichi, the Province of Bingo. The . . . day of June in the third year of Enhun" (which corresponds to 1358), presumably indicating the year that it came into the possession of the temple, where it remains today.[143] It appears therefore that the boxes, all of which are very similar, were produced in China in or about 1315, and by 1358 at least one had been exported to Japan.

In the *qiangjin* technique, the motifs are incised into a red or black lacquer ground and the impressions are filled with gold. The contrast of light on dark that results is akin to that of Muzaffarid illuminations, wherein a similar effect is created by the contrast of gold blossoms on a deep blue ground. As noted previously,

the light pattern on a dark ground combination, specifically gold on blue, has a long history in Islamic illumination. Thus, imported examples of lacquer would have served only as a catalyst for renewed interest in this aesthetic.[144]

The closely packed individual motifs of the *qiangjin* sutra boxes, though relatively large, are delineated by a series of fine, parallel lines that create a visual effect of great density that is also somewhat like that typical of Muzaffarid illuminations. More striking, however, is the correlation between the basic composition of the decoration of the boxes and that of the illuminations, because in each a centrally positioned, lobed cartouche dominates the overall design. The cartouches on the boxes are gently lobed and enclose pairs of birds or animals (not script), while the area surrounding each cartouche is filled with large petaled blossoms, typically lotuses or peonies.[145] Thus, while textiles and ceramics provided the model for the more deeply in-cut cartouches used in Muzaffarid illuminations, lacquer in its turn may have provided the inspiration for many of the more gently lobed examples and may as well have served as an overall compositional model.[146]

As in Iran, and in fact as in almost any society, artists in China relied on the same basic decorative repertoire, whether they were painters, woodworkers, or stonemasons or employed in some other craft. Not surprisingly then, the aesthetic and motifs of *qiangjin* lacquer are similar to those of other media. For example, a carved stone slab dated to the Yuan era (1279–1368) and excavated at the site of the Yuan capital, Dadu (now Beijing), is decorated with a lobed cartouche

containing two animals and set against a ground comprising a dense mat of proportionately small motifs. The density of the motifs, the use of a lobed cartouche, and the effect of light on dark created by the deep carving of the elements all relate to the decoration of the *qiangjin* sutra boxes and thus in turn to Muzaffarid illuminations.[147] For obvious reasons of portability, however, it is more likely to have been lacquerwares and not stone slabs that were imported into Iran to influence the development of Shiraz illuminations, but actual examples of Chinese lacquer have not survived in Iran and few texts mention its importation.[148] Nevertheless, based on the evidence of the group of *qiangjin* sutra boxes and items of carved lacquer exported to Japan, it can be put forth that in the years before the fall of the Yuan dynasty in China in 1368, considerable quantities of Chinese lacquer were likely also being exported to other regions, in particular Iran.[149] Thus, in the late 1350s and 1360s, the apparent importation of Chinese textiles, ceramics, and incised lacquer effected—or at least helped to effect—specific changes in the style and aesthetic of Shiraz illuminations. These were the incorporation of both deeply in-cut and gently lobed cartouches, a dense application of forms, and a revived interest in light-on-dark patterns.

The Blue-and-Gold Floral Style following the Demise of the Muzaffarids

Shah Shujaʿ Muzaffar's rule of Shiraz lasted until his death in 786/1384. A few months before he died, he wrote a letter to Timur commending his sons to the advancing conqueror, but his sons did not willingly yield to Timur as their father had advised. Over the next ten years, they lost and regained various parts of their father's domain until, on 20 Rabiʿ I 795/5 March 1393, having taken Shiraz a second time, Timur executed Shah Shujaʿ's nephew Mansur, the last Muzaffarid ruler of the city, and then some two months later he issued an order that all surviving members of the Muzaffarid dynasty be executed.[150] From that date until the arrival of Jahan Shah Qara Qoyunlu in 856/1452, Shiraz remained under the control of Timur and his successors.

The blue-and-gold floral illumination style of manuscripts produced in Shiraz remained more or less unchanged through to and even following the end of Timurid rule of the city in 1452. The basic features of the style as seen in the illuminations of the 1360s and 1370s were those of illuminations in later years as well. Bands of gold and green define the contour of both headings and frontispieces and may also define certain interior forms (e.g., figs. 43–44). Compositions are

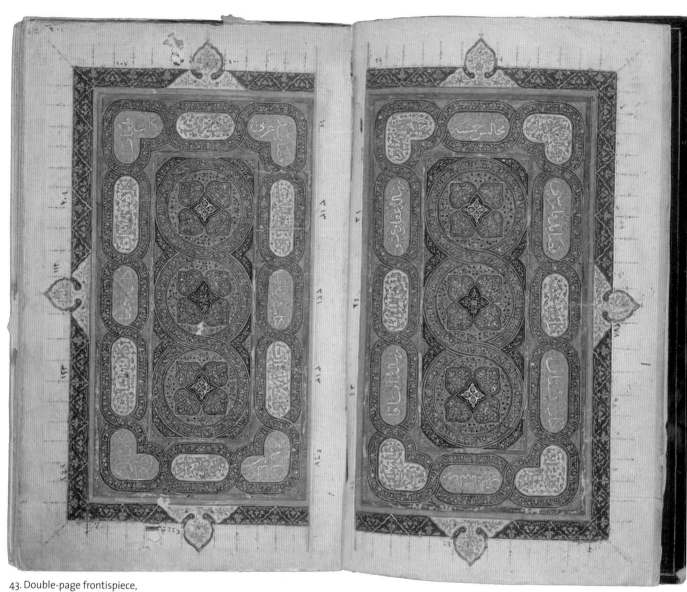

43. Double-page frontispiece,
Kulliyyat of Saʿdi, c. 1440, 20.8 x 13 cm
(folio). © The Trustees of the Chester
Beatty Library, Dublin, Per 123, ff.
1b–2a.

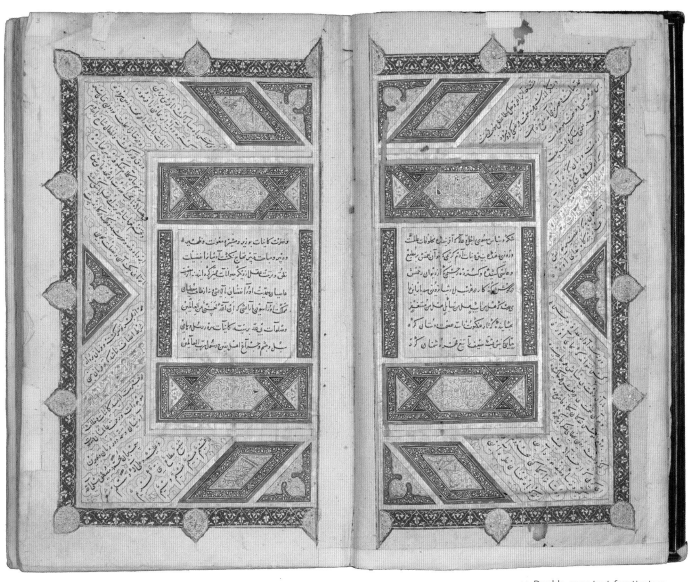

44. Double-page text-frontispiece,
Kulliyyat of Sa'di, c. 1440, 20.8 x 13 cm
(folio). © The Trustees of the Chester
Beatty Library, Dublin, Per 123, ff.
2b–3a.

usually highly complex: wide bands may interlace and overlap to create a multitude of even-edged cartouches (see figs. 43–44), or the composition might instead consist of an array of baroque-edged, deeply in-cut elements (figs. 45–46). Cruciform-shaped cartouches are especially popular (see fig. 45), as are small pear- or teardrop-shaped elements that break through the exterior contour of both headings and frontispieces, increasing the complexity of the composition (see figs. 44 and 46). Larger, *ansa*-type forms (sections of the cloud-collar motif) may protrude from the upper edge of headings or extend from midpoint along the exterior edges of frontispieces (fig. 47; see also fig. 43). Cartouches and all other spaces are filled with an intricate array of minute and unoutlined floral motifs that may be well spaced and clearly defined or densely applied masses of less distinct forms, but always painted mainly in gold on a dark blue ground or set against the plain unpainted page. Though blue and gold predominate, grounds of black or burgundy are also used, and touches of other colors, mainly orange and green, can further enliven the palette. In some manuscripts, each heading is a unique, intriguing, and carefully planned composition (see figs. 45 and 47), but in others there is little variation, each heading almost (and sometimes actually) identical to those that precede and follow it (fig. 48). In this latter type, the division of space is simpler and cartouches tend to be smooth contoured or only slightly lobed. Usually these rather pedestrian versions of the style appear in manuscripts such as a *kulliyyat*, a compilation of a poet's oeuvre for which numerous headings are required to mark the divisions between the many works (or types of work) contained within. In manuscripts in which there are fewer major divisions of the text, and therefore fewer headings are needed, as in a *khamsa*, there tends to be more diversity in the headings—but this statement is of course dangerously generalized, for many other factors come into play, such as patronage.

Within the central cartouche of almost every heading is an inscription written in gold and outlined in black on a bed of what is often a very sparse and spindly, scrolling palmette-arabesque, which is itself painted in gold and black and interspersed with groups of three tiny dots (see figs. 47–48). Subheadings that mark minor divisions of the text stretch across the central two columns only (or three if a six-column format is used). Often the text of the subheading is written in gold, outlined so that it appears to float in a cloud and then surrounded by a gold, hatched ground (fig. 49). Sometimes the "cloud" sprouts a few leaves, sketchily outlined in black. Or the subheading may be simpler, the text written in colored ink (usually blue or burgundy) or even in gold, but with no other decoration at

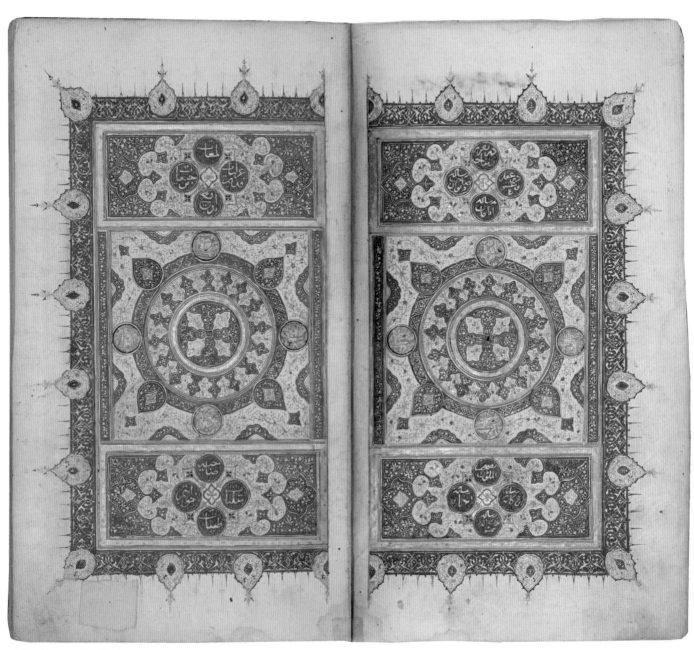

46. Double-page frontispiece,
Kulliyyat of Sa'di, 856/1452, 22 x 13 cm
(folio). © The Trustees of the Chester
Beatty Library, Dublin, Per 133, ff.
1b–2a.

47. Folio with heading, *Majnun va layla* and *Hasht bihisht* of Amir Khusraw, mid-fifteenth century, 23 x 14 cm (folio). © The Trustees of the Chester Beatty Library, Dublin, Per 253, f. 1b.

all. On some pages, the text might be written in short, oblique lines, creating a series of small triangular spaces running across the width of the folio. These triangular spaces, and also those created by the usual addition of an outer, marginal column of text, are then filled with gold blossoms, perhaps with added touches of color (fig. 50; see also fig. 49). Colophons and endpieces (usually triangular in shape and marking the end of the manuscript or merely the end of one section of the text) are often illuminated, too, and the decoration typically consists of sprays of large blossoms and leaves, painted directly onto the plain, unpainted page, sometimes completely in gold but often with colored (usually orange) blossoms (see fig. 50).

From the time of the demise of the Timurids in Shiraz, the blue-and-gold floral style was in fact used only infrequently in the manuscripts of Shiraz, although a few examples (or variations) of the style exist from as late as the final years of the fifteenth century. One of these is a Qur'an (CBL Is 1502), dated 888/1483, that bears a benediction in the name of the Aq Qoyunlu ruler Ya'qub Beg (r. 1478–90), who controlled both Shiraz and Tabriz.[151] Shiraz manuscripts—and hence the blue-and-gold floral style—were exported far and wide, and Ottoman and Mamluk examples of the style from the second half of the fifteenth century also exist.[152] An otherwise unknown and highly exuberant variation of the style is also used in a manuscript (CBL Ar 4204) made for the Tahirid sultan of Yemen, al-Malik al-Zafir Salah al-Din 'Amir ibn 'Abd al-Wahhab (r. 894–922/1489–1516); though it is not clear where the manuscript was actually produced, it may well have been in Yemen itself.[153] However, it was to India that Shiraz manuscripts (and artists) were most frequently exported, especially, it appears, those of the 1430s and 1440s. Evidence of the lingering impact of the style in India, through to the early sixteenth century, is found in painting, where it is used for architectural decoration.[154] No other illumination style survived for as long a time—more than a century and a half—and traveled as far and wide as did the immediately recognizable blue-and-gold floral style of Shiraz.

ILLUMINATION UNDER THE JALAYIRIDS

Like the Muzaffarids, the Jalayirids were a local dynasty, based in the northwest, whose power increased greatly in the years following the death, in 736/1335, of the Il-Khanid sultan Abu Sa'id. In 784/1382, Sultan Ahmad Jalayir, a renowned patron of the arts, killed his brother Husayn and gained control of Baghdad and

50. Double-page opening with decorated endpiece and heading, *Kulliyyat* of Sa'di, c. 1440, 20.8 x 13 cm (folio). © The Trustees of the Chester Beatty Library, Dublin, Per 123, ff. 34b–35a.

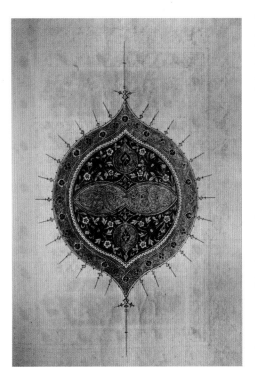

51. *Shamsa*, *Divan* of Sultan Ahmad, 809/1407, Baghdad, 27 x 18.7 cm (folio). Türk ve İslam Eserleri Müzesi, Istanbul, no. 2046, f. 118a. Photograph by author.

Tabriz, but his control was tenuous, and throughout his rule, until his death in 813/1410, he was repeatedly ousted from one or both of these two centers of book production by, variously, the Golden Horde, the Shirwanshahs, the Qara Qoyunlu, and Timur and his descendants.

The Jalayirid illumination style is a continuation and development of the Il-Khanid style. However, very few illuminated manuscripts can be securely attributed to Jalayirid patronage and our understanding of Jalayirid illumination in fact relies very heavily on one manuscript, a copy of the *Divan* of Sultan Ahmad, dated 809/1407 (TIEM 2046).[155] Each of the four sections of this lavishly decorated manuscript begins with a *shamsa* (fig. 51), followed by a double-page frontispiece without text (fig. 52), which is followed in turn by a double-page text-frontispiece enclosing the first lines of the poem (fig. 53).[156] In these illuminations, the palmette-arabesque reigns supreme, often laid out in an intricate web pattern. Bold geometric forms are also a prominent feature, as are large blossoms arranged either in sprays or in long lines of linked stems. (Most typical is a large, "flattened" six-petaled rosette.) Wide bands of gold or colored strapwork and equally wide bands filled with blossoms define and divide the space of each frontispiece. Gold in abundance, red, blue, and orange are all used, but often this vibrant palette is juxtaposed to one of somber tones in which a deep blue, rust, black, and gold prevail. The result is a style that in its boldness and vibrancy stands in sharp contrast to the intricacy and delicacy of the blue-and-gold floral style of Shiraz.

ISKANDAR SULTAN IN SHIRAZ AND ISFAHAN

Upon the death of Mansur, the last Muzaffarid ruler of Shiraz, Timur placed his son 'Umar Shaykh in control of Fars, but 'Umar Shaykh soon departed to join his father on campaign and, according to some accounts, left in command of the city was 'Umar Shaykh's own son Iskandar Sultan (b. 786/1384), who was just nine or ten years old at the time.[157] When 'Umar Shaykh died the following year, in 1394, another of his sons, Pir Muhammad, was designated by Timur as governor of the city.[158] With the exception of a period of exile of about four years, Pir Muhammad retained this position until his death in 811/1409.[159]

At the time of Timur's death, on 17 Sha'ban 807/18 February 1405, Iskandar

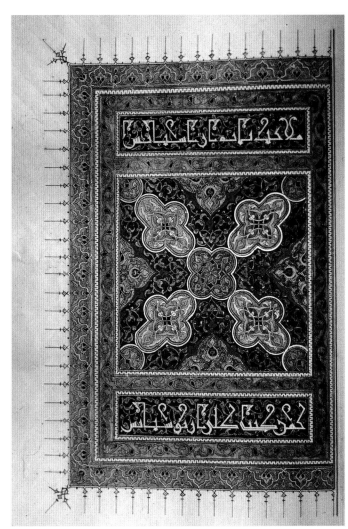

52. One half of a double-page frontispiece, *Divan* of Sultan Ahmad, 809/1407, Baghdad, 27 x 18.7 cm (folio). Türk ve İslam Eserleri Müzesi, Istanbul, no. 2046, f. 198a. Photograph by author.

53. One half of a double-page text-frontispiece, *Divan* of Sultan Ahmad, 809/1407, Baghdad, 27 x 18.7 cm (folio). Türk ve İslam Eserleri Müzesi, Istanbul, no. 2046, f. 199a. Photograph by author.

was governor of Hamadan, but a short time after his grandfather's death he was forced to flee Hamadan to the safety of his brother's realm of Shiraz, where it is said that he was warmly received and granted the province of Yazd. Nevertheless, the brothers' relationship was tumultuous to say the least, and in 809/1406–07, as a result of a dispute, Pir Muhammad seized Iskandar and sent him in chains to the sultan, his uncle Shah Rukh. According to Khwandamir, Iskandar escaped before reaching Herat and, following an attempt to seize Shiraz with his brother Rustam's assistance, was eventually reconciled with Pir Muhammad and returned to Shiraz, entering the city (on foot as a sign of humility) on 26 Ramadan 811/12 February 1409. A few months later, in the spring of 812/1409, during a joint expedition to Kirman, Pir Muhammad was poisoned by one of his amirs. Iskandar took control of Shiraz almost immediately and then maintained the city as his residence until the end of 814/March–April 1412, at which time he seized control of Isfahan from his brother Rustam and transferred his residence there.[160] That Iskandar moved his artists to Isfahan with him is suggested by a manuscript that bears his name and states that it was copied in Isfahan (TS B. 411, 816/1413–14). Also, Francis Richard has published a copy of a letter written on behalf of Iskandar to the poet Qivam al-Din, commanding him to join what the letter implies is the prince's very large entourage of artists and intellectuals in Isfahan.[161]

The Illuminated Manuscripts of Iskandar Sultan

The patronage of three manuscripts, each illuminated in the blue-and-gold floral style and produced in Shiraz in the final years of the fourteenth century and the very early years of the fifteenth, is uncertain. These manuscripts are a now-divided anthology, commonly referred to as the Collection of Epics, dated 800/1397 (CBL Per 114 and BL Or. 2780); a copy of the *Zafarnama*, dated 807/1405 (BL Or. 2833); and the so-called Yazd Anthology, copied in Yazd and dated 810/1407 (TS H. 796). The two anthologies, in particular, are of a very high quality and as such are generally considered to be the result of royal patronage. Frequently all three are attributed to Iskandar; however, as Priscilla Soucek has pointed out, the Yazd Anthology surely cannot be the result of his patronage,[162] and, as he was not established in Shiraz until 811/1409, he could not be responsible for the production of the other two manuscripts either, each of which is presumed to be a product of Shiraz.[163]

However, eight manuscripts exist (two of which are now divided to form a total of eleven discrete volumes) that actually do bear dedications to Iskandar.[164]

One of these is a collection of poems—now divided between Istanbul (TIEM 2044) and Lisbon (LA 158)—that is unillustrated but extensively illuminated. Dated 815–16/1412–13, the manuscript was copied during Iskandar's residency in Isfahan, though the place of production is not actually stated. The manuscript is unique among the known corpus of manuscripts bearing Iskandar's name, because, unlike all others, it is illuminated completely in the standard blue-and-gold floral style that developed during the Muzaffarid era. Indeed, when Iskandar took Shiraz he arrived in a city with a well-established tradition of book production, and this manuscript is a perfect example of that tradition (despite being made in Isfahan). However, his presence in the city signaled a change in the tradition's long-standing stylistic homogeneity.[165]

The most elaborate of the other manuscripts that bear Iskandar's name are his two lengthy anthologies of both poetry and prose texts: one is now in London (BL Add. 27261); the bulk of the other is in Lisbon (LA 161), with smaller sections of it in London (WL Pers. 474) and Istanbul (IUL F. 1418). These are truly exquisite manuscripts, especially in terms of the vast number and high quality of their illuminations.[166] In each, a distinctly Shiraz textblock format is used (to be discussed in the following chapter), in which a central block of text (most often divided into several columns) is surrounded on three sides by a marginal column filled with oblique lines of script.[167] The oblique positioning of the script in this outer column creates three triangular spaces—one so-called thumbpiece and two cornerpieces—that are usually filled with decoration, as in these two manuscripts (e.g., fig. 54). Fitted within this typical Shiraz layout are headings, frontispieces, decorated colophons, and other panels of full-color decoration. One double-page frontispiece in the Lisbon Anthology (ff. 2b–3a) is illuminated completely in the blue-and-gold floral style of Shiraz.[168] Some other illuminations in the anthologies are in a style derived exclusively from that of the Jalayirids of Baghdad and Tabriz (e.g., see fig. 54), but most incorporate elements of both this latter style and the blue-and-gold floral style (figs. 55–56). When elements of the two styles are combined, the Jalayirid-style elements usually dominate: the palmette-arabesque is the main motif, the palette is bright and varied, and the cartouches are most often even-contoured. These elements generally differ from those in surviving manuscripts made for actual Jalayirid patrons, such as Sultan Ahmad, in that the motifs in Iskandar's manuscripts tend to be smaller and less robust, perhaps the result of contact with the minutely detailed blue-and-gold floral style, and although the palette is vibrant—characterized by its use of a

54. Folio with heading,
Anthology, 813–14/1410–11,
18.4 x 12.7 cm (folio).
© The British Library Board,
Add. 27261, f. 28b.

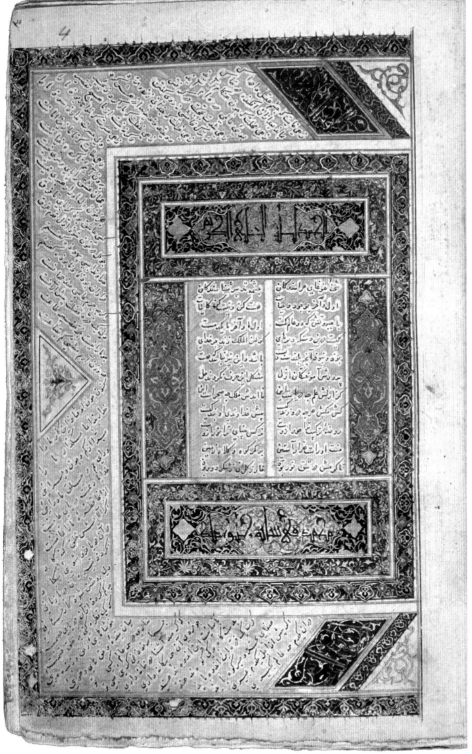

55. One half of a double-page text-frontispiece, Anthology, 813–14/1410–11, 18.4 x 12.7 cm (folio). © The British Library Board, Add. 27261, f. 4a.

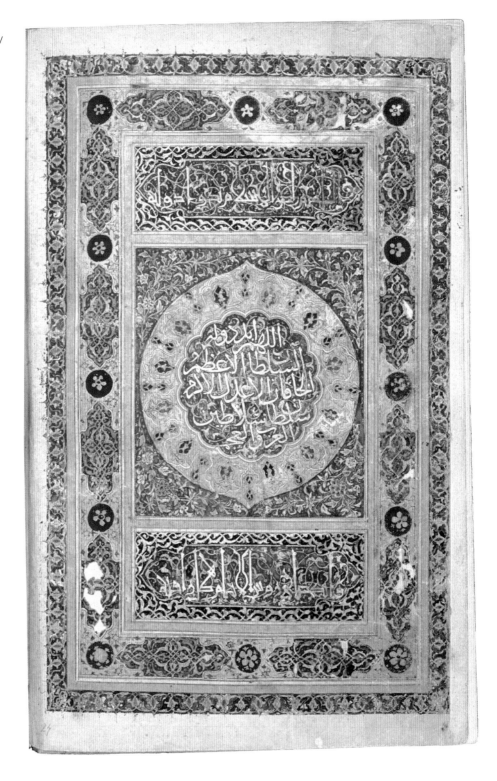

56. One half of a double-page
frontispiece, Anthology, 813–14/
1410–11, 18.4 x 12.7 cm.
© The British Library Board,
Add. 27261, f. 2b.

delicate purple and an almost overwhelming use of gold—it lacks the intense color contrasts used in much of Sultan Ahmad's *Divan*. The main elements borrowed from the blue-and-gold floral style and used in conjunction with these "foreign" (non-Shiraz) elements are baroque- or uneven-contoured cartouches and sprays of blossoms that are long-petaled derivatives of the lotus and other types used in the blue-and-gold floral style but which, unlike their blue-and-gold floral style cousins, tend to be painted in bright colors and outlined in gold.[169] The frequent tripartite division of headings, with a central cartouche and two smaller end sections each approximately half the width of the central cartouche, is also borrowed from the blue-and-gold floral style,[170] and in some cases there is a distinct and very Shirazi "playing with space" in the use of forms that appear cut off or half hidden.[171] In a very few of these "blends," it is the blue-and-gold floral style that prevails, in particular in the double-page text-frontispiece of the London Anthology (ff. 3b–4a) wherein all "foreign" elements are subjugated through use of a blue-and-gold palette (see fig. 55).

Despite the noted differences between Iskandar's "Jalayirid" illuminations and those made for actual Jalayirid patrons, the obvious confidence and familiarity with the Jalayirid style exemplified by these illuminations suggest that they are not the work of Shiraz artists copying Jalayirid models but rather are more likely the work of actual Jalayirid artists who had migrated to Shiraz. A reverse situation exists in the case of many of the blue-and-gold floral style elements used in the illuminations of Iskandar's two anthologies, in particular the florals that often simply do not seem "quite right." It is not merely the bright and highly varied palette in which the blossoms are rendered and their gold outlining, but rather it is more that they are not correctly delineated: they are basic Shiraz types but somehow altered, sometimes a bit too full and robust, sometimes with petals that are a bit too intricate. There is a strong sense of their having been produced by artists not completely familiar with the blue-and-gold floral style, suggesting that they were produced, perhaps, by Jalayirid artists working from Shirazi models. It is rather surprising, however, that there is no earlier evidence of Jalayirid illuminators having made their way to Shiraz.

Twice Timur captured the Jalayirid capital, Baghdad, in 795/1392–93 and in 803/1401. His second attack was particularly destructive and presumably would have resulted in the dispersal of artists employed by Sultan Ahmad Jalayir. But no evidence of a migration of illuminators to Shiraz at that time exists, and the

first Shiraz manuscripts to show any evidence of the Jalayirid illumination style are those of Iskandar, the earliest of which is dated 813/1410, just one year after he was established as ruler of Shiraz. The Jalayirid artists responsible for these manuscripts presumably were dispersed and/or lured to Shiraz by Iskandar not long before the execution of Sultan Ahmad, in 813/1410, by his old friend and ally, Qara Yusuf of the Qara Qoyunlu.[172] However, Iskandar may also have had access to Jalayirid artists through one of his wives, the daughter of Sultan Ahmad, whom he apparently married in or shortly after 804/1402.[173]

Within Iskandar's manuscripts, there exists a dichotomy additional to that between the "Jalayirid" style and the "Muzaffarid" blue-and-gold floral style. The various types and styles of illumination, in particular in his two anthologies, can also be divided into two further categories based on a broader geographical and cultural division: Islamic and Chinese. The two double-page frontispieces that introduce each manuscript (e.g., see figs. 55–56), the numerous headings (see fig. 54), and most of the decorated colophons or endpieces scattered throughout each of these two very long manuscripts are all purely Islamic in terms of style and motifs.[174] However, based on technique, coloring, and motifs, numerous other illuminations in the London and Lisbon anthologies can be termed Chinese. These are the black line drawings of dragons, simurghs, swimming and flying ducks, long-tailed birds, rabbits, swirling cloud scrolls, blossoms, and various other motifs that fill the cornerpieces, thumbpieces, and sometimes also the outer marginal columns of the folios or even the main textblock space.[175] Each brush stroke swirls and curves with tremendous energy, giving the impression of having been executed quickly and with great flourish. Soft washes of color fill in the forms, most frequently a soft blue-gray used in conjunction with a thin layer of gold. "Chinoiserie" is a more appropriate term for these illuminations, because few examples are purely Chinese and exact parallels in Chinese art would probably be impossible to locate. More often than not, they are a Chinese-Islamic blend, but to ever differing degrees, and whether it is more correct to characterize them as composed of Chinese forms that have been Islamicized, or of Islamic forms that have been sinicized, varies from folio to folio. For example, in the London Anthology, an Islamic arabesque is populated with Chinese-style blossoms and flying ducks, all drawn and colored in the Chinese style (fig. 57), and elsewhere in the manuscript, Chinese-style florals are treated in a distinctly Islamic manner, being painted in bright blues, orange, and magenta and thickly outlined in gold (fig. 58).

The inclusion of chinoiserie decorations, painted in soft washes, in a manuscript otherwise filled with brightly colored illuminations, at first seems rather startling and highly incongruous. The apparent incompatibility of the two styles surely did not escape the artists who planned and executed the manuscripts' decoration. Indeed, the contrast was certainly intentional, because the excessive amount of decoration in each manuscript might in fact have been oppressive if all were executed in the vibrant, Islamic-style palette. Thus, the chinoiserie decoration lightens the load of the viewer, so to speak, through its proffering of a most welcome visual respite. Likewise in the London manuscript, the marginal columns of facing pages are always decorated differently, which, like the Islamic-Chinese clash of styles and techniques, serves to pique and maintain visual interest. Although many of these Chinese, or chinoiserie, motifs are not new to Islamic art, their extensive use in Iskandar's anthologies is, and one of the legacies of Iskandar seems to have been a renewed, or the cementing of a renewed, interest in chinoiserie motifs,[176] an interest that was to find its greatest expression in fifteenth-century bookbinding decoration; indeed, many of the chinoiserie designs in Iskandar's anthologies consist of isolated panels, cartouches, or other elements that could well have served as patterns for the decorating of bindings.[177]

Two final features of Iskandar's two anthologies require mention. The first is the great extent to which they are illuminated: few, if any, earlier manuscripts other than copies of the Qur'an are so extensively illuminated. The second is their extensive use of panels, or pieces, of illumination that lack any of the usual external or internal structures to contain or restrain the perceived free flow of the (usually arabesque) decoration. These seemingly unstructured panels of illumination occur in the central textblock space (e.g., fig. 59),[178] where they are used to mark the end of a section of text (surrounding the triangular space of a colophon or endpiece), or they may completely fill the central textblock space of a page that faces or follows a page on which a decorated colophon or endpiece appears.[179]

In the fourteenth century, the decoration of Il-Khanid and Mamluk manuscripts, in particular copies of the Qur'an, sometimes included frontispieces of "pure" illumination, namely, those in which no script whatsoever is included (often referred to as "carpet-pages"). Typically, these are highly structured compositions, as is the page reproduced here as figure 10: the arabesque forms of the central panel are tightly confined within a network of interlaced bands of white braid;[180] this central panel is in turn locked in place by several wide bands of gold strapwork, which are themselves bounded by a wide arabesque border.[181] In the

57. Folio with decorated margins,
Anthology, 813–14/1410–11, 18.4 x
12.7 cm (folio). © The British Library
Board, Add. 27261, f. 406a.

92

58. Folio with decorated margins,
Anthology, 813–14/1410–11, 18.4 x
12.7 cm (folio). © The British Library
Board, Add. 27261, f. 410a.

Hamadan Qur'an, dated 713/1313 (Cairo 72), panels of decoration may be highly structured internally, but they are not always confined within strapwork bands and arabesque borders.[182] In two frontispieces in Sultan Ahmad Jalayir's *Divan* of 809/1407 (TIEM 2046, ff. 1b–2a and 55b–56a), large panels of arabesque in a web- or net-like pattern are used, but they are set within a surrounding super-structure of upper and lower panels of script, linked by wide bands of decoration (and see also fig. 52).[183] Similar compositions are known from other manuscripts, two of which are surely Jalayirid.[184] Yet another such composition is found in Is-kandar's Lisbon Anthology (LA 161, f. 201a),[185] but like the several other, smaller panels of arabesque used in his London Anthology (see fig. 59), this example is not so structured and restrained, either internally or externally, as it lacks both the bordering panels and the surrounding bands of decoration of the Jalayirid examples. The lack of an external, confining structure is reminiscent of the Hama-dan Qur'an, but considering that this manuscript pre-dates Iskandar by a full cen-tury, the use in Iskandar's manuscripts of such "free," externally and internally unstructured panels of "pure" illumination must be considered a highly innova-tive development of their Jalayirid precursors. Even when the designs are fitted around a triangular colophon, they are more free ranging than any earlier compo-sitions and certainly much less structured than other decorated colophons. The original use of such panels of "pure" illumination and the unusual extent to which the two anthologies are illuminated are part of Iskandar's legacy to his cousin Baysunghur ibn Shah Rukh, as evidenced, for example, by the illumination of Baysunghur's *Gulistan* of Sa'di now in the Chester Beatty Library (Per 119, fig. 60).[186] In this manuscript, palmette-arabesques in a range of forms and sizes ap-pear on almost every page (from tall, almost tree-like panels to extracted "bits" of arabesque that resemble tiny shields or blazons), creating a breathtakingly luxuri-ous manuscript. But the manuscript's decoration is in fact "merely" a rich com-posite of variations on a single theme, because, despite its many guises, the same palmette-arabesque, in the same three colors (gold, blue, and sometimes green), is used again and again. It is a sharp contrast to Iskandar's London Anthology, in which a potentially cacophonous variety of elements are ingeniously juxtaposed to create a continuous stream of intense visual excitement.[187]

Iskandar Sultan's Role as a Patron of Manuscripts

In Rajab 816/October 1413, Shah Rukh set out to subjugate Qara Yusuf of the Qara Qoyunlu, commanding Iskandar to join him near Rayy. Suspecting that his

uncle was actually planning to move against him and not Qara Yusuf, Iskandar refused to comply. Instead, he responded by immediately instituting the *sikka* and *khutba* in his own name, impertinently replacing the name of his uncle, Shah Rukh. He then issued edicts to the various rulers of the provinces of Qandahar, Kabul, Ghazin, and Sistan, commanding them to obey him and stamped with a seal that stated, "Regent of Muslims, Friend of the Prince of the Faithful, Sultan Iskandar: of his command, which is to be obeyed."[188] These treasonous acts soon resulted in the demise of Iskandar, because Shah Rukh in turn responded by abandoning his campaign against Qara Yusuf to deal with the more immediate problem of his nephew.[189] On 4 Rabi' I 817/3 June 1414, he laid siege to Isfahan, Iskandar's new place of residence. Less than two months later, on 2 Jumada I 817/20 July 1414, the sultan's forces succeeded in taking the city and in taking Iskandar himself captive; on the authority of Shah Rukh, the recalcitrant prince was blinded by his brother Rustam, then executed the following year, in 818/1415.[190]

The surviving documentary and visual evidence demonstrates that this display of independence was, so to speak, nothing new. It was, however, these final and most blatant acts of sovereignty that caused Shah Rukh finally to move to subjugate his nephew. As early as 802/1399–1400, Iskandar had shown signs of insubordination. That winter his maternal grandfather, Khizr Khwaja Oghlan, the ruler of Moghulistan, died. Not content with the lands already granted him by Timur,[191] Iskandar quickly laid claim to and raided his grandfather's lands. This act led to the seizure and forcible imprisonment of Iskandar and his amirs by Muhammad Sultan, another of Timur's grandsons, who had been left in Samarqand as Timur's deputy during his absence while on campaign. The ensuing investigation resulted in the execution of Iskandar's amirs, while Iskandar himself was spared but remained imprisoned in Samarqand. A year later, he was taken before Timur for trial, given the bastinado, and then released.[192] He then appears to have temporarily redeemed himself by joining Timur on his Anatolian campaign of 804/1402. As a reward, he was granted the districts of Hamadan, Nihavand, Burujird, and Lesser Lur.[193]

Iskandar's lengthy imprisonment and punishment are completely overlooked in a purportedly historical account of his time, written anonymously in Isfahan and dated 21 Rabi' I 816/21 June 1413; a copy is included in a manuscript made for Iskandar and now held in the Topkapi Saray Library.[194] The document clearly presents Iskandar's own, biased view of events. The tone of the document is overly exuberant, and it is an exceptionally glorious view of Iskandar that is presented,

even considering the usual bombastic tone of contemporary official writings, especially those commissioned by a ruler.

According to the document's author, of the sons of 'Umar Shaykh, it was Iskandar whom Timur singled out "to view with favor and attention" and that he "set all his hopes upon his [Iskandar's] glory."[195] Moreover, sometime after the death of 'Umar Shaykh in 796/1393, Timur, having "recognized the light of fortune and felicity and the aura of rule" in Iskandar, is said to have sent the prince "to consolidate Transoxiana and to guard the borders of the realm against the Moghuls."[196] Such claims are obviously an attempt to justify Iskandar's annexation, in 802/1399–1402, of his maternal grandfather's lands. Instead of appearing as an act of rebellion, the annexation of the lands is presented as an act of loyalty, thereby creating the impression that Timur would never have had any reason to question Iskandar's faithfulness to him. The author implies that Iskandar was later granted Hamadan because of his trustworthiness and as a defense against the distrust Timur felt for the sons of Jahangir, one of whom, Muhammad Sultan, had rebelled against Timur.

Iskandar's point of view, as presented in the Topkapi document, also indicates that although Timur had granted Pir Muhammad control of Fars after the death of 'Umar Shaykh, it was Iskandar who was preeminent over his brothers and that it was he who, after Timur's death, secured his brothers' control of the region.[197] Other sources make it clear, however, that 'Umar Shaykh's eldest son, Pir Muhammad, was in fact the highest ranking of the brothers and that upon the death of Timur, Pir Muhammad, as head of his branch of the family, sent a letter to Shah Rukh pledging his allegiance along with that of his brothers and confirmed that allegiance by striking coins and reading the *khutba* in Shah Rukh's name. And it was Pir Muhammad who, as the predominant brother, granted Yazd to Iskandar in 1405.[198]

The document omits all mention of the second time that Iskandar was sent in chains to the sultan, at that time Shah Rukh. As noted previously, in 809/1406–07, a dispute between Iskandar and Pir Muhammad broke out and Iskandar fled from Yazd.[199] He was soon captured by Pir Muhammad's forces and sent to Herat, but he managed to escape before reaching his uncle's court. He then fled to Isfahan, where his brother Rustam joined forces with him. Eventually, after several skirmishes and battles and a forty-day siege of Shiraz, Shah Rukh intervened and the dispute was settled, enabling Iskandar to return to Shiraz at the end of Rama-

dan 811/February 1409.[200] A much wiser move on the part of Shah Rukh would have been to keep Iskandar close by, under a watchful eye.

The following year, in 812/1409–10, while on an expedition to Kirman with Iskandar, Pir Muhammad was murdered by one of his closest amirs, Husayn Sharbatdar; Iskandar quickly rushed back to take control of Shiraz. Understandably, he was at first suspected of complicity in his brother's murder, but his story was soon verified by others returning from Pir Muhammad's camp.[201]

The anonymous document includes a lengthy passage telling of the vast lands supposedly conquered by Iskandar and how all rulers prostrated themselves before him. It is, perhaps, not mere coincidence that the only two rulers specifically named are the emperor of China and Sultan Ahmad of the Jalayirids and that the two non-Shiraz styles Iskandar incorporated into his illuminations, in such obvious preference over the "local" blue-and-gold floral style, were those associated with the Chinese and the Jalayirids. The author of the document then continues, stating that the deeds of Iskandar's grandfather and father have surpassed those of all other rulers, yet, he claims rather audaciously, their combined deeds and those of thousands of other rulers are in fact nothing in comparison with the greatness of Iskandar.[202]

According to Khwandamir, on his deathbed Timur named Pir Muhammad ibn Jahangir his heir.[203] However, the anonymous document claims that Timur had named Iskandar his heir.[204] Iskandar's vision of himself as a great world leader in the image of his paternal grandfather is evident from the statements made in the document. It is equally evident from the visual evidence present in his Lisbon Anthology. A double-page painting occurs in the section of the manuscript that relates Nizami's poem *Khusraw va shirin* (ff. 27b–28a; figs. 61–62). The painting is unusual and immediately piques the viewer's curiosity on two counts: size and subject. First, it is spread across two full pages and thus one would assume that it is more important than smaller illustrations included elsewhere in the manuscript.[205] Second, it depicts Khusraw enthroned, and illustrations that do not depict the two lovers or at least relate directly to the story of their love for each other are unusual.[206] Soucek has carefully analyzed the illustration and has suggested that the scene depicts the five rows of citizens whom Nizami relates as coming before Khusraw: the rich, the dervishes and those in need, the ill, those in chains, and the murderers. On the right-hand page (see fig. 62), the rich (and perhaps some courtiers) are portrayed in the three rows on the left; in the rows on the

61. Left half of a double-page painting, Anthology, 813/1411, 27.5 x 17.7 cm (folio). Calouste Gulbenkian Museum, Lisbon, LA 161, f. 28a.

62. Right half of a double-page painting, Anthology, 813/1411, 27.5 x 17.7 cm (folio). Calouste Gulbenkian Museum, Lisbon, LA 161, f. 27b.

right are the dervishes at the top, then the bare-chested ill, and the men in chains stand in the bottom row with ropes about their necks, while a bloody, decapitated figure lies on the ground, presumably a punished murderer. Khusraw, surrounded by courtiers and a young prince, looks on from the left-hand page (see fig. 61). Soucek has suggested that the enthroned figure is actually a depiction of Iskandar Sultan, with the citizens of his domains before him, and that the young prince might be his brother Rustam or, more likely, his younger brother Bayqara who had been sent to Shiraz from Herat at Iskandar's request. Moreover, the headgear of the rich citizens suggests that both Arabs and Persians are portrayed, perhaps a reference to the inscription in the frontispiece to the manuscript in which Iskandar is described as "Sultan among Sultans of the Arabs and Persians." Soucek therefore sees this double-page illustration as reflecting Iskandar's growing ambitions.[207] Indeed, it clearly depicts his view of himself as a world ruler and serves as the visual equivalent to the written account of his military feats contained in the anonymous document. In addition to the accomplishments referred to previously, the document claims that the lands Iskandar conquered and was in control of included ones covering the width and breadth of Iran and Turan, from Khurasan to Darband, and also lands from Mecca and Medina to Kuch—and thus both Persian and Arab lands. In the same vein, the author of the document states that "all the various nations and classes of creatures of the world, externally and internally, bow to his generous existence in fealty."[208]

The anonymous document also recounts what the author sees as Iskandar's incredible accomplishments in all sciences, such as philosophy, mathematics, and all religious and mystical sciences. He states that even the finest scholars, each of whom is proficient in "several thousand arts and sciences," benefit from association with Iskandar, for any problem that might prove too difficult for them, they can rely on Iskandar to solve.[209] The greatness of Iskandar is made even more apparent by comparison, later in the document, with the accomplishments of Shah Rukh, who, it is patronizingly said, "knows well how to maintain the externals of the religious and customary law, but . . . has not embarked upon any particular science or art."[210] Iskandar, therefore, is an expert in so many of the arts and sciences, while his uncle is an expert in none.[211]

Iskandar's Lisbon and London anthologies each comprise (largely excerpts of) both prose and poetry texts, covering a vast range of topics and composed by a great assortment of authors and poets. Among the poetry texts contained in the Lisbon manuscript are the *Khamsa* of Nizami, a romantic epic; the *Gushtasp-*

nama of Asadi, a heroic epic; and the mystical *Mantiq al-tayr* of 'Attar. Some of the excerpted prose works included are *Tarikh-i guzida* of Hamdallah Mustawfi and Asadi's *Kitab dar lughah-i furs*.[212] The texts contained in his London Anthology are equally diverse. The poetry texts include excerpts of the *Shahnama*; the poems of 'Attar, Nizami, Khwaju Kirmani, and Amir Khusraw Dihlavi; a selection of the work of more than three hundred other poets arranged according to subject or metrical forms; and *qasidas* in praise of Muhammad and the imams. Some of the various prose texts are a manual of Shi'a law and a variety of treatises on religious observances, astronomy, astrology, geometry, alchemy, and diseases of the horse.[213] All this diverse material is in each case contained within a highly compact format: the London manuscript measures 184 x 127 millimeters, while its somewhat larger Lisbon counterpart measures 265 x 170 millimeters.[214]

The wide range of texts in Iskandar's Lisbon and London anthologies would seem to provide material proof of Iskandar's broad interests and great intellectual capacities as recounted in the anonymous Topkapi document. However, the hyperbole that permeates the document's accounts of Iskandar's military feats is, without doubt, equally a feature of the account of the level and breadth of his intellectual capacities, and the anthologies are simply another manifestation of this hyperbole. The diversity of the texts included in the anthologies was surely intended as a form of propaganda aimed at promoting Iskandar's vision of himself as a great intellectual in the same way that the double-page illustration promotes his vision of himself as a world leader. A collection of such diverse material, both poetry and prose, all contained within a single, lengthy book, creates an impression more powerful than would a collection of individual books on individual subjects: so much knowledge crammed into one compact, easily portable space, and hence always available for immediate reference, surely is a convenience only a great intellectual would require. Anthologies dealing with such varied and numerous topics appear to be unique to Iskandar, probably because they served a function specific to his needs.

The likelihood that the double-page painting of Khusraw in the Lisbon Anthology and the choice of contents for both the London and Lisbon anthologies had a propagandistic purpose makes it easier to accept the idea that for Iskandar the patronage of fine manuscripts was in itself not a benign act. The commissioning of fine manuscripts had long been considered an aspect of royalty.[215] It is with Iskandar, however, that we first have material evidence of extensive patronage additional to that of the ruling sultan, on the part of princes of the

royal house. There are also a greater number of manuscripts bearing Iskandar's name than that of any earlier Persian patron, and no earlier secular manuscript is as extensively illuminated as are his London and Lisbon anthologies. Thus, Iskandar's patronage is exceptional on a number of counts, suggesting that he may have intentionally appropriated this kingly act as a yet another show of independence and his right to rule. At the very least, there was an undoubted aim to impress and to display the splendor of his rule through the commissioning of magnificent manuscripts.

It may not, however, have been Iskandar's political ambitions only that worried Shah Rukh, because the prince's obvious Shiʿa beliefs undoubtedly caused his Sunni uncle additional concern. Evidence of these beliefs is found in Iskandar's two large anthologies. In the Lisbon Anthology, in one of the double-page frontispieces (ff. 3b–4a), a wide band containing cartouches filled with a palmette-arabesque forms a rectangle around the central *shamsa*.[216] Set in each corner of this band is a small circle containing the name "Muhammad" written three times. A similarly inscribed diamond-shape is placed midway between the circles in each of the two vertical extensions of the band, but here "Muhammad" is repeated four times around the name "ʿAli." Likewise is ʿAli's name, written in square *kufic*, inserted into the illumination on folios 28a and 345a of the London Anthology. Also in this same manuscript, on folios 345b–48a, is a manual of Shiʿa law according to Imam Riza;[217] while other religious texts are included in the manuscript, only this specifically Shiʿa text is singled out, for the text of all six pages is written on a splendid ground of gold.

Having captured and blinded Iskandar, Shah Rukh gathered up Iskandar's artists and transported them back to Herat.[218] This act brought to an abrupt end a short and somewhat aberrant era in the history of book production in Shiraz, because, apparently with just one exception, Iskandar's distinctive style of manuscript illumination disappeared.[219] For the next decade and a half, the standard blue-and-gold floral style of the Muzaffarids again became the dominant—and presumably sole—illumination style used in Shiraz. It is instead in the manuscripts produced in Herat that Iskandar's influence is clearly evident, but in the area of illustration rather than illumination. There the compositions used to illustrate Iskandar's manuscripts were repeated, presumably often by the same artists who had originally produced them for Iskandar.[220] But perhaps Iskandar's greatest legacy to book production—and surely his greatest legacy to his cousin Baysunghur—was his propagandistic, political use of books. In no earlier period

of Islamic history does an individual's role as a patron of fine manuscripts appear to have had more overtly political connotations. It was Iskandar's political ambitions, however, that led to his demise, a demise that would surely have been immediate upon the fall of Isfahan and not delayed a year if his uncle had read one of the final statements contained within the anonymous Topkapi document, because it is there stated that "the most outstanding virtue he [Shah Rukh] possesses is that he loves His Highness Sultan Iskandar extremely well, wishes him well and supports him heartily by sending several times a year emissaries, messages and correspondences to His Highness the Sultan, and treading the path of devotion and affection."[221]

A TIME OF CHANGE: FROM IBRAHIM SULTAN
TO THE END OF TIMURID RULE IN SHIRAZ

Following the capture of Iskandar in 817/1414, Shah Rukh named Amir Mizrab governor of Shiraz. However, he died shortly after his appointment, and control of Shiraz then passed to the sultan's second eldest son, Ibrahim Sultan. Within a year Ibrahim's governorship was threatened by Iskandar, who had managed to incite his brother Bayqara to rebellion. Together they marched on Shiraz, and, although Iskandar himself was captured, Ibrahim was forced to flee and Bayqara entered the city at the end of Rabi' I 818/June 1415. Reaction was swift and the captured prince was immediately executed; some two months later Shah Rukh marched to Shiraz, regaining the city in the late autumn and reinstating Ibrahim as governor.[222] Ibrahim then retained control of the city until his death in Shavval 838/May 1435, at which time he was succeeded by his two-year-old son 'Abd Allah, who governed Shiraz until 851/1447.[223]

With the demise of Iskandar, the blue-and-gold floral style appears to have regained its former position of prominence as the dominant style in which Shiraz manuscripts were illuminated. But this situation was to change. An analysis of manuscripts produced both during and after the reign of Ibrahim, in conjunction with an analysis of contemporary manuscripts produced in Herat, reveals that changes and modifications in the actual appearance of the manuscripts, as well as in the manuscript industry of Shiraz *per se*, either occurred specifically during the decade immediately following Ibrahim's death, 839–48/1435–36 to 1444–45, or were concentrated during those years. These changes can be explained in relation to the life and personality of Ibrahim Sultan.

The Emergence of a New Illumination Style

In the early 1430s, the eventual but slow demise of the blue-and-gold floral style was signaled by the appearance of a new illumination style in the manuscripts of Shiraz. The most apt, though slightly cumbersome, name for the new style is "floral/palmette-arabesque," because overall (and unlike the earlier style) florals and palmette-arabesques are equally prominent features of it (figs. 63–68), although usually either one or the other dominates in any one heading or frontispiece. Before long the two styles were equally popular, and there in fact exist numerous manuscripts in which both are used, resulting in a rather odd conjunction of two very different illumination styles: as in a copy of the *Kulliyyat* of Sa'di, dated 856/1452 (CBL Per 133), a non-text-frontispiece in one style (see fig. 46) is frequently followed by a text-frontispiece in the other style (see fig. 63).[224] Possibly the earliest manuscript in which the fully developed floral/palmette-arabesque style is used is a copy of *Kamil al-ta'bir* (TS A.III 3169), a treatise on the interpretation of dreams, dated 835/1432. In this manuscript, a beautiful double-page frontispiece in the blue-and-gold floral style (fig. 69) is followed by a heading in the new floral/palmette-arabesque style (fig. 70).[225] The latest examples of the new style date to the 1460s,[226] but, based on the evidence of more than thirty manuscripts illuminated either partially or fully in this style, its peak years of use were the period 839–48/1435–36 to 1444–45. The distribution of these manuscripts over a period of four decades is a follows: 6 percent produced in the decade 829–38/1425–26 to 1434–35;[227] 58 percent produced in the decade 839–48/1435–36 to 1444–45; 24 percent produced in the decade 849–58/1445–46 to 1454; and 12 percent produced in the decade 859–68/1454–55 to 1463–64.

Florals arranged in the form of small sprays are a distinctive feature of the blue-and-gold floral style (e.g., see fig. 48), although long bands, or streamers, of blossoms are also common (e.g., see figs. 43–44), and it is this latter arrangement of blossoms that is more commonly used in the new illumination style, as it is in the illuminations of Iskandar Sultan and Baysunghur. More intriguing, however, is the role accorded the palmette-arabesque, which, though never more than a minor player in the blue-and-gold floral style, is now elevated to a position of prominence, once more somewhat akin to its role in illuminations produced for Iskandar (e.g., see figs. 54 and 59) and Baysunghur (figs. 71–72; and see fig. 60). But in comparison with illuminations made for these two great patrons, the palmette-arabesques, and in fact all elements of the new style, tend to be overall plumper, often more densely applied, and generally much more vigorous and robust.[228] The

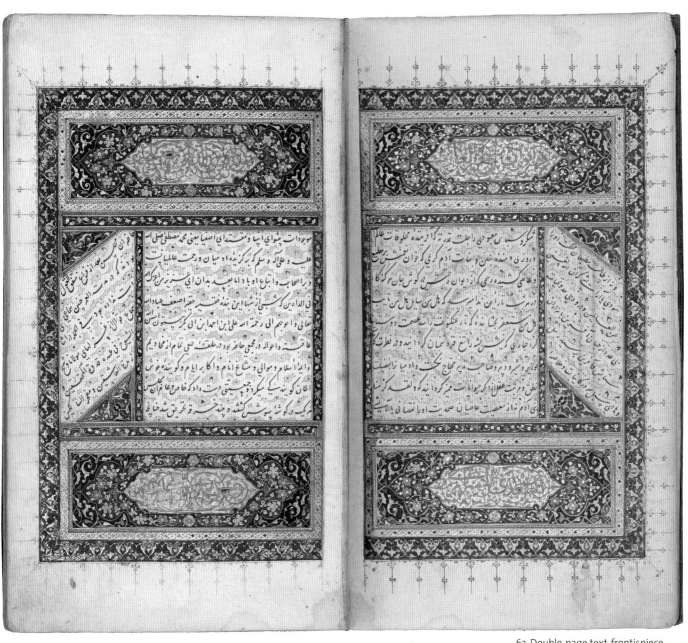

63. Double-page text-frontispiece, *Kulliyyat* of Saʿdi, 856/1452, 22 x 13 cm (folio). © The Trustees of the Chester Beatty Library, Dublin, Per 133, ff. 2b–3a.

(top) 64. Heading, *al-Mathnawi al-ma'nawi* of Rumi, 849–50/1445–46, 23.6 x 16.5 cm (folio). Topkapi Saray Library, Istanbul, R. 434, f. 196b. Photograph by author.

(bottom) 65. Heading, *Khamsa* of Nizami, dated 844/1440 and 846–47/1442–43, 18 x 13.5 cm (folio). Topkapi Saray Library, Istanbul, R. 862, f. 146b. Photograph by author.

66. Heading, *al-Mathnawi al-ma'nawi* of Rumi, 846/1442, 23.6 x 16.1 cm (folio). © The Trustees of the Chester Beatty Library, Dublin, Per 125, f. 1b.

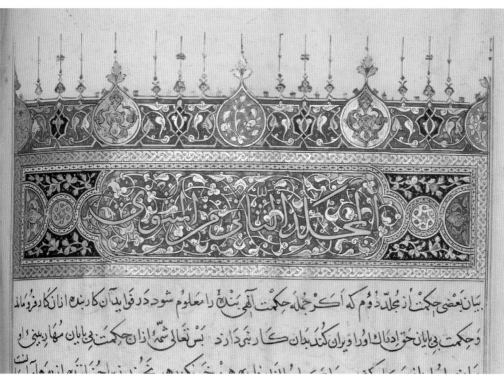

67. Heading, *al-Mathnawi al-ma'nawi* of Rumi, 846/1442, 23.6 x 16.1 cm (folio). © The Trustees of the Chester Beatty Library, Dublin, Per 125, f. 58b.

68. One half of a double-page text-frontispiece, *Khamsa* of Nizami, 839/1435, 19.6 x 13.5 cm (folio). © The British Library Board, Or 12856, f. 2a.

palette is broad and bright, yet it is distinguished from that of Iskandar or Baysunghur in its frequent use of blossoms in colors such as peach, aqua, pale blue, rose, and yellow. Highly characteristic are clover-leaf-like blossoms, each comprising three evenly spaced, heart-shaped petals, prominently outlined in white (e.g., see figs. 64 and 70). Although very different from the unoutlined blossoms so typical of the blue-and-gold floral style, blossoms outlined in white are actually not new: they are found in some Jalayirid illuminations and sometimes also in those of Iskandar and Baysunghur.[229] But only in the floral/palmette-arabesque style of Shiraz are they used in such profusion and is the white outline so prominent. Other blossoms are closer to the types found in earlier Shiraz illuminations and include small buds, a flower with three toothed petals, the familiar five-petaled butterfly-like blossom (see fig. 65 for each of these types), and, less often, multipetaled rosettes (e.g., see fig. 63). Usually these other blossoms are simply outlined in black, but they may also be defined by fine white or black striations or by a feathery fringe of thicker white striations (see fig. 63).[230] They may be placed on a gold ground (see figs. 65–66) or a dark (usually black) ground, in which case they are often interspersed among a dense mat of lush, thick-stemmed gold vegetation (e.g., see fig. 64). This vivid contrast of gold on black is a characteristic feature of the new style, and even brighter contrasts may be used, such as the placing of a bright orange palmette-arabesque atop a royal blue ground (see fig. 65), the latter also being a common combination in Baysunghur's illuminations. However, a somber palette of rust, black, olive green, deep blue, gold, and white is equally characteristic (see fig. 68), and frequently the two contrasting palettes are used in conjunction: a somber-colored palmette-arabesque border often surmounts an otherwise brightly colored heading (see fig. 65). A similar conjunction of two contrasting palettes is used (though less frequently) in Baysunghur's manuscripts, borrowed like so much else from the Jalayirids, but, in Baysunghur's manuscripts, the brighter palette is often almost shockingly brilliant, tending to bright pinks and ice blues.[231] Other defining features of the new style are clusters of three tiny white dots sprinkled across dark grounds, thick bands of gold strapwork (e.g., see figs. 64–65), and cartouches formed from geometrically interlaced bands (see figs. 67–68), though baroque-edged cartouches are more characteristic (see figs. 65–66). Occasionally emerging from the upper border of a heading are the small pear- or teardrop-shaped elements commonly seen in the blue-and-gold floral style (see figs. 67–68).[232]

A comparison of frontispieces in each of the illumination styles mentioned

69. One half of a double-page frontispiece, *Kamil al-ta'bir*, 835/1432, 26.8 x 18 cm (folio). Topkapi Saray Library, Istanbul, A.III 3169, f. 2a. Photograph by author.

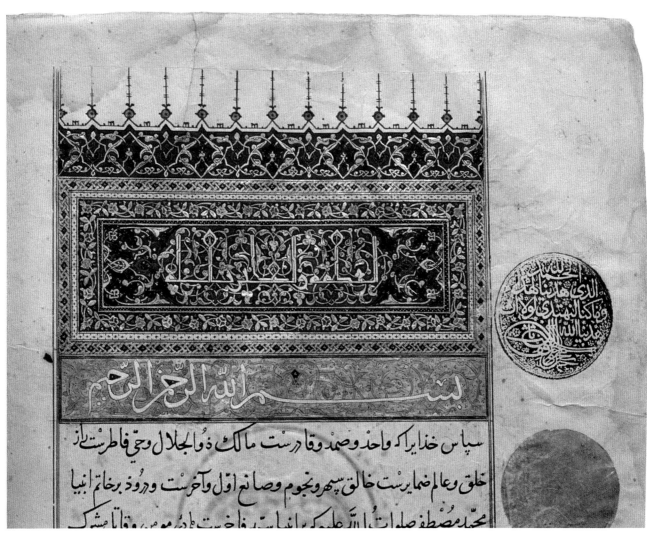

70. Heading, *Kamil al-ta'bir*, 835/1432, 26.8 x 18 cm (folio). Topkapi Saray Library, Istanbul, A.III 3169, f. 2b. Photograph by author.

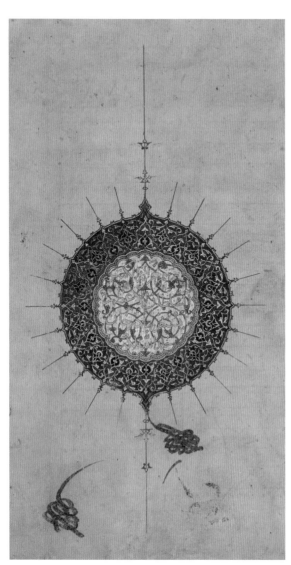

71. *Shamsa*, *Gulistan* of Sa'di, 830/1426–27, 24.8 x 15.4 cm (folio). © The Trustees of the Chester Beatty Library, Dublin, Per 119, f. 1a.

above allows the similarities and differences among the four styles to be clearly discerned. The frontispiece in Iskandar's London Anthology (see fig. 56) is typical of illuminations produced for that prince in that it is predominantly "Jalayirid" in its extensive use of the palmette-arabesque, but equally typical is its use of sprays of brightly colored blossoms outlined in gold, which are here prominently placed in the corners of the central, rectangular space. Blossoms are also often used in Baysunghur's illuminations, but the palmette-arabesque is much more pervasive in, and hence more characteristic of, illuminations made for him (see fig. 72). Very different, indeed, are the restricted palette, intricate composition, minute forms, and prevalent use of floral sprays of a typical blue-and-gold floral style frontispiece (see fig. 69). Both this latter frontispiece and figure 68—an example of the "new" floral/palmette-arabesque style—are products of Shiraz, and despite the fact that they also share certain obvious features, such as the teardrop-shaped elements that interrupt the border, there are striking differences in detail and overall effect between them.

The origins of the new floral/palmette-arabesque style seem to be firmly rooted in the contemporary illumination style of Herat, which is of course itself a development of the Jalayirid style, in part via the artists and manuscripts of Iskandar.[233] Yet this new Shiraz style is very different from that of Herat. Clearly it was not imported "ready-made" from the capital, and no precise parallels for it have yet been located in any Herat manuscript. Rather it seems that artists working in Shiraz selected mainly Herat motifs, adopting and altering them to create a new style.

Hints of the new style are present in two manuscripts made for Ibrahim Sultan: a copy of *Jami' al-sahih*, dated 832/1429 (Bayezit Feyzullah 489), and a *Shahnama* (BOD Ouseley Add. 176) that is undated but which was probably also produced in the final years of the 1420s or the early 1430s. In both manuscripts there are some illuminations purely in the blue-and-gold floral style and others that are a mix of Shiraz and Herat elements (fig. 73).[234] These mixed-style illuminations employ a mainly blue-and-gold palette. In the *Shahnama*, blossoms thinly outlined in gold,

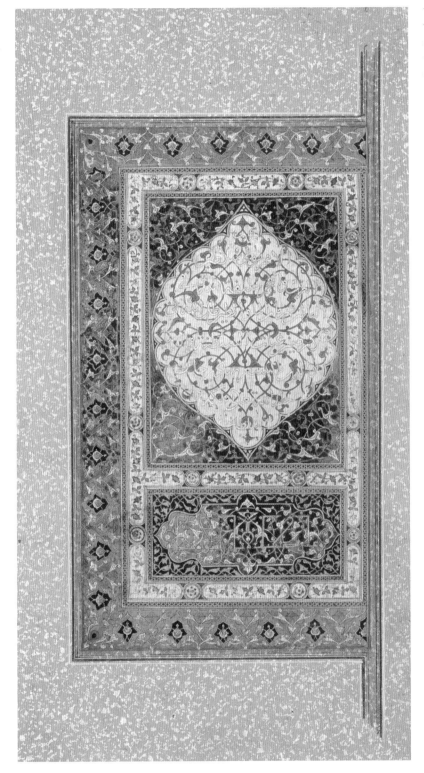

72. One half of the double-page frontispiece to an anonymous collection of Arabic proverbs and sayings, c. 1430, 25.1 x 14.1 cm (folio). © The Trustees of the Chester Beatty Library, Dublin, Per 120.2.

73. One half of a double-page
frontispiece, *Shahnama*, n.d., but
late 1420s or early 1430s, 28.8 x
19.8 cm (folio). Bodleian Library,
University of Oxford, Ouseley
Add. 176, f. 17a.

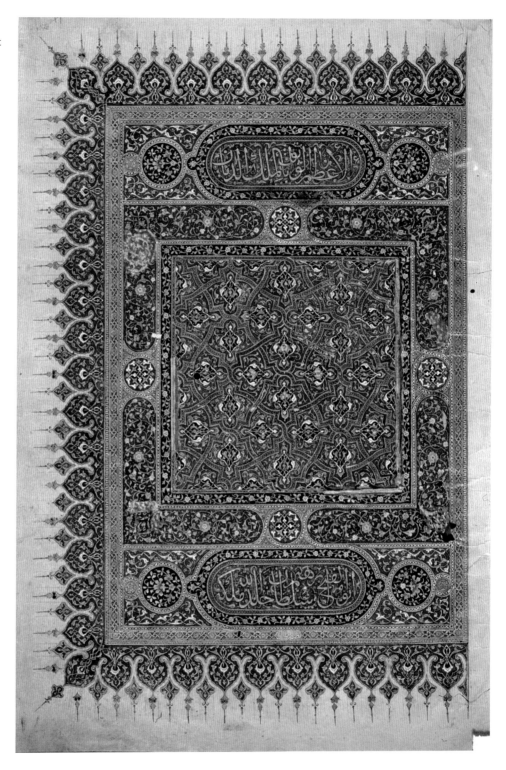

and more elaborate and more colorful than those typical of the blue-and-gold floral style, spring from arabesque vines. Finely outlined palmette-arabesques, geometrically interlaced bands that divide and compartmentalize space, and wide bands of gold strapwork are all used extensively. Some elements recall Iskandar's illuminations (such as the gold outlining of the blossoms); others are features of contemporary Herat illuminations. Florals laid out in long bands of linked stems are also a feature of these illuminations, and, although their use is nothing new, the specific use of clover-leaf-type blossoms, only, in colors such as peach and light blue, prominently outlined in white and placed on a black ground, is indeed new and will, of course, become one of the hallmarks of the floral/palmette-arabesque style. As previously noted, these clover-leaf-type blossoms sometimes appear in Baysunghur's illuminations, but always as just one type among many. The selecting and isolating of one specific and apparently insignificant motif or element and its subsequent elevation to a position of prominence within a new illumination or illustration style, as in the case of these blossoms, is a phenomenon that occurs repeatedly in Islamic art. It was therefore through an apparent process of selection, adoption, and adaptation that the Herat illumination style gave rise—perhaps in part at the hands of Herat artists working in Shiraz—to a new Shiraz style, one that would often be used in conjunction with the strikingly different and much older blue-and-gold floral style, elements of which also contributed (though to a lesser degree) to the development of the new style.

The Introduction of a New Type of Paper

The development of a new illumination style was not the only change in the appearance of Shiraz manuscripts to take place, because a new type of paper appeared at the same time (the specific features of which are discussed in the following chapter). As with the new illumination style, the earliest Shiraz manuscript in which it is used is the copy of *Kamil al-ta'bir*, dated 835/1432 (TS A.III 3169). Use of this new type of paper was likewise concentrated in the period 839–48/1435–36 to 1444–45, but then declined sharply during the following ten years. Despite being associated almost exclusively with Shiraz, the earliest examples of this type of paper so far located are two manuscripts copied in Herat, in 834/1431, for Baysunghur (BOD Elliott 210 and BL Or. 2773). It might be argued that the Herat and Shiraz paper were simply purchased from a common source. However, the development in Shiraz of a new illumination style based on that of Herat, at

precisely the same time as the appearance of a new type of paper that can itself be traced to Herat, suggests that a migration of artists and craftsmen from Herat to Shiraz, probably in the late 1420s, did indeed take place. This occurrence can best be understood in relation to the patronage of Ibrahim Sultan.

The Illuminations of Ibrahim Sultan and Baysunghur

Illuminations in manuscripts made in Shiraz for and by Ibrahim are in a variety of styles.[235] Most common are those in the blue-and-gold floral style that was synonymous with Shiraz throughout his rule, such as a heading and one of three double-page frontispieces from his undated *Shahnama*. As discussed above, other illuminations in this same manuscript combine elements of the blue-and-gold floral style with those more common to manuscripts made for Baysunghur. And a copy of the *Divan* of Amir Khusraw Dihlavi states that it was copied for Ibrahim in Shiraz, in 834/1430–31 (TIEM 1982), yet some of its illuminations could well pass as products of Herat.[236] The skill with which the Herat-style illuminations were produced and the understanding of the style that they exhibit suggest that they were produced by artists trained in, and well used to practicing, this style—in other words, artists actually from Herat.

In comparison with manuscripts made for Ibrahim, those produced in Herat at Baysunghur's behest constitute a very homogeneous corpus of illuminations (e.g., see figs. 60 and 71–72). The earliest manuscript that appears actually to have been commissioned by Baysunghur and produced in his own atelier is a copy of *Khusraw va shirin*, dated 824/1421 and now in St. Petersburg (StP-IOS B-132).[237] This manuscript, like all others made for the prince from this date onward, is illuminated only in the palmette-arabesque style derived from that of the Jalayirids.[238] That Baysunghur shunned the blue-and-gold floral style of Shiraz by deliberate choice—and not through ignorance of it—is suggested by the existence of three manuscripts, each illuminated in this style and each surely known to him. The earliest of these is a copy of the *Tabaqat-i nasiri* (Berlin-SB Petermann I. 386) with a double-page frontispiece illuminated in the blue-and-gold floral style. The manuscript bears Baysunghur's name but was copied in Herat in 814/1411–12, about ten years before he established his own atelier and when he was just fifteen years old. It is therefore generally assumed that the manuscript was intended for his use but not made at his request. The second manuscript is surely one of the first to be illuminated by artists taken from Shiraz by Shah Rukh after he deposed Iskandar. It is a copy of Hafiz-i Abru's *Kulliyyat-i tarikhi* (TS B. 282), dated 818–

19/1415–16 and made for Shah Rukh. The manuscript is extensively illuminated, both in the palmette-arabesque style of Herat and in the blue-and-gold floral style of Shiraz. The third manuscript is an anthology dated 823/1420 (Berlin-MIK I. 4628), illuminated completely in the blue-and-gold floral style.[239] Its *shamsa* is inscribed with Baysunghur's name, but it has long been assumed that it was actually made in Shiraz and sent by Ibrahim as a gift to his brother. Manuscripts illuminated in the blue-and-gold floral style were therefore actually in Baysunghur's possession, and artists employed by his father were working in this style, leaving little doubt that he was well acquainted with the style.

Baysunghur's apparently deliberate exclusion of the blue-and-gold floral style from all manuscripts commissioned by him can be explained in light of his approach to manuscript illustration. Tom Lentz and Glenn Lowry have shown how under Baysunghur cultural prowess came to be equated with political prowess.[240] Text illustration was merely a secondary concern for Baysunghur. Of greater importance than subject was the setting, devised to portray brilliantly the highly sophisticated, cultured—and, by implication, politically powerful—Timurid court, so that the illustration served first and foremost as a glorification of royalty. To ensure that a unified image was presented to the world, Baysunghur carefully guided the development of text illustration, maintaining tight control of his atelier. For example, a stock set of images, many of which can be traced to Iskandar's manuscripts, was used repeatedly. Personal artistic expression, never very visible in Islamic art, appears to have been almost totally suppressed. Technique, instead, was held in high esteem: flawless draftsmanship and a jewel-like finish resulted in technically breathtaking images. Such images ultimately functioned as symbols of Timurid cultural—and hence political—authority.

Baysunghur's corpus of illuminations contributed equally to this image of Timurid cultural-political authority. A stylistically mixed corpus such as that of his brother would have been highly unsuited to his needs. Furthermore, he understandably shunned the blue-and-gold floral style, for it was a style associated so very strongly with the merely princely center of Shiraz. Instead, he employed only the palmette-arabesque style developed from, and thereby strongly associated with, manuscripts produced in the culturally sophisticated milieu of the Jalayirid court. It can be assumed, therefore, that there was no place in Baysunghur's atelier for illuminators working in the Shiraz style. Ibrahim, on the other hand, seems clearly to have employed Herat illuminators. He may even have made actual requests for Herat artists and craftsmen to travel to Shiraz to work for him,

because it is known that he made similar requests with respect to other individuals. For example, the sources record that Ibrahim asked that the historian Sharaf al-Din ʿAli Yazdi come from his father's court in Herat to facilitate the writing of a new history of Timur.[241] They also report Ibrahim's numerous and unsuccessful attempts to have Baysunghur send him the famous musician Khwaju Yusuf Andigani.[242] Based on a comparison of the corpus of illuminations complied by each brother, it can thus be suggested that what might be termed a more liberal and perhaps somewhat less politically motivated attitude on Ibrahim's part fostered an atmosphere that enabled the emergence of a new illumination style and, as well, the introduction of a new type of paper in Shiraz.[243]

Changes in the Manuscript Industry: Production and Patronage

Based on the evidence of more than 140 manuscripts, two further changes occurred in the years immediately following Ibrahim's death. This time they were changes that affected the manuscript industry *per se*.

Throughout the years 809–38 /1406–07 to 1434–35, manuscript production in Shiraz was fairly consistent. Then, in the period 839–48/1435–36 to 1444–45, a dramatic change occurred, for production increased three and a half to four times over what it had been in each of the three preceding ten-year periods (809–18, 819–28, and 829–38). This surge in production was somewhat short-lived, however, because production then dropped by almost half in the following ten years, 849–58/1445–46 to 1454, although this was still double pre-839 levels. The increased production of 839–48 is also remarkable in comparison with non-Shiraz levels. Production peaked in Herat in 829–38/1425–26 to 1434–35, earlier than in Shiraz and at just two-thirds of the peak Shiraz years.[244] There is, moreover, a fundamental difference in the peak production years of the two centers, because, during the years 829–38, production in Herat was dominated by the atelier of Baysunghur and to a lesser extent by that of his father, Shah Rukh. And while so very many manuscripts produced in Herat in these years bear the name of either of these two individuals, manuscripts produced in Shiraz in the peak period 839–48 are almost all anonymous.

A shift away from court-centered patronage is in fact the second change evident in Shiraz production in the years following Ibrahim's death in 838/1435. Between the years 809 and 838 (1406–07 to 1434–35), the number of Shiraz manuscripts that can be linked to the ruler (royal governor) is high, but then a change again

occurs in the period 839–48: court production decreased drastically to a mere 5 percent of all manuscripts produced; in the period 849–58, it was 10 percent.[245] The close correlation between the death of Ibrahim, in 838/1435, and the overall increase in production and the sudden drop in court patronage that occurred in Shiraz in the period 839–48 surely is not coincidental. Rather, it illustrates the effect that the death of a strong, royal patron had on local production.

The dramatic increase in production levels, combined with a move away from court patronage, suggests a move to, or at the very least a great increase in, commercial production. Moreover, in the period 839–48, there occurred an intense increase in the production of copies of the *Khamsa* of Nizami and of the *Shahnama* over levels in earlier periods. In these years, almost one-quarter of the manuscripts produced were copies of the *Khamsa*, with another approximately one-quarter being copies of the *Shahnama*.[246] The similarity in the program of illustrations used in these manuscripts suggests that many were produced to be sold commercially: not only are the same scenes illustrated from one manuscript to the next, but the compositions used are often very similar, at times exceedingly so (figs. 74–75). Mass demand meant that once a set formula had been devised for illustrating a specific text, that same formula could be used over and over again with little variation, a practice that saved time and thereby reduced costs for both the producer and purchaser.[247]

With the death of Ibrahim in 838/1435, governorship of Shiraz passed to his son, 'Abd Allah, whose rule lasted until 851/1447 and thus spanned the whole of the critical period 839–48.[248] 'Abd Allah was born in 836/1432–33, and as he was therefore just two or three years old at the time of his father's death, real political power initially fell to the amir, Shaykh Muhib al-Din Abu'l Khayr bin Shaykh al-Qarrai, sent from Herat by Shah Rukh.[249] That Ibrahim's atelier continued to function in some form for at least a while during the period of Muhib al-Din's control of Shiraz is indicated by two manuscripts, each bearing dates in the years immediately following Ibrahim's death and most likely planned and begun at Ibrahim's direction.[250] But with the demise of court patronage, artists formerly in the employ of the court presumably were dispersed into the community, which would explain the high quality of so many of the supposedly commercial manuscripts produced between 839 and 848. Perhaps to support themselves, it simply was necessary to increase production, while in turn the increased availability of manuscripts on the market stimulated interest and thereby spurred demand.[251]

74. "Sultan Sanjar and the Old Woman," *Khamsa* of Nizami, dated 844/1440 and 846–47/1442–43, 18 x 13.5 cm (folio). Topkapi Saray Library, Istanbul, R. 862, f. 21b. Photograph by author.

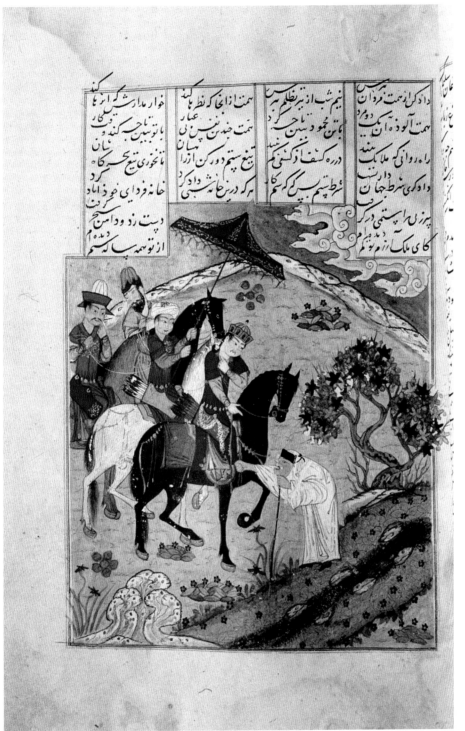

ILLUMINATION IN THE YEARS FOLLOWING
THE DEMISE OF TIMURID CONTROL OF SHIRAZ

In late 850/1447, Shah Rukh died, and some six months later, in Rajab 851/ October 1447, Shiraz fell to Sultan Muhammad ibn Baysunghur and 'Abd Allah was forced to flee the city.[252] Shiraz then suffered a period of political and presumably civil unrest that continued until the establishment of Turcoman rule in 856/1452. A somewhat diverse assortment of illumination styles adorns manuscripts bearing the name of Pir Budaq of the Qara Qoyunlu, the first of two Turcoman tribes to rule Shiraz. However, in the late 1450s and 1460s, there began to appear a distinctly Turcoman style, which reached its fully developed form under the Aq Qoyunlu Turcomans, who also controlled Tabriz.[253] Faint echoes of both the blue-and-gold floral and the floral/palmette-arabesque styles can be detected in this new style, because it is characterized by an extensive use of blue and gold, which serve as grounds for finely wrought yet vigorous arabesques, from which spring brightly colored blossoms. The style was characteristic of Shiraz production through to the downfall of the Turcomans in the first decade of the sixteenth century, and it then continued in use during the early years of Safavid control of the city.[254]

A slightly altered form of this Turcoman style is typical of Ottoman manuscripts of the late 1470s to as late as 1570.[255] Two other Shiraz-based illumination styles were also employed during the reign of the Ottoman ruler Mehmed II (r. 1468–96). Most obviously of Shiraz origin is the variant of the blue-and-gold floral style used in several of his manuscripts,[256] but also derived ultimately from the ateliers of Shiraz is the version of the floral/palmette-arabesque style used in the majority of manuscripts made for him and in which large and robust palmette-arabesque forms appear in conjunction with rosettes in shades of peach and blue, outlined in white, and often set against a black ground. It is in particular the dominant role of emerald green and a vibrant orange, in addition to the frequent use of a distinctly grayish tone of blue (in addition to a purer blue), that most clearly distinguishes these Ottoman variants of the floral/palmette-arabesque style from their Shirazi forebears.[257]

Codicology

Codicology is broadly defined in most dictionaries as the study of manuscripts. However, for those who are actually concerned with the study of manuscripts, it is usually defined more narrowly as the study of the most rudimentary features of a manuscript, such as the format or arrangement of the text on the folio, the size and proportions of the textblock and of the folio itself, and the characteristics of the paper from which the folios are cut. Often overlooked in favor of the more tantalizing decorative elements, these codicological features of a manuscript can reveal much about the complexities of book design and its evolution over the years.

TEXTBLOCK FORMAT

The arrangement of the text on a folio, referred to here as the textblock format, is one of the most immediately visible features of a manuscript. In addition to the standard format used in most Islamic manuscripts, two other types—the one- and three-sided marginal column formats—are frequently encountered in manuscripts produced in Shiraz.

The Standard Format

The most common format is one in which the text is written horizontally across the page, either as one undivided block or divided into columns, depending on the type of text.[1] Qur'ans and prose texts, such as histories, scientific and medical treatises, and most tales and fables, are written as one continuous block of text. Poetry is divided into two, four, or six columns, with each half-line, or hemistich, of a couplet written in a separate column. As the most popular rhyming patterns for Persian poetry are *aa ba ca,* etc., for *qasida*s and *ghazal*s, and *aa bb cc,* etc., for *masnavi*s, the text could be arranged in any even number of columns—or even in one long, narrow column for that matter—without any disruption to the flow of the reading of the poem.[2]

A specific text-format correlation appears to exist in the case of manuscripts copied in six columns. Included among the comparatively few pre-fourteenth-

century poetry manuscripts that exist are two unillustrated copies of the *Shahnama*, dated 614/1217 (Florence Cl. III. 24)[3] and 675/1276 (BL Add. 21103). The textblock is divided into four columns in the earlier manuscript but into six in the later one, a division that marks the start of a long tradition of *Shahnama* manuscripts copied in six columns. Nine *Shahnama* manuscripts have survived from the first half of the fourteenth century and another five from the second half. Of these fourteen manuscripts, ten are written in six columns of text[4] and four are copied in just four columns.[5] In the fifteenth century and later, poetry texts, including the *Shahnama*, were almost always arranged on the page in four columns of text. Of the very few manuscripts that use a six-column format, all are copies of the *Shahnama* (and all were produced in the fifteenth century), suggesting an obvious awareness of, and an intentional reference to, the established fourteenth-century association between the *Shahnama* and the six-column format.[6]

In the mid-fourteenth century, the four-column format began to gain in popularity. Perhaps the earliest example of a four-column division of a text is the 614/1217 *Shahnama*; another early manuscript, a collection of *divan*s dated 699/1300 (CBL Pers 103), also uses a four-column textblock. From the early 1330s through the 1350s, at least five more four-column manuscripts have survived: three of the copies of the *Shahnama* referred to in the preceding paragraph (and listed in note 5) and one copy each of the *Garshaspnama* (TS H. 674, 755/1354) and the *Khamsa* of Amir Khusraw Dihlavi (Tashkent 2179, 756/1355).[7] These four-column manuscripts are all poetry texts, but they are not all the same genre of poetry. The four-column manuscript of 699/1300 consists primarily of poetry that is panegyrical or laudatory in nature; the aim of this type of poetry is to recount the traits of the ideal ruler or patron as a model of behavior for the earthly ruler or patron.[8] The *Shahnama* and the *Garshaspnama* are a different genre of poetry—the heroic epic. The emphasis in poetry of this type is the narrative exposition of action, heroism, and valor.[9] By comparison, the *Khamsa* of Amir Khusraw Dihlavi is an example of romance poetry. Although also considered a narrative verse epic, it is a romantic epic, a genre characterized as "romantic love . . . suffused with a lyrical strain."[10] Typically in this type of poetry, the devices of monologue, dialogue, discourse, and description are used as a means of interpreting and explaining the moral complexities of the experiences of the main characters and as a means of commenting on the action, which itself, says Julie Scott Meisami, "reveals the moral qualities of its agents."[11] It is the inner lives, the emotions of the characters, not merely the recounting of their heroic acts, that are the emphasis.[12] In short,

while the heroic epic is an expository genre, romance is an interpretive genre, one in which action does not function merely to "demonstrate a hero's prowess" but "typically points to values beyond itself."[13]

These two types of epic both employ the *masnavi* verse form. Jan Rypka has discussed Persian poetry based on divisions of genre (lyric versus epic and didactic), though primarily based on divisions determined by the formal structure of a poem, namely, rhyming patterns (the *qasida*, *ghazal*, and *ruba'i*, etc., for lyric poetry and the *masnavi* for heroic, historic, and romantic epics as well as didactic poetry).[14] Thus, according to Rypka's divisions, heroic and romantic epics belong to the same category of Persian poetry. Meisami, however, states that contemporary rhetorical usage did not recognize distinct genres based on the formal structure of a poem,[15] and her division into genres is based on the function of a poem and the manner by which that function is achieved.[16] According to Meisami's system, heroic and romantic epics should therefore fall into separate categories. Likewise panegyric poetry, such as the early fourteenth-century collection of *divan*s (CBL Per 103) that employs the *qasida* verse form, is also a separate genre. However, for the purposes of this discussion, the panegyric and heroic epic can be broadly grouped together, because both are clearly distinguished from the romantic epic due to the emphasis on the interpretive function, as well as the distinctly "lyrical strain" of the latter.[17]

The importance of this division between heroic and panegyric poetry, on the one hand, and the romantic epic, on the other, is clear in light of the group of manuscripts copied in the late 1350s and 1360s that was discussed in the previous chapter. Three of these manuscripts employ a four-column format and are also copies of the romantic epic, the *Khamsa* of Nizami; a fourth copy of the *Khamsa* is written in just two columns of text. They are in fact the earliest extant copies of this text.[18] From the 1360s through to the end of the fifteenth century, the romantic epic was the single most popular genre of poetry produced in manuscript form. Although there were times when the *Khamsa* of Nizami and the *Shahnama* were almost equally popular, as in Shiraz in the period 839–48/1435–36 to 1444–45, if one genre of poetry can be seen as, overall, typical of manuscript production in each of the fourteenth and fifteenth centuries, it must be the heroic epic, specifically the *Shahnama*, in (about the first half of) the fourteenth century, and the romantic epic, specifically the *Khamsa* of Nizami, in the fifteenth century. This move from the predominance of one text type to another actually had begun to take place by the mid-1350s, as evidenced by the *Khamsa* of Amir Khusraw Dih-

lavi of 756/1355 (Tashkent 2179). As seen, it is a division of poetry types based not on formal structure (rhyme patterns) but rather on the manner in which the poetry achieves its function of serving a moral end. It is not known why this move to a new genre of poetry occurred at this time.[19] However, it clearly coincided with the move to the copying of texts of poetry in four columns, because, from the 1360s onward, this was the most popular textblock division for poetry texts produced both in Shiraz and elsewhere. Based on surviving evidence, these two changes were first concentrated in Shiraz in the 1360s.[20]

The initial association between the romantic epic and the four-column textblock is not one dictated by the formal structure of the poems. Rather, the association seems to have been a practical and aesthetic one, a point that will be discussed later in this chapter. It may also have been that the strong association of the *Shahnama* with six columns of text created a desire to distinguish manuscripts of the "new" genre from those of older tradition;[21] thus the four-column textblock, already used in a few thirteenth- and early fourteenth-century manuscripts, was adopted.[22]

The Three-Sided Marginal Column Format

A marginal column of text was sometimes added to the three exterior sides of the standard textblock format (e.g., see figs. 44 and 50). This arrangement not only provided the scribe with more space in which to write; it also set up an interesting visual contrast to the horizontal lines of script in the central block of text, because the numerous short lines of script in the marginal column were written obliquely, placed parallel to the base of the small illuminated triangle that fills each of the upper and lower gutter corners of the column. A third triangle—a so-called thumbpiece—placed midpoint of the long vertical side of the column, facilitated the necessary change in the direction of the script.

As indicated in appendix 1, the earliest example located of this second type of textblock format is a copy of the *Khamsa* of Nizami in Berlin (Berlin-SB Minutoli 35), dated 764/1362 and 765/1363. A gap of twenty years separates this and the next example, a *Kulliyyat* of Sa'di of 786/1384 (BN Supp. pers. 816).[23] Its use was clearly concentrated between the final years of the fourteenth century and the mid-fifteenth century, because of all examples located, 60 percent are dated between 1384 and 1449, another 25 percent date between 1450 and 1500,[24] while some 13 percent were produced in the period after 1500. This type of textblock format generally is regarded as typical of Shiraz, because, with the notable excep-

tion of two early examples, it is found almost exclusively in manuscripts that can be attributed to that city.[25]

Anthologies (here defined as manuscripts containing the work of three or more poets or authors) constitute almost 28 percent of the manuscripts in this format listed in appendix 1. Another almost 18 percent of the manuscripts contain the work of two poets, frequently the *Khamsa*s of Nizami and Amir Khusraw Dihlavi, while 55 percent contain the work of one individual only, either a single work, such as a *khamsa*, or else a collection of works, namely a *divan* or *kulliyyat*.[26] This correlation between use of the three-sided marginal column format and specific types of manuscripts varied with time: with one exception all the anthologies in this format listed in the appendix were produced before 1440, while almost all examples produced after 1440 are single-poet manuscripts.

The arrangement of the texts within these types of manuscript differs. In an anthology, or *jung*, the poem copied in the central columns (the *matn-jung*, or "substance" of the *jung*) normally differed from that copied in the marginal columns (the *hashiyyat-i jung*, or "margins" of the *jung*).[27] In the first volume of Iskandar's Lisbon Anthology (LA 161, 813/1411), the volume that contains the poetry texts, the central and marginal texts often begin and end on the same folio, with illumination marking the beginning and often also the end of each text.[28] Each well-planned section therefore forms a physically and visually identifiable unit.[29] However, this neat arrangement of texts was possible only because it is often merely excerpts of longer works or selections of short poems that were included in the margins, setting up a hierarchical relation between the intact central text and the abbreviated marginal texts. Within the manuscript, the works are arranged according to literary form, so that all poetry of one type (e.g., *masnavi*s) is grouped together.[30] This same type of arrangement was used even more effectively in an anthology copied almost a decade later for Iskandar's cousin Ibrahim Sultan (Berlin-MIK I.4628, 823/1420). But the problem with such an arrangement of the text, as Ernst Kühnel pointed out in his study of the latter manuscript, is that the works of one poet can end up being spread throughout the manuscript.[31] These two manuscripts are, however, unique among those examined, for all other anthologies and dual-poet manuscripts appear to contain complete poems, not excerpts, both in the central and in the marginal columns.[32] Because the length of the individual poems varies, coordinating the start and end points of the poems in the central and marginal columns was not possible. So, in these manuscripts, the central and marginal columns function independently of one another. How-

ever, they often contain similar types of texts, in which case the result is akin to two separate, though complementary, manuscripts. For example, several of these anthologies and dual-poet works are combinations of the *Khamsa* of Nizami and other texts, usually *khamsa*s written in imitation of Nizami. Following the hierarchical arrangement of texts used in the Lisbon and Berlin anthologies, Nizami's text typically occupies the central columns of the textblock, while the works of his imitators or of other lesser poets fill the marginal columns.

In single-poet manuscripts, the marginal columns are most often treated merely as additional folios: the calligrapher began copying the text in the central columns and continued to use this space through to the final pages of the manuscript; only then did he revert to the beginning of the manuscript to copy the remainder of the text in the marginal columns. For example, in a copy of the *Khamsa* of Amir Khusraw Dihlavi, dated 840/1436–37 (BOD Elliott 191), the first three *masnavi*s (*Matlaʻ al-anvar*, *Shirin va khusraw*, and *Majnun va layla*) occupy the central columns of the textblock through to the bottom of folio 239b, the last (but one) folio of the manuscript. The calligrapher then went back to the beginning of the manuscript and filled in the marginal columns, up to folio 203a, with the last two poems of the *Khamsa* (*Haft paykar* and *Ayinaʻi iskandari*).[33] This same arrangement of texts tends to be found in manuscripts that are collections of more varied works by a single poet, as in a copy of the *Kulliyyat* of Saʻdi dated 856/1452 (BOD Ouseley Add. 39). Here the scribe once again began by copying the text in the central textblock space only. With the end of the thirteenth *risala*, *Kitab-i badaʻi* or Book of Marvels, he jumped back to the beginning of the manuscript and copied the first lines of the fourteenth *risala*, the *Gulistan*, in the marginal column of folio 2b and then continued to fill the marginal columns through to the end of the manuscript.[34] This arrangement is typical of most single-poet manuscripts that employ the three-sided marginal column format. In these manuscripts, the central and marginal columns function independently of one another. There was no attempt to coordinate the beginning and end points of the various poems, and on any given folio the central columns might well contain a verse form different from that in the marginal column. The central and marginal spaces are instead united by the mere coincidence of containing works by the same poet.[35]

The number of couplets contained within the marginal column is usually about two-thirds the number contained in the central block of columns, but in a few manuscripts this number actually equals or even exceeds the number of couplets

in the central columns. Therefore, the three-sided marginal column format was both a paper saver (to accommodate an equivalent number of couplets, a larger sheet of paper or more sheets of paper would be required) and, as mentioned previously, the contrast of oblique and horizontal lines of script provided an element of visual variety. Another attraction of the three-sided marginal column format was that it allowed the opportunity to draw parallels between texts, as when the poems of Nizami and his imitators were placed side-by-side in a single manuscript. It is not surprising that the two manuscripts that employ this format in a more sophisticated manner—the Lisbon Anthology (LA 161) and the Berlin Anthology (Berlin-MIK I. 4628)—are the products of royal patronage, because in each case the arrangement of the texts would have been a highly labor-intensive task. In both the preceding and following chapters, it is suggested that Iskandar's two anthologies served a very specific, pseudo-political function. This, in addition to their status as royal manuscripts, would explain the time and care lavished on them, not only (in the case of the Lisbon Anthology) in the arranging of the texts, but in all other aspects of them as well. It was a model for the production of anthologies that clearly influenced Iskandar's cousin and successor, Ibrahim Sultan.

The One-Sided Marginal Column Format

The third type of textblock format comprises a central block of text usually divided into two columns of horizontal script and bordered on its exterior side, only, by a third, marginal, column filled with oblique lines of script (see fig. 48). The sixteen manuscripts of this type listed in appendix 1 are spread between the years 1407 and about 1535. They are distributed fairly evenly throughout this period, although with a somewhat heavier concentration of production after 1450. Again, this format is strongly associated with manuscripts produced in Shiraz. All but two manuscripts using this format contain the poems of a single individual.

With this format each folio comprises a textually integrated unit, for the text in the marginal column of any page is read immediately following that in the central columns of the same page. However, the resulting reading pattern is confused. As indicated in figure 76, the text on the "b" side of a folio begins in the central columns; therefore, in order to begin, the eye must first jump over the marginal column on the right side of the page to the uppermost line of the two central columns. Reading then progresses in the normal manner, across and down the central columns, finishing at the lower left-hand corner of the page. To complete the

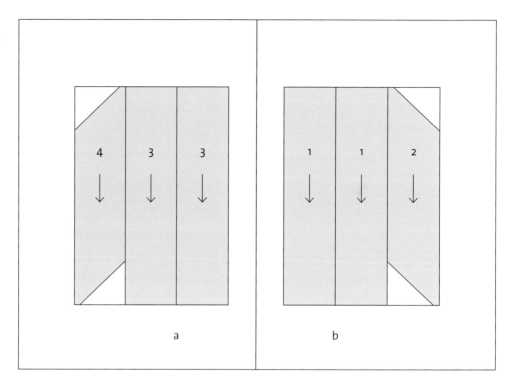

a b

reading of this page, the eye must then jump up and across the central columns,
back to the upper right-hand corner of the page in order to commence reading
the hemistiches of the marginal column, written one below the other in oblique
lines of script. Once this column has been read, the eye makes an even longer
leap from the lower right-hand corner of the page to the upper right-hand corner
of the "a" side of the following folio (the facing folio). Reading of the "a" side of
the folio is both more coherent and logical, for the eye again moves across and
down the two central columns and then moves up to the top of the marginal
column.[36]

Despite the relatively early date (1407) of the first known manuscript to use
this textblock format (TS H. 796), the disjointed, zigzag reading (and writing)
pattern suggests that it was a rather unfortunate variation of the more popular
three-sided marginal column format. In the latter, the marginal column plays
a secondary role in terms of both its physical, or visual, and its textual relation
to the central columns. Visually, it appears as a mere appendage to the standard
textblock type. Textually, the greater importance of the central column is often
indicated, first, by the hierarchical relation that may exist between the texts of the
central and marginal columns and, second, by the fact that the marginal columns

are often treated merely as "extra folios," existing simply to provide added space for the completion of the text. This hierarchical relationship between central and marginal columns was then adopted for the one-sided marginal column format, even though it resulted in a highly confused reading pattern.[37]

Placement of the Textblock on the Folio

Lines to guide the writing of the text were marked onto each folio with a ruling frame, or *mistar*, a card sewn with a lattice of fine strings or threads in the precise pattern and dimensions planned for the textblock. Two or three sheets of paper at a time might be placed over top the *mistar*. The pattern of the threads was then impressed into the paper by running a finger firmly along each thread. The common practice was for the textblock to be placed off-center of the vertical axis of the page, so that the outside margin is about twice the width of the gutter margin. As a result, when the book is open to display facing pages, the space between the two facing textblocks is more or less equal in width to each outer margin.[38] The practice of placing the textblock off-center probably originated with early illuminated copies of the Qur'an, wherein it served a pragmatic function, because a wider outer margin was necessary to accommodate the small illuminated roundels that were added to indicate every fifth and tenth verse and points requiring ritual prostration, and which thereby guide the reading of the sacred text.[39] The Qur'anic practice thus was carried over into the production of secular manuscripts.

THE SIZE AND PROPORTIONS OF FOLIOS AND TEXTBLOCKS

Historical sources record the names applied to different papers. The most frequently noted are place names such as Baghdadi or Misri, but the names of renowned individuals were also commonly used, such as Ja'fari, in honor of Ja'far al-Barmaki (d. 803), or Nuhi, named for Nuh ibn Nasr of the Samanids (d. 954). Place names of course referred to the center in which the paper was made, but each name appears also to have indicated paper of specific dimensions.[40] Al-Jawhari has recorded nine categories, based on folio dimensions, of Arab papers used in the late fourth/tenth and early fifth/eleventh centuries. J. Irigoin has studied Islamic (probably Syrian) papers used in mid-eleventh-century Byzantine manuscripts and has determined that, based on dimensions, they can be divided into three principal and interrelated groups, with the width of one sheet

size equal to the length of the next smaller sheet size. The information presented by each of these authors thus suggests that paper was manufactured according to standardized sheet sizes.[41]

Following the example of these two authors, the manuscripts examined for this study were initially arranged according to folio height. However, unlike the findings of Irigoin, for any one period there exist no clear divisions between the heights or sheet sizes of folios. Instead, there is a gradual and slight increase in folio height from the smallest to greatest measurement recorded.[42] Moreover, folio widths do not always increase or decrease in precisely the same ratio as folio heights. Therefore, it was decided that for the purposes of this study, which aims to identify periods of change in production, an analysis of the size of Shiraz papers based on folio area would be more accurate than one based strictly on folio dimensions.

Within the site and size categories indicated by the names of paper listed in the historical sources are divisions based on quality, referring at least in part to the degree of burnishing.[43] Unfortunately, the descriptions of these various papers that are given in the sources are generally inadequate to allow the paper in existing manuscripts to be identified: Iraj Afshar, for example, has extracted thirty-one names of paper from the sources, yet admits that he knows no way of correctly correlating these names with the actual types of paper used in manuscripts.[44] In a few rare instances, an ʿarz, or note, that includes mention of the type of paper used has been added to a manuscript. However, as Afshar stresses, the only secure way to identify paper using historical names is if the date of the ʿarz is roughly contemporary with that of the manuscript, for only then can it be assumed the name stated is that which was in common use for that type of paper at the time the manuscript was copied.[45] As no comments regarding the type of paper used have been noted in any of the manuscripts included in this study, there has been no attempt to identify the papers by name.

The time periods into which the manuscripts analyzed have been divided correspond approximately to those followed in the previous chapter.[46] The span of years included in each period is not standard but rather is determined, as previously, by changes in style, which usually correspond at least roughly to changes in dynasties or individual rulers. The actual selection of manuscripts was limited by their condition: manuscripts, the folios of which have obviously been retrimmed or have been remargined, or the textblocks of which have been remounted, are excluded from much of the analysis.[47]

Folio Area

The distribution of Shiraz and non-Shiraz manuscripts according to folio area, expressed as square millimeters, is recorded in tables 1 and 2, respectively. For each time period the total number of manuscripts examined is listed and then the percentage of this total that falls into each of six size-groups. These size-groups were determined, in the first instance, through a consideration of more or less natural divisions between certain groups of manuscripts and then, as necessary, through more arbitrarily imposed divisions. The (approximate) proportional relationship among manuscripts of the various size-groups is illustrated graphically in figure 77.

In the period 700–55 (1300–54), the greatest percentage of both Shiraz and non-Shiraz manuscripts (80 percent and 84 percent, respectively) fall into the three largest size-groups (groups 4–6), that is, the folios of each manuscript are more than 55,000 square millimeters. Mamluk Qur'ans produced throughout the fourteenth century tend to be equally large.[48] A group of manuscripts produced in the first half of the thirteenth century in Iraq and Syria are, however, noticeably smaller.[49] The overall difference in size between these groups of thirteenth- and fourteenth-century manuscripts might be explained by the fact that, while it has been suggested that many in the group of thirteenth-century manuscripts were made for the merchant class,[50] many of the largest of the Il-Khanid and Mamluk manuscripts are known to have been made for royal patrons. Wealth or patronage as a determining factor of size does not, however, seem to apply to manuscripts produced in Shiraz during the period of Injuid rule, for most of the largest of the Injuid manuscripts (in particular those of the early Injuid era) are anonymous and give no strong indication, in terms of either quality or extent of decoration, of being products of royal patronage. If wealth or patronage can be cited as a determining factor of size with respect to these manuscripts, it was only so indirectly, perhaps through a desire to mimic the Injuids' overlords' apparent taste for large manuscripts.

The move to the production of manuscript copies of romance poetry, cited previously as having occurred in the mid-fourteenth century, coincided with a change in the size of manuscripts being produced. From 756/1355 onward, more than 70 percent of all Shiraz manuscripts, in each period, fall into size-groups 2 and 3, and thus comprise folios that are between 15,001 and 55,000 square millimeters. Non-Shiraz manuscripts of these years are likewise, though somewhat less heavily, concentrated in these two size-groups.[51] Thus, there occurred a shift

TABLE 1 Distribution of Shiraz manuscripts according to folio area

Time periods	700–55 (1300–54)	756–70 (1355–69)	771–801 (1370 to 1398–99)	802–17 (1399–1400 to 1414–15)	818–55 (1415–16 to 1451)
Total number of mss	15	7	17	13	52
Group 1 15,000 mm² or less	—	—	—	—	2%
Group 2 15,001–35,000 mm²	13%	43%	6%	54%	33%
Group 3 35,001–55,000 mm²	7%	43%	71%	31%	42%
Group 4 55,001–75,000 mm²	27%	—	12%	8%	2%
Group 5 75,001–95,000 mm²	20%	14%	—	8%	15%
Group 6 95,001 mm² or greater	33%	—	12%	—	6%

Note: Percentages have been rounded off to the nearest whole number; therefore, percentages listed for each time period do not always total exactly 100 percent.

For each size-group, the range of corresponding folio dimensions, based on an average folio height to width ratio of 3:2, is approximately:
Group 1: 150 x 100 mm or less
Group 2: more than 150 x 100 mm up to 230 x 152 mm
Group 3: more than 230 x 152 mm up to 290 x 191 mm
Group 4: more than 290 x 191 mm up to 335 x 225 mm
Group 5: more than 335 x 225 mm up to 370 x 257 mm
Group 6: more than 370 x 257 mm

TABLE 2 Distribution of non-Shiraz manuscripts according to folio area

Time periods	700–55 (1300–54)	756–801 (1355 to 1398–99)	802–17 (1399–1400 to 1414–15)	818–55 (1415–16 to 1451)
Total number of mss	25	6	5	28
Group 1 15,000 mm² or less	4%	—	—	—
Group 2 15,001–35,000 mm²	—	—	20%	29%
Group 3 35,001–55,000 mm²	12%	67%	40%	32%
Group 4 55,001–75,000 mm²	20%	33%	20%	11%
Group 5 75,001–95,000 mm²	32%	—	20%	14%
Group 6 95,001 mm² or greater	32%	—	—	14%

Note: Percentages have been rounded off to the nearest whole number; therefore, percentages listed for each time period do not always total exactly 100 percent.

from the first half of the fourteenth century, when most manuscripts comprised folios with an area of 55,001 square millimeters or *more* (size-groups 4–6), to the second half of the century onward, when most manuscripts consisted of folios of 55,000 square millimeters or *less* (size-groups 2–3). Manuscripts in the largest size groups continued to be produced but, with few exceptions, they were restricted to those text types favored prior to about 1350: historical, geographical, and other didactic texts; the Qur'an; and the *Shahnama*. For example, 23 percent (12 of 52) of the Shiraz manuscripts of the period 818–55/1415–16 to 1451) fall into size-groups 4–6. One manuscript is an anthology of poetry (BL Or. 3486) and another is an untitled collection of seven of 'Attar's *masnavi*s (CBL Per 321), but all others are copies of the Qur'an, *hadith*, the *Shahnama*, and the *Zafarnama*. These texts were not, however, produced only in large-size formats, for the size-group 3 manuscripts of this same period include several copies of the *Shahnama*

77. Folio area of manuscripts: Approximate proportional relationship among various size-groups

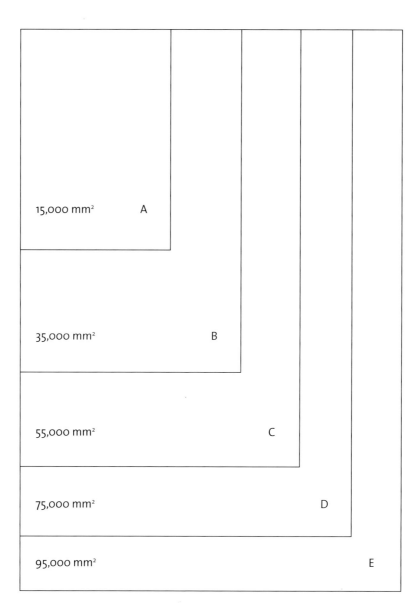

15,000 mm² A

35,000 mm² B

55,000 mm² C

75,000 mm² D

95,000 mm² E

Actual size of manuscripts is approximately 2.5 times larger than shown here.

FOLIO AREA SIZE-GROUPS
Group 1: 15,000 mm² or less (manuscripts equal in size to drawing A or smaller)
Group 2: 15,001–35,000 mm² (manuscripts equal in size to B or smaller, but larger than A)
Group 3: 35,001–55,000 mm² (manuscripts equal in size to C or smaller, but larger than B)
Group 4: 55,001–75,000 mm² (manuscripts equal in size to D or smaller, but larger than C)
Group 5: 75,001–95,000 mm² (manuscripts equal in size to E or smaller, but larger than D)
Group 6: 95,001 mm² or greater (manuscripts larger than E)

(e.g., BN Supp. pers. 493) and a copy of Juvayni's *Ta'rikh-i jahan-gushay* (BN Supp. pers. 206), while a Qur'an (Khalili QUR212) is included in the size-group 2 manuscripts.

Folio and Textblock Proportions: Height to Width Ratios

The ratio of folio height to folio width was also determined for each manuscript, and the analysis of these ratios again reveals the second half of the fourteenth century as a time of change. The ratios in tables 3 and 4 are recorded in terms of a folio height of 100 millimeters.[52] Examples of folio height to folio width ratios are presented graphically in figure 78.

Sixty-sixty percent of Shiraz manuscripts produced in the years 700–55/1300–54 have a height to width ratio in the range of 100:70 to 100:89. In each following period, more than 70 percent of manuscripts have lower ratios, in the range of 100:50 to 100:69; in these later periods, however, the greatest percentage is always in the 100:60 to 100:69 range, or approximately 3:2. As table 4 shows, the emphasis on manuscripts with a height to width ratio in the 100:60 to 100:69 may have occurred slightly later in non-Shiraz manuscripts.

This move to folios of narrower proportions was paralleled by a move to textblocks of narrower proportions.[53] Even slight changes in the proportions of the folio and textblock affect the overall aesthetics of the manuscript: narrower proportions give the visual impression of a lighter, more elegant, and streamlined manuscript, while squatter proportions may be perceived as heavier and less refined, though perhaps more powerful. The mid-fourteenth-century shift to the predominant production of copies of romantic as opposed to heroic epics coincided with this change in folio and textblock proportions. That the two changes were probably closely related, perhaps the former even prompting the latter, is suggested by the fact that, from the second half of the fourteenth century onward, it is copies of the *Shahnama*, the Qur'an, *hadith*, and didactic works, such as historical and geographical texts, that most often employ folios (and hence textblocks) with squatter proportions, in the range of 100:70 and greater.[54] As with folio size, this is not an exclusive association, yet it again demonstrates a definite tendency to cling to early fourteenth-century practices in the production of copies of certain types of texts.

The move to the predominant use of four as opposed to six columns of text presumably occurred as a result of the change in folio and textblock proportions: six columns of text on a textblock of smaller size and narrower proportions may

TABLE 3 Distribution of Shiraz manuscripts according to the ratio of folio height to folio width (expressed in terms of a folio height of 100 mm)

Time periods	700–55 (1300–54)	756–70 (1355–69)	771–801 (1370 to 1398–99)	802–17 (1399–1400 to 1414–15)	818–55 (1415–16 to 1451)
Total number of mss	15	7	17	13	52
100:50–100:59	—	14%	12%	—	4%
100:60–100:69	33%	57%	76%	77%	71%
100:70–100:79	53%	29%	6%	23%	23%
100:80–100:89	13%	—	—	—	2%
100:90–100:99	—	—	6%	—	—

Note: Percentages have been rounded off to the nearest whole number; therefore, percentages listed for each time period do not always total exactly 100 percent.

TABLE 4 Distribution of non-Shiraz manuscripts according to the ratio of folio height to folio width (expressed in terms of a folio height of 100 mm)

Time periods	700–55 (1300–54)	756–801 (1355 to 1398–99)	802–17 (1399–1400 to 1414–15)	818–55 (1415–16 to 1451)
Total number of mss	25	6	5	28
100:50–100:59	—	—	—	7%
100:60–100:69	32%	50%	80%	71%
100:70–100:79	68%	33%	20%	21%
100:80–100:89	—	16%	—	—
100:90–100:99	—	—	—	—

Note: Percentages have been rounded off to the nearest whole number; therefore, percentages listed for each time period do not always total exactly 100 percent.

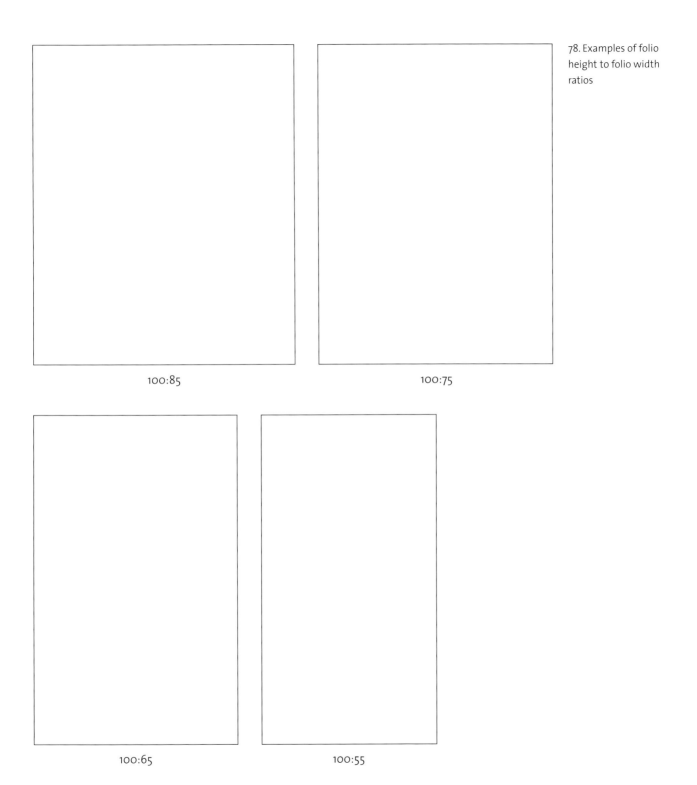

100:85

100:75

100:65

100:55

78. Examples of folio height to folio width ratios

simply have proved to be too many, requiring script in a very small hand to fit within the narrow columns. To maintain a proper balance between script size (height) and line width, the lines would have to be close together, perhaps producing an undesired visual effect of great density.[55]

PAPER PRODUCTION

Before paper could be purchased for a manuscript, a number of decisions had to be made.[56] These included the textblock format to be used (a decision partially conditioned by the text or texts to be copied) and the size of the textblock and folios. Only when these decisions had been made could the actual number of folios required to copy the complete text be determined. The paper might be purchased from a distant location: paper mills needed to be situated in close proximity to large resources of running water; hence centers of book production were not necessarily well situated for papermaking.[57] Tabriz, Isfahan, and Samarqand are all known to have been papermaking centers.[58] Paper may have been purchased as large uncut sheets or perhaps as precut bifolios. The finishing of the paper—the sizing and burnishing of the folios—was often carried out by the actual papermaker, but it could also be done by the paper seller or even at the site at which the manuscript was being made, perhaps by the calligrapher himself.[59] Other traits of the paper, such as its thickness and color, were, however, neither under the direct control of, nor, it seems, necessarily of great concern to, the actual book producers.

Paper of Laid Construction
With few exceptions, the manuscripts examined in the course of this study comprise paper of laid construction. The molds used to produce paper of this type consisted of a rectangular wooden frame with a base of wooden bars, upon which the mold cover or screen was laid. The cover was made of strips of grass or reed cut the length of the frame;[60] these were stitched together at intervals, probably with horsehair. A mash ("stock" or "pulp") consisting of water and pulverized linen or cotton rags or, perhaps, hemp rope was ladled onto the mold cover;[61] alternatively, the whole frame was dipped into a large vat of mash and the mash scooped up. The mold cover was then lifted from the frame, and the sheet of wet paper was placed face down on a flat surface or stuck to a wall to dry. As the mold cover was flexible along the axis running parallel to the reeds, it could be bent

backward and easily rolled off the wet sheet of paper, allowing it to be placed back in the frame and used repeatedly.

The grass or reeds (and sometimes the horsehair, too) left visible impressions in the dried paper, which, incidentally, are usually visible only in strong, rather slanting backlight. The reeds leave white impressions known as laid lines; those of horsehair are referred to as chain lines. The spaces between the reeds show as dark shadows, resulting in a pattern of alternating light and dark lines that allows the density of the laid lines to be discerned.[62] For this study, the density was recorded as the number of laid lines per centimeter. No discernible difference was found to exist in the laid line count of paper used in Shiraz and non-Shiraz manuscripts; thus the comments made below refer to both groups.

Counts of six to seven laid lines per centimeter are standard in paper of the earliest period, 700–55/1300–54; a few counts of eight were recorded, but none of less than six. A wider range of laid line counts, from five to nine per centimeter, was recorded for paper of the following period, 756–70/1355–69, perhaps an indication that this was a time of change and experimentation in papermaking practices. But considerable variation in laid line counts is typical of later periods also, although it is clear that by about 770/1369 a move to higher counts had begun: paper with a laid line density of seven lines per centimeter prevails in manuscripts of the period 771–801/1370 to 1398–99; counts of seven and eight are equally common in the period 802–17/1399–1400 to 1414–15; and counts of eight and nine (and many of ten, as well) are standard in manuscripts of about 830/1430 and later. However, the wide range of laid line counts recorded for the paper of any given period makes it difficult to use laid line density as a precise diagnostic tool. Really all that can be said is that paper with a count of nine or more lines per centimeter would be highly unusual in the early fourteenth century, while a count of six or less would be equally remarkable in manuscripts produced in the fifteenth century. Moreover, it is not possible to suggest why there occurred a gradual increase in laid line density up to the mid-fifteenth century;[63] perhaps it was due to a gradual perfecting of skills in the making of the paper mold.

Chain lines can be discerned in less than thirty of all the Shiraz and non-Shiraz manuscripts examined, although it is difficult to compile an accurate record of them because the lines are typically visible on only a few folios of any given manuscript, and rarely are they visible across the full width or length of a folio. Most common are single chain lines, more or less evenly spaced across a page. Other manuscripts have chain lines arranged in twos, threes, or alternating groups of

two and three lines.[64] Because of the great variety of patterns encountered (no two manuscripts were identical), it is not possible to associate any given pattern with a specific center or time period or, say, to note any change over time in the frequency of use of any particular pattern.[65]

Paper of Wove Construction

Only a small number of the manuscripts examined appear to comprise paper of wove construction.[66] To produce paper of this type, a piece of fabric was stretched taut across a rigid frame—either the mold cover or perhaps the base of the mold itself (the actual mold frame). The pulp or mash was then scooped or ladled onto the taut fabric. The mold was therefore much simpler than that used to produce laid paper, but the necessary rigidity of all parts was a disadvantage because it meant that the wet sheet of paper could not be removed from the mold (or cover) until it had dried.[67] Thus, many more individual molds (or covers) were needed than for the production of laid paper.[68] The wove mold may have produced paper with an inherently smoother surface,[69] but it surely was the technical advantage of the laid mold—namely, its ability to be reused immediately—that was responsible for the preponderance of laid paper.[70]

Flocculency of Paper

Flecks of threads and other matter are often visible in handmade paper, and in a short article on the traits by which to judge Islamic paper, Don Baker referred to his practice of recording the "see-through" quality of paper as "uniform" or "floccular," while allowing for gradations of flocculency.[71] Baker noted that papers are less floccular from about the eleventh or twelfth century onward and that, based on his research, beginning in the fourteenth century it was Persian papermakers who "led the way" in producing more uniform and hence less floccular papers. Of the paper examined for this study, none can be cited as "very floccular," paper that, in Baker's description, has the "appearance of swirling clouds, perhaps with identifiable threads or even pieces of cloth in it." What are presumably small threads are indeed visible in many examples, but rarely are they so numerous or obvious that they can be considered to detract from the quality of the paper. The visible presence of tiny threads seems in fact not to have been a concern, for several manuscripts of high quality comprise paper recorded as containing a great number of dark-colored flecks and dots.[72]

Paper Color

Ibn Badis tells how the raw flax—and presumably linen, cotton, or hemp rags as well—was prepared for the papermaking process. The raw fibers or rags were soaked in a mixture of water and lime overnight to soften and then were spread in the sun to dry. This process was repeated for three to seven days, after which time the softened fibers were soaked in sweet (fresh) water for seven days to remove all traces of the lime. Next, the fibers were pounded to produce the mash or pulp from which the sheets of paper were formed.[73]

Soaking the fibers in lime both broke them down and whitened them. The sizing and burnishing of paper could also make the paper appear whiter. Pure white paper was not, however, what was desired. Simi Nishapuri, in his treatise on the calligraphic arts, written in 833/1433, comments that it is best to give paper a slight tint, because white paper is hard on the eyes;[74] Sultan 'Ali, writing a few decades later, in the late fifteenth century, agrees, stating that slightly tinted paper (*nim-rang*) is best suited for writing, because white, as well as red and green, paper "strikes the eye, like looking at the sun."[75] Thus, it is not surprising that pure white paper does not exist in any of the manuscripts examined, though it is not possible to determine if the paper has actually been tinted slightly as Simi and Sultan 'Ali recommend.

Simi lists a number of recipes for producing paper dyes of various colors.[76] Presumably, these were most often intended to tint the paper only lightly; nevertheless, the range of colors and the space he devotes to recording these recipes are surprising, for there is no hint of most of the dyes he discusses being used on the paper included in the manuscripts examined—most of which were produced before or only slightly after Simi composed his treatise. The dye compounds he cites and the colors that each produces include: saffron for yellow; brazilwood, anemone flowers, or mulberry juice for red; safflower for a lighter red; indigo or blue flowers for dark blue; lac and blue powder (made from sunflower seeds and earth) for a blackish color; and lac and saffron for a rose color.[77] Simi also refers, in particular, to a "natural dye" made from henna, which he says produces a color that was "the choice of most calligraphers."[78] Safflower could also be used to produce a straw color, and the dye extracted from marshmallow seeds was in his opinion "extremely choice and pleasing, for it makes the paper soft and calligraphy looks good on it."[79]

Judging and recording the color of paper are difficult, and a standard for com-

parison is necessary. Compiling a standard—and a vocabulary—suitable for one's own use is difficult enough, but establishing a standard that the wider community of scholars, researchers, and other interested persons could have access to and that would, thereby, allow data and conclusions to be conveyed accurately and precisely has not been possible.[80] Judgments based on the standard used are admittedly imprecise. Nevertheless, certain observations regarding fourteenth- and fifteenth-century papers can be made. These apply to manuscripts of Persian origin in general, because no difference was found between the paper used in Shiraz manuscripts and those made elsewhere in Iran, with the exception of one type of paper to be discussed below.

Early fourteenth-century papers tend to be a slightly tan color.[81] In the first two decades of the fifteenth century, there was a gradual move to lighter and less brown papers, and by the late 1430s most papers were this lighter color. However, considerable variation in paper color could exist in any one period, and paper color—specifically whiteness or lightness—is not an indicator of quality, as is evident from a comparison of the paper used in manuscripts made in Herat for Baysunghur. The paper in one of these manuscripts is quite white (BOD Elliott 210, 834/1431). The paper of two others (TS R. 1022, 833/1429, and TS H. 362, 834/1430–31), each of which is more extensively decorated than the former manuscript, is noticeably darker—a distinctive tan color.[82] A fourth manuscript of note (BL Or. 11919, 838/1434) does not bear Baysunghur's name although it is signed by Ja'far al-Tabrizi, who served as director of his atelier. The text is copied on paper that is an exceptionally dark tan color, yet the manuscript is equally exceptional in terms of its very fine script and illuminations.[83]

Paper Thickness

A micrometer was used to measure the thickness of the paper used both in Shiraz and non-Shiraz manuscripts. Numerous readings per manuscript were used to calculate an overall average paper thickness for each manuscript.[84] The range of possible thicknesses was divided into increments of 0.02 millimeters, from a thickness of 0.07 millimeters or less to one of 0.16 millimeters or more. The distribution of the average readings for each time period, in terms of these increments, was then calculated. These readings are recorded in tables 5 and 6.

Once again, although the number of manuscripts in some groups is small, some general observations are possible, the most apparent of which is that over

TABLE 5 Distribution of Shiraz manuscripts according to average paper thickness

Time periods	700–55 (1300–54)	756–70 (1355–69)	771–801 (1370 to 1398–99)	802–17 (1399–1400 to 1414–15)	818–55 (1415–16 to 1451)
Total number of mss	14	6	13	13	36
0.07 mm or less	—	—	8%	8%	27%
0.08–0.09 mm	—	—	38%	38%	64%
0.10–0.11 mm	—	17%	15%	23%	6%
0.12–0.13 mm	14%	50%	8%	15%	3%
0.14–0.15 mm	64%	33%	23%	15%	—
0.16 mm or greater	21%	—	8%	—	—
Overall range	0.13–0.18 mm	0.11–0.15 mm	0.07–0.16 mm	0.07–0.14 mm	0.05–0.12 mm

Note: Percentages have been rounded off to the nearest whole number; therefore, percentages listed for each time period do not always total exactly 100 percent.

TABLE 6 Distribution of non-Shiraz manuscripts according to average paper thickness

Time periods	700–55 (1300–54)	756–801 (1355 to 1398–99)	802–17 (1399–1400 to 1414–15)	818–55 (1415–16 to 1451)
Total number of mss	14	5	5	17
0.07 mm or less	7%	—	20%	6%
0.08–0.09 mm	7%	20%	40%	35%
0.10–0.11 mm	7%	40%	20%	41%
0.12–0.13 mm	14%	20%	20%	6%
0.14–0.15 mm	21%	—	—	—
0.16 or greater	43%	20%	—	11%
Overall range	0.06–0.21 mm	0.08–0.16 mm	0.07–0.12 mm	0.07–0.17 mm

Note: Percentages have been rounded off to the nearest whole number; therefore, percentages listed for each time period do not always total exactly 100 percent.

the years there was a gradual move to the use of thinner papers. Eighty-five percent of the Shiraz manuscripts produced in the period 700–55/1300–54 comprise paper that is an average 0.14 millimeters thick or more. But about a century later, in the period 818–55/1415–16 to 1451, the average paper thickness for 91 percent of the manuscripts is just 0.09 millimeters or less. This change is equally evident in non-Shiraz manuscripts. Based on the evidence of the Shiraz manuscripts,[85] the move to thinner papers appears to have begun in the period 756–70/1355–69, and during the following period, 771–801/1370 to 1398–99, the use of thinner papers was firmly established as the norm.[86]

No inherent advantage to the use of thinner paper is apparent, and, indeed, the evidence of four manuscripts suggests that paper thickness in itself was not always a concern. The manuscripts are all dated between 774/1372 and about 814/1411, and each comprises paper of two distinct average thicknesses.[87] In each manuscript, one group of folios between 0.13 and 0.14 millimeters thick is interspersed among another group of folios between 0.07 and 0.09 millimeters thick. The mixture of thick and thin folios surely was not the result either of resources too limited to purchase better paper or of simple carelessness, because one of these manuscripts was made for Iskandar Sultan (BL Add. 27261) and, based on the extent and quality of its decoration, can be considered one of the finest manuscripts of all time. Thus the only conclusion that can be drawn is that a variety of paper thicknesses in one manuscript simply was not considered a problem.

Other manuscripts are of interest for their use of paper that is exceptionally thick or thin for their time. Two non-Shiraz (Tabriz) copies of the Qur'an of the earliest period each have paper that, at 0.06 millimeters and 0.08 millimeters, is unusually thin for that time (Khalili QUR832, 731/1332, and TIEM 430, 739/1338–39, respectively). By comparison, the paper in a copy of the *Jami' al-tavarikh* made for Shah Rukh in 837/1433–34 (BN Supp. pers. 209) is an average 0.17 millimeters and thus is exceptionally thick for its time. Another copy of the same text, also made for Shah Rukh (BL Add. 7628) and undated but probably also produced in the early 1430s, has paper that averages 0.13 millimeters thick. The correlation between unusually thick or thin paper and text type that might seem to be suggested by these manuscripts must be dismissed, however, in light of the evidence of all other manuscripts. Moreover, the two Shah Rukh manuscripts may have been copied on thicker paper to make them more durable, as each is large for its time: in terms of folio area, BN Supp. pers. 209 is in size-group 5 (349 x 258 millimeters

or 90,0042 square millimeters), and BL Add 7628 is in size-group 6 (458 x 278 millimeters or 127,324 square millimeters).

A group of three small manuscripts from later in the century suggests that function may at times have determined paper thickness. Although now bound as individual manuscripts, these three were surely once bound together. Made for Pir Budaq in 865/1460 (BOD Ouseley 131, 140, and 141), each is a *safina*, a long narrow format thought to be designed to be carried in one's pocket. The unusually thick paper of these manuscripts, 0.19 millimeters, would have made the original single manuscript highly durable and well able to withstand being carried about in a pocket. Paper used for purposes other than to copy manuscripts certainly could vary in thickness according to function: it is known, for example, that messages tied to the legs of carrier pigeons were written on a very fine paper, so thin that it was completely transparent.[88]

Sizing and Burnishing

Once the newly formed sheet of paper had dried, it was sized and then burnished. This process created a better (harder and smoother) writing surface. The size filled in the pores of the paper, and the burnishing process then compressed any raised fibers that might prevent the pen from moving swiftly and smoothly over the paper. It also made the paper less absorbent, thereby preventing the ink from "feathering" or bleeding.[89] The size consisted of starch alone or, alternatively, a mixture of starch and glue[90] or starch and chalk.[91] The starch could be vegetal, such as wheat, rice,[92] or corn;[93] the glue, too, could be vegetal, such as gum arabic, or animal, such as the fish glue known as isinglass, which is made from the air bladders of freshwater fish.[94] Most size recipes were fairly simple, requiring only a little water to be added to these ingredients. Simi, however, cites a more complicated recipe that called for sweet-melon juice, the liquid of cucumber and muskmelon seeds, molasses of seedless grapes, nonoily rice paste, and gum arabic "or the like." He states that these ingredients "reinforce the paper and make it (as smooth) as a mirror."[95] The size could be applied in one of several ways. Sheets of paper could be tub-sized, that is, dipped into a large container of the sizing solution; as a paste, the size could be spread onto either side of the dampened paper using the hand or a brush; or in a dry state it could be sprinkled onto a moistened sheet. Once dry, the sheets were rubbed and polished with a smooth, round stone such as an agate or, perhaps, with an oyster or mussel shell.[96]

Scientific testing to determine the precise substances used in the sizing of the manuscripts examined has not been possible. Judging and recording the degree of sizing and burnishing by means of sight and touch alone are difficult and inaccurate, to say the least. Just one of the problems in attempting to do so is that the visual perception of the degree of burnishing can be affected by the lighting conditions under which the manuscript is examined, but despite these problems certain observations and conclusions can be stated.

The paper of an Injuid manuscript dated 732/1332 (BL Or. 2676) has an overall rough feel with only a slight sheen to it; it feels and looks as though it has perhaps been lightly burnished with only a minimal degree of size having been applied. However, the paper of a slighter earlier Injuid manuscript, dated 729/1329 (BL Or. 3623), despite having a slightly rough, almost granular, surface texture, appears to have been burnished to a slightly greater degree, for it has a smoother surface, with more sheen.[97] The paper of some Muzaffarid manuscripts of the period 756–70/1355–69 is much better finished than the paper of either of these Injuid manuscripts. For example, a manuscript of 763/1362 (BN Supp. pers. 1817) has paper that is very shiny (recorded as a medium to high burnish), and its surface texture is very smooth, with a waxy, almost greasy, feel to it. Overall, the more heavily sized and more highly and more thoroughly burnished papers of these early Muzaffarid manuscripts mark the first significant step in the move to the generally very sleek, overall smooth texture of fifteenth-century papers.

That the surface treatment of paper could increase a manuscript's aesthetic appeal was undoubtedly was a motivating factor in the move to, and the continuing use of, more highly finished papers. But the initial impetus for change may have been much more pragmatic. The inks, pen types, and script styles used in early Islamic manuscripts had all been developed for use on the compact and relatively smooth surface of prepared parchment, a surface texture that paper lacked but which could be achieved through sizing and burnishing. Thus the sizing and burnishing of paper were probably first introduced to enable the proper and effective execution of the writing process on a new surface material (paper) with materials and techniques designed for an older, different writing surface (parchment).[98] As will be discussed in chapter 4, a change in script styles occurred in the fourteenth century and may likewise have served as a pragmatic impetus for a move to more highly finished paper surfaces.[99]

Of the traits of paper that have been discussed, it seems that finish was the

most important. Evidence suggests that paper flocculency, color, and thickness cannot be used to judge the quality of a manuscript. A smooth, even, and hard surface, however, made writing easier, and surface finish may thus be the one trait of paper that was of greatest concern to the scribe.

"Wove-Like" Paper in Manuscripts of the Period 839–48/1435–36 to 1444–45

As mentioned at the end of the previous chapter, one of the several changes in Shiraz book production associated with Ibrahim Sultan is the appearance of a new type of paper. Not all examples of this paper are identical. Nevertheless, they can all be considered as conforming to a specific type, because all examples are characterized by the same distinctive traits.[100]

The most visible trait is the paper's unusually white color in comparison with that used in other Islamic manuscripts.[101] Tiny brown flecks of fibers are typically present, to varying degrees, throughout the paper and are easily discerned in all light conditions, though in no way do they impinge upon the paper's overall white appearance. The paper also has a high sheen and is exceptionally smooth to the touch, with an almost porcelain-like finish. These surface traits appear to be the result of an unusually heavy application of size, perhaps in conjunction with an excessive degree of burnishing (and perhaps the addition of some type of glaze). Other features of the paper may likewise result from the amount of size used: its crisp nature and the hint of a crackling sound made when a folio is lightly shaken; the slight curl of some folios; and the often sharp and brittle edges of the paper, perhaps a result of the knife used to trim the folios having to cut through a thick, hard layer of size or glaze. The average thickness of the paper—0.07 to 0.10 millimeters—is typical for the period.[102]

The paper appears at first glance to be of wove construction because no laid or chain lines are visible on most of the folios of any given manuscript. Careful scrutiny of all the folios in a manuscript, however, always reveals at least a few on which laid lines can be discerned clearly: mainly counts of eight lines per centimeter but sometimes nine. These folios resemble all others in the manuscript in all other respects, a finding that suggests all folios are the same type and that the laid lines have merely been masked on most folios by the very heavy layer of size or glaze. That the laid lines are usually most visible on folios that have been damaged by water and the size washed away supports the supposition that all folios are indeed of laid construction.[103]

The earliest examples of this type of paper are, as noted previously, in two manuscripts made for Baysunghur in 834/1431 (BOD Elliott 210 and BL Or. 2773). Otherwise, it appears to be used only in Shiraz manuscripts, and though the first recorded example of its use in Shiraz is a manuscript dated 835/1432 (TS A.III 3169), its use is most heavily concentrated in the period following Ibrahim's death, in the years 839–48/1435–36 to 1444–45.[104]

Illustration

Figurative painting under Iskandar Sultan had a major impact on the development of painting in Herat, and for this reason paintings produced for Iskandar are included in most overviews of Persian painting. However, the period of Iskandar's rule differs essentially from all other periods to be discussed here and thus must be considered somewhat aberrant in terms of the overall development of Shiraz illustration styles, just as it was with respect to the development of Shiraz illumination styles. Shiraz painting in other periods of both the fourteenth and fifteenth centuries has, overall, received much less attention.[1] Moreover, when speaking broadly of these other periods, there has been a tendency, in overviews at least, to treat each period as a distinct entity, when in fact the unity, rather than the apparent disunity, of Shiraz painting can be demonstrated.[2] A clear understanding of the basic mode of painting on which this unity is based, as well as of the precise stylistic development of painting in Shiraz, is a necessary prelude to the broader study of the function—and manipulation—of a painting program in terms of style, folio layout, and selection of images that is the focus of this chapter.

AN OVERVIEW OF SHIRAZ STYLES

The Basic Shirazi Mode of Painting

The artists of Shiraz (here always meaning with the exclusion of the period of Iskandar) sought not to depict the "real" world but rather to rearrange and alter it, thereby increasing the visual impact of the event depicted. Artists working in other production centers strove to portray a more realistic world, as is evident from a comparison of two paintings: "Ardashir Battles Bahman, Son of Ardavan," from the Great Mongol *Shahnama*, presumably produced in Tabriz in about 1335 (fig. 79), and "Rustam Shoots Isfandiyar," from the Injuid *Shahnama* of 1330 (fig. 80). In terms of overall composition, the two paintings are similar: each is a face-to-face combat between two figures, closely focused and with proportionately large figures. However, the two artists have in fact each portrayed the scene in a vastly different manner. Both compositions are basically symmetrical, the Injuid

79. "Ardashir Battles Bahman, Son
of Ardavan," the Great Mongol
Shahnama, n.d., but c. 1335, Tabriz,
59 x 38.7 cm (folio). Detroit Institute
of Arts/Founders Society Purchase,
Edsel B. Ford Fund (The Bridgeman
Art Library), no. 35.54.

80. "Rustam Shoots Isfandiyar,"
Shahnama, 731/1330, 37.7 x 29.3 cm
(folio). Topkapi Saray Library, Istanbul,
H. 1479, f. 156a. Photograph by author.

one strictly and unrealistically so, with each group (of horse and rider) occupying its own carefully though invisibly demarcated little space, the boundaries of which neither horse nor rider dare breach. Pressed up against the picture surface, the horses with their riders stand balanced, more or less, along the thin red line that marks the lower boundary of their world; one false move and they will surely topple sideways into the abyss of text below. The strict symmetry of the composition creates a patterned effect and a sense that the artist's sole concern was to produce as pretty a picture as possible (despite the gruesome event being enacted). The intent of the Tabriz artist was very different indeed. His simple addition of a large gnarled tree has introduced an element of asymmetry that transforms his composition into a much more believable scene. Likewise in the Tabriz painting do the series of receding, low grassy hillocks and the layering of the figures (some of which are clearly positioned in the space behind the tree) contribute to a clear, albeit limited, illusion of spatial depth, which contrasts markedly with the rigorously flat, shallow, and strictly two-dimensional space of the Shiraz painting. All elements of the Tabriz painting are more naturalistically portrayed than in its Shiraz counterpart, wherein the two protagonists are as awkward and wooden as their horses and the blossoms have grown to almost terrifying proportions. In every detail, the two paintings stand in sharp contrast to each other, yet each is, in its own way, equally successful as a text illustration.

The Tabriz painting could almost be accepted as replicating an actual scene that the artist had observed, but not so the Injuid example, in which the "hand of man" is so very evident. The Injuid artist has carefully and consciously arranged and manipulated each individual form in order to define and accentuate distinct areas, or pockets, of space—though of course not in the sense of creating an illusion of recession and/or of three-dimensional space. There is a definite sense of the artist "playing with space" or, more precisely, of playing with the means of depicting space to create a visually more striking and more powerful image than if he *merely* attempted to replicate the real world. This "playing with space" through the obvious arranging and manipulating of forms is in fact a basic Shirazi mode or manner of painting, one not restricted to a specific period but that instead serves as the basis of painting in the Injuid and Muzaffarid eras, as well as in the years following the demise of Iskandar until the end of Timurid rule in Shiraz in 1452.[3]

Three main, interrelated traits are typical of this basic Shirazi mode of painting. The first is a tendency toward the simplification and stylization of elements, in particular human and animal forms, which accentuates the form and contour of

the object. Figures strike simple, rigid poses; the bend of a knee or elbow is made excessively sharp; and outstretched limbs appear locked in position and frozen in time (e.g., figs. 80–84). In comparison with naturalistically rendered forms, the visual impact of these highly stylized and simplified Shiraz forms is dramatic, because they are not at all what the eye expects to perceive.

 Second is a propensity for the careful positioning of these (whole) forms. Shiraz compositions often resemble carefully arranged stage sets, each figure, human or otherwise, occupying its own precisely defined space on the stage. Simple, dramatically posed forms are silhouetted against a plain (or nearly plain) ground (e.g., fig. 82); figures, or groups of figures, are carefully placed so that neither impinges on the space of the other (e.g., figs. 85–86; see also figs. 80 and 82); and horses, their bodies cut off by the frame of the composition, delineate the boundaries of the stage on which the scene unfolds (see fig. 84). The careful positioning of a dramatically simplified form frequently results in a greater-than-usual sense of positive versus negative space, as is the case of the tightly coiled, isolated form of Ashkabus in figure 83.

 The third trait (very much a corollary of the second) is a tendency toward the arranging of multiple forms in a distinctly patterned manner, which betrays an overall fondness for decorativeness (and which is not, as it might seem, contrary to the tendency to simplify forms). Examples include figures (and even whole compositions) arranged in mirrored positions (see fig. 80); figures striking parallel poses; serried rows of hills or of heads peaking from behind a hill (see fig. 84); the careful arrangement of rocks of graduated sizes along the edge of a stream (see fig. 85); and the equally precise arrangement of spears and other accoutrements (see fig. 36). In this same category falls the restricted palette of most Shiraz paintings, which likewise is expressive of an interest in patterning and decorativeness, for the (patterned) repetition of the same few colors—either within a single painting or throughout a manuscript—contributes to the creation of an artificial or stylized world. Not only does the eye return to the same colors again and again, but colors tend to be used in an unnatural way, such as the bunches of oversized turquoise blades of grass strewn about the ground in Muzaffarid paintings (see fig. 36).

 These same traits and tendencies are sometimes evident in non-Shiraz paintings, and certainly not all—and sometimes even none—of these tendencies are necessarily evident in any one Shiraz painting. Nevertheless, they are evidence of a basic conceptual mode of painting underlying Shiraz production as a whole,

ILLUSTRATION 157

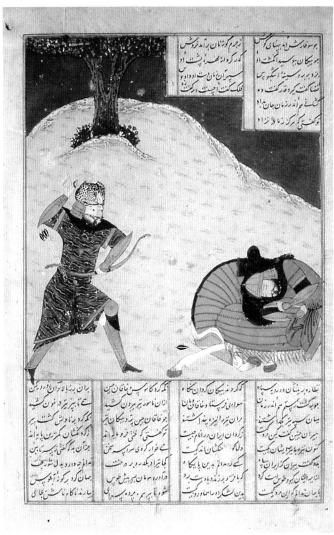

82. "The Combat of Gudarz and Piran," *Shahnama*, 796/1393–94, 35.5 × 23 cm (folio). Dar al-Kutub, Cairo, Ta'rikh farisi 73, f. 138a. Photograph by Bernard O'Kane.

83. "Rustam Shoots Ashkabus," *Shahnama*, n.d., but late 1420s or early 1430s, 28.8 × 19.8 cm (folio). Bodleian Library, University of Oxford, Ouseley Add. 176, f. 156b.

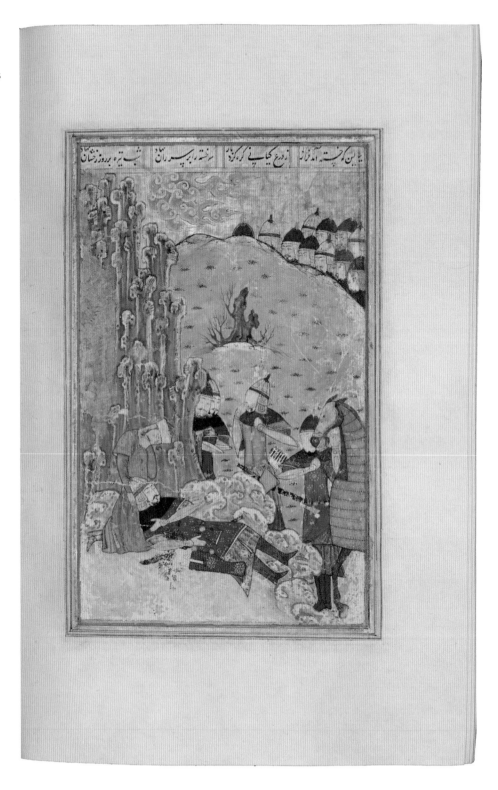

84. "Iskandar and the Dying Dara," *Khamsa* of Nizami, n.d., but mid-fifteenth century, 21.5 x 14 cm (folio). © The Trustees of the Chester Beatty Library, Dublin, Per 141, f. 278b.

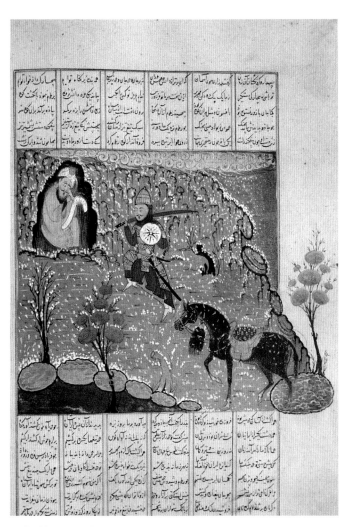

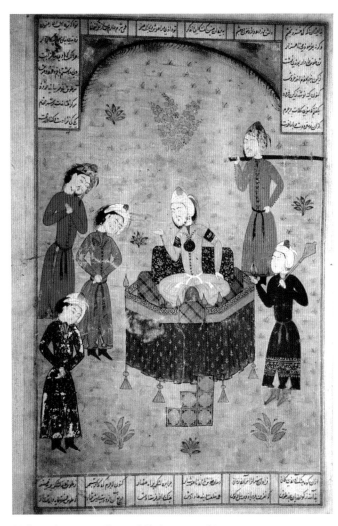

85. "Ruhham and the Sorcerer Bazur," *Shahnama*, 772/1371, 26 x 16 cm (folio). Topkapi Saray Library, Istanbul, H. 1511, f. 82b. Photograph by author.

86. "Kay Khusraw Reviles Tus," *Shahnama*, 796/1393–94, 35.5 x 23 cm (folio). Dar al-Kutub, Cairo, Ta'rikh farisi 73, f. 94a. Photograph by Bernard O'Kane.

throughout the periods in question, one that clearly distinguishes Shiraz paintings from those of other centers, such as Herat during the time of Baysunghur. In the 1420s and 1430s, artists working for Baysunghur attempted to perfect the real world through a need to make it more aesthetically pleasing and desirable. Unrealistic colors and highly idealized forms are typical of Baysunghur's paintings, but because there is in them a more naturalistic rendering of forms and space (e.g., fig. 87), one is always much less conscious of the manipulations of the "hand of man" than in any contemporary Shiraz painting. At first glance, the stylized and often rigid forms of Shiraz might seem to suggest that a more naturalistic depiction of the world was simply beyond the capabilities of many Shiraz artists. However, a more careful analysis of the paintings indicates clearly that a more naturalistic depiction of the world was simply of little interest to them, and so to judge those artists on their ability to render faithfully—or not—the world around them is to misconstrue totally the paintings of Shiraz.[4]

Injuid Paintings

Illustrated Injuid manuscripts span the years from 731/1330 to about the early 1350s.[5] The paintings in these manuscripts employ a very shallow picture space, in which large, very bold figures are set close to the picture surface, and the number of figures and background details are kept to a minimum, so that nothing distracts the eye from the main action taking place (see figs. 80–81 and 112–16). These same traits in fact characterize early fourteenth-century paintings of all centers. It is, however, a greater sense of naiveté, created primarily through the simplistic and often highly stylized rendering of forms, that distinguishes Injuid, and indeed almost all later Shiraz paintings, from those of other centers.

Grounds of red or ocher predominate within a restricted palette.[6] Sharp contrasts of color are used to great effect, namely red, ocher, and gold juxtaposed to strong greens and blues. Gold is used more extensively than in any contemporary style, although it seems to be of a low quality. The black drawing line of all elements is frequently visible through the layers of pigment and gold, creating the impression that these are actually drawings to which color has only incidentally been added. Moreover, the application of the pigments, and most especially the gold, is often rather slapdash, spilling beyond the black contour lines. The skill with which the color has been applied and the level of draftsmanship can, however, vary considerably, even within one manuscript, as it does in the Bodleian

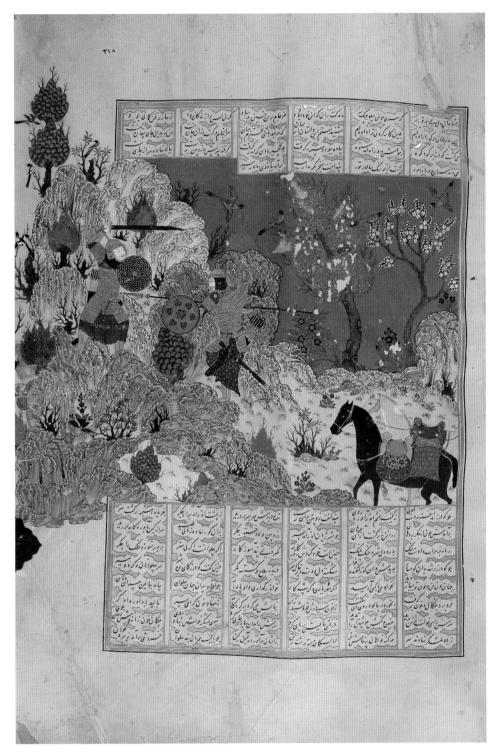

87. "The Battle between Gudarz and Piran," *Shahnama*, 833/1429–30, 38.0 x 26.0 cm (folio). Gulistan Palace Library, Tehran, no. 716, p. 318.

Library's undated copy of the romance novel *Kitab-i samak 'ayyar* (BOD Ouseley 379–81).

The sharp pinnacles so characteristic of Injuid paintings are not in themselves an innovation of the Shiraz artist, though their extreme stylization is (see figs. 114–16). Reduced to simple triangular shapes, they are defined by bands of color and, in some examples, by parallel rows of white circles and dots as well.[7] Oversized vegetation divides and defines space (see fig. 80).[8] Other background details are equally bold and broadly treated. Robes patterned with large blossoms are, for example, common in most paintings of the time, but in Injuid paintings the blossoms are larger and bolder, and they also more often tend to be lotuses, specifically the type used in Injuid illuminations (compare, for example, figs. 7 and 113). The most common architectural setting is a castle consisting of a simple brick wall topped by a parapet of brightly colored pentagonal shapes. These architectural constructions indicate clearly that the rendering of straight lines was much beyond the concern of the Injuid artist. The concern instead was the creation of a visually dramatic composition.

Muzaffarid-Style Paintings

Knowledge of a Muzaffarid painting style rests primarily on four manuscripts: two copies of the *Shahnama*, one dated 772/1371 (TS H. 1511; figs. 36 and 85),[9] the other 796/1393–94 (Cairo Ta'rikh farisi 73; figs. 82 and 86);[10] an undated copy of *Kalila wa dimna* (BN Pers. 377);[11] and a partial, undated copy of the *Khamsa* of Nizami (Keir III.7–27).[12] A fifth manuscript, an undated *Khamsa* of Amir Khusraw Dihlavi (Tashkent 3317), is less well known as few of its illustrations have been reproduced.[13] An anthology of poetry, dated 801/1398 (TIEM 1950), is illustrated with landscape paintings only, as was a *Khamsa* of Nizami, dated 776/1374 (TS H. 1510).[14] The anthology and the Cairo *Shahnama* (and perhaps also the *Khamsa* of Amir Khusraw) were in fact illustrated after the fall of the Muzaffarids and therefore demonstrate the continuation of the style into the early years of the new era of Timurid rule.

The most recognizable feature of the Muzaffarid style is the figures: a peculiar little oval-shaped head juts out at an odd angle from each rather petite and delicate body. Perched haphazardly atop each head is a white turban, loosely wrapped around a short, thick baton and flopping apparently carelessly down one side. Faces are characterized by pointy black beards and mustaches that are determinedly straight, stiff, and thin, along with small beady eyes and tiny pursed

mouths. Bodies, too, are abnormally straight and stiff, with long torsos, slim waists, and feet set in tiny pointed boots.

Again, usually a minimal number of figures are used in each composition, but the figures are now smaller, more in proportion with the surrounding background details, and set into a slightly deeper space. Horizons are high with only a small bit of deep blue or gold sky visible, or the ground rises up to fill the whole space of the painting. Rounded hills are standard, the edges of which are delineated by a thick black outline, while the texture of rock is frequently defined by parallel gold markings. Grounds are shades of gray in the earlier of the two *Shahnama*s, but tend to ocher or a pale rosy rust in the later *Shahnama*. In both manuscripts, the most distinctive ground cover consists of bunches of two-toned turquoise leaves, often set against a less conspicuous ground of small, carefully arranged tufts of grass, although more common in the 796/1393–94 *Shahnama* are one or two black bushes, devoid of all leaves and set starkly against the colored ground. In the Keir Collection *Khamsa* of Nizami, compositions are much more elaborate, for more landscape elements are included, creating a lyrical atmosphere similar to that portrayed in each of the landscape paintings in the Istanbul anthology of poetry.

The palette is much broader than in the Injuid era, yet distinctive for its reliance on red and blue, in particular in the 796/1393–94 *Shahnama*, where, in battle scenes, for example, the palette is restricted mainly to the ground colors and the red, gold, and black of the figures' armor and clothing. In detail, the Muzaffarid style is therefore very different from that of the Injuid era, yet, as shown previously, the paintings of both periods are expressions of the same basic Shirazi mode of painting.

Paintings of the Early Timurid, Pre-Iskandar Era

The two most important and well known of the few illustrated manuscripts that have survived from the period from about the late 1390s until the establishment of Iskandar Sultan's atelier are both anthologies. The first is the Yazd Anthology, copied, as its name suggests, in Yazd, in 810/1407 (TS H. 796; fig. 88).[15] Yazd was at the time under the control of a Timurid governor and clearly fell very much under the cultural umbrella of Shiraz in terms of book production.[16] The second manuscript, known as the Collection of Epics, is now divided between two institutions: the first half of the manuscript, a copy of the *Shahnama*, is in the Chester Beatty Library (CBL Per 114; fig. 89), while the second half, comprising

ILLUSTRATION 165

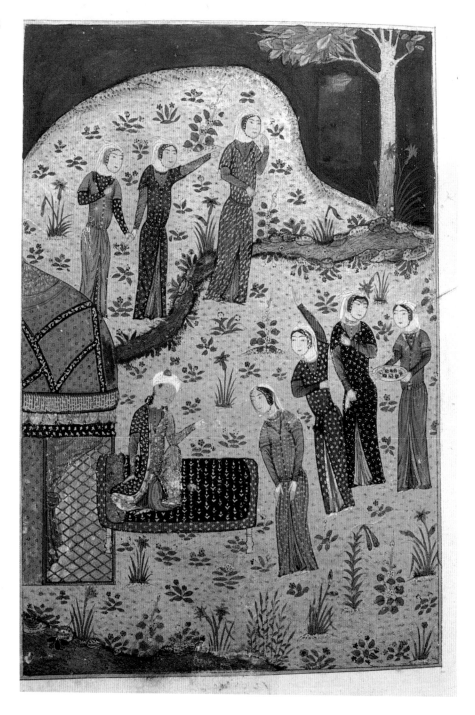

four shorter epics written in imitation of Firdawsi, is in the British Library (Or. 2780).[17] The text of the manuscript was copied in 800/1397, but the paintings were added later and probably should be dated closer to the period of Iskandar's two lengthy anthologies produced in 813–14/1410–11 and now in collections in Lisbon and London (Lisbon LA 161 and BL Add. 27261).[18]

There are several obvious differences between the paintings of these two manuscripts. For example, the figures in the Epics are generally much larger and bolder and set in a shallower picture space than are those in the Yazd Anthology. However, they are similar in that each group of paintings shares common, general or specific, traits with the earlier Muzaffarid era, yet also employs elements that are clearly foreign to earlier Shiraz paintings. In the Epics, the link with the earlier era is the basic Shirazi interest in the manipulation of form in order to define and arrange space that is evident in some paintings (see fig. 89). Links with the Muzaffarid era are more difficult to ascertain in the Yazd Anthology and consist of specific shared iconographical and stylistic elements, such as the odd, slightly jutting heads of some figures, straight and stiff mustaches, and extreme undulations of the fungus-like rocks in certain paintings. The new, foreign elements visible in some of the paintings of both manuscripts include a broad palette, a more natural rendering of figures, a more detailed and more lyrical natural environment, the attention to detail evident in architectural settings, and the inclusion of additional figures not mandatory for the relating of the tale at hand. Few illustrated Jalayirid manuscripts have survived, but based on those that have, in particular the 798/1396 *Masnavi*s of Khwaju Kirmani (BL Add. 18113), these foreign elements seem to have resulted from the presence of Jalayirid artists in Shiraz.[19] Both manuscripts are, however, illuminated purely in the blue-and-gold floral style of Shiraz, and it has earlier been suggested that Jalayirid illuminators were not working in Shiraz prior to the establishment of Iskandar as governor of the city in 811/1409. That one group of Jalayirid artists but not another might have made their way to Shiraz in the early fifteenth century is not implausible: recall the somewhat reverse situation in the late Injuid era, wherein the evidence speaks much more loudly for the presence of Il-Khanid illuminators working in Shiraz than it does for Il-Khanid illustrators.

Paintings of Iskandar Sultan

Paintings in manuscripts made for Iskandar Sultan were produced in the years 813–16/1410–14. With the exception of a single painting, they are distinct from all

ILLUSTRATION 167

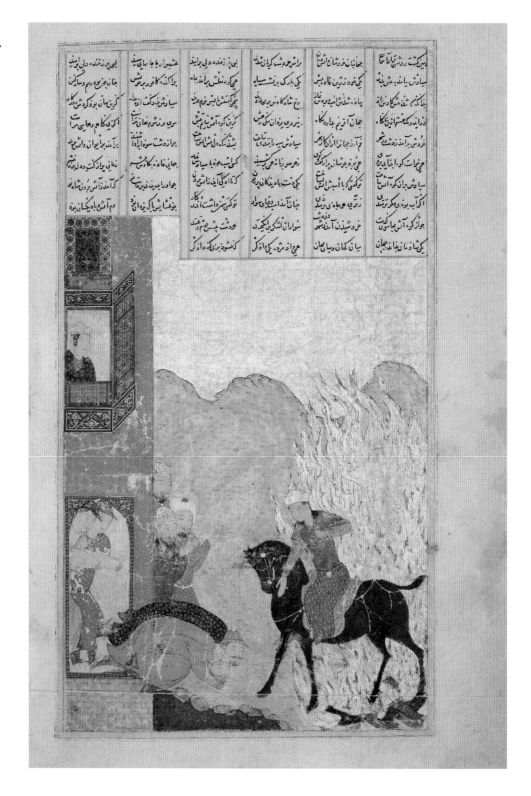

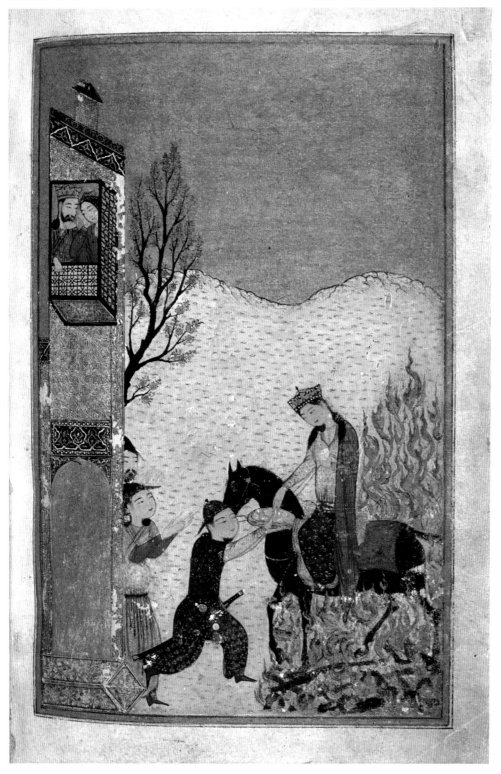

90. "Siyavush Emerges from the Flames," Anthology, 813–14/ 1410–11, 18.4 x 12.7 cm (folio). © The British Library Board, Add. 27261, f. 295b.

other groups of paintings discussed here, for the interest in "playing with space" that links these groups is not normally evident in Iskandar's paintings (figs. 90–91).[20] Some features of Iskandar's paintings relate to earlier Shiraz paintings, such as the close focus used, for example, to portray Adam and Eve in the Lisbon Anthology;[21] and some compositions clearly are derived from those used in the Yazd Anthology.[22] It is obvious, however, that on the whole Iskandar's artists were more strongly influenced by the tradition of the Jalayirids than that of Shiraz, and this is again evident in the broad palette, the attention to detail, and the more completely developed and naturalistically rendered environments (see fig. 91). The altering of form and the manipulation of space that occasionally appear in the Collection of Epics is also evident in a very few of the paintings of the Lisbon Anthology, but in all of Iskandar's later paintings these traits seem to have been avoided or at least diluted to the point of being barely noticeable. (And the absence, or near absence, of these traits in later paintings would suggest that if the Epics paintings do indeed date to the time of Iskandar, then they are best understood as early works of his atelier.) The result is a greater and more consistent realism than in earlier Shiraz paintings. A comparison of the scene of Siyavush's fire ordeal in the Epics (see fig. 89) with the same scene in Iskandar's London Anthology (see fig. 90) aptly illustrates this point. The latter composition is closely based on the (presumably) earlier one; both are finely executed and both show strong Jalayirid influence, yet the visual impact of each is very different indeed. The "hand of man," carefully arranging each form, is highly apparent in the Epics version. By comparison, the London Anthology painting seems more natural: there is no sharp demarcation of the space between Siyavush and the courtiers, the figures' movements are softer and more natural (notice the soft curve of Siyavush's arm versus the rigid thrust of his arm in the Epics scene), and their movements also are not unrealistically synchronized, as they are in the Epics painting. The London Anthology painting is highly naturalistic, but it is the Epics version that makes a more dramatic impact on the eye of the viewer, and thus is the more memorable of the two images.[23]

It has been said that following the demise of Iskandar there was a revival of Muzaffarid-style painting.[24] There is evidence, however, to suggest that the "Muzaffarid style" never fell into disuse. Rather, it may well have flourished in now-lost manuscripts produced contemporaneously with those in which the apparently more courtly (and predominantly Jalayirid) painting style prevails. The evidence

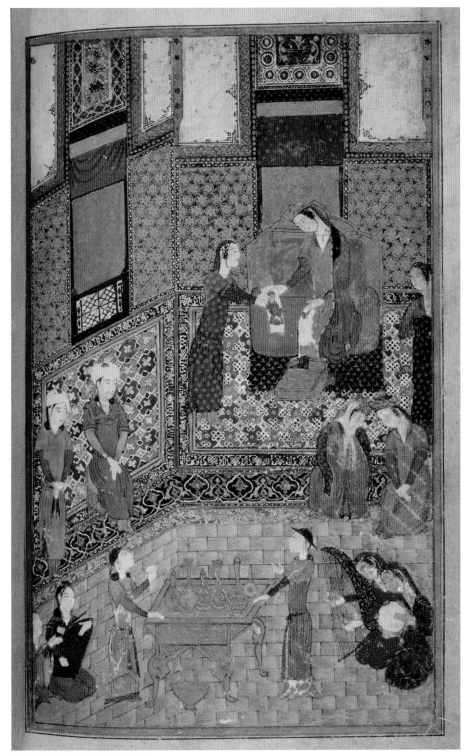

91. "Nushabeh Recognizes Iskandar from His Portrait," Anthology, 813–14/1410–11, 18.4 x 12.7 cm (folio). © The British Library Board, Add. 27261, f. 225b.

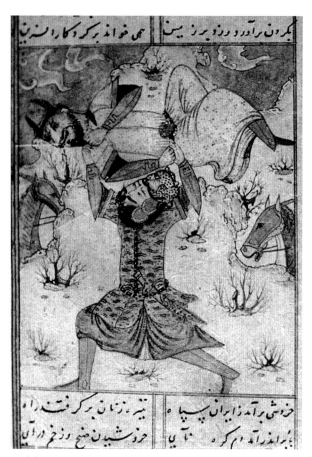

Arabic text visible in the painting:

همی خواند برکرد اسپ بین

بکردن برآورد و روز برز یمین

خوش برآمد زایران سپاه
برآمد زمان برکرفت راه
تیر زمان برکرفت راه
حروشیدن ضیح روزخ رای

92. "The Combat of Rustam and Pulavand," Anthology, compiled c. 1425–47, 32.5 x 25 cm (folio). Topkapi Saray Library, Istanbul, B. 411, f. 161b. Photograph by author.

is a single painting of "The Combat of Rustam and Pulavand" made for Iskandar Sultan and now part of an album in Istanbul (TS B. 411; fig. 92). The section of the album to which the painting belongs is dated 816/1413–14, at Isfahan.[25] The framing horses and the sharp movements of Rustam all conform to the precepts of the so-called basic Shirazi mode of painting. This painting in fact closely resembles many of those produced in the 1430s for Iskandar's cousin Ibrahim Sultan, paintings that, as will be discussed below, exhibit numerous traits in common with pre-Iskandar paintings. A single painting admittedly provides only slight evidence of a continuing tradition, yet it does suggest that two traditions of figurative painting were being practiced in Shiraz (and Isfahan) during Iskandar's rule, though Iskandar obviously preferred the "Jalayirid" style. The likelihood of this is corroborated by the evidence of illuminations in manuscripts made for Iskandar. It will be recalled that although predominantly Jalayirid-style illuminations prevail in most of Iskandar's manuscripts, one manuscript (now bound as two) is illuminated exclusively in the blue-and-gold floral style (TIEM 2044 and Lisbon LA 158). In light of the continued use of this illumination style, continued use of the so-called basic Shirazi mode of figurative painting would not be surprising.

Painting from the Time of Ibrahim Sultan to 1452

The Berlin Anthology of 823/1420 that was made by Ibrahim as a gift for his brother Baysunghur is stylistically rather eclectic. Some paintings—mostly battle scenes (fig. 93)—are very much in the style of the small painting of Rustam and a pulavand made for Iskandar (see fig. 92). More passive scenes employ a slightly deeper space, are noticeably more lyrical in tone, and are set in more fully developed environments (fig. 94).[26] While these latter traits may initially seem to suggest a continuing of Jalayirid influence, closer scrutiny of text and image indicates that they are more specifically a reaction to text type. It is, however, the former type of painting—those executed in the basic Shirazi mode—that prevails in manuscripts made for Ibrahim Sultan (e.g., fig. 95; see also figs. 104, 108,

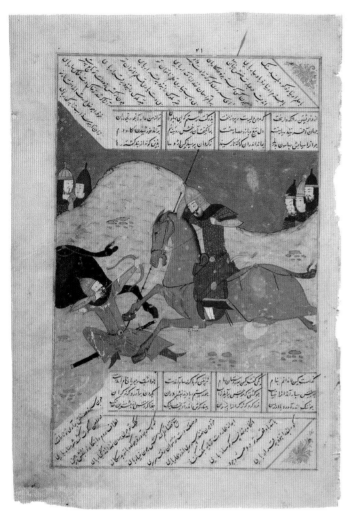

93. "Rustam and Afrasiyab in Battle," Anthology, 823/1420, 28.3 x 20.2 cm (folio). bpk / Museum für Islamische Kunst, Staatliche Museen zu Berlin, I. 4628, f. 21a.

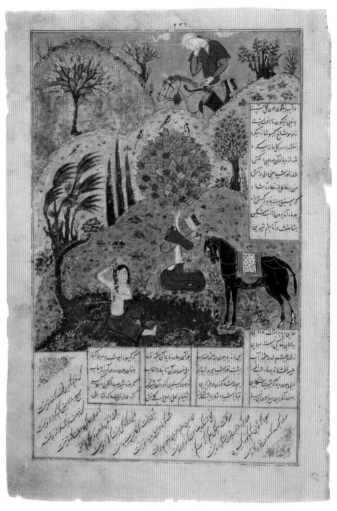

94. "Khusraw Spies on Shirin Bathing," Anthology, 823/1420, 28.3 x 20.2 cm (folio). bpk / Museum für Islamische Kunst, Staatliche Museen zu Berlin, I. 4628, f. 231a.

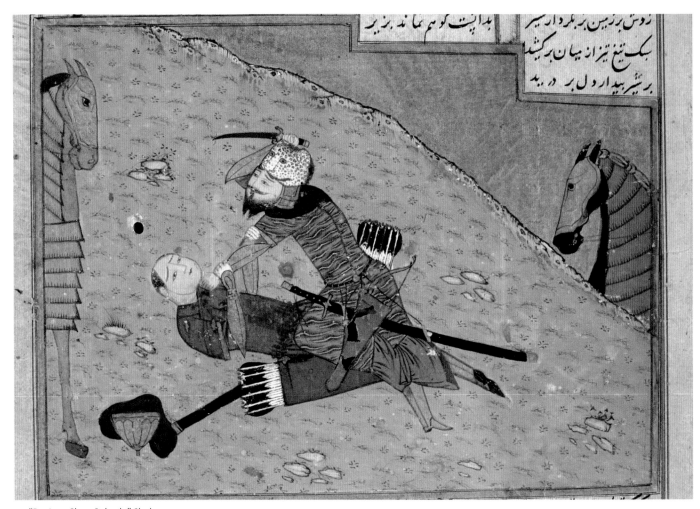

95. "Rustam Slays Suhrab," *Shahnama*,
n.d., but late 1420s or early 1430s,
28.8 x 19.8 cm (folio). Bodleian Library,
University of Oxford, Ouseley Add. 176,
f. 92a.

and 110).[27] Generally, paintings made for Ibrahim employ a very shallow picture space, a restricted palette with strong contrasts of color, a limited numbers of figures, high horizons, and either rounded hills or fungus-type rocks. Most obvious, however, is the evident concern with the manipulation and arranging of forms to help define the space of a composition: figures move with sharp, dramatic gestures; horses demarcate the lateral space of the composition; and rows of heads peak from behind hills. All is contrived for the greatest possible visual effect. It is not the real world that is presented, but rather one that has been fashioned to elicit an immediate reaction from the viewer.

Paintings of this type continued to be produced after Ibrahim's death, but in the later 1430s and 1440s there increasingly appeared paintings more closely related to the second type found in the Berlin Anthology. Both action scenes and more passive scenes, such as enthronements, began to employ a slightly deeper space and to include both more figures and background details—such as flowering plants, swaying cypress trees, and swirling clouds—that once would have been considered extraneous to the telling of the story and therefore excluded. For example, in a painting depicting Bahram Gur seizing the crown from between two lions (fig. 96), the figures watching from behind the hill, the swirling clouds, the very pretty flowering plants, and the "babbling brook" in the foreground of the painting are all details that are quite unnecessary to the accurate relating of the story.

This changing approach to painting is illustrated through a comparison of the scene of "Rustam Slays Suhrab" in Ibrahim's *Shahnama* (see fig. 95) with the same scene in a late 1430s to 1440s *Shahnama* (fig. 97).[28] As in the painting of Bahram Gur, numerous "unnecessary" sweet and pretty details have been included in the later version so that, overall, a lyrical tone pervades, even though it is a scene of deadly combat that is being portrayed. By the start of the second half of the century, any interest in the manipulation of space for the sake of dramatic visual impact will have largely disappeared. In paintings made for the new Turcoman rulers of Shiraz, a shallower space and fewer figures than in contemporary Herat paintings continued to be employed, but figures in these Shiraz paintings now often move with gentler, less sharply defined, and thus more naturalistic gestures. In general, features that once served as evidence of a distinct interest in the manipulation of space and form now function only as decorative details. Serried rows of heads, for example, are frequently so numerous that they in fact distract

ILLUSTRATION 175

96. "Bahram Gur Seizes the Crown from between Two Lions," *Khamsa* of Nizami, 844/1440 and 846–47/1442–43, 18 x 13.5 cm (folio). Topkapi Saray Library, Istanbul, R. 862, f. 238a. Photograph by author.

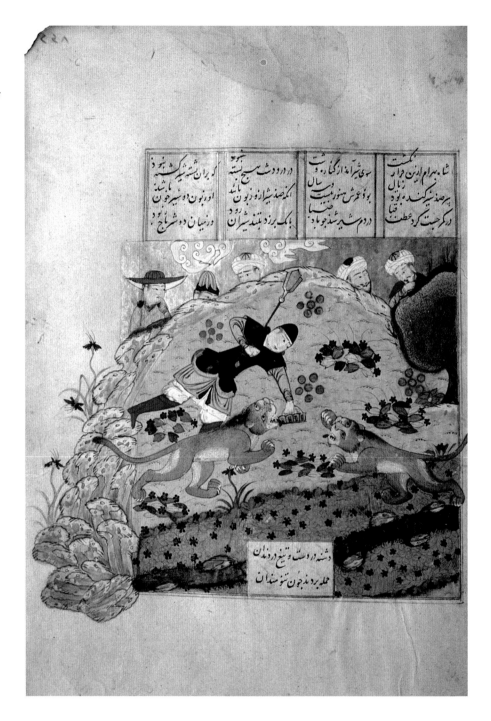

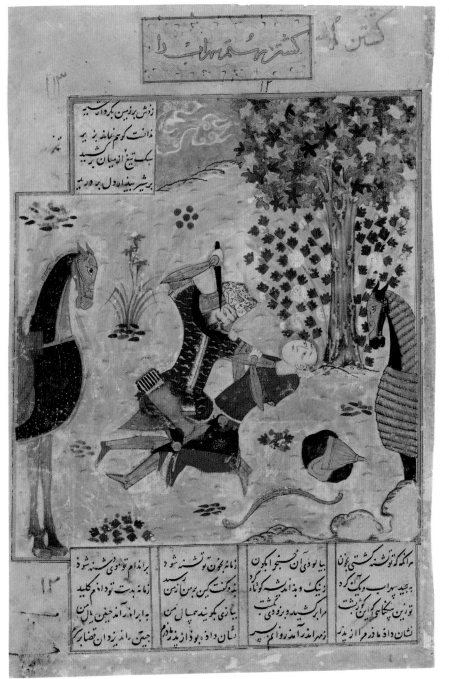

97. "Rustam Slays Suhrab," *Shahnama*, n.d., but late 1430s to 1440s, 25 x 18 cm (folio). © Trustees of the British Museum, OA 1948-10-9-51.

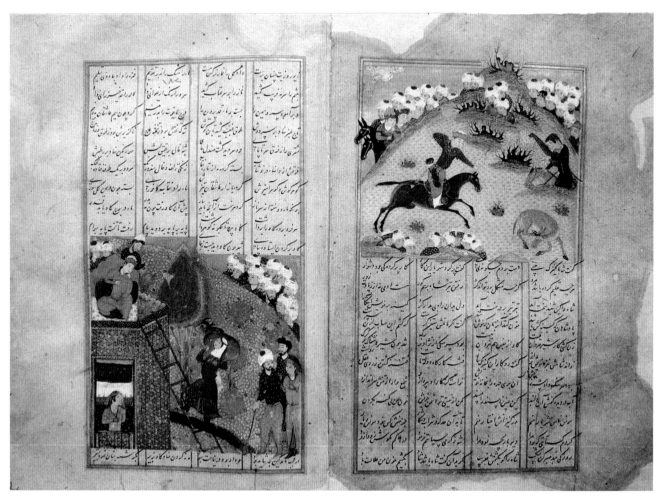

98. "Bahram Gur Hunting with Fitna" and "Fitna Carries an Ox," *Khamsa* of Nizami, 881/1477, 31 x 19 cm (folio). Topkapi Saray Library, Istanbul, R. 874, ff. 181b–82a. Photograph by author.

one's vision, while small groups of individuals often turn their backs on the hero to talk among themselves, further averting the viewer's attention from the main event (fig. 98). A fundamental change occurred with the demise of Timurid rule in Shiraz: use of the basic Shirazi mode of painting that linked the outwardly diverse styles of the Injuids, Muzaffarids, and Timurids appears to have largely dissipated, thus marking the true end of an era in Shiraz painting.

MODES OF ILLUSTRATION

Ettinghausen's Literary Model for the Categorization of Persian Painting

Many of the traits of Injuid painting are not unique but rather are common to painting of the early fourteenth century as a whole. Thus, the close focus, few

figures, and sparse background details of the scene of "Rustam Shoots Isfandi-yar" from the Injuid *Shahnama* of 731/1330 (see fig. 80) are equally features of an Il-Khanid painting from the *Jami' al-tavarikh* of Rashid al-Din, copied in Tabriz in 714/1314–15 (Khalili MSS727) that depicts "Ya'qub and His Family" (fig. 99). Considering for the moment specifically non-Shiraz painting, these same features are not, however, characteristic of the majority of paintings produced during the course of the following century. A typical painting of the fifteenth century is the scene portraying "Khusraw Feasting with Shirin in a Garden" from a copy of the *Khamsa* of Nizami (TS H. 781; fig. 100). The manuscript is dated 849/1445–46 and was produced in Herat for Ismat al-Dunya, wife of two Timurid princes, Muhammad Juki ibn Shah Rukh and then, after his death, Abu'l Qasim Babur ibn Baysunghur. In both this and the *Jami' al-tavarikh* depiction of "Ya'qub and His Family," the two main figures are a seated man and woman, and, despite the pillars and hanging textile in the earlier painting, both scenes are clearly set outdoors. Other figures are also shown, but the points of similarity between the two paintings end there. They are in fact starkly different compositions, and as such they are highly representative of the differences that exist between paintings of the fourteenth and fifteenth centuries.

The *Jami' al-tavarikh* painting presents a very close, eye-level view of the event taking place, one that almost seems to invite the viewer's active participation in the scene. This effect is enhanced by Ya'qub's feet, which extend beyond the edge of the picture frame, suggesting that at any moment he might step from the space of the painting into the space of the viewer. The figures dominate the picture space: the feet of the three standing men (Ya'qub's sons) are planted firmly along the baseline, yet they are so tall that the tips of their slightly bowed and turbaned heads touch the upper frame of the painting. But, even so, they would be dwarfed by Ya'qub if he were suddenly to stand and rise to his full height. There is a mere hint of a setting: the pillars, the textile hanging, and the two thin saplings that bend around the figures of Ya'qub and one of his two wives—either Leah or Rachel—to signal their importance. (The other kneeling woman is presumably his wife's handmaiden.) There is no horizon, and indeed no indication whatsoever of a ground because all elements are set against the blank, unpainted page. Details of clothing and faces are well executed, although facial expressions give little hint of interaction between the figures: Ya'qub's three sons look at him, but his eyes are downcast and inattentive. That the figures are in fact all engaged in active—indeed spirited—communication is left for their hands to express.

ILLUSTRATION 179

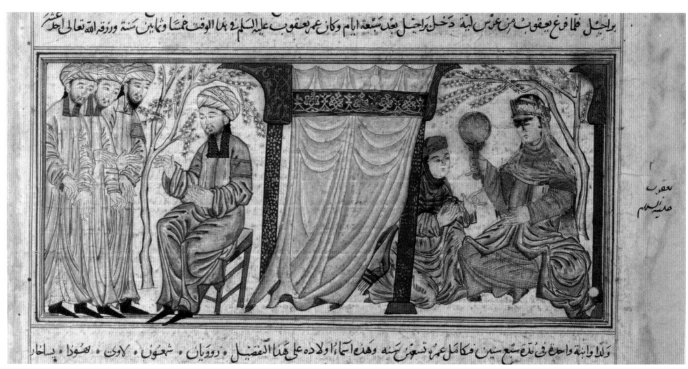

99. "Ya'qub and His Family,"
Jami' al-tavarikh, 714/1314–15,
Tabriz, 43.5 x 30 cm (folio).
Nasser D. Khalili Collection of
Islamic Art, MSS727, f. 47b.
© Nour Foundation. Courtesy
of the Khalili Family Trust.

The simple, straightforward, no frills approach of the artist of the *Jami' al-tavarikh* painting is remarkably different from that of the artist of the *Khamsa* painting, which depicts the two would-be lovers Khusraw and Shirin. The viewpoint has been drastically altered, facilitated by the change in the shape of the painting from a horizontal to a vertical rectangle. The use of smaller figures that are now in proportion to the background elements, in conjunction with the increased height of the painting, permits a whole world to unfold in and around the figures. The viewer now looks down on the scene and becomes an observer rather than a near participant in the events taking place. In the *Jami' al-tavarikh* painting, the eye of the viewer is forced onto a scene enacted by a very few figures in a sparse setting. Now a multitude of details catch the eye, detracting it from the two protagonists: the women on the right talk among themselves, paying little heed to Khusraw and Shirin, while the musicians are equally engrossed in their own activities. Only those actually serving the couple seem concerned about their immediate welfare. Heads turn and hands gesture, creating a greater and surer sense of the interaction taking place. However, all this activity—even in a relatively passive scene such as this—and the more distant view mean that the artist has had to manipulate the various elements carefully to ensure that the

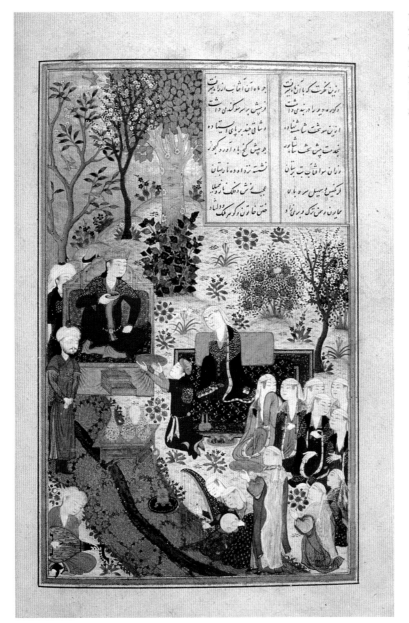

100. "Khusraw Feasting with
Shirin in a Garden," *Khamsa*
of Nizami, 849/1445–46,
24.1 x 16 cm (folio). Topkapi
Saray Library, Istanbul,
H. 781, f. 48b. Photograph by
author.

viewer's attention is not totally distracted from the main character. Thus all the
figures are in fact arranged in a (right-angled) triangular composition that follows
the path of the once-silver stream up to Khusraw at the triangle's pinnacle. The
slightly blue ground spreads out above the heads of Khusraw and Shirin, dot-
ted with lush bunches of blossoms, flowering bushes and trees, and reaching to a
golden sky: the romance of the scene is heightened by the beauty of the vegeta-

ILLUSTRATION 181

tion. This is without doubt an idealized version of the real world, but each element is so carefully and naturalistically portrayed that the improbability of a pale blue ground and a gold sky is not in the least disturbing.

The differences in the treatment of the two scenes is astounding, even making allowances for the fact that the *Jami' al-tavarikh* painting essentially depicts a very different type of scene in that it focuses on a (somewhat formal) meeting between a father and his sons, while the *Khamsa* of Nizami painting depicts two lovers. The intent of the early fourteenth-century artist was the straightforward illustration of historical figures, a relating of "facts" for posterity, and he aimed to do so in as expedient a manner as possible. Although the fifteenth-century artist, too, was depicting a historical figure—the pre-Islamic king Khusraw Parviz—he was illustrating a love story, so he created a mood typical of such an event, a scene in which one can almost hear the trickling of the stream and the gentle melody of the music and smell the sweet scent of the blossoms. Two very different types of texts have prompted the artists to produce two very different types of paintings.

In an article published in 1981, Richard Ettinghausen noted that different text types indeed are often illustrated differently, and he therefore proposed that Persian painting might be better categorized according to text types than dynasties.[29] Using Ivan Stchoukine's four books on Persian painting to exemplify the problems that can follow from the traditional use of dynastic labels, Ettinghausen noted that the volume dealing with painting of the Muzaffarid, Jalayirid, Turcoman, *and* Timurid dynasties is simply entitled *Les peintures des manuscrits timurides*.[30] Thus all paintings produced during the years when the Timurids held power in various, but certainly not all, parts of Iran, Stchoukine rather generically and incorrectly labeled as Timurid. Conversely, he divided his study of paintings produced during the reign of the Safavid dynasty into two separate volumes in order to deal with the two very different styles of painting produced for Safavid patrons.[31] Thus in each case the dynastic label, either Timurid or Safavid, does not serve to identify precisely a single style of painting.

Ettinghausen's aim was to develop a better means of categorizing Persian painting, one based on the dominant features of any given style, but features that are not categorically exclusive. A style would therefore not have to be seen as starting and ending at a given date and could even exist concurrently with another style. He attempted to establish a suitable terminology for these categories that would immediately call to mind a visual image in the same way as do the terms "gothic" or "baroque." In formulating his system, he noted that Persian painting is primar-

ily manuscript painting and that the predominant type of text illustrated changed with time. Based on the evidence of surviving manuscripts, this changing preference for illustrated copies of certain texts followed the order in which the main literary genres of Iran developed, though with a considerable gap of time between when a text was actually written and when it was first illustrated. And finally, he also stated that the changing styles of painting paralleled this changing preference for illustrated copies of certain text types. Ettinghausen therefore suggested that specific periods of painting be named according to the author of the most popular illustrated text of any given period of time.

Paintings of the first half of the fourteenth century Ettinghausen dubbed the epic or historical category, or the Firdawsi group, because of the popularity of Firdawsi's epic, the *Shahnama*, and because of the more general preference for historical texts during that period. The emphasis of this type of text is the action of heroes, with little attention paid to developing the milieu in which the action takes place. The painting style of the time likewise is rather simple and straight-forward. As has been previously stressed, the scenes of "Ya'qub and His Family," in the *Jami' al-tavarikh* manuscript (see fig. 99), and "Rustam Shoots Isfandiyar," in the Injuid *Shahnama* (see fig. 80), are typical of the first half of the fourteenth century in their use of large figures placed close to the picture plane and with little attention paid to background detail. Although most popular during the first half of the fourteenth century, the style did continue. For example, during the first half of the fifteenth century, Shah Rukh, in Herat, employed the style for various copies of historical texts, such as a replacement volume to a fourteenth-century *Jami' al-tavarikh* that he commissioned from Hafiz-i Abru. The fifteenth-century paintings in this manuscript, and in other contemporary copies of the text, clearly are a continuation of the heroic/historical-epic, or Firdawsi, mode, one that responds very directly to the nature of the text (fig. 101). Moreover, they demonstrate that Ettinghausen's model indeed is not restricted by chronological boundaries as is the dynastic model, even though a specific style or mode might be more closely associated with one period than another.[32]

The subsequent stylistic period Ettinghausen designated the romantic or Nizami category because of the popularity throughout the fifteenth century of illustrated copies of Nizami's *Khamsa*. Nizami's poems and others of this same literary type (the romantic epic) are a dramatic contrast to those of the heroic/historical-epic genre, as noted previously. Tales of heroic feats give way to an emphasis on tales of love and romance and interpersonal relations. Ettinghausen saw

ILLUSTRATION 183

this change in the most favored type of illustrated text as being reflected in the change in the mode or manner of painting that takes place. More fully developed scenes were depicted, with fewer action and a greater number of passive scenes being illustrated. The artist's portrayal of the environment aids the narration by conveying the overall mood of the story; in the romantic epic the artist can less often rely on action, or perceived action, to maintain the viewer's interest. The scene of "Khusraw Feasting with Shirin in a Garden" (see fig. 100) is typical of this mode of painting.

Ettinghausen believed that it was the desire to illustrate new types of literature that brought about changes in style, stating that literary types developed first and that artists "*then* endeavor[ed] to achieve by visual means what the leading authors had tried to accomplish in the verbal medium" [emphasis mine].[33] The four earliest extant copies of the *Khamsa* of Nizami provide evidence of an apparently new interest, in Shiraz in the 1360s, in manuscript copies of texts of the romantic-epic genre. (Just one of these four, BN Supp. pers. 580, was planned as an illustrated copy, although the blank spaces left for the illustrations were not filled until a much later date.)[34] The existing Firdawsi mode was largely unsuited to the illustration of such texts, but the desire to illustrate them cannot on its own be credited with the development of the Nizami mode.

In the Great Mongol *Shahnama* of c. 1335, the contribution of the surrounding environment to the action is seen on a scale vastly greater than ever before. In the well-known scene of "Rustam Shoots Isfandiyar,"[35] nature mirrors the drama of the fatal duel between the two heroes. Mounted on their faithful steeds, they face one another in a balanced, symmetrical composition, the pairing of the two figures mirrored by the two flowering tree stumps of the foreground and the two trees of the background. The stumps are bent and twisted in a reflection of the agony and drama of the event, while dark and ominous clouds swirl overhead.[36] In "The Bier of Iskandar" (fig. 102), another well-known illustration from the same manuscript, the depiction of masses of mourning figures crowded together and the cramped and highly detailed architectural setting serve equally to convey to the viewer the emotional frenzy of the event taking place. No longer are only those details absolutely mandatory to set the scene portrayed. Throughout much of this manuscript artists relied less completely on action and increasingly on the environment for the telling of the tale. Figures no longer dominate these scenes, because they are generally smaller and more in proportion with the surrounding environment. Many paintings are vertically oriented, though admittedly still with

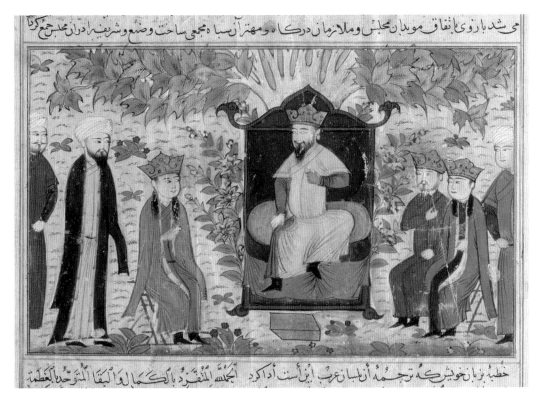

quite squat proportions. These are pragmatic changes prompted by an obvious new interest in the surrounding world and its narrative potential.[37]

The burgeoning awareness on the part of the Persian artist of the narrative potential of the surrounding world can be credited to the impact of Chinese landscape painting of the Song (960–1279) and Yuan (1279–1368) dynasties. Pure landscapes of certain Chinese inspiration are found in the existing fragments of the *Jami' al-tavarikh*.[38] In other of the surviving illustrations and in those from the slightly later Great Mongol *Shahnama*, the figures are placed in more fully developed landscape settings than is otherwise the norm in the early fourteenth century, and the landscape details are almost always of Chinese inspiration (fig. 103). The realization that landscape could serve as a narrative aid through its ability to evoke a variety of moods surely led to the inclusion of other, say architectural, details for the same purpose, and indeed in many of these paintings figures are likewise placed in more detailed architectural settings. It appears that an interest in the exploitation of the surrounding environment as a narrative aid was increasing gradually throughout the first half of the fourteenth century. It clearly preceded, and did not occur as a result of, the rise in the production of manuscripts

ILLUSTRATION 185

102. "The Bier of Iskandar,"
the Great Mongol *Shahnama*,
c. 1335, Tabriz, 57.6 x 39.7 cm
(folio). Freer Gallery of Art,
Smithsonian Institution,
Washington, D.C.: Purchase,
F1938.3.

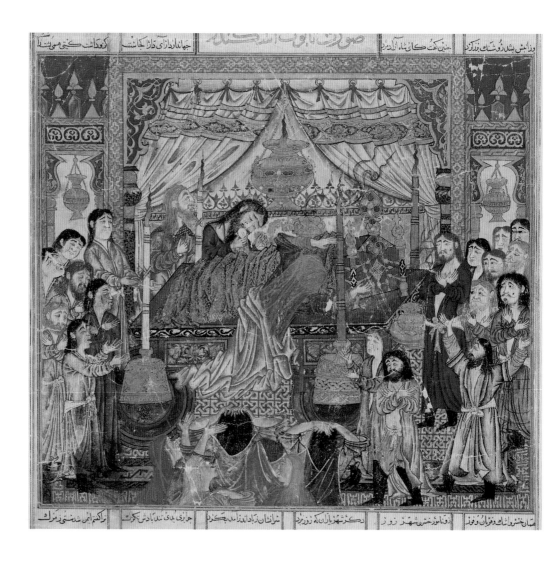

103. "The Mountains between India and Tibet," *Jami' al-tavarikh*, 714/1314–15, 43.5 x 30 cm (folio). Nasser D. Khalili Collection of Islamic Art, MSS727, f. 22a. © Nour Foundation. Courtesy of the Khalili Family Trust.

of poetry of the romantic-epic genre that began in earnest in the 1360s; further developments in this field would, however, surely have been encouraged by this new interest in manuscript copies of the *Khamsa*.[39] It may even be that the increasing interest in the environment as a narrative aid itself gradually encouraged the copying of manuscripts in the romantic-epic genre, with patrons eager to have artists display their ability to convey effectively the mood of a story through the inclusion of details of the surrounding world. This change in the perceived course of events does not invalidate Ettinghausen's proposed literary model for the categorization of Persian painting. The association between stylistic modes and text types remains a useful method for distinguishing differences in painting styles or modes of any given period, but perhaps it is most effective used in conjunction with, rather than in place of, dynastic labels.

According to Ettinghausen's model, the usual visual expression of a specific text often gave way under the influence of the predominant literary genre of the time. For example, the painting depicting "The Battle between Gudarz and Piran" (see fig. 87) fits exactly with what we now know of the typical Nizami or romantic-epic mode of illustration: the figures are set in a well-developed space and the flowering trees and bushes create, as in the Khusraw and Shirin painting, a lyrical and idyllic setting. The setting and tale are, however, highly incongruous, because it is a duel to the death that is taking place, not a quiet encounter of two would-be lovers. The scene in fact illustrates an episode from the *Shahnama*, specifically from a copy of the text produced in Herat for Baysunghur and dated 833/1429–30 (Gulistan no. 716).[40] All paintings in this manuscript are typical of the romantic-epic or Nizami mode, which is of course surprising because they illustrate a heroic epic, and one would therefore expect them to conform to the basic tenets of the early fourteenth-century heroic/historical-epic style, as do the illustrations in Baysunghur's father's historical texts, mentioned previously, such as the *Jami' al-tavarikh* (see fig. 101). But as Ettinghausen explained, the impact of the dominant text type of the time could override the usual association between text type and visual expression. Artists working for Shah Rukh illustrated epic and historical texts in the Firdawsi mode and thereby remained true to the nature of the text despite the prevailing literary genre of the time and its associated painting style, namely the romantic-epic or Nizami mode. Baysunghur's artists instead yielded to the leading mode of the time, one associated with the earlier Jalayirid dynasty and used by Iskandar Sultan in Shiraz.[41]

Manuscripts produced for Ibrahim Sultan are illustrated in the heroic/

historical-epic mode, except for parts of the Berlin Anthology of 823/1420. That manuscript includes excerpts of both the *Shahnama* and various texts of the romantic-epic genre, and the paintings included in it suggest that in Shiraz artists responded more directly to the tone of an individual episode of a story than to the tone of the text as a whole. The *Khamsa* of Nizami section, for instance, comprises paintings distinctly in each of the two modes: battle scenes tend to be more (or highly) epic in nature, while more passive scenes, especially those involving romance, tend more toward the Nizami mode.[42] For example, the scene of "Khusraw Spies on Shirin Bathing" (see fig. 94) is one of the most lyrical of all Shiraz paintings produced during the first half of the fifteenth century, while "Rustam and Afrasiyab in Battle" (see fig. 93) is purely in the heroic/historical-epic mode.[43] Like this latter example, the paintings in the remainder of Ibrahim's manuscripts are often exceedingly stark, but they are also exceedingly successful as illustrations to historical and epic texts (fig. 104; see also figs. 83, 95, and 108).[44] However, as previously discussed, paintings from the later 1430s and 1440s tend to employ a slightly deeper space and to include greater details of the surrounding world and more figures incidental to the story; they are also generally more lyrical in tone. Powerful portrayals of heroic feats could still be presented, but increasingly they conformed more completely to the Nizami mode (see figs. 96–97). The result was paintings that are generally much less visually dramatic than any earlier examples in which the basic Shirazi mode of painting is employed.

The evidence of the Berlin Anthology suggests that the boom in the production of copies of the *Khamsa* of Nizami that took place in the years 839–48/1435–36 to 1444–45 undoubtedly would have played a role in bringing about these changes. Although an apparently equal number of copies of the "old favorite," the *Shahnama*, were produced at this time, the intense demand for illustrated copies of the *Khamsa* of Nizami was an unprecedented phenomenon, one that surely had a greater overall impact on the psyche of the book-making and book-buying community than did the production of copies of the *Shahnama*. However, as in the fourteenth century, a reaction to text type alone was not the cause for the changes in painting that occurred. The influence of painting at the Timurid capital, at the court of Baysunghur where the Nizami mode held sway, probably helped tip the scales, so to speak, in favor of the Nizami mode for the illustration of all types of text produced in Shiraz in years following Ibrahim's death. Ibrahim himself may well have helped bring about this change through his recognition, as

ILLUSTRATION 189

will be discussed in more detail later in this chapter, of the potential political and cultural impact of illustrations in the Nizami mode in comparison with those in the starker Firdawsi mode.

So far manuscripts made for Iskandar Sultan have been excluded from this discussion because their strong reliance on the Jalayirid style sets them apart from the mainstream of development, namely, those paintings executed in the so-called basic Shirazi mode. The illustration of these manuscripts in fact had a much greater impact on later Timurid illustration in Herat under Baysunghur than in Shiraz in the years immediately following Iskandar's demise. In particular, it is their political or propagandistic function that is of interest here: the political function of one of the double-page paintings in Iskandar's Lisbon Anthology (ff. 27b–28a; see figs. 61–62) has already been discussed and, in speaking specifically of the *Khamsa* of Nizami sections of both Iskandar's Lisbon and London anthologies (BL Add. 27261 and Lisbon LA 161), Thomas Lentz and Glenn Lowry have commented upon the fact that the paintings "consistently emphasize certain themes underlying the depicted incident: heroics, romance, and above all royal myth. In short these paintings stress the celebratory aspect of Iskandar's rule by including court ritual that is often extraneous to the text" (e.g., see fig. 91).[45] This manipulation of illustrations for nontextual purposes through the inclusion of "unnecessary" details of court ceremony is first evident in the paintings of the British Library's copy of the *masnavis* of Khwaju Kirmani of 798/1396 (Add. 18113).[46] Surely Jalayirid attitudes to manuscript illustration, as evidenced by this manuscript, affected practices in Iskandar's atelier. But just as Iskandar's manuscripts demonstrate a more obvious manipulation of text illustration for nontextual purposes than do those of the Jalayirids, so did Baysunghur greatly build upon the model of Iskandar. For Baysunghur, actual text illustration was only a secondary concern: in his manuscripts setting is accorded precedence over subject, the poet's tale being secondary to the tale of the wondrous life of the royal patron (a point underscored by Baysunghur's frequent depiction in his own manuscripts).[47] The development of the setting was therefore taken a large step beyond its initial function as a narrative aid. The text itself assumes a secondary role and functions merely as a pretext for the pragmatic and worldly aim of royal image building. For Iskandar in Shiraz and his relatives in Herat, especially Baysunghur, books were, say Lentz and Lowry, "capable of conveying a variety of social and political messages," uppermost of which was the "power and cultural

prowess" of the dynasty.[48] Thus an awareness of the narrative potential of the setting quickly led to an awareness of its pseudo-political potential. Considering the implications of power with which the Nizami mode came to be imbued, it could not be wasted merely on texts of the romantic-epic genre. It therefore came to be used to illustrate a wide variety of texts, including the *Shahnama* produced for Baysunghur in 833/1429–30.

In Herat, under Baysunghur, political concerns influenced and at times even overrode any basic concerns regarding the illustration of a text, but in Shiraz, under Ibrahim, the actual illustrating of a story remained a paramount concern. The political connotations of the Nizami mode as developed in Herat were not, however, wasted on Ibrahim, and it is clear that he understood them well. A comparative study of the *Shahnama* manuscripts made for Ibrahim Sultan (BOD Ouseley Add. 176) and for his brother Baysunghur (Gulistan no. 716) during the second quarter of the fifteenth century makes this point abundantly clear. A very different function and intent served as the impetus for the illustrating of each manuscript.

The Case of Ibrahim Sultan's Shahnama

Ibrahim Sultan's *Shahnama* is undated, but it was probably produced sometime in the final years of the 1420s or early in the 1430s. The close-up view and sparse background details in the scenes of "Rustam Pulls the Khaqan of Chin from His Elephant" (see fig. 104) and "The Murder of Siyavush" (see fig. 110) are typical of paintings in the manuscript in the heroic/historical-epic, or Firdawsi, mode. The same episodes are also illustrated in Baysunghur's *Shahnama*, but they are very different because each is in the Nizami or romantic-epic mode, as are all other paintings in the manuscript (fig. 105; see also fig. 111). The few times that Ibrahim's *Shahnama* has been discussed in the scholarly literature, the paintings have always been treated as if they are in one homogeneous style.[49] This is not so, however, because the actual text illustrations, exemplified by the scenes of the "Khaqan of Chin" and the "Murder of Siyavush," differ not only from Baysunghur's versions of the same scenes but also from certain other paintings within the manuscript itself.

Ibrahim's *Shahnama* comprises forty-seven paintings, of which forty-two illustrate the text and are in the heroic/historical-epic mode.[50] The other five paintings consist of an approximately half-page depiction of "Firdawsi and the Poets of Ghazna," which accompanies the prose preface to the *Shahnama*, and

ILLUSTRATION 191

104. "Rustam Pulls the Khaqan
of Chin from His Elephant,"
Shahnama, n.d., but late 1420s or
early 1430s, 28.8 x 19.8 cm (folio).
Bodleian Library, University of
Oxford, Ouseley Add. 176, f. 164a.

۳۱۹

105. "Rustam Pulls the Khaqan of Chin from His Elephant," *Shahnama*, 833/1429–30, 38 x 26 cm (folio). Gulistan Palace Library, Tehran, no. 716, p. 219.

four double-page paintings, three of which function as frontispieces and one of which is placed in the approximate middle of the manuscript (on ff. 239b–40a). As with the preface painting, none of the double-page paintings illustrate, or in any way appear to relate to, the text of the actual poem. An enthronement, a battle (figs. 106–07), and a hunt are the scenes depicted in the three double-page frontispieces. Enthronements were used as standard frontispiece iconography from at least the early thirteenth century, while royal hunts were used from the early fourteenth century. The double-page painting on folios 239b–40a is unusual however, because, although one half depicts an enthroned ruler, the facing folio depicts a woman (presumably the ruler's consort) in a palace window with a gardener working below.[51] (The ruler portrayed in all four double-page paintings is thought to be Ibrahim himself.) The overall style or mode of each of these double-page paintings is different from that of most of the text illustrations, and, despite differences in the quality of draftsmanship, in many respects they relate more closely to paintings in Baysunghur's manuscript, because, like them, each scene is depicted from a higher and wider point of view, the numerous figures are set into a more fully developed environment, and the palette is generally broader than in the text illustrations. Indeed, like those in Baysunghur's manuscript and in sharp contrast to the actual text illustrations within the body of the manuscript, the double-page paintings have all been executed in the so-called Nizami mode.

The battle portrayed in one of the frontispieces has been identified as a depiction of Ibrahim's confrontation, in September 1429, with Iskandar ibn Qara Yusuf of the Qara Qoyunlu Turcomans. The Timurid army, including a contingent led by Baysunghur, faced the Turcomans at Salmas, in northwestern Iran; the battle ended with a rout of the enemy forces that was regarded as being in large part due to the bravery of Ibrahim and his men.[52] Oddly, on the reverse of each half of the frontispiece, as well as on the reverse of three of the other frontispieces, is either a drawing or a painting in gold.[53] The inclusion of these works in the manuscript is highly atypical, and therefore they must have been added for a very specific reason: surely they were especially treasured, presumably older, works, ones that perhaps had been salvaged from the atelier of Iskandar Sultan and thus were included to add a measure of prestige to the manuscript. Furthermore, the three frontispieces precede all illumination, an arrangement that is likewise extremely unusual, if not unprecedented. It seems, therefore, that while the forty-two text illustrations are contemporary with the copying and illuminating of the text, the

three frontispieces, at least, were added at a slightly later date, certainly sometime after 1429.[54]

Basil Robinson has suggested that the manuscript was made as a response to Baysunghur's copy of the same text, dated 1430,[55] and although much of Ibrahim's manuscript might already have been completed before work on his brother's had begun, it does seem that the style or mode of the three frontispieces may indeed have been a reaction to the work of Baysunghur's artists. Although it is doubtful that Ibrahim would have seen the paintings being produced for Baysunghur's *Shahnama*, the brothers were in close contact and are known to have discussed cultural matters through letters.[56] Thus, Ibrahim was probably well aware of the painting style employed for Baysunghur's manuscript, and he would have been equally aware of the royal—and hence politico-cultural—message that his brother intended the style to convey. Many of the text illustrations in Ibrahim's manuscript are superlative in terms of technical skill and aesthetic appeal, yet they create little sense of royal power and splendor; even the few throne scenes are comparatively austere. Ibrahim's highly praised role in the 1429 Timurid defeat of the Turcomans may have prompted a review of the already magnificent manuscript, one that resulted in the addition to it of a series of frontispieces produced in a justifiably more imperial style, an act intended to imbue the manuscript with the political nuances by then associated with the Nizami mode. The desired force of the statement that Ibrahim intended to make by altering his manuscript can be gauged by the fact that he added, not a single frontispiece, as in Baysunghur's *Shahnama*[57] and as is typical of both earlier and later manuscripts, but instead he chose to add an actual series of three frontispieces—and, on the reverse of these he placed older, treasured works, ones probably derived from the renowned atelier of his cousin Iskandar. He also chose to cast himself in the leading role of each frontispiece, thus appearing a surprising three times at the beginning of the manuscript: enthroned among his courtiers, engaged in the traditional royal pastime of the hunt, and directing a battle in defense of his country. Even if not intended as an actual "reply" to his brother's manuscript, this unprecedented series of frontispieces—executed in the style or mode associated with the Timurid capital and used exclusively in manuscripts made for brother—was at the very least designed to make a bold statement of Ibrahim's position within the Timurid hierarchy, a statement that was likely prompted by his recent military victory.[58]

ILLUSTRATION 195

106. Left half of a double-page frontispiece, "Battle Scene," *Shahnama*, n.d., but late 1420s or early 1430s, 28.8 x 19.8 cm (folio). Bodleian Library, University of Oxford, Ouseley Add. 176, f. 6a.

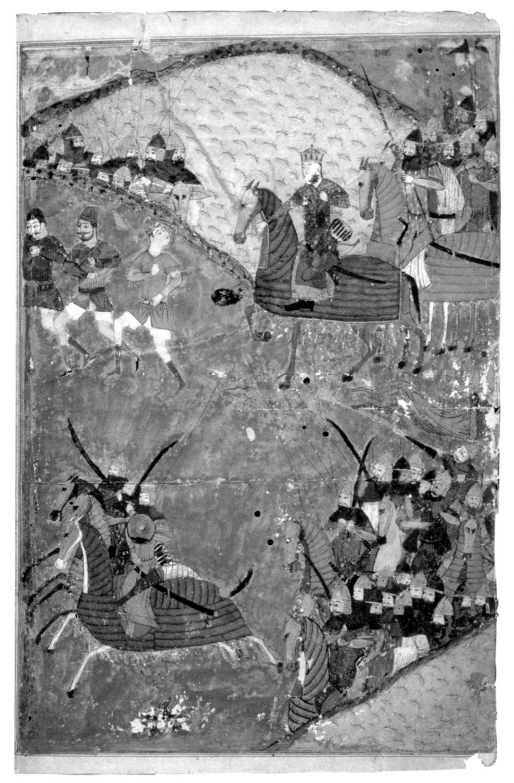

107. Right half of a double-page frontispiece, "Battle Scene," *Shahnama*, early 1430s, 28.8 x 19.8 cm (folio). Bodleian Library, University of Oxford, Ouseley Add. 176, f. 7b.

THE LAYOUT OF THE FOLIO:
THE INTEGRATION OF TEXT AND IMAGE

The Shahnama *Manuscripts of Baysunghur and Ibrahim Sultan*

The layout of, or arrangement of text and image on, the illustrated folios in Ibrahim's *Shahnama* generally differs from the layout used in Baysunghur's *Shahnama*, and it also differs from, though is clearly a development of, the types of layout common in manuscripts of the fourteenth century, specifically those of Shiraz. Determining why these differences exist leads to a greater understanding of the function and evolution of manuscript illustration in Shiraz.[59]

There are three main differences between the layout used in Ibrahim's manuscript versus that used in Baysunghur's. First, 37 percent (7/19) of the illustrated folios in Baysunghur's *Shahnama* include six or fewer couplets of text, compared with just 10 percent (4/42) in Ibrahim's.[60] Indeed, 21 percent (4/19) of the text illustrations in Baysunghur's manuscript are full-page paintings, but only 5 percent (2/42) in Ibrahim's are. Illustrations in Ibrahim's manuscript therefore tend to be juxtaposed to larger blocks of text.

The frequent placement of an illustration between two blocks of text in Ibrahim's manuscript (e.g., see fig. 110), as opposed to the usual use of a single block of text in Baysunghur's manuscript (e.g., see fig. 111), is the second difference between these two copies of the *Shahnama*. This layout is in fact a general difference between fifteenth-century manuscripts of Shiraz and those of Herat. The third difference concerns the usual shape of the textblock:[61] in all manuscripts, when text and image are juxtaposed on a folio, the text most often is written in a rectangular block, but symmetrically or asymmetrically stepped textblocks were also used, in which case the text appears to impinge upon the space of the illustration (e.g., fig. 108; see also fig. 110). Stepped textblocks were used much more frequently in manuscripts produced in Shiraz. It is therefore not surprising that 67 percent (28/42) of the text illustrations in Ibrahim's manuscript employ a stepped textblock,[62] while only 32 percent (6/19) in Baysunghur's do so.[63] Moreover, some textblocks in Ibrahim's manuscript are very dramatically or deeply stepped, but in Baysunghur's the steps are always just one or two text lines deep. It is in fact the textual and compositional functions of stepped textblocks that are of particular interest here. These will be considered with respect to Ibrahim's and Baysunghur's manuscripts, as well as in light of other fourteenth- and fifteenth-century manuscripts, primarily copies of the *Shahnama*.

In the *Shahnama*, Rustam performs seven heroic feats, one of which is his killing of the White Div. In this story, Rustam discovers the div sleeping in a cave, wakens him with a great roar, and, in the fight that ensues, maims him by cutting off his hand and leg. The story then climaxes with the moment when Rustam finally kills the div. In Ibrahim's painting (see fig. 108 and app. 2.1), the text in the upper textblock describes the battle between Rustam and the div, with the couplet in the stepped area relating specifically how Rustam thrust his dagger into the White Div, twisted it, tore open the div's chest, and then pulled out its liver. In the stepped area of the lower textblock, the story continues, describing how the div's huge body filled the cave and how the cave was quickly turned into a sea of blood. Then there is a distinct change in the action and pace of the story as Rustam turns away from the div and from the cave: the two couplets placed in the first full (nonstepped) line of the lower textblock relate how Rustam went over to Ulad (the local chieftain who served as his guide to the captive Kavus, shah of Iran), gave him the div's liver, and then continued on his way to release the captive shah. The stepped areas of the two textblocks therefore serve a definite textual function, because, in two closely related ways, they highlight the dramatic climax of this particular episode of Rustam's travails. First, placing the critical couplets in the steps and thus physically separating them from the rest of the text emphasizes them visually. The irregularity in the shape of the textblock signals to the reader, before one even begins to read, that something is—or may be—awry. Second, the long, sweeping motions of the eye, as one reads across the full width of the folio, are interrupted when the steps are encountered. The tenseness that this altering of the eye movements creates in the reader, however subtle, coincides with, and accentuates the tenseness created by, the mounting action of the story. In this case the steps are shallow, but often they are very deep, an arrangement that aggravates the tenseness by forcing increasingly furtive eye movements as one reads quickly down the narrow step. The steps also serve a compositional function, and, despite being shallow, each step helps to focus the viewer's vision on the scene taking place, which is in fact the precise moment described in the two steps. And the actual placement of the illustration—squeezed between two blocks of text—reflects the cramped space of the cave interior. In this illustration, then, text and image are a thoroughly integrated unit; the physical layout of the text has been carefully planned to emphasize both the composition of the painting and the reading of the text.

This same episode is illustrated in Baysunghur's manuscript (fig. 109 and app.

ILLUSTRATION 199

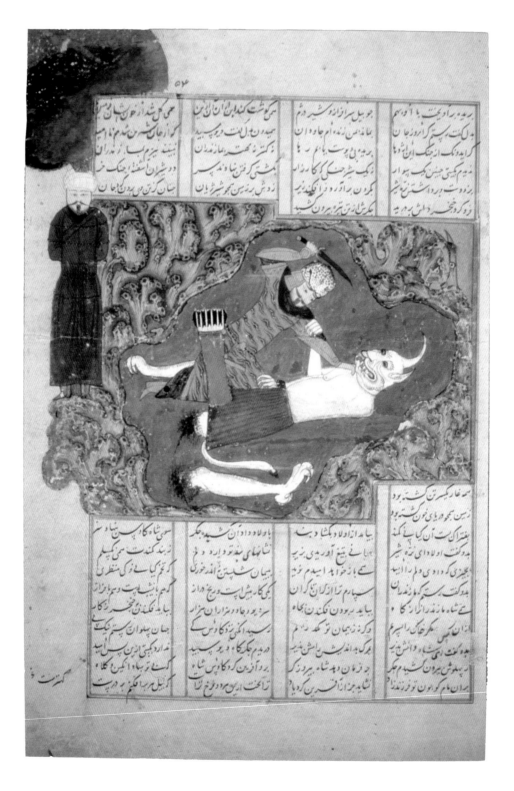

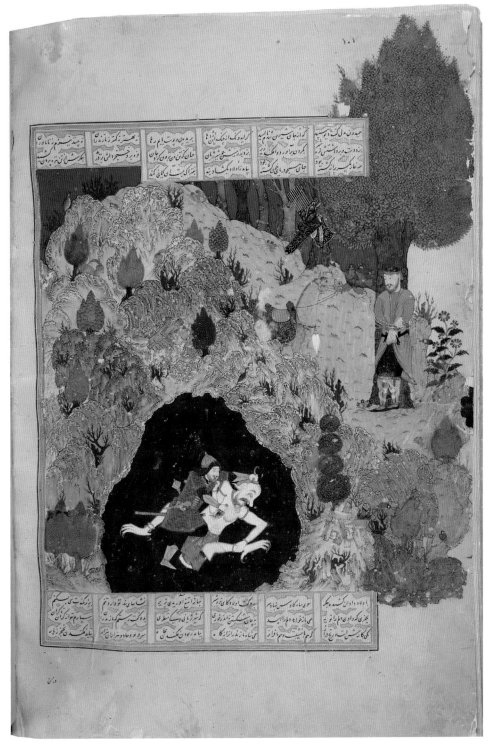

109. "Rustam Kills the White Div," *Shahnama*, 833/1429–30, 38 x 26 cm (folio). Gulistan Palace Library, Tehran, no. 716, p. 101.

2.2), and the basic composition in fact closely parallels that in Ibrahim's manuscript. Here, too, the illustration is placed between two blocks of text, but each consists of fewer lines and they frame a higher and wider view of the scene. As a result, the two textblocks seem merely appended to the scene, not a part of the overall composition, as in Ibrahim's version of it. Moreover, the actual shape of the textblock serves neither a compositional nor a textual function. Only the upper block is stepped, and the potential visual impact of the single step is lost, buried among the morass of detail included in the more distant view of the scene that the artist has presented; in no way does the step direct one's eye to the life-and-death struggle taking place below. Textually, too, it has little impact. The two couplets describing the critical point in the text—when Rustam kills the div, pulls out its liver, and thereby transforms the cave into a sea of blood—are the final one of the last full (nonstepped) line and the first one in the stepped section of the upper textblock. But also placed in the step—in the last two columns—is the first couplet marking the change in pace, noted above, in which the text continues, telling how Rustam then turned away from the div, released Ulad, and went to free Shah Kavus. The potential for increasing the drama of the text by placing the critical moments in the step has thus been overlooked, or at least greatly diminished, through the inclusion of subsequent events in the step also.

"The Murder of Siyavush" (the son of Shah Kavus) is also illustrated in both manuscripts (see figs. 110–11 and app. 2.3–4). The climax of the story is related in the two couplets that describe how Garshivaz set a round, gold basin upon the ground, twisted Siyavush's head, and then severed his head from his body, the gold basin filling with the blood of the young prince. The following couplets relate, first, that a tree sprang up from the spot onto which the basin of royal blood was emptied, and, second, how all the world grew dark and terrible, because when Afrasiyab, the shah of Turan, heard his pregnant daughter bewailing the death of her husband, Siyavush, he ordered her beaten till she miscarried in order to prevent the birth of an Iranian on Turanian soil—an order that shocked and disgusted even his own nobles. (However, at the last minute, the order was stayed.) The moment of Siyavush's death clearly is the critical point in the action and serves to divide the story into two separate parts. In Ibrahim's illustration (see fig. 110), the two couplets that describe this critical point have been placed in the two steps of the upper textblock; in Baysunghur's (see fig. 111), the first of these same two couplets is placed at the end of the last full line of text, while the following couplet appears in the step. Thus, this time, in each painting, the stepped block

serves a textual function by highlighting, visually and in terms of one's reading patterns, the critical point of the text. The stepped textblock also serves a compositional role in Ibrahim's painting: the two steps fill what would otherwise be empty sky, and they also accentuate the contour of the hill, directing the viewer's eye down onto the two most important figures in the scene. In Baysunghur's manuscript, the event is depicted as taking place in a busier, more fully developed environment, and thus, again, the steps of the textblock have little if any impact on the composition. Once more, Ibrahim's artists and calligraphers appear to have proved themselves more astute in the manipulation of a folio layout.

In general, there is a close correlation between text and image in both manuscripts, but overall it can be said that Baysunghur and his artists and calligraphers were less concerned with the exploitation of folio layout for both textual and compositional purposes than were Ibrahim and the members of his atelier. First, stepped textblocks are less often used in Baysunghur's manuscript, and only about half of those that are used aid the dramatic reading of the text. Second, because of the style, or mode, of illustration used in Baysunghur's manuscript (namely the Nizami mode), when steps are employed, they have at best minimal impact on the composition. The tendency in Ibrahim's manuscript to exploit the compositional potential of the textblock shape through the inclusion of stepped portions suggests that the composition of certain illustrations had to be planned more precisely *before* the layout of the text was determined than in the case of Baysunghur's illustrations. In the latter, the textblock is so very less intrusive upon the scene that the composition, in every case, could easily have been worked around the shape of the textblock. It may thus be that Ibrahim's manuscript required a stage of preplanning not necessary in Baysunghur's.

The textual function of the textblock shape in Ibrahim's manuscript is not always as immediately apparent as it is in the two examples presented so far. At times the critical point of the text is not a point of great action, and many illustrations that employ a stepped textblock are passive scenes, such as enthronements. Often there is a presumed familiarity with the text, and the importance of the text placed within the step is only apparent if the reader knows what is to come; otherwise, it becomes apparent only in retrospect. For example, the scene "The Iranians Place the Arabian King Zahhak on the Throne"[64] depicts the evil king in the center of the painting, seated on a throne on a flower-strewn hillside, while three courtiers attend him, one on the right and two on the left. The initial couplets of text on the folio tell of the politically chaotic situation in Iran during the

ILLUSTRATION 203

110. "The Murder of Siyavush," *Shahnama*, n.d., but late 1420s or early 1430s, 28.8 x 19.8 cm (folio). Bodleian Library, University of Oxford, Ouseley Add. 176, f. 116a.

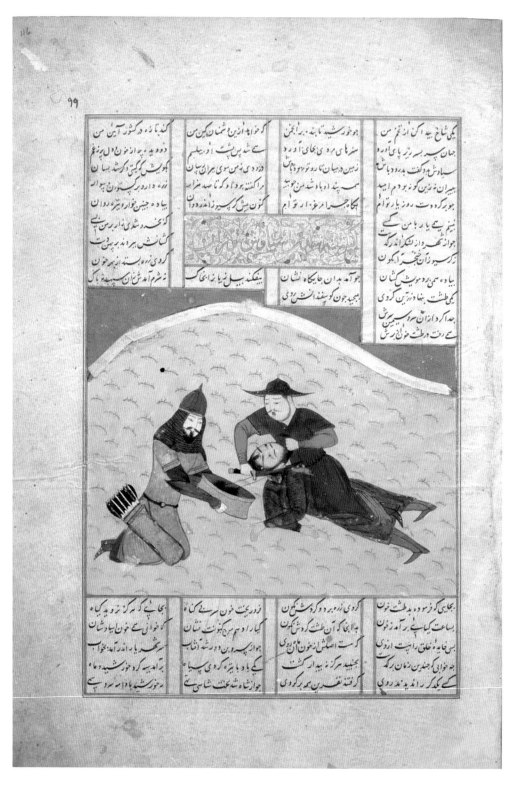

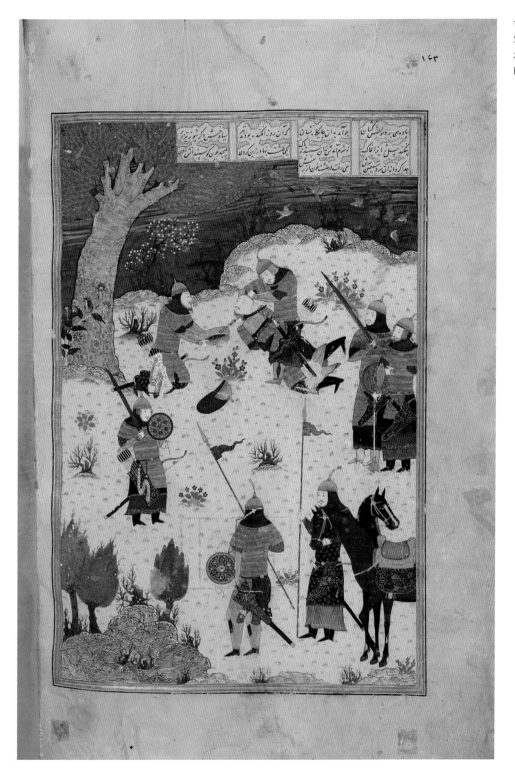

111. "The Murder of Siyavush," *Shahnama*, 833/1429–30, 38 x 26 cm (folio). Gulistan Palace Library, Tehran, no. 716, p. 163.

final years of Jamshid's rule, after his fall from grace, while the final six couplets of the text—contained in a step six-lines deep and placed on the left side of the page above the painting—relate that during their search for a new monarch, the nobles of Iran receive news of Zahhak, a dragon-faced king in Arabia, to whose realm they then travel, offering him their fealty and the crown of Iran. The critical moment when Zahhak actually dons the crown of Iran is related in the final couplet of the step, but only through prior knowledge of the story does one know that this act marks the advent of one thousand years of the rule of evil in Iran. Likewise, the story "Zal and Rustam Advise Kay Khusraw," in which the king is admonished for his apparent lack of desire to continue to rule Iran, is a very passive episode in which no critical action point can be discerned.[65] In the painting, Rustam and his father Zal are seated outside on the ground, on the right side of the composition, facing Kay Khusraw, who likewise is seated on the ground, at the far left side of the painting; the figures are depicted on a hill dotted with bunches of flowering plants, and, as indicated by their gesturing hands, Zal and the king are in the midst of an animated conversation. Again, a step six-lines deep extends from the upper textblock, protruding into the space of the painting, but this time the step is placed on the right side of the textblock. The text in the step ends with Zal professing his wish that Kay Khusraw rule forever. This is not, of course, an unusual blessing, but for those acquainted with the story it is a grave and critical statement. They know the shah will not rule forever and that his demise is in fact imminent: very soon he will renounce his throne and disappear into the mountains.

The apparent omission of couplets on some illustrated folios can be interpreted as a further indication of a desire to manipulate folio layout to heighten textual impact. In the story of the battle with the king of Mazandaran, the stepped area of the textblock (above the painting) is eight lines deep (and two columns wide) and so contains a greater amount of text than is usual.[66] The step ends with the couplet that tells how the div-king turned himself to stone before Rustam's eyes, the exact moment depicted in the illustration and obviously a climactic point in the action. However, it seems that a miscalculation occurred in the planning of the manuscript and that it became obvious that adjustments had to be made if the step were to end at this critical point in the action of the story, because a total of twenty-four couplets have been omitted from this folio.[67] Or, perhaps, it was not a miscalculation as such, because through this omission, all references to other heroes involved

in the battle with the army of the div-king have been avoided, thereby forcing the reader's attention onto the exploits of Rustam.[68]

On a few folios there seems to be no apparent reason for having used a stepped textblock. For example, the painting of "Tahmina Visits Rustam's Bedchamber" is rather narrow in comparison with other paintings in the manuscript, accentuating the long horizontal shape of the bed on which Rustam lounges, his head propped upon his elbow as he gazes with considerable interest at the deceptively shy beauty at his door, who has in fact come to offer herself to him.[69] The painting is placed between two textblocks: the lower one is not stepped (it is just one column wide and four lines deep) and the step of the upper block is just one line deep, so it intrudes only minimally on the scene and therefore does not serve a compositional function. Moreover, the couplets in the step are purely descriptive and merely tell of Tahmina's beauty, so they serve no obvious textual function either.

There are also examples of what can be termed missed opportunities, namely, folios on which no step at all has been used even though the textblock ends with a climactic point of the story. The illustration of Bahram Gur and his harpist Azada is a good example. The text tells the familiar story of how Azada goaded Bahram Gur into showing off his hunting skills by turning a doe into a buck (by shooting two arrows into its head) and a buck into a doe (by shooting its antlers off) and, finally, by pinning the buck's foot and ear together. This last feat is depicted in the painting: Bahram Gur rides a camel across a hillside with Azada mounted behind him; in the lower right corner the unfortunate buck has fallen to the ground.[70] According to the story, as soon as Bahram Gur had accomplished these feats, Azada's heart began to burn with compassion for the poor animals. The climax of the story is usually considered to be the couplets (included on the following folio) that describe the moment when she then chides Bahram Gur for hurting the gazelles and, furious at being scolded for expertly accomplishing the very tasks he was asked to perform, Bahram Gur pushes Azada to the ground and tramples her beneath the camel's feet, vowing never again to take a woman hunting. But, in Ibrahim's manuscript, the final couplet of the nonstepped textblock is that which tells of Azada's sudden change of heart and, as anyone familiar with the story well knows, it is this critical moment that in fact marks her demise. It is curious, however, that a stepped textblock was not employed to dramatize the reading of this crucial couplet. Thus, although Ibrahim's manuscript suggests great concern

ILLUSTRATION 207

for the manipulation of the folio layout for the purpose of precise and careful text illustration, it is nevertheless not a concern evident in each illustrated folio in the manuscript.

Folio Layout in Other Manuscripts of the Fourteenth and Early Fifteenth Centuries

The careful thought given to folio layout in Ibrahim's *Shahnama* is even more apparent in comparison with earlier manuscripts, specifically those also produced in Shiraz. Illustrated Injuid folios demonstrate a less conscious and hence less well-developed approach to both text and composition. Stepped textblocks are also more common in these manuscripts than they are in those of other production centers. For example, more than 50 percent of the text illustrations in the Injuid *Shahnama* dated 731/1330 (TS H. 1479) employ a stepped textblock; 31 percent (15/49) of those in the *Shahnama* dated 733/1333 (StP-RNL Dorn 329) do so; and 21 percent (17/80) of those in an undated copy of the romantic novel *Kitab-i samak 'ayyar* (BOD Ouseley 379–81) also do so.[71] The frequency of stepped textblocks in the extant paintings of the three so-called Small *Shahnama* manuscripts[72] and in those of the Great Mongol *Shahnama* can perhaps be taken as indicative of trends in other production centers. Just 12 percent (19/161) of the paintings in the First and Second Small *Shahnama*s (treated as one manuscript) employ a stepped textblock,[73] and just 8 percent (5/65) of those in the Freer Small *Shahnama* do so.[74] In the Great Mongol *Shahnama*, too, only 12 percent (7/58) of the extant paintings are stepped.[75] Although many folios have been lost from each of these four *Shahnama*s, it is significant that the percentages of extant paintings employing a stepped format are close (12 percent, 8 percent, and 12 percent) and are considerably smaller than those for the Shiraz manuscripts. Thus, it seems fair to state that stepped formats were more commonly used in the Injuid manuscripts of Shiraz than in those produced in other centers.

In Ibrahim's *Shahnama*, the variety of sizes and shapes of textblocks suggests that each textblock was designed for a specific painting,[76] but until the final years of the fourteenth century textblock shapes were highly standardized and they functioned in quite a different manner. Two basic textblock shapes were used. An example of the first is the folio in the Injuid *Shahnama* of 731/1330 that depicts the episode in which King Faridun tests his three sons to determine which of them is best suited to rule Iran (fig. 112 and app. 2.5). He does this by taking the form of a terrible dragon and then judging the response of each son when confronted

by the dragon. The illustration is placed at the top of the folio, below a textblock of just four couplets. The illustration cuts up into the central portion of the textblock, creating a symmetrically stepped textblock. The text begins with the brave response of the third son to the threatening dragon. The two hemistichs that constitute the final couplet of the upper textblock are placed in the two lateral steps. This divided couplet relates the critical moment in this episode, for it states that Faridun has heard all he needs to know and so disappears. Having tested all three sons, he now knows the response of each to the fierce and terrible dragon and so knows which of the three he considers fit to rule Iran, a decision that will have dire consequences for the history of his country. And his decision will be in favor of the third son, whose most appropriate response to the challenge of the dragon is, as noted, related above the illustration in the first line of the textblock, running across the full width of the folio. The text beneath the illustration goes on to describe the reappearance of Faridun before his sons, but now in his own human form and accompanied by all the pomp and circumstance of his royal retinue. Although the text immediately above the painting, especially that in the stepped areas, relates the critical moment of the episode, the artist has depicted an earlier moment, when the middle son readies his bow to attack the dragon. All three sons have been depicted, although at this point in the text the eldest son has already fled. The placement of the two hemistichs of the final, critical couplet in two widely separated columns interferes with the smooth reading of the text. The movement of the eye is interrupted and thus slowed as the eye is forced to jump from one side of the painting across to the other. The rhythm of one's reading and any momentum built up is thereby halted. The textblock shape thus has a negative impact on the reading of the text, while in Ibrahim's manuscript the stepped textblocks create more furtive eye movements and thereby increase the drama of the events related.

This same type of textblock format often employs many more and deeper steps, as in the folio illustrating the scene of "Rustam and Kay Khusraw Enthroned" from the same manuscript (fig. 113 and app. 2.6). In this example, it is difficult to pinpoint a critical moment in the story, for the accompanying text is largely passive rather than active in that it describes the setting and recounts the conversation between Rustam and the king. The text of the upper textblock sets the mood of the scene: the last full line of text above the painting and the first three couplets of the upper step describe precious fruits hanging from a tree of gold and silver, each made of pierced gold, encrusted with fine jewels and filled with

ILLUSTRATION 209

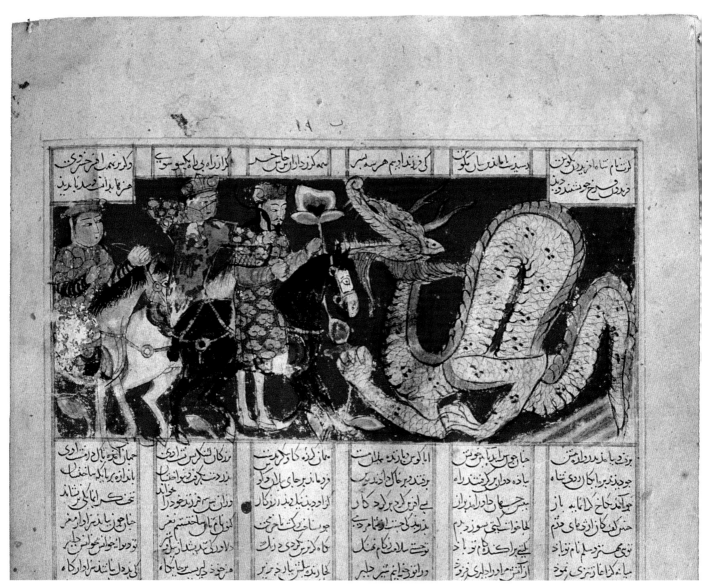

112. "Faridun before His Sons in
the Form of a Dragon," *Shahnama*,
731/1330, 37.7 x 29.3 cm (folio). Topkapi
Saray Library, Istanbul, H. 1479, f. 11b.
Photograph by author.

210

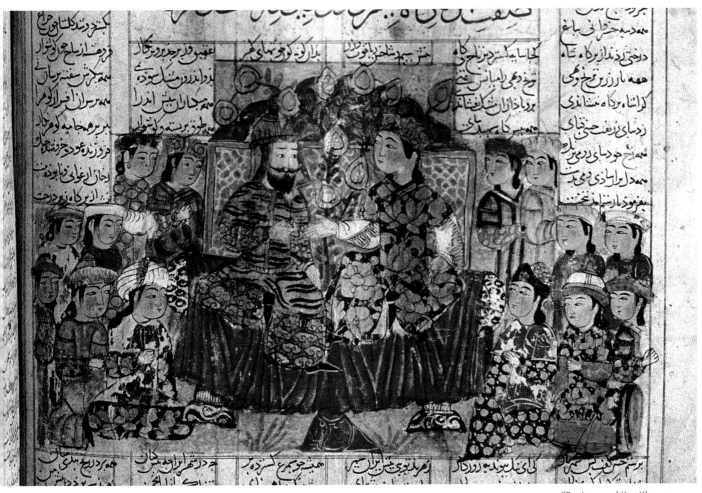

113. "Rustam and Kay Khusraw Enthroned," *Shahnama*, 731/1330, 37.7 x 29.3 cm (folio). Topkapi Saray Library, Istanbul, H. 1479, f. 89b. Photograph by author.

ground musk, the sweet scent of which gently wafts about the head of the king. The next five couplets tell of the courtiers, resplendent in robes of Chinese silk and jeweled crowns, who happily sip goblets of wine, while in the final couplet of the upper textblock Kay Khusraw calls Rustam to come sit with him. The first line of the lower textblock then continues with the king's speech to the brave hero. Again the scene depicted does not relate in all details to that described in the text, because although it does depict Rustam enthroned beside the king, who is clearly speaking to him, it shows only a simply portrayed tree; only a few of the courtiers wear crowns, and no one is happily imbibing. Because there is no critical point of action in the story, the steps in no way highlight the text. In fact, just as in the preceding example of Faridun testing his sons, the shape of the textblock is actually a hindrance to the reading of the text and thus has, one might say, an antitextual function, for the two rhyming hemistichs of a single couplet are often divided by the steps. When the two hemistichs of a couplet remain together, as in the upper step of the upper textblock of "Rustam and Kay Khusraw Enthroned," the division of couplets by the steps may serve to highlight the text by causing a more emphatic break after the reading of each two-part couplet, as the eye jumps across the painting and searches (often quite literally) for the following couplet. But on the level of the lower step, wherein the break divides the hemistichs of a single couplet, the interruption in the movement of the eye and the resulting pause in rhythm are more disturbing. In largely descriptive scenes such as this, these breaks are not a major problem, but in tense, action-packed scenes, such breaks can be highly disruptive.

The second basic textblock shape used throughout most of the fourteenth century is asymmetrical, with several steps on one side only, as in the painting of "The Daughter of Haftvad Finds a Worm in Her Apple" from the dispersed *Shahnama* of 741/1341 (fig. 114 and app. 2.7). With textblocks of this shape, it is difficult to highlight just a few pertinent couplets. A greater problem, however, is that, because of careless planning, sections of text that are three columns wide often occur. As a couplet spans two columns, the two hemistichs of a couplet can therefore be divided, with each appearing on a separate line and divided by a section of text several columns wide. The tension that is built up through the reading of increasingly narrow spans of text—through the consequently more furtive eye movements—can be countered by these three column divisions, for the eye is forced to jump down and back in search of the other half of the couplet. Thus, in each of the two basic fourteenth-century textblock types—even if the critical

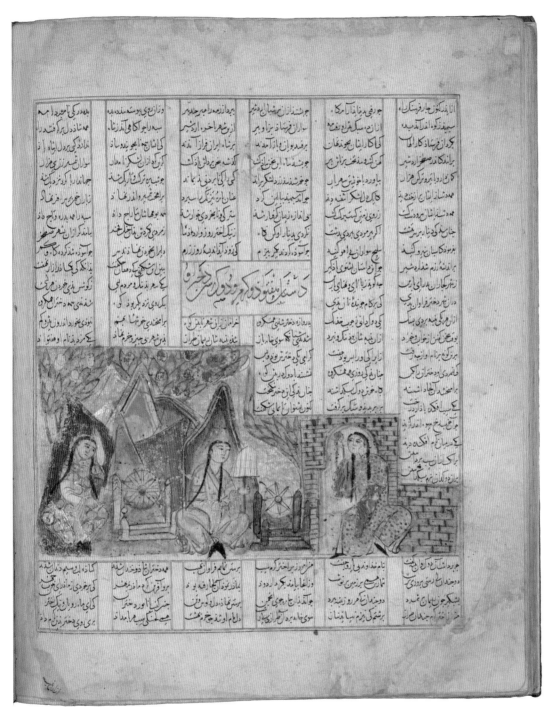

point of the text is placed in the steps—the actual movements of the eye that are required slow one's reading, thereby lessening the dramatic impact of the text.

The compositional function of these two types of stepped textblocks is also very different from that of the illustrated folios in Ibrahim's manuscript, because at this time a very clear, though not exclusive, relationship existed between the composition of a scene and the shape of the textblock employed. Symmetrically stepped textblocks were used predominantly for two types of scenes: enthronements and face-to-face combats. For example, in the 733/1333 manuscript (StP-RNL Dorn 329), five illustrations employ a symmetrically stepped textblock: three are enthronements and two are face-to-face combats.[77] The same relationship between textblock shape and composition appears to exist in the 731/1330 *Shahnama* (TS H. 1479; see figs. 112–13). A similar compositional association exists with the asymmetrically stepped textblock: when a textblock of this type is used, the steps typically slope down to the lower right corner of the painting following the contour of a hill or castle wall. This is the case with three of the five illustrated folios in the 733/1333 manuscript that use this same textblock shape,[78] and, again, the same relationship between textblock shape and composition appears to exist in the 731/1330 *Shahnama* also (TS H.1479; see fig. 116). The association between these two textblock shapes and specific types of composition was long-lived, as is evidenced by the *Shahnama* copied in Shiraz in 796/1393–94 (Cairo Ta'rikh farisi 73). In this manuscript, all seven of the paintings that use a symmetrically stepped textblock depict enthroned rulers (see fig. 86), and asymmetrically stepped textblocks always follow the contour of a hill or castle wall (see fig. 82).[79] Use of each textblock shape—symmetrically or asymmetrically stepped—accentuates the types of composition with which the textblock shape is most commonly associated. It seems likely, however, that the decision to use either of these particular textblock shapes was more automatic than conscious: mention in the text of a certain type of scene triggered in the mind of the calligrapher or painter the need for a textblock of a specific shape. Therefore, the use of one or the other type of stepped textblock should be seen as arising from established artistic practice, and though these textblock shape-composition associations were not exclusive, they nevertheless provided the artist with easy and ready options. They were options, however, that seem to have no longer been available to artists in Ibrahim and Baysunghur's time, because they generally do not exist in either of their *Shahnama* manuscripts. The rather primitive and simplistic approach to the illustration of a text, of which the divided couplets and compositional asso-

ciations of the stepped textblocks of these Injuid manuscripts are indicative, is especially apparent in comparison with the carefully thought out and hence more conscious and sophisticated approach taken in Ibrahim's manuscript.

The most effective textblock shape is one in which the text is placed in just one or two steps with a marked difference between the width of the steps and that of the main textblock, and of course with the text arranged so that no three-column-wide sections are created.[80] This is the precise type used, with minor exceptions, for all stepped textblocks in Ibrahim's *Shahnama*. It is a type that permits a few critical couplets to be isolated more clearly from the main body of the text and is a type not commonly used during the first half of the fourteenth century. From as early as the 1340s, however, there are hints of a growing awareness of the potential for increasing both textual and compositional impact through the manipulation of folio layout, though of course changes came about gradually.

The dispersed 741/1341 *Shahnama* is of especial interest because many of its illustrated folios display a greater originality in terms of the relationship between textblock shape and composition than those of any earlier manuscript. The basic associations between format and composition discussed above are not as consistently encountered in this manuscript, providing evidence of a more conscious arrangement of the text. This is apparent from a comparison, for example, of the treatment of the scene of "Gushtasp Slays a Dragon" in this manuscript (Freer F1948.15) with that in the slightly earlier 731/1330 *Shahnama*.[81] In the latter, the standard association between composition and format is evident, because a face-to-face combat between two figures has been used in conjunction with a symmetrical textblock format: as in "Faridun before His Sons in the Form of a Dragon" (see fig. 112), a step one column wide and one line deep has been placed at each edge of the textblock, with Gushtasp and the dragon facing one another in the center of the composition. Because the textblock rises up to accommodate and accentuate equally, though ever so slightly, the heads of both Gushtasp and the dragon, the two figures appear to be fairly evenly matched, at least in terms of size. Much more inventive and certainly more interesting is the layout of the text and image of the same scene in the 741/1341 manuscript; here an asymmetrical textblock has been used, one with a step on the right side of the composition (jutting down into the space of the painting) that is three columns wide and two lines deep. (In both manuscripts the textblock is six columns wide.) The step is just one line deeper than that in the 1330 illustration, but more careful planning of composition and textblock format as an integrated unit has resulted in a more ef-

ILLUSTRATION 215

fective illustration. In the shallower, right-hand portion of the composition is the stretched form of Gushtasp's horse, facing inward as it races toward the dragon's gaping jaws. Placing Gushtasp and his horse here, in the more cramped space beneath the step, emphasizes both the speed of the horse and it and Gushtasp's diminutive size in comparison with that of the dragon, situated on the left side of the composition where the textblock rises up to accommodate and accentuate the immense, coiled form of its body.

The stepped areas of the two folios contain different points of the text, although each ends with a critical moment. In the 731/1330 manuscript, the last full line above the painting describes Gushtasp thrusting his sword into the dragon's mouth—the moment depicted in the illustration. Then, as related in the final couplet of the two steps, Gushtasp imparts the final death blow, finishing off the dragon by striking him on the head with his sword. But the two halves of the couplet have unfortunately been separated through the use of a symmetrical format. More effective and evident of more careful thought is the layout of the folio in the 741/1341 manuscript in which an earlier moment in the action—the first critical moment—is described in the last couplet of the step. This couplet tells how the dragon, immediately upon catching sight of Gushtasp, uses its enormous strength to breathe in deeply in a devious attempt to suck the hero toward him. The step is three columns wide, and thus the width of the textblock has been dramatically reduced by half, but, as a result, the second to last couplet is divided between two lines. Despite this division, no earlier manuscript examined demonstrates as effective a manipulation of a folio layout. In terms of both textual and compositional impact, the layout is much more effective than that employed for the same scene in the 731/1330 manuscript.[82]

Even more successful, however, is the illustration in the undated, but probably late 1340s or early 1350s Stephens *Shahnama* that portrays the episode in which the Turanian army attempted to use sorcery to defeat the Iranian army (Sackler LTS1998.1.1.49a; fig. 115 and app. 2.8). Bazur, a sorcerer, caused the weather in the area of the Iranian army to drop to freezing temperatures. In an attempt to prevent the army from freezing to death, the hero Ruhham heads up the mountain in the hope of defeating Bazur. The climax of the story, told in the last couplet of the step, is the moment when Ruhham draws his sword and cuts off Bazur's hand: the spell is immediately broken, putting an end to the unfair advantage of the Turanians (though the Iranians are later forced to retreat). As the two-column-wide step ends with the couplet that relates the critical moment of the breaking of the spell,

the step serves a definite textual function. It is, moreover, this precise moment that the artist has depicted. The standard relationship between textblock shape and composition remains, because the narrow step accommodates the mountain that rises up behind Ruhham. Nevertheless, the shape of the textblock effectively serves to heighten the impact of both the dramatic reading of the text (with no divided couplets) and the composition.

The same scene appears in the 731/1330 *Shahnama* (TS H. 1479; fig. 116 and app. 2.9), and again a comparison of the two versions of the scene demonstrates the greater effectiveness of that in the later manuscript. The two images are closely related, but this time the asymmetrical format used on the 731/1330 folio has two steps, one of which is three columns wide and thereby results in divided couplets. Moreover, because the stepped area contains so much more text, it includes not only the critical moment when the sorcerer's hand is cut off (the hemistichs at the end of the fourth last line and the beginning of the third last line of the step), but goes on to describe how the weather then returned to normal and ends by telling how Ruhham went back to the army and reported to his father. Therefore, the couplet describing the most critical point in the action is not distinguished in any way from the rest of the text, and, furthermore, it is one of the couplets divided by the three-column-wide arrangement of that section of the text. The layout of text in the Stephens manuscript is much more effective in its ability to dramatize the reading of the text. Moreover, use of the more usual multistep format in the 731/1330 manuscript increases the suspicion that it was merely established artistic practice that caused this particular format to be used.

Only 11 percent (11/102) of the illustrated folios in the Stephens manuscript actually employ a stepped format (perhaps another indication of Il-Khanid influence in this manuscript), and in most cases the folio layout functions in a highly traditional manner.[83] Just as in the Muzaffarid *Shahnama* of 1393, here, too, all enthronement scenes employ the typical symmetrical, stepped textblock shape. Tradition therefore seems to be the main guiding force in the layout of illustrated folios through to the final years of the fourteenth century. In the Collection of Epics, dated 800/1397 but with paintings added a decade or so later (BL Or. 2780 and CBL Per 114), tradition does not rule, but when a stepped textblock format is employed, it is not yet used very effectively.[84] In terms of composition, it is not overly effective in part because some of the scenes, such as that in which "Garshasp Visits the Brahmans on the Mountain of Sarandib,"[85] employ a slightly more distant view, so the step has a less immediate visual impact on the

ILLUSTRATION 217

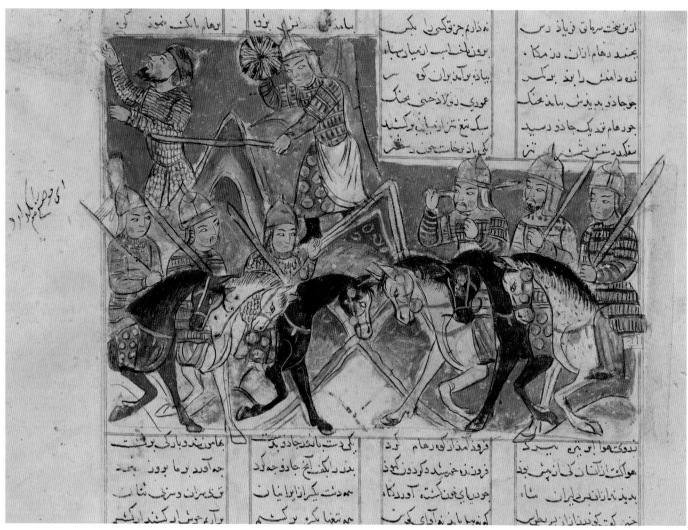

115. "Ruhham and the Sorcerer
Bazur," Stephens *Shahnama*,
n.d., but late 1340s to early 1350s,
29.1 x 20.2 cm (folio). Lent by
Mr. and Mrs. Farhad Ebrahimi;
Courtesy of the Arthur M. Sackler
Gallery, Smithsonian Institution,
Washington, D.C., LTS1998.1.1.49a.

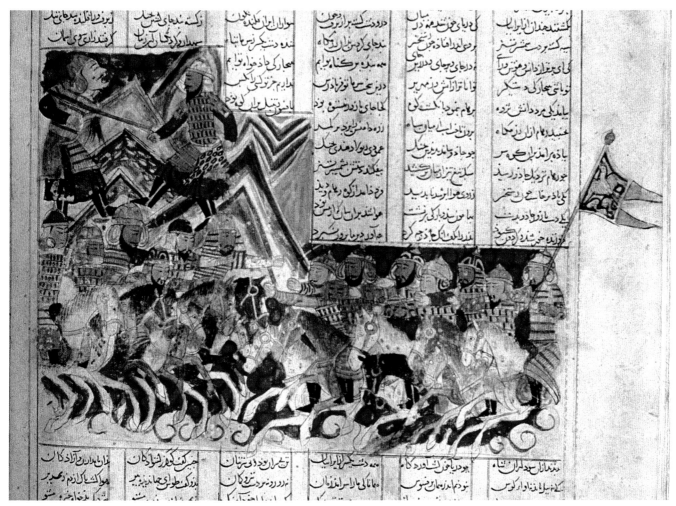

116. "Ruhham and the Sorcerer Bazur," *Shahnama*, 731/1330, 37.7 x 29.3 cm (folio). Topkapi Saray Library, Istanbul, H. 1479, f. 68b. Photograph by author.

composition. Of the three illustrations in the *Shahnama* section of the manuscript (CBL Per 114) that employ a stepped textblock, it is "Siyavush Emerges from the Flames" (see fig. 89 and app. 2.10) that uses it most effectively. The textblock rises up on the left, making room for the castle wall from which Sudabeh watches the test of her stepson's innocence, and thus the stepped shape of the textblock could be considered to serve some compositional function; but the step is shallow—just two lines deep—and so has little actual visual impact on the scene. The text within the step describes the moment when Siyavush's horse steps free of the flames and also tells of the joy of the watching crowds. This is, of course, the critical moment in the story,[86] but the textual impact of using a stepped textblock nevertheless is not as great as it might have been. Not only is the step shallow, but the reduction in the width of the textblock is not great, from six to four columns. The altering of the movements of the eye when reading across the width of the textblock is therefore much less dramatic than if the artist had instead chosen to use a step just two columns wide.

Of the twenty-seven illustrations in the anthology produced in Shiraz in 823/1420 as a gift for Baysunghur (Berlin MIK I. 4628), twenty-three illustrate the *Khamsa*s of Nizami, Khwaju Kirmani, and Amir Khusraw Dihlavi. As might be expected considering this emphasis on poetry of the romantic-epic genre, many of the illustrations portray a more distant view of the scene being depicted, with smaller figures and more fully developed environments than previously encountered in Shiraz paintings—with the exception, of course, of those made for Iskandar Sultan.[87] As a result of these features, when a stepped format is used, it often has little visual impact. The manuscript does, however, include some folios in which a stepped textblock has been used to great effect. The manuscript employs a three-sided marginal column format with the central block of text divided into four columns. In the scene of "Majnun at the Ka'ba Door," illustrating the *Khamsa* of Nizami, the painting is placed in the central block of text, as are all the paintings.[88] On the left side of the composition is the Ka'ba, the equivalent of two columns wide and stretching almost the full height of the textblock space. Three full lines of text are placed above the Ka'ba, and a step at the right is two columns wide (and therefore equal in width to the Ka'ba itself) and twelve lines deep. Majnun stands at the Ka'ba door, stretching to reach for its knocker, while seemingly "squished" into the small space beneath the step are his father and companion, gesturing, imploringly, toward the distraught Majnun. The text contained in the step begins with Majnun's father's decision to make the journey to the Ka'ba

in the hope that his son's lovesick condition can be cured. It continues to tell of his advice to his son regarding how he should phrase his prayer at the Ka'ba door. The final couplets of the step relate that when at the Ka'ba, immediately upon hearing his father's words, Majnun leaped up and began to pound on the door of the shrine, loudly proclaiming his presence. Thus, the step ends with what can be considered a critical and dramatic moment in the text, because at this moment the reader does not yet know what Majnun will do—will he or will he not follow his father's advice and plead for freedom from his love of Layla? The step is in fact used most effectively, both textually and compositionally. By far the deepest step yet encountered, the dramatically stepped format highlights the height of the Ka'ba, but, more important, it emphasizes the vigor with which the crazed Majnun stretches to grab hold of the doorknocker. Equally, it isolates the figures at the right. Although illustrations in this manuscript rarely use a stepped format as effectively as here, the manuscript is of interest for the very fact that it does employ such very deep steps and that 67 percent (18/27) of its illustrations employ an irregular textblock of some type. In addition to stepped textblocks, on ten folios an isolated textblock one or two columns wide and from two to ten lines deep has been inserted into the illustration, placed in an upper corner or set right in the midst of the composition.[89]

It is Ibrahim's *Shahnama* that displays the greatest interest in the use of a stepped format to heighten both the narrative impact of a particular episode and the compositional impact of its corresponding illustration. In the fourteenth century, use of a stepped format seems to have been dictated largely by artistic convention or tradition. Breaking free of tradition did not, however, mean that stepped textblocks were always used more effectively, either textually or compositionally, in the early years of the fifteenth century. Indeed, it seems that often a stepped textblock was chosen over a straight-edged one for no better reason than an added touch of visual interest, with little heed paid to exploiting its textual or compositional potential. The more consistent concern for effective text illustration evident in Ibrahim's *Shahnama* did not set a standard for book illustration in the following years. Even Ibrahim's dispersed *Zafarnama* manuscript, dated 839/1436 and thus completed a few years after his death (though presumably planned under his auspices), seems not to follow the pattern of the earlier *Shahnama*. Narrow columns of text, often stretching the full height of a (full-page) painting, are a distinctive feature of the later manuscript,[90] but they do not seem to serve the same function as do irregular (stepped) textblocks in Ibrahim's

ILLUSTRATION 221

Shahnama and other manuscripts because they do not accentuate the composition so much as they define space—but in the sense of creating a more definite sense of the viewer's space versus that of the picture space.[91] In other words, by cutting off figures and abruptly limiting the space of the scene depicted, as they most often do, they create for the viewer a sense of peeking through an open window or doorway to catch a glimpse of another world. They do not accentuate the action taking place but rather limit the amount of action that the viewer can observe. It is, nevertheless, an effective and dramatic use of textblocks of nonstandard shape and, though a different use from that otherwise discussed here, it is one that demonstrates equally a clear interest in text illustration, in general, and the manipulation of folio layout, in particular.[92]

In the years following Ibrahim's death, the changes that took place in painting effected a vastly decreased use of stepped textblocks. As noted previously, paintings came to include a profusion of detail not absolutely necessary to portray the scene at hand. In such compositions, stepped textblocks are much less frequently used, presumably because they are visually less effective, embedded, as they are, in a myriad of detail (see figs. 96 and 97).

THE SELECTION OF ILLUSTRATIONS

The double-page paintings of Ibrahim's *Shahnama* depict traditionally royal themes, with the exception, of course, of the unusual genre scene in which Ibrahim's consort is portrayed at a palace window while a gardener works below. Enthronements and hunts in particular were, by the 1430s, well established as standard frontispiece iconography. The decision as to what to depict in (all but one half of) the four double-page paintings thus would have been rather straightforward and uncomplicated. With respect to the actual text of the *Shahnama*, however, there exists a seemingly infinite number of scenes suitable for illustration. A comparison of the scenes selected to illustrate Ibrahim's manuscript with those selected for Baysunghur's and other copies of the *Shahnama* enhances further our understanding of factors influencing the illustration, not only of Ibrahim's manuscript but of fourteenth- and fifteenth-century manuscripts in general.

Rate (or number) and distribution are two important features to consider when first analyzing any program of illustrations. A high rate of illustration is a common feature of *Shahnama* manuscripts of all periods. For example, the four extant *Shahnama*s made during the period of Injuid rule in Shiraz range from

a minimum of forty-nine text illustrations[93] to a maximum of 105.[94] Other well-known *Shahnama* manuscripts had even larger illustration programs. The Great Mongol *Shahnama*, probably produced in Tabriz in the mid-fourteenth century, is now thought to have contained approximately 190 paintings,[95] while that copied in the early sixteenth century for the Safavid ruler Tahmasp was even more extensively illustrated, with 258 paintings. It is therefore rather surprising that Ibrahim's manuscript has only forty-two text illustrations and Baysunghur's a mere twenty. According to Eleanor Sims, "such pictorial restriction implies the deliberate elimination of material so that what remains constitutes a very specific choice of subjects."[96]

The distribution of illustrations can be considered in light of the divisions in the text itself. Chronologically, these divisions are the mythological, the heroic, and the historical eras.[97] The mythological period corresponds to the era of the earliest kings of Iran through to the death of Faridun. The heroic era begins with the start of the reign of Manuchihr, spans the six hundred years of Rustam's life, and ends with the death of Rustam's son Faramarz, at the hand of Bahman, son of Isfandiyar. The story of Iskandar (Alexander the Great), beginning with the marriage of his grandmother Humay to her own father, Bahman, marks the start of the historical era. Dick Davis characterizes the first period, the mythological era, as a time when "the eradication of evil threats to the kingdom either in the fabulous form of monsters or in the more literal forms of foreign invasion and internal dissension" is carried out by the kings themselves, and thus they themselves serve as the champions or heroes of the realm.[98] In the heroic era, however, these duties pass to other, nonkingly individuals, primarily Rustam and the other descendants of Nariman who rule the province of Sistan, and it is on the activities of these individuals that the text of the heroic section focuses. The historical era deals with those individuals actually known to us from history, not merely from myth and legend.

The text is not evenly distributed among these three periods, and in fact only about 5 percent of the total poem deals with the mythological era; about 55 percent treats the heroic era; and approximately 40 percent is devoted to the historical era. The text illustrations are, however, rarely distributed among the three sections of the text in these same proportions. Table 7 records the distribution of illustrations, with respect to the textual divisions, in twenty-two copies of the *Shahnama* of the fourteenth, fifteenth, and sixteenth centuries (including Ibrahim's and Baysunghur's manuscripts).[99] Both the percentage and the actual

ILLUSTRATION 223

TABLE 7 Distribution of *Shahnama* text illustrations with respect to textual divisions

Manuscript	Mythological Period (5% of total text)		Heroic Period (55% of total text)		Historical Period (40% of total text)	
	% of total illustrations	no. of total illustrations	% of total illustrations	no. of total illustrations	% of total illustrations	no. of total illustrations
Ibrahim's *Shahnama*, BOD Ouseley Add. 176, n.d., but late 1420s or early 1430s	17%	7/42	74%	31/42	10%	4/42
Baysunghur's *Shahnama*, Gulistan no. 716, 833/1429–30	11%	2/19	68%	13/19	21%	4/19
TS H.1479, 731/1330	1%	1/92	58%	53/92	41%	38/92
StP-RNL Dorn 329, 733/1333	4%	2/49	65%	32/49	31%	15/49
Stephens *Shahnama*, Sackler LTS1998.1.1.1–94, n.d., but late 1340s or early 1350s	8%	8/105	79%	83/105	13%	14/105
TS H. 1511, 772/1371	8%	1/12	42%	5/12	50%	6/12
BL Or. 4384, n.d., but c. 1430	0%	0/9	67%	6/9	33%	3/9
Sotheby's, 11 October 1982, lot 214 (Dufferin and Ava), 839/1436–37	11%	6/57	79%	45/57	11%	6/57
Leiden Codex Or. 494, 840/1437	11%	2/18	72%	13/18	17%	3/18
BL Or. 1403, 841/1437	7%	6/90	61%	55/90	32%	29/90
BN Supp. pers. 493, 844/1441	4%	2/52	60%	31/52	37%	19/52
BL Or. 12688, 850/1446	10%	8/83	90%	75/83	0%	0/83
TS H. 1496, 868/1464	14%	4/28	64%	18/28	21%	6/28
Sotheby's, 18 October 1995, lot 65, 878/1473	0%	0/60	55%	33/60	45%	27/60
CBL Per 157, 885/1480	14%	4/29	72%	21/29	14%	4/29
CBL Per 158, 885/1480	4%	1/28	64%	18/28	32%	9/28
BL Add. 18188, 891/1486	1%	1/72	63%	45/72	36%	26/72
BOD Elliott 325, 899/1494	9%	5/53	51%	27/53	40%	21/53
BL Add. 15531, 942/1536	5%	2/44	55%	24/44	41%	18/44
JRL Pers 932, 949/1542	5%	2/37	54%	20/37	41%	15/37
BOD Ouseley 369, 959/1552	8%	2/24	67%	16/24	25%	6/24
Christie's, 19 October 1995, lot 79, 969/1561–62	6%	2/33	58%	19/33	36%	12/33

Note: Percentages have been rounded off to the nearest whole number; therefore, percentages listed for each time period do not always total exactly 100 percent.

number of paintings that illustrate each of the three sections are recorded. Most often the historical period contains fewer than 40 percent of the text illustrations, while either the mythological period or the heroic, or both, are more heavily illustrated than might be expected.

The division between the mythological and heroic eras is less sharp than that between the heroic and historical eras, and Davis has suggested that the two earlier sections might actually be better treated as one unit. The tendency to illustrate more heavily the two earlier sections, which together constitute 60 percent of the total text, may be largely a function of the text itself. This portion of the text is very much more descriptive than is the historical section, which is characterized by lengthy passages of discourse that make it less conducive to illustration.[100] Davis suggests that Firdawsi stuck much more closely to his sources for the final section, which at times amounts to little more than a succinct chronicle of the reigns of various kings, while in the initial two sections he seems to have felt freer to let loose, so to speak, his poetic and storytelling skills. He notes that it is in this earlier 60 percent of the text that the most "artistically compelling" tales are to be found.[101] The mythological and heroic sections therefore were far more likely to fuel the imagination of any artist, resulting in these portions of the text usually being proportionately more heavily illustrated than the perhaps overall drier, less well written, and less action-packed historical section.[102]

The distribution of illustrations in these manuscripts is rarely even. When it is, it is generally accepted as a sign that little or no preplanning of the illustration program took place. At, say, every third or fourth page, the calligrapher simply left a space for another painting, the artist then illustrating whatever point of the story happened to appear at that spot—thus a rather unimaginative and unconscious selection of images.[103] Some manuscripts, notably the Injuid *Shahnamas*, typically have pockets of even—and heavy—distribution interspersed among stretches of more unevenly distributed illustrations.[104] Such a distribution of images suggests that certain sections of the story were more widely known and that independent illustrative cycles for these sections had long existed. Thus it seems that when models existed the artist made ready and plentiful use of them, more sparsely and erratically illustrating sections of the text for which he had fewer or no models.[105] This, too, is a very conservative approach to book illustration and one that is guided by preexisting pictorial traditions.

Table 8 lists the distribution of illustrations in both Ibrahim's and Baysunghur's *Shahnama* manuscripts; the information is indicated in terms of the number of

ILLUSTRATION 225

TABLE 8 Distribution of text illustrations in Ibrahim's and Baysunghur's *Shahnama* manuscripts

Manuscript	Number of Pages between Consecutive Illustrations
Ibrahim's *Shahnama*, BOD Ouseley Add. 176, n.d., but late 1420s or early 1430s	3, 4, 7, 2, 4, 4, 9, 23, 19, 2, 9, 0, 1, 1, 3, 15, 1, 3, 10, 4, 14, 14, 17, 14, 44, 20, 14, 11, 3, 5, 21, 60, 31, 61, 17, 15, 3, 53, 3, 51, 8
Baysunghur's *Shahnama*, Gulistan no. 716, 833/1429–30	8, 21, 29, 8, 61, 154, 0, 15, 21, 4, 30, 7, 13, 13, 39, 28, 73, 31

pages (or single sides of a folio) existing between any two consecutive text illustrations. (Appendix 3 lists the distribution of text illustrations for all other *Shahnama* manuscripts listed in table 7.)[106] As is evident from the table, in each of these two manuscripts the distribution of illustrations is very uneven. There is in Baysunghur's manuscript one point at which there occurs a 154-page gap between illustrations, followed by illustrations on immediately successive pages (indicated in the table as a gap of zero pages). The distribution is not quite so erratic in Ibrahim's manuscript, but, still, it varies again from illustrations placed on successive pages to a gap of sixty pages at another point. In manuscripts such as these two *Shahnama*s, the marked unevenness of distribution is taken as a sign of very conscious decision making and therefore a sign of a preplanned program, one in which random choice played no part.

Both the restricted program and the uneven distribution of text illustrations in Ibrahim's *Shahnama* suggest that certain episodes of the story were carefully and consciously selected for illustration—and an unusually high number of these episodes relate the exploits of Rustam. In fact, 50 percent (21/42) of all text illustrations portray the hero (table 9).[107] By comparison, he is depicted in only 32 percent (6/19) of the text illustrations in Baysunghur's manuscript. Rustam is a major figure in the *Shahnama*, and as he lives for six hundred years he figures largely in most illustrative programs of the text. But to emphasize him so overwhelmingly, as in Ibrahim's manuscript, is extraordinary.

The evident passion for the exploits of Rustam exhibited in the illustration program of Ibrahim's *Shahnama* is matched by no other manuscript (with the exception of the 868/1464 *Shahnama*, TS H. 1496, which will be discussed below). The emphasis on Rustam in the other manuscripts listed in table 9 averages just 24 percent of all text illustrations, ranging from a low of 8 percent in one manu-

TABLE 9 Percentage and number of text illustrations depicting Rustam

Manuscript	Depictions of Rustam	
	% of total illustrations	no. of total illustrations
Ibrahim's *Shahnama*, BOD Ouseley Add. 176, n.d., but late 1420s or early 1430s	50%	21/42
Baysunghur's *Shahnama*, Gulistan no. 716, 833/1429–30	32%	6/19
TS H. 1479, 731/1330	18%	17/92
StP-RNL Dorn 329, 733/1333	20%	10/49
Stephens *Shahnama*, Sackler LTS1998.1.1.1–94, n.d., but late 1340s or early 1350s	25%	26/105
TS H. 1511, 772/1371	17%	2/12
BL Or. 4384, n.d., but c. 1430	33%	3/9
Sotheby's, 11 October 1982, lot 214 (Dufferin and Ava), 839/1436–37	37%	21/57
Leiden Codex Or. 494, 840/1437	33%	6/18
BL Or. 1403, 841/1437	13%	12/90
BN Supp. pers. 493, 844/1441	8%	4/52
BL Or. 12688, 850/1446	25%	21/83
TS H. 1496, 868/1464	43%	12/28
Sotheby's, 18 October 1995, lot 65, 878/1473	30%	18/60
CBL Per 157, 885/1480	34%	10/29
CBL Per 158, 885/1480	29%	8/28
BL Add. 18188, 891/1486	26%	19/72
BOD Elliott 325, 899/1494	23%	12/53
BL Add. 15531, 942/1536	16%	7/44
JRL Pers. 932, 949/1542	16%	6/37
BOD Ouseley 369, 959/1552	33%	8/24
Christie's, 19 October 1995, lot 79, 969/1561–62	33%	11/33

script to a high of 37 percent in another. Furthermore, in Ibrahim's manuscript, only 10 percent (4/42) of all text illustrations are included in the final, historical section of the text. This dramatic drop in the illustration rate likewise serves to emphasize Rustam, because it is as though all interest is lost once the hero dies. Four other manuscripts also place very little emphasis on the historical period: BL Or. 12688 (850/1446), which in fact has no illustrations at all in this final section; the Dufferin and Ava *Shahnama* (Sotheby's, 11 October 1982, 839/1436–37), with just 11 percent of its text illustrations in the historical section; and the Injuid Stephens *Shahnama* (Sackler LTS1998.1.1.1) and CBL Per 157 (885/1480) with 13 percent and 14 percent, respectively, of their text illustrations in this final section. But in these manuscripts, displaying, as they do, much less interest in Rustam, the sudden decline in the number of illustrations in the period following his death does not bear the same dramatic impact. Surely there can be no doubt that the emphasis placed on Rustam in Ibrahim's manuscript was not accidental.

The 868/1464 manuscript (TS H. 1496)—made for the Qara Qoyunlu Turcomans and therefore possibly a product of Shiraz—is deserving of special note. As table 9 shows, with 43 percent (12/28) of its text illustrations portraying Rustam, it is the only manuscript that comes at all close to matching Ibrahim's interest in this much-loved hero. Moreover, fourteen of its total twenty-eight text illustrations are scenes that are also depicted in Ibrahim's manuscript. Three of these shared scenes are relatively uncommon ones: "Jamshid Teaches the Crafts," "Faridun and the Sisters of Jamshid," and "The King of Mazandaran Changes Himself into a Rock."[108] The tentative explanation for the similar, though less intense, emphasis on Rustam is that Ibrahim's manuscript served, ultimately, as the model for the selection of scenes to be illustrated by the artists of the 868/1464 manuscript.[109]

But what was it that motivated Ibrahim's exceptional interest in Rustam? As Marcia Maguire points out in her discussion of the *haft khwan* (seven feats) of Rustam, he certainly was not a figure noted for his cunning intellect, his royal blood, or even his undying devotion to the kings of Iran, but rather he was noted primarily for his supernatural strength.[110] The other main hero of the *Shahnama* is Isfandiyar, whose seven heroic feats largely mirror the seven feats of Rustam. As Crown Prince, Isfandiyar might seem a more appropriate choice for Ibrahim's attention, and, in her analysis of the two heroes, Maguire casts Isfandiyar in a rather more favorable light. She especially notes Rustam's naive approach to the dangers that face him and his tendency to fall asleep at the most inopportune times. He

achieves victory over his adversaries through basic and natural elements such as brute strength, the aid of his horse Rakhsh, or the chance invocation of God. And while Rustam's acts symbolize a more general victory of good over evil, Isfandiyar's heroic feats are motivated by the religious fervor of the new Zoroastrian religion. In contrast to Rustam, Maguire sees Isfandiyar's acts of heroism as more directed and his adversaries overcome by the more sophisticated and intellectual means of foreknowledge, planning, and ingenuity, which are supplementary though necessary aids to his physical strength. But all these positive features are overshadowed by the question of Isfandiyar's loyalty, for his father was convinced that Isfandiyar harbored an undying desire for the throne—and it would certainly have been for this reason that Isfandiyar would have been seen as a rather unwise choice for Ibrahim's attentions.

The analysis of the illustrations suggests that Ibrahim's choice of scenes to be illustrated was in fact motivated not by political or princely concerns but by concerns purely literary in nature: how to relate a centuries-old story in a new and refreshing way. Relating the story in such a manner was achieved simply by focusing on the most popular heroic figure in the story and one who, by the way, with his tiger-skin suit, his leopard hat, his bull-headed mace, and his faithful steed Rakhsh, is the most immediately recognized figure in the whole story.

Of course, within this illustrative cycle it may be possible to detect numerous subthemes. It has in fact been demonstrated how the text of a manuscript could relate one story while the illustrative program could be rather deviously manipulated to tell a second story. Most often this second story has been seen as political in nature. Thus, Sims has shown that in Ibrahim's dispersed *Zafarnama* manuscript of 839/1436 the illustrations appear to have been chosen specifically to emphasize the continuity of rule after the death of Timur by Shah Rukh and his line of descendants.[111] In Sultan Husayn's copy of the same text, dated 872/1467-68 and now part of the Garrett Collection of Johns Hopkins University in Baltimore, she sees a different selection of illustrations as emphasizing the rule of Husayn's line of descent from 'Umar Shaykh.[112] The theme, according to Sims, that motivated the selection of illustrations for Baysunghur's *Shahnama* is "princely obligation and the duty to govern fairly and wisely."[113] This, she believes, is evident from the emphasis on scenes such as "Jamshid Teaching the Crafts," which illustrates the teaching of a people in their earliest years as a nation; "Gulnar Glimpses Ardashir," which illustrates the courting of princesses to ensure posterity; and "Bahram Gur Given into the Care of Munzir the Arab," which illustrates the edu-

ILLUSTRATION 229

cation of royal heirs. The various battle scenes depicted illustrate the royal duty to protect the land and its people against invaders.[114] *Bazm u razm*, the traditional Iranian princely theme of "feasting and fighting," is the theme Sims sees as having motivated the illustrative program of Ibrahim's *Shahnama*.[115] Though still of a distinctly royal nature, this theme is less sober than that of Baysunghur's manuscript, laying less stress on the royal duty of legitimate government and more on princely pastimes.[116] Therefore the motivation for both manuscripts, as Sims sees it, is generally political in tone, for each conveys a "potent . . . political message" and together they "illuminate a set of political aspirations shared at a particular stage of Timurid dynastic history, in the fourth decade of the century."[117] The evidence presented throughout this chapter regarding modes of illustration, folio layout, and selection of images, with respect to Ibrahim's *Shahnama*, in no way disputes Sims' interpretation. It does, however, suggest that actual text illustration was the prime—or at least the initial—concern of those responsible for the production of the manuscript. It was only after effective narration, by means of both text and image, of an age-old and well-known story had been achieved that other concerns or subthemes were considered.

In the past several decades, through such studies as those by Eleanor Sims and Oleg Grabar and Sheila Blair's study of the Great Mongol *Shahnama*, it has become increasingly apparent that a program of illustrations could be much more than a mere collection of pretty pictures, that the various scenes could be carefully and very consciously selected to convey to the reader a very specific theme or concept. However, the tendency has been to see such selection only in political, mainly legitimizing, terms. Examination of Ibrahim's *Shahnama* has shown that the motive behind the selection of illustrations perhaps was not always quite so divorced from the actual text, and, more generally, it has broadened our understanding of the overall process of planning a program of illustrations and of the changes that occurred with respect to this process over the course of time.

CHAPTER 4 Calligraphy

C alligraphy is the most esteemed of all the arts, and in treatises on the arts of the book it is the names of calligraphers that are preeminent over those of painters, illuminators, and other artists and craftsmen.[1] Some individuals were admired for their exceptional skill in one or several scripts, such as Ja'far and Azhar, who worked in Herat for Baysunghur in the first half of the fifteenth century. Others were esteemed more for specific innovations: Ibn Muqla (d. 328/940) established a system of geometric proportions for perfecting existing scripts; Ibn al-Bawwab (d. 413/1022) is credited with being the first to copy a Qur'an completely in a cursive script;[2] and Yaqut al-Musta'simi (d. 698/1298–99) devised a method of trimming the nib of the pen that made his style of writing a model for centuries to come.[3]

THE EVOLUTION OF *NASTA'LIQ* SCRIPT

'Ali ibn Hasan al-Tabrizi worked during the late fourteenth and early fifteenth centuries. He is less renowned than Ibn Muqla, Ibn al-Bawwab, and Yaqut, yet he, too, is esteemed for a specific innovation: the "invention" of *nasta'liq* script. In his treatise on calligraphy, written in 920/1514, Sultan 'Ali Mashhadi refers to 'Ali ibn Hasan as the "original inventor" of the new script. He also credits him with being the person who "laid down the rules" for *nasta'liq*.[4] An examination of the visual evidence of the manuscripts themselves, however, removes some of the glory from 'Ali ibn Hasan, because it proves that the new script did not suddenly emerge fully formed, the result of the genius of one gifted individual; rather, it evolved gradually over a period of several decades. 'Ali ibn Hasan may indeed have played a role in the formation of *nasta'liq* by developing a canon of proportions for the script, but it is a contribution that came only at the end of a long period of development, several decades, in fact, after fully developed examples of the new script had appeared.[5]

Priscilla Soucek has pointed out that when Islamic authors use the terms "invention" or "inventor," they usually mean that a given calligrapher has indeed merely established a canon of proportions for an already existing script.[6] Never-

theless, it remains the tendency to credit a particular calligrapher with the actual invention of a particular script,[7] fostering the notion of an individual genius motivated by almost divine bursts of creative inspiration. Not only does this practice mask the true time frame for the development of a script; it also shrouds the coincidence of factors and events that actually forced and fostered its development. The analysis of mainly fourteenth-century manuscripts that this chapter entails is an attempt, therefore, to establish the true factors that occasioned the emergence of the Persian script *nasta'liq*.

Persian Hanging Scripts

The Arabic and Persian word *ta'liq* translates as "hanging" or "suspended," and *ta'liq* is a cursive script in which individual letters and words tend to be written with an upper right to lower left slant, and thus appear to hang as though suspended from a single invisible point above.[8] In other cursive scripts such as *naskh*, one perceives definite vertical and horizontal axes, created by the adherence to a baseline and by the long, straight uprights of letters such as *alif* and *kaf* (fig. 117). In *ta'liq*, the sensation of letters and words being hung or suspended obliquely from above is enhanced by certain, but not all, of the unusual ligatures that are a characteristic feature of the script.[9] *Nasta'liq*, as its name implies, is likewise a cursive script with a characteristic hanging quality, but it only rarely employs the unusual ligatures of *ta'liq* (fig. 118).

Hanging scripts were originally a distinctly Persian phenomenon. *Ta'liq* is the earliest of the Persian hanging scripts, and Bernhard Moritz credits its development to the impact of the script used for the old Persian language, Pahlavi, a script that tended to slant from upper right to lower left. This ancient script continued in use in Iran after the Arab conquest and was used, for example, on coins issued by the Arab governors of Tabaristan in 140/757–58. Even after it fell into disuse, some learned individuals retained knowledge of it.[10] The early history of *ta'liq* is rather confused. However, Francis Richard's account of its history establishes that *ta'liq*, or at least a form of it, was in use in the thirteenth century, and a document in scroll form issued by the Jalayirid Sultan Ahmad in 773/1372 proves that by the late fourteenth century the script was fully developed.[11]

Therefore the appearance in the fourteenth century of the hanging script *nasta'liq* was not in itself innovative. What was innovative was its function, for *ta'liq* was a chancery script, used primarily for official letters and other documents: because of the abundance of unusual ligatures that characterize *ta'liq*, it

117. Detail of a folio of *naskh* script, Great Mongol *Shahnama*, n.d., but c. 1335, Tabriz, 59.3 × 40.3 cm (folio). © The Trustees of the Chester Beatty Library, Dublin, Per 111.5a.

118. Detail of a folio of *nasta'liq* script, *Khusraw va shirin*, c. 1405–10, 30.7 × 21.4 cm (folio). Freer Gallery of Art, Smithsonian Institution, Washington, D.C.: Purchase, F1931.29, p. 52.

can be written quickly and is difficult to copy. *Nasta'liq*, however, evolved in the sphere of, and quickly became the predominant script for the copying of, poetry manuscripts. Moreover, it did not evolve from a simple combining of *naskh* and *ta'liq*, as Sultan 'Ali Mashhadi and others throughout the centuries have often said.[12] Instead, the visual evidence of the manuscripts themselves indicates that *nasta'liq* is primarily an evolution of *naskh*—a hanging version of *naskh*, as its original name *naskh-i ta'liq* ("hanging" *naskh*) indicates.

The Distinguishing Traits of Naskh *and* Nasta'liq

To understand the gradual development of *nasta'liq* from *naskh*, the main traits differentiating the two scripts need to be considered. Twelve traits have been identified;[13] they are discussed and illustrated in the following text but also have been listed in abbreviated form in table 10. The twelve traits are primarily concerned with individual letter forms, the thickness of the line or pen stroke, and the overall impression created by the script on the page. The use of certain letter types in one script, but not the other, has been noted as well.[14]

1. *ALIF, KAF,* AND *LAM* (SLANT)

naskh جوكردى كينراسرح راسرغار *nasta'liq* وزانبس فى سَتادَدَ راشاه كفت

In *naskh*, the *alif*, the *lam*, and the upright of the *kaf* stand straight, perpendicular to the baseline, or they slant slightly to the left (upper left to lower right slant). In *nasta'liq*, they may also stand straight or slant to the right (upper right to lower left).

2. *ALIF* AND *KAF* (HEIGHT)

naskh منافسونهائى ورّاسكان زنيمان او *nasta'liq* زمَانى نكردم زنيَان او نم

A characteristic feature of *naskh* is its opposing vertical and horizontal axes. The tall *alifs* and the tall uprights of the *kaf*—standing perpendicular to the baseline or with a slight leftward slant—contribute greatly to the sense of a vertical axis. In *nasta'liq*, however, the impression of a vertical axis—and thus of opposing axes—is lost, largely because the *alif* and the upright of the *kaf* are

TABLE 10 Distinguishing traits of *naskh* and *nasta'liq*

	Naskh	Nasta'liq
1. *Alif, kaf,* and *lam*	Stand straight or slant very slightly to the left	Stand straight or slant very slightly to the right
2. *Alif* and *kaf*		*Alif* and the upright of *kaf* are proportionately shorter than in *naskh*
3. *Kaf*		The cap is longer, more sweeping, and it reaches closer to the line above
4. *Re, ze, zhe,* and *vav*	Tail generally curves upward	Straighter, shorter, and often a rather sketchy quality
5. *Dal* and *zal* (joined)	Upward curve of tail	Quite straight, little definition
6. *Dal* and *zal* (separate)	A 45-degree angle joins the two halves of the letter; the lower half sits firmly on the baseline	Less definition, more of a 90-degree curve than a sharp angle
7. *Be, pe, te, se, sin,* and *shin*	Teeth are well defined, very pointed	Teeth are less defined, tend to be shorter and slightly more rounded (often very rounded "bumps")
8. Elongation of letters		Extensive use of extended, elongated letters
9. Variation in the width of the pen stroke		Greater variation (greater pen movement)
10. Piling up of letters and words/adherence to the baseline	Minimal undue piling up of letters/words; script adheres closely to a baseline, creating a definite sense of horizontality	More extensive and undue piling up of letters and words (creates a hanging quality)
11. Combined effect of the preceding traits	Overall impression of definite horizontal and vertical axes	Definite upper right to lower left slant
12. General impression of precision and control	Very precise and controlled, often a sense of tightness and rigidity; a sense of being written slowly and with a definite consciousness of the form of each letter	More casual, greater freedom and expressiveness on the part of the scribe; a sense of being written quickly and with great bravado

proportionately shorter than in *naskh* and therefore are not as readily distinguished from among the other letters.

3. KAF (CAP)

naskh كَفُتْ كَزْنَا *nasta'liq* كَرَكُرَ

In *nasta'liq*, the cap of the *kaf* is usually proportionately longer and more sweeping, and it reaches closer to the line above than in *naskh*.

4. RE, ZE, ZHE, AND VAV (CURVE OF TAIL)

naskh وَنْدَمَرْدَى وُهُوشَ هُنَرْ *nasta'liq* دراسب ودرشمشير ودرز

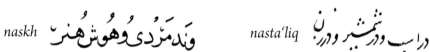

The tail of these letters is generally curved in *naskh*, but in *nasta'liq* it is distinctly straighter and shorter, and there is often a rather sketchy quality to it. It can at times be very straight indeed. This altering of the form of the *re*, *ze*, *zhe*, and *vav* is part of an overall tendency in *nasta'liq* to transform curves into straight strokes. It is also one of the cursive tendencies evident in the Arabic script used in official letters and other documents copied on papyri, after the second/eighth century, that have been noted by Geoffrey Khan.[15] Although *naskh* and *nasta'liq* are both cursive scripts, *nasta'liq* has a more curvilinear quality and can, therefore, be considered as "more cursive" than *naskh*.

5. DAL AND ZAL (JOINED FORM)

naskh دَيِدَنْد *nasta'liq* نذيذذ

A transforming of curves into straight strokes is apparent here, too. In *naskh*, there usually is a clear though slight upward curve of the tail in the joined forms of the letters *dal* and *zal*, but in *nasta'liq* the letter as a whole has little definition and is quite straight—and may even consist of a short, straight, downward stroke only.

6. DAL AND ZAL (SEPARATE FORM)

naskh دَهْ بَاد *nasta'liq* دار

Another of the cursive tendencies evident in the script of Arabic papyri noted by Khan—and equally evident in the evolution of *nasta'liq*—is the transforming of angles into curves.[16] Thus in *naskh*, the separate forms of *dal* and *zal* are well defined with a distinct triangular shape: the two halves of each letter are joined in a 45-degree angle, with the lower half sitting firmly on the baseline. If this same basic shape is retained in *nasta'liq*, the letter is tilted so that the lower half slants from upper right to lower left. However, more usually in *nasta'liq*, these letters are less defined, for the sharp angle is softened into what can be described as a 90-degree curve.

7. *BE, PE, TE, SE, SIN,* AND *SHIN* (TEETH)

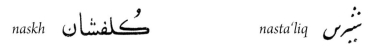

naskh كلفشان *nasta'liq* شبرس

The teeth of these letters are clearly defined and distinctly pointed in *naskh*. However, in *nasta'liq* they can be much less well defined, because the teeth tend to be shorter and more rounded, at times actually taking on more the form of low, rounded "bumps."

8. *MASHQ* (THE ELONGATION OF LETTERS)

nasta'liq شبرس

The toothless, often very elongated forms of *sin* and *shin* are typical of *nasta'liq*, but are rarely used in *naskh*. Likewise, elongated forms of *be, pe, te,* and *se* are much more common to *nasta'liq* than *naskh*. In *kufic*, elongated letter forms serve a combined pragmatic-aesthetic function, for they are used to fill the remaining space of a line of script and thus to maintain the visual aesthetics of the page. In *nasta'liq*, such extensions of the letter have a more purely aesthetic function, and they often seem to be used primarily to add a sense of bravado to the script.

9. VARIATION IN THE WIDTH OF THE PEN STROKE

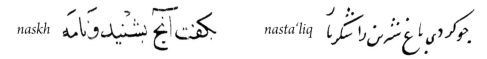

naskh كفت آنچ بشنيدو نامه *nasta'liq* جوكردی باغ شرس راشكرا

In *nasta'liq*, there is much greater variation in the width of the pen stroke, created by greater movement of the pen on the part of the calligrapher. This variation imbues the script with a greater sense of fluidity and overall movement, making it appear much less rigid than *naskh*.

10. THE PILING UP AND OVERLAPPING OF LETTERS AND WORDS AND THE ADHERENCE TO THE BASELINE

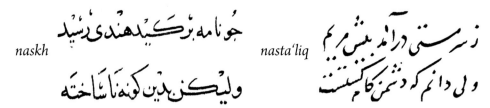

The basic nature of the Arabic and Persian alphabets and the way in which certain letters must be joined encourages a "piling up of letters" in an upper right to lower left slant, as in the writing of the name "Muhammad." As a result, words often overlap one another with the first few letters of one word being written above the final letters of the previous word. In *naskh*, the individual letters and words tend to adhere to the baseline as closely as possible, and the piling up and overlapping of letters and words are kept to a minimum. Consequently, the integrity of the horizontal axis is maintained. But in the hanging scripts this basic feature inherent to the writing of Persian and Arabic is exaggerated and exploited. Because of the extensive, undue piling up and overlapping of letters and words, the visual impact of the horizontal axis of the baseline gives way to what in effect is a series of oblique axes cutting through the horizontal baseline.

11. THE COMBINED EFFECT OF THE PRECEDING TRAITS

Not only the immediately preceding trait, but all the traits discussed, combine to create in a page of *naskh* an overall impression of definite horizontal and vertical axes; in *nasta'liq* the overall impression is of movement from the upper right to the lower left of the page.

12. THE GENERAL IMPRESSION OF PRECISION AND CONTROL

In comparison with *nasta'liq*, the best *naskh* gives the impression of being the result of a precise and controlled act on the part of a calligrapher working slowly and with a clear consciousness of the exact form each letter should take. *Nasta'liq* has a sense of being written quickly and with great bravado, and although the impression of great speed is false, for even in *nasta'liq* the best calligraphers form each letter carefully and slowly, the development of *nasta'liq* was nevertheless a process of altering specific *naskh* letter forms in ways that allow them to be written more quickly. Again though largely false, *nasta'liq* generally gives the appearance of being a more casual script, one that allows for greater freedom and expressiveness on the part of the scribe.

In addition to these twelve traits that distinguish *naskh* from *nasta'liq*, certain letter shapes are associated more closely, or even exclusively, with only one or the other of the two scripts.

13. *KAF*

naskh *a.* *b.*

The more usual shape of the *kaf*, in both *naskh* and *nasta'liq*, is that shown as sample 13a. However, an alternative shape, sample 13b, is also commonly used in *naskh*. In this *naskh-kaf*, the "upright" lies parallel to the unusually long base stroke, thereby accentuating the horizontal axis of the script. It is presumably for this reason that this particular shape of *kaf* is not used in *nasta'liq*.

14. MEDIAL *HE*

naskh نها ن *nasta'liq* جها ن

The medial *he* typical of *naskh* consists of two loops one atop the other. A more quickly executed and less well defined form is used in *nasta'liq*, one which is occasionally used in *naskh* also and which resembles an inverted "v."

15. FINAL *HE*

naskh ꝺ *nasta'liq* ⌇

The type of final *he* used in *naskh*, which loosely resembles a lower-case "d" or a lower-case typed "a," is supplanted in *nasta'liq* by a more quickly executed type, similar to an inverted "v," the slant of which contributes to the oblique axis characteristic of the script.

The Method of Analysis

The script of each manuscript was judged according to a five-point scale for each of the twelve distinguishing traits of *naskh* and *nasta'liq* and the results recorded in tables such as that reproduced here as table 11. On the scale, number 1 indicates that for that particular trait, the script is considered "pure" *naskh*, whereas a score of 5 indicates it is "pure" *nasta'liq*. In a few instances, a scale of just 5 points proved inadequate to judge the script precisely, and therefore a trait was marked as spanning two numerical grades. In other cases, multiple scores were awarded to indicate variations in the script sample. This was often the case, especially with regard to the first trait, the slant of the *alif, kaf,* and *lam,* for which the scoring system is slightly different. Here a score of 3 indicates that these letters stand straight, with no slant; a score of less than 3 indicates an increasing leftward slant; and a score of more than 3 indicates an increasing rightward slant. In the Bodleian Library's *Khamsa* of Nizami dated 766–67/1365 (BOD Ouseley 274–75), these letters may stand straight or slant either to the left or right, so scores of 2, 3, and 4 had to be assigned (see table 11). Tables recording the analysis of seven of the manuscripts examined for this portion of the study and samples of each script are included in appendix 4.

An overall final score out of 9 for the script of each manuscript was then determined: the ratings for each of the twelve traits were considered collectively, although considerably more weight was accorded the scores of the last three traits (namely, the piling up and overlapping of letters and words, and the adherence to the baseline; the combined effect of the first ten distinguishing traits; and the general impression of precision and control). Because the individual distinguishing traits were deemed of unequal importance in distinguishing between the two scripts, *naskh* and *nasta'liq*, arriving at a final, overall score for the script of each manuscript could not be a strictly mathematical matter of determining an ag-

TABLE 11 Script analysis: BOD Ouseley 274–75

Khamsa of Nizami, 766–67/1365, Shiraz	*naskh* ← 1	2	3	→ 4	*nasta'liq* 5
1. *Alif*, *kaf*, and *lam*, slant		X	X	X	
2. *Alif* and *kaf*, height			X		
3. *Kaf*, sweeping cap				X	
4. *Re*, *ze*, *zhe*, and *vav*				X	
5. *Dal* and *zal*, joined form				X	
6. *Dal* and *zal*, separate form			X		X
7. Teeth	X				
8. Elongation of letters			X		
9. Variation in the width of the of pen stroke		X			
10. Piling up of words/adherence to the baseline				X	
11. Combined effect of the preceding traits			X		
12. General impression of precision and control				X	

Final analysis: more than halfway to *nasta'liq*

Final Score: 7/9

General comments: same scribe as BN Supp. pers. 1817; but unlike BN Supp. pers. 1817, *alif*s slant mainly to left or are straight with only a very few slanted to the right; often great variation in letter forms from one word to the next, as if experimenting

gregate score by tallying up the scores awarded for each trait. The latter method was equally unsuitable because it could not take into account the fact that several of the traits are related, in that the use of one forces the appearance of another. For example, the most important individual feature distinguishing *nasta'liq* from *naskh* is the hanging or slanted nature of the script, and once the words are written in a slant a chain reaction of alterations to the script is set in motion. Some of the changes effected are, first, that the adherence to an obvious baseline disappears; second, that the natural mechanics, not to mention the visual aesthetics, of writing almost demand that once whole words are made to slant or hang, the *alif* and *kaf* must also bend in the same direction; and, third, that although the *alif* and *kaf* are proportionately shorter in *nasta'liq* than in *naskh*, they appear even shorter because they become buried among the slanted letters and words that overlap them. A purely mathematical and inflexible scoring system also would not allow the variation between different hands—and even between examples of the same hand—to be taken into consideration. Bearing all these points in mind,

the scripts were then compared and grouped according to overall similarities and differences and the final scores determined. A 9-point scale was used because it provided a broad enough range to distinguish between quite subtle differences in scripts and an odd-numbered scale allowed for certain scripts to be designated as precisely halfway between *naskh* and *nasta'liq*. A score of 9/9 indicates a script deemed to be a fully developed form of *nasta'liq*, while a score of 1/9 indicates a *naskh* script with only the slightest possible, if any, *nasta'liq* tendencies. These final scores are recorded in tables 12a–d.[17]

The Corpus of Manuscripts Analyzed

Of the many manuscripts examined, forty-six are listed in tables 12a–d. Although most manuscripts copied in a pure *naskh* script are not listed (because their inclusion would have had no effect on the results), many others have been included to illustrate the balance between manuscripts of a similar date that show *nasta'liq* tendencies and those that do not. Of the forty-six manuscripts, twenty-seven can be attributed to Shiraz, fourteen to Baghdad or Tabriz, and the provenance of another five is uncertain.[18] Although the majority of the manuscripts were produced in the fourteenth century, they range in date from 614/1217 to the latest, undated manuscript of about 1405. This last manuscript is the Freer Gallery of Art's copy of Nizami's *Khusraw va shirin* (F1931.29–37), copied by 'Ali ibn Hasan al-Tabrizi. The majority of the manuscripts are poetry, but also included are copies of *Kalila wa dimna*, scientific, historical and geographical texts, and a biography of the Prophet.

Results of the Script Analysis

The data in tables 12a–d show that the development of *nasta'liq* script was a gradual process, though marked by three main periods of change: the 1330s and 1340s (see table 12b); from about 1355 to the late 1360s (see table 12c); and the years from the appearance of the fully developed form of the script in 1370 until about 1405 (see table 12d), from which time onward it would serve as the Persian script of choice for the copying of poetry and also many prose texts. Script from each of these three important periods is reproduced as figure 119. The data also show that, with minor exceptions, the process of change can be traced only in the manuscripts of Shiraz.

A score of 2/9 has been given to the script of six of the earliest manuscripts (nos. 1–6 in table 12a).[19] Clearer *nasta'liq* tendencies are evident in several Shiraz

TABLE 12a Final scores of script analysis: Manuscripts 1–8 (614/1217 to 729/1329)

| Manuscript | naskh ← | | | | | | | → nasta'liq | |
	1	2	3	4	5	6	7	8	9
1. Florence Cl.III.24, 614/1217 (*Shahnama*)		x							
2. BL Add. 21103, 675/1276 (*Shahnama*)		x							
3. BL-IOL Ethé 903 etc., 713–14/1314–15 (poetry)		x							
4. Freer 30.1, Small *Shahnama*, n.d., but c. 1300		x							
5. First Small *Shahnama*, n.d., but c. 1300 (see app. 4.1)		x							
6. Second Small *Shahnama*, n.d., but c. 1300		x							
7. EUL Arab 20; Khalili MSS727, 714/1314–15 (prose)	x								
8. BL Or. 3623, 729/1329* (prose)	x								

* For Tables 12a–d, indicates manuscripts produced in Shiraz and related centers, such as Isfahan.

Note: Copies of the *Shahnama* and the *khamsa*s of Nizami and Amir Khusraw Dihlavi are identified as such, but all other texts are identified only as either prose or poetry texts. (Other titles are listed in appendix 5.) See appendix 4 for individual script analyses charts and script samples for manuscripts nos. 7, 17, 23, 29, 34, 39, and 46.

TABLE 12b Final scores of script analysis: Manuscripts 9–22 (731/1330 to 755/1354)

| Manuscript | naskh ← | | | | | | | → nasta'liq | |
	1	2	3	4	5	6	7	8	9
9. TS H. 1479, 731/1330* (*Shahnama*)			x						
10. BL Or. 2676, 732/1332* (prose)	x								
11. Dispersed *Kalila wa dimna*, 733/1333*	x								
12. StP-RNL Dorn 329, 733/1333* (*Shahnama*)			x						
13. BL Add. 7622, 734/1334* (prose)	x								
14. Great Mongol *Shahnama*, n.d., but c. 1335	x								
15. BOD Ouseley 379-81, n.d.* (prose)	x								
16. BL Or. 4392, 741/1340 (prose)	x								
17. Dispersed *Shahnama*, 741/1341* (see app. 4.2)			x						
18. Kuwait LNS 9 MS, 741/1341* (poetry)			x						
19. Cairo Adab farisi 61, 744/1343–44 (prose)	x								
20. TS H. 231, 744/1344* (prose)	x								
21. Stephens *Shahnama*, Sackler LS1998.1.1.1–94, n.d., but late 1340s or early 1350s*	x								
22. TS H. 674, 755/1354 (poetry)	x								

TABLE 12c Final scores of script analysis: Manuscripts 23–32 (756/1355 to 769/1367)

Manuscript	naskh ←						→ nasta'liq		
	1	2	3	4	5	6	7	8	9
23. Tashkent 2179, 756/1355* (*Khamsa*) (see app. 4.3)					x				
24. BL Or. 3646, 761/1360 (prose)	x								
25. IUL F. 1422 (*Kalila wa dimna* folios), n.d., but late fourteenth century	x								
26. BN Supp. pers. 1817, 763/1362* (*Khamsa*)							x		
27. Berlin-SB Minutoli 35, 764/1362 and 765/1363* (*Khamsa*)				x					
28. BOD Pers. d. 31, 766/1365* (prose)	x								
29. BOD Ouseley 274–75, 766-67/1365* (*Khamsa*) (see app. 4.4)							x		
30. BN Supp. pers. 580, 767/1366* (*Khamsa*)						x			
31. BN Supp. pers. 1778, 767/1366* (poetry)							x		
32. BOD Marsh 491, 769/1367* (prose)					x				

manuscripts of the 1330s and 1340s, each of which has been rated 3/9 (nos. 9, 12, and 17–18 in table 12b). The basic nature of Persian and Arabic script that causes an unavoidable piling up of letters in certain words has been slightly exaggerated and exploited in these manuscripts. These are all poetry texts, copied in four or six columns, while most manuscripts rated 1/9 are prose texts copied in just one undivided block of text. Thus it appears that the tendency to pile up or slant words may be related to use of the multicolumn textblock format.

A visible frame delineates the space of the textblock. When a calligrapher neared the end of a line and realized that there was insufficient space for all the words he wished to place on that particular line, he could either squeeze in the final few words by writing them horizontally on a second level above the main line of text, or he could create extra space by writing the final few words in a slant, thereby causing the words to overlap each other. Restricting the space in which the calligrapher could write by means of a frame could therefore force a change in the way certain words were written. In a multicolumn format, the possibility of such changes occurring increased. Moreover, when copying a prose text, a calligrapher had the option of continuing the text on the following line; in poetry, he did not. The multicolumn format mirrors the formal structure and rhyming

TABLE 12d Final scores of script analysis: Manuscripts 33–46 (772/1370 to c. 1405)

Manuscript	naskh ←							→ nasta'liq	
	1	2	3	4	5	6	7	8	9
33. TS H.2153, *Shahnama* folios, c. 1370–75	X								
34. StP-RNL Dorn 406, 772/1370* (poetry) (see app. 4.5)									X
35. TS H.1511, 772/1371* (*Shahnama*)				X					
36. BL Or. 2866, 774/1372* (poetry)	X								
37. BN Pers. 276, 781/1380* (prose)					X				
38. BN Supp. pers. 745, 786/1384* (poetry)					X				
39. BL Or.13297, 788/1386, 790/1388 (*Khamsa*) (see app. 4.6)								X	
40. BN Pers. 377, n.d., but c. 1380–90* (prose)				X					
41. BN Supp. pers. 332, 790/1388 (prose)									X
42. CBL Per 318, 789/1389*† (*Khamsa*)						X			
43. BN Supp. pers. 913, 794/1392 (prose)								X	
44. Cairo Ta'rikh farisi 73, 796/1393–94* (*Shahnama*)					X				
45. BL Add. 18113, 798/1396 (poetry)								X	
46. Freer 1931.29–37, c. 1405 (poetry) (see app. 4.7)								X	

† Only the first and final folios of no. 42 are included in the script analysis, as all other folios in the manuscript are a copy of the *Divan* of Salman that is undated but probably c. 1400.

pattern of a poem: each line of each column contains just one hemistich of the poem. To continue any hemistich in another column or on another line would vastly disturb the rhythmic reading of the poem and would render use of the multicolumn format meaningless.

In manuscripts rated 1/9, there is a minimal or no undue slanting of words, so the impression of contrasting horizontal and vertical axes is maintained. In those rated 2/9 and 3/9, the visual aesthetics of the page are altered by the increased number of words written on an oblique axis and also because of their more even distribution throughout the length of the line: in the smaller space of a column line (as opposed to the longer lines of an undivided block of text), the calligrapher could better judge the need to slant some words and then spread them out more evenly within that space. The impact that the multicolumn format could have on script is especially evident if one compares two folios from the *Shahnama* of 741/1341 (copied by the same calligrapher, of course). One is a page of the

119. The development of *nasta'liq* script.

(a) *Shahnama*, 741/1341, 37 × 29 cm (folio). © The Trustees of the Chester Beatty Library, Dublin, Per 110, f. 5a

(b) *Khamsa* of Nizami, 766–67/1365, 26.5 x 16.5 cm (folio), Bodleian Library, University of Oxford, Ouseley 274, f. 118b

(c) *Kulliyyat* of 'Imad Faqih, 772/1370, Russian National Library, St. Petersburg, Dorn 406, f. 186b

prose preface written as an undivided block of text (fig. 120). The other is a page of the poem copied in six columns in a script that shows considerable piling up and slanting of words (fig. 121).[20]

It is not, however, only the undue slanting and piling up of letters and words *per se* that first effected a change in the appearance of the script. Three of the early manuscripts rated 2/9 are the so-called Small *Shahnama*s (see table 12a and app. 4.1). The script of these manuscripts has been aptly described by Abolala Souda-var as a "loosened *naskh*."[21] A looser handling of the pen created scripts that are freer, with letters and words more rounded and flowing. The scripts are overall less rigid than, for example, that of the Great Mongol *Shahnama* of about 1335, which creates the impression of a calligrapher astutely aware of every stroke of his pen (see fig. 117).[22] In those manuscripts rated 3/9 (see table 12b and app. 4.2)— all products of Shiraz (or Isfahan)—this "looseness" is even more apparent.

It was in the approximate decade between 1355 and the late 1360s that the most dramatic and comprehensive changes in script occurred (see table 12c): the script of two manuscripts produced in Shiraz in those years is rated 5/9 (nos. 23 and 32; and see app. 4.3),[23] the script of one is rated 6/9 (no. 30)—slightly more than halfway between *naskh* and *nasta'liq*—while that of another three manuscripts is rated 7/9 (nos. 26, 29, and 31; see app. 4.4). Of these six manuscripts, five are poetry texts: one copy of the *Khamsa* of Amir Khusraw Dihlavi (no. 23), three copies of the *Khamsa* of Nizami (nos. 26, 29, and 30),[24] and one copy of the *Kull-iyyat* of Sa'di (no. 31). However, the sixth is a prose text, the Persian translation of Dioscorides' *De Materia Medica*, entitled *Miftah al-khaza'in* (no. 32). Not only do these manuscripts exhibit the same but more exaggerated *nasta'liq* tendencies as those rated 2/9 and 3/9, but many other features of the script have also been altered. Most obvious is the general tendency to transform angles into curves and curves into straight strokes. In these manuscripts the impression of opposing horizontal and vertical axes, still prominent in the scripts rated 2/9 and 3/9, fades noticeably in favor of the oblique axis that is now a feature of both individual words and groups of words. The changes are not consistent however, and even two manuscripts copied by one scribe, Ahmad ibn al-Husayn ibn Sana, do not score identical ratings for each individual point.[25] Differences in the form of a let-ter, even on the same page, are not uncommon and suggest a considerable degree of experimentation on the part of the calligrapher.[26]

The final period of change is marked by the appearance of the first example of what can be considered pure *nasta'liq* script, rated 9/9 and also a product of

Shiraz—the *Kulliyyat* of 'Imad Faqih of 772/1370 (StP-RNL Dorn 406; no. 34 in table 12d; and see app. 4.5). Based on the evidence of the manuscripts examined, it was more than a decade and a half before *nasta'liq* appeared in manuscripts produced outside Shiraz, and then it appeared suddenly with no evidence of a gradual development. The first non-Shiraz manuscripts in which it is found are a copy of the *Khamsa* of Nizami, dated 788/1386 and 790/1388 and actually rated only 8/9, and a manuscript containing both Qazvini's *Aja'ib al-makhluqat* and *Kalila wa dimna*, dated 790/1388 and rated 9/9 (nos. 39 and 41 in table 12d, respectively; and see app. 4.6). Both manuscripts were copied in Baghdad. The latest manuscript included in the study is the undated copy of Nizami's *Khusraw va shirin*, copied by 'Ali ibn Hasan al-Tabrizi himself (no. 46 in table 12d; and see app. 4.7 and fig. 118).[27]

121. Detail of an illustrated folio, *Shahnama*, 741/1341, 37 x 29 cm (folio). © The Trustees of the Chester Beatty Library, Dublin, Per 110, f. 84a.

Interpretation

Despite the uncertain provenance of those manuscripts the script of which is rated 2/9, the visual evidence is clear: it was the scribes of Shiraz who were responsible for the development of *nasta'liq* script. The manuscripts of the 1330s and 1340s that are rated 3/9 are products of that city; the dramatic changes of the approximate decade from about 1355 to the late 1360s can be traced *only* in Shiraz manuscripts (those rated 5–7/9); and the first appearance of a fully developed form of the script is in a Shiraz manuscript. The earliest evidence of *nasta'liq* being used outside Shiraz is a manuscript dated both 788/1386 and 790/1388, more than a decade and a half after the fully developed form of the script had appeared in Shiraz. There is no strong hint of *nasta'liq* tendencies in any earlier non-Shiraz manuscript: when the script finally appears in non-Shiraz manuscripts, it does so in its fully developed form. The evidence therefore suggests that the calligraphers of Baghdad—and presumably of Tabriz as well—merely poached the fully developed form of the script from their colleagues in Shiraz.

It is also clear from the visual evidence that *nasta'liq* is the result of the gradual transformation of *naskh*.[28] A process of change involving experimentation on the part of, and a gradual change in, a number of individual hands is suggested by several factors. These include the great number of different calligraphers involved;[29] the considerable differences that can exist in the script of manuscripts of a similar date;[30] the variation that is often evident in the script of a single manuscript;[31] and the variation in the hand of a single calligrapher in two different manuscripts.[32]

It can be assumed that each calligrapher knew, in theory, how to execute a fine *naskh* hand. Geoffrey Khan employs the term "script competence" to refer to the actual capability of a calligrapher to execute the standard or ideal form of the letters that constitute a particular script.[33] The script competence of different calligraphers of course varied, and not all had the skill to execute the fine *naskh* hand of the Great Mongol *Shahnama*. The training of a calligrapher probably was the main factor affecting script competence. The great Arab calligraphers of the preceding centuries had worked in Baghdad, and it can perhaps be assumed that the tradition of classically trained calligraphers was stronger there and in Tabriz than it was in a more distant center such as Shiraz. Certainly, the scripts of the Injuid *Shahnama*s are no equal for that of the contemporary Great Mongol *Shahnama*, almost certainly a product of Tabriz.[34]

A calligrapher would not, however, always perform at his peak "script compe-

tence" level, and the level of excellence actually attained at any given time Khan refers to as "script performance." Any number of factors could affect the calligrapher's performance on a particular day, including his actual physical and mental state, the quality of his materials, the cut of the nib of the pen, the amount he was being paid for the job, or the general conditions under which he was working, such as the amount of time allocated to execute a project. Any combination of such factors could prevent him from achieving the peak of his script competence level. The alteration of the usual form of letters forced by the restricted space of a multicolumn textblock format would fall into the realm of factors affecting script performance. The script performance of the calligrapher of the Great Mongol *Shahnama*, however, was not affected by the multicolumn format. Thus it was not the multicolumn textblock format *per se* that served as an initial impetus for the development of *nastaʿliq*. It was instead that this format was used by a specific group of calligraphers who, perhaps by virtue of their training, were willing to work below their level of script competence rather than make other adjustments necessary to preserve their ideal form of the script.[35]

A dramatic move toward greater incorporation of *nastaʿliq* tendencies began about 1355 (as is indicated by the script of the *Khamsa* of Amir Khusraw Dihlavi of that date; see app. 4.3) but is most evident in manuscripts of the 1360s. Furthermore, in the 1360s, the formerly strict association between the incorporation of *nastaʿliq* characteristics and poetry manuscripts, with their multicolumn format, began to break down, so that even the script of a manuscript such as the Persian translation of Dioscorides' *De Materia Medica* (*Miftah al-khazaʾin*, BOD Marsh 491), a prose text copied in 769/1367 as one undivided block of text, exhibits strong *nastaʿliq* tendencies. Nevertheless, an important factor in the continuing development of *nastaʿliq* script was surely the rise in the production of poetry manuscripts, all of which were of course copied in a multicolumn format, that occurred in the 1360s. Perhaps as important, however, was the change in the predominant genre of poetry being copied, from the heroic epic to romance poetry.

Soudavar has suggested that the more angular Arabic scripts were not particularly well suited to Persian poetry and that this fact encouraged the development of a more cursive script.[36] The visual aesthetics of the finest *nastaʿliq* are indeed better suited to the overall nature of a text such as the *Khamsa* of Nizami, much of which recounts tales of love, than they are to the seemingly never-ending detailing of the battles and bloodshed of so much of the *Shahnama*. The calligrapher, and thus his script, may well have been affected by the emotion and mood of the

poem, expressed through both its language and rhythm.[37] Although the apparently new and growing interest in producing manuscript copies of poetry of the romantic-epic genre clearly was not the impetus for the initial changes evident in *naskh* script, nevertheless this phenomenon may well have stimulated further the development of *nasta'liq* and the eventual adoption of this new script as the primary one used for the copying of poetry, from the final quarter of the fourteenth century and throughout the centuries to come.[38]

Supporting Documentation

The historical sources tell a rather different tale of the development of *nasta'liq* script from that told by the manuscripts themselves. Sultan 'Ali's treatise on calligraphy was written in 920/1514 and was followed by several others that also award Mir 'Ali Tabrizi sole credit for being the originator or inventor of *nasta'liq*. Dust Muhammad, in the preface to the Bahram Mirza album of 951/1544, goes so far as to state that "the line [of the disciples of *nasta'liq*] can go no further than to him [Mir 'Ali Tabrizi],"[39] thereby stating rather emphatically that Mir 'Ali and no one else was responsible for the script.[40] However, there exists a document, attributed to Ja'far, the early fifteenth-century scribe and head of Baysunghur's atelier in Herat, in which the author recounts his version of the history of *nasta'liq*, and it is a version that accords precisely with the visual evidence. Ja'far states:

> It must be known that *nasta'liq* is derived from *naskh*. Some Shirazi [scribes] modified it [*naskh*] by taking out the flattened [letter] *kaf*[41] and the straight bottom part of [the letters] *sin, lam, nun*;[42] then brought in from the other scripts the curved *sin* and stretched forms,[43] and introduced variations in thickness of the line and a new script was created, to be named *nasta'liq*. After a while the Tabrizi [scribes] modified what the Shirazi [scribes] had created by gradually rendering it thinner and defining its canons. Until such time that Khaje Amir 'Ali-ye Tabrizi brought this script to perfection.[44]

Sometime between Ja'far and Sultan 'Ali Mashhadi, the early history of *nasta'liq* clearly was forgotten—or perhaps purposely overlooked. Why this might have occurred can be explained if the historical and cultural climate of the time is considered.

From the final quarter of the fifteenth century and then increasingly so throughout the sixteenth century, there was a growing preoccupation with the individual.

The first evidence of this preoccupation is the increasing incidence of signatures in manuscripts. It had always been common for calligraphers to sign manuscripts, and the majority of manuscripts included in this study of *nasta'liq* are signed. But signatures of artists are rare before the late fifteenth century. For example, the names of only a few early fourteenth-century illuminators are known from signatures in manuscripts produced for Il-Khanid and Mamluk patrons,[45] and the signatures of only a few illustrators pre-date that of Junayd in the 798/1396 copy of the *Masnavis* of Khwaju Kirmani (BL Add. 18113).[46] In the first half of the fifteenth century, too, signatures other than those of calligraphers are scarce.[47] It is only in the final years of that century that signatures become more common; most notable are the illustrations signed, but mainly attributed to, Bihzad, and the illuminations signed by Ruzbihan.[48] Then, in the sixteenth century, signatures abound.[49]

In this same period there developed a burgeoning interest in the collecting of the works of master painters and calligraphers, gathered together in the form of albums, one example of which is Bahram Mirza's album of 951/1544 (TS H. 2154).[50] Written accounts naming individual artists and calligraphers, of both the past and present, also began to appear, the earliest of which is Dust Muhammad's preface to the Bahram Mirza album.[51] These accounts, however, were perhaps a response to two occurrences with respect to the writing of biographical accounts, or *tazkira*s (meaning "biography," "remembrance," or "memory"), of poets. First, there appears to have been an increase in the writing of such *tazkira*s beginning with Mir Dawlatshah Samarqandi's *Tazkirat al-shu'ara* (Biography of Poets), which he completed in 892/1487. And, second, there was a change in the focus of these works. Traditionally authors of *tazkira*s began with accounts of ancient poets and perhaps ended with a few brief remarks on contemporary poets. However, in the *Majalis al-nafa'is* (Assemblies of Precious Things) of 'Ali Shir Nawa'i, written in the 1490s, the author deals solely with contemporary poets—a striking break with tradition.[52]

Thus, the increasing incidence of actual signatures, the collecting of samples of calligraphy and painting in the form of albums, the writing of accounts of master scribes and painters, and the changes in *tazkira* writing, all of which took place at the end of the fifteenth century, but especially in the sixteenth and later centuries, attest to a growing fascination with the individual. It was in this climate that Sultan 'Ali's treatise appeared. It can therefore be understood why he might have overlooked the contribution of a group—the scribes of Shiraz—in favor of focus-

ing on, and erroneously awarding all credit for the development of *nasta'liq* to, a single individual, 'Ali ibn Hasan of Tabriz.[53]

An Overview of the Development of Nasta'liq

During the first half of the fourteenth century *naskh* was the predominant script used for the copying of non-Qur'anic manuscripts, including historical and scientific texts and poetry.[54] By the final years of the fourteenth century, *nasta'liq* had usurped *naskh*'s role to become, in the following centuries, the main script in which poetry (and also many prose) manuscripts were copied. During the course of the fourteenth century, *nasta'liq* had gradually evolved from *naskh*. The visual evidence of the manuscripts of the time indicate that it is the calligraphers of Shiraz who were responsible for the development of the new script and that it was only several years after the fully developed form of the script emerged in Shiraz that the script appeared in manuscripts produced outside Shiraz, first in Baghdad. This pattern of events suggests that only after the script had fully evolved at the hands of the Shirazi calligraphers did the calligraphers of other centers pick up on the changes and adopt (and adapt) the script for their own use.

It might be argued that the relative lack of extant non-Shiraz manuscripts in comparison with those of Shiraz discredits the conclusions of this study, because the same changes in script might well have been occurring simultaneously in the now-lost manuscripts of other centers. However, Ja'far's statements regarding the history of the script provide evidence that supports conclusively that of the manuscripts. The manuscripts also show how rather facile is the idea of associating a single creative genius with the "invention" a new script. Rather, the interaction of a number of factors was responsible: the training of the scribes, an overall rise in the production of poetry manuscripts, the increased use of the multicolumn textblock format that this latter phenomenon brought about, and a change in the favored type or genre of poetry copied in manuscript form. These facts make it clear that although traditionally credited as the inventor of the new script, 'Ali ibn Hasan al-Tabrizi in fact appeared only at the end of a long period of development. However, he purportedly laid down a canon of proportions for the script and thereby eventually managed to wrest from the calligraphers of Shiraz all the glory for the "invention" of *nasta'liq*.[55]

Bookbinding

Once the text had been copied and the illustrations and illuminations added, the binding of the book—the final stage in its production—began. This stage was geared primarily toward the protection and preservation of the book, to which end the folios were stitched together to ensure they retained their proper order and a hard cover and fore-edge flap were added, creating a protective shell for the folios. But the primarily utilitarian function of the binding was often largely masked by its elaborate decoration and as well by the addition of brightly colored and patterned endbands.

Much of the evidence of both bookbinding technique and decoration has been lost. The problem is especially acute for the fourteenth century, and the conclusion put forth here for that period rests largely on the evidence of a single binding. It is nevertheless possible to suggest that yet another major development in book production, this time in the area of binding decoration, occurred in Shiraz under the Muzaffarids, and it was one that was to have a profound and long-lasting impact both throughout Iran and beyond its borders. On the whole, a much larger and better documented body of evidence exists for the fifteenth century, but many of the distinctions that will be drawn between Shiraz and Herat bindings of the first half of the century can really only be considered tentative at this time. However, parallels with conclusions put forth in other chapters again exist, because new developments in bookbinding also occurred in Shiraz in the 1430s.

The relative dearth of secure evidence for the bookbinding tradition is due to weaknesses in the structure of Islamic bindings. These weaknesses (discussed below) often cause the binding to become detached from the folios it was designed to protect, resulting in the need to rebind the manuscript in later years. Therefore, the date or other documentary evidence in a manuscript cannot always be accepted as also applying to the binding, and there exist numerous collections of loose bindings that cannot be securely attributed to any given time or place. With the rebinding of a manuscript, other information was also often lost, such as the arrangement of the folios and the type of endbands used.

CONSTRUCTION

The text was copied onto bifolios, folded sheets of paper twice the width of a single folio. Several bifolios were grouped together in a unit referred to as a gathering, quire, or signature. Thus a complete manuscript comprises numerous gatherings, each of which in turn comprises several bifolios. For example, a manuscript of two hundred folios would consist of twenty-five gatherings if each gathering were made up of four bifolios (i.e., eight folios). Information on the arrangement of gatherings is not always possible to obtain, sometimes because the folios have been remargined or perhaps because the manuscript has been rebound too tightly for it to be opened wide enough for the gutter stitches to be seen.[1] Nevertheless, it is clear that gatherings of four bifolios were the most commonly employed in Persian manuscripts—both those of Shiraz and other production centers—from the early fourteenth century until the end of the fifteenth century at least.[2] The use of four bifolios seems to have been a well-established practice and is one of the few features of the book that did not undergo a major change in the 1360s. In the manuscripts of Shiraz, however, gatherings of five bifolios are also frequently encountered. They are used in all five of the early Injuid manuscripts for which this type of information is available;[3] in one manuscript from the late Injuid period;[4] in two of the only three early Muzaffarid manuscripts for which information is available;[5] and in three later Muzaffarid and early Timurid manuscripts.[6] In the large group of manuscripts dated between 839/1435–36 and 848/1444–45, gatherings of five and of four bifolios are about equally common. By comparison, gatherings of five bifolios were rarely used in other production centers, making it possible to cite gatherings of five bifolios as characteristic of Shiraz production.[7]

The gatherings were sewn together using a chain or link stitch. In both Shiraz and non-Shiraz manuscripts, the threaded needle usually pierced the inside fold of the gathering at two points, known as sewing stations, to create one long stitch in the center of the gathering (fig. 122). Stitching that does not conform to this pattern can invariably be proven to be later restitching.[8] On the outside, the threaded needle was looped through the thread extending from the previous gathering, a technique that served to secure the gatherings together and created a long line of linked stitches at the point of each sewing station (fig. 123). The thread used for these stitches most often appears to be a fine silk, in white or cream, though colored threads were also used.[9]

Once the gatherings had been stitched together, a fabric or paper lining, cut

122. Diagram of a gathering of four bifolios sewn at two sewing stations (one long central stitch), with an end stitch at either end of the gathering.

123. Diagram of basic link-stitch sewing at two sewing stations. Reproduced courtesy of the Oriental Institute of the University of Chicago, from Gulnar Bosch, John Carswell, and Guy Petherbridge, *Islamic Bindings and Bookmaking*, fig. 6 © 1981.

the width and length of the spine, was pasted onto the spine of the textblock.[10] (Here "textblock" is used to refer to the block of stacked and stitched folios, not the area of a folio on which the text is written.) Next was the creation of the endbands, a two-step process.

First, the threaded needle pierced the inside fold of the gathering at a point about two to three centimeters below the upper or lower edge of the bifolio, passed through the spine lining and over a piece of leather cut the width of the spine,[11] and then pierced the inside fold of the next gathering.[12] This primary sewing of the endband resulted in a row of threads equivalent to what has been described as the warp threads on a sort of miniature loom and onto which the end band was woven.[13] These "warp threads" were frequently sewn with thread of a color different from that used for the link-stitch sewing. With the link-stitch sewing and the primary sewing of the endband completed, three stitches were visible in the inside fold of each gathering: one long central stitch and two shorter stitches, one at either end of the fold (see fig. 122). The next step—the secondary sewing of the endband—consisted of the actual weaving of the endband. Unfortunately, in most of the manuscripts examined, the endbands no longer exist (often lost with the rebinding of the manuscript), or they are so badly damaged that it is difficult if not impossible to discern either the weaving pattern or the color of the threads used. It does seem, however, that usually two contrasting colors of threads were woven into a chevron pattern.[14]

Most Islamic bindings are case bindings, which means the binding was produced as a single entity separate from the textblock. To attach the completed binding to the textblock, the spine of the binding was glued to the spine of the textblock, and the front and back boards of the binding were joined to the textblock by means of paper, or perhaps thin leather or cloth, hinges. However, the glue might eventually prove ineffective, and the textblock is frequently too heavy for hinges of such fragile material. Moreover, the traditional link stitching, used to stitch the gatherings together along the outer spine, often provides insufficient support for a large and heavy manuscript. In particular, it allows for both horizontal and vertical movement along the spine, resulting in a scissoring effect that loosens and thus weakens the sewing and that also puts pressure on the hinges joining the front and back boards of the binding to the textblock. Consequently, the inner joints between the front and back boards and the textblock may eventually give way completely, causing the binding to become detached from the textblock.[15]

DECORATION

Binding Decoration in the Fourteenth Century

The problem of lost evidence due to detached bindings is indeed acute for the fourteenth century, because, of the manuscripts examined, just six bindings, forming three distinct groups, are from the Injuid and Muzaffarid eras. The first group consists of the binding that once protected the late Injuid *Mu'nis al-ahrar* manuscript of 741/1341 (fig. 124)[16] and the binding of a late Muzaffarid copy of Nizami's *Haft paykar*, a *safina* dated 788/1386–87 (TS H. 690) and decorated with Shiraz-style illuminations. A tooled line delineates the rectangular space of each cover, with small knotwork or linear motifs in each corner; and in the center of the cover is a pointed-oval medallion, filled with simple geometric motifs.[17] As noted by Julian Raby and Zeren Tanındı in their study of fifteenth-century Ottoman bindings, this is a generic type of binding decoration, one that has a long history and cannot be regarded as unique to any one production center.[18] Generic types of decoration—as well as plain, undecorated bindings—were most often used on manuscripts intended for what can perhaps be considered a more erudite or scholarly use and as such these manuscripts tended to be less extensively decorated, if at all, with illuminations and illustrations. However this certainly was not always the case: as Raby and Tanındı note, some Ottoman manuscripts

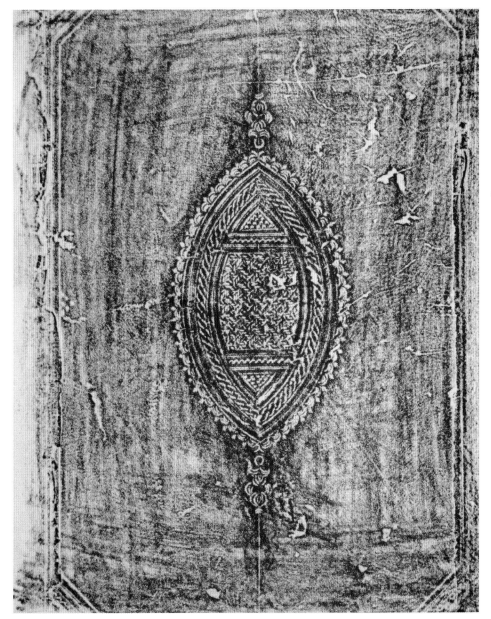

124. Front cover, *Mu'nis al-ahrar*, 741/1341, Isfahan (location unknown), 26.8 x 18.4 cm (folio). Reproduced courtesy of Princeton University Press, from Richard Ettinghausen, "The Covers of the Morgan *Manafi'* Manuscript and Other Early Persian Bookbindings," *Studies in Art and Literature for Belle da Costa Greene*, fig. 349, © 1954 renewed 1982.

with generic bindings are beautifully illuminated and others bear dedications to Sultan Mehmed II.[19]

Three Qur'an manuscripts (two of which are the separately bound sections of the Fars Malik Khatun Qur'an) make up the second group of Injuid and Muzaffarid bindings (Khalili QUR159 and QUR181–82; fig. 125). All six front and back covers are identical. The central medallion consists of an eight-point star overlaid by a smaller octagon and set inside a circle, which is circumscribed by two slightly larger circles, the outer one of which has a sixteen-lobed border. Large circular upper and lower pendants, with small leaf finials, complete the central medallion. The interior spaces between the gold tooled lines that define these forms are filled with punched knotwork motifs. The rectangular space of each cover is defined by a single gold-tooled line with a small knotwork triangle placed in each corner.[20] Although Khalili QUR159 is not dated, its illumination is very similar to that of QUR181, the section of the Fars Malik Khatun Qur'an that was illuminated for the Muzaffarid vizier Turan Shah, presumably in the 1370s. It is therefore possible to attribute, with some degree of certainty, all three bindings to the 1370s. However, the robust proportions, lobed border, and geometrically divided interior space of the large central roundel of each cover relate to early Injuid illuminated frontispieces (see figs. 1–2 and 4) and not to the motifs and aesthetic of Muzaffarid illuminations. The cover decoration is in fact a type frequently encountered on fourteenth-century manuscripts produced both within the broad confines of the Persian cultural sphere and within Mamluk domains, thus rendering it impossible, on the basis of these three (identical) bindings alone, to identify any specifically Shirazi traits.[21]

The third "group" of bindings in fact consists of a single example—the binding of the *Shahnama* dated 772/1371 (TS H. 1511; figs. 126a–b). The binding does not relate closely to any other known fourteenth-century binding, yet in terms of both decoration and technique it is completely acceptable as a product of the 1370s, suggesting that it is original to the manuscript it now protects. The decoration of the front and back covers and the doublures is basically identical; however, the covers are a medium tan leather, while the leather of the doublures is a soft rosy red. Each rectangular space is decorated with a tooled pointed-oval medallion with pendants, set against the plain leather ground of a rectangular space that is demarcated by several lines of tooling (one of these lines is a tiny S-tool cable, the others are straight lines or fillets). Set into each corner of the rectangular space is a quarter section of a cloud-collar motif. Both the central oval

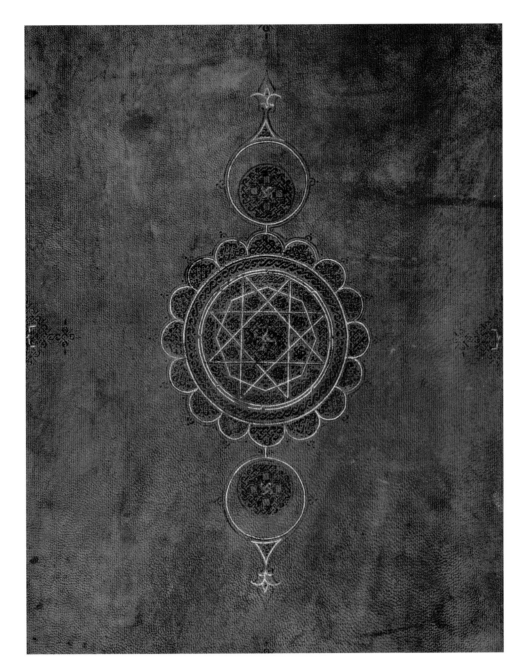

125. Detail of front cover, Qur'an, c. 1375, 42.8 x 30.9 cm (folio). Nasser D. Khalili Collection of Islamic Art, QUR181. © Nour Foundation. Courtesy of the Khalili Family Trust.

261

126a. Front cover, *Shahnama*, 772/1371,
26 x 16 cm (folio). Topkapi Saray Library,
Istanbul, H. 1511. Photograph by author.

126b. Detail of fig. 126a.

medallion and the cornerpieces are filled with blossoms and leaves. The binding is the typical Islamic type with an envelope flap, the decoration of the flap being a reduced version of that on the covers: set in the point of the flap is a small roundel filled with blossoms and with just one pendant, and each of the two inner corners of the flap are here, too, filled with a quarter section of a cloud-collar motif.

Center-and-corner compositions such as this, in which the cornerpieces are large and play a prominent role in the overall composition, are typical of Persian bindings from the early fifteenth century onward. On fourteenth-century and earlier bindings, it is usual that the (mainly triangular) cornerpieces are small and play a minor, even minimal, decorative role, as they do on the bindings of the two previous groups.[22] Nevertheless, the center-and-corner composition used on the 1371 binding clearly is not in itself an innovation but merely a development of an established type. Similarly, the specific type of cornerpiece (consisting of a quarter section of a cloud-collar motif) may also seem surprising on a purportedly fourteenth-century binding—but only until developments in other media are considered.

In the section entitled "Impetus for Change," in chapter 1, the impact of Chinese art, in general, and of the cloud-collar motif, in particular, on Persian art, especially in Shiraz under the Muzaffarids, was discussed. Mention was made of the illuminated frontispiece of a copy of the *Khamsa* of Amir Khusraw Dihlavi, dated 756/1355 (Tashkent 2179; see fig. 32), and of a wall painting in the tomb of Shams al-Din Muhammad in Yazd, dated 767/1365,[23] both of which make prominent use of sections of the cloud-collar motif to frame a central medallion, as on the *Shahnama* binding, though in both of these earlier examples the medallion is circular. These examples were cited in explanation of the use of the cloud-collar motif, in a less obvious form, in the illuminated headings of Muzaffarid manuscripts. One example not previously cited is especially pertinent to the current discussion, for it in fact occurs within the folios of the 772/1371 *Shahnama* itself. On folio 276a is a painting depicting an enthroned ruler. The octagonal blue throne upon which he sits is decorated with various gold motifs, the central one of which (partially hidden behind what appears to be a small set of steps) is a complete cloud-collar pattern, its first appearance in Persian illustration.[24] Therefore, by 1371 the cloud-collar motif was being used in both the illuminations and illustrations of manuscripts, so its prominent use on a binding at this same time is not the least bit surprising.[25]

Prior to the fifteenth century, central medallions, whether incorporated into a center-and-corner composition or standing alone, are most often circular (either framed, or not, by a series of semicircular lobes; see fig. 125); and circular medallions are also typical of fourteenth-century illuminations. Nevertheless, the use of pointed-oval medallions on a binding of the 1370s is not as unusual as it might first seem: not only are they the defining feature of the first group of bindings discussed here, that designated "generic" (see fig. 124), but they are also used as marginals in the sections of the Fars Malik Khatun Qur'an that were illuminated in the 1370s for Turan Shah (Khalili QUR181; see fig. 31).[26]

Many of the blossoms and leaves that decorate the *Shahnama* binding have close parallels in other Shiraz illuminations (see fig. 126b). For example, the oak-leaf-type form—placed prominently in the center of each oval medallion (and around which the whole composition revolves)—appears several times, in gold, throughout the undated, but probably 1340s, Khalili Qur'an (QUR242);[27] it can also be found, in red, in both a text-frontispiece of the Stephens *Shahnama* (see fig. 21) and in the central roundel of the frontispiece of the 1355 copy of the *Khamsa* of Amir Khusraw Dihlavi (see fig. 32). However, what looks like a leaf on the binding is clearly a blossom in these illuminations. Two types of rosettes are also used on the binding, one of which is a simple five-petal example (placed on the lower right side of the medallion), common in many styles of illumination; the other (placed on the mid-left side of the medallion) is more interesting and has six petals, the two lateral ones being slightly attenuated, giving the blossom a flattened appearance. The only rosettes similar to this latter type seem to be those used in the Jalayirid copy of Sultan Ahmad's *Divan*, dated 809/1407, on two folios of which the blossoms are placed on a crosshatched ground that creates the same effect as does the placement of the blossoms on the punched ground of the binding.[28] Another blossom—a small bud-like form (visible on the right side of the medallion)—consists of two lateral petals and a central trilobed petal; this bud (along with a similar one in the cornerpieces) is a distant relative of the distinctive butterfly-like blossom used in Muzaffarid illuminations (see fig. 33). In the lower end of the medallion is a large leaf-like blossom, similar to those used on some folios of the other late Injuid Khalili Qur'an (QUR182).[29] No parallels have been found for the rose-like blossom, set in the upper end of the medallion, but the three-toothed leaf springing from the top of it is, as seen previously, common in Shiraz illuminations and is found in each of the manuscripts cited above and in Muzaffarid illuminations. The particular version of the leaf used here, which has

a small protrusion extending from its lower edge, appears in the illuminations of the Stephens manuscript. Several other long (nontoothed) leaves on the binding are bent backward, adding a sense of depth and naturalism to the composition. This is in fact a highly distinctive feature of the vegetation of the Fars Malik Khatun Qur'an (Khalili QUR182), though leaves of this type are also found on a few folios of Khalili QUR242 (see fig. 30) and in the frontispiece of the Stephens *Shahnama* (see fig. 20). Although close fourteenth-century parallels for each individual blossom or leaf have not been located, enough exist to make the composition as a whole acceptable as a product of the later fourteenth century; certainly, there is no single motif that strikes one as odd and out of place for the time.

The decoration of the *Shahnama* binding also fits well within the corpus of fourteenth-century book production in terms of technique, because, like other bindings of the time, it was hand-tooled, presumably with the aid of a paper pattern and using an array of tools, including fillets, small stamps, and punches.[30] Therefore, in terms of both decoration and technique, the *Shahnama* binding can be explained and accepted as contemporary with the 1371 manuscript it today protects. It is, however, the specific combination of elements and motifs within the sphere of binding decoration that is innovative and that stands as evidence of yet another of the many developments in book production that took place in the second half of the fourteenth century and that, based on current evidence, can be attributed to Shiraz under Muzaffarid rule. It is, moreover, a development that had a strong and lasting impact on book production in the Islamic world, because, from the early fifteenth century onward, the most common type of composition for both covers and doublures is the center-and-corner composition in which the central medallion is a pointed oval and the cornerpieces are sections of the cloud-collar motif. It is, indeed, one of the most important developments in the history of Islamic book production.[31]

Binding Decoration in the First Decade of the Fifteenth Century

Not surprisingly, the covers of two of the earliest and most well-known manuscripts of the fifteenth century are each decorated with a center-and-corner composition consisting of a pointed-oval medallion in the center and quarter sections of a cloud-collar motif in the corners. The two manuscripts are the Freer Gallery of Art's *Divan* of Sultan Ahmad, dated 805/1402 and presumably copied in Baghdad (Freer F1932.29–37),[32] and the Topkapi Saray Library's Yazd Anthology, dated 810/1407 (TS H. 796; fig. 127). However, the covers of these two

127. Front cover, Yazd Anthology, 810/1407,
26 x 18 cm (folio). Topkapi Saray Library,
Istanbul, H. 796. Photograph by author.

manuscripts are very different from that of the 1371 *Shahnama*, largely because they were produced using a very different technique. The *Shahnama* cover was tooled, but the decoration of the covers of both the *Divan* and the Anthology was pressure-molded. On the *Shahnama* and other bindings of the same period, large areas of decoration were built up bit by bit using a variety of tools, including an array of individual stamps, each one carved with a single motif. For example, the speckled ground surrounding the blossoms and leaves (see fig. 126b) was created with a small stamp or punch, a tool with a small dot (or dots) on the end that was repeatedly hammered into the soft leather to produce the overall ground pattern. The creation of designs in this manner was typical of binding decoration in the fourteenth century and earlier. Stamps were also used on the *Divan* and Yazd Anthology covers, but they were shaped panel stamps, each composed of several different motifs. Thus the central medallion (see fig. 127) was created using a single large stamp. Another shaped and carved stamp was used for the cloud-collar cornerpieces and, for the pendants that extend from both the central medallion and the corner elements, there would have been two more stamps—a full-pendant stamp and a matching half-pendant stamp. And, of course, the "speckling" of the ground surrounding the animals and blossoms was no longer the laborious task it was in the fourteenth century, because now the speckled ground was a "built-in" feature of each stamp.[33]

For the next several centuries, the predominant method of decorating the covers of bindings would be through the use of panel stamps. On most bindings of this type, depressions in the shape of each stamp were carved into the hard pasteboard that forms the core of the cover. Prepared leather was pasted over the pasteboard (sometimes after an extra layer of paste had been poured into each depression), and the stamps were set in place and pressure was applied, forcing the carved pattern of the stamp into the soft leather. Details, in particular details of borders, were often then added using the "old" techniques of tooling and single-motif stamps.[34] The actual stamping process was therefore much quicker than in the fourteenth century, but any time gained at this stage was offset by the more laborious task of producing more complex stamps. So the new technique surely was not developed with the aim of economizing on time; rather, the advantage seems to have been that bookbinding decoration could now be brought closer to the realm of the painter by allowing more complex compositions, especially in terms of spatial depth, to be developed. By bringing the two media closer to-

gether, decoration of the book became a more integrated unit, for the compositions, individual motifs and elements, and conceptual approach of the illustrator and illuminator came to be used equally by the bookbinder.

A more pragmatic advantage of the use of panel stamps was reuse. Once the laborious task of carving the panel stamps was completed, any number of identical compositions—or variations on a composition—could be produced with comparative ease and speed. Although no evidence of mass reuse of stamps has survived, it was a possibility and surely occurred within the domain of commercial production at least. However, one example of the reuse of stamps at the highest level of production has been identified by Barbara Brend, namely, the *Divan* of Sultan Ahmad of 805/1402 and the Yazd Anthology of 810/1407, the covers of which have been produced using the same panel stamps. Brend has proposed two possible explanations for this occurrence: either the stamps somehow ended up in Yazd to be used a second time, or the earlier manuscript was itself taken from Baghdad to Yazd where both manuscripts were bound in the same atelier. She favors the second scenario.[35] One piece of evidence in favor of this scenario is that the only illumination in the *Divan* is a heading in the blue-and-gold floral style of Shiraz, the same basic style used in the Yazd Anthology. While use of the Shiraz-style in Yazd is not surprising, one would expect the *Divan* to employ the Jalayirid illumination style, as does the later copy of the *Divan* of Sultan Ahmad, also produced in Baghdad, in 809/1407 (TIEM 2046; see figs. 51–53). Perhaps the reason is that the two manuscripts—the *Divan* of Sultan Ahmad of 1402 and the Yazd Anthology of 1407—were both bound *and* illuminated in Yazd at the same time. Of course, such a suggestion assumes that the *Divan* left Ahmad's court in an unbound state, as its binding is unlikely to have become so damaged in so short a time as to require replacement.

The doublures of the *Divan* of 1402 and of the Yazd Anthology are also of interest because, unlike the tooled doublures of the 1371 *Shahnama*, they are decorated with filigree, or cutwork leather designs, placed against a colored ground.[36] This time the decoration of the two manuscripts is different, though on both it is restricted. On the doublures of the *Divan*, there is a central medallion in the shape of a pointed oval, framed by very small cloud-collar cornerpieces, each filled with a palmette-arabesque carefully cut from leather. On the front doublure of the Anthology, a small central medallion in the form of a complete cloud-collar is filled with a palmette-arabesque in filigree. On the back doublure, the filigree pattern

128. Detail of back doublure,
Yazd Anthology, 810/1407,
26 x 18 cm (folio). Topkapi
Saray Library, Istanbul, H. 796.
Photograph by author.

of the cloud-collar medallion consists of two foxes set among a bed of chinoiserie blossoms (fig. 128).[37] Although limited, on both manuscripts the workmanship is very refined and presumably not a first attempt at this new technique.

Much more complex is the filigree composition of the doublures of the later copy of Sultan Ahmad's *Divan*, dated 809/1407 (TIEM 2046). Although often cited as an early example of the use of filigree (fig. 129), the binding certainly is not original to the manuscript. Even taking into consideration the possibility that late fourteenth-century examples of the filigree technique have been lost,[38] the technique as used for the doublures of the *Divan* of 1407 is much too advanced in comparison with other examples of the early fifteenth century. In fact, another manuscript with identical covers and almost identical doublures exists in the same collection in Istanbul, attached to an Anthology of *Divan*s, copied in Yazd and dated 837/1433–34 and 840/1436–37 (TIEM 2009).[39] As will be discussed more fully below, all features of these two bindings are typical of Shiraz production from the 1430s until the 1450s at least: an extensive use of filigree for the doublures, covers tooled in a very shallow relief and with wide and intricate borders (fig. 130), and an abundant use of gold on both doublures and covers.[40] There can

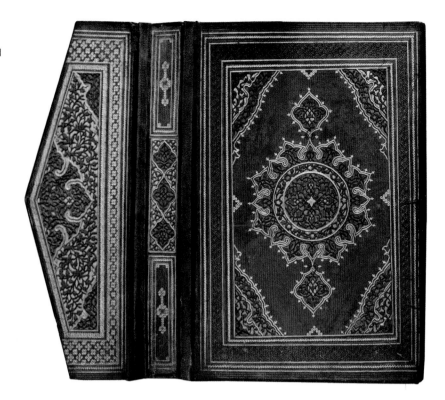

129. Back doublure, *Divan* of
Sultan Ahmad, manuscript dated
810/1407, Baghdad, but binding
added 1430s; 27 x 18.7 cm (folio).
Türk ve İslam Eserleri Müzesi,
Istanbul, no. 2046. Photograph
by author.

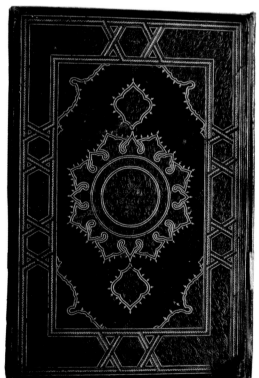

130. Front cover, *Divan* of Sultan
Ahmad, manuscript dated
810/1407, Baghdad, but binding
added 1430s; 27 x 18.7 cm (folio).
Türk ve İslam Eserleri Müzesi,
Istanbul, no. 2046. Photograph
by author.

therefore be no doubt that the Istanbul *Divan* of Sultan Ahmad of 810/1407 was bound, or perhaps rebound, in the 1430s, and that at the same time an almost identical binding was produced for a new manuscript, the Anthology of *Divans*, dated 837/1433–34 and 840/1436–37,[41] but whether this took place in Yazd, where the latter manuscript apparently was produced, or in Shiraz, seems impossible to determine, at least for the time being.

With the provenance of the binding of the 1402 Freer *Divan* in doubt, and as none of the other decorated manuscripts generally attributed either directly to Ahmad's patronage or simply to Baghdad during his reign has a contemporary binding, there is unfortunately at this time no evidence of the bookbinding practices of the artists and craftsmen working for Sultan Ahmad.[42]

Shiraz versus Herat: Bindings from the
Time of Ibrahim Sultan and Baysunghur

Definitive remarks on the distinguishing traits of bindings produced either in Shiraz or Herat and incorporating the "new" developments of pressure-molded covers, filigree doublures, and center-and-corner cloud-collar compositions are not yet possible, but some general observations can be made. In speaking initially of the first half of the fifteenth century as a whole, floral motifs are more common on bindings of Shiraz. This distinction is clearest if one compares the filigree doublures in manuscripts made for Baysunghur, such as a copy of *Kalila wa dimna*, dated 833/1429 (TS R. 1022; fig. 131), which tend to employ predominantly palmette-arabesques, with those made in Shiraz for his brother Ibrahim Sultan, such as a copy of the *Divan* of Amir Khusraw Dihlavi, dated 834/1430–31 (TIEM 1982; fig. 132). It is, however, a less certain method of distinguishing the two centers than in the case of illuminations. The filigree work in Baysunghur's manuscripts often seems to have a more lacquered finish than anything ever produced in Shiraz, and the motifs tend to be more densely wrought. Moreover, in both the *Kalila wa dimna* and in at least one other of his manuscripts (BL Or. 2773, 834/1431), the doublure is a deep red leather with the filigree placed over grounds of blue, gold, and green. By comparison, in Shiraz, pressure-molded covers were often used in conjunction with doublures of a more subdued palette, with filigree of a very dark brown or black leather set against a green ground, as in Ibrahim's *Divan*. Shiraz filigree is also distinguished by a greater use of gold to demarcate the contours of the main elements of the design.

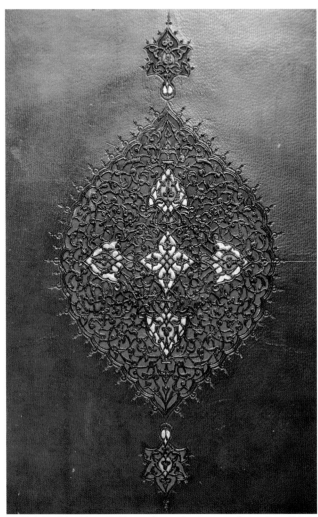

131. Detail of doublure, *Kalila wa dimna*, 833/1429, 29.6 x 19.6 cm (folio). Topkapi Saray Library, Istanbul, R. 1022. Photograph by author.

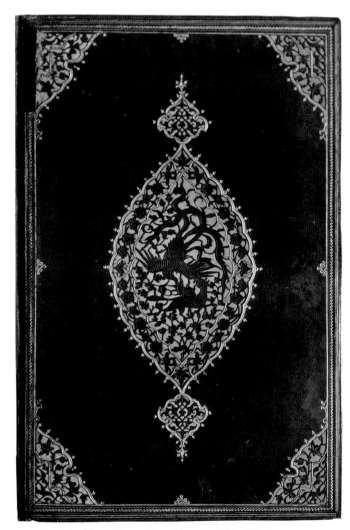

132. Front doublure, *Divan* of Amir Khusraw Dihlavi, 834/1430–31, 26.5 x 17.5 cm (folio). Türk ve İslam Eserleri Müzesi, Istanbul, no. 1982. Photograph by author.

Both centers are noted for a new use of animal motifs. In Shiraz, however, there appears to have been a greater propensity for the use of small groups (usually pairs) of animals or birds, as on the covers and doublures of Ibrahim's *Divan* (see fig. 132). Full-blown landscape scenes, in which numerous different types of animals are depicted, are used on the bindings of both centers but seem to be more frequently associated with Herat.[43] In each of these types of compositions, whether produced in Shiraz or Herat, chinoiserie animals and blossoms prevail, surely an important legacy (as suggested in chapter 1) of Iskandar Sultan, in whose manuscripts chinoiserie motifs often played a newly prominent role.

The Tooled Bindings of Shiraz

Late in the reign of Ibrahim Sultan, a new type of binding decoration emerged, coinciding with the other changes in book production that took place in Shiraz at this same time: tooling reemerged as a major technique for the decoration of covers. Compositions were again built up using a variety of tools (including single-motif stamps, punches, and fillets) but impressed lightly into the leather to produce flat, very low relief designs quite unlike the effect produced by the use of deeply carved panel stamps. An early but well-developed example of the new style is the binding of a copy of *hadith* (*Jami' al-sahih* of al-Bukhari), copied for Ibrahim in 832/1429 and now stored in the Bayezit Library in Istanbul (Feyzullah 489).[44] In the Chester Beatty Library, a very similar binding protects another collection of *hadith* (*Jami' al-usul* of Ibn al-Athir), produced slightly later, in 839/1435–36 (CBL Ar 5282; figs. 133a–b). The high quality of the binding in particular, which it would be difficult to exceed, suggests that this latter manuscript, too, is surely a product of Ibrahim's workshop. As it has been estimated that the binding might have taken up to five years to complete,[45] work on (or at the very least the planning of) the binding would likely have begun well before the prince's death in 838/1435. The covers of the two manuscripts are exquisite examples of the very shallow tooling that is typical of covers of this type. On each, the compositions are what one would expect in both Shiraz and elsewhere at this time: a central oval medallion with cloud-collar cornerpieces (with the addition of a whole cloud-collar motif delineated within the oval on the cover of the later manuscript). Distinctly Shirazi, however, is the predominant use of floral motifs, especially chinoiserie-style florals, the very wide knotwork borders, and the extensive use of gold to demarcate all major elements. These are all

133a. Front cover, *Jami' al-usul* of Ibn al-Athir, 839/1435–36, 34.5 x 26.5 cm (folio). © The Trustees of the Chester Beatty Library, Dublin, Ar 5282. The binding is currently placed on the manuscript "back to front"; therefore the cover reproduced here is what was *originally* the front cover.

133b. Detail of fig. 133a

features seen neither earlier nor on contemporary pressure-molded bindings of either Shiraz or Herat.

The filigree doublures of the Chester Beatty *hadith* manuscript (fig. 134) are likewise typical of Shiraz work of the time: a center-and-corner composition, though the cornerpieces are not sections of a cloud collar; wide knotwork borders; a rich tan leather from which the filigree pattern is cut and laid over grounds of blue, gold, and (in a few small areas) green; and, as on the covers, a liberal use of gold to outline all major elements of the composition. The manuscript's envelope flap is of course as lavishly decorated as the rest of the binding. However, while the exterior decoration of the flap is, as one would expect, a close variation of that seen on the two flat faces of the cover, the interior decoration of the flap does not mimic that used elsewhere on the doublures. Instead, in a particularly Shirazi fashion, it consists of an all-over, net-like diaper pattern of brown leather filigree laid atop a ground of blue and gold.

The decoration of most bindings of this type is much simpler than it is for the two *hadith* manuscripts; in particular, on the covers, the space between the central medallion and cornerpieces is usually left plain (as it is on the back cover of each of the *hadith* manuscripts).[46] However, the central medallion and other design elements may be almost completely gold tooled, as they are on a *Shahnama* manuscript dated 842/1439 (TS R. 1547; fig. 135). The *Kamil al-ta'bir* manuscript of 835/1432 (TS A.III 3169), which has been cited as the earliest example of the new floral/palmette-arabesque illumination style of Shiraz and also as the first Shiraz manuscript to employ the new wove-like paper, has retained its original binding, both the covers and doublures of which are especially simple, yet common, versions of their type. On each cover is a central shallow- and (completely) gold-tooled pointed-oval medallion, filled with blossoms and a palmette-arabesque; the very same medallion is used for the filigree doublures (figs. 136–37). The cornerpieces on the cover are not the elaborate sections of a cloud-collar motif typical of so many contemporary bindings but instead are smaller and much simpler quarter sections of an eight-lobed medallion. Even simpler are the small triangles filled with knotwork that fill the corners of the doublures of this and so many other manuscripts. In this very basic version of the type, the borders of the covers and doublures consist only of several narrow bands of decoration.

In keeping with the contemporary change in illumination style, the palmette-arabesque now plays a greater role on many of these bindings, although usually

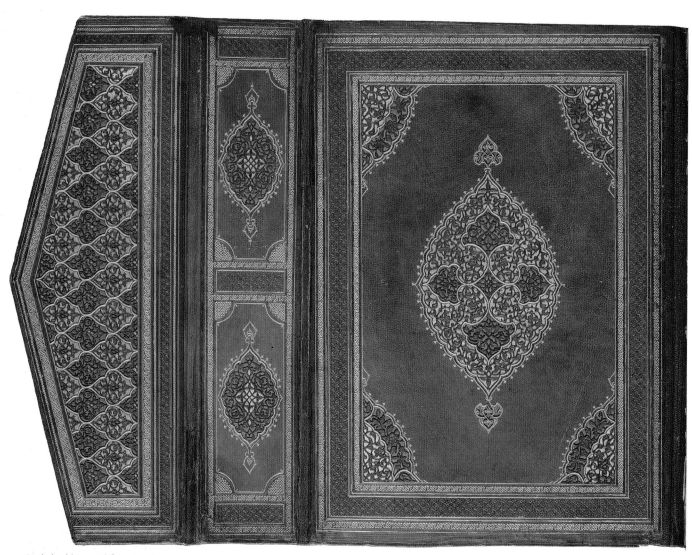

134. Back doublure and flap, *Jami'
al-usul* of Ibn al-Athir, 839/1435–36,
34.5 x 26.5 cm (folio). © The Trustees
of the Chester Beatty Library,
Dublin, Ar 5282. The binding is
currently placed on the manuscript
"back to front"; therefore the
doublure reproduced here is what
was *originally* the back doublure.

135. Front cover, *Shahnama*, 842/1439, 36 x 26 cm (folio). Topkapi Saray Library, Istanbul, R. 1547. Photograph by author.

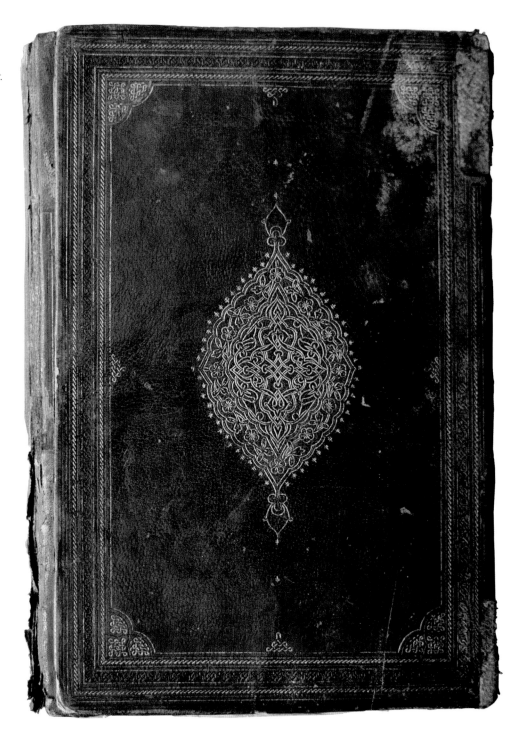

136. Front cover, *Kamil al-ta'bir*,
835/1432, 26.8 x 18 cm (folio).
Topkapi Saray Library, Istanbul,
A.III 3169. Photograph by author.

278

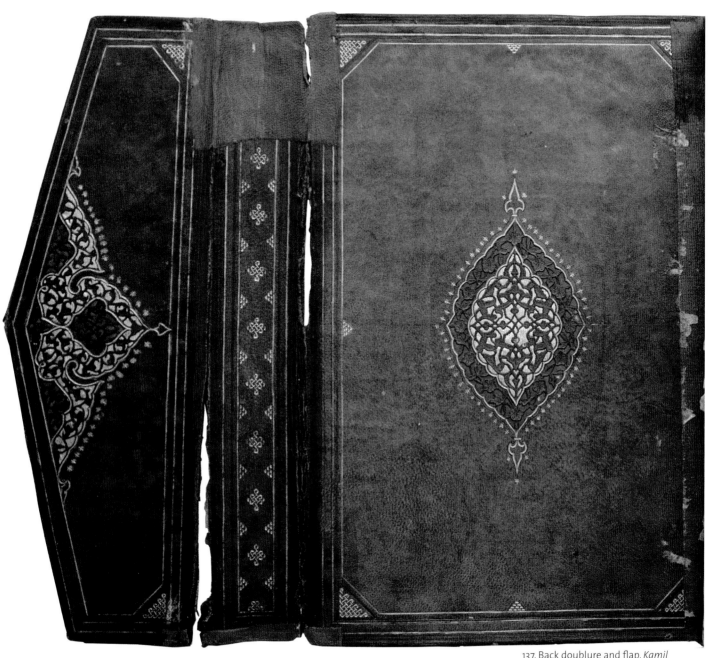

137. Back doublure and flap, *Kamil al-ta'bir*, 835/1432, 26.8 x 18 cm (folio). Topkapi Saray Library, Istanbul, A.III 3169. Photograph by author.

more so on covers than on doublures, where floral motifs may be used as, if not more, extensively than the palmette-arabesque (fig. 138). The leather of the doublures varies in color from binding to binding: sometimes it is the rich tan used for the binding of the Chester Beatty *hadith* manuscript, sometimes a deep chestnut or a purer medium-to-dark shade of brown, as was used for the binding of the 1432 *Kamil al-ta'bir* manuscript. The combination of colors used in this latter manuscript, of medium brown leather filigree laid atop grounds of blue and gold only, seems to be the most popular, especially in the latest examples, and it is one that produces a visually more somber and heavier effect than does the combination of colors used for the doublures of the Chester Beatty *hadith* manuscript (compare fig. 134 with figs. 137–38).

The filigree doublures of these bindings are clearly an evolution of the doublures produced earlier in the century, but the origin of the shallow-tooled covers is less clear. There is in fact evidence to suggest that, perhaps, as with the floral/palmette-arabesque illumination style and the new "wove-like" paper, there may be connections between the appearance of shallow-tooled bindings in Shiraz and contemporary book production in Herat. That this may be so is suggested by Baysunghur's *Kalila wa dimna* manuscript of 833/1429 (TS R. 1022), the covers of which are each decorated with a central pointed-oval medallion and cloud-collar cornerpieces. (The medallion on the front cover is filled with fighting animals, but the one on the back with a palmette-arabesque.) The binding is in fact extremely worn, making it impossible to make any definitive statement about how the decoration has been executed, but it does appear that it is the result of very shallow tooling. Likewise does the very similar composition on the covers of another Baysunghur manuscript—a *Chahar maqala*, dated 835/1431 (TIEM 1954)—appear to be the result of the same technique.[47] But even if the shallow-tooled bindings of Shiraz owe their origin to earlier examples produced in Herat, the technique apparently was only ever a minor aspect of Herat production, while in Shiraz shallow-tooled bindings were elevated to a position of prominence.

Production of these Shiraz bindings—both the tooled covers and the filigree doublures—was presumably highly labor-intensive, surprisingly so in an era when commercial production seems to have increased dramatically. Although various styles of filigree doublures continued to be used in both Shiraz and non-Shiraz manuscripts for centuries to come, the production of shallow-tooled covers was a comparatively short-lived phenomenon. Shiraz examples exist from the late 1450s at least,[48] but with the coming of the Turcomans to Shiraz, pressure-

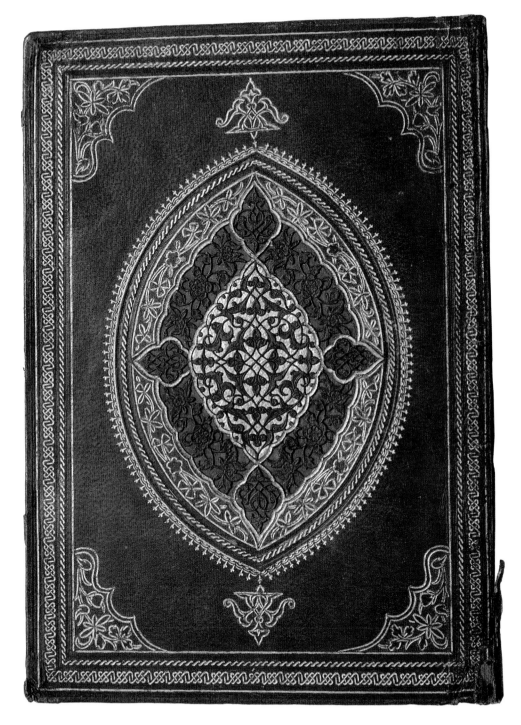

138. Front doublure, *Khamsa* of Nizami, 844/1440 and 846–47/1442–43, 18 x 13.5 cm (folio). Topkapi Saray Library, Istanbul, R. 862. Photograph by author.

molded covers again became the norm.[49] Thus, the pattern revealed in earlier chapters is mirrored in the field of bookbinding: the development of center-and-corner compositions, comprising a central pointed-oval medallion and cloud-collar cornerpieces, can be credited to Muzaffarid Shiraz and had a profound and lasting impact on manuscript production far beyond the borders of Shiraz; but the fashion for shallow-tooled bindings, which arose in Shiraz in the last years of Ibrahim's reign, was limited, both geographically and chronologically.

CHAPTER 6 A Chronological Overview

Three periods of especial interest in the history of book production in Shiraz have been revealed: the period of the late 1350s to the late 1360s, the years of Iskandar's governorship of Shiraz, and the decade following the death of Ibrahim Sultan. A fourth period, though one of lesser note, is that of the late Injuid era, the years following 1340. The preceding chapters took a basically thematic approach to the topic of book production, with a chapter each on illumination, codicology, illustration, calligraphy, and bookbinding. By comparison, a chronological approach is taken in this final chapter, the intent of which is to highlight the differences and similarities among the three main periods of change that have been identified. They will be discussed and compared in terms of the actual changes in the appearance of the book that occurred, the impetus for these changes, and the resulting geographical and chronological impact of the changes of each period. To a certain extent these points have already been dealt with in the preceding chapters, especially so for the final two periods of change. The period of the late 1350s and 1360s is, however, the most important in terms of the extent and impact of the changes introduced, and consequently it demands greater consideration; hence, this chapter will focus largely on that period.

THE ORIGINS OF THE CLASSICAL PERSIAN MANUSCRIPT: CHANGES OF THE LATE 1350S AND 1360S

A change in the visual aesthetics of manuscripts occurred in the fourteenth century, with decorated books of the second half of the century appearing overall more elegant and refined than those of earlier periods. An examination of manuscripts produced in Shiraz in the late 1350s and 1360s has revealed that the process of transformation that occurred involved a series of individual changes in the appearance of the book, with a change in one aspect of the book often having forced changes in other aspects. Although the impetus for individual (or sequences of related) changes is often difficult to discern, two factors appear to have been largely responsible for the overall change in aesthetics that took place: the impact of Chinese art and, especially, an apparent change in literary taste,

specifically the move from the production of manuscript copies of poetry of the heroic/historical-epic genre to an increased production of ones of the romantic-epic genre.

The importation into Iran of goods from China contributed to the development of the Muzaffarid illumination style: use of the cloud-collar motif (resulting in both deeply in-cut and more gently lobed cartouches), a dense application of forms, and an interest in light-on-dark patterns are all features of Chinese textiles, ceramics, and incised lacquer. Chinese landscape painting has been credited with the increasing interest in the exploitation of the surrounding environment as a narrative aid that is a feature of figurative painting of the first half of the fourteenth century. Further developments in this area probably encouraged the production in Shiraz of manuscripts in the romantic-epic genre, a genre better suited to illustrations of this type than is the heroic/historical-epic genre. The emphasis on the ethical and moral character of the lover-hero in poems of the romantic-epic genre imbue them with a tone very different from that typical of heroic/historical epics. It has been described as being, in a sense, a more sophisticated genre of poetry in that plots rely on insight into a character's psyche more than the simple recounting of heroic deeds and actions. Perhaps it is mere coincidence that the final stages in the development of *nasta'liq* script are associated with copies of the *Khamsa* of Nizami made in the 1360s, but the slanting strokes and more elegant nature of the script do seem better suited, aesthetically, to the general tone of romance poetry than are the seemingly more restrained, upright strokes of *naskh*. Certainly, the new script contributes in large part to the increased elegance and visual refinement of the book, as does the smoother, harder, and usually glossier finish of the paper, a change that enabled the pen to move more easily across the surface of the page. Coinciding, too, with the rise in the production of manuscripts of romance poetry was the move to folios and textblocks of smaller size and narrower, more elegant proportions, which then forced a move to the copying of poetry texts in just four columns instead of six. At the same time that these changes occurred, the blue-and-gold textblock frame, previously reserved for use in only the very finest manuscripts (almost always Qur'ans), became the standard textblock frame for all decorated manuscripts. Each of these changes—as well as the appearance of an illumination style in which finer, more delicate motifs prevail—contributed to an increased elegance of the book, and that each occurred at the same time as did the rise in the production of copies of the *Khamsa* of Nizami and other texts of this same

genre suggests that they may have come about, at least in part, through a desire to produce manuscripts, the visual aesthetics of which are more in keeping with the overall tone and seemingly greater sophistication of the poetry. Despite the impossibility of providing any firm evidence for such a proposition, the new popularity of manuscript copies of romance poetry does appear to have been one of two critical factors in the development of the classical Iranian manuscript. But what was the environment that occasioned this apparently new desire to possess a copy of romance poetry?

The Cultural and Political Milieu of Fourteenth-Century Shiraz

A high level of literary activity was a marked trait of court life in fourteenth-century Iran, from the 1330s—the time of Abu Sa'id—onward. This was, however, in contrast to the preceding years of Il-Khanid rule. Abu Sa'id and many of the Iranian rulers to succeed him, such as Abu Ishaq Inju and Shah Shuja' Muzaffar of Shiraz and the Jalayirid rulers of Baghdad, were avid patrons of poetry, often being accomplished poets themselves. Shiraz was the main center of literary activity, a reputation that rests largely on the talents of a single poet, Hafiz.[1] Like the numerous other poets who resided in the city from the time of Abu Ishaq and throughout the rule of Shah Shuja', Hafiz wrote in a wide range of poetical genres. His name is, however, most closely associated with the lyric *ghazal*, a genre that developed in the early years of the twelfth century but which is considered to have reached its zenith only in the second half of the fourteenth century, thanks to the talents of Hafiz, and at about the same time that manuscript copies of romance poetry became popular. The terms "the age of Hafiz" and "the age of the *ghazal*" are in fact both commonly used in reference to this period.[2]

In the romantic epic, the poet—speaking in the third person—uses love as a pretext for exploring other, related issues, but in the lyric *ghazal* he speaks in the first person of his own trials and tribulations of love,[3] which are now the sole *raison d'être* of the poem. Nevertheless, in both genres there is a greater sense of intimacy with, and insight into the mind of, the hero than in any heroic/historical epic or panegyrical *qasida*. For this reason, the conjunction in the second half of the fourteenth century of the move to the copying of romance poetry and the apogee of the composing of the lyric *ghazal* need not be seen as conflicting developments. In fact, seen as two levels of increasing intimacy between hero-lover and reader, or rather in terms of the secrets of the life of the hero revealed to the reader, it may even be that the flourishing of the *ghazal* helped in some small way

to spark the obvious increased desire to possess a copy of a classic of romance poetry.

Politically, the fourteenth century was a period of unrest. From the 1330s to the 1360s, Shiraz was continuously under the control of first the Injuids and then the Muzaffarids, but internecine fighting was usual during those years.[4] The political situation perhaps could be explained as having brought about a disillusionment with the ethos of the *Shahnama* in particular, which upholds the right to rule by descent, and then as having encouraged the production of manuscripts in the romance genre in which it is an individual's moral character, often his ethical and moral suitability to rule in particular, that is explored and held in high regard. Indeed, Julie Meisami comments that the aristocratic overtones of the panegyric *qasida*—and presumably the royal overtones of the *Shahnama* as well—held little appeal for the growing middle class of post-Il-Khanid Iran; more to their tastes were the lyric *ghazal* and, by extension (though Meisami herself does not suggest it), the romantic epic.[5] This would seem to suggest that it was a group other than royal or court patrons who encouraged the change in literary tastes reflected in the new preference for manuscript copies of romance poetry. However, the actual patrons of the clutch of early Muzaffarid manuscripts are not known, although, as noted previously, the translator and scribe of one of this group (though not a copy of romance poetry) was the personal physician of Shah Shujaʿ,[6] a fact that perhaps suggests some link with the court. In addition, the quality of the manuscripts' decoration also makes royal patronage a strong possibility.

It could be suggested that rulers of non-Iranian descent might favor the production of works that stress an individual's ethical suitability and moral right to rule over right to rule by descent, even though the production of copies of the *Shahnama* has long been considered a means by which non-Iranian rulers symbolically integrated themselves into the long chain of rightful rulers of Iran and, thereby, justified their sovereignty. The Muzaffarids were in fact an Arab family that had settled in Khurasan in the seventh century and then moved to Yazd at the time of the Mongol invasion. That seven centuries later they might still have considered themselves even slightly "foreign" is unlikely; certainly, they felt no immediate need to assert their right to rule through the commissioning of copies of the *Shahnama*, for the earliest extant Muzaffarid *Shahnama* is the Istanbul copy of 772/1371; instead, the early years of their rule are remarkable for the production of copies of romantic epics.[7]

Literary tastes might also have been affected by the increasing role that Sufism

played in Iranian society from the beginning of the fourteenth century. The interpretive function of the romantic epic is much more akin to the nature of Sufism than is the mere recounting of heroic acts and physical feats typical of the heroic epic. Some poems have distinct mystical overtones that fit especially well with Sufi ideals. In Nizami's *Haft paykar*, for example, "self-knowledge is announced as the explicit goal of the quest" that Bahram Gur embarks upon, as Meisami points out.[8] The tales related in the poem tell of his "spiritual progress from ignorance to wisdom, and from the stage of kingship by will (temporal kingship) to that of kingship by law (spiritual kingship), while the tales told by the seven princesses in the seven domes recount, in particular, his progress from spiritual darkness to illumination."[9]

Nizami composed his *Khamsa* in the late sixth/twelfth century, though the first examples of romance poetry appeared more than a century earlier, within the culturally sophisticated milieu of the court of Mahmud of Ghazna (r. 971–1030).[10] Meisami has succinctly portrayed the atmosphere of the time as one in which the "development of a new human image, set in the context of a dialogue examining the given truths—intellectual, social, religious . . . gave rise to the genre of romance, the vehicle for the literary expression of this dialogue in courtly society."[11] The appearance of the new genre is considered a reflection of "a growing disaffection with the social values embodied in the [heroic] epic," despite the fact that it was also during the reign of Mahmud that Firdawsi wrote the *Shahnama*.[12] Unlike the heroic epic, romance is a purely Persian genre, and it is perhaps of significance that the first examples of the new genre emerged under the tutelage of the Ghaznavids, for it was at the Ghaznavid court that Persian first came to replace Arabic as the standard language of the court and of literary expression.[13]

Thus the Ghaznavid court and that of the Muzaffarids in the 1360s were similar in that each was a center for new literary developments, and, more generally, each can be regarded as a court of considerable cultural sophistication. With respect to Shiraz, the latter statement is based on the concentration of poets residing in the city and known to have worked at, or for, the court, and also on the known personal interests and talents of Shah Shuja'.[14] Like many Iranian princes, his talents were wide ranging: he is said to have memorized the Qur'an by heart by the time he was nine, he was skilled in all the martial arts, and he was an avid patron of poets and other men of learning.[15] Hafiz was among the poets he is known to have patronized, though he much preferred the talents of the now less well known poet 'Imad al-Din of Kirman. He was in fact a poet himself and wrote verses in

both Persian and Arabic, and it is said that on occasion he even conducted his correspondence in verse.[16] A man of such interests surely would also have been a patron of finely decorated manuscripts.

Shiraz as a Center of Innovation

It has long been recognized that the appearance of the book underwent changes in the course of the fourteenth century, but the extent of these changes has been overlooked and attention has focused on changes in figurative painting and, to a lesser extent, calligraphy. Moreover, though changes in figurative painting are evident in several manuscripts that are undated but generally attributed to the 1360s and 1370s, credit for developments in this area has largely fallen to the artists of Sultan Ahmad Jalayir working in Baghdad in the final quarter of the century. Likewise has one of his scribes unduly been accorded recognition as the "inventor" of *nasta'liq*. One of the prime goals of this study has been to demonstrate the need to widen our view of artistic production, first by moving further afield from the traditional focus on production in the main political center of any given period, and second by enlarging the corpus of manuscripts studied to include those that are illuminated but not illustrated. The result has been a broader (though admittedly still incomplete) picture, especially of fourteenth-century manuscript production. Although the talents of the artists of Ahmad's court cannot be denied, their role in the evolution of the classical Iranian book is now better understood. Ahmad's artists and scribes may have perfected some of the various changes that took place, but there is no strong evidence that they initiated any of them.

To say that Shiraz played a greater role, initially at least, in the development of the classical Iranian book may seem almost heretical, and many may argue that the greater number of fourteenth-century Shiraz, as opposed to non-Shiraz, manuscripts to have survived has skewed the impression of events as presented here, because, based on the manuscripts now known, all changes are evident first in dated manuscripts made in Shiraz. Moreover, the decade from the late 1350s to the late 1360s has emerged as the period of most critical change, although change was generally a gradual process; thus, the transformation of the appearance of the book occurred much earlier than once thought. As more manuscripts are discovered, many specific points made here may need to be altered, more or less, but the general thesis—that it was Shiraz artists, scribes, and craftsmen who at the very least initiated the changes—will surely hold. This supposition is supported by the evidence of the fifteenth-century document stating clearly that it was the scribes

of Shiraz who initiated the developments in *nasta'liq* and that the scribes of Baghdad merely picked up on and then perfected what their Shirazi counterparts had begun—a picture of the development of *nasta'liq* that accords precisely with the visual evidence of the manuscripts themselves. Furthermore, from what we know of the talents of Shah Shuja', there is no reason to regard the atmosphere in Shiraz and specifically at its court as any less cultured and thus any less likely to serve as a so-called trendsetter in the arts than any other contemporary court.

THE PERIOD OF CHANGE UNDER ISKANDAR SULTAN

The second main period of change is associated with Iskandar Sultan's tenure as governor of Shiraz and Isfahan. This period can be considered something of an aberration in terms of the overall development of book production in Shiraz because, despite the several changes that took place, only the motifs of his chinoiserie illuminations had a lasting impact, and this in the area of bookbinding not illumination. It was instead in Herat, in the ateliers of his cousin, Baysunghur, and his uncle, Shah Rukh, that the impact of his manuscripts was greatest, serving as they did both as one of the means by which the Jalayirid illustration and illumination styles reached the capital and as a model of the propagandistic potential of manuscripts. That the "normal" development of Shiraz styles was not interrupted by Iskandar's period of patronage is proven by the existence of a manuscript, now divided between Istanbul (TIEM 2044) and Lisbon (LA 158), bearing his name and illuminated only in the blue-and-gold floral style, as well as by the single *Shahnama* illustration executed in the so-called basic Shirazi mode (TS B. 411, f. 161b; see fig. 92). Thus, the picture that evolves is of the introduction and practice of the Jalayirid style, presumably undertaken both by former Jalayirid artists living in Shiraz as well as by local artists working in the style, while the use and development of basic, pre-Iskandar Shiraz styles of illumination and illustration continued, apparently unimpeded by the presence of Jalayirid artists in the city. The Jalayirid style, associated with the court, seems never to have developed the force to affect the development of these Shiraz styles, and while many of Iskandar's illuminations can be considered Muzaffarid-Jalayirid blends, it was only a temporary marriage of styles. The present evidence suggests that the demise of Iskandar meant the demise of the Jalayirid style in Shiraz. With the exception of bindings, manuscript production in the city in the years immediately following his death seems to have continued almost as if Iskandar and his artists had never existed.[17]

Iskandar's incentives for patronizing book production were in many ways very different from those of his cousin Ibrahim Sultan. Iskandar appears to have been more purely politically motivated, and for him the production of fine manuscripts was one means of asserting his sovereignty. Ibrahim's patronage was not totally apolitical, as proven by his patronage of historical accounts of the Timurid dynasty in which the line of decent from his father, Shah Rukh, is emphasized, and also by the addition of the frontispieces to his *Shahnama*. But he does seem to have been very much more interested in the actual process of book production *per se*, specifically in the apt telling of a tale through the careful illustration of it. This was an interest that surely evolved from personal skills, for surviving manuscripts and historical accounts attest to his proficiency as both calligrapher and illuminator. By comparison, no accounts of Iskandar's skill as an artist, and certainly no manuscripts either copied or illuminated by him, have survived, if indeed he ever produced any.

THE DECADE OF CHANGE FOLLOWING THE DEATH OF IBRAHIM SULTAN

The third period of change that this study has dealt with is that concentrated in the years 839–48/1435–36 to 1444–45, the decade following the death of Ibrahim Sultan. Some of the changes of these years, specifically in the areas of illumination, bookbinding, and paper production, were in fact introduced prior to his death. Their introduction to Shiraz, apparently from Herat, has been attributed to Ibrahim's more open and less politically motivated attitude toward manuscript patronage, this time in comparison with that of his brother Baysunghur. The move to commercial production and the overall increase in production were, on the other hand, a result of the death of Ibrahim and the demise of his patronage.

The broad question of commercial production is a matter only briefly touched upon in the course of this study, yet one well worthy of further study. It has been suggested here that the majority of early Injuid manuscripts to have survived were produced commercially, while most of those of the late Injuid era are the result of court patronage. Shiraz was therefore a center of commercial production by the early years of the fourteenth century, at least. Presumably it continued as such throughout the fourteenth and early fifteenth centuries, for it has long been recognized that during the second half of the fifteenth century Shiraz functioned as a major center of commercial production. The change in patronage after the

death of Ibrahim thus should be regarded as a resurgence of, rather than a move *per se* to, commercial production.

The factors occasioning rises and falls in commercial production need to be considered. For example, the death of Ibrahim and the apparent dispersal of his atelier meant that artists and craftsmen formerly in his employ were suddenly in need of employment. Presumably they were forced to produce a greater number of less luxurious manuscripts in order to maintain an income equal to that which they had received in the prince's employ. Often these manuscripts are, however, less luxurious not so much in terms of quality but rather because their illustration programs are less original than would be usual for a court manuscript, and also because they are less extensively decorated, for many are only illuminated. The flood of manuscripts onto the market may in itself have stimulated buying. Equally, the example of the late prince as a connoisseur of fine manuscripts may have served as an impetus to purchase the then more readily available manuscripts. It has not, however, been possible at this time to determine other social or historical factors that might have occasioned commercial production in the years following Ibrahim's death or, for that matter, in any earlier period.

Little is also known regarding the actual logistics of producing manuscripts for commercial sale. It is recorded that in Shiraz in the sixteenth century, a complete manuscript could be produced in a single home, for often each member of a family was skilled in a different aspect of book production.[18] It is not known, however, if this held true as well for the fourteenth and fifteenth centuries. Perhaps commercial ateliers existed that were basically cooperatives, comprised of artists functioning as a group as they would in a court atelier but instead working for themselves to produce manuscripts for the local market. It is also not known how closely bound to the court artists were. In the late sixteenth century, artists apparently could work for the court as well as produce work to sell in the market. Could they do so in the fourteenth and fifteenth centuries also? This question of course raises the question of *nisba*s and of whether or not a manuscript signed by an artist or scribe designating himself, say *al-sultani*, can be securely accepted as made for the prince in question. The *arzadasht* written by the scribe Ja'far, as head of Baysunghur's atelier in Herat, has shed much light on the workings of a court atelier, but much remains to be learned of the basics of how and where both court and commercial manuscripts were produced.

The impact on later manuscript production of the two later periods of change—associated with Iskandar on the one hand and Ibrahim on the other—

was quite different. The changes effected under Iskandar had a much greater and more long-term effect on manuscript production in Herat than in Shiraz. By comparison, the changes that came about either during Ibrahim's era, or as a result of his death, were mostly limited to Shiraz. Neither the immediate nor long-term impact of the changes of either of these periods could, however, equal the impact—both chronological and geographical—that the changes effected during the course of the fourteenth century had on Persian manuscript production as a whole. Many of the changes were gradual and evolved over several decades; nevertheless, the late 1350s and the 1360s stand out as the period of most critical change. It was at that time that what was to come to be regarded as the classical Persian book took form—that form of the book so admired by later generations both within and beyond the boundaries of Iran.

The original intent of this study was to examine the physical appearance of a fifteenth-century Islamic book produced in Shiraz and to determine, quite simply, why it looks the way it does. To do so, manuscripts of the preceding century—and also those produced at the Il-Khanid and Timurid courts—needed to be examined as well, and, significantly, a broader, more comprehensive examination of the book than is usual needed to be undertaken. As a result, this study differs from most manuscript studies in two key ways. First, the corpus of manuscripts examined is broader than is usual, because it includes manuscripts that are illuminated, only, in addition to ones that are also illustrated. Second, and more significant, is the consideration of the book as a complete entity, and thus, instead of a focusing on only one or two aspects of the book, illumination, codicology, illustration, calligraphy, and bookbinding have all been studied. That the changes that took place in the "look of the book" were so varied and extensive is surprising, but more surprising—and very intriguing—is how interrelated many of them were, with a change in one component of the book often having forced changes in others. More important, however, is the revelation that there were three main periods of change (the period of the late 1350s and 1360s, the period of Iskandar Sultan's governship of Shiraz, and the decade following the death of Ibrahim Sultan) as well as a fourth, more minor, one (the late Injuid era).

Change is a complicated process. At times it is as much the result of accidents of history—of time and place—as it is the result of conscious decision-making, and when conscious decisions are made, they often are not the result of free will but rather are more or less forced upon the individual or individuals who make them. Thus, artists and artisans forced by chaos and turmoil in their home cities to seek new sources of patronage elsewhere may unconsciously, or not, introduce elements of book production from one center into another, as was the case in the late Injuid era when traits typical of Il-Khanid illumination were introduced into manuscripts produced in Shiraz. Change may be the result of gradual developments made by a group of individuals, as in the case of the development of *nasta'liq* script in the fourteenth century, but a single individual or event can also be the cause of change, as in the mid-1430s when the death of Ibrahim Sultan

brought about a move to, or increase in, commercial production. Studying the actual process of change has provided glimpses into the working of the collective mind of the artists and scribes of Shiraz; for example, over time there developed an increasing sophistication in the use of a stepped format for illustrations, while the move from the use of the three-sided marginal column textblock to one with a marginal column on just one side demonstrates an obvious loss of understanding of the original, intended function of such textblock formats. Change can, however, be countered by continuity: the same basic traits present in illustrations produced throughout the course of the time span of this study (with the exclusion of the period of Iskandar Sultan's governship of Shiraz) allowed a basic Shirazi mode of figurative painting to be identified.

Despite the fact that the chronological and geographical impact of the changes revealed in this study varied, an important result of the study is a reassessment of the role that Shiraz played in Iranian book production, especially in the formation of what would come to be regarded as not merely the classical Persian but indeed the classical Islamic manuscript. This reassessment would not have been possible had a more limited approach to the subject been undertaken. Therefore, although one cannot deny the value of studies focused on a single aspect of book production, perhaps the most significant result of this study is the demonstration of the importance of treating the book as a complete entity, as a sum of its parts, rather than as something always to be divided and its various parts studied individually.

1. MANUSCRIPTS EMPLOYING THE THREE-SIDED-MARGINAL COLUMN TEXTBLOCK FORMAT

Multi-Author/Poet Manuscripts

TIEM 1950, Anthology, 801/1398

Lisbon LA 161, Anthology, 813/1411

BL Add. 27261, Anthology, 813–14/1410–11

TIEM 2044, Anthology, 815–16/1412–13

BL Add. 27259, Anthology, 821/1419

Berlin-MIK I.4628, Anthology, 823/1420

BL Or. 8193, Anthology, 835/1431

BOD Elliott 121, *Divan*s of Amir Khusraw Dihlavi, Hasan, Kamal, and Hafiz, 839/1435–36

BL Or. 3486, Anthology, 841/1437–38

CBL Per 178, *Divan*s of Hafiz and Ibn Yamin, the *Ruba'iyyat* of 'Umar Khayyam, and *Khulasa-i jamshid* (an anonymous arrangement of sections of the *Khamsa* of Nizami), n.d., but early sixteenth century

Dual-Poet Manuscripts

BN Supp. pers. 584, Poems from the *khamsa*s of Nizami and Amir Khusraw Dihlavi, 800/1398

BL Or. 2833, *Zafarnama* of Hamdallah Mustawfi Qazvini and the same author's recension of the *Shahnama*, 807/1405

BL Or. 13802, *Khamsa* of Nizami, 824/1421, with poems of Amir Khusraw Dihlavi added in margins in 838/1435

TS H. 789, *Khamsa*s of Nizami and Amir Khusraw Dihlavi, 841–42/1439

CBL Per 138, *Kulliyyat* of Katibi and *Zad al-musafirin* of Amir Husayni, 868/1464

CBL Per 153, Poems of 'Attar and *al-Mathnawi al-ma'nawi* of Rumi, 881/1476 (with two marginal columns)

BL-IOL Ethé 976 and 1200 (IOL no. 387), *Khamsa*s of Nizami and Amir Khusraw Dihlavi, n.d., late fifteenth–early sixteenth century

Single-Poet Manuscripts

Berlin-SB Minutoli 35, *Khamsa* of Nizami, 764/1362 and 765/1363

BN Supp. pers. 816, *Kulliyyat* of Sa'di, 786/1384

FITZ McClean 199, *Bahiyya-i naqiyya* of Amir Khusraw Dihlavi, 800/1397–98

TIEM 2046, *Divan* of Sultan Ahmad, 809/1407

Lisbon LA 168, *al-Mathnawi al-ma'nawi* of Rumi, 822/1419

BOD Elliott 191, *Khamsa* and poetical love letters of Amir Khusraw Dihlavi, 840/1436–37

BOD Pers. e. 26, *Kulliyyat* of Sa'di, 840/1437

Sackler S1986.34, *Khamsa* of Khwaju Kirmani, 841/1437

CBL Per 123, *Kulliyyat* of Sa'di, n.d., but c. 1440

BL Or. 5012, *al-Mathnawi al-ma'nawi* of Rumi, 844/1440

TS R. 434, *al-Mathnawi al-ma'nawi* of Rumi, 849–50/1445–46

BOD Ouseley Add. 39, *Kulliyyat* of Sa'di, 856/1452

Sotheby's, 22 October 1993, lot 147, *Bustan* of Sa'di, 864/1459

CBL Per 143, *Kulliyyat* of Khwaju Kirmani, 873/1468

CBL Per 145, *al-Mathnawi al-ma'nawi* of Rumi, 874–75/1470

BOD Elliott 48, *Kulliyyat* of Da'i, 879/1474

CBL Per 171, *Khamsa* of Nizami, 897/1492

BL-IOL Ethé 1432, *Kulliyyat* of Ahli Shirazi, n.d., but late fifteenth–early sixteenth century

CBL Per 217, *Gulistan* and *Bustan* of Sa'di, n.d., but c. 1550

BL Add. 24944, *Kulliyyat* of Sa'di, 974/1566 (with two marginal columns)

Sackler S1986.45, *Kulliyyat* of Sa'di, 995/1587

Sackler S1986.483, *Khamsa* of Nizami, 1055/1645

2. MANUSCRIPTS EMPLOYING THE ONE-SIDED-MARGINAL COLUMN TEXTBLOCK FORMAT

TS H. 796, Anthology, 810/1407

CUL Browne V.65 (7), Anthology, 827/1424

Vienna, N. F. 382, *Humay u humayun* of Khwaju Kirmani, 831/1427

StP-HM VR 1000, *Khamsa* of Nizami, 835/1431

TS H. 898, *Khamsa* of Amir Khusraw Dihlavi, 850/1446

CBL Per 275, *Kulliyyat* of Sa'di, 852/1448

CBL Per 133, *Kulliyyat* of Sa'di, 856/1452

BL Or. 6634, *Hallajnama* of 'Attar, 861/1457

TS E.H. 1239, *al-Mathnawi al-ma'nawi* of Rumi, 862/1457

BOD Elliott 216, *Kulliyyat* of Katibi, 873/1469

CBL Per 160, *Mantiq al-tayr* of 'Attar, n.d., but late fifteenth century[*]

TS H. 831, *Mihr u mushtari*, 905/1499–1500

BOD Elliott 224, *Kulliyyat* of Sa'di, 918/1512

BOD Fraser 73–75, *Kulliyyat* of Sa'di, n.d.

TS H. 748, *Kulliyyat* of Sa'di, 920/1514–15

CBL Per 202, *Kulliyyat* of Sa'di, n.d., but c. 1535

[*]The marginal column of this manuscript is treated in a highly unusual manner: it is divided horizontally into four columns; the lines of script are therefore not written obliquely but rather they run perpendicular to the horizontal script of the two central columns. As would be expected, each couplet is spread over two columns.

The usually frustrating and often incomprehensible translations of George Warner and Edmond Warner (1905–12) have been used to varying degrees, and references to them are included here for the reader's convenience only. The printed version of the *Shahnama* text used is that of Jules Mohl (1994). In the translations that follow, generally, each line of the English translation corresponds to one hemistich (or column line) of the Persian text.

2.1

Rustam Kills the White Div
Shahnama of Ibrahim Sultan, n.d., but late 1420s or early 1430s
BOD Ouseley Add. 176, f. 71a
Mohl 1373/1994, pp. 306–07
Warner and Warner 2:60–61
fig. 108

Upper Textblock

Couplets in nonstepped area:
1. The space between them narrowed,
 And like a great elephant and an enraged lion
2. They battled and cut each other's flesh,
 The earth turning red from their blood;
3. Rustam said to himself, "If I survive this day,
 I will live forever."
4. Now, the White Div in turn said to himself,
 "I despair of this sweet life,
5. For if I escape the claws of this dragon,
 With my skin and flesh all cut,
6. Neither young nor old in Mazandaran
 Will regard me as a hero,
7. For we do not see the world through the eyes of the soldier
 Or through those of the brave lion
8. Whose lives [heads]
 Are seized by the claws of death."
9. Rustam struck the div with his hand, and, with the
 strength and fury of a lion, grabbed it,
 Pulled it up by the neck, then threw it downward;
10. Like a ferocious lion, he flung the div onto the ground,
 Forcing its soul to depart from its body;

Couplet in step:
11. Thrusting his dagger deep into the div's heart, he then tore
 open its body,
 And ripped out the creature's liver.

Lower Textblock

Couplet in step:
12. The body of the dead div so completely filled the cave
 That it was transformed into a veritable sea of blood.

First two couplets of nonstepped area:
13. Rustam [then] went and tied his royal lasso to his saddle,
 Having untied the ropes binding Ulad;
14. He presented Ulad with the div's liver,
 Then bowed his head [and headed off] toward Shah Kavus.

2.2

Rustam Kills the White Div
Shahnama of Baysunghur, 833/1429–30
Gulistan no. 716
Mohl 1373/1994, pp. 306–07
Warner and Warner, 2:60–61
fig. 109

Upper Textblock

Couplets in nonstepped area:
1. Now, the White Div said [in turn] to himself,
 "I despair of this sweet life,
2. For if I escape the claws of this dragon,
 With my skin and flesh all cut,
3. Neither old nor young in Mazandaran
 Will regard me as a hero."
4. Rustam struck the div with his hand, and, with the
 strength and fury of a lion, grabbed it,
 Pulled it up by the neck, then threw it downward;
5. Like a ferocious lion, he flung the div onto the ground,
 Forcing its soul to depart from its body;

6. Thrusting his dagger deep into the div's heart, he then tore
 open its body,
 And ripped out the creature's liver;

Couplets in step:
7. The body of the dead div so completely filled the cave
 That it was transformed into a veritable sea of blood.
8. Rustam went and untied the ropes binding Ulad
 And then tied his royal lasso to his saddle.

Lower Textblock

9. He presented Ulad with the div's liver,
 Then bowed his head (and headed off) toward Shah Kavus;
10. Ulad said to him, "Oh, you lion,
 You brought down the world with your sword,
11. Your lasso has left its marks upon my body,
12. This brings joy to my heart,
 And also hope to my heart,
13. For to break one's promise would not be not worthy
 Of one of such strength and radiance."
14. Rustam said to him, "Mazandaran
 I give to you, from border to border,
15. There is much work and toil ahead,
 Along with many ups and downs:
16. The shah of Mazandaran must be seized from his throne,
 And thrown in a pit;
17. And the heads of thousands and thousands of sorcerer divs
 Must I seize by the weight of my sword."

2.3
The Murder of Siyavush
Shahnama of Ibrahim Sultan, n.d., but late 1420s or early 1430s
BOD Ouseley Add. 176, f. 116a
Mohl 1373/1994, p. 527
Warner and Warner, 2:320
fig. 110

Upper textblock

Couplets in nonstepped area:
1. [Siyavush prayed to God], "Bring forth from my seed a branch,
 Like the shining sun to all the multitudes,
2. Who will wreak my revenge upon my enemies,
 Reinstate my customs within the land,
3. Bring the world, one by one, under his control,
 And bring all the arts of man to his place."
4. Pilsam then came up behind him [Gurvi],
 His eyes full of blood and his heart full of grief;
5. Siyavush said to him, "Farewell!
 May the earth be the warp and you the weft;
6. Bid Piran farewell for me,
 And tell him that the world has changed;
7. I had not hoped for anything of this sort from Piran,
 For his advice was like the wind and I like the willow,
8. He told me that with his hundred thousand
 Soldiers in mail, all mounted on armored horses,
9. He would, when the day arrived, be my defender,
 Like a meadow for one in need of pasture;
10. But now I am here, put to shame before Garshivaz,
 As I stumble along, my soul wretched and filled with sorrow;
11. I do not see a friend—no one
 Who will weep for me."
12. Once he was past the city and the army,
 They dragged him out onto the plain;
13. A shining sword from Garshivaz
 Gurvi received, for the killing [of Siyavush];
14. He dragged the prince by the hair
 Until they reached the spot,[1]
15. And threw that formidable elephant [Siyavush] to the ground,
 Feeling neither shame nor fear;

Couplets in step:
16. Setting a round, gold basin onto the ground,
 He twisted Siyavush's head as though he were a sheep,
17. And cut off the head of that fair cypress,
 All the blood from his body running into the basin.

[1] The two couplets explaining the significance of this specific location have
been omitted; to compare with the text of Baysunghur's manuscript, see
app. 2.4.

Lower Textblock

18. To the place he had been ordered to do so, Gurvi carried the bowl of blood,
 And turned it upside down;
19. The blood from the head of the innocent poured down,
 At a place where nothing grew;
20. [But] at that moment, a plant sprung forth from the blood,
 At that spot where the basin had been emptied;
21. I will now show you the plant
 Which is called the Blood of Siyavush,
22. For many roots grew
 From the blood of that moon-faced one;
23. When the sun turned away from that cypress root,
 The head of the king fell asleep,
24. And such a sleep it was that much time passed,
 And never did it move or wake again;
25. A wind of black dust rose up,
 And hid both sun and moon,
26. No one could discern another's face,
 And so they cursed Gurvi—
27. For when a king has left his throne,
 Let there be neither sun nor cypress!

2.4
The Murder of Siyavush
Shahnama of Baysunghur, 833/1429–30
Gulistan no. 716
Mohl 1373/1994, p. 527
Warner and Warner, 2:320
fig. 111

Couplets in nonstepped area:
1. He [Gurvi] dragged him [Siyavush] by the hair
 Until they reached the spot,
2. Where on that day Garshivaz was defeated in the shooting bout:[2]
3. He threw that formidable elephant [Siyavush] to the ground,
 Feeling neither shame nor fear;
4. And setting a round, gold basin onto the ground,
 He twisted Siyavush's head as though he were a sheep,

[2] This appears to refer to the episode of Siyavush displaying his skills before Manuchihr, when Garshivaz was embarrassed before the king because he was unable to string and shoot Siyavush's bow.

Couplet in step:
5. And cut off the head of that fair cypress,
 All the blood from his body running into the basin.

2.5
Faridun before His Sons in the Form of a Dragon
Shahnama, 731/1330
TS H. 1479, f. 11b
Mohl 1373/1994, p. 104
Warner and Warner, 1:187
fig. 112

Upper Textblock

Couplets in upper (nonstepped) line (response of the first son):
1. "If you have heard the name of king Faridun,
 Do not attempt to engage us,
2. For we are his children—all three of us his sons,
 Each ready to wield the mace and eager to do battle;
3. Unless you turn from this path,
 I will crown you royally."[3]

Couplet in second line, divided between steps:
4. Once Faridun the Auspicious had heard and seen this
 [i.e., his sons' various responses to the dragon],
 He knew [what he needed to know] and so disappeared.

Lower Textblock

First four lines:
5. He departed and then returned before his sons,
 With due ceremony and in his own form—
6. With wondrous drums and large and fierce elephants,
 Grasping his bull-headed mace,
7. And with the commanders of his army behind him,
 The world was fully at his feet;
8. When the commanders saw the face of the shah,
 At a run, they dismounted,
9. And, going to him, they kissed the ground,
 Bewildered by the noise of the elephants and drums;

[3] Meaning, "I will strike you upon the crown of your head."

10. Faridun greeted each one,
 According to his proper rank;
11. When he returned to the royal palace,
 Before the world he went to god,
12. And offered up bounteous praises to the Lord,
 From whom he saw [met] both the good and the bad of
 the world;
13. He then summoned his three sons,
 And seated them upon the royal throne,
14. Thus saying that the furious dragon,
 Who wanted to burn the world with its breath
15. Was your father, who was seeking [to prove] your bravery,
 And when this was known, he returned, gladdened;
16. Now with this knowledge I have chosen names for you—
 names worthy of princes.

2.6
Rustam and Kay Khusraw Enthroned
Shahnama, 731/1330
TS H. 1479, f. 89b
Mohl 1373/1994, p. 857
Warner and Warner, 3:329–30
fig. 113

Upper Textblock

Last full line above the illustration:
1. They erected a tree by the king's throne
 To shade both crown and throne;
2. Its trunk was of silver and its branches of gold,
 Encrusted with precious gems of every sort,
3. And decorated with emeralds and agates
 That hung from its branches like earrings,

Couplets of the upper steps (two two-column-wide spaces, with
the second hemistich of each couplet immediately succeeding the
first hemistich):
4. All fruit of gold, oranges and quinces, the middles of which
 were hollow,
5. And filled with ground musk
 And sides pierced like a nay [flute];

6. When the king sat upon his throne,
 The scent of musk was scattered about by the breeze;
7. All were gathered before him, sipping wine,
 And on each head was a crown of jewels;
8. Clothed in robes of Chinese silk brocade,
 All stood before the king,
9. Wearing necklaces and earrings
 And robes covered with fine gems;

Couplets of lower steps (two one-column-wide spaces, with the
two hemistichs of each couplet separated by the illustration):
10. All faces shone like colored Greek brocade,
 Like shining lutes and singing harps;
11. Each heart was filled with gladness, with wine in hand;
 Faces were flushed, but not from drunkenness;[4]
12. The king ordered Rustam to approach the throne,
 And to sit in that place [with him] under the tree.

Lower Textblock

First line:
13. Thus the exalted king then said to Rustam,
 "Oh, you of noble stock, good fortune to you!
14. You are the shield that stands between Iran and all evil,
 Always, like the Simurgh, with your wings outstretched,
15. Whether in support of Iran or of its kings,
 You are in the midst of all trouble."

2.7
The Daughter of Haftvad Finds a Worm in Her Apple
Shahnama, 741/1341
CBL Per 110, f. 60b
Mohl 1373/1994, pp. 1511–12
Warner and Warner, 6:232–34
fig. 114

Upper Textblock

First five couplets of the story (which begins with the first couplet
to the upper left of the subheading):
1. Know the wonder of which the dihqan spoke!
 He revealed the hidden secret

[4] Rather, presumably, from joy and happiness.

2. Of the city of Kujaran by the sea of Pars,
 While speaking of the height and breadth of Pars.
3. It was a most well-populated city,
 And it was only by great toil did everyone survive;
4. In that city were many girls,
 Who without complaint worked for their bread;
5. On one side [of the city] was a nearby mountain,
 To which the girls went together;

Two full lines beneath the subheading:
6. Each one of them took cotton to the mountain,
 And a spindle case made of white poplarwood;
7. At the city gate, they gathered together,
 And walked happily from the city to the mountain ahead;
8. They put their food together,
 None eating more or less than the others;
9. They did not speak of food or sleep,
 For on their cotton their honor depended;
10. When evening fell, they headed home,
 Their cotton now embroidery thread;
11. Now in that cheerless city,
 There lived a man named Haftvad,

Six couplets of the upper step (the three-column-wide space, in which the two halves of couplets number 13 and 16 are divided):
12. Whose name and fame arose from the fact
 that he had seven sons;
13. He also had one dearly beloved daughter,
 Though to him daughters were of no account;
14. One day the girls were seated together
 With their spindles on the mountainside,
15. When it was time to eat, putting aside their spindles,
 They mixed together what they had;
16. Thus it happened that this lucky girl,
 An apple thrown from a tree by the wind,
17. She did see and quickly picked it up;
 Now listen to this amazing tale!

Two couplets of lower step (the one-column-wide space, in which each half of each couplet is placed on a separate line):
18. When that girl bit into the fruit,
 She saw in the middle of it a fat worm!
19. With her finger, she picked him out of the apple,
 And gently placed him in her spindle case;

Lower Textblock

First full line beneath the illustration:
20. When she next picked up that spindle case and cotton,
 She said, "In the name of God, who has no partner and
 no peer.
21. Today, by the luck of the Apple-Worm,
 I'll spin 'like never before.'"
22. All the girls were happy, and they laughed [heartily],
 With their mouths [lips] open, revealing their silver teeth.

2.8
Ruhham and the Sorcerer Bazur
Stephens *Shahnama*, f. 123b, n.d., but late 1340s to early 1350s
Sackler LTS1998.1.1.49a
Mohl 1373/1994, p. 693
Warner and Warner, 3:128–29
fig. 115

Upper Textblock

Last full line above the illustration:
1. "You are our only defense against this intense cold—
 We have no one but you [to help us]."
2. A wise and searching man came
 And showed Ruhham the pinnacle of the mountain.[5]

Five couplets in the step:
3. Ruhham turned from the battlefield,
 Hastening his horse from the midst of the army;
4. Pulling the skirt of his mail up to his waist,
 He went by foot to the mountain top;
5. When the sorcerer saw him he came to fight,
 A sword of Chinese steel in his hand;
6. As Ruhham drew near the sorcerer,
 He quickly drew his sword.
7. As he cut off the sorcerer's hand with his sharp sword,
 A wind rose up as though it were the Day of Resurrection.

[5] Where the sorcerer Bazur was situated; the couplet explaining this appears in Mohl, but is absent from this manuscript.

Lower Textblock

First full line beneath the illustration:
8. The dark clouds were swept away,
 As Ruhham descended from the mountain.

2.9
Ruhham and the Sorcerer Bazur
Shahnama, 731/1330
TS H. 1479, f. 68b
Mohl 1373/1994, p. 693
Warner and Warner, 3:128–29
fig. 116

Upper Textblock

Last full line above the illustration:
1. [Because of the intense cold], holding sword in hand was
 impossible,
 Yet, like a maddened beast he [Human] rushed into the midst
 of the fallen;
2. There was no room to turn around on the battleground
 [so choked with snow and bodies was it],
 And the hands of the soldiers turned black from the cold;
3. The commander and the other leaders
 Cried out with grief to the heavens:

Six couplets in upper step (the four-column-wide space):
4. "Oh, you who are greater than all knowledge, judgment
 and wisdom,
 And who art neither on, in, or under a single place,
5. We are your sinful slaves,
 And in our sorry state we appeal to you for help,
6. You are the helper of those in need,
 Take us all from this terrible cold,
7. For you are our only defense against this intense cold—
 We have no one but you [to help us]!"

8. A wise and searching man came
 And showed Ruhham the pinnacle of the mountain,
9. On which was situated the wicked Bazur,
 With his all spells and trickery;

Nine couplets in lower step (the three-column-wide space, in
which the two halves of couplets 11, 14, and 17 are divided):
10. Then Ruhham turned from the battlefield,
 Hastening his horse from the midst of the army;
11. Pulling the skirt of his mail up to his waist,
 He then went by foot to the mountain top;
12. When the sorcerer saw him he came to fight,
 A sword of Chinese steel in his hand;
13. As Ruhham drew near the sorcerer,
 He quickly drew his sword;
14. He sliced off the sorcerer's hand with his sharp sword,
 And a wind rose up as though it were the Day of
 Resurrection;
15. The dark clouds were swept away,
 As Ruhham descended from the mountain;
16. With the hand of Bazur in his hand,
 He went to the plain and mounted a horse;
17. The weather changed:
 The sun shone and the sky was blue;
18. Reporting to his father, he said: "It was the work of the
 sorcerer,
 What happened to us, Bazur brought on."

2.10
Siyavush Emerges from the Flames
Collection of Epics, 800/1397
CBL Per 114, f. 14b
Mohl 1373/1994, p. 443
Warner and Warner, 2:219–21
fig. 89

Nonstepped area of textblock:
1. The earth became brighter than the sky,
 And, as the people shouted, the fire burned higher;
2. All on the plain became scorched,
 And wept upon seeing the joyful face of Siyavush;
3. Dressed in robes of white,
 With smiling lips and a heart full of hope,
4. Siyavush came before his father,
 A gold helmet upon his head,
5. And mounted on a black horse,
 Whose hooves sent dust flying to the moon;
6. He sprinkled camphor upon himself,
 As when bodies are prepared for burial;
7. Again he went before Kavus,
 Dismounted from his horse and bowed low before him;
8. The face of Shah Kavus was full of shame,
 And the words he spoke to his son were gentle;
9. Siyavush spoke to him of the sorrow of this turn of events,
 How fate had brought them to this point,
10. "If I have sinned in this deed,
 The world will not bless me,
11. But, by the power of God who gives all good,
 I will not feel the heat of this mountain of fire,
12. I may now be dishonored and ruined,
 But if I am without sin, I will escape."
13. A great wail arose from plain and city,
 As all the world grieved at what took place;
14. Siyavush urged his black horse forward, into the fire;

15. Sudabeh heard the wail from the plain,
 And went from the palace up to the roof to watch the fire—
16. Wishing him ill luck,
 And muttering to herself in agitation;
17. From every direction the flames burst forth—
 No one could see either helmet or horse;
18. The people all stared at Kavus
 With tongues of reproach and lips of anger;
19. Siyavush urged his black horse farther into the fire—
 One would say it were as though fire agreed with his horse;
20. All eyes were full of blood—
 "How will he ever come out of the fire?"
21. When they saw him again, a great roar rose up—
 "The young shah is emerging from the fire!"
22. If it had been water, he would not have gotten wet,
 For his garments would have absorbed none of it;
23. Horse and rider were in such an undamaged state,
 That all said, "He has jasmine on his breast!"
24. For when it is the will of God,
 The breath of fire and wind are one and the same;

Four couplets in step:
25. As the youth pulled his horse free of the mountain of fire,
 A great shout again rose from city and plain;
26. The horsemen of the army drew forward,
 While all those on the plain scattered coins before the prince,
27. Happiness spread throughout the world,
 Among both mean and mighty,
28. As the good tidings passed from one to another,
 All satisfied that the innocent had been righteously treated.[6]

[6] In the preceding examples, the order of the couplets does not always match precisely the order as given in Mohl. However, in this particular instance, the difference in the ordering of the couplets is much more pronounced than in any other example; the order as given in Mohl is: 1, 2, 4, 3, 5, 6, 7, 8, 9, 12, 10, 11 (three couplets not in the Collection of Epics) 13, 15, 16, 18, 19, 20 (one couplet not in the Collection of Epics) 23, 22, 24, 25, 26, 27, 28.

APPENDIX 3. THE DISTRIBUTION OF TEXT ILLUSTRATIONS IN *SHAHNAMA* MANUSCRIPTS: NUMBER OF PAGES (SINGLE SIDES OF A FOLIO) BETWEEN CONSECUTIVE ILLUSTRATIONS

The numbers in the following sequences indicate the number of pages (or single sides of a folio) that exist between any two consecutive text illustrations. "0" indicates that illustrations appear on immediately consecutive pages; "(2)" indicates that there are two illustrations on a single folio. Folio numbers are not known for the illustrations of the manuscript sold at Sotheby's, 18 October 1995, lot 65 (878/1473); it is therefore not included here.

TS H. 1479, 731/1331

24, 7, 1, 2, 1, 0, 3, 14, 9, 9, 5, 8, 8, 9, 9, 1, 9, 8, 10, 3, 10, 0, 6, 3, 0(2), 0(2), 0(2), 0(2), 0(2), 2, 17, 3, 7, 7, 7, 4, 8, 7, 3, 0, 0, 0, 0, 0, 3, 13, 3, 4, 3, 10, 7, 8, 10, 24, 5, 15, 5, 0, 0, 6, 4, 1, 7, 6, 0, 6, 4, 5, 0, 7, 9, 9, 4, 7, 4, 3, 5, 4, 5, 2, 6, 1, 9, 5, 2, 4

StP-RNL Dorn 329, 733/1333

7, 11, 21, 14, 9, 0, 0, 2, 34, 24, 20, 17, 10, 25, 15, 26, 15, 13(2), 0(2), 0(2), 0(2), 0(2), 0, 16, 25, 10, 36, 7, 15, 24, 16, 30, 17, 12, 27, 16, 20, 27, 28, 14, 18, 21, 9

Stephens *Shahnama*, n.d., but late 1340s to early 1350s

The following sequence excludes seven text illustrations, on six folios, that are dispersed, the original folio numbers of which are not known.

1, 3, 7, 0, 8, 5, 2, 1, 2, 7, 13, 1, 9, 2, 4, 7, 1, 1, 1, 3, 7, 1, 3, 1, 2, 5, 7, 6, 6, 6, 6, 4, 10, 3, 3, 3, 2, 0, 6, 12, 7, 6, 1, 3, 3, 11, 5, 9, 10, 2, 1, 6, 10, 6, 3, 12, 14, 0, 1, 14, 5, 10, 11, 6, 10, 11, 4, 2, 2, 14, 11, 0, 0, 0, 1, 0, 3, 1, 1, 7, 3, 6, 3, 2, 5, 3, 8, 9, 7, 7, 19, 5, 3, 13, 5, 5, 41

TS H. 1511, 772/1371

69, 8, 64, 44, 46, 107, 47, 9, 54, 40, 32

BL Or. 4384, n.d., but c. 1430

40, 66, 16, 70, 58, 66, 94, 72

Sotheby's, 11 October 1982, lot 214 (Dufferin and Ava *Shahnama*), 839/1436–37

7, 10, 10, 8, 2, 14, 20, 1, 2, 8, 5, 9, 5, 5, 2, 0, 2, 1, 38, 2, 1, 55, 11, 1, 21, 27, 36, 3, 1, 11, 22, 4, 26, 47, 5, 18, 1, 14, 13, 1, 9, 31, 24, 7, 15, 1, 2, 9, 42, 13, 26, 88, 73, 33, 74, 35

Leiden Codex Or. 494, 840/1437

25, 49, 35, 44, 48, 38, 35, 58, 47, 72, 36, 18, 54, 43, 71, 61, 68

BL Or. 1403, 841/1437

1, 0, 0, 3, 11, 58, 0, 16, 2, 5, 11, 41, 8, 5, 44, 12, 17, 11, 11, 17, 3, 18, 1, 10, 11, 2, 4, 5, 30, 13, 4, 3, 4, 10, 5, 16, 10, 14, 3, 3, 2, 3, 3, 8, 1, 2, 4, 9, 2, 0, 1, 0, 0, 4, 2, 1, 16, 2, 9, 4, 1, 10, 3, 8, 4, 4, 9, 0, 0, 1, 2, 12, 1, 3, 4, 17, 13, 1, 5, 5, 3, 2, 11, 2, 15, 21, 0, 44, 10

BN Supp. pers. 493, 844/1441

32, 50, 23, 30, 17, 39, 75, 88, 19, 11, 10, 0(2), 0(2), 0, 0(2), 0(2), 1, 27, 13, 22, 28, 29, 0, 1, 0, 0, 53, 9, 38, 0, 17, 24, 33, 10, 56, 47, 34, 1, 6, 39, 0, 51, 5, 11, 2, 26, 28

BL Or. 12688, 850/1446

1, 2, 5, 12, 14, 1, 8, 7, 14, 26, 19, 5, 2, 4, 0, 4, 7, 1, 0, 1, 2, 1, 2, 2, 7, 6, 3, 3, 7, 2, 4, 3, 0, 12, 2, 5, 20, 3, 1, 3, 9, 12, 5, 6, 5, 6, 9, 2, 8, 1, 2, 5, 6, 16, 3, 19, 5, 3, 5, 9, 4, 17, 7, 4, 3, 5, 7, 9, 27, 19, 7(2), 0(2), 0(2), 0(2), 0(2), 0(2), 0, 8, 15, 8, 7

TS H. 1496, 868/1464

4, 13, 6, 58, 3, 21, 27, 6, 14, 9, 25, 20, 22, 61, 85, 22, 17, 44, 56, 95, 174, 28, 48, 20, 29, 45, 23, 307

CBL Per 157, 885/1480

3, 4, 22, 47, 2, 41, 18, 7, 21, 15, 17, 23, 28, 25, 46, 21, 51, 27, 66, 22, 40, 41, 54, 13, 39, 80, 20, 119

CBL Per 158, 885/1480

41, 77, 15, 31, 18, 71, 76, 20, 18, 51, 27, 39, 25, 21, 12, 26, 42, 10, 57, 69, 10, 109, 80, 77, 36, 42

BL Add. 18188, 891/1486

23, 14, 35, 8, 12, 14, 10, 4, 5, 10, 1, 0, 1, 0, 1, 7, 9, 9, 1, 19, 13, 3, 2, 11, 28, 14, 3, 7, 5, 4, 5, 2, 17, 36, 7, 26, 13, 12, 38, 8, 21, 9, 16, 22, 10, 22, 15, 10, 11, 13, 12, 20, 9, 11, 21, 5, 11, 7, 9, 13, 15, 10, 14, 13, 24, 14, 13, 5, 14, 23

BOD Elliott 325, 899/1494

8, 12, 13, 18, 18, 24, 37, 13, 7, 18, 12, 18, 17, 43, 27, 38, 36, 39, 18, 12, 19, 51, 27, 30, 8, 34, 31, 18, 10, 24, 11, 22, 17, 16, 29, 33, 11, 23, 33, 15, 50, 11, 23, 20, 28, 39, 30, 12, 33, 7, 11, 27

BL Add. 15531, 942/1536

17, 55, 20, 20, 16, 21, 17, 22, 15, 18, 28, 19, 25, 20, 20, 20, 23, 25, 25, 7, 31, 14, 32, 55, 19, 13, 23, 15, 20, 20, 30, 27, 22, 24, 32, 18, 29, 47, 33, 24, 21, 12, 14

JRL Pers. 932, 949/1542

17, 28, 43, 12, 14, 18, 17, 31, 18, 44, 57, 34, 29, 42, 50, 37, 18, 12, 19, 22, 50, 31, 20, 15, 25, 10, 50, 31, 20, 34, 64, 29, 28, 83, 24, 34

BOD Ouseley 369, 959/1552

20, 33, 27, 16, 15, 30, 15, 51, 45, 73, 17, 15, 5, 71, 71, 18, 85, 165, 104, 31, 35, 36, 64

Christie's, 19 October 1995, lot 79, 969/1561–62
The distribution of three illustrations is uncertain and is indicated by an ellipsis (. . .) in the sequence.
21, 43, 35, 15, 17, 31, 15, 30, 17, 36, 18, 17, 26, 21, 69, 15, 41, 11, 47, 25, 26, 20, 31, 11, 48, 48, 41, 113 . . . 39, 45

4.2 *Shahnama*, dispersed, 741/1341, Shiraz
(no. 17 in table 12b)

| | naskh ← | | | → nasta'liq | |
	1	2	3	4	5
1. *alif*, *kaf*, and *lam*, slant		x	x		
2. *alif* and *kaf*, height	x				
3. *kaf*, sweeping cap	x				
4. *re*, *ze*, *zhe*, and *vav*	x				
5. *dal* and *zal*, joined form		x			
6. *dal* and *zal*, separate form	x				
7. teeth	x				
8. elongation of letters	x				
9. width of pen stroke	x				
10. piling up of words/adherence to the baseline		x	x		
11. combined effect of the preceding traits		x			
12. general impression of precision and control		x			

Final analysis: *naskh* with some *nasta'liq* tendencies

Final score: 3/9

General comments: most words adhere closely to the baseline but others have a definite, undue slant; changes are about equal to those of TS H. 1479

App. 4.2. *Shahnama*, 741/1341, 37 x 29 cm (folio).
© The Trustees of the Chester Beatty Library, Dublin, Per 110, f. 84a.

Detail of app. 4.2.

4.3 Tashkent 2179, *Khamsa* of Amir Khusraw Dihlavi, 756/1355, Shiraz
(no. 23 in table 12c)

	naskh ←			→ nasta'liq	
	1	2	3	4	5
1. *alif*, *kaf*, and *lam*, slant			x		
2. *alif* and *kaf*, height	x				
3. *kaf*, sweeping cap		x	x		
4. *re*, *ze*, *zhe*, and *vav*	x	x			
5. *dal* and *zal*, joined form		x			
6. *dal* and *zal*, separate form	x				
7. teeth	x				
8. elongation of letters	x	x			
9. width of pen stroke	x				
10. piling up of words/adherence to the baseline			x		
11. combined effect of the preceding traits			x		
12. general impression of precision and control			x		

Final analysis: definite tendency to *nasta'liq*

Final score: 5/9

General comments: a very noticeable move to *nasta'liq*, more so than any earlier manuscript

App. 4.3. *Khamsa* of Amir Khusraw Dihlavi, 756/1355, 29.5 x 19.5 cm (folio). al-Biruni Institute for Oriental Studies, Academy of Sciences of the Republic of Uzbekistan, Tashkent, no. 2179, f. 39b.

Detail of app. 4.3.

4.4 BOD Ouseley 274–75, *Khamsa* of Nizami, 766–67/1365, Shiraz
(no. 29 in table 12c)

	naskh ←			→ nasta'liq	
	1	2	3	4	5
1. *alif*, *kaf*, and *lam*, slant		x	x	x	
2. *alif* and *kaf*, height			x		
3. *kaf*, sweeping cap				x	
4. *re*, *ze*, *zhe*, and *vav*				x	
5. *dal* and *zal*, joined form				x	
6. *dal* and *zal*, separate form			x		x
7. teeth	x				
8. elongation of letters			x		
9. width of pen stroke		x			
10. piling up of words/adherence to the baseline				x	
11. combined effect of the preceding traits			x		
12. general impression of precision and control				x	

Final analysis: more than halfway to *nasta'liq*

Final Score: 7/9

General comments: same scribe as BN Supp. pers. 1817, but, unlike that manuscript, here the *alif*s slant mainly to left or are straight, with only a very few slanted to the right; often a great variation in letter forms from one word to the next, as if experimenting

App. 4.4. *Khamsa* of Nizami, 766–67/1365, 26.5 x 16.5 cm (folio). Bodleian Library, University of Oxford, Ouseley 274, f. 118b.

Detail of app. 4.4.

4.5 StP-RNL Dorn 406, *Kulliyyat* of 'Imad Faqih, 772/1370, Shiraz
(no. 34 in table 12d)

	naskh ←			→ nasta'liq	
	1	2	3	4	5
1. *alif*, *kaf*, and *lam*, slant					x
2. *alif* and *kaf*, height				x	x
3. *kaf*, sweeping cap					x
4. *re*, *ze*, *zhe*, and *vav*			x	x	
5. *dal* and *zal*, joined form					x
6. *dal* and *zal*, separate form					x
7. teeth					
8. elongation of letters					x
9. width of pen stroke				x	
10. piling up of words/adherence to the baseline				x	x
11. combined effect of the preceding traits				x	x
12. general impression of precision and control					x

Final analysis: *nasta'liq*

Final score: 9/9

General comments: the first example of pure *nasta'liq*; the fact that not every point is rated a number 5 is acceptable in light of the usual variation in individual hands (probably no example would ever score all 5s)

App. 4.5. *Kulliyyat* of 'Imad Faqih, 772/1370. Russian National Library, St. Petersburg, Dorn 406, f. 186b.

Detail of app. 4.5.

4.6 BL Or. 13297, *Khamsa* of Nizami, 788/1386 and 790/1388, Baghdad
(no. 39 in table 12d)

	naskh ← 1	2	3	→ *nasta'liq* 4	5
1. *alif*, *kaf*, and *lam*, slant					x
2. *alif* and *kaf*, height					x
3. *kaf*, sweeping cap		x			
4. *re*, *ze*, *zhe*, and *vav*		x	x	x	
5. *dal* and *zal*, joined form		x			
6. *dal* and *zal*, separate form	x				
7. teeth			x		
8. elongation of letters		x			
9. width of pen stroke			x		
10. piling up of words/adherence to the baseline		x			
11. combined effect of the preceding traits				x	x
12. general impression of precision and control					x

Final analysis: *nasta'liq*

Final score: 8/9

General comments: not as well developed as StP-RNL Dorn 406; a very small, very sketchy hand; a slight hanging of words but an overall slant to individual letters

App. 4.6. *Khamsa* of Nizami, 788/1386 and 790/1388, 24.1 x 16.5 cm (folio). © The British Library Board, Or. 13297, f. 55a.

Detail of app. 4.6.

4.7 Freer F1931.29–37, *Khusraw va shirin*, n.d., but c. 1405–10, Tabriz
(no. 46 in table 12d)

| | *naskh* ← | | | → *nasta'liq* | |
	1	2	3	4	5
1. *alif*, *kaf*, and *lam*, slant		x	x		
2. *alif* and *kaf*, height					x
3. *kaf*, sweeping cap					x
4. *re*, *ze*, *zhe*, and *vav*				x	
5. *dal* and *zal*, joined form				x	
6. *dal* and *zal*, separate form			x	x	
7. teeth					x
8. elongation of letters					x
9. width of pen stroke					x
10. piling up of words/adherence to the baseline					x
11. combined effect of the preceding traits					x
12. general impression of precision and control					x

Final analysis: *nasta'liq*

Final score: 9/9

General comments: although it is certainly *nasta'liq*, there are still some traits that do not conform with the "ideal"; for example, *alif*s are usually straight or even slightly slanted to the left.

App. 4.7. *Khusraw va shirin*, n.d., but c. 1405–10, 30.7 x 21.4 cm (folio). Freer Gallery of Art, Smithsonian Institution, Washington, D.C.: Purchase, F1931.29, p. 52.

Detail of app. 4.7.

Collections are arranged alphabetically according to the abbreviations used throughout the text. Dispersed manuscripts and those for which the location is unknown are given at the end of the list. Primary textual sources that have not been consulted firsthand, but for which a manuscript or album reference is provided in the text, are not included here.

Aga Khan (Collection of the Late Prince Sadruddin Aga Khan, Geneva)

11: *Shahnama*, 861/1457, copied by Mahmud ibn Muhammad ibn Mahmud al-Jamali

IR.M.28: *Khamsa* of Nizami (eight folios), 984/1576 (part of the same manuscript as Sotheby's, 14 December 1987, lot 120)

Asiatic Society of Bengal, Calcutta

D.31: *Tarikh-i ghazani*, c. 1425

Bayezit Library, Istanbul (former Millet Library Collection)

Feyzullah 489: *Jami' al-sahih*, dated 832/1429, for Ibrahim Sultan

Feyzullah (Efendi) 1566: *Kitab al-aghani* (vols. 17 and 19), n.d., but c. 1218, probably Mosul

Feyzullah 1983: *Commentaries on the Grammar of Sibawayh*, n.d., but c. 1460–65, for Mehmed II

Berenson (Berenson Collection, I Tatti, Florence)

Anthology for Baysunghur ibn Shah Rukh (*Gul va mul, Nuzhat al-'ashiqin, Risalat-i tarbi', Radd-i shatranj, Tigh va qalam, Risalat-i chang*), 830/1426–27, Herat, copied by Shamsuddin al-Sultani

Berlin-MIK (bpk / Museum für Islamische Kunst, Staatliche Museen zu Berlin)

I. 4628: Anthology (*khamsa*s of Nizami, Khwaju Kirmani, and Amir Khusraw Dihlavi; and excerpts from the *Shahnama*, *Mantiq al-tayr* of 'Attar and the work of several other poets, including Rumi, Awhadi, Sa'di, 'Ubayd Zakani, and Hafiz; for a complete list of contents, see Kühnel 1931, pp. 138–40), 823/1420, for Baysunghur, copied by Mahmud al-Husayni (see figs. 93–94)

Berlin-SB (Staatsbibliothek, Preussischer Kulturbesitz)

Diez A folio 70: Album, including, among other material, paintings of enthroned couples (s. 10 and 21–23), n.d., but early fourteenth century

Diez A folio 71: Album, including, among other material, paintings of enthroned couples (s. 41–42, 45–46, 48, 52, 63), n.d., but early fourteenth century

Diez A folio 74: Album, including, among other material, a frontispiece of the Chupanid amir Malik Ashraf (no. 1.21), n.d., but probably c. 1340

Minutoli 21: *al-Mathnawi al-ma'nawai*, 738/1337

Minutoli 35: *Khamsa* of Nizami, 764/1362 and 765/1363

Mixt. 1594: *Rababnama* and *Intihanama* of Sultan Walad, 768/1366–67

Orient folio 4255: *Shahnama*, 894/1489

Petermann I. 386: *Tabaqat-i nasiri*, 814/1411–12, for Baysunghur, copied by Ahmad ibn Mas'ud al-Rumi

BL (British Library, London)

Add. 5965: An explanation of the Arabic proverbs that occur in *Kalila wa dimna*, 626/1229

Add. 7622: *Tarikh-i tabari*, 734/1334, copied by al-Husayn ibn 'Ali ibn al-Husayn al-Bahmani

Add. 7628: *Jami' al-tavarikh*, n.d., but no later than 837/1433, for Shah Rukh (no decoration)

Add. 7729: *Khamsa* of Nizami, 802/1400

Add. 7759: *Divan* of Hafiz Shirazi, 855/1451, copied by Sulayman al-Fushanji

Add. 7768: *Kulliyyat* of Katibi, 857/1453, copied by Sultan 'Ali

Add. 15531: *Shahnama*, 942/1536

Add. 17330: *Bustan* and *Gulistan* of Sa'di, 871/1467

Add. 18113: *Masnavi*s of Khwaju Kirmani, 798/1396, Baghdad, copied by Mir 'Ali ibn Ilyas al-Tabrizi al-Bavarchi, illustrations signed by Junayd al-Naqqash al-Sultani

Add. 18188: *Shahnama*, 891/1486, copied by Ghiyath al-Din ibn Bayazid Saraf

Add. 21103: *Shahnama*, 675/1276 (with later illuminations)

Add. 23564: *'Aja'ib al-mukhluqat* of Qazvini, 845/1441

Add. 24944: *Kulliyyat* of Sa‘di, copying completed 974/1566, illuminations completed 976/1568–69, copied by Muhammad al-Qivam al-Katib al-Shirazi

Add. 25026: *Kimiyya-i sa‘adat* of Abu Hamid Muhammad al-Ghazali al-Tusi, 672/1274

Add. 27259: Anthology (*khamsa*s of Nizami and Amir Khusraw Dihlavi; *Gul va nawruz* of Jalal; *Gul va nawruz* of Khwaju Kirmani), 821/1419, copied by Turanshah

Add. 27261: Anthology (*Khamsa* of Nizami; excerpts from the *Shahnama* and *Humay va humayun* of Khwaju Kirmani; *qasida*s in praise of Muhammad and the Imams; treatises on religious observances, on computation of the calendar and use of the astrolabe, and on astrology; for a complete list of contents, see Rieu 1879–83, pp. 868–71), 813–14/1410–11, for Iskandar Sultan, copied by Muhammad al-Halva’i and Nasir al-Katib (see figs. 54–59 and 90–91)

Or. 1403: *Shahnama*, 841/1437

Or. 2676: *Javami‘ al-hikayat* of Muhammad ‘Awfi, 732/1332 (see figs. 4 and 7)

Or. 2773: *Tarikh-i isfahan*, 834/1431, for Baysunghur, copied by Ja‘far al-Baysunghuri

Or. 2780: Collection of Epics (*Garshaspnama, Shahanshahnama, Bahmannama*, and *Kushnama*), 800/1397, copied by Muhammad ibn Sa‘id ibn Sa‘d al-Hafiz al-Qari (part of CBL Per 114)

Or. 2833: *Zafarnama* of Hamdallah Mustawfi Qazvini and the same author's recension of the *Shahnama*, 807/1405, copied by Mahmud al-Husayni

Or. 2866: *Divan* of Rumi, 774/1372, copied by Ahmad ibn Vali al-Shirazi

Or. 3486: Anthology (*divan*s of Anvari, Sayf al-Din Isfarangi, and Salman-i Savaji; and *ghazal*s of Amir Khusraw Dihlavi), 841/1437–38, copied by ‘Ali ibn Sha‘ban ibn Haydar al-Ashtarjani (main text) and Zayn al-Katib al-Isfahani (marginal text)

Or. 3623: *Athar al-bilad* of Qazvini, 729/1329, copied by Muhammad ibn Mas‘ud ibn Muhammad al-Hamadani (see figs. 2–3)

Or. 3646: *al-Masabih*, 761/1360, Baghdad

Or. 4384: *Shahnama*, n.d., but c. 1430

Or. 4392: *Jami‘ al-hikayat* of Muhammad ‘Awfi, 741/1340, for Hasam al-Din Siraf, copied by Mahmud ibn Ahmad Muhammad al-Tatari(?)

Or. 4945: Qur’an, *Juz’* 25, 710/1310, Mosul, for Uljaytu, copied by Ali ibn Muhammad al-Husayni; dispersed, for the location of other sections, see James 1988, cat. no. 42

Or. 5012: *al-Mathnawi al-ma‘nawi* of Rumi, 844/1440

Or. 6634: *Hallajnama* of ‘Attar, 861/1457

Or. 8193: Anthology (works by Kamal al-Din Khujandi, Amiri, and the scribe Baqir Mansur Bakhshi), 835/1431, for Jalal al-Din Firuz Shah (a minister of Shah Rukh), copied by Baqir Mansur Bakhshi

Or. 9718: *Maqamat* of al-Hariri, n.d., but c. 1300

Or. 9863: *al-Mathnawi al-ma‘nawi* of Rumi, 843/1439

Or. 11919: *Makhzan al-asrar* of Nizami, 838/1434, copied by Ja‘far al-Tabrizi (with late fifteenth-century illuminations)

Or. 12087: *Khamsa* of Nizami, 823/1420, copied by Ja‘far al-Hafiz

Or. 12688: *Shahnama*, 850/1446, copied by Fathallah ibn Ahmad al-Sabzavari

Or. 12856: *Khamsa* of Nizami, 839/1435, copied by ‘Abd al-Rahman al-Katib (see fig. 68)

Or. 13297: *Khamsa* of Nizami, 788/1386 and 790/1388, Baghdad, copied by Mahmud ibn Muhammad, but differences in hands suggests two scribes (see app. 4.6)

Or. 13506: *Kalila wa dimna*, 707/1307–08, copied by Abu’l-Makarim Hasan

Or. 13802: *Khamsa* of Nizami, 824/1421, copied by Ma‘ruf ibn ‘Abdallah; with poems of Amir Khusraw Dihlavi added in the margins in 838/1435

Or. 13836: *Iskandarnama*, 1531–32, for Nusrat Shah, ruler of Bengal

BL-IOL (British Library, India Office Library Collections, London)

Ethé 903, 911, 913, 1028–30 (IOL no. 132): Collection of *Divan*s (of Nasir-i Khusraw, Amir Mu‘izzi, Asir al-Din Akhsikati, Adib Sabir, Nizam al-Din Mahmud Qamar Isfahani, and Shams al-Din Mahmud al-Tabasi), 713–14/1314–15, copied by ‘Abd al-Mu‘min al-‘Alavi

Ethé 976 and 1200 (IOL no. 387): *Khamsa*s of Nizami and Amir Khusraw Dihlavi, n.d., but late fifteenth–early sixteenth century

Ethé 1118: *Kulliyyat* of Sa‘di, 819/1416, copied by Firuzbakht ibn Isfahanshah (who also copied TIEM 1979)

Ethé 1432 (IOL no. 550): *Kulliyyat* of Ahli Shirazi, n.d., but late fifteenth–early sixteenth century

BM (British Museum, Department of Oriental Antiquities, London)

OA 1948-10-9-48–52: *Shahnama*, detached folios only; part of FITZ 22-1948, n.d., but late 1430s to 1440s (see fig. 97)

BN (Bibliothèque nationale de France, Paris)

Arabe 2324: *al-Majmu'a* of Rashid al-Din, 710/1310, copied by Muhammad ibn Mahmud ibn Muhammad, known as Zudnivis al-Baghdadi, and illuminated by Muhammad ibn al-'Afif al-Kashi

Arabe 2964: *Kitab al-diryaq*, 595/1199 (see fig. 5)

Arabe 3365, *Rawzat al-nazir va nuzhat al-khatir* (an anthology of Persian and Arabic verse), 793/1391, Baghdad (no decoration other than titles in colored ink)

Arabe 5847: *Maqamat* of al-Hariri, 634/1237

Pers. 14: *Kimiyya-i sa'adat* of Abu Hamid Muhammad al-Ghazali al-Tusi, 708/1308, copied by Yahya ibn Muhammad ibn Yahya al-Dudi

Pers. 276: *Taj al-ma'athir* (a history of the sultans of Delhi), 781/1380, Kirman, copied by Faraj ibn Karim al-Mutatib

Pers. 376: *Kalila wa dimna*, 678/1279–80, Baghdad, but with illustrations and a heading that date to about 1380, copied by Abu Tahir ibn Abi Nasr ibn Muhammad ibn Muhammad al-Wadkali

Pers. 377: *Kalila wa dimna*, n.d., but c. 1380–90, Shiraz

Supp. pers. 95: *Javami' al-hikayat* and *Lavami'al-rivayat* of Muhammad 'Awfi, 717/1317

Supp. pers. 206: *Tarikh-i jahan gushay* of Juvayni, 841/1438, copied by Abu Ishaq ibn Ahmad . . . al-Sufi

Supp. pers. 209: *Jami' al-tavarikh*, 837/1433–34, for Shah Rukh, copied by Mas'ud ibn 'Abdallah

Supp. pers. 332: *'Aja'ib al-makhluqat* of Qazvini and *Kalila wa dimna*, 790/1388, Baghdad, for Sultan Ahmad, copied by Ahmad al-Haravi

Supp. pers. 386: *Tuhfat al-muhibbin*, n.d., but late fifteenth or early sixteenth century, India

Supp. pers. 493: *Shahnama*, 844/1441, copied by Ya'qub ibn 'Abd al-Karim

Supp. pers. 494: *Shahnama*, 848/1444, for 'Abdallah ibn Ibrahim Sultan, copied by Muhammad al-Sultani

Supp. pers. 580: *Khamsa* of Nizami, 767/1366, copied by Muhammad 'Abd al-Latif ibn Muhammad al-'Aqafiri al-Shirazi (with fifteenth-century, Ottoman illustrations) (see fig. 34)

Supp. pers. 584: *Makhzan al-asrar* and *Khusraw va shirin* of Nizami; and *Matla' al-anwar* and *Shirin va khusraw* of Amir Khusraw Dihlavi, 800/1398

Supp. pers. 727: *Kulliyyat* of Sayyid Qivam al-Din, n.d., but c. 1430s, Fars

Supp. pers. 745: *Divan* of 'Imad Faqih, 786/1384

Supp. pers. 816: *Kulliyyat* of Sa'di, 786/1384

Supp. pers. 913: *Kalila wa dimna*, 794/1392, Baghdad, copied by al-Hafiz Ibrahim

Supp. pers. 1113: *Jami' al-tavarikh*, c. 1425, Herat

Supp. pers. 1375: *Tarikh-i jahan-gushay* of Juvayni, n.d., but after 1362, Shiraz, for the library of Kamal al-Din Jamali al-Islam (presumably Kamal al-Din Husayn Rashidi, vizier to Shah Shuja')

Supp. pers. 1465: Poems of Kamal al-Din Muhammad al-Khujandi, 845/1441, copied by Ahmad ibn 'Ali

Supp. pers. 1469: Anthology (poems of Khusraw, Hasan Dihlavi, and Nasir Bukhari), 820/1417, copied by Nur al-Husayni

Supp. pers. 1488: Astrological and astronomical treatises, n.d., but probably c. 1410, possibly for Iskandar Sultan

Supp. pers. 1531: *Divan* of Mawlana Humam al-Din al-Tabrizi, 816/1413, copied by Ja'far ibn 'Ali al-Tabrizi

Supp. pers. 1630: Document, 773/1372

Supp. pers. 1778: *Kulliyyat* of Sa'di, 767/1366, copied by 'Ali ibn Muhammad (al-Ka)shi

Supp. pers. 1817: *Khamsa* of Nizami, 763/1362, copied by Ahmad ibn al-Husayn ibn Sana

Supp. pers. 1946: Folio with illuminated heading, detached from the Great Mongol *Shahnama*, n.d., but c. 1335, Tabriz

Supp. pers. 1963: *al-Aghraz al-tibbiyat*, n.d., for Iskandar Sultan

BOD (Bodleian Library, Oxford)

Bodl. Or. 133: *Kitab al-bulhan*, 801/1399, Baghdad

Elliott 48: *Kulliyyat* of Da'i, 879/1474, copied by Sultan 'Ali

Elliott 121: *Divan*s of Amir Khusraw Dihlavi, Hasan, Kamal, and Hafiz, 839/1435–36

Elliott 171–72: *Javami' al-hikayat va lavami' al-rivayat*, 833/1429–30, copied by Darvish 'Ali Katib

Elliott 189: *Khamsa* of Amir Khusraw Dihlavi, 866–67/1463 (with Safavid illuminations)

Elliott 191: *Khamsa* and poetical love letters of Amir Khusraw Dihlavi, 840/1436–37

Elliott 210: *Kulliyyat* of 'Imad Faqih, 834/1431, for Baysunghur, copied by Azhar

Elliott 216: *Kulliyyat* of Katibi, 873/1469

Elliott 224: *Kulliyyat* of Sa'di, 918/1512

Elliott 325: *Shahnama*, 899/1494, copied by Sultan Husayn ibn Sultan 'Ali ibn Aslanshah al-Katib, illuminated by Darvish 'Ali

Fraser 73–75: *Kulliyyat* of Sa'di, n.d., illuminated by Ruzbihan

Fraser 171: *Mukhtasari dar 'ilm-i 'aruz*, 815/1412–13, for Ibrahim Sultan

Marsh 491: *Miftah al-khaza'in* (a translation/redaction of Dioscorides' *De Materia Medica*), 769/1367, autograph copy of 'Ali ibn al-Husayni al-Ansari, called Hajji Zayn al-'Attar

Ouseley 131: *Dasturnama*, 865/1460, for Pir Budaq, copied by Shaykh Mahmud Pir Budaqi

Ouseley 133: *Dilsuznama*, 860/1456, Edirne

Ouseley 140: *Ruba'iyyat* of 'Umar Khayyam, 865/1460, for Pir Budaq, copied by Shaykh Mahmud Pir Budaqi

Ouseley 141: *Ruba'iyyat* of Afzal Kashi, 865/1460, for Pir Budaq, copied by Shaykh Mahmud Pir Budaqi

Ouseley 148: *Divan* of Hafiz, 843/1439, copied by Isma'il ibn Mahmud al-Razmi

Ouseley 263: *Zafarnama*, 852/1448, Abarquh, copied by Muhammad ibn Abu Bakr ibn Muhammad bin Ahmad ibn Muhammad . . . al-Khwarazmshah

Ouseley 274–75: *Khamsa* of Nizami, 766–67/1365, copied by Ahmad ibn al-Husayn ibn Sana (see figs. 33, 35, 37, 119b, and app. 4.4)

Ouseley 369: *Shahnama*, 959/1552

Ouseley 379–81: *Kitab-i samak 'ayyar*, n.d., but c. 1340

Ouseley Add. 39: *Kulliyyat* of Sa'di, 856/1452, copied by Nasir ibn Hasan of Mecca

Ouseley Add. 176: *Shahnama*, n.d., but late 1420s or early 1430s, for Ibrahim Sultan, illuminated by Nasr al-Sultani (see figs. 73, 83, 95, 104, 106–08, and 110)

Pers. c. 4: *Shahnama*, 852/1448, copied by 'Abdallah ibn Sha'ban ibn Haydar al-Ashtarjani

Pers. d. 31: *Tarjuma-i mawlud-i mustafa*, 766/1365, Shiraz, copied by Abu Tahir Muhammad ibn Ahmad al-Shirazi

Pers. d. 95: *Kulliyyat* of Sa'di, 843/1439, copied by Sayyid Hasan Astarbadi ibn Sayyid 'Alishah ibn Sayyid 'Ali (Kiya) Astarbadi

Pers. d. 97: Poems of Amir Khusraw Dihlavi, 879/1475, illuminated by Darvish 'Ali

Pers. e. 26: *Kulliyyat* of Sa'di, 840/1437, copied by Nasir

Cairo (Dar al-Kutub)

72: Qur'an, 713/1313, Hamadan, for Sultan Uljaytu, copied and illuminated by 'Abdallah ibn Muhammad ibn Mahmud al-Hamadani

Adab 579: *Kitab al-aghani* (vols. 2, 4, and 11), n.d., but c. 1218, probably Mosul

Adab farisi 61: *Kalila wa dimna*, 744/1343–44, Baghdad

Ta'rikh farisi 73: *Shahnama*, 796/1393–94, Shiraz, copied by Lutfallah ibn Yahya ibn Muhammad (see figs. 82 and 86)

CBL (Chester Beatty Library, Dublin)

Ar 4033: *Azhar al-afkar fi jawhir al-ahjar* of al-Tifashi, 697/1298

Ar 4176: *Sahih* of al-Bukhari, 694/1294, Egypt or Syria, copied by Ahmad ibn 'Ali ibn 'Abd al-Wahhab

Ar 4183: *Nasa'ih iskandar* (Counsels of Alexander), 829/1425–26, copied by Ja'far al-Baysunghuri

Ar 4204: *Banat su'ad*, by Ka'b bin Zuhayr, for the Tahirid sultan of Yemen, al-Malik al-Zafir Salah al-Din 'Amir ibn 'Abd al-Wahhab (r. 894–922/1489–1516), copied by Mahmud ibn Muhammad al-Shirazi

Ar 4248, *Jami' al-sahih*, 863/1459

Ar 5282: *Jami' al-usul* of Ibn al-Athir, 839/1435–36, copied by Muhammad ibn Hajji al-Hafiz (see figs. 133–34)

Is 1406: Qur'an fragment, probably tenth century, possibly Iraq

Is 1431: Qur'an, 391/1000–01, Baghdad, Iraq, copied and illuminated by Ibn al-Bawwab

Is 1434: Qur'an, 361/972, Iran

Is 1435: Qur'an, 592/1195, copied by Abu Nu'aym ibn Hamza al-Bayhaqi

Is 1457: Qur'an, n.d., but c. 1306–10, Cairo

Is 1466: Qur'an, 677/1278, Konya, copied by al-Hasan ibn Juban ibn 'Abd Allah al-Qunawi

Is 1469: Qur'an fragment, 734/1334, copied by Amir Hajj ibn Ahmad al-Sa'ini (see fig. 11)

Is 1470: Qur'an, *Juz'* 11, 738/1338, Maragha, copied by 'Abdallah ibn Ahmad ibn Fadlallah ibn 'Abd al-Hamid al-Qadi al-Qazvini; for the location of other sections, see James 1988, cat. no. 61 (see figs. 12–13)

Is 1475: Qur'an, 740/1339–40, copied by Yahya al-Sufi (with early sixteenth-century, Ottoman illuminations)

Is 1482: Qur'an, n.d., but fifteenth century, for Sultan Khushqadam

Is 1498: Qur'an fragment, n.d., but c. 1335

Is 1502: Qur'an, 888/1483, copied by Zayn al-'Abidin ibn Muhammad al-Katib al-Shirazi, for Ya'qub Beg Aq Qoyunlu

Is 1527: Qur'an, 977/1570, copied by Hasan ibn Ahmad al-Qarahisari

Is 1614.2: Qur'an, one half of a double-page illuminated frontispiece from the Anonymous Baghdad Qur'an, 710–07/1302–08 (see fig. 10)

Per 103: *Majmu'a-i davavin-i dah-ganah* (*divan*s of Kamal al-Din Isma'il, 'Abd-al-Vasi' Jabali, Rashid al-Din Vatvat, Abu al-Faraj Rumi, Shams al-Din Azraqi, Shams al-Din Tabasi, Najib al-Din Jurbazaqani, Rafi' al-Din Lunbani, Imami-i Hirvai, and Anvari), 699/1300

Per 104: Folios of the dispersed First Small *Shahnama*, n.d., but c. 1300, generally attributed to Baghdad; for the location of other folios, see "Dispersed Manuscripts" below (see app. 4.1)

Per 105.2: "Faridun Enthroned Outdoors at His Accession, with His Sons and Courtiers," detached folio from a replacement volume of *Jami' al-tavarikh*, c. 1426, Herat, made for Shah Rukh (see fig. 101)

Per 107: *Divan* of Qumri, 710/1310, copied by 'Umar ibn Muhammad Lala ibn al-Marvazi

Per 109: *Kulliyyat* of Sa'di, n.d., but early fourteenth century (see figs. 8–9)

Per 110 and 110.4, 72, 83, and 85: *Shahnama*, 741/1341, for the Injuid vizier, Qivam al-Din Hasan; for the location of additional, dispersed folios, see "Dispersed Manuscripts" below (see figs. 81, 114, 119a, 120–21, and app. 4.2)

Per 111: Detached folios from the Great Mongol *Shahnama*, n.d., but c. 1335, Tabriz (see fig. 117)

Per 113: *Kulliyyat* of Sa'di, n.d., but mid-fourteenth century (see figs. 6 and 17)

Per 114: *Shahnama* portion of the Collection of Epics, 800/1397, copied by Muhammad ibn Sa'id al-Qari (part of BL Or. 2780) (see fig. 89)

Per 117: Five *masnavi*s of 'Attar, 819–21/1416–18 (see figs. 45 and 49)

Per 119: *Gulistan* of Sa'di, 830/1426–27, for Baysunghur, copied by Ja'far al-Baysunghuri (see figs. 60 and 71)

Per 120: Double-page, illuminated frontispiece from an anonymous collection of Arabic proverbs and sayings, n.d., but c. 1430, for Baysunghur (see fig. 72)

Per 122: *Lama'at* of Iraqi and an anthology of mystical *ghazal*s by Persian poets, 835/1432, copied by Ja'far al-Tabrizi

Per 123: *Kulliyyat* of Sa'di, n.d., but c. 1440, for 'Abdallah ibn

Ibrahim Sultan, copied by Shams al-Din 'Ali (see figs. 43–44 and 50)

Per 125: *al-Mathnawi al-ma'nawi* of Rumi, 846/1442, copied by Bayazid ibn Ibrahim Tabrizi, for Amir Shams al-Din Muhammad (see figs. 66–67)

Per 127: Anthology of *ghazal*s (includes the poems of Awhadi, Hafiz, Katibi, Khwaju Kirmani, Sa'di, Shahi, and Sayyid Qasim-i Anvar), 853/1449

Per 129: *Tashrih al-badan*, n.d., but c. 1430 (medical diagrams)

Per 133: *Kulliyyat* of Sa'di, 856/1452, copied by 'Ali ibn Isma'il ibn Yahya al-Husayni (see figs. 46 and 63)

Per 138: *Kulliyyat* of Katibi and *Zad al-musafirin* of Amir Husayni, 868/1464, copied by Sultan 'Ali

Per 141: *Khamsa* of Nizami, n.d., but mid-fifteenth century (see fig. 84)

Per 143: *Kulliyyat* of Khwaju Kirmani, 873/1468, copied by Sultan 'Ali

Per 145: *al-Mathnawi al-ma'nawi* of Rumi, 874–75/1470, copied by Qambar 'Ali ibn Khusraw al-Isfahani

Per 153: Poems by 'Attar and *al-Mathnawi al-ma'nawi* of Rumi, 881/1476, signed Sultan 'Ali (but apparently not "al-Mashhadi")

Per 157: *Shahnama*, 885/1480, copied by Muhammad Baqqal

Per 158: *Shahnama*, 885/1480

Per 159: Anthology (poems of Rumi, Khayali, 'Ubayd-i Zakani, 'Attar, Hafiz Sa'd, and Amir Khusraw), n.d., but mid-fifteenth century

Per 160: *Mantiq al-tayr* of 'Attar, n.d., but late fifteenth century, Herat, copied by Sultan 'Ali al-Mashhadi

Per 171: *Khamsa* of Nizami, 897/1492, copied by Muhammad ibn Nasr Allah ibn Fazl Allah al-Murshidi al-Shirazi

Per 178: *Divan*s of Hafiz and Ibn Yamin, the *Ruba'iyyat* of 'Umar Khayyam, and *Khulasa-i jamshid*, n.d., but early sixteenth century

Per 185: Anthology (mainly poems by 'Attar, 'Imad Faqih, and 'Ismat of Bukhara, but also of Rumi, Amir Khusraw, Awhadi, Hafiz, Khwaju Kirmani, Salman Savaji, and Talib), n.d., but mid-fifteenth century

Per 202: *Kulliyyat* of Sa'di, n.d., but c. 1535, Shiraz

Per 217: *Gulistan* and *Bustan* of Sa'di, n.d., but c. 1550, copied by Shah Muhammad

Per 253: *Majnun wa layla* and *Hasht bihist* of Amir Khusraw, n.d., but mid-fifteenth century (see fig. 47)

Per 275: *Kulliyyat* of Sa'di, 852/1448 (see figs. 37 and 48)

Per 294: Anthology (poems of 'Attar, Awhadi, Fakhr al-Din Ibrahim 'Iraqi, 'Ismat ibn Mas'ud of Bukhara, Amir Khusraw, and 'Imad Faqih), n.d., but probably 1430–40

Per 317: *al-Majmu'a al-mubariziyya*, 791/1389, copied by Amir Ahmad ibn Mahmud al-Dashti

Per 318: *Khamsa* of Nizami, 789/1389 (first and final folio only; the remainder of the manuscript is the *Divan* of Salman, n.d., but c. 1400)

Per 321: Seven of 'Attar's *masnavi*s, 821/1418, copied by 'Ali ibn Muhammad

Christie's (Christie's Sales Catalogues, London)

19 October 1995, lot 79: *Shahnama*, 969/1561–62, copied by Muhammad al-Qivam al-Katib al-Shirazi

29 April 2003, lot 106: *Risalal fi'l tawhid* and *Risala dar haqiqat-i ashya* of Shah Ni'matullah Vali, 821/1418

Copenhagen, Royal Library

168: *Kitab al-aghani* (vol. 20), n.d., but c. 1218, probably Mosul

CUL (Cambridge University Library)

Browne V.65 (7): Anthology (selections from about eighty poets, including Nizami, Sa'di, Amir Khusraw Dihlavi, 'Attar, Anvari, 'Iraqi, and Khwaju Kirmani), 827/1424

Detroit (Detroit Institute of Arts)

35.54: "Ardashir Battles Bahman, Son of Ardavan," detached folio from the Great Mongol *Shahnama*, n.d., but c. 1335, Tabriz (see fig. 79)

EUL (Edinburgh University Library)

Arab 20: *Jami' al-tavarikh*, 714/1314–15, Tabriz (part of Khalili MSS727)

Arab 161: *al-Athar al-baqiya 'an al-qurun al-khaliya*, 707/1307, copied by Ibn al-Qutbi

FITZ (Fitzwilliam Museum, Cambridge)

22-1948: *Shahnama* fragment, n.d., but late 1430s to 1440s (part of BM OA 1948-10-9-48–52)

McClean 199: *Bahiyya-i naqiyya*, the fourth *divan* of Amir Khusraw Dihlavi, 800/1397–98

Florence (Biblioteca Nazionale Centrale)

Cl. III.24: *Shahnama*, 614/1217

Freer (Freer Gallery of Art, Smithsonian Institution, Washington, D.C.)

F1929.25–46, 1930.1–17, and 1940.12–13: Freer Small *Shahnama*, n.d., but c. 1300

F1931.29–37: *Khusraw va shirin*, n.d., but c. 1405–10, Tabriz, copied by 'Ali ibn Hasan al-Tabrizi (see fig. 118 and app. 4.7)

F1932.29–37: *Divan* of Sultan Ahmad, 805/1402

F1938.3: "The Bier of Iskandar," detached folio from the Great Mongol *Shahnama*, n.d., but c. 1335, Tabriz (see fig. 102)

F1948.15: "Gushtasp Slays a Dragon," from the *Shahnama* of 741/1341

F1954.31: *Tarikh-i ghazani* (single folio), n.d., but c. 1596, India

F1957.16: *Tarikh-i bal'ami*, n.d., but c. 1300

Georgian (Institute of Manuscripts of the Georgian Academy of Sciences)

P-458: *Khamsa* of Nizami, 831/1428, for Ibrahim Sultan

Gulistan (Gulistan Palace Library, Tehran)

716: *Shahnama*, 833/1429–30, for Baysunghur, copied by Ja'far Baysunghuri (figs. 87, 105, 109, and 111)

IAM (Istanbul Archaeology Museum)

216: *Marzubannama*, 698/1299, copied by al-Murtada ibn Abi Tahir ibn Ahmad al-Kashi

IUL (Istanbul University Library)

F. 1418: Astrological Treatises (*Ahkam al-a'wam* of al-Bukhari; *Rawdat al-munajjimin* of Abi'l-Khayr Razi; *Burhan al-kifaya* of al-Bakri; and *Zij-i ilkhani* of al-Tusi), 813–14/1411, Shiraz, for Iskandar Sultan

F. 1422: Shah Tahmasp Album, containing *Kalila wa dimna* illustrations, n.d., but late fourteenth century

FY 496/1: *Divan* of Zahir Faryabi, 759/1358, copied by al-Husayn ibn Muhammad al-Madini

FY 496/2: *Divan* of Anvari, 759/1358, copied by al-Husayn ibn Muhammad al-Madini

Johns Hopkins University, Baltimore (John W. Garrett Collection, Milton S. Eisenhower Library)

Zafarnama, 872/1467–68, Herat, for Sultan Husayn Bayqara

JRL (John Rylands Library, Manchester)
Pers. 36: *Khamsa* of Nizami, 848–49/1444–45
Pers. 932: *Shahnama*, 949/1542
Pers. 933: *Shahnama*, n.d., but c. 1430–40

Keir (Keir Collection, London; cat. no. as listed in Robinson et al. 1976)
III.7-27: *Haft paykar, Layla u majnun, Makhzan al-asrar*, and *Khusraw va shirin* of Nizami, n.d., but late fourteenth century

Khalili (Nasser D. Khalili Collection of Islamic Art, London)
MSS685: *Qisas al-Anbiya*, 821/1418
MSS727: *Jami' al-tavarikh*, 714/1314–15, Tabriz (part of EUL Arab 20) (see figs. 99 and 103)
QUR159: Qur'an, n.d., but c. 1370
QUR162: Qur'an (single folio), n.d., but c. 1313–25, possibly Baghdad
QUR171: Qur'an, 807/1404–05, copied by Ibrahim ibn Murad al-Hafiz
QUR181: Qur'an, parts 24–25, n.d., but copied c. 1340s for Fars Malik Khatun and illuminated 1370s for Turan Shah (part of the same manuscript as QUR182) (see figs. 28, 31, and 125)
QUR182: Qur'an, parts 10 and 14, n.d., but copied and illuminated c. 1340s for Fars Malik Khatun (part of the same manuscript as QUR181) (see figs. 18–19 and 29)
QUR212: Qur'an, 823/1420, possibly for Ibrahim Sultan, copied by Khwaja Jalal al-Din Mahmud, called Qutb al-Mughaythi al-Sultani
QUR242: Qur'an, n.d., but probably 1340s (see fig. 30)
QUR495: Qur'an, n.d., but probably early fourteenth century
QUR832: Qur'an, 731/1332, copied 'Abdallah al-Sayrafi

Krauss (former Collection of Hans P. Krauss; cat. nos. as listed in Grube n.d.)
30-32: Two illustrated folios from an unidentified text, n.d., but c. 1330s

Kuwait (Dar al-Athar al-Islamiyyah)
LNS 9 MS: *Mu'nis al-ahrar*, 741/1341, Isfahan, copied and complied by Muhammad Ibn Badr al-Din Jajarmi (the illustrations, except for the figurative-frontispiece, are dispersed, for the location of which, see Swietochowski and Carboni 1994) (see figs. 24 and 26; and also fig. 124 for missing binding)

Leiden (University Library)
Codex Or. 494: *Shahnama*, 840/1437, copied by 'Imad al-Din 'Abd al-Rahman al-Katib

Lisbon (Calouste Gulbenkian Foundation)
LA 158: Anthology of Poetry, 815–16/1412–13, for Iskandar Sultan, copied by Hasan al-Hafiz (part of TIEM 2044)
LA 161: Anthology (excerpts of the *Khamsa* of Nizami; *Gushtaspnama* of Asadi; *Abkar al-afkar* of Khata'i; sections of the *Tarikh-i guzida* of Hamdallah Mustawfi; *Mantiq al-tayr* of 'Attar; *al-Mathnawi al-ma'nawi* of Rumi; and *Kitab dar lughah-i furs* of Asadi; for a complete list of contents, see Soucek 1992, pp. 129–31), 813/1411, for Iskandar Sultan, copied by Hasan al-Hafiz and Mahmud ibn Murtadi al-Husayni (see figs. 61–62)
LA 168: *al-Mathnawi al-ma'nawi* of Rumi, 822/1419, for Ibrahim Sultan
M 28A and M 28B: unidentified Arabic and Persian text (two folios), n.d., but probably first decade of fifteenth century, Baghdad or Tabriz
M 66A–B: *Shahnama* (detached folios), n.d., but 1430–50

Majlis (Majlis Library, Tehran)
36782: *Zafarnama*, 840/1436
61866: *Iskandarnama* of Nizami, 839/1435–36, for Ibrahim Sultan, copied by Mir 'Ali

Malek (Malek Library, Tehran)
5932: Anthology, n.d., but early fifteenth century
6531: *Shahnama* and *Khamsa* of Nizami, 833/1430, for Baysunghur, copied by Muhammad Muhtahhar (with two later illustrations)

Mashhad (Mashhad Shrine Library)
215: Qur'an, 837/1434, perhaps copied by Ibrahim Sultan
414: Qur'an, 827/1424, copied by Ibrahim Sultan

MET (Metropolitan Museum of Art, New York)
13.288.1–2: Qur'an, 830/1427, copied by Ibrahim Sultan (with late illuminations)
13.228.19: Anthology, n.d., but c. 1420
20.120.244: *Shahnama* (single folio), n.d., but c. 1436
48.144: *Tarikh-i ghazani* (single folio), n.d., but c. 1596, India
1974.290.1–42: Gutman *Shahnama*, n.d., but c. 1340

Morgan (Pierpont Morgan Library, New York)

M500: *Manafi'i hayavan*, date is unclear but is 694/1294–95, 697/1297–98, or 699/1299–1300, for Shams al-Din ibn Ziya al-Din al-Zushaki, Maragha

Munich (Bayerische Staatsbibliothek)

Codex pers. 228: *Athar muluk al-'ajam* of Fazl Allah, 878/1473

New York Public Library (Spencer Collection)

Persian Ms. 41: *Makhzan al-asrar* of Mir Haydar Khwarazmi, 883/1478, Tabriz, for Ya'qub ibn Uzun Hasan Aq Qoyunlu

Pars (Pars Museum, Shiraz)

417: Qur'an, n.d., but c. 1340s, for Fars Malik Khatun, illuminated for Turan Shah in the 1370s (part of Khalili QUR181 and QUR182)

427: Qur'an, n.d., but probably 1340s

430: Qur'an, 834/1430–31, copied by Ibrahim Sultan

456: Qur'an, 745–46/1344–46, probably for Tashi Khatun, copied by Yahya al-Jamali al-Sufi, illuminated by Hamzah ibn Muhammad al-'Alavi (see fig. 14)

Punjab (Punjab University Library)

318: *Kulliyyat* of Sa'di, 829/1426, ordered by Khwaja Giyath al-Din Muhammad Faraj-Allah for Ibrahim Sultan, copied by Muzaffar ibn 'Abdullah

Qatar (Museum of Islamic Art, Doha, Qatar)

MS.6.1998: *al-Majmu'a* of Rashid al-Din, 711/1311–12, copied by Muhammad ibn Mahmud ibn Muhammad, known as Zudnivis al-Baghdadi

Rampur, Reza Library

1820: *Tarikh-i ghazani* (vol. 1 of *Jami' al-tavarikh*), n.d., but probably late fourteenth century, probably Tabriz

RAS (Royal Asiatic Society Library, London)

239: *Shahnama*, n.d., but c. 1444, for Muhammad Juki

Sackler (Arthur M. Sackler Gallery, Smithsonian Institution, Washington, D.C.)

LTS1998.1.1.1–94: Stephens *Shahnama*, n.d., but late 1340s to early 1350s (the date inscribed on the *shamsa*, 753/1352, is not original to the manuscript) (see figs. 20–21, 25, and 115)

LTS2003.1.20.3: *Sahih* of al-Bukhari, 758–60/1357–58, for the Muzaffarid vizier Qutbuddin Sulaymanshah, copied by Sayin Mashaza al-Isfahani (see fig. 27)

S1986.33: *Khamsa* of Nizami, 837/1433–34, for 'Ali ibn Lutfallah ibn al-Sadiq al-Husayni

S1986.34: *Khamsa* of Kirmani, 841/1437

S1986.45: *Kulliyyat* of Sa'di, 995/1587

S1986.99a: "Lahhak and Farshidvard before Afrasiyab," detached folio from the *Shahnama* of Qivam al-Din, 741/1341, Shiraz

S1986.102: "Sindukht Becomes Aware of Rudaba's Actions," detached folio from the Great Mongol *Shahnama*, n.d., but c. 1335, Tabriz

S1986.110: *Shahnama* (right half of a double-page frontispiece), 741/1341

S1986.111: *Shahnama* (left half of a double-page frontispiece), 741/1341 (see fig. 16)

S1986.127–30: *Shahnama*, n.d., but fifteenth century

S1986.142–43: Double-page figurative-frontispiece to a lost manuscript for Baysunghur, n.d., but 1420s–30s

S1986.154: *Shahnama* (loose illustrated folio), n.d., possibly Indian (part of Sotheby's, 7 April 1975, lot 186)

S1986.483: *Khamsa* of Nizami, 1055/1645

Sam Fogg (Islamic Manuscripts, Catalogue 22, London 2000)

15: Qur'an, 767/1365, copied by 'Abd Allah Ibn Muhammad, known as Karim

57: *Kitab al-adhkar*, 772/1371, Egypt or Syria

Sotheby's (Sotheby's Sales Catalogues, London)

7 April 1975, lot 186: *Shahnama*, n.d., but probably fifteenth century (part of Sackler S1986.154)

27 April 1981, lot 111: *Durrat al-taj al-ghurrat al-dubaj*, n.d., but c. 1410, for Iskandar Sultan (diagrams)

11 October 1982, lot 214: Dufferin and Ava *Shahnama*, 839/1436–37, copied by Jahangir

14 December 1987, lot 120: *Khamsa* of Nizami (single folio), 984/1576 (part of Aga Khan IR.M.28)

14 December 1987, lot 231: Qur'an fragment, c. 1370

22 October 1993, lot 147: *Bustan* of Saʿdi, 864/1459

18 October 1995, lot 42: *Kitab al-kashshaf ʿan haqaʿiq al-tanzil al-qurʾan* of Abu al-Qasim Mahmud ibn ʿUmar al-Zamakhshari, 681/1282

18 October 1995, lot 62: *al-Mathnawi al-maʿnawai*, 743/1342

18 October 1995, lot 65: *Shahnama*, 878/1473

15 October 1998, lot 20: Qurʾan, 702/1303

StP-HM (St. Petersburg, Hermitage Museum)

VR 1000: *Khamsa* of Nizami, 835/1431, for Shah Rukh, copied by Mahmud

StP-IOS (St. Petersburg, Institute for Oriental Studies, Russian Academy of Sciences)

B-132: *Khusraw va shirin*, 1421, for Baysunghur, copied by Jaʿfar ibn ʿAli al-Baysunghuri

C. 650: *Jaydan Khirad* of Qazvini, 759/1358

C. 1654: *Shahnama*, 849/1455

D. 228: *Rasaʾil al-rusul wa aʿmaluhum*, 741/1341, Damascus, copied by Thuma al-Mutarahhib, known as Ibn al-Safi

StP-RNL (St. Petersburg, Russian National Library)

Dorn 255: *Tarjuma-i ihyaʾ-i ʿulum al-din* of al-Ghazali, n.d., but 1330s

Dorn 329: *Shahnama*, 733/1333, copied by ʿAbd al-Rahman al-H . . . ʿAbdallah ibn al-Zahir

Dorn 406: *Kulliyyat* of ʿImad Faqih, 772/1370, presented by the poet's son to the vizier, Amir al-Din Hasan of Shiraz (see fig. 119c and app. 4.5)

Suleymaniye (Suleymaniye Library, Istanbul)

A.S. 3857: Collection of *Masnavis* and *Ghazals*, 815–16/1412–13, for Iskandar Sultan

Feyzullah 489: *Jamiʿ al-sahih*, 832/1429, for Ibrahim Sultan

Fatih 3682: Anthology of Prose Texts (*Kalila wa dimna*; *Marzubannama*; and *Sinbadnama*), n.d., for Ibrahim Sultan

Tashkent (al-Biruni Institute for Oriental Studies, Academy of Sciences of the Republic of Uzbekistan, Tashkent)

1620, *Tarikh-i ghazani* (an incomplete copy of *Jamiʿ al-tavarikh*), n.d., but early fourteenth century (but with at least one painting added later, probably in the fifteenth century), probably Tabriz

2179: *Khamsa* of Amir Khusraw, 756/1355, copied by Hafiz Shirazi

and Ahmad ibn Vali ibn ʿAbdallah al-Shirazi (see fig. 32 and app. 4.3)

3317: *Khamsa* of Amir Khusraw Dihlavi, n.d., but late fourteenth century

TIEM (Türk ve İslam Eserleri Müzesi, Istanbul)

430: Qurʾan, 739/1338–39, copied by Yahya al-Jamali al-Sufi

450: Qurʾan, 713/1313, Cairo

541: Qurʾan, 706–10/1306–10, Mosul, for Uljaytu

1906: *al-Mathnawi al-maʿnawi* of Rumi, 849/1445–46

1950: Anthology (poems of Nizami, Amir Khusraw Dihlavi, ʿImad Faqih, Kamal Ismaʿat, Saʿdi, and Amid al-Mulk), 801/1398, copied by Mansur ibn Muhammad ibn Varaqa ibn ʿUmar ibn Bakhtiyar Bihbihani

1954: *Chahar maqala*, 835/1431, for Baysunghur

1979: Anthology, 820/1417, for Ibrahim Sultan, copied by Firuzbakht (ibn Isfahanshah) al-Sultani, who also copied BL-IOL Ethé 1118, illuminated by Nasr al-Sultani

1982: *Divan* of Amir Khusraw Dihlavi, 834/1430–31, for Ibrahim Sultan (see fig. 132)

1992: *Khamsa* of ʿAttar, n.d., but probably 841/1438, for Shah Rukh

2009: Anthology of *Divan*s, 837/1433–34 and 840/1436–37

2044: Anthology (*khamsa*s of Nizami, ʿAttar, Khwaju Kirmani and Amir Khusraw Dihlavi), 815–16/1412–13, for Iskandar Sultan, copied by Ismaʿil (part of Lisbon LA 158)

2046: *Divan* of Sultan Ahmad, 809/1407, Baghdad, copied by ʿAbdallah ibn ʿAli al-Katib al-Sultani (see figs. 51–53 and 129–30)

TS (Topkapi Saray Library, Istanbul)

A.III 1357: *al-Mathnawi al-maʿnawi* of Rumi, 853/1449, copied by Abu al-Qasim ʿAli ibn Ahmad ibn ʿAbd al-Vahhab

A.III 1996: *Sharh masaʿil hunayn ibn ishak*, n.d., Ottoman, with a dedication to Mehmed II

A.III 2097: *Taqwim al-abdan fi tadbir al-insan*, 869/1465, for Mehmed II

A.III 2177: *al-Waqfiya* of Rukn al-Din al-Astarabardi, 871/1467, Istanbul

A.III 2208: *Unmuzaj* of Mahmud b. ʿUmar al-Zamakhshari, n.d., but late fifteenth century, for Mehmed II

A.III 3059: *Sitta* of ʿAttar, 841/1438, for Shah Rukh, copied by ʿAbd al-Malik

A.III 3169: *Kamil al-taʿbir*, 835/1432, copied by Hasan al-Qari (see figs. 69–70 and 136–37)

A.III 3183: *Hikmat al-israk*, n.d., with a dedication to Mehmed II

A.III 3213: *Sharh hidayat al-hikma*, 872/1467, for Mehmed II

A.III 3513: *Zij-i ilkhani* of Nasruddin al-Tusi, 814/1412, for Iskandar Sultan, copied by Mahmud al-Hafiz al-Husayni

A.S. 3703: *De Materia Medica*, 621/1224

B. 282: *Kulliyyat-i tarikhi* of Hafiz-i Abru, 818–19/1415–16

B. 411: The Timurid Calligraphy Album, probably compiled second quarter of the fifteenth century, Herat (includes an unfinished anthology for Iskandar Sultan, dated 816/1413–14; see fig. 92); for full contents, see Roxburgh 1996, pp. 489–643 and Roxburgh 2005, especially chap. 3

E.H. 1239: *al-Mathnawi al-ma'nawi* of Rumi, 862/1457, copied by Abu al-Makarim Muhammad ibn 'Ali ibn Muhammad al-Murshidi

H. 231: *Tarjuma-i ihya'-i 'ulum al-din* of al-Ghazali, 744/1344, Shiraz (see fig. 15)

H. 362: *Kalila wa dimna*, 834/1430–31, for Baysunghur, copied by Ja'far

H. 363: *Kalila wa dimna*, n.d., but probably late thirteenth century, probably Baghdad or Konya

H. 674: *Garshaspnama*, 755/1354, copied by al-Hajji Hasan Rukn al-Din

H. 690: *Haft paykar* of Nizami, 788/1386–87, copied by Ahmad ibn Muhammad al-Mulaqatab

H. 748: *Kulliyyat* of Sa'di, 920/1514–15, Shiraz

H. 753: *Khamsa* of Nizami, n.d. (with Turcoman illuminations and Safavid illustrations)

H. 761: *Khamsa* of Nizami, 866/1461 and 881/1476, for Pir Budaq and Sultan Khalil, copied by Shaykh Mahmud Pir Budaqi and Fakhr al-Din Ahmad

H. 762: *Khamsa* of Nizami, mid-fifteenth to early sixteenth centuries, for Timurid, Turcoman, and Safavid patrons

H. 773: *Khamsa* of Nizami, 864–65/1460–61, copied by 'Abd al-Rahman ibn Muhammad Isma'il

H. 781: *Khamsa* of Nizami, 849/1445–46, for Ismat al-Dunya, copied by Yusuf al-Jami, illustrated and illuminated by Khwaja 'Ali al-Tabrizi (see fig. 100)

H. 786: *Khamsa* of Nizami, 850/1446–47, for Yusuf Shah ibn Amir Miran al-Tabrizi, copied by 'Ali ibn Iskandar al-Kuhistani, illustrated and illuminated by Sultan 'Ali al-Bavarchi

H. 789: *Khamsas* of Nizami and Amir Khusraw Dihlavi, 841–42/1437–39

H. 796: Yazd Anthology (*Khamsa* of Amir Khusraw Dihlavi; *Gul u nawruz* of Khwaju Kirmani; *Marzubannama*; and *divans*

of Sayf al-Din Isfarangi, 'Abd al-Vasi al-Jabali, Amir Khusraw Dihlavi, Zahir al-Din Faryabi, and Fakhr al-Din 'Iraqi), 810/1407, Yazd (see figs. 88 and 127–28)

H. 831: *Mihr u mushtari*, 905/1499–1500, copied by Shaykh Muhammad ibn Fakhr al-Din Ahmad al-Ansari

H. 841: *Varqa va gulshah*, n.d., but c. 1250, Anatolia

H. 870: *Khamsa* of Nizami, 848/1444, copied by Abu Bakr ibn Isma'il ibn Mahmud bin 'Ali al-Faruqi

H. 898: *Khamsa* of Amir Khusraw Dihlavi, 850/1446

H. 1007: *Kulliyyat* of Kamal ibn Ghiyath, 861/1457

H. 1015: *Divan* of Hafiz, 870/1465–66, for Pir Budaq, copied by Shaykh Mahmud

H. 1412: *Zafarnama*, 857/1453, copied by Ahmad ibn Mahmud 'Izz(?) al-Din al-Jinji(?)

H. 1479: *Shahnama*, 731/1330, copied by al-Husayn ibn 'Ali ibn al-Husayn al-Bahmani (see figs. 1, 80, 112–13, and 116)

H. 1496: *Shahnama*, 868/1464, copied by Muhammad ibn Muhammad ibn Muhammad al-Baqqal

H. 1510: A composite manuscript of three texts: *Shahnama*, probably 783/1382, copied by Mansur ibn Muhammad ibn Warqah ibn 'Umar ibn Bakhtiyar al-Bihbihani (with sixteenth-century illustrations); *Lughat al-Furs*, n.d., but probably 1380s; and *Khamsa* of Nizami, 776/1374, copied and illuminated by Lutf Allah al-Tabrizi, *dar al-mulk* Shiraz

H. 1511: *Shahnama*, 772/1371, copied by Mas'ud ibn Mansur ibn Ahmad al-Mututayyib (see figs. 36, 85, and 126)

H. 1653: *Jami' al-tavarikh*, 714/1314, Tabriz

H. 1654: *Jami' al-tavarikh*, 717/1317, Tabriz

H. 2152: The Timurid Workshop Album, compiled probably second quarter of the fifteenth century, Herat (f. 60b, a double-page painting of an enthroned ruler and procession, c. 1300); for full contents, see Roxburgh 1996 and also Roxburgh 2005, especially chap. 3

H. 2153: Album, compiled probably last quarter of the fifteenth century, probably for Ya'qub Beg Aq Qoyunlu (includes *Shahnama* folios, c. 1370–75)

H. 2154: Bahram Mirza's Album, compiled 1544–45; for contents, see Roxburgh 1996 and also Roxburgh 2005, in particular chap. 6

H. 2310: Baysunghur's Calligraphy Album, compiled about 1426–33, for full contents, see Roxburgh 1996 and Roxburgh 2005, especially chap. 2

M. 6: Qur'an, 826/1422–23, copied by Ibrahim Sultan

R. 69: Qur'an fragment, n.d., but fourteenth century, possibly

copied by Arghun Kamali; for the location of other folios, see James 1988, cat. no. 74

R. 325: *Tuhfat al-khaqan*, 751/1350–51, for Jani Beg of the Golden Horde

R. 395: *Akhlaq-i nasiri*, 846/1442, copied by Sadr ibn Ahmad al-Khanisari

R. 434: *al-Mathnawi al-ma'nawi* of Rumi, 849–50/1445–46, copied by Isma'il al-Katib (see fig. 64)

R. 855: *Khamsa* of Nizami, 849–50/1445–47 (see fig. 75)

R. 862: *Khamsa* of Nizami, 844/1440 and 846–47/1442–43, with a dedication to Mehmed II (see figs. 65, 74, 96, and 138)

R. 874: *Khamsa* of Nizami, 881/1477, Shiraz (see fig. 98)

R. 947: *Divan* of Hafiz, 822/1419, copied by Ja'far al-Hafiz

R. 1022: *Kalila wa dimna*, 833/1429, for Baysunghur, copied by Muhammad ibn Husam Shamsuddin Baysunghuri (see fig. 131)

R. 1547: *Shahnama*, 842/1439, copied by 'Abdallah ibn Muhammad . . . al-Malqub Sadr (see fig. 135)

TUL (Tehran University Central Library)

5179: *Khamsa* of Nizami, dated 718/1318, but late fourteenth century

Vienna (Nationalbibliothek)

A. F. 9: *Maqamat* of al-Hariri, 734/1334, probably Egypt

A. F. 10: *Kitab al-diryaq*, n.d., but mid-thirteenth century, probably Mosul

N. F. 141: Collection of Mystical Poetry, 859/1455, Balkh, for Abu'l Qasim Babur, copied by Muhammad al-Jami

N. F. 382: *Humay va humayun* of Khwaju Kirmani, 831/1427, for Baysunghur, copied by Muhammad ibn Husam Shamsuddin Baysunghuri

N. F. 442: *Divan* of Hafiz, 855/1455, Balkh, for Abu'l Qasim Babur, copied by Muhammad al-Jami

WL (Wellcome Library, London)

Pers. 474: *Kitab-i Viladat-i Iskandar*, 813/1411, for Iskandar Sultan, compiled, copied, and illuminated by Mahmud ibn Yahya ibn al-Hasan ibn Muhammad al-Kashi, known as 'Imad al-Munajjim

Dispersed Manuscripts

Shahnamas

First Small *Shahnama*: n.d., but generally attributed to c. 1300, Baghdad; includes CBL Per 104; for the location of other folios, see Simpson 1979, pp. 369–76 (see app. 4.1)

Second Small *Shahnama*, n.d., but c. 1300; for the location of folios, see Simpson 1979, pp. 377–82

Great Mongol (Demotte) *Shahnama*: n.d., but c. 1335, Tabriz; includes BM OA 1948-12-11-025, BN Supp. pers. 1946, CBL Per 111, Detroit 35.54, Freer F1938.3, and Sackler S1986.102; for the location of other folios, see Grabar and Blair 1980 (see figs. 79, 102, and 117)

741/1341 *Shahnama* for Qivam al-Din Hasan, copied by Hasan ibn Muhammad ibn 'Ali, known as al-Mawsili; includes CBL Per 110, Freer 1948.15, and Sackler S1986.110–11; for the location of other folios, see Simpson 2000, pp. 236–45 (see figs. 16, 81, 114, 119–21, and app. 4.2)

Other Texts

Kalila wa dimna: 733/1333, copied by Yahya ibn Muhammad Yahya al-Dudi

Zafarnama: 839/1436, probably for Ibrahim Sultan, copied by Ya'qub ibn Hasan, called Siraj al-Husayni al-Sultani; for the location of folios, see Sims 1990–91

Location Unknown

ex-Hagop Kevorkian: *Khamasa* of Amir Khusraw, 831/1427, for Ibrahim

NOTES

PREFACE

1. Although the excellent 1979 compendium, *The Arts of the Book in Central Asia, 14th–16th Centuries* (edited by Basil Gray), treats each of the areas of book production considered here (with the exception of codicology), it is very much a collection of isolated studies by a series of different scholars, with no serious attempt to see the book as an integrated whole. Studies that take a broader, more integrated approach to their topic include *Turkish Bookbinding in the 15th Century* (1993), in which Julian Raby and Zeren Tanındı examine not only bookbinding but also illumination and codicology; and Shreve Simpson's study, *Sultan Ibrahim Mirza's* Haft Awrang: *A Princely Manuscript from Sixteenth-Century Iran* (1997), in which she discusses all aspects of the manuscript.

2. These tend to be the resource books and textbooks, dealing with a wide range of subjects and which were used by scholars, students, physicians, jurists, etc., perhaps on a day-to-day basis.

3. An even broader picture would, of course, emerge if undecorated manuscripts were included, but for those manuscripts that make no mention of where, when, or for whom they were made, decoration of some sort is often the only means of attribution. (Most manuscripts examined for this study do, however, contain some sort of documentary information, although it has often not been possible, for simple lack of space, to include this information here.)

4. However, with regard to the Injuid period of fourteenth-century Shiraz, two studies must be mentioned: M. Shreve Simpson's 2000 article "A Reconstruction and Preliminary Account of the 1341 *Shahnama*, With Some Further Thoughts on Early *Shahnama* Illustration"; and Eleanor Sims's forthcoming article "The Stephens *Shahnama*: An Inju Manuscript of 753/1352–53." Moreover, Sims's many articles on the illustrated manuscripts of Ibrahim Sultan, who succeeded his cousin Iskandar as governor of Shiraz, are listed in the bibliography. Almost all studies of Persian painting refer to the manuscripts made for Iskandar, but the only detailed examination of any of his manuscripts is Priscilla Soucek's 1992 article, "The Manuscripts of Iskandar Sultan: Structure and Content," a study of his so-called Lisbon Anthology (LA 161).

5. However, the earliest dated Injuid manuscript included in this study (and the earliest of which I am aware) is a copy of *Kimiyya-i sa'adat* of Abu Hamid Muhammad al-Ghazali al-Tusi, dated 708/1308 (BN Pers. 14).

6. Although the categorization of artistic production according to dynasties certainly is not always appropriate, the end of Timurid rule in Shiraz marks a more or less natural division in the manuscript history of the city. The division between the Injuid and pre-Injuid eras is less clear.

7. Chabbouh (1995, p. 60) notes that "early scholars divided the subject of codicology into four main areas: paper, ink, pens (or, sometimes, script) and binding." However, codicology, calligraphy, and bookbinding are treated here as separate subjects.

8. This is in opposition to the claim that "any picture in a book is an illustration"; see Hodnett 1982, p. 1.

1. ILLUMINATION

1. The Injuid dynasty was a political force in Iran between 703/1303–04 and 758/1357. From 703/1303–04, Sharaf al-Din Mahmud Shah Inju, with the aid of his four sons, controlled various parts of Iraq-i 'Ajam. Initially he ruled from his base in Shiraz on behalf of the reigning Il-Khan, but by 725/1325 he did so in name only, having gained virtual independence from his onetime Il-Khanid overlords. Under Abu Ishaq, the youngest of Sharaf al-Din's four sons, the Injus remained in power in Shiraz until 754/1353 and then in Isfahan until 758/1357.

2. The manuscript is now widely dispersed with the largest single group of folios (eighty-five) in the Chester Beatty Library, Dublin (CBL Per 110). The folios bearing the dedication to Qivam al-Din are part of the collection of the Arthur M. Sackler Gallery, Smithsonian Institution, Washington, D.C. (S1986.110 and S1986.111). The manuscript is thoroughly discussed and numerous folios are reproduced (including the dedication folios) in Simpson 2000, pp. 217–47; for Stchoukine's attribution of all similar manuscripts to Shiraz, see Stchoukine 1936, pp. 93–94. (Portions of this discussion of Injuid illuminations have previously been published in Wright 2006.)

3. Titley 1983, pp. 229–33 and fig. 77. The single-page *shamsa*-frontispiece of the 731/1330 *Shahnama* (TS H. 1479) was in fact first published by Waley and Titley in 1975. In 1979, Akimushkin and Ivanov published another *shamsa*-frontispiece (and double-page text-frontispiece) of an undated manuscript in St. Petersburg (StP-RNL Dorn 255), which they attributed to the 1330s, on the basis of its similarity to the 731/1330 *Shahnama* frontispiece, but without suggesting a place of production. Even earlier, in 1940, Basil Gray published the *shamsa*-frontispiece of a dispersed 733/1333 *Kalila wa dimna* manuscript, noting that in the Bibliothèque nationale exhibit of 1938 (no. 22) the manuscript was attributed to Shiraz, presumably on the basis of its illustration style. See, respectively, Waley and Titley 1975, fig. 1; Akimushkin and Ivanov 1979, pp. 35 and 53 n. 5, and figs. 17 and 19; and Gray 1940, p. 135 and fig. 1.

4. The conclusions of this section of the study are based on the evidence of the following early Injuid manuscripts: (1) BN Pers. 14, 708/1308, see Richard 1997b, pp. 27 and 48, cat. no. 18; (2) BN Supp. pers. 95, 717/1317, see Richard 1997b, p. 49, cat. no. 20; (3) BL Or. 3623, 729/1329; (4) TS H. 1479, 731/1330, see note 3 above; (5) BL Or. 2676, 732/1332; (6) StP-RNL Dorn 329, 733/1333, see Adamova and Gyuzal'yan 1985; (7) dispersed *Kalila wa dimna*, 733/1333, see note 3 above; (8) BL Add. 7622, 734/1334, the text-frontispiece (ff. 1b–2a) is reproduced in Wright 2006, fig. 40; and (9) CBL Per 109, a somewhat confused and undated copy of the *Kulliyyat* of Sa'di, copied in two different hands and with typical early Injuid headings and, also, possibly late thirteenth-century, all-gold text-frontispieces surrounding the beginning of various sections of text and consisting of linked upper and lower panels; similar text-frontispieces are found in StP-RNL Dorn 255, n.d., referred to in note 3 above.

5. These two types of border are also used in BN Supp. pers. 95, f. 1a; see note 4 above. A petal or leaf border may also frame the double-page figurative-painting that is often included among the introductory illuminations of copies of the *Shahnama*, as in the 731/1330 (TS H. 1479) and 733/1333 (StP-RNL Dorn 329) manuscripts. The latter example is reproduced in Adamova and Gyuzal'yan 1985, pp. 42–43.

6. As in BN Supp. pers. 95.

7. The rather early date of BN Pers. 14 is reflected in what might be termed the transitional nature of its illuminations: in addition to its typical early Injuid single-page frontispiece, it also includes two single-page frontispieces (ff. 144a and 225a) of a different type (each is followed by a single heading), each of which is predominately gold in color and consists of a large, central, diamond-shaped element bordered above and below by inscribed panels that are linked by bands of gold (the panels are not divided into three sections as are typical early Injuid panels); the resulting rectangular form is densely illuminated and enclosed by several bands of white strapwork, with a leaf border extending from its upper edge. Three examples of similar frontispieces can be cited: the earliest adorns a manuscript dated 626/1229 (BL Add. 5965, f. 1a), which comprises explanations of the Arabic proverbs included in *Kalila wa dimna*; a second example, almost contemporary with BN Pers. 14, is dated 707/1307–08 (BL Or. 13506, ff. 3b–4a) and is also in a copy of *Kalila wa dimna*; while a third, in a copy of Qazvini's *Jaydan Khirad*, is dated 759/1358 (StP-IOS C.650, f. 1a). For BL 13506, see Waley and Titley 1975, fig. 4; and for StP-IOS C.650, see Akimushkin and Ivanov 1979, fig. 18, and also see pl. VIII, for one half of the double-page frontispiece that follows it. (The calligrapher of BN Pers. 14, Yahya ibn Muhammad ibn Yahya al-Dudi, also copied the dispersed *Kalila wa dimna* manuscript, dated 733/1333, referred to previously, in note 3 above.)

8. Al-Ghazali's *Kimiyya-i sa'adat* (BL Add. 25026) and al-Zamakhshari's commentary on the Qur'an, *Kitab al-kasshaf an haqa'iq al-tanzil al-qur'an*, respectively. The current location of the latter manuscript is not known. No place of production is named in either manuscript. The al-Ghazali manuscript has not been published; the frontispiece of the al-Zamakhshari manuscript is reproduced in Sotheby's, 18 October 1995, lot 42. For further comments on these two manuscripts, see note 12 below.

9. The manuscript is in a fragmentary state—only thirty-six folios have survived—and, although it has been refurbished, the folios are in a state of considerable disorder. Hence, the two halves of this double-page frontispiece now appear in the manuscript as folios 16a and 18b; see note 12 below for the program of illuminations used in this manuscript. Even earlier parallels than this manuscript exist for the petal or leaf border in illuminations: for example, the Qur'an copied in Baghdad in 391/1000–01, by Ibn al-Bawwab (CBL Is 1431), and another Qur'an, dated 592/1195 (CBL Is 1435). Parallels for the leaf or petal border also exist in manuscript illustration and are likewise found at an early date in manuscripts of Iraqi and also Syrian origin, wherein the motif serves as a grassy baseline. It is also used as such in some Injuid illustrations. For an example of its early use, see an undated but probably mid-thirteenth-century copy of the *Kitab al-diryaq* attributed to Mosul (Vienna A. F. 10): in the illustration on folio 1a, the motif serves as a base for a frieze of hunting figures, reproduced in Ettinghausen 1977, p. 91. Also see the copy of *Kalila wa dimna*, referred to in note 7 above, dated

707/1307–08 but of uncertain provenance (BL Or. 13506), reproduced in Waley and Titley 1975, figs. 10 and 13; Titley 1983, p. 37, fig. 14; and Komaroff and Carboni 2002, cat. no. 3, fig. 266.

10. "Strapwork" refers to wide bands of gold with intricate interior delineations in black, drawn in imitation of woven or flat-braided bands or straps (e.g., see figs. 10 and 14), at times in a type of Greek key pattern (see fig. 3).

11. In a few early examples, there are no smaller roundels, only the larger, midpoint palmette, as in BN Pers. 14 (708/1308), ff. 1b–2a.

12. The basic Injuid program of introductory illuminations is used in the pre-Injuid, 672/1274 copy of al-Ghazali (BL Add. 25026), but not in the 681/1282 copy of al-Zamakhshari's commentary on the Qur'an (Sotheby's, 18 October 1995), both of which are referred to in note 8 above. The illumination program of the latter manuscript is simpler, because the *shamsa*-frontispiece is followed on the next page by a heading consisting of an inscription in Eastern *kufic* set against an arabesque scroll of large, fleshy palmettes, which is itself set against the unpainted page. The 595/1199 *Kitab al-diryaq* has a very elaborate program of illuminations. According to Bishr Farès's reconstruction of the manuscript, it began with a double-page text-frontispiece, followed by a double-page painting of an enthroned figure surrounded by peris. This, in turn, was followed by the double-page frontispiece that relates to the early Injuid single-page frontispiece type (see fig. 5); a single-page frontispiece of a similar type is also included in the manuscript. Numerous other folios are illuminated with headings of the type described above for the 681/1282 manuscript; for reproductions of all extant folios of the *Kitab al-diryaq* manuscript, see Farès 1953.

13. The group of early Injuid manuscripts includes no copies of the Qur'an. For reproductions of the two frontispieces of *juz'* 13 of the Anonymous Baghdad Qur'an, see James 1988, cat. no. 39 and figs. 51–52; and for the single-volume Qur'an, see Sotheby's, 15 October 1998, lot 20.

14. Most of the 733/1334 Qur'an is in the Chester Beatty Library (Is 1469); for the location of other sections of it, see James 1988, p. 242, cat. no. 55. The surviving sections of the 738/1338 Maragha Qur'an are in Ankara, Boston, and Dublin; see James 1988, p. 245, cat. no. 61; and Komaroff and Carboni 2002, p. 259, cat. no. 66. Also see Gray 1985 for a discussion of various so-called monumental Qur'ans of the Il-Khanid (and Mamluk) period.

15. Examples of Il-Khanid manuscripts in which a freestanding *shamsa* is followed by a single heading are (1) Morgan M500, 697/1297 or 699/1300 (one *shamsa* and heading), reproduced in

Schmitz 1997, back slipcover and fig. 2; (2) IAM 216, 698/1299 (one *shamsa* and heading), reproduced in Simpson 1982, figs. 46–47; (3) BL-IOL Ethé 903, etc., 713–14/1314–15 (six *shamsa*s, five of which are followed by a heading); (4) Khalili MSS727 and EUL Arab 20, 714/1314–15 (four *shamsa*s, each followed by a heading), reproduced in Gray 1978, figs. 36–37; Rice and Gray 1976, pp. 184–85; Sotheby's, 8 July 1980 [no lot no.]; and Blair 1995. In a copy of the *Jami' al-hikayat* dated 741/1340 (BL Or. 4392), the *shamsa* is followed by single headings placed on facing folios.

16. The earlier of the two copies of Rashid al-Din's text, dated 710/1310, is in Paris (BN Arabe 2324); the second, dated 711/1311–12, is in the Museum of Islamic Art in Doha, Qatar (MS.6.1998). The Paris manuscript begins with a double-page frontispiece followed by a heading; the slightly later manuscript begins with both a single- and a double-page frontispiece. Each of these two manuscripts also includes thirty-nine *shamsa*s that mark internal divisions of the text. Most of the *shamsa*s are set within elaborate rectangles and followed by a heading on the next page. In a very few examples, such as f. 54a of BN Arabe 2324, the rectangle takes the form of linked upper and lower panels; however, the motifs and the incredibly vibrant palette clearly set these *shamsa*-frontispieces apart from all Injuid examples. The calligrapher of both is Muhammad ibn Mahmud ibn Muhammad, known as Zudnivis al-Baghdadi, but only in the Paris manuscript does the illuminator give his name—Muhammad ibn al-'Afif al-Kashi—and differences in the two manuscripts suggest a different artist was responsible for the later manuscript. In particular, a wider and more unusual range of motifs is used in the later manuscript—so much so that this manuscript will surely eventually offer new and as yet unexplored insights into Il-Khanid illumination. For BN Arabe 2324, see Richard 1997b, p. 44, cat. no. 12; and Komaroff and Carboni 2002, p. 245, cat. no. 5. For the later manuscript, see Christie's, 13 October 1998, lot 55; and Komaroff 2006, color plate 9.

17. For example, see James 1988, p. 87, fig. 54.

18. As noted by James, Yahya's *nisba* "al-Jamali" is obviously in reference to the throne name, Jamal al-Din, of his patron Abu Ishaq. That Tashi Khatun was the patron of the Yahya Qur'an is assumed because it was she who later bequeathed it to the mosque of Shah-i Chiragh in Shiraz; see James 1988, p. 163.

19. The manuscript has not been viewed personally and its illuminations are known only from two published folios; see James 1988, p. 247 and fig. 115.

20. Another Qur'an signed by Yahya, dated 739/1338–39 (TIEM 430), is illuminated in the Il-Khanid style and was probably made

in Tabriz; see James 1988, pp. 163–64; and Ölçer et al. 2002, pp. 202–03. A third Qur'an signed by him, dated 740/1339–40 (CBL Is 1475), has Ottoman illumination; see James 1980, p. 66.

21. In 740/1339, Shams al-Din Muhammad, the son of Sharaf al-Din Mahmud Shah Inju, took control of Shiraz, with the aid of the Chupanid Pir Husayn. (In the immediately preceding years, the city had been held by Mas'ud Shah and Kay Khusraw, also sons of Mahmud Shah.) Muhammad ruled only briefly, because in 740/1340 he was executed by Pir Husayn, who then tried to establish himself more securely in Shiraz. But Pir Husayn was soon chased from the city by the inhabitants, only to return about a year later in an unsuccessful attempt to retake the city; in 743/1343 he was killed by his cousin Amir Hasan Kuchak. It is not clear for exactly how long Pir Husayn actually controlled Shiraz. Ibn Battuta says he held the city for two years, but even so this does not account for the whole of the interim period between the death of Shams al-Din Muhammad and the start of Abu Ishaq's rule. Abu Ishaq was the fourth son of Mahmud Shah. In 742/1341–42 he was granted control of Isfahan by Pir Husayn. That same year he traveled to Tabriz to join the Chupanid Malik Ashraf, and then in 743/1342 he accompanied Malik Ashraf on his campaign to Fars on behalf of Amir Hasan Kuchak. Shortly afterward, in Rajab 744/December 1343, Amir Hasan Kuchak was brutally killed by his wife, an event that effectively marked the end of Chupanid power. Upon hearing of Amir Hasan Kuchak's death, Malik Ashraf immediately returned to Tabriz (in Sha'ban 744/December 1343–January 1344). With the Chupanids out of the way, Abu Ishaq quickly laid claim to Shiraz (although the exact date he did so seems to be uncertain). He remained there until 754/1353, at which time the city was besieged by the Muzaffarids and he was forced to flee to Isfahan. The Muzaffarids in turn laid siege to Isfahan, executing Abu Ishaq in 758/1357. This information is derived from Album 1974, pp. 159–62; Arberry 1960, p. 139; Boyle 1971, p. 1208; Ibn Battuta 1958–71, 2:306 n. 118; Kutubi 1913, pp. 157–61; and Roemer 1986, pp. 12–13. (It should be noted that there is considerable discrepancy regarding the dates given for various events.)

22. The program of illuminations at the beginning of the 741/1341 *Shahnama* consists of: (1) a double-page painting (of a hunt and enthronement) immediately followed by, (2) a double-page text-frontispiece similar to the usual early Injuid type and surrounding the beginning of the prose text of the so-called old preface; (3) folios with the remainder of the text of the old preface then appear, at the end of which is the double-page *shamsa*-frontispiece

with a dedication and date (see fig. 16a), immediately followed by, (4) a double-page text-frontispiece with the beginning lines of the poem. The opening preceding that of the double-page *shamsa*-frontispiece includes a small painting depicting Firdawsi and the poets of Ghazna, as well as several narrow headings. For the arrangement of these folios and for color reproductions of both halves of the *shamsa*-frontispiece, see Simpson 2000, pp. 220–25 and pls. 1–2; the double-page figurative-painting is reproduced in Komaroff 2006, pl. 18.

23. Minovi suggests the manuscript dates to about 1380, but this is surely about four decades too late; see Arberry, Minovi, and Blochet 1959, p. 30.

24. The "Sindukht" painting is reproduced in Grabar and Blair 1980, p. 77; Lowry and Beach 1988, p. 61; Lowry and Nemazee 1988, p. 81; Komaroff and Carboni 2002, fig. 90; and Sims 2002, fig. 150. The technique of painting the tips of leaves black is used in a number of fifteenth-century Persian drawings of various Chinese motifs, many of which are preserved in albums in Berlin and Istanbul; see folios reproduced in Lentz and Lowry 1989, p. 182ff.

25. For the suggestion that the two Tabriz-style paintings might be fakes or later additions to the 741/1341 manuscript, see Arberry, Minovi, and Blochet 1959, p. 25, speaking specifically of the Chester Beatty Library painting; that they may instead have been painted by a Tabriz artist was first suggested by James 1992b, p. 124 n. 12, also referring specifically to the CBL painting; and for comparative paintings from the Great Mongol *Shahnama*, such as the scene of "Iskandar Enthroned," see Grabar and Blair 1980, p. 113; and Komaroff and Carboni 2002, fig. 51.

26. The endowment notices naming Fars Malik Khatun were later painted over with ones naming the Muzaffarid vizier Turan Shah (though two of the latter have now been removed: Khalili QUR182, ff. 2a and 26a). The manuscript is not dated, but in the endowment notices the father of Fars Malik Khatun is referred to as "the late" and, as he was executed in 1336, this provides a *terminus post quem* for the dating of the manuscript. Moreover, James has pointed out that Fars Malik Khatun was still alive in 1343–44, because the author of the *Shiraznama*, writing at that time, comments on building projects then being undertaken by her, namely a mausoleum over the grave of 'Ali ibn Bazghash (d. 1279–80), a local saint, as well as the construction of several other buildings at the same site. Another reference, this time to a dispute taking place between the mother and an unnamed sister of Abu Ishaq, perhaps Fars Malik Khatun, was made by Ibn Battuta, who visited Shiraz

in 1347–48. Although the whole manuscript was copied for Fars Malik Khatun, of the eight surviving parts only four were also illuminated during her lifetime: parts 1, 10, 12, and 14 (of which parts 1 and 12 are in the Pars Museum, no. 417, and parts 10 and 14 are in the Khalili Collection, bound together as QUR182). The other four surviving parts were not illuminated until the 1370s, during the reign of the Muzaffarids (754–95/1353–93) and presumably by command of the vizier Turan Shah, who is named in the later endowment notices: parts 13, 24–25, and 30 (of which parts 13 and 30 are in the Pars Museum, also as no. 417, and parts 24–25 are in the Khalili Collection, bound together as QUR181). See James 1988, pp. 197 and 204; James 1992b, pp. 122–24 and cat. nos. 29–30; and also Lings 1976, fig. 60.

27. The single-page *shamsa*-frontispiece of the Stephens *Shahnama* (f. 211a; see fig. 20) is followed by a double-page text-frontispiece that marks the beginning of the second half of the poem (ff. 211b–12a). At the bottom of the page facing the *shamsa* (f. 210b) is a heading noting the start of the reign of Luhrasp. Although the first folios of the manuscript have been lost, it can be assumed that this same combination of *shamsa* and double-page text-frontispiece originally marked the beginning of the manuscript. The surviving introductory illumination consists only of the left-hand side of what would have been a double-page frontispiece surrounding the first lines of the prose preface (see fig. 21) and another double-page text-frontispiece surrounding the first lines of the poem. (The double-page figurative-painting, to be discussed below, precedes this latter frontispiece.)

28. For example, large gold blossoms set against a dark ground decorate a throne back in a painting of about 1330, now preserved in one of the Istanbul albums (TS H. 2153, f. 148b), reproduced in Rogers et al. 1986, fig. 44. Textiles likewise decorated with gold blossoms against a dark ground are depicted in paintings in the Great Mongol *Shahnama* of about 1335 and also in various early Injuid paintings, reproduced, respectively, in Grabar and Blair 1980, pp. 135, 137, and 165; and Rogers et al. 1986, figs. 32 and 38. For examples in illuminations, see the three headings in a fragmentary Qur'an (Khalili QUR495) that James (1992b, p. 10) dates to 1250–1350 and attributes to "Iran" in general; and the illuminated double-page frontispiece of a *Sahih* of al-Bukhari, dated 694/1294 and attributed to Mamluk patronage in either Egypt or Syria (CBL Ar 4176), which consists mainly of large and fleshy palmettes and blossoms painted in gold against a blue ground.

29. In the Khalili Qur'an QUR242 (the second of the two un-dated Khalili Qur'ans of the late Injuid era), a double-page text-frontispiece introduces the manuscript, the palmette-arabesque side *ansa*s of which extend almost the full length of the frontispiece, and wide palmette-arabesque borders frame both the upper and lower panels of the frontispiece. Based on similarities in style, James has suggested that this Qur'an may be from the same workshop as Khalili QUR182, though no documentation exists for the former; for this suggestion and a reproduction of QUR242, see James 1992b, cat. no. 31.

30. See James 1992b, p. 124, for the suggestion that artists who fled the turmoil of Tabriz might have been responsible for the decoration of the Fars Malik Khatun manuscript.

31. For the candlestick, now in the Museum of Islamic Art in Qatar (MW.122.1999), see Allan 1987, p. 100 and illus. 27; and Komaroff and Carboni 2002, cat. no. 161, fig. 224. Bowls of the type under discussion are frequently reproduced; for example, see those in Melikian-Chirvani 1982, cat. nos. 95–98.

32. Melikian-Chirvani 1971, pp. 1–41; and Allan 1982, pp. 106–09. Also, in the endowment notice of a Qur'an (presumably Pars 456), Tashi Khatun, mother of Abu Ishaq, is said to be referred to as "the supreme Khatun, queen of the Sulaimani kingdom"; see Ibn Battuta 1958–71, 2:307 n. 121.

33. Despite their abundance and frequent publication, there has not yet been any serious attempt to determine a chronology for these bowls.

34. Allan 1987, p. 100. He initially suggests the existence of two workshops in Shiraz, producing metalwork of different qualities, but then concludes that a Baghdad provenance for the candlestick is a more likely explanation.

35. For the Nisan Tasi, now in the collection of the Mevlevi Museum, Konya, see Baer 1973–74, pp. 1–46. For the bowl inscribed with the name of Abu Ishaq that is now in the Musées Royaux d'Art, Brussells (E.O. 1492), see Montgomery-Wyaux 1978, fig. 18. A third object inscribed with the name of Abu Ishaq (also a bowl) is in the Hermitage Museum, St. Petersburg, and is described by Gyuzal'yan 1960, pp. 7–9; it has not been published, but Komaroff (1994, p. 33 n. 53) notes that it relates to both the Brussels bowl and the candlestick in terms of decorative and epigraphic style. However, she also points out that neither bowl is equal in decorative detail and quality to the candlestick.

36. The 1305 bowl is in the Galleria Estense, Modena (no. 8082), reproduced in Atil, Chase, and Jett 1985, p. 25, fig. 13; Baer 1968, pls. I–V; and Baer 1973–74, fig. 50. However, Komaroff and Carboni

(2002, p. 221) have noted that the true date of the bowl may be 750/1349–50, referring the reader to Michelle Bernadini in Curatola 1993, p. 267.

37. The 1338 bowl is in the Louvre Museum, Paris (Cl. 14544); see Melikian-Chirvani 1969, pl. II.

38. Komaroff 1994, pp. 9–12 and figs. 7–8; and for the album folio only, see also Rogers et al. 1986, p. 69, no. 44. Other closely related images are listed and discussed below.

39. Komaroff 1994, p. 19.

40. Komaroff 1994, p. 10. She also notes the placement of winged figures above the enthroned couple on the tray. Similar figures appear on the Abu Ishaq candlestick, and, as she notes, they are another trait that harks back to thirteenth-century Mesopotamian metalwork (p. 12 and also p. 12 n. 33).

41. Komaroff 1994, p. 32 n. 30.

42. For the illumination programs in the 1341 and Stephens *Shahnama*s, see notes 22 and 27 above, respectively.

43. A few also appear rubbed, as if an earlier inscription might once have existed; for example BL Or. 2676.

44. Of course, the size of *shamsa* center cannot in itself be used to indicate commercial or noncommercial origin. Two of the early Injuid *shamsa*s have medium-sized centers, one of which is blank (BN Pers. 14), the other filled with a colored arabesque-web pattern, probably added in the early fifteenth century (BN Supp. pers. 95). The *shamsa* of the late Injuid Stephens *Shahnama* also has a medium-sized center and now bears a late inscription. The patronage of this manuscript will be discussed below.

45. Togan 1963, p. 2.

46. I wish to express my gratitude to Teresa Fitzherbert for her comments on this painting and her suggestion that the figures holding a falcon, geese, a dead gazelle, and a gold bowl might be part of a Nawruz ceremony. Togan (1963, p. 2) assumes that it is the Il-Khanid ruler Abu Saʿid who is depicted enthroned on the left half of the painting. The frontispiece is reproduced in Komaroff 2006, pl. 17.

47. Ettinghausen 1977, p. 64. The manuscripts to which he refers are: (1) the surviving volumes of a copy of *Kitab al-aghani*, c. 1218, probably Mosul, with a single-page frontispiece of a ruler enthroned or engaged in a princely activity in each volume (vols. 2, 4, and 11: Cairo Adab 579; vol. 20: Copenhagen, Royal Library, no. 168; vols. 17 and 19: Bayezit Library, Istanbul, Feyzullah [Efendi] 1566), reproduced in Ettinghausen 1977, p. 65; and Sims 2002, fig. 54; (2) Vienna A. F. 10, *Kitab al-diryaq*, n.d., but mid-thirteenth century, probably Mosul, with a single-page frontispiece in three registers with an informally seated ruler, a hunt scene, and a procession of royal women, reproduced in Ettinghausen 1977, p. 91; and Sims 2002, fig. 55; and (3) Vienna A. F. 9, *Maqamat* of al-Hariri, 734/1334, probably Egypt, with a single-page frontispiece of a ruler enthroned, reproduced in Ettinghausen 1977, p. 148.

48. Other early fourteenth-century manuscript frontispieces are: (1) Freer F1929.25a, Freer Small *Shahnama*, possibly Baghdad, c. 1300, with a single-page frontispiece—perhaps one half of what was originally a double-page painting—in two registers depicting a royal polo game and a royal hunt; (2) Berlin-SB Diez A folio 71, s. 46 no. 8, n.d., with a single-page frontispiece of a ruler enthroned, reproduced in İpşiroğlu 1964, pl. IV, fig. 8; (3) Freer F1957.16, *Tarikh-i balʿami*, n.d., but c. 1300, with a single-page frontispiece of a ruler enthroned, reproduced in Komaroff 2006, pl. 14; (4) TS H. 2152, f. 60b, c. 1300, a double-page painting of an enthroned ruler on the left half and a two-tiered procession on the right half, reproduced in İpşiroğlu 1965, pp. 52 and 99; and (5) BL Or. 13506, *Kalila wa dimna*, 707/1307–08, with a double-page frontispiece of a ruler enthroned on the left half and on the right half courtiers with hunting leopards and a falcon, reproduced in Waley and Titley 1975; Swietochowski and Carboni 1994, fig. 7; and Komaroff 2006, pl. 14.

49. See note 35 above.

50. İpşiroğlu 1964, p. 14 (in the index of paintings on pp. 130–31, s. 45 no. 4 is erroneously listed as no. 5); s. 63 no. 1 is reproduced in Komaroff and Carboni 2002, fig. 133.

51. İpşiroğlu 1964, p. 28, reproduced in Komaroff and Carboni 2002, fig. 133; s. 63 no. 6 is also reproduced in Rührdanz 1997, fig. 1.

52. Ismailova 1980, no. 2, for a reproduction of f. 109a; and Poliakova and Rakhimova 1987, p. 264 and figs. 6–7 for reproductions of ff. 109a and 193a, respectively (but with f. 193a listed incorrectly as f. 191); and also see Blair 1995, p. 110 n. 45. (The manuscript has been incorrectly foliated so that facing folios are numbered as, for example, ff. 109a and 109b; the folio numbers used here are those on the actual folios.)

53. İpşiroğlu 1964, p. 22 and pl. VII, fig. 11, also reproduced in Blair 1995, fig. 58; Komaroff 2006, pl. 7; and Sims 2002, p. 114, fig. 31.

54. İpşiroğlu 1964, p. 24.

55. İpşiroğlu 1964, p. 24, reproduced in Rührdanz 1997, fig. 2.

56. İpşiroğlu 1964, p. 22, reproduced in Komaroff and Carboni 2002, fig. 222.

57. İpşiroğlu 1964, p. 23, reproduced in Rührdanz 1997, fig. 3 (but with numbers reversed).

58. İpşiroğlu 1964, p. 23.

59. Rogers et al. 1986, p. 69, no. 43; and Blair 1995, fig. 59.

60. Rogers et al. 1986, p. 69, no. 44; and Komaroff 1994, fig. 8.

61. Blair 1995, figs. 60–61. It is not known if this manuscript includes any other illustrations of enthroned couples.

62. Komaroff 1994, fig. 7.

63. The Rampur manuscript (number 12 in the list) probably dates to the late fourteenth century. The two Tashkent paintings cited as number 3 in the list are rather curious and much inferior in quality to most others listed here. That a third painting, on f. 50a of this same manuscript (for which see note 69, number 1), is probably a fifteenth-century or later addition is suggested, in part, by its use of large blocks of solid, bright colors and figures that are smaller in size in relation to the total picture area than in typical fourteenth-century works.

64. The six paintings listed as number 1 are full-color works that İpşiroğlu has classified as "Seljuq-Mongolian" and that he therefore presumably regarded as being of an earlier date than those listed here as numbers 2 to 12. These latter paintings, with the exception of those in the Tashkent manuscript (number 3) and the full color-painting listed as number 10 (and perhaps also number 12, which is known to me only from Blair's black-and-white reproduction of it) are all painted in the lightly colored wash technique used in the three surviving early fourteenth-century *Jami' al-tavarikh* manuscripts made in Tabriz in the Rab'-i Rashidi, namely, the Arabic copy, dated 714/1314–15 (Khalili MSS727 and EUL Arab 20), and two Persian copies, one dated 714/1314 (TS H. 1653) and one dated 717/1317 (TS H. 1654), none of which are complete. For the "Seljuq-Mongolian" attribution, see İpşiroğlu 1964, p. 14.

65. The paintings have long been recognized as illustrations to the *Jami' al-tavarikh*; Rührdanz (1997) identifies them as relating specifically to *Tarikh-i ghazani.* The Tashkent manuscript is identified in the available sources only as a copy of the *Jami' al-tavarikh*, but it seems clear that the paintings illustrate the *Tarikh-i ghazani* section of the text.

66. Each measures approximately 95 x 93 mm.

67. Rührdanz 1997, p. 298; Ismailova (1980, no. 2) states specifically that in the Tashkent manuscript, the painting of Ogedei and his wife marks the start of the section on Ogedei and that likewise that of Hulagu and his wife introduces the account of Hulagu's reign.

68. Rührdanz 1997, pp. 298–99.

69. Although not common, several depictions of enthroned couples from later centuries are known. Included among those that clearly derive from the tradition established in the fourteenth century are: (1) Tashkent 1620, f. 50a, "Batan-Bahadur and His Wife Sunigil-Fudjin" (the grandparents of Ghengis Khan), an incomplete copy of *Jami' al-tavarikh*, probably fifteenth century (the painting appears to have been pasted into the manuscript; for the other two, fourteenth-century, paintings in the manuscript, see number 3 in the list on p. 36), reproduced in Ismailova 1980, no. 1; and in Poliakova and Rakhimova 1987, p. 264 and fig. 8; (2) two paintings of "Chaghatay Enthroned with His Wife," from no. D.31, Asiatic Society of Bengal, Calcutta, ff. 56a and 58b, *Tarikh-i ghazani*, c. 1425, reproduced in Gray 1985, p. 250, fig. 22 and p. 243, fig. 15, respectively; (3) Lisbon LA 161, f. 260b, "Ogedei Enthroned," from Iskandar Sultan's Lisbon Anthology, Shiraz, 813/1411, reproduced in Gray 1979, fig. 74; and in Blair 1995, fig. 68; (4) four paintings from BN Supp. pers. 1113, *Jami' al-tavarikh*, c. 1425, Herat: f. 22b, "Qabul Khan Enthroned with His Wife," reproduced in Gray 1985, p. 229, fig. 1; f. 126b, "Ghengis Khan Enthroned with His Wife," reproduced in Richard 1997a, pl. 1; f. 194a, "Abaqa Khan Enthroned with His Wife," reproduced in Gray 1985, p. 232, fig. 4; and ff. 227b–28a, "Ghengis Khan Enthroned with His Wife," reproduced in Rührdanz 1997, fig. 4; (5) two paintings from a copy of *Tarikh-i ghazani*, n.d., but c. 1596, India: "Kublai Khan Enthroned with His Wife," Freer F1954.31, reproduced in Beach 1981, p. 52, and "Ghengis Khan Enthroned with His Wife" (with the woman seated on the left), MET 48.144, reproduced in Blair 1995, fig. 72. Also, a *Khamsa* of Nizami manuscript (TS H. 786), dated 850/1446–47 and possibly produced in Samarqand, includes two depictions of an enthroned couple, on ff. 1b and 49b (on the latter the woman is seated on the left); f. 1b is reproduced in Grube 1981, fig. 360.

70. Berlin-SB Diez A folio 71, s. 63 no. 1 (see note 50 above) and possibly also s. 41 no. 4.

71. For Komaroff's comparison of the imagery on the tray and the *Jami' al-tavarikh* painting, see note 38 above. Carboni states that the placement of the woman on the left in the *Mu'nis al-ahrar* manuscript indicates that she is of higher status than her companion; however, as far as I am aware, there is no literary evidence for this, the assumption being based solely on the fact that it is indeed the ruler himself who usually occupies this position; for Carboni, see Komaroff and Carboni 2002, cat. no. 9, p. 246.

72. Of note are the compositional similarities between the tray and the candlestick: in each a female figure holding a book stands on the same side as the enthroned woman, and paired angels fly above the throne. As Komaroff notes (1994, p. 9), the tray is very worn and the details of the scene are not easily discerned. However, in her published drawing of it, part of just one of what can be assumed to have been a pair of angels kneeling beneath the throne

is indicated. On the candlestick, paired lions crouch beneath the throne.

73. Morton in Swietochowski and Carboni 1994, pp. 49–51.

74. The decoration of gold florals on a blue ground in this manuscript recalls the illumination of the Khalili Qur'an, QUR182, parallels for which in Il-Khanid painting have already been noted; see note 28 above. The striking use of a row of tiny white dots set against black to mark the center of each petal in the brightly colored borders of the frontispiece is notable in at least two Il-Khanid manuscripts: Khalili MSS727, *Jami' al-tavarikh* of Rashid al-Din, 714/1314–15, ff. 259b and 282b, reproduced in Blair 1995; and Khalili QUR162, a single folio that James attributes to Baghdad in about 1313–25, reproduced in James 1992b, p. 24. In addition to the *shamsa*-frontispiece on f. 1a, the illumination and illustration program of the manuscript consists of: ff. 1b–2a, a double-page figurative-painting with illuminated frame; ff. 2b–3a, a double-page text-frontispiece, each half of which consists of an inscribed upper panel linked to a narrow lower band of florals; ff. 4b–5a, a double-page text-frontispiece, consisting of linked upper and lower panels, and listing the names of two hundred Persian poets; f. 5b, an illuminated heading (ff. 3b–4a are an unilluminated table of contents). The manuscript includes six illustrated folios, which are now dispersed among various collections. The manuscript itself, including the illuminated folios, is preserved in the Dar al-Athar al-Islamiyya, in Kuwait (LNS 9 MS). The text is an anthology of Persian poetry compiled by the poet and including eight of his own poems as well as a verse colophon. The manuscript is thoroughly discussed and reproduced in Swietochowski and Carboni 1994.

75. The frontispiece of the manuscript states that it was made for the library of Kamal al-Din Jamali al-Islam, identified by Richard as Kamal al-Din Husayn Rashidi, who was appointed vizier to the Muzaffarid ruler Shah Shuja' after the latter ordered the death of the vizier Qivam al-Din Hasan in 764/1362–63; see Richard 1997b, p. 65, cat. no. 24. By 1362, a distinct Muzaffarid style of illumination had developed, in comparison with which the illuminations of this manuscript must have seemed rather old-fashioned. The precise combination of colors in the petal border of the *Mu'nis al-ahrar* manuscript is brighter and more varied than in this manuscript.

76. The hunt scene is reproduced in Swietochowski and Carboni 1994, p. 25; and Sims 2002, fig. 39.

77. However, the six folios (eleven pages or folio sides) of text illustrations of animals, birds, and astrological figures (referred to in note 74 above) seem a much more mature style and may well be later.

78. See note 21 above.

79. That the ruler wears a different headdress in each painting in no way contradicts this assumption, because, on Abu Ishaq's candlestick, he is portrayed twice wearing the simple Mongol cap, which he wears in the *Shahnama*, and once wearing the owl-feather headdress of Mongol rulers and princes, which he wears in the *Mu'nis al-ahrar* manuscript. (And on the candlestick, his consort is portrayed once wearing the Mongol *bughtaq*.) The depiction of rulers in the dress of their present or former overlords is certainly not without precedent in Islamic art. It should also be noted that Komaroff and Carboni believe that the enthronement scenes on the candlestick should not be regarded "as some form of visual accompaniment to the inscriptions" (which name Abu Ishaq); however, I disagree, and believe it unlikely that such unusual iconography (for a piece of metalwork) would have been chosen to decorate an object that so loudly proclaims the ruler's name unless the iconography was indeed of major significance, namely, that it was in fact intended to portray the ruler himself; see Komaroff and Carboni 2002, cat. no. 162, p. 278. Furthermore, Carboni has stated that the white kerchief held by the woman in the *Mu'nis al-ahrar* painting indicates her royal status; see Swietochowski and Carboni 1994, p. 12. Soudavar holds a similar view and has discussed the function of the kerchief as a symbol of kingship and its prevalent appearance in enthronement scenes, beginning with the copy of al-Biruni's *al-Athar al-baqiya 'an al-qurun al-khaliya* dated 1307 and now in Edinburgh (EUL Arab 161); see Soudavar 1996, p. 200 n. 98; and Soudavar 2003, pp. 9–12. However, that it always (even when held by women) functions as an indicator of royal and hence superior status seems questionable in light of the evidence of at least two other scenes of enthroned couples in which a kerchief is held by other members of the gathering: (1) TS H. 2153, f. 23b (number 10 in the list of enthronements scenes on page 36), in which the enthroned female holds a brown kerchief and three of the women in the upper register and one in the third register from the top, all seated to the right of the throne, also hold kerchiefs; and (2) Berlin-SB Diez A folio 70, s. 21 (number 8 in the list on page 36), in which the enthroned ruler appears to hold a kerchief and also one woman in each of the top three registers holds a kerchief. In each case there is no other detail of dress or seating arrangement (see note 71 above) that would indicate that these women are in any way superior to the others depicted around them. (On Abu

Ishaq's candlestick, the enthroned woman holds what looks like a wineskin but is probably intended to represent a kerchief.)

80. Chapter 29 of the *Mu'nis al-ahrar* manuscript is illustrated (see notes 74 and 77 above) with the first of the three poems in the chapter having been written by the poet Ravandi in praise of the early thirteenth-century Seljuq ruler of Rum, Suleyman. Soudavar has speculated that Ibn Badr included this poem in his manuscript, and, in particular, highlighted it by illustrating it, because he intended it as a direct reference to the current Il-Khanid "puppet" sultan, Suleyman, husband of Sadi Beg (sister of the Il-Khanid sultan Abu Sa'id), and he therefore concludes that it is Sadi Beg and Suleyman who are depicted in the frontispiece. However, this suggestion overlooks the fact that, as Alexander Morton notes, Ibn Badr's illustrating of the poem was in fact nothing new, so to speak, because earlier illustrated versions of the poem surely existed. This is suggested by the version of the poem included in Ravandi's history of the Seljuqs of Iran, *Rahat al-sudur*, which is prefaced by a couplet (absent from the 1341 manuscript) that indicates clearly that the poem was to be illustrated. For Soudavar's hypothesis, see Soudavar 1996, p. 210 n. 98; for Morton's discussion of the poem, see Swietochowski and Carboni 1994, pp. 51–55.

81. The fourth copy of the Qur'an (in addition to the Fars Malik Qur'an, Khalili QUR181–82 and Pars 417; Khalili QUR242; and Pars 456) is Pars 427, the remains (*juz' 8*) of an unpublished thirty-part Qur'an, which has not been examined firsthand and is known to me only through James's reference to it; see James 1992b, p. 124 and n. 11.

82. This is the *Tarjuma-i ihya'-i 'ulum al-din* of al-Ghazali (TS H. 231), which is in fact the same text as the two theology texts in the early Injuid group, StP-RNL Dorn 255 and BN Pers 14, although the latter manuscript bears the title *Kimiyya-i sa'adat*.

83. It is not clear precisely what buildings already existed at the site; however, a domed structure was built over the tomb between about 628/1230 and 658/1259. No thirteenth-century remains are today visible; see Wilber 1955, p. 105.

84. James 1988, p. 163, quoting Ibn Battuta 1958–71, 2:307 and 313–14. Neither the *madrasa* nor *zawiyya* has survived.

85. For Pars 427, see note 81 above.

86. See note 26 above.

87. See Galdieri 1982, p. 301, who suggests that the four corner towers of the structure were added at the time of Abu Ishaq, as was the inscription that runs along the upper edge of the building and contains the date 1351, but that the building itself was actually constructed about 1281 to 1314. The inscription was designed by Yahya al-Jamali al-Sufi, calligrapher of the Qur'an Pars 456. Among other, secular buildings commissioned by Abu Ishaq was a palace, the vaulted hall of which he hoped would rival that of Ctesiphon; see Ibn Battuta 1958–71, 2:310.

88. Roemer 1986, p. 13.

89. Ibn Battuta 1958–71, 2:311 and 313.

90. For example, see James 1988, pp. 76–131.

91. This is the date of the earliest coin located by Stephen Album; personal communication, 11 July 1995. Coins bearing the name Abu Ishaq are known from as early as 719 and 724 but are probably mementos of Shaykh Abu Ishaq; see Howorth 1970, p. 692.

92. Album 1974, p. 159; and Kutubi 1913, p. 160.

93. See Christie's, 24 April 1990, lot 161; and Soudavar 1992, pp. 47–49, cat. no. 18. I would like to thank Abolala Soudavar for generously providing both important documentary material and study slides of this manuscript.

94. For example, those on ff. 17a and 44b of Khalili QUR242.

95. For the division of the various sections of the Qur'an between the Pars Museum and the Khalili Collection, and for sources of reproductions, see note 26 above. A second Qur'an in the Khalili Collection (QUR159) has illuminations very similar to those of the Muzaffarid-illuminated sections of the Fars Malik Qur'an; James has suggested this manuscript was probably illuminated in the same workshop and for the same patron, Turan Shah; see James 1992b, cat. no. 33; and Sotheby's, 14 December 1987, lot 231.

96. However, a single example of the early use of a cartouche with an uneven, or baroque, contour occurs in the second late Injuid Qur'an in the Khalili Collection (QUR242), reproduced in James 1992b, cat. no. 31, f. 38b.

97. For the Hamadan Qur'an, see Ettinghausen 1939, pl. 934; Lings 1976, nos. 54–59; and James 1988, pp. 111–26 and figs. 75–82.

98. This is the only marginal of this type; all others in the Injuid-illuminated sections are composed of palmette-arabesques. In the Muzaffarid-illuminated sections, there is a more even division between vegetal and palmette-arabesque marginals.

99. Kutubi 1913, p. 154; Kutubi's account of the Muzaffarid dynasty, from its origins in 718/1318 to 795/1393, was composed in 823/1420 as an addition to Hamdullah Mustawfi, *Tarikh-i guzida* of 730/1329–30. Also see Roemer 1986, p. 13; and Schimmel 1986, p. 934; and for a general description of Shiraz in the fourteenth century, Limbert 2004 (in particular, pp. 36–37 and 105, for Hafiz on Mubariz al-Din's closing of the wineshops).

100. One of the two scribal signatures in the manuscript is that of Hafiz al-Shirazi, whom Schimmel interprets as being the poet Hafiz, working as a scribe to supplement his income as a poet; see Schimmel 1986, p. 932.

101. See Suleiman and Suleimanova 1983, pp. 87–88, fig. 83; the heading on f. 39b is reproduced in Ansari, n.d., pl. G.

102. The heading referred to in the preceding sentence is on f. 39b. The three headings in the manuscript with baroque-edged cartouches are on ff. 84b, 131b, and 160b; each cartouche consists of script on a bed of arabesque, and in each corner of the rectangle in which the cartouche sits are one or two large colored blossoms and gold vegetation on a burgundy ground; the latter recalls the illumination of the Fars Malik Khatun Qur'an (figs. 18–19) and the Stephens *Shahnama* (fig. 20). All that survives of the heading on f. 1b is its upper arabesque border.

103. Other examples of its use other than as a ground for inscriptions include: TS H. 796, Yazd Anthology, 810/1407; and IUL F. 1418 (especially ff. 2a, 63, and 149b), part of an anthology made for Iskandar Sultan in 813/1411 (Lisbon LA 161).

104. For ancient Egyptian origins and variations of this motif, see Rawson 1984, p. 204, fig. 179. For a more in-depth analysis of the specific features of the blue-and-gold floral illumination style of Shiraz, see Wright 1991.

105. In particular, in two manuscripts copied by the same calligrapher, Ahmad ibn al-Husayn ibn Sana: BN Supp. pers. 1817, dated 763/1362, and BOD Ouseley 274–75, dated 766–67/1365.

106. As used in this study, "textblock" refers to the rectangular block of space on each page in which the text is copied, and which is usually surrounded by a frame of colored lines. In bookbinding terminology, it is used more broadly to refer to the stitched-together, but unbound pile, or block, of folios.

107. Mention should be made of the 756/1355 copy of the *Khamsa* of Amir Khusraw Dihlavi, the transitional nature of which is evident from the type of textblock frame and column dividers it uses: on all folios that are not otherwise illuminated, a blue-and-gold textblock frame is used in conjunction with two red lines for the column dividers; however, those openings on which a heading appears use gold for the column dividers as well.

108. See Keshavarz 1986, p. 54; and Storey 1927–39, 2:2, no. 380.

109. For IUL FY 496/1, see Ateş 1968, p. 59, cat. no. 88. The manuscript has not been viewed firsthand and is only known through Ateş's black-and-white reproduction of a folio with an illuminated heading. Although I have treated it as part of the group of 1360s manuscripts, certain features of the heading that are not clear in the reproduction may relate more closely to the 1355 *Khamsa* of Amir Khusraw Dihlavi (Tashkent 2179).

110. For reproductions of BN Supp. pers. 1817, see Richard 1997b, pp. 53 and 65, cat. no. 23. BOD Ouseley 274–75 has not previously been published.

111. The introductory illuminations of BOD Ouseley 274–75 are badly damaged, but the types and program used may have been that typical of Injuid manuscripts. Only three-quarters of the *shamsa* remains, and this has been remounted on a new folio, leaving no evidence to indicate if it was ever bordered by upper and lower panels. The double-page text-frontispiece of linked upper and lower panels that follows has also been remounted, likewise leaving no evidence of any side *ansa*s or marginal roundels that might once have existed. (Each of the four following sections of the text is introduced by a single heading.) Even if this manuscript did originally employ the typical Injuid program of introductory illuminations, its influence was largely depleted by this time, for it is not used in any of the other known manuscripts of the Muzaffarid era.

112. BOD Pers. d. 31 opens with a single-page frontispiece that consists of a lobed roundel or *shamsa* set between linked upper and lower panels, clearly a derivation of the early Injuid type; it is followed by a single heading.

113. The Qur'an opens with a double-page text-frontispiece only; see Black and Saidi 2000, p. 41.

114. For BN Supp. pers. 580, see Richard 1997b, p. 66, cat. no. 25. For the historical details noted here, see Kutubi 1913, pp. 176–85; and Roemer 1986, p. 14.

115. Soudavar 1992, pp. 47–48.

116. Komaroff 1994, pp. 22–27.

117. Komaroff 1994, p. 25.

118. It seems, however, that inscriptions are always placed against a ground of palmette-arabesque scrolls, no matter what ground decoration is used elsewhere on the object.

119. On this type of bowl, short-stemmed floral motifs frequently fill the interstices between the cartouches and roundels, and floral motifs are also usually used to decorate the area of the bowl immediately beneath the cartouches and roundels.

120. Two other fine examples of this type of decorative scheme are a bowl in the David Collection (no. 14/1966), reproduced in von Folsach 2001, fig. 511; and a bowl in the Victoria and Albert Museum (no. 453-1888), reproduced in Melikian-Chirvani 1982, cat. no. 102, p. 221.

121. For the Hermitage bucket (no. IR-1484), see Pope and Ack-

erman 1939, vol. 6, pl. 1363B; Ivanov 1990, pp. 21–22 and 82, cat. no. 51; Loukonine and Ivanov 1995, p. 155, cat. no. 146; Piotrovsky and Vrieze 1999, p. 172, cat. no. 127; and Komaroff and Carboni 2002, fig. 44, cat. no. 161. For the Victoria and Albert casket (no. 459-1873), see Melikian-Chirvani 1982, pp. 197–200, cat. no. 90.

122. Of the type frequently used by the Mamluks and Il-Khanids in illuminations and in the decoration of, among other things, bookbindings and wooden doors.

123. For example, see Makariou et al. 2001, in particular, cat. nos. 42, 122, and 124.

124. Komaroff 1994, pp. 22–27; and, as she notes, figural representation in metalwork is almost unknown by the second quarter of the fifteenth century.

125. Komaroff 1994, pp. 25–26.

126. Komaroff makes no specific reference to the move to a more divided decorative surface of the body of an object. She does, however, stress an increased interest in more abstract ornament, as exemplified in the decoration of the base of some bowls, in which cusped cartouches are filled with floral motifs. She attributes use of these cartouches as resulting from the influence of imported blue-and-white Chinese porcelain. She states that a general change in taste was initiated by this porcelain, and this, in conjunction with the inability of the metalworker to compete with contemporary painting, served as the impetus for the move away from figural decoration. Her use of "change of taste" does not precisely parallel what is here meant by a change in aesthetic, for at no time, either in her text or through the objects illustrated, does she stress the move to the greater compartmentalization of the main decorative surface (the body) of the bowls. In fact, the small cartouches and roundels that result from this process are rarely if ever cusped and thus do not come about through the impact of decorated Chinese porcelain. See Komaroff 1994, pp. 25–27.

127. Museum for Islamic Art, Cairo, no. 15066. I would like to thank Linda Komaroff for informing me of the current location of the candlestick, and especially for her comments on this section of my text.

128. Bowls decorated in this manner are very much less common than those discussed earlier. Published examples include: (1) Fehervari 1976, no. 144; (2) Sotheby's, 20 April 1983, lot 306; (3) Sotheby's, 15 October 1985, lot 214; and (4) Sotheby's, 14 October 1987, lot 393.

129. Komaroff illustrates a brass pen case, now in the Musée des Beaux Arts in Lyons (no. D617), that is decorated with baroque-edged cartouches and very similar types of florals; see Komaroff 1994, fig. 24.

130. Reproduced in Sotheby's, 20 April 1983, lot 306.

131. The Mongol Yuan dynasty ruled in China from 1260 to 1368, and so very closely paralleled the period of Mongol rule in Iran.

132. For a discussion of the various motifs used on the tiles and their derivation from Chinese textiles, see Crowe 1991; and also see Masuya 2002. For a general discussion of Chinese motifs used in Iranian (and Turkish) art, see Rawson 1984, pp. 146–98 and figs. 140–41, but p. 148, in particular, for how the form of the Chinese lotus was altered (and misunderstood) by the Persian artists who decorated the Takht-i Sulayman tiles.

133. See, for example, the more spatially complex composition depicting "The Mountains between India and Tibet," in the *Jami' al-tavarikh* (f. 262a) of 714/1314–15, in which Chinese landscape elements are used to portray a much deeper space than is usual for the time, reproduced in Blair 1995.

134. Included among the many such examples in the manuscript are the scenes of "Rustam Shoots Isfandiyar" and "Iskandar Building the Iron Rampart." The former is reproduced in Golombek 1972, p. 25, figs. 3–4; Grabar and Blair 1980, p. 99, no. 21 and also, in color, following p. 18; and Komaroff and Carboni 2002, fig. 188. The latter painting is reproduced in Grabar and Blair 1980, no. 37; and Komaroff and Carboni 2002, fig. 191.

135. Da-Sheng 1992, p. 190 and n. 4. For later cultural embassies between the Ming and Timurid courts, beginning with that of 1395, see Samarqandi 1844, pp. 304–06 and 387–424; Barthold 1958, pp. 48, 109–12; Gray 1979, p. 136; Thackston 1989, pp. 279–97; and Hecker 1993, pp. 85–98.

136. Cammann 1951, p. 5.

137. Watt and Wardell 1997, figs. 12 and 26–28.

138. For an example of a *meiping* vase decorated with the cloud-collar motif, see Lee and Ho 1968, no. 156.

139. For the start of the production of blue-and-white ceramics in China, see Medley 1976, p. 176. (The earliest depiction of a blue-and-white vessel in a Persian painting is in a copy of the *Masnavi* of Khwaju Kirmani, dated 798/1396, BL Add. 18113.) Other, earlier types of Chinese ceramics decorated with (sections of) the cloud-collar motif include a rectangular pillow, dated to the thirteenth century, Jin dynasty (r. 1115–1234), now in the Art Institute of Chicago (Gift of Russell Tyson, 1946.945).

140. The Yazd vault painting is reproduced in Wilber 1955, fig. 206; and Crowe 1992, fig. 1. Shams al-Din was the son-in-law of the Il-Khanid vizier Rashid al-Din.

141. The only examples of a deeply in-cut contour deriving from the cloud-collar motif that are earlier than the Tashkent frontispiece and the Yazd vault painting are the illuminated certificates of commissioning in a thirty-part Qur'an, copied for Sultan Uljaytu in Mosul in the years 706–10/1306–10, wherein a deeply in-cut half-lobe of a cloud collar fills each upper corner of the textblock; the certificate on f. 9a of *juz'* 21 (TIEM 541) is reproduced in James 1988, p. 108, fig. 72.

142. As in the heading on f. 134b of BN Supp. pers. 580. Earlier, pre-Muzaffarid examples of this type of cartouche (wherein it is the negative, background space, not the positive space of the cartouche itself, that can be read as part of a cloud-collar motif) do exist but are extremely rare; the only two examples located are: (1) a heading in the late Injuid Qur'an, Khalili QUR242 (f. 38b), referred to in note 96 above; James notes that this must be one of the earliest appearances of a cartouche of this type; the manuscript is not dated, but I have suggested that it dates to the 1340s, although a date in the very early years of the 1350s would not be impossible; and (2) the upper and lower panels of the frontispiece made for the Chupanid amir Malik Ashraf (Berlin-SB Diez A folio 74, no. 1.21), n.d., but probably c. 1340. (The Chinese ceramic pillow mentioned in note 139 above is decorated with this same type of cartouche.) Despite the existence of these earlier examples, it appears that it was not until the reign of the Muzaffarids in Shiraz that the cloud-collar motif began to exert a serious and extensive impact on the art of Iran.

143. See Figgess 1964–66, pp. 39–40; and also Garner 1979, pp. 155–78.

144. While one would expect contemporary and earlier Chinese and Central Asian textiles to have played a major role in this respect, in fact none of the surviving examples seem to use the precise combination of gold patterns on a dark blue ground, though grounds in a range of other colors are known (e.g., burgundy, rose/rust, green, turquoise, blue, and brown). Moreover, on each the pattern woven in gold consists of an animal, real or mythical (ducks, rabbits, deer/antelope, simurghs, and phoenixes), surrounded by vegetation or clouds and arranged to create a circular, teardrop, or pentagonal shape. Not only are these elements arranged in a widely spaced repeat pattern across the fabric, very unlike the aesthetic of Muzaffarid illuminations, but they do not relate in any way to the types of lobed cartouches that are used on Muzaffarid illuminations. For examples of these textiles, see Watt and Wardell 1997, cat. nos. 28–31, 33–34, 51, 47, and 60.

145. As with the illuminations, the negative space surrounding the cartouche can often be read as deriving from the cloud-collar motif.

146. See Tim Stanley in Khalili, Robinson, and Stanley 1996, pp. 12–18, for parallels (in terms of decoration, shape, size, and proportions) between the *qiangjin* sutra boxes and a carved wooden box bearing the name of the Timurid prince Ulugh Beg (d. 1449), and for the impact of similar boxes on fifteenth-century Ottoman and Timurid lacquer bookbindings; he suggests that boxes similar to the sutra boxes may have been included among the imperial gifts sent to the Timurids by the Chinese in the early fifteenth century and which the Timurids may, in turn, have given to the Ottomans. For imperial contacts between the Timurids and the Chinese, see note 135 above.

147. The present location of the stone slab is not known, but it is reproduced in Rawson 1984, p. 140, fig. 126; and for another stone slab of the same type, from the Daoist temple Fushouxingyuan Guan in Dadu, founded in 1316 (whether or not the stone slab illustrated by Rawson is from this same site is not known), see Watt and Wardell 1997, fig. 82. Another similar example of stone carving is "The Guardian of the East," part of the relief carving on the Chu-yung-kuan gate, north of Beijing, dated 1342–45, reproduced in Lee and Ho 1968, fig. 2. For *qiangjin* lacquer as an intermediary in the area of decoration between Chinese silver and ceramics, see Rawson 1984, pp. 97–104.

148. Crowe 1992, p. 172, but in reference to carved lacquer, not *qiangjin*.

149. For documentary evidence of the exporting of carved (not incised gold or *qiangjin*) lacquer to Japan, see Garner 1971–72; and also Garner 1979, pp. 101–02. Moreover, the depictions of presumably lacquer thrones, tables, and stools in the early fourteenth-century illustrations to the *Jami' al-tavarikh* indicate that lacquer was probably being imported into Iran by the first half of the century, at least. Certain traits of carved lacquer, namely, the density of the motifs and the contrast of light and dark created by the deep carving, also relate to Muzaffarid illuminations, though less closely than do *qiangjin* lacquer wares. (The carved lacquer to which reference is being made here is generally a solid red or black in color and often is decorated with pairs of birds on a ground of large blossoms. This type is quite different from the marbled red, black, and yellow lacquer that was typically, though not exclusively, carved in a bold scroll motif known in China as *ju-i* and in Japan as *guri*. For illustrations of each type, see Garner 1979, figs. 43–45, and Clifford 1992, pl. 4, respectively.) Yolande Crowe has discussed the impact of carved lacquer in Central Asia (and Iran), noting how the Cen-

tral Asian artist attempted to replicate in wood and stone the deep carving and dense designs of Chinese lacquer. Thus, while Islamic carving was traditionally very flat and shallow, under the influence of Chinese carved lacquer, there occurred a move to objects on which a dense array of motifs were very deeply carved, in several different levels. Included among the examples of this new technique and style that she cites are a Qur'an stand dated 761/1360 (Met Rogers Fund 1910, 10.218) and also a glazed ceramic panel, dated 1371, from the tomb of Shad-i Mulk Aqa, in the Shah-i Zinde in Samarqand; see Crowe 1992, especially pp. 172–75, and figs. 8–9; and for the Qur'an stand, also see Komaroff and Carboni 2002, fig. 159, cat. no. 176.

150. Although the eldest and youngest of Shah Shuja''s sons, Zayn al-'Abidin and Sultan Shibli, were initially spared and taken by Timur, along with the artists, artisans, and scholars of Shiraz, when he departed for Samarqand, they were both killed before the entourage reached Isfahan; see Khwandamir 1994, p. 257; and also Roemer 1986, p. 63; and Limbert 2004, p. 42.

151. Copied by Zayn al-'Abidin ibn Muhammad al-Katib al-Shirazi; two sections of this Qur'an are now in the Chester Beatty Library (CBL Is 1502), while other sections, including that which names Ya'qub, are in the Mashhad Shrine Library; for reproductions, see James 1980, p. 73; and Sotheby's, 19 April 1983, lot 187. Two other examples of the style from after the fall of the Timurids in Shiraz, but from much earlier in the century than CBL Is 1502, are TS H. 1007, *Kulliyyat* of Kamal ibn Ghiyath, 861/1457, and TS H. 773, *Khamsa* of Nizami, 864–65/1460–61 (only the border of the double-page figurative-frontispiece is this style).

152. Ottoman examples include: (1) BOD Ouseley 133, *Dilsuznama*, 860/1456, Edirne; (2) TS A.III 2097, *Taqwim al-abdan fi tadbir al-insan*, 869/1465, for Mehmed II; and (3) Munich codex pers. 228, *Athar muluk al-'ajam* of Fazl Allah, 878/1473, reproduced in *Türkische Kunst* 1985, cat. no. 1/52. A Mamluk example is a Qur'an (CBL Is 1482) made for Sultan Khushqadam (r. 865–72/1461–67), reproduced in Arberry 1967, pl. 4.

153. Reproduced in Wright 2009, figs. 19–20.

154. For example, see the domes of a building in an illustration to an *Iskandarnama* of 1531–32, made for Nusrat Shah, ruler of Bengal (BL Or. 13836, f. 21b), reproduced in Titley 1983, pl. 3. For further comment on the impact of Shiraz manuscripts on India in the 1430s and 1440s, see note 251 below.

155. Some of the few other Jalayirid manuscripts that contain contemporary illuminations are: (1) BL Or. 13297, 788/1386 and 790/1388, see Soucek 1979, p. 27, illus. no. 12; (2) CBL Per 317,

791/1389; (3) BN Supp. pers. 913, 794/1392; (4) FITZ McClean 199, 800/1397–98; (5) BOD Bodl. Or. 133, 801/1399, f. 1b; (6) Khalili QUR171, 807/1404–05, reproduced in James 1992a, cat. no. 10, who suggests that the illuminations are Mamluk or Ottoman; and (7) Lisbon M 28A-B, two detached folios, n.d., but probably Jalayirid, first decade of the fifteenth century, M28 is reproduced in Gray and Kühnel 1963, cat. no. 120; and Sims 2001, fig. 4. A copy of *Kalila wa dimna* dated 678/1279–80 (BN Pers. 376) has both illustrations and an illuminated heading that are surely Jalayirid and perhaps date to about 1380; see Richard 1997b, p. 69, cat. no. 30. An undated copy of *Khusraw va shirin* (Freer F1931.29–37), signed by 'Ali ibn Hasan al-Sultani, in Tabriz, if not actually made for a Jalayirid patron, was probably illuminated by artists who worked at one time for the Jalayirids. Also, a copy of the *Divan* of Mawlana Humam al-Din al-Tabrizi (BN Supp. pers. 1531), though dated 816/1413 and thus copied after the downfall of the Jalayirids, also belongs in this group, because its illuminations are extremely close to those in the *Divan* of Sultan Ahmad (TIEM 2046); no mention is made of where or for whom the manuscript was made, but it is signed by the calligrapher Ja'far ibn 'Ali al-Tabrizi, who was later to serve as head of Baysunghur's atelier in Herat. Other Jalayirid manuscripts that do not have contemporary illuminations are: (1) BN Supp. pers. 332, 790/1388, the only illumination of which is a heading in the fifteenth-century Turcoman style; (2) BL Add. 18113, 798/1396, with sixteenth-century illuminations only; and (3) Freer F1932.29, 805/1402; its only illumination is a heading in the blue-and-gold floral style of Shiraz.

156. Ff. 55b–56a, another double-page frontispiece from this manuscript, are reproduced in Lentz and Lowry 1989, p. 58, cat. no. 16.

157. For 'Umar Shaykh being left in control of Shiraz, see Khwandamir 1994, p. 257. Khwandamir, however, makes no mention of Iskandar having been left in charge in 'Umar Shaykh's absence; that he was is noted in an anonymous account of the house of Timur, preserved on f. 159a of an album in the Topkapi Palace Library (B. 411) and translated by Thackston (1989, pp. 237–46). The reliability of the document will be discussed below. The historical details presented here are drawn primarily from Thackston's translation of Khwandamir's *Habibu's-siyar*; for an overview of Iskandar's life, also see Soucek 1998a.

158. Khwandamir 1994, pp. 259–60.

159. Sometime late in 802/1399, Timur ordered Pir Muhammad to march on Baghdad against Sultan Ahmad Jalayir. However, shortly after setting out he turned back, feigning illness, and

it is said that then once back in Shiraz a group of "black-hearted Persians" clouded his mind with unfounded suspicions, with the eventual result that Timur removed him as governor of Shiraz, installing his brother Rustam in his place. Shiraz appears to have been returned to Pir Muhammad in, or shortly after, 805/1403, at which time Rustam was granted Isfahan; see Khwandamir 1994, pp. 271 and 286–87.

160. Khwandamir 1994, pp. 317–18 and 325–26.

161. See Richard 1996, pp. 1–22. As Richard explains, the letter is one of a collection of letters written to the poet Sayyid Qivam al-Din (d. 830/1426–27) included at the end of a copy of the poet's *Kulliyyat* (BN Supp. pers. 727, ff. 143a–46b). The manuscript is undated, but based on the style of its illuminations and script, Richard has attributed it to Fars in about 1430; the letter itself is dated only "the middle of Safar," which Richard suggests probably means the end of May 1412 or mid-May 1413. This dating is based on two points: first, from the praises of Isfahan that are included in the letter, it can be assumed that it was written when Iskandar was resident in that city; and second, by 817/May 1414 one of the personages mentioned in the letter, Mir Sayyid Sharif, was already dead. The whole manuscript is written in a single hand, thus the letter is a copy of the original. Following profuse praise of Iskandar, the letter enumerates ten categories of individuals who grace the court: *sayyid*s, shaykhs, amirs, viziers, *qadi*s, *hadith* and *fiqh* scholars, astrologers, physicians, *hafiz*es (reciters of the Qur'an, and also *muezzin*s and musicians), and finally artists of the book. The author names specific and highly illustrious individuals of each category; the only artists of the book that he names are the figure painter Mawlana 'Abd al-'Ali, the calligrapher Mawlana Ma'ruf (who is known to have also worked for Sultan Ahmad Jalayir), and the bookbinder Khwaja Mahmud. After discussing the artists and craftsmen of the book, he notes that if he were to mention even one of every one thousand individuals of every craft or art (*hirfat*) who are at Iskandar's court (*dar astana-ye sultan*), the letter would prove too long and boring to read. It is not clear if in this instance he is referring only to the artists and craftsmen of the book or as well to all other categories of individuals discussed. (Although *astan* normally translates as "king's court" or "royal palace," it does not necessarily refer to a physical structure; even if it does in this case, it cannot be assumed that Iskandar maintained an actual physical space in which the artists and craftsmen who produced his manuscripts all worked together, as did his cousin Baysunghur in Herat a few years later.) Francis Richard very generously brought this document to my attention and provided me with a copy of it before his publication of it.

162. Soucek 1971, p. 254, who notes that the anthology was produced at a time when Iskandar was not present in Yazd, and moreover that in 1407 Iskandar was in no position to be dispensing patronage of any sort (see the historical information in the previous section); she suggests that the manuscript may be the result of the patronage of the amir who was in charge of the city during Iskandar's absence and who is known to have been an eager patron of architecture in the city, Khwaju Jalal al-Din Mahmud Khwarazmi.

163. The illuminations of CBL Per 114 and BL Or. 2780 are contemporary with the copying of the manuscript, but the illustrations are not and may in fact date to the period of Iskandar Sultan's governorship of Shiraz; see Wright 2004.

164. The manuscripts bearing dedications to Iskandar are (references are to reproductions of illuminations only): (1) Lisbon LA 161, 813/1411, see Akimushkin and Ivanov 1979, p. 51, fig. 27; Lentz and Lowry 1989, p. 140, fig. 45; and Soucek 1992, figs. 1–9; (2) WL Pers. 474, 813/1411, see Keshavarz 1984; Keshavarz 1986, no. 224; and Lentz and Lowry 1989, pp. 145–47, cat. no. 36; (3) IUL F. 1418, 813–14/1411, see Soucek 1992, figs. 9–12; (4) BL Add. 27261, 813–14/1410–11, see Gray 1977, p. 71; and Titley 1983, fig. 75; (5) Sotheby's, 27 April 1981, n.d., but c. 1410; (6) TS A.III 3513, 814/1412; (7) TIEM 2044, 815–16/1412–13; (8) Lisbon LA 158, 815–16/1412–13, see Gray and Kühnel 1963, p. 11, no. 118; and Sims 2001, p. 96, fig. 1; (9) Suleymaniye A.S. 3857, 815–16/1412–13; (10) TS B. 411, 816/1413–14; (11) BN Supp. pers. 1963, n.d., see Richard 1997b, p. 74, no. 37. An undated astrological treatise in the Bibliothèque nationale (Supp. pers. 1488) may also have been produced for Iskandar; this is suggested by the style of its illuminations and by the fact that the folio and textblock sizes match those of TS A.III 3513. As is noted in the main text, the first three manuscripts listed here (Lisbon LA 161, WL Pers. 474, and IUL F. 1418) are in fact all parts of the same manuscript (see Soucek 1992), and numbers 7 and 8 in the list (TIEM 2044 and Lisbon LA 158) also originally formed a single manuscript; Iskandar's name is included only in TIEM 2044. Each of the latter two, now discrete, manuscripts comprises an apparently random selection of folios, with poems frequently divided between the two manuscripts; however, in the files of the Gulbenkian Museum is an (unpublished) reconstruction by Priscilla Soucek of the original manuscript, listing the correct order of the folios. A collection of *masnavi*s in the Metropolitan Museum of Art is also sometimes attributed to Iskandar (e.g., Soucek 1992, p.

128), but there is no basis for this suggestion: in addition to there being no documentary evidence, the illustrations are late additions and the illuminations do not relate closely to those in any known manuscript produced for him.

165. One of the manuscripts listed in the previous note is a collection of poems made for Iskandar, dated 815–16/1412–13 and now in the Suleymaniye Library in Istanbul (A.S. 3857). In it are two double-page frontispieces and several headings illuminated purely in the blue-and-gold floral style. However, the numerous other headings in the manuscript either consist of brightly colored "Jalayirid" palmette-arabesques only or are Jalayirid-Shirazi blends, as in his London and Lisbon anthologies (to be discussed below). While the frontispieces are quite well executed, many of the headings (in all styles) are of a quality very inferior to those of all other manuscripts made for Iskandar. The precise relation of this manuscript to all others bearing dedications to Iskandar is a matter for further study.

166. Throughout this discussion, the reader should assume that any reference to Lisbon LA 161 is also meant to refer to WL Pers. 474 and IUL F. 1418. The Lisbon portion of the anthology is one of the several manuscripts in the Gulbenkian Museum that suffered severe water damage during the course of a flood the night of 25–26 November 1967. On the advice of conservators, Iskandar's Lisbon Anthology was subsequently sent to Istanbul to be repainted, a decision that at the time was thought to be the best option for preserving the manuscript. Although the artist(s) who carried out the repainting of both the double-page illustration and the illuminations was/were clearly talented, it was of course impossible to restore the manuscript to its former brilliance. Nevertheless, the basic layout and the elements, motifs, and to some extent the palette that constituted each composition remain evident.

167. It is actually a variation of this usual textblock format that is used in the first volume of Lisbon LA 161 (ff. 1–234): the central block of text consists of four columns of horizontal lines of script and a fifth column with oblique lines, all of which are then surrounded by a marginal column, on three sides of the textblock, filled with oblique lines of text.

168. Reproduced in Soucek 1992, p. 118, figs. 1–2.

169. However, baroque-edged cartouches do appear in one frontispiece of the *Divan* of Sultan Ahmad, on ff. 118b–19a, and floral sprays, very unlike those typical of Shiraz manuscripts, are used in the *shamsa* of this same manuscript, on f. 118a (see fig. 51).

170. For example, BL Add. 27261, ff. 372b and 340b.

171. As in the panels that border Iskandar's illuminated horoscope (WL Pers. 474), reproduced in Lentz and Lowry 1989, pp. 146–47, cat. no. 36.

172. Sultan Ahmad was defeated by Qara Yusuf on 28 Rabi' II 813/30 August 1410. The earliest of several dates in Iskandar's London Anthology is Jumada I 813/1–30 September 1410. Therefore the manuscript surely had been planned well before Sultan Ahmad's death, which means that artists did not migrate to Shiraz (only) as a direct result of his death and the possible final dissolution of his atelier.

173. This is the date of the battle of Ankara in which Iskandar took part and in which Timur defeated and captured the Ottoman sultan Bayezid I. Apparently, before the battle, Ahmad's daughter was placed in Bayezid's harem for security, and then after his defeat she was given to Iskandar in marriage. See Schroeder 1942, p. 58 and p. 57 n. 19, where he states that information on Iskandar's life is "scattered through 'Ali Yazdi's *Zafarnama* and 'Abd al-Razzaq al-Samarqandi's account of the years following Timur's death," but with no specific page references; it has not been possible to find the exact source of this often-noted event.

174. The London Anthology is 546 folios long; the extant sections that originally made up the second anthology, the main bulk of which is now in Lisbon, total 771 folios (440 folios in LA 161, 86 in WL Pers. 474, and 245 in IUL F. 1418).

175. There are just three folio-sides in the Lisbon Anthology that have their outer marginal column filled with decoration (ff. 73a, 87a, and 130a); on the first two folios, the decoration consists of an all-gold, purely "Islamic" arabesque, while on the third folio is a chinoiserie-type arabesque. However, in the London Anthology, there are sixty-two pages (or folio-sides) on which the marginal column is filled with decoration. This is often figural (human) but does not necessarily relate to the text. For examples of marginal decoration including human figures, see Gray 1977, p. 71; and Akimushkin and Ivanov 1979, p. 42, pl. IX.

176. The black-ink line drawings in the margins of the Freer Gallery of Art's *Divan* of Sultan Ahmad, dated 805/1402 and presumably copied in Baghdad (Freer F1932.29–37)—or other similar but now-lost Jalayirid chinoiserie designs—perhaps were the inspiration for the chinoiserie designs in Iskandar's manuscripts. (Whether the drawings in the margins of Ahmad's *Divan* are original to the manuscript is not clear. Sheila Blair has suggested that they may in fact be Islamic renderings in black ink of Chinese paintings in gold on colored paper, as in manuscripts BOD Pers.

e. 26, TIEM 1992, and TS A.III 3059, described in chapter 2, note 79; see Blair 2000, p. 27; and for reproductions of the Freer *Divan*, see Atil 1978, pp. 18–27, figs. 1–7.) The whole broad question of continuing waves, throughout the fourteenth and fifteenth centuries both in Shiraz and other production centers, of direct Chinese influence and of the incorporation of designs and motifs more aptly termed chinoiserie is a topic in dire need of being addressed in a more thorough manner than has to date been undertaken.

177. For example, BL Add 27261, f. 543a; Lisbon LA 161, f. 130a, reproduced in Soucek 1992, fig. 8; and WL Pers. 474, ff. 85b–86b, reproduced in Lentz and Lowry 1989, p. 119, cat. no. 36; and Roxburgh 2005, fig. 69.

178. For example, in the London Anthology, Add. 27261, ff. 28a, 89b–90a, 190a, and 259a; for reproductions of examples in Iskandar's other manuscripts, see Akimushkin and Ivanov 1979, p. 51, fig. 27; and Soucek 1992, figs. 6–9, 10, and 12.

179. Soucek has studied the occurrence in the Lisbon Anthology (LA 161) of successive, full pages of illumination, and she suggests that they are intended specifically to mark a change from one type of text to another; see Soucek 1992.

180. "Braid" is used in this study to refer to the narrow bands, usually in white but also in green, blue, or black, that are used to outline an illuminated heading or the main elements of a frontispiece. The interiors of the bands are delineated with black (or white if on dark blue or black) strokes, crosses, circles, or, less commonly, a "Y" motif (e.g., see figs. 1–4 and 51). These various interior delineations appear to have originated as shorthand attempts to depict twisted rope or braid. For "strapwork," see note 10 above.

181. For other similar examples, see James 1988, figs. 52, 55, 66, 69, 135, and 142.

182. For reproductions of the illuminations of the Hamadan Qur'an, see note 97 above.

183. Ff. 55b–56a of the *Divan* are reproduced in Lentz and Lowry 1989, p. 58, cat. no. 15.

184. Khalili QUR171, f. 1a, and Lisbon M 28A; each is one half of what was originally a double-page frontispiece; see note 155 above.

185. Unlike the earlier, brightly colored Jalayirid examples, this one is predominantly gold, with a few touches of blue, reproduced in Akimushkin and Ivanov 1979, fig. 27.

186. For reproductions of other illuminations from CBL Per 119, see Soucek 1979, p. 25, illus. nos. 10–11; and Lentz and Lowry 1989, pp. 122–23, cat. no. 41.

187. One possibly pre-Iskandar example of a panel of "pure"

decoration, as is typical of Iskandar's manuscripts, does exist. This is the (unpublished) panel of palmette-arabesque that decorates the colophon folio in a *Khusraw va shirin* manuscript in the Freer Gallery of Art (F1931.29, f. 63b). The manuscript is undated but is generally thought to have been copied in about 1405–10, in Tabriz, although it is uncertain for whom the manuscript was made. Many unanswered questions exist concerning the production history of this manuscript, and it is not possible to say precisely when the colophon decoration would have been executed.

188. Khwandamir 1994, p. 326.

189. Mir Dawlatshah Samarqandi states that Shah Rukh set out to defeat Iskandar because "the roar of autonomy was affecting the balance of his [Iskandar's] mind"; see Thackston 1989, pp. 30–31.

190. Khwandamir 1994, pp. 327–30.

191. In 802/1399, Timur granted Iskandar the region of Andakhan; see Khwandamir 1994, p. 270.

192. Khwandamir 1994, pp. 270–71; Yazdi 1336/1957, 2:158–61 and 275; also see Soucek 1998a.

193. Khwandamir 1994, p. 289.

194. TS B. 411, f. 159a; see note 157 above.

195. Thackston 1989, p. 240.

196. Thackston 1989, p. 239.

197. Thackston 1989, pp. 240–41.

198. Khwandamir 1994, p. 317.

199. Khwandamir (1994, p. 317) merely states that "the amiable relations [between the two brothers] was shattered by some mischief-makers." However, other sources suggest that the cause of the dispute was that Iskandar marched on Kirman without first consulting Pir Muhammad; see Soucek 1971, p. 254, in reference to Samarqandi 1844, pp. 113–14.

200. Khwandamir 1994, pp. 317–18.

201. Khwandamir 1994, p. 318.

202. Thackston 1989, pp. 240–41.

203. Khwandamir 1994, p. 296.

204. It states that Timur "left his great empire as a legacy to his Highness Sultan Iskandar—may he enjoy long life and great fortune"; Thackston 1989, p. 239.

205. Although double-page paintings are used elsewhere in Iskandar's anthologies (Lisbon LA 161, ff. 265b–66a, 317b–18a, 326b–27a; and BL Add 27261, ff. 362b–63a), they are in fact not known within the body of a text before Iskandar's era.

206. Soucek 1971, p. 290.

207. See Soucek 1971, pp. 289–92, for a full discussion of this illustration. Soucek believes that it may be Iskandar who is por-

trayed, because in this illustration the facial features of Khusraw are different from all other portrayals of Khusraw in the manuscript; however, one must bear in mind that the illustrations have been repainted (for which, see note 166 above).

208. Thackston 1989, pp. 240–41. Soucek presumably was unaware of the anonymous historical account (TS B. 411), as she makes no mention of it. However, its contents definitely corroborate her interpretation. She also interprets two other paintings (the scene of the "Dying Dara," in the Lisbon Anthology, and that of "Iskandar and the Hermit," in the London Anthology) as relating directly to Iskandar, assumptions based upon her belief that in these scenes also it is Iskandar Sultan himself who is portrayed; Soucek 1971, pp. 302–05.

209. Thackston 1989, p. 241.

210. Thackston 1989, p. 246.

211. Once the author of the document has exhausted his praise of Iskandar, he continues on to discuss the sons of Miran Shah and then Shah Rukh and his sons. He expressly says that he is including these accounts so that one can see, by comparison, how very great Iskandar is, for, as he says, "If other comparisons are not made, like black jet strung on a cord of pearls, then how can the distinction be made?" Thackston 1989, p. 243.

212. For a complete list of the contents of the Lisbon Anthology, see Soucek 1992, pp. 129–31.

213. For a complete list of the contents of the London Anthology, see Rieu 1879–83, 2:868–71.

214. The topic of manuscript (or folio) size, expressed mainly in terms of folio area, is discussed in the following chapter. For the time being, however, a few comments are in order. First, of the Shiraz manuscripts examined, the London Anthology is the second smallest, in terms of folio area, of those produced between the years 756/1355 and 817/1414–15. However, although the manuscripts of Iskandar are, as a group, traditionally held to be unusually small, they are in fact not remarkable in this respect, even considering the size of the London Anthology: more than 70 percent of manuscripts produced between 1355 and 1452 have a folio area between 15,001 mm^2 and 55,000 mm^2. The folio areas of the London and Lisbon anthologies are 23,368 mm^2 and 45,050 mm^2, respectively, and so each manuscript falls within the normal size range for the time. Thus when seen within the scope of wider trends, the size of the London Anthology is not so exceptional. However, the impression of both smallness and compactness—in the case of each manuscript, but especially so in the London Anthology—is enhanced, in the first instance, by its size (folio area) *in relation to*

its considerable length—546 folios in the London Anthology and 771 in the surviving sections of the Lisbon Anthology (see note 174 above)—and, second, by the relative density of the small script, which is copied on most folios both in a central block of text and in one or more marginal columns. (This and other types of text-block format are discussed in the following chapter; also see note 167 above.) The density of decoration also adds immensely to the sense of compactness.

215. One need only consider, for example, the manuscripts made for the Il-Khanid Sultan Uljaytu in the early years of the fourteenth century and for the Mamluk Sultan Sha'ban in the second half of the fourteenth century; see James 1988, pp. 76–131 and 178–214.

216. Reproduced in Soucek 1992, figs. 3–4.

217. See Rieu 1879–83, 2:870.

218. The visual evidence of manuscript illustration suggests this movement of artists. Soucek notes that it is, in fact, only in calligraphy that there exists actual documentary evidence of the movement of artists from Baghdad to Shiraz and then to Herat. She cites the example of the calligrapher Mawlana Ma'ruf Khittat Baghdadi, who, according to Khwandamir, grew to despise Ahmad and went to work for Iskandar Sultan in Shiraz. After Iskandar's defeat, Shah Rukh took Ma'ruf with him to Herat; see Soucek 1971, p. 263; and also Khwandamir in Thackston 1989, p. 144.

219. The one exception is BL-IOL Ethé 1118, a copy of the *Kulliyyat* of Sa'di, dated 819/1416 and presumably a product of Shiraz. It is extensively illuminated, primarily in the standard blue-and-gold floral style, but some of its illuminations could well have been plucked from Iskandar's London Anthology: in the heading on f. 206b, for example, gold lotus-type blossoms and larger gold-outlined blossoms are placed on a purple ground, all very "Iskandari" elements. Likewise could the panel of all-gold palmette-arabesque that surrounds the endpiece and fills the bottom two-thirds of f. 35a have come from either of Iskandar's two anthologies. (One very close parallel is f. 129a of the Lisbon Anthology, reproduced in Soucek 1992, p. 123, fig. 6.) However, in this manuscript, panels of pure illumination in the blue-and-gold floral style are in fact more common. Most headings (and the double-page frontispiece) are in this style, while others are constructed completely of palmette-arabesques in a range of colors. This conjunction of very different styles in one manuscript is itself an "Iskandari" concept. The debt that later artists and craftsmen, in all fields of book production, owe to Iskandar and those employed by him will undoubtedly eventually emerge as much greater than it has been possible to determine within the parameters of this study. For example, in the Gulben-

kian Museum, Lisbon, is an unusual double-page of illumination that once marked the middle of a now-lost copy of the *Shahnama*, presumably produced in about 1430–50 (Lisbon M 66A–B). Where this magnificent bifolio was produced is not known, but that the decoration of it owes much to manuscript illumination as practiced by Iskandar's artists is evident on a number of counts: (1) its margins are filled with decoration, a practice that, with the exception of the folios (of uncertain date) in the *Divan* of Sultan Ahmad in Washington, first appears in Iskandar's anthologies; (2) the marginal decoration of the two facing folios is different, which is a prominent feature of the margins of Iskandar's London Anthology; (3) there is blatant and extensive use of chinoiserie; (4) the marginal decoration of the left-hand folio consists of an arabesque scroll from which spring human and animal heads, as in Iskandar's London Anthology (f. 536b), and, although the two examples are indeed very different (that in Iskandar's Anthology is, for instance, executed in a light wash), the earlier example nevertheless establishes a precedent for the use of this basic type of scroll as marginal decoration. The bifolio is reproduced in Lentz and Lowry 1989, pp. 128–29.

220. See Adamova 2001, pp. 59–73, for illustrations in Shah Rukh's *Khamsa* of Nizami, dated 835/1431 (StP-HM VR-1000, ff. 55a, 100a, 175a, 185a, and 393b), based on compositions in Iskandar's London Anthology (BL Add. 27261).

221. Thackston 1989, p. 246.

222. Khwandamir 1994, pp. 328–30.

223. For a synopsis of and bibliography relating to Ibrahim's life, see Soucek 1997, pp. 76–78; and also Soucek 1998b.

224. Other manuscripts in which both styles of illumination are used include (listed in chronological order): (1) TS A.III 3169, 835/1432; (2) Sackler S1986.33, 837/1433–34; (3) CBL Ar 5282, 839/1435–36; (4) BL Or. 12856, 839/1435; (5) FITZ 22-1948/ BM OA 1948-10-9-48 to 52, c. 1435; (6) dispersed *Zafarnama* of 839/1436; (7) BOD Pers. e. 26, 840/1437; (8) Sackler S1986.34, 841/1437; (9) BL Or. 3486, 841/1437–38; (10) BN Supp. pers. 494, 848/1444; (11) TIEM 1906, 849/1445–46; (12) CBL Per 275, 852/1448; (13) BL Add. 7768, 857/1453; (14) TS H. 1412, 857/1453; (15) TS H. 773, 864–65/1460–61. While in these manuscripts the two different styles of illumination are contemporary, it is more usual that different styles of illumination or illustration within a single manuscript are the result of different periods of production. One well-known example is a copy of the *Khamsa* of Nizami in the Topkapi Saray Library (H. 762). As recorded on folios 316b–17a of the manuscript, it passed through the hands of four rulers and

princes (of the Timurid, Qara Qoyunlu, Aq Qoyunlu, and Safavid dynasties) before it was finally completed. For a translation of these folios, see Thackston 1989, pp. 333–34; the folios are also discussed in Rogers et al. 1986, p. 113.

225. No distinctions could be discerned, in terms of quality, text type, illustration style, or codicological features, between manuscripts that use one or the other style or between those that use the two styles in conjunction and those that do not.

226. An example from this period is TS H. 773, *Khamsa* of Nizami, 864–65/1460–61. All illuminations are in the floral/palmette-arabesque style except for the border of the double-page figurative-frontispiece.

227. Once it was noted that the changes that took place were concentrated in the years 839–48/1435–36 to 1444–45, the preceding and succeeding years were divided into ten-year periods accordingly. Many manuscripts do not state the month in which they were copied, making it impossible to determine precisely the corresponding year of the Gregorian calendar. Therefore, to maintain both accuracy and precise ten-year divisions, the *hijra* years only are used throughout much of this section.

228. An obvious exception is the frontispiece on folios 1b–2a of CBL Ar 5282, the palmette-arabesque of which is much finer than is usual in this style. This manuscript has previously been attributed to Herat, but on no certain grounds (see Lentz and Lowry 1989, pp. 349–50, cat. no. 101); that it is instead surely a product of Shiraz and was made for Ibrahim Sultan himself is suggested by the fact that it also includes a text-frontispiece in the blue-and-gold floral style (ff. 2b–3a) and by its binding, which will be discussed in chapter 5.

229. For Jalayirid examples, see TIEM 2046, ff. 55b–56a, reproduced in Lentz and Lowry 1989, p. 58, cat. no. 15, and also BN Supp. pers. 913, 794/1392, f. 2b. In both manuscripts, only some of the florals are outlined with a white, feathery contour. White-outlined blossoms are also a standard feature of Timurid cut-tile mosaic from as early as the late fourteenth century, as on the mausoleums of the Shah-i Zinde and on the entrance portal of the Aq Saray at Shahr-i Sabz; the latter is reproduced in Lentz and Lowry 1989, figs. 11–12.

230. An illuminated heading in a manuscript made for Baysunghur (*Nasa'ih iskandar*, 829/1425, CBL Ar 4183, f. 1b) consists of a central panel of palmette-arabesque surrounded by a band of colored blossoms on a black ground and an upper border of palmette-arabesque. Despite basic similarities with Shiraz headings in the floral/palmette-arabesque style, this heading is in fact very

un-Shirazi: the blossoms are very different types from those used in Shiraz, and they are outlined in gold not white.

231. Published examples of Baysunghur's illuminations include Ettinghausen 1939, pl. 946C; Binyon, Wilkinson, and Gray 1971, pl. XLIII; Robinson et al. 1976, pl. 42, cat. no. VII.62; Soucek 1979, figs. 10–11; Duda 1983, fig. 1; Lentz and Lowry 1989, pp. 12, 82–83, 110–11, 120, 122–25, and 139; James 1992a, cat. no. 5, pp. 30–31; Roxburgh 2005, figs. 19–21, and 33; and Wright 2009, fig. 28 (a Qur'an attributed to Baysunghur on the basis of the close similarity of its illuminations to others made for him).

232. A band of thick-stemmed florals of the type characteristic of the new floral/palmette-arabesque style of Shiraz is included in the painted stucco decoration of the south dome of the Madrasa Du Dar in Mashhad, dated 843/1439, providing evidence of the spread of the style to other centers, reproduced in O'Kane 1987, pl. 15.15. Also, the decoration of each of two manuscripts copied in Balkh in 859/1455, for Abu'l Qasim Babur ibn Baysunghur, includes a heading in the floral/palmette-arabesque style (Vienna N. F. 141, a collection of mystical poetry, and N. F. 442, the *Divan* of Hafiz). They surely once formed a single manuscript, for they are the same size, bear exactly the same date, and were copied by the same calligrapher, Muhammad al-Jami. The *shamsa* of N. F. 442, which bears the name of Abu'l Qasim Babur, is in the illumination style associated with manuscripts produced in Herat; both are reproduced in Duda 1983, figs. 21–23.

233. The time lag between the demise of Iskandar and the appearance of the new floral/palmette-arabesque style and the fact that Iskandar's illumination style seems not to have continued in Shiraz after his demise make it unlikely that the earlier style had any direct impact on the development of the later style.

234. The headings on ff. 185b, 245a, and 371a of the *Jamiʿ al-sahih* are in the blue-and-gold floral style, as are the heading (f. 12b) and a double-page frontispiece (ff. 237b–38a) in the *Shahnama*. For reproductions of one of the *Jamiʿ al-sahih* frontispieces, see Sakisian 1934a, p. 90, fig. 10; and Sakisian 1934b, p. 149, fig. 2; and for the *Shahnama* in general, see Abdullaeva and Melville 2008, but especially figs. 10 and 26–29 for reproductions of the illuminations, and also see pp. 28–30 and 124–25 for their suggestion of a date of about 1425 or earlier for the manuscript. However, the similarity of some of the *Shahnama* illuminations to those in the *Jamiʿ al-sahih* (dated 1429) suggests that the two sets of illumination are more or less contemporary and that the *Shahnama* is therefore closer in date to the earliest manuscripts in the new floral/palmette-arabesque style than it is to earlier illuminated manuscripts made for Ibrahim,

such as the Qur'an in the Mashhad Shrine Library (no. 414), dated 827/1424, reproduced in Lings 1976, no. 81. (However, the manuscript appears not to be of a single date; see the section "The Case of Ibrahim Sultan's *Shahnama*" in chapter 3 for further discussion of this problem.)

235. As noted by Qadi Ahmad, Ibrahim was himself an accomplished calligrapher, copying both Qur'ans and designing inscriptions for a number of buildings that he had constructed in Shiraz. He says the prince "wrote very well, was extremely gifted and capable"; see Qadi Ahmad 1959, pp. 69–71. The manuscripts made by order of, and in some cases also copied by, Ibrahim are: (1) BOD Fraser 171, 815/1412–13; (2) TIEM 1979, 820/1417; (3) LA 168, 822/1419, illuminations reproduced in Gray and Kühnel 1963, no. 119; and in Sims 2001, p. 97 and fig. 2; (4) Berlin-MIK I. 4628, 823/1420 (bears the name of Baysunghur, but presumably made at the behest of Ibrahim for his brother), illuminations reproduced in Ettinghausen 1939, pls. 943a and 941a; and Enderlein 1991; (5) TS M. 6, 826/1422–23, copied by Ibrahim; (6) Mashhad 414, 827/1424, copied by Ibrahim, illuminations reproduced in Lings 1976, no. 81; (7) MET 13.228.1–2, 830/1427, copied by Ibrahim; (8) formerly Hagop Kevorkian Collection (current location unknown), 831/1427, see Sims 1996, p. 619; (9) Georgian P-458, 831/1428, see Sims 1996, p. 619, who suggests it was made as a matching pair with the previous manuscript; (10) Bayezit Feyzullah 489, 832/1429; see note 234 above; (11) BOD Ouseley Add. 176, n.d., but late 1420s or early 1430s, see Sims 1992b; and Abdullaeva and Melville 2008; (12) TIEM 1982, 834/1430–31, illuminations reproduced in Lentz and Lowry 1989, pp. 72–73, cat. no. 18; (13) Pars 430, 834/1430–31, copied by Ibrahim Sultan, illuminations reproduced in Lings 1976, nos. 82–83; (14) Mashhad 215, 837/1434, perhaps copied by Ibrahim Sultan; (15) Suleymaniye Fatih 3682, n.d., see Grube 2000; (16) dispersed *Zafarnama*, 839/1436 (presumably begun for Ibrahim but completed after his death), see Sims 1990–91 and Sims 1992a; (17) Majlis 61866, 839/1435–36 (also completed after his death), see Richard 2001, p. 92. Qadi Ahmad also refers to a Qur'an, 2 cubits long and 1.5 cubits wide, made by Ibrahim for the cemetery of Baba Lutfallah ʿImad al-Din; see Qadi Ahmad 1959, p. 71. Richard has suggested that the following manuscripts may also have been made for Ibrahim, although none bear a dedication to him: (a) BN Supp. pers. 1469, 820/1417; (b) Khalili QUR212, 823/1420; (c) Malek 5932, n.d. He notes as well that Punjab 318, 829/1426, was ordered as a gift for Ibrahim Sultan, see Richard 2001, p. 91. Likewise, as suggested in note 228 above, CBL Ar 5282, though dated after Ibrahim's death, was surely begun at his

command. A manuscript sold at Christie's in 2003 (lot 106) and dated 821/1418 does not name Ibrahim but was copied by Nasir, who signed himself *al-katib al-sultani* and who is also associated with other manuscripts made for Ibrahim. (I am grateful to Eleanor Sims for providing me with photographs of this manuscript.) Another manuscript (Khalili MSS685), an anthology of the same date and also illuminated in the blue-and-gold floral style, states that it was copied merely "in the reign of Ibrahim." For Ibrahim's manuscripts in general, see Sims 2000.

236. In particular, the *shamsa* on f. 1a of TIEM 1982 is very "Herati"; the blossoms used are of interest for they include red-orange florals of a type that is almost ubiquitous with Baysunghur's illuminations (but which also appear in later illuminations). The double-page text-frontispiece (ff. 1b–2a) has small side *ansas*, typical of Shiraz, not Herat, illuminations and also uses small, white-outlined blossoms that can be considered an early form of those typical of the floral/palmette-arabesque style; for reproductions of the illuminations, see note 235 above.

237. Reproduced in Petrosyan et al. 1995, pp. 178–81.

238. However, it should be noted an anthology made for Baysunghur and now in the Malek Library in Tehran (no. 6531) has not been viewed; for the corpus of manuscripts made for Baysunghur, see Lentz 1985, pp. 302–470; and Lentz and Lowry 1989, pp. 368–69.

239. For reproductions of the manuscript's illuminations, see note 235 above.

240. See Lentz 1985; and Lentz and Lowry 1989.

241. Mir Dawlatshah Samarqandi, in Thackston 1989, p. 33, who refers to Sharaf al-Din as "foremost among the learned men in Iraq and Fars"; also Sims 1973, pp. 42–43, in reference to Rieu 1879–83, 1:174–75, who notes his *return* to Shiraz.

242. Mir Dawlatshah Samarqandi, in Thackston 1989, p. 23, says that Ibrahim finally offered his brother 100,000 dinars in cash for the musician, to which Baysunghur replied, in verse: "We do not sell our Joseph. You keep your black silver." Dawlatshah (pp. 23–24) also records that the three brothers, Ibrahim, Baysunghur, and Ulugh Beg in Samarqand, were in close contact, stating that "many witticisms and much correspondence" were exchanged among them. He also notes the debate between Baysunghur and Ulugh Beg on the merits of the *Khamsa*s of Nizami and Amir Khusraw.

243. According to Dust Muhammad, when Baysunghur died in 837/1434, his artists were taken as a group into the employ of his son Ala'uddawla; see Dust Muhammad in TS H. 2154, f. 15b, trans-lated by Thackston 1989, p. 346. However, even if as a result of Baysunghur's death a few of his artists did travel to Shiraz in search of work, the new illumination style had by that time already emerged in Shiraz; these artists may have stimulated further production, but the new style did not originate with them.

244. Production in Shiraz in the years 829–38 appears to have been only about half what it was in Herat.

245. In the three preceding ten-year periods (809–18, 819–28, and 829–38) court production in Shiraz ranged between just less than half to more than three-quarters of all manuscripts recorded. In the following ten-year period, 859–68, production levels, in particular court production, increased in Shiraz as a result of the patronage of Pir Budaq Qara Qoyunlu.

246. This figure refers only to single copies of each text, not anthologies. See Sims 1996, pp. 611 and 619, where she notes the "intense production" of illustrated copies of the *Shahnama* in the fifteen years following the production of Ibrahim's own *Shahnama* (in about 1430), and also notes that many of these copies are extensively illustrated (especially in comparison with earlier Timurid copies of the text).

247. The phenomenon of repeated compositions has been dealt with by Adel Adamova, who has suggested that a clear set of rules and conventions guided the painter in his selection of scenes to be included in a manuscript. These rules and conventions dictated that new compositions invented by the artist to demonstrate his skill and ingenuity could be included only within the framework of compositions copied more or less exactly from older manuscripts and that demonstrated the painter's respect for tradition and more specifically for the masters who preceded him. She has noted that usually three (or four) repeated compositions were included in each manuscript. While I am not disputing her conclusions in the least, the manuscripts that she deals with are mainly high-quality court manuscripts produced in Herat (e.g., StP-HM VR-1000). The evidence presented here suggests that, alternatively, within the context of manuscripts produced anonymously for the commercial market (where these "rules" were probably less closely adhered to), repeated compositions could fulfill a more practical, though perhaps complementary, function. See Adamova 1992, pp. 67–75; Adamova 2001, pp. 74–78; and also Lentz and Lowry 1989, pp. 176–79, for reproduced examples of repeated compositions.

248. An undated manuscript in the Chester Beatty Library (Per 123) has a damaged inscription that appears to name 'Abd Allah as its patron; see Arberry, Minovi, and Blochet 1959, p. 44. Another

manuscript (BN Supp. pers. 494), dated 848/1444 and copied by a calligrapher named Muhammad and using the *nisba al-sultani*, was probably also produced for him; see Richard 1997b, p. 81, cat. no. 46.

249. Khwandamir 1994, pp. 343–44.

250. CBL Ar 5282 and the well-known, dispersed *Zafarnama*, both dated 839/1436; the former will be discussed in further detail in the chapter on bookbinding; for the latter, see Sims 1990–91; Sims 1992a; and Sims 2000.

251. India also provided a ready market for Shiraz manuscripts and probably artists, as well. A number of manuscripts of uncertain provenance are illuminated in the blue-and-gold floral style of Shiraz and are also illustrated in Shiraz styles. Stylistic and iconographic incongruities often abound, however, making it difficult to determine if the manuscripts were produced in Shiraz itself or in India and, if the latter, if they were produced by Shiraz or Indian artists. Many of these manuscripts are undated, but those that are indicate that in the 1430s and 1440s large numbers of manuscripts were both exported to India and also produced there in Shiraz styles. For preliminary studies of this group of manuscripts, see Fraad and Ettinghausen 1971; Robinson 1980, pp. 95–96; Adahl 1981; Losty 1982, pp. 37–73; and Titley 1983, pp. 161–86. For general comments on the spread of the "Ibrahim style," see Sims 2000, pp. 123–24.

252. Roemer 1986, p. 111. Sultan Muhammad had previously, in about 848/1444, laid siege to Shiraz, but abandoned his attempt to take the city when he learned that the sultan's forces were coming to 'Abd Allah's rescue; see Khwandamir 1994, p. 348.

253. For an example of the style as it appeared in manuscripts made for Pir Budaq, see Lentz and Lowry 1989, pp. 248–49.

254. For examples of the fifteenth-century Turcoman style, see Soudavar 1992, cat. no. 48; and Wright 2009, figs. 124 and 183; and for Safavid versions of the Turcoman style, see Thompson and Canby 2003, figs. 5.7 and 6.15.

255. An especially fine and late Ottoman example of the Turcoman style is a Qur'an in the Chester Beatty Library (CBL Is 1527), dated 977/1570, reproduced in James 1980, p. 93. For other Ottoman examples, see Raby and Tanındı 1993, cat. no. 41; and Rogers 1995, cat. nos. 14, 17, and 19.

256. For example, see the illuminations reproduced in Rogers 1995, cat. no. 11.

257. For example, see the illuminations reproduced in Raby and Tanındı 1993, cat. nos. 11–12. However, Raby and Tanındı (p. 69) regard this style as an original creation of Ottoman court artists.

2. CODICOLOGY

1. This section treats Shiraz and non-Shiraz manuscripts as a single group, as the treatment of Shiraz manuscripts generally could not be distinguished from that of other centers.

2. Poetry in the *ruba'i* form is not frequently encountered during the period of this study. With a usual rhyme pattern of *aaba*, this is one of the very few types of verse that would not divide equally well into two, four, or six columns. A six-column division would, of course, interrupt the rhyme pattern and cause a disjuncture in one's reading. A single narrow column of text was used to copy two manuscripts of *ruba'i* verse, each of which is dated slightly later than the period of this study (BOD Ouseley 140 and Ouseley 141).

3. For a detailed analysis of this manuscript, the earliest known copy of the *Shahnama*, see Piemontese 1980.

4. The six-column manuscripts are: (1) dispersed Great Mongol *Shahnama*, n.d., but c. 1335; (2) dispersed First Small *Shahnama*, n.d., but c. 1300; (3) dispersed Second Small *Shahnama*, n.d., but c. 1300; (4) Freer F1929.25–46, 1930.1–17, and 1940.12–13, the so-called Freer Small *Shahnama*, n.d., but c. 1300; (5) TS H. 1479, 731/1330; (6) the dispersed *Shahnama* of 741/1341; (7) TS H. 2153, which includes folios of a lost Jalayirid *Shahnama*, n.d., but generally thought to date to c. 1370; (8) TS H. 1511, 772/1371; (9) Cairo Ta'rikh farisi 73, 796/1393–94; and (10) CBL Per 114, the *Shahnama* portion of the Collection of Epics of 800/1397, the other half of which is BL Or. 2780.

5. The four-column manuscripts are: (1) StP-RNL Dorn 329, 733/1333; (2) Sackler LTS1998.1.1.1–94, the Stephens *Shahnama*, n.d., but late 1340s to early 1350s; (3) MET 1974.290.1–42, the so-called Gutman *Shahnama*, n.d., but c. 1340, often said to be Indian but attributed to Isfahan by Swietochowski and Carboni 1994, p. 81; and (4) TS H. 1510, the *Shahnama* portion of what is now a composite manuscript, probably 783/1382; see Soucek and Çağman 1995.

6. Sims suggests that the six-column division used in a *Shahnama* made for the Timurid prince Baysunghur, in 833/1429–30 (Gulistan 716), was a deliberate reference to fourteenth-century practices. In addition to this manuscript, she lists the following six-column *Shahnama*s: (1) JRL Pers. 933, n.d., but c. 1430–40; (2) StP-IOS C.1654, 849/1455; (3) Berlin-SB (no. not known), 895/1489. See Sims 1992b, pp. 44, 55, 61 n. 18, and 67–68. Two other six-column *Shahnama*s are: (1) Sackler S1986.127–30, four illustrated folios, n.d., but fifteenth century, reproduced in Lowry and Beach 1988, pp. 78–79; and (2) Berlin-SB Orient folio 4255, 894/1489.

7. A parallel or related move to the four-column format may have been taking place in Turkey, for three early fourteenth-century manuscripts, all of which were either definitely or presumably produced in Konya, are also copied in four columns. Curiously, two are copies of Rumi's text; the third is by his son: (1) Berlin-SB Minutoli 21, *al-Mathnawi al-ma'nawai*, 738/1337; (2) Sotheby's, 18 October 1995, lot 62, *al-Mathnawi al-ma'nawai*, 743/1342 (present location unknown); and (3) Berlin-SB Mixt. 1594, *Rababnama* and *Intihanama* (the second and third sections of the *Mathnawi* of Rumi's son, Sultan Walad), 768/1366–67.

8. "The panegyric poem . . . constitutes a ritual text that functions to affirm both the institution of the state (at the center of which was the monarch) and the membership of those present [at the reading of the poem, namely, the members of the court] in that institution"; Meisami 1987, p. 43, quoting J. W. Clinton, "Myth and History," paper delivered at the Fifteenth Annual Meeting of the Middle East Studies Association, Seattle, Washington, November 1981.

9. Meisami 1987, p. 87.

10. Bosworth 1968, p. 43, quoted in Meisami 1987, p. 81.

11. Meisami 1987, pp. 87 and 131.

12. The romantic epic is in fact one of three types of love poetry. "In the *qasida*, the topic of love serves as a preliminary to panegyric . . . [and] its role is subsidiary to the primary topic of encomium." In the romantic epic, "love is the central topic around which the plot . . . revolves . . . [but] it also provides a means of exploring analogous or related issues." By comparison, the lyric *ghazal* is "primarily identified as a vehicle for expressing the varied aspects and perspectives of the experience of love." It "presents a courtly view of love intended to inspire its audience to self-perfection through identification with the lover's refined sentiments and self-sacrificing stance." (These courtly ideals of love are in fact criticized in the romantic epic as being impractical in the noncourtly, more public sphere.) See Meisami 1987, pp. 237 and 307.

13. Meisami 1987, p. 87.

14. Rypka 1968, pp. 94–98.

15. Meisami 1987, p. 238 n. 1.

16. Specifically, Meisami states that "panegyrists, romance writers, and lyric poets [all] shared the conviction that poetry served moral ends, although the specific manner in which these ends were to be achieved varied according to the dictates of their respective genres"; see Meisami 1987, p. 305. Meisami's study deals only briefly with the heroic epic. However, it, too, can be broadly considered as serving moral ends, and does so through a recounting of the deeds of kings and heroes entrusted with the protection and preservation of the realm.

17. See Meisami 1987, pp. 112–16, for a comparison of Firdawsi's treatment of the story of the Sasanian king Khusraw Parviz with that of Nizami; see also Burgel 1988, pp. 172–75, for a comparison of how these two poets treat the story of Bahram Gur and the slave girl Azada, or Fitna.

18. The three four-column manuscripts are: (1) BN Supp. pers. 1817, 763/1362; (2) BOD Ouseley 274–75, 766–67/1365; and (3) BN Supp. pers. 580, 767/1366. Another, slightly later Muzaffarid four-column *Khamsa* is TS H. 1510, dated 776/1374; for further reference to this manuscript, see chapter 3, note 39. The two-column *Khamsa* is Berlin-SB Minutoli 35, dated 764/1362 and 765/1363, with a third, marginal column of text running around three sides of the textblock, a textblock format that will be discussed below. In the Tehran University Central Library, there is an illustrated copy of the *Khamsa* of Nizami, dated 718/1318 (no. 5179). Titley has noted that its paintings are in a style consistent with that of about the 1380s, assuming them therefore to be late additions to the manuscript. However, it is most likely that the 1318 date itself is a late addition to the manuscript, because it has curiously been written outside the boundaries of the triangular-format colophon. As the style of both the illuminations and the calligraphy is also consistent with that of Shiraz in the 1380s, the manuscript as a whole was surely produced in that period. See Titley 1972, pp. 120–25; and Titley 1983, pp. 42 and 168–69. I am deeply grateful to the late Norah Titley, who, in response to my plea for information on this manuscript, very kindly lent me her microfilm copy of it.

19. This point is addressed in chapter 6.

20. Of the ten four-column manuscripts of Persian origin dated or datable to the 1360s and earlier that have been discussed in the preceding pages, only four cannot be attributed to Shiraz. These three are: (1) Florence Cl. III. 24, 614/1217, provenance unknown; (2) CBL Pers 103, 699/1300, with Il-Khanid-style illuminations; (3) MET 1974.290.1–42, for a suggested provenance of which, see note 5 above; and (4) TS H. 674, 755/1354, generally attributed to Tabriz. See note 7 above, for manuscripts in four columns produced in Konya.

21. This is not to imply that the romantic epic was in itself a new genre of poetry or that no earlier manuscript copies of this genre existed, but rather only that the obviously keen interest in the copying of texts of this genre was new.

22. The two-column division was used throughout the period of this study, from the early years of the fourteenth century through to the mid-fifteenth century and later. Some early examples are: (1) CBL Pers 109, n.d., but early fourteenth century; (2) CBL Pers 107, 710/1310; and (3) Kuwait LNS 9 MS, 741/1341. Also copied using a two-column format is the romance *Varqa va gulshah* (TS H. 841), n.d., but probably thirteenth century and perhaps copied in Konya; for a brief discussion and bibliography of this manuscript, see Rogers et al. 1986, p. 50.

23. However, it appears that the copying of the text of this manuscript was not completed until 811/1409, at which time the marginal columns were filled.

24. The two manuscripts in appendix 1 designated as "late fifteenth–early sixteenth century" are included in this grouping.

25. The two early, non-Shiraz examples are: (1) TIEM 2046, 809/1407, Baghdad; and (2) FITZ McClean 199, 800/1397–98, the illumination of which, though minimal, is similar to that of TIEM 2046, suggesting that it, too, was made in Baghdad.

26. Although a *khamsa* is in fact a collection of five poems, they are all of the same verse type (i.e., *masnavi*) and are generally regarded as a single, unified group, despite occasionally being presented individually.

27. See Kühnel 1931, p. 138; and also Soucek 1992, pp. 121–22.

28. In fact, between the beginning and end points of each (major) text in the central columns, there is in the marginal columns usually not just one text, but rather two or three short texts, and therefore two or three beginning and end points, although arranged so that the first and last of these marginal texts coincide with the beginning and end of the central text (but see note 29 below also). The identification and arrangement of the manuscript's texts have been thoroughly discussed and analyzed by Soucek 1992; see, in particular, pp. 122–25 and also pp. 129–31 for a list of the contents and illuminations of the manuscript.

29. There are actually just three such units: ff. 1–38a, 38b–57a, and 57b–80a. From f. 80b onward, the system of separate units is much less clear, in part because the manuscript was not completed. (There was originally no marginal text on ff. 98a–130a; Jami's *Yusuf and Zulaykha* was later added but is now largely erased). In volume 2, which contains the prose texts, usually both central and marginal columns contain the same texts; see Soucek 1992, pp. 129–31.

30. Soucek 1992, p. 122.

31. As is the case, for example, with the works of the poets Khwaju 'Imad Faqih and Sa'di in the Berlin Anthology; see Kühnel 1931, pp. 138–40.

32. An exception is Iskandar's London Anthology (BL Add. 27261), which does contain a few excerpts of texts. However, there is no evidence in this manuscript of the careful arrangement of texts seen in parts of the Lisbon Anthology.

33. From f. 203b to the end of the manuscript, the marginal columns contain a collection of love letters, apparently not known elsewhere; see Ethé and Sachau 1889, cat. no. 766. In the second volume of the Lisbon Anthology (LA 161), the arrangement differs from that in the first volume and is closer to that used in single-poet manuscripts. This volume contains longer prose texts, and the same text often occupies both central and marginal columns of one section of the manuscript. Soucek (1992, p. 125) notes that a shift to the marginal column usually occurs at a major division of the text and that the scribe directs the reader—in the colophons of the central block—to the continuation of the text in the marginal column.

34. See Ethé and Sachau 1889, cat. no. 681. In fact, the calligrapher slightly misjudged the space required to copy out the final portions of the text and thus had to add just over twenty folios more to the end of the manuscript, on which he copied the final verses, using both the central and marginal columns of each page before moving onto the next page.

35. The *Divan* of Sultan Ahmad (TIEM 2046, 809/1407) is an exception to these comments, for in this manuscript the poems in the central and marginal columns always begin at the same point; therefore, the manuscript comprises individual, unified units. However, at the end of each section, there are several folios on which either the central or marginal columns have been left blank, this being necessary in order to avoid having to abridge any of the poems, yet accommodate their varying lengths. Nevertheless, the arrangement of texts in this Jalayirid manuscript may well have served as the inspiration for Iskandar's Lisbon Anthology.

36. Two of the single-poet works employing the three-sided marginal column format also follow this same disjointed reading (and writing) pattern, for on each page the central columns are to be read and then the marginal column, before moving onto the next page. The manuscripts are CBL Per 145, *al-Mathnawi al-ma'nawi* of Rumi, 874–75/1470, and CBL Per 171, *Khamsa* of Nizami, 897/1492.

37. Some, often very unusual, variations of these textblock formats exist. For example, both the first volume of Iskandar's Lisbon Anthology (as noted in chapter 1, note 167) and an undated anthology of about 1420 (MET 13.228.19) employ a combination of the three-sided and one-sided marginal column formats. The central

block of four columns is bordered on its long exterior edge, only, by a marginal column, in which oblique lines of script are written in two opposing directions, with a thumbpiece at the midpoint of the column. On each page, this group of five columns is then surrounded, on three sides, by another marginal column. An even more elaborate variation is used in a dispersed copy of a *Khamsa* of Nizami, dated 984/1576, wherein the central block of four columns of horizontal script is bordered on its long exterior edge by two, not one, marginal columns of oblique script; these six columns are then in turn bordered again by two, not one, three-sided marginal columns, for a total of eight central and marginal columns. Eight folios of this manuscript are in the collection of the late Prince Sadruddin Aga Khan (no. IR.M.28), see Welch 1972–78, p. 158; another folio is reproduced in Sotheby's, 14 December 1987, lot 120. An undated but late fifteenth-century copy of 'Attar's *Mantiq al-tayr* in the Chester Beatty Library (Per 160) employs a one-sided marginal column format in which the marginal column is divided horizontally with the script placed perpendicular to the horizontal script of the two central columns. An equally unusual format is used in a once fine, but now damaged, small anthology of poetry, also in the Chester Beatty (Per 294), which, based on the style of its illustrations and illuminations, dates to the late 1430s or 1440s. A two-column format is used, with the script written obliquely in each column and arranged so that in one column the lines slant upward and in the other downward. As a result, the two columns are mirror images of each other; at the upper and lower edge of each column is a small triangle filled with gold blossoms.

38. Many modern printed texts follow this same practice.

39. In early copies of the Qur'an, extra space in the margins was likewise needed to accommodate the palmette that typically extends from the *sura* heading.

40. See Weir 1957, pp. 46–47; and Bosch, Carswell, and Petherbridge 1981, pp. 30–31.

41. For the precise folio dimensions of each group noted by al-Jawhari and Irigoin, see Bosch, Carswell, and Petherbridge 1981, p. 31. For a discussion of the size of paper used in Il-Khanid Qur'ans, especially those made for Sultan Uljaytu, see James 1992b, p. 63.

42. This finding might seem to suggest that there were no production standards regulating the size or format of these papers. If so, it may not necessarily have been so unusual a situation, for Oriol Valls i Subira records that, as he phrases it, anarchy reigned in the area of paper production in Catalonia, for "every papermaker made, and always has made his paper in accordance with his own, or his customer's wishes, and the most anarchic craft in all Spain

must surely have been that of paper manufacture." (The reference appears to be to thirteenth-century production.) See Valls i Subira 1970, p. 34, cited in Bosch, Carswell, and Petherbridge 1981, p. 31.

43. See Bosch, Carswell, and Petherbridge 1981, p. 30, who state that Misri paper was made in two varieties, the Mansuri and the "ordinary"; the former was larger but also more thoroughly burnished. However, Weir states that the Mansuri was burnished on one side only while there were two qualities of "ordinary," each of which was burnished on both sides. Adding that quality also varied in terms of the durability of the paper, he notes that according to al-Qalqashandi (d. 821/1418), Moroccan paper decayed quickly and the Egyptian paper known as al-Foumi was generally made from the cheapest of materials, such as shrouds taken from the dead; it was used by merchants for wrapping goods, as it was said to be coarse, thick, and ill suited for writing; see Weir 1957, pp. 47–48.

44. Afshar 1992, p. 22.

45. Afshar 1995, pp. 86–87.

46. However, the non-Shiraz manuscripts have been divided into only four time periods as compared to five for the Shiraz manuscripts. This is because for the period 756–70/1355–69, only one non-Shiraz manuscript is included in the codicological study (BL Or. 3646, copied in Baghdad in 761/1360). Thus, this and the following period, 771–801/1370 to 1398–99, have been conflated into one period.

47. The analysis also includes only dated or securely datable manuscripts. *Safina*s have also been excluded because, even in periods of great popularity, their long thin format can be considered atypical.

48. The distribution of the twenty-three Mamluk Qur'ans recorded in James (1988, cat. nos. 1–23) and produced from the start of the fourteenth century through to 755/1355 is: 4 percent in size-group 3; 9 percent in group 4; 30 percent in group 5; and 57 percent in group 6. Thus, a total of 87 percent of the manuscripts fall into groups 5 and 6, the two largest size-groups. Of the eleven manuscripts produced from 756/1356 to the end of the century (cat. nos. 24–25 and 27–35), 82 percent fall into group 6, and 9 percent in each of groups 3 and 4 (with none in group 5).

49. The distribution of the sixteen manuscripts examined is: 6 percent in group 2; 31 percent in group 3; 31 percent in group 4; 13 percent in group 5; and 19 percent in group 6. These Arabic manuscripts include copies of the *Maqamat* of al-Hariri, Dioscorides' *De Materia Medica*, and *Kitab al-aghani*, but no copies of the Qur'an or poetry texts.

50. Grabar 1970.

51. This concentration of manuscripts in size-groups 2 and 3 continues through to the end of the fifteenth century. The distribution of eighty-three Shiraz and non-Shiraz manuscripts combined, dated from 856/1452 to 900/1495, is: 6 percent in group 1; 47 percent in group 2; 25 percent in group 3; 11 percent in group 4; 10 percent in group 5; and 1 percent in group 6.

52. The height to width (h:w) ratio of a manuscript measuring 250 mm x 169 mm was, for example, calculated as: 169/250 = 0.676 x 100 = 67.6 or 68. Assuming a height of 100 mm, the width would be 68; thus the h:w ratio is 100:68. The folio h:w ratio of the manuscripts could have been presented in alternative forms. However, each alternative was discarded as being either less convenient or less accurate than the form used.

53. Textblock proportions are usually slightly narrower than those of the folio; for example, a textblock with the proportions 100:54 might be placed on a folio with the proportions 100:64.

54. The majority of Mamluk Qur'ans produced throughout the fourteenth century have folio h:w ratios of 100:70 or greater (78 percent and 64 percent for the first and second halves of the century, respectively; see note 48 above). Although the thirteenth-century (non-Qur'anic) manuscripts of Syria and Iraq (see note 49 above) are generally smaller than Iranian and Mamluk manuscripts of the first half of the fourteenth century, they nevertheless employ the same rather squat proportions: 76 percent have a folio height to width ratio of 100:70 or greater.

55. As mentioned in note 22 above, the two-column format was used throughout the period of study, but was never popular. Perhaps it was simply deemed impractical, as placing only one short couplet on each line would mean that more (inordinately narrow) folios would be required.

56. I am greatly indebted to the late Don Baker, who, in the summer of 1992 at his conservation studio in London, kindly provided me with a brief but vital introduction to the "mysteries" of Islamic paper. Working on behalf of the Don Baker Memorial Fund, Helen Loveday has catalogued Don's archive of notes and also continued and expanded his research on Islamic paper. She has published the results of their combined examination of 1,237 dated Persian and Syro-Egyptian papers of the twelfth to eighteenth centuries, along with a history of Islamic paper. In most cases, Loveday's results for the fourteenth and fifteenth centuries closely parallel mine. However, in contrast to her broader view of the subject, in which each century is treated as single unit, I have here, as elsewhere in this chapter, dealt with smaller units of time, comparing Shiraz and non-Shiraz papers. See Loveday 2001, especially pp. 83–84, for the results of their examination of fourteenth- and fifteenth-century papers.

57. Damascus, for example, served as a prominent center of paper production from the late fourth/tenth century, at least, through to the early twelfth/eighteenth century, because of the numerous rivers flowing through the city (in addition to its large hemp industry); see Weir 1957, p. 47.

58. Other centers were Qazvin, Zanjan, Kirman, Yazd, Nishapur, and Herat; see Afshar 1995, pp. 78–82. The sources from which Afshar derived this information are largely of the seventh/thirteenth to tenth/sixteenth centuries, so it can be presumed that most of these sites were active throughout the fourteenth and fifteenth centuries. No mention of Shiraz as a center of papermaking has been located.

59. Bosch, Carswell, and Petherbridge 1981, p. 37, quoting from the account of the seventeenth-century travels of Evliya Çelebi published by Hammer-Purgstall 1845, p. 8. Even if the calligrapher purchased the paper already burnished, he may have burnished it further himself to ensure that the finish met his precise requirements.

60. In a personal communication of July 1992, Don Baker stated that the fineness of the laid lines in Persian papers, in comparison with those of Arab papers, may be the result of the use of grass, not reeds, to form the mold cover. Loveday in fact believes that it is possible to differentiate between the use of grass and reed molds in the production of Persian papers, noting that in the fourteenth century both types of molds were used in Iran but that in the fifteenth century only grass molds were used. She states that with grass molds, there is often a "noticeable curving" of the laid line at its head or tail, and in her recording of laid line counts she gives separate readings for each type of mold; see Loveday 2001, pp. 61, 76 n. 4, and 83–84. In this study, I have not made any such differentiation in laid line counts.

61. See Bosch, Carswell, and Petherbridge 1981, pp. 28–29, who note that the linen and hemp fibers underwent "washing, alkaline and other treatments to remove any impurities and to reduce them to a workable state mechanically or by fermentation" before being beaten to create the pulp stock or mash. Olearius records that old rags, mostly of cotton and silk, were also used. Weir (1957, p. 45) likewise notes that Khurasan was a cotton-producing region; therefore it is more likely that paper produced there was made of cotton, perhaps of raw cotton fibers. Also see Olearius 1662, p. 332.

62. Laid lines throughout the period of this study have a rather ragged edge, while the edges of those in manuscripts of later cen-

turies (specifically Qajar manuscripts of about the eighteenth century onward) are much smoother and more even, presumably because they are the impressions of fine metal threads, not reeds.

63. Rather surprisingly, in the second half of the fifteenth century, laid line counts of just seven lines per centimeter are most common.

64. See Bosch, Carswell, and Petherbridge 1981, p. 29, who mention groupings of two, three, or four chain lines in their study of mainly Egyptian and Syrian manuscripts of the fourteenth and fifteenth centuries.

65. Rib shadows are dark shadows created in a sheet of paper by the settling of the pulp or mash in the spaces between the ribs of the mold frame. According to Baker (1989, p. 68), they are usually visible in Persian papers up to the fourteenth century and in Arab papers up to the sixteenth century; they were seldom noted in the papers examined and therefore are not discussed further.

66. Wove paper, produced in Islamic lands as early as the fifth/eleventh century, is equally rare in the years preceding the fourteenth century; see Baker 1991a, p. 30.

67. No wove molds of the period have survived, and therefore their precise form is not known for certain.

68. Because of their greater simplicity, Dard Hunter (1947, p. 82) assumes that wove molds were the first type used to make paper. He admits, however, that there is as yet no material evidence to support this assumption, for the earliest extant paper, produced in China in the second century A.D., is of laid construction.

69. In the mid-eighteenth century, the British printing industry developed a woven wire mold to create a smoother surface for printing; see Hunter 1947, p. 127.

70. The flexible cover of the laid mold is regarded by Hunter (1947, p. 86) as the first great advantage in the history of papermaking. But see Bosch, Carswell, and Petherbridge 1981, p. 32, who state that by the fifteenth century European paper being exported to Islamic lands was being produced on the "advanced rigid mold."

71. Baker 1989, pp. 67–68.

72. For example, an undated manuscript made for Iskandar Sultan (BN Supp. pers. 1963) and adorned with high-quality illuminations. A related matter is the occasional occurrence of paper with what can be termed smeared mash marks, the undoubted result of the still wet paper being accidentally touched. Such marks occur, for example, on several folios of a manuscript copied in 845/1441 (BN Supp. pers. 1465, e.g., ff. 78 and 93).

73. Levey 1962, p. 39.

74. Porter 1985, p. 188; and Thackston 1990, p. 219. The various

manuscript copies of extracts from Simi's text, *Hasl al-hayat wa jawhar al-safat*, written in 833/1433, are discussed by both authors.

75. Qadi Ahmad 1959, p. 113. Apparently taste had changed, for al-Jawhari, writing in the late fourth/tenth–early fifth/eleventh century, considered the finest paper to be "pure white, full-size, smooth, symmetrical of edges, and of a quality that will last a long time"; see Bosch, Carswell, and Petherbridge 1981, p. 30.

76. See Porter 1985, pp. 188–89; and Thackston 1990, pp. 219–21.

77. Thackston 1990, p. 219.

78. Thackston 1990, p. 220.

79. Thackston 1990, p. 221. The manuscripts examined for this study are, with few exceptions, decorated with illuminations, illustrations, or both. As already stated, rarely is there any sign of the paper used in these manuscripts having been dyed. However, beginning in about the 1430s, *safinas* became popular. These small manuscripts of a long and narrow format, usually anthologies of poetry, often include a few folios of colored paper scattered among the other cream/white folios. These colored sheets are usually either a light pinky salmon color or a pale purple. The folios are colored on both sides, the dye obviously having been added to the mash from which the sheet of paper was formed (e.g., CBL Per 122, 835/1432; CBL Per 127, 853/1449; CBL Per 159, n.d., but mid-fifteenth century; and CBL Per 185, n.d., but mid-fifteenth century). On two other types of folios in these manuscripts, the color is merely surface decoration, having been applied after the sheet was fully formed. These are: (1) folios (usually purple) with stenciled patterns; unlike the dyed sheets, the color does not extend to the edges of the folio and often just one side of the folio is colored; and (2) folios that appear to be crude (or early) attempts at producing marbled (*ebru*) paper; the paper is covered with (usually) gold or reddish "drips" of pigment, often with very unappealing results; again, often just one side of the folio is colored. The only other paper used in the manuscripts included in this study that has obviously been dyed (and that is original to the manuscript) is of Chinese origin. (The dyed paper in the *safinas* is presumably of local manufacture, possibly originally produced in imitation of imported Chinese paper.) This Chinese paper is a highly distinctive type, not only because it is colored and decorated with large flecks of gold or with various scenes and designs of Chinese origin painted in gold, but also because it is coated with what appears to be a clay glaze, which renders each folio very heavy with an unusually sleek and smooth surface. The most well known examples of this paper are two companion manuscripts made in Herat for Shah Rukh (TS A.III 3059, 841/1438, and TIEM 1992,

n.d.; see Lentz and Lowry 1989, cat. nos. 39 and 40 and p. 121; and Roxburgh 2005, figs. 84–86). The paper in these two very similar manuscripts is a range of shades of pink, purple, yellow, beige, and blue. A copy of the *Kulliyyat* of Saʻdi in the Bodleian Library, Oxford, dated 840/1437 (BOD Pers. e. 26), also uses this same type of paper, but the folios are all shades of gray. That this manuscript was produced in Shiraz is suggested by its illuminations, which are in both the blue-and-gold floral style and the floral/palmette-arabesque style that became popular in Shiraz in the years following Ibrahim's death. A small anthology of poetry in the Chester Beatty Library (Per 294) includes just seven folios of this paper (two bifolios and another three folios that appear to have been "tipped in"), but in a light olive green color only. It, too, was most likely produced in Shiraz in the 1430s–40s (see note 37 above). For a list and discussion of other manuscripts employing this same type of paper, see Sotheby's, 26 April 1995, lot 29; and also see Soucek 1988, for a discussion of a late fifteenth-century manuscript with colored paper in the Spencer Collection of the New York Public Library (Persian Ms. 41). Sheila Blair also discusses several types of colored and decorated paper of Persian manufacture, stating that the taste for such papers arose from contacts with China. She asserts that the taste for "colored paper clearly grew in the thirteenth century, when trade contacts between China and Iran intensified." In support, she cites several examples of the use of (dark-toned) colored paper in manuscripts of the thirteenth and fourteenth centuries before moving on to discuss the many varied types of decorated paper in use in manuscripts of the fifteenth century and later (such as gold-flecked or gold-painted papers, marbled and stenciled papers, and those with variously decorated borders). However, of the thirteenth- and fourteenth-century manuscripts she names, those in the Chester Beatty Library (which include folios of a deep olive green color) are all otherwise undecorated and are the result of quite a different level of patronage and production from that of the fifteenth-century manuscripts in which decorated papers are usually just one of many aspects of their overall decoration. Although I must admit I have not yet studied this problem in depth, it seems that the use of colored paper in these "early," undecorated, and highly "practical" manuscripts is quite a different phenomenon from the clearly Chinese-based taste for decorated papers so evident in fine manuscripts of the fifteenth century and later; see Blair 2000, in particular p. 25.

80. An extensive array of modern papers was collected in an attempt to create a color standard against which to judge the color of paper used in manuscripts, but none were sufficiently close to the manuscript papers to be of any use. The Pantone Color Formula Guide used in the printing industry likewise was not suitable. In the end, the standard used was based on domestic interior house paint—the Dimensions range of the Dulux paint company. Of the color swatches (available free in most hardware stores), five colors on chart 10 provided the best standard against which to judge fourteenth- and fifteenth-century Persian papers. [These are Dulux numbers 0504-Y21R (Gardenia) BS 10B15; 0811-Y16R (Buttermilk) BS 10C31; 1010-Y20R; 1116-Y18R (Country Cream); and 1515-Y24R (Muffin). These were available in Britain in the 1990s, but the range appears to have been discontinued.] Even this standard, however, was not precise, for while the paint colors could be used as a standard for the actual color or hue of a particular paper sample, the papers were almost always much lighter than the paint samples.

81. The terms used to describe the color of paper can at best only hint at the actual color. The terms most commonly used by those writing about paper are white (although Islamic paper is never pure white when compared with modern paper), cream, biscuit, tan, and brown.

82. Two other manuscripts made for Baysunghur fall between these two extremes in terms of paper color (BL Or. 2773, 834/1431, and TIEM 1954, 835/1431).

83. The illuminations of BL Or. 11919 are not contemporary with the copying of the text, for they are in the style of illuminations produced in the late fifteenth century during the rule in Herat of Husayn Bayqara.

84. Three readings each were taken from the top, outer, and bottom edges of each of several folios of each manuscript, but only the highest and lowest of each group of three readings were recorded, for a total of six readings per folio. In calculating the average paper thickness for a manuscript, the highest and lowest readings were then discarded if they were more than 0.01 mm greater or less than the next consecutive reading (unless the reading had been recorded more than once). In taking the readings, obviously thick or thin spots on a folio were avoided, as were areas of water damage (although water damage and the possible washing away of the finish of the folio did not appear to affect readings).

85. For the non-Shiraz manuscripts, it again has been necessary to conflate the two periods of 756–70/1355–69, and 771–801/1370–98 to 1399; see note 46 above.

86. For the period 856–900/1452–94 to 1495, the average paper thickness of thirty-eight Shiraz and non-Shiraz manuscripts, combined, was determined. The results are: 11 percent with paper 0.07

mm thick or less; 34 percent with paper 0.08–0.09 mm thick; 34 percent with paper 0.10–0.11 mm thick; 16 percent with paper 0.12–0.13 mm thick; and 5 percent with paper 0.16 mm thick or greater. The overall range of thicknesses is 0.06–0.19 mm.

87. The manuscripts are: (1) BL Or. 2866, 774/1372; (2) BL Add. 7729, 802/1400; (3) BL Add. 27261, 813–14/1410–11; and (4) BN Supp. pers. 1488, n.d. The latter manuscript bears no dedication, but the style of its illuminations suggests that it was made for Iskandar Sultan, as was BL Add. 27261.

88. Weir 1957, p. 48, in reference to the production of pre-fourteenth-century Arab papers.

89. Many pre-fourteenth-century manuscripts are characterized by a slight shadow around the letters indicating bleeding of the ink, presumably because the paper was insufficiently sized and burnished.

90. Sultan ʿAli Mashhadi, writing in the late fifteenth century, quoted by Qadi Ahmad 1959, p. 114.

91. Ibn Badis, writing in the fifth/eleventh century, in Levey 1962, pp. 39–40. By comparison, from the fourteenth century at least, Western manuscripts were sized with gelatin; see McParland 1982, p. 21.

92. Ibn Badis in Levey 1962, p. 40.

93. Weir 1957, p. 45, in reference to pre-fourteenth-century Arab manuscripts, but not stating the source of his information.

94. Bosch, Carswell, and Petherbridge 1981, p. 79 n. 101, in reference to a study of Turkish papers by Kağitçi (1976, p. 18), who also notes the use of albumen as an adhesive. Simi Nishapuri refers simply to the use of white fish glue, by which he presumably also means isinglass; see Thackston 1990, p. 221.

95. Quoted in Porter 1985, p. 189; and Thackston 1990, p. 221.

96. Olearius 1662, p. 332.

97. A few of the folios have a very waxy feel and a smoother finish than most others in the manuscript. Two different types of paper also appear to have been used in the sections of the Qurʾan made in the 1340s for Fars Malik Khatun that are now in the Khalili Collection: the paper of QUR181 is very much less well polished than, and feels rougher in comparison with, the paper of QUR182. There is also a difference with respect to laid line density: QUR181 has a count of eight lines per centimeter, but QUR182 has a count of just six to seven. These counts differ from those cited by David James, who records an "indeterminate" number of lines for QUR181 and "perhaps" nine per centimeter for QUR182; see James 1992b, cat. nos. 29–30.

98. Bosch, Carswell, and Petherbridge 1981, p. 35. The impor-

tance of the type or quality of paper to the execution of fine calligraphy is underscored by the remarks of al-Qalqashandi (d. 821/1418), who, in reference to the four foundations of writing, says: "A quarter of writing is in the blackness of the ink, and a quarter is in competence in the writer's craft; a quarter is in the fine trimming of the pen, and on [the quality of] the paper rests the fourth of these." See al-Qalqashandi 1963, p. 463, quoted in Chabbouh 1995, p. 60 n. 3.

99. The paper of fifteenth-century manuscripts is usually very smooth to the touch. It might be assumed that the smoothness is the result of an extensive degree of burnishing and that the paper would also have a high sheen or gloss to it. But this is not always the case, and many such examples have been recorded as having only a "medium" sheen (e.g., BL Add. 27261, 813–14/1410–11; WL Pers. 474, 813/1411; TIEM 2044, 815–16/1412–13; BN Supp. pers. 206, 841/1438; and TS H. 781, 849/1445–46). It may be that the type of size used did not produce a high sheen regardless of the amount of burnishing, or it may be that the type or degree of size applied was capable of producing a very smooth surface without the extensive burnishing needed to produce a high sheen. As sheen is an aesthetic quality, the lack of a very high sheen on very smooth paper can perhaps be taken as indicating that the sizing and burnishing of paper remained a process executed primarily for functional rather than aesthetic purposes.

100. For example, BOD Ouseley 263, a copy of the *Zafarnama*, dated 852/1448, can be considered a rather utilitarian version of this type of paper, a classification that can as well be applied to the poorer quality illuminations of this manuscript.

101. As noted previously, pure white paper, or at least what would today be considered "pure white," was not found in any manuscript examined for this study. Therefore, it must be kept in mind that "white," as used here, is a relative term.

102. Whether this type of paper was actually made in Shiraz or not is impossible to say. (As noted previously, no specific mention of Shiraz as a papermaking center has been located.) However, even if not, it is possible that Shiraz calligraphers or other craftsmen added a further, heavy layer of size or glaze to prepurchased paper, then burnished it to produce this specific type of paper.

103. According to Baker, the laid construction of what might initially appear to be a wove paper is often revealed only when the paper has been water damaged or skinned; see Baker 1989, p. 68; and Baker 1991b, p. 33.

104. Manuscripts employing wove-like paper, in addition to those listed in the text, include (in chronological order):. (1)

BOD Elliott 121, 839/1435–36; (2) BN Supp. pers. 206, 841/1438; (3) TS H. 789, 841–42/1437–39; (4) BL Or. 9863, 843/1439; (5) BOD Ouseley 148, 843/1439; (6) BOD Pers. d. 95, 843/1439; (7) BL Or. 5012, 844/1440; (8) BN Supp. pers. 493, 844/1441; (9) BL Add. 23564, 845/1441; (10) BN Supp. pers. 1465, 845/1441; (11) BN Supp. pers. 494, 848/1444; (12) TS H. 870, 848/1444; (13) TIEM 1906, 849/1445–46; (14) BOD Pers. c. 4, 852/1448; (15) TS A.III 1357, 853/1449; (16) TS H. 1412, 857/1453; and (17) BL Add. 7768, 857/1453. Other fifteenth-century Persian manuscripts that employ a wove-like paper, but one that appears to differ in almost all traits from the 1430s–40s type discussed here, include: (1) BL Ethé 1118, 819/1416; (2) BOD Elliott 189, 866–67/1463; and (3) TS H. 1496, 868/1464. A wove-like paper similar to the typical Shiraz type is also known in Ottoman manuscripts bearing dedications to Fatih Mehmed, perhaps providing yet further evidence of the impact of Shiraz book production on that of the Ottomans. Examples include: (1) TS A.III 1996, n.d.; (2) BL Add. 17330, 871/1467; and (3) TS A.III 3183, n.d.

3. ILLUSTRATION

1. However, see note 4 of the preface.

2. Despite the ongoing controversy over the appropriateness of using dynastic names to distinguish periods of art and architecture, throughout this study dynastic names and/or those of individual rulers are employed as convenient chronological indicators of style. Of course, a measure of flexibility in the use of such terms is required, as the death of a ruler or the end of a dynasty rarely, if ever, occasions an immediate and drastic change in style, as is the case in Shiraz in the 1390s: control of Shiraz passed from Muzaffarid to Timurid hands in 795/1393, yet an anthology of poetry, dated 801/1398 (TIEM 1950), is here labeled "Muzaffarid" because its painting style is consistent with that of the earlier, Muzaffarid period. See the following section, "Modes of Illustration," for a discussion of Ettinghausen's views on the problems of using dynastic labels.

3. For brief reference to a similar "playing with space" in Shiraz illuminations, see the section on "Manuscripts of the Late 1350s and 1360s" in chapter 1.

4. Having said this, I must note that there can of course be considerable discrepancy among the abilities of artists, in particular in the Injuid era: the paintings of the 731/1330 *Shahnama* are, overall, of a much higher quality than are those of most other Injuid manuscripts, such as the 741/1341 *Shahnama*.

5. The corpus of illustrated Injuid manuscripts consists of the four *Shahnama*s discussed in chapter 1: (1) TS H. 1479, 731/1330, see Binyon, Wilkinson, and Gray 1971, pls. XVB, XVIA–B and XVIIA–B; Rogers et al. 1986, figs. 32–42; and Titley 1983, fig. 15; (2) StP-RNL Dorn 329, 733/1333, see Adamova and Gyuzal'yan 1985; (3) the dispersed Qivam al-Din manuscript of 741/1341, see Canby 1993, fig. 20; and Simpson 2000; (4) Sackler LTS1998.1.1.1–94, the Stephens *Shahnama*, n.d, but late 1340s to early 1350s, see Binyon, Wilkinson, and Gray 1971, pl. XIIIA; and Sims forthcoming. Another two manuscripts are: (5) a dispersed *Kalila wa dimna*, 733/1333, see Binyon, Wilkinson, and Gray 1971, pls. XIA–B; Gray 1940; and Canby 1993, figs. 18–19; and (6) a romance novel, BOD Ouseley 379-81, *Kitab-i samak 'ayyar*, n.d., but c. 1340; see Binyon, Wilkinson, and Gray 1971, pls. XIIA–XIIIB; Robinson 1958, pls. 2–3; and Sims 2002, fig. 177. A few folios from another manuscript illustrated in the same style are also known (Krauss 30–32, n.d., but c. 1330s); neither the author nor the title of the manuscript is known, but according to Grube (n.d., p. 65), the text of the surviving folios consists of the horoscopes of various historical figures, such as ancient Persian kings, Islamic rulers, and members of the Prophet's family. Mention must also be made of a copy of the stories of *Kalila wa dimna*, dated 707/1307–08 (BL Or. 13506), which Norah Titley has attributed to Shiraz. She sees its painting style as a link between the thirteenth-century Mesopotamian painting tradition and that of Injuid Shiraz in the 1330s–40s; see Titley 1983, p. 36, fig. 14. In terms of both illustration and illumination styles, this manuscript is more firmly rooted in the earlier Arab tradition as practiced in Iraq than are the Injuid manuscripts, even though the latter can be characterized as highly conservative and more closely bound to the Arab tradition than contemporary manuscripts of Tabriz. For a fuller discussion of the *Kalila wa dimna* manuscript, see Waley and Titley 1975.

6. Red grounds are a link with the earlier Seljuq tradition, as they are used in several thirteenth-century manuscripts, the most commonly known of which is the tale of *Varqa va gulshah* (TS H. 841), n.d., but c. 1250 and probably produced in Anatolia; deep blue grounds are also used in this manuscript, reproduced in color in Rogers et al. 1986, figs. 21–22; and Sims 2002, fig. 4. Other examples of the use of a red ground are: (1) Vienna, A. F. 10, *Kitab al-diryaq*, n.d., but mid-thirteenth century, probably Mosul, f. 1a, reproduced in Ettinghausen 1977, p. 91; and (2) TS H. 363, *Kalila wa dimna*, n.d., but probably late thirteenth century, reproduced in Rogers et al. 1986, figs. 25–31; and Sims 2002, fig. 200. See also a fourteenth-century *Shahnama*, the folios of which are now preserved in an album in Berlin (Berlin-SB Diez A folio 71, s. 6–7, 11,

29–30, and 40–42), reproduced in İpşiroğlu 1964, pls. I–II; and Swietochowski and Carboni 1994, figs. 13–19.

7. The ultimate source of such mountains is Chinese art (replicating actual Chinese mountains): in the tenth-century wall paintings at Wu-t'ai shan (reproduced in Marchand 1976, figs. 4–19), the peaked mountains are layered, creating a striped effect; and in an early twelfth-century Northern Song silk tapestry "Immortals in a Mountain Pavilion," the mountains are both layered and shaded in bands of color (reproduced in Watt and Wardell 1997, p. 57, fig. 14). The white dots and elongated circles that define the contour of the peaks in Injuid paintings may be a simplified version of the treatment of trees and rocks in Chinese paintings. Peaks of the same type, though more rounded and brightly colored (and without the contour dots), are also common in Arab painting of the thirteenth and early fourteenth centuries; see, for example: (1) TS A.S. 3703, *De Materia Medica*, 621/1224, f. 29a, reproduced in Ettinghausen 1977, p. 89; and (2) TS H. 363, *Kalila wa dimna*, n.d., but probably late thirteenth century, probably Baghdad or Konya, f. 72b, reproduced in Grube 1991, p. 41, fig. 36.

8. This, too, is a development of thirteenth-century Arab painting, though in the latter, tall spindly stalks tend to serve merely as a backdrop for the action and are not used to divide space; thus they function somewhat differently. The use of oversized vegetation in fourteenth-century Mamluk painting does, however, relate closely to its use in Injuid manuscripts. For examples of thirteenth-century Arab and fourteenth-century Mamluk painting, see Ettinghausen 1977, pp. 91 and 153, respectively.

9. For reproductions of other paintings, see Gray 1979, pl. XXXIV; Rogers et al. 1986, fig. 54; and Titley 1983, fig. 16.

10. See O'Kane 2006 for a discussion of this manuscript; and for reproductions of paintings, also see Binyon, Wilkinson, and Gray 1971, pls. XXIXA–B and XXXA–B; and Gray 1979, figs. 72–73. I would like to express my gratitude to Bernard O'Kane for very kindly providing me with photographs of this manuscript.

11. See Stchoukine 1954, pl. IX; and Richard 1997b, cat. no. 29, p. 68.

12. See Robinson et al. 1976, pls. 15–17; and Canby 1993, figs. 21–22.

13. See Suleiman and Suleimanova 1983, figs. 4–5; and Brend 2003, pp. 37, 39–43, and 284–85. The manuscript and its illustrations are all very badly damaged; most of the illustrations have also been at least partially repainted, making it difficult, and often impossible, to discern details of composition or even to get a sense of the original, overall quality of the manuscript. Also see note 79 below.

14. For a discussion of and illustrations from TIEM 1950, see Aga-Oğlu 1935, pp. 77–98; Gray 1977, p. 68; Lentz and Lowry 1989, p. 57; and O'Kane 1999–2000. The manuscript actually does include one figural scene (f. 287b), but it is a later addition to the manuscript. Only one of the original landscape paintings of H. 1510 is now intact; see note 39 below.

15. For reproductions of other paintings, see Gray 1979, pl. XXXV; Rogers et al. 1986, fig. 55; and Lentz and Lowry 1989, pp. 166 and 178, cat. no. 59.

16. See chapter 1, note 162.

17. For reproductions of other paintings from the CBL portion of the manuscript, see Binyon, Wilkinson, and Gray 1971, plates XXXIA–B; and Wright 2004. For reproductions of the British Library portion of the manuscript, see Stchoukine 1954, pls. XI–X and XIII–XV; Robinson 1990, figs. 1–3; Titley 1983, pl. 3; and Canby 1993, fig. 27.

18. Wright 2004.

19. For reproductions of the paintings of BL Add. 18113, see Titley 1983, pl. 4; Lentz and Lowry 1989, pp. 54–55, cat. no. 13; Fitzherbert 1991, pls. XIX–XX and XXII; and Canby 1993, fig. 28.

20. For other paintings made for Iskandar, see Binyon, Wilkinson, and Gray 1971, pls. XXXII–III; Gray 1979, pl. XXXVIII, figs. 74–76; Titley 1983, pl. 4; and Canby 1993, fig. 28.

21. Reproduced in Robinson 1990, fig. 8.

22. For example, it seems clear that the scene of "Humay Killing the Demon-Sorcerer" in Iskandar's London Anthology (BL Add. 27261, f. 300a) is closely based on the scene of "Nawruz Killing a Dragon" in the Yazd Anthology (TS H. 796, f. 136b), though Iskandar's artists used a reversed version of the composition; reproduced in Robinson 1990, fig. 11, and Stchoukine 1966, fig. 6, respectively.

23. For a further discussion of the predominantly Jalayirid-style paintings made for Iskandar, see Gray 1979, pp. 134–36.

24. Gray 1979, p. 138.

25. The painting, on f. 161b of the album, is part of an incomplete anthology that now constitutes ff. 138a–66b of album TS B. 411. The painting bears the title "Rustam Conquers . . . , from the Words of Firdawsi" and is the only one of the three paintings on the folio in this precise style. The other two paintings, entitled "The Darvish Who Fell in Love with the Shahzada, from the Words of 'Attar" and "The Fable of the Hunter, Dog and Fox, from the Words of Shaykh Nizami," are in a style more consistent with that of other paintings made for Iskandar. A note attributes all three as being "the work of Shaykh Muhammad." The only illumi-

nated folio (164a) is in a chinoiserie/Jalayirid style; see Roxburgh 1996, pp. 639–41, and more generally pp. 632–41 for the contents of the other folios of this section of the album.

26. All paintings and most illuminations from the Berlin Anthology are reproduced in Enderlein 1991.

27. For references to other illustrated manuscripts made for Ibrahim Sultan (specifically, Suleymaniye Fatih 3682 and the dispersed 1436 *Zafarnama*), see chapter 1, note 235.

28. The late 1430s to 1440s *Shahnama* is in a very fragmentary state, and it is mainly the paintings that have survived. Five of these are now preserved in the British Museum (OA 1948-10-9-48–52) and another twenty-five are in the Fitzwilliam Museum (no. 22-1948).

29. Ettinghausen's proposed model for the categorization of Persian painting is based, as he states clearly, on the rationale of S. D. Goitein's four-stage periodization of Islamic history. Goitein had argued against the traditional dynastic division of Islamic history that tends to dominate. He instead proposed that specific periods be characterized and thus categorized according to "dominant features," "sets of values," and "constituent factors," or "organic units"; see Goitein 1968, pp. 224–28. Ettinghausen refers to and commends Lisa Golombek's attempt to propose a categorization of Persian painting for which she takes into consideration, among other factors, rates of illustration, textual relevance, format, and iconographic significance. However, noting that the wording of the title of her article, "Toward a Classification of Islamic Painting," indicates that she was indeed merely suggesting a starting point for this task, Ettinghausen rejects her model, stating that although "recognition of these features certainly helps our understanding of the full significance of specific paintings . . . they do not yet establish basic categories in which the large material can be readily divided"; see Ettinghausen 1981, pp. 55–63; and Golombek 1972, pp. 23–34.

30. Stchoukine 1954.

31. Stchoukine 1959; and Stchoukine 1964.

32. For Shah Rukh's patronage of copies of, and replacement volumes for, early fourteenth-century Il-Khanid historical manuscripts, see Ettinghausen 1955; Inal 1992; Soudavar 1992, pp. 64–66; and Blair 1995, pp. 27–30 and 101. The fifteenth-century artists would, of course, have been influenced by the style of the early fourteenth-century paintings in the original volumes. Nevertheless, that an element of choice, presumably conditioned by text type, and not a mere desire to mimic, was at play is suggested by the fact that the artists chose to incorporate certain traits (simple

compositions) of the Il-Khanid paintings but rejected others (a limited palette).

33. Ettinghausen 1981, p. 57.

34. For these four earliest copies of Nizami's *Khamsa*, see the section on "Manuscripts of the Late 1350s and 1360s" in chapter 1. The twenty-five illustrations of BN Supp. pers. 580 are discussed by Brend 2001, who suggests that they were added by Ottoman artists in about 1500.

35. For reproduction references, see chapter 1, note 134.

36. Golombek 1972, pp. 25–27.

37. See Grabar and Blair 1980 for reproductions of the other surviving paintings from this manuscript.

38. For example, Khalili MSS727, f. 21a, reproduced in Lentz and Lowry 1989, p. 51, cat. no. 12a; and Blair 1995, f. 261a. Also see an album folio of a Chinese-type landscape (Berlin-SB Diez A folio 71, s. 10), reproduced in Komaroff and Carboni 2002, fig. 168. For related Chinese landscapes, see Fong 1973, cat. no. 16; and Cahill 1960, p. 114.

39. It is of particular interest that the earliest surviving *Khamsa* of Nizami with contemporary illustrations (TS H. 1510)—a clearly Muzaffarid manuscript of 776/1374 (although its colophon was later altered)—was illustrated completely with landscape scenes only. (However, Soucek and Çağman state that all but one scene were painted over with figural compositions in the early sixteenth century; but also see O'Kane 2006, p. 176 n. 23.) The surviving landscape is similar to, though somewhat simpler than, those in the Anthology of Poetry of 801/1398 (TIEM 1950), but with the important difference that while illustrations in the later manuscript serve as endpapers, filling spaces between colophons and section headings, those in the earlier manuscript appear within the body of the text. Moreover, as noted by Soucek and Çağman in their analysis of this complex manuscript, the illustrations often appear in sections of Nizami's text that "describe a setting rather than a dramatic moment." See Soucek and Çağman 1995, especially pp. 182 and 191.

40. All illustrations and some illuminations in this manuscript are reproduced in Gray 1971; Sims 1992b, figs. 5, 9, 14, and 16; and *Iranian Masterpieces* 2005, pp. 38–67.

41. Ettinghausen's two subsequent stylistic categories will not be dealt with in detail as they do not pertain directly to the material under discussion. Very briefly, they are the didactic or realistic group, which begins in the late fifteenth century and which he associates with the moralistic tales recounted in the *Gulistan* of the poet Sa'di and best exemplified by the genre paintings of the artist

Bihzad. Ettinghausen then identifies a final move, about a century later, to the mystical love poems of Hafiz. He entitles this the enraptured group, and it is best illustrated in the single-page drawings of lovers; see Ettinghausen 1981, pp. 61–63.

42. This distinction is apparent even when one takes into consideration possible stylistic differences among individual artists.

43. Even the Nizami-mode paintings in this and other Shiraz manuscripts tend to retain a much closer focus than contemporary Herat paintings.

44. For reproductions (and discussion) of the paintings in Ibrahim Sultan's dispersed *Zafarnama* manuscript of 839/1436, see Sims 1990–91; and Sims 1992a. In a study of the *Khamsa* of Nizami of 835/1431, made in Herat for Ibrahim Sultan's uncle Shah Rukh, Adamova comments upon the "different pictorial approaches" employed in the illustration program of the manuscript, apparently a reaction to the "content and emotional resonance" of the particular section of text being illustrated; see Adamova 2001, pp. 80 and 82.

45. Lentz and Lowry 1989, pp. 116–18, in reference to Soucek 1971, pp. 368–89.

46. Lentz 1985, p. 85.

47. Lentz 1985, pp. 85–86; and Lentz and Lowry 1989, p. 122.

48. Lentz and Lowry 1989, p. 112.

49. Style is being used to refer to the general, overall presentation of a scene, including elements such as palette, composition, and iconography. It also refers to the actual mode or manner in which the iconographical elements are drawn or painted.

50. All paintings in the manuscript are reproduced in Abdullaeva and Melville 2008. In a few of the text illustrations, the figures are smaller and less bold, though they are still set in characteristically sparse environs, such as the scene of "Rustam Fights with a Sea Monster" (f. 172a), reproduced in Binyon, Wilkinson, and Gray 1971, fig. B.46(d); and in Abdullaeva and Melville 2008, fig. 67.

51. Reproduced in Sims 1992b, p. 46, fig. 2; and Abdullaeva and Melville 2008, figs. 73–74; the left half of the composition (garden scene) only is reproduced in Binyon, Wilkinson, and Gray 1971, color plate facing p. 16. The other double-page paintings are reproduced in Abdullaeva and Melville 2008, figs. 7–8.

52. For the identification of the painting and for an account of Ibrahim's military career in general, see Soucek 1998b, especially pp. 33–37. .

53. For example, see Abdullaeva and Melville 2008, fig. 23.

54. The problem of the date of the bulk of the manuscript versus the date of the three frontispieces is compounded by the presence of the fourth double-page painting, in a style similar to that of the frontispieces, in the middle of the manuscript and which appears to be an integral part of structure of the manuscript and therefore original to it. (The decorated folios have in fact all been removed from the manuscript and mounted separately, making any study of the manuscript's original codicology difficult, if not impossible.)

55. Robinson 1958, cat. nos. 81–132.

56. See chapter 1, note 242.

57. For the frontispiece to Baysunghur's *Shahnama*, see Gray 1971; and Sims 1992b, fig. 16. For the frontispiece to his *Kalila wa dimna* manuscript (TS R. 1022, 833/1429) and the frontispiece to a lost manuscript (Sackler S1986.142–43), see Lentz and Lowry 1989, pp. 110–11 and 125, respectively.

58. Following the three frontispieces are genealogical tables and a dictionary of the ancient words used in the *Shahnama*. Although this whole section (and the final folio of the manuscript) is written in a different hand from the rest of the manuscript, these folios presumably replace "original" damaged folios that would have been added to the manuscript at the same time as the frontispieces, and they, too, were likely added in "response to" similar folios in Baysunghur's manuscript.

59. Comments made in this section refer only to paintings that actually illustrate the actual text of the poem—not frontispieces or other such paintings—unless stated otherwise.

60. Ibrahim's manuscript is copied in four columns, while Baysunghur's is copied in six. A couplet consists of two rhyming hemistichs, each of which is copied in one column. Therefore, in Ibrahim's manuscript, each four-column line of text equals two couplets; in Baysunghur's, each six-column line equals three couplets.

61. It would be equally correct to speak of the shape of the illustration; however, as the impression of the text impinging on the illustration is stronger than *vice versa*, all references will be to textblock shape. "Shape" not "format" will be used to avoid confusion with the various textblock formats discussed in the preceding chapter.

62. Another five text illustrations have textblocks that are only one or two columns wide but are not stepped.

63. The folio depicting "The Murder of Siyavush" (see fig. 111) is the only occurrence in Baysunghur's manuscript of a textblock that is less than six columns wide.

64. Reproduced in Walzer 1969, p. 78, fig. 45; and Abdullaeva and Melville 2008, fig. 35.

65. Abdullaeva and Melville 2008, fig. 72.

66. Reproduced in Lentz and Lowry 1989, p. 166, cat. no. 58; and Abdullaeva and Melville 2008, fig. 51.

67. This is in comparison with the version of the text presented by Mohl 1373/1994, pp. 316–17.

68. For the possible importance of this point, see note 107 below.

69. Reproduced in Stchoukine 1954, pl. XXIII; and Abdullaeva and Melville 2008, fig. 53.

70. Reproduced in Walzer 1969, p. 82, fig. 49; and Abdullaeva and Melville 2008, fig. 82.

71. Information on textblock shape is known for only eighty-one of the ninety-two text illustrations of the 731/1330 *Shahnama* (TS H. 1479); of these, some 66 percent (54/81) employ a stepped textblock. Even if none of the remaining illustrations employ a stepped textblock, the percentage of those that do would still be at least 59 percent. (I would like to thank Teresa Fitzherbert for kindly allowing me to view her photographs and notes on this manuscript.) In two cases in the *Kitab-i samak 'ayyar* (BOD Ouseley 379–81), the textblock is actually worked around a pentagonal painting (ff. 196b and 243b). Complete information is not available for the dispersed *Shahnama* of 741/1341.

72. The date and provenance of these manuscripts are a matter of much dispute, although Simpson (1979, p. 343) has argued in favor of a production date of about 1300, in Baghdad.

73. These two manuscripts are widely dispersed, and not all folios of each have been personally examined; therefore these calculations are based on the data given by Simpson (1979, pp. 99–100), who treats the two manuscripts as a single unit. (Of the total 161 paintings, 114 belong to the First Small *Shahnama* and 47 to the Second.) Moreover, the calculations are, of course, based on the number of extant paintings.

74. The total of sixty-five illustrations excludes the frontispiece. These calculations are again based on the number of extant paintings, with the calculations based on the data given by Simpson (1979, pp. 71–72), who speculates that the manuscript may have once included an additional forty-two paintings.

75. Although only fifty-eight paintings are now known, Blair (1989, p. 127) has calculated that the manuscript may once have included as many as 190 illustrations. (In addition to the seven stepped paintings, on another three folios the text immediately above the painting is interrupted by a subtitle, creating a false impression of a stepped format.) For reproductions of the extant paintings, see Grabar and Blair 1980; and also see Soudavar 1996, p. 177, who suggests a much lower number of illustrations, perhaps not many more than sixty-one.

76. This is especially so in the case of some oddly shaped and placed textblocks, such as that used in conjunction with the paint-ing of "Rustam Kicks Aside the Rock Pushed by Bahman," reproduced in Sims 1992b, p. 47, fig. 3; and Abdullaeva and Melville 2008, fig. 77.

77. The three enthronements are on ff. 196b, 321a, and 335b; and the two face-to-face combats are on ff. 156b and 274b (each of these textblocks employs a single step only).

78. The three folios are 97a, 123b, and 154b. Of the other two, in one the textblock rises up to accommodate a tree in which the musician Barbad is concealed (f. 352b), and in the other the textblock rises up, following the shape of a gallows from which a man hangs (f. 288a). In two further examples (ff. 137b and 214a) the step is placed in the lower textblock, beneath the painting.

79. Fourteen of a total of sixty-seven illustrations (21 percent) in the Cairo manuscript employ a stepped textblock; in another (f. 51b), a block of text only two columns wide and six lines deep is placed in the upper right corner, next to the tower of a fort. The seven enthronements employing a symmetrically stepped textblock are on ff. 94a, 120b, 158a, 195a, 248a, 285b, and 291a; another six enthronements do not use a stepped textblock of any kind. Seven illustrations have an asymmetrically stepped textblock: four are multistepped (ff. 109b, 136b, 137b, and 138a), with the step following the line of a hill; two have a single step that rises to accommodate a castle tower (f. 88a) or hill (f. 64a); and another has a single step that confusingly rises for a castle wall while sitting above a hill (f. 149b). According to O'Kane (2006, p. 175), nineteen paintings have been repainted and parts of another seven are obscured by rubbing or partial repainting; however, it can be assumed that the shape of the textblock would not have been altered. Somewhat surprisingly, none of the illustrations in the late fourteenth-century *Khamsa* of Amir Khusraw Dihlavi (Tashkent 3317) employ a stepped textblock.

80. Most effective of course are very deep steps, as in the paintings of "Zal and Rustam Advise Kay Khusraw" (six lines deep) and "The King of Mazandaran Changes Himself into a Rock" (eight lines deep); for the reproduction of the latter painting, see note 66 above.

81. The 731/1330 (H. 1479) version is reproduced in Rogers et al. 1986, fig. 32; the 741/1341 version of the scene has not been published.

82. In the First and Second Small *Shahnama*s, the standard associations between textblock shape and composition are also highly apparent. Single-stepped, asymmetrical textblocks are common, but the step is usually more than half the width of the textblock, so the change from textblock to step is much less dramatic than,

say, in the 741/1341 scene of "Gushtap Slays a Dragon." Moreover, divided couplets are frequent, the result of three-column-wide steps and also because a rectangular painting is sometimes set in the middle of a six-column-wide textblock.

83. However, the scene of "Zal Displaying His Skills before Manuchihr" (f. 35a) in this manuscript also suggests a more conscious planning of the folio layout. It employs a single-step, asymmetrical textblock in which the text of the step tells of Zal's first demonstration of his skill, by piercing the center of a tree with an arrow. The textblock rises up at the left to make room for the tree, while the enthroned ruler sits in the lower right-hand section of the illustration beneath the step. On folio 255a, an illustration of "Two Warriors in Mountains" is set in the topmost section of the textblock space, with a block of text five lines deep and two columns wide inserted in its upper right corner. This is the first known example of an inserted, isolated textblock, a device that becomes increasingly common with the appearance of the *Masnavi*s of Khwaju Kirmani, dated 798/1396 (BL Add. 18113). I am extremely grateful to Eleanor Sims for very generously providing me with both slides of the Stephens *Shahnama* and copies of her notes on the folio layouts used in the manuscript.

84. A total of 56 percent (9/16) of the illustrations in the two sections of this manuscript employ a stepped textblock.

85. BL Or. 2780, f. 14b, reproduced in Sims 1981, fig. 42.

86. However, that he is managing to pass through the flames unscathed has already been related in the last couplet of the second to last full line of text above the painting.

87. Paintings made for Iskandar Sultan in fact incorporate these traits in even greater abundance and more thoroughly, the result of the impact of Jalayirid painting. It is therefore not surprising that stepped textblocks, clearly a predominantly Shiraz trait, are not used in either of his two lengthy anthologies (Lisbon LA 161 and BL Add 27261).

88. Reproduced in Gray 1979, pl. XXXIX; and Enderlein 1991, pl. 17

89. Similar inserted blocks of text are used in earlier manuscripts, but this again is the most extensive use to date in any manuscript; see note 83 above.

90. For reproductions of the paintings of the *Zafarnama*, see Sims 1990–91, figs. 11–12, 26–28, and 36–37; and Sims 1992a, pp. 132–43.

91. These textblocks are not necessarily stepped, but they are irregular in the sense of not spanning the full width of the textblock space.

92. In reference to the paintings of this manuscript, Sims comments on their "notable originality of placement on the page." She also notes that twenty-six of the thirty-seven paintings are part of double-page compositions and suggests that this unusual and extensive use of double-page paintings within the body of a text is an innovation of Ibrahim's artists; see Sims 1990–91, p. 178.

93. StP-RNL Dorn 329, 733/1333; in addition to the text illustrations the manuscript includes one double-page figurative-frontispiece and one other painting not related to the text, placed at the end of the text and depicting Mahmud of Ghazna. According to Adamova and Gyuzal'yan, the manuscript, which now consists of 369 folios, is incomplete. They calculate that about 10 percent of the text is missing but do not specify which parts other than to note that the opening pages of the so-called old preface are lost; see Adamova and Gyuzal'yan 1985, p. 159. Even if the manuscript originally contained a few more text illustrations than the forty-nine that exist today, the overall rate of illustration would still be comparatively low for a fourteenth-century manuscript.

94. The Stephens *Shahnama* (Sackler LTS1998.1.1.1–94); the manuscript also includes one double-page figurative-frontispiece. Seven of the text illustrations (on six folios) are dispersed; see Sims forthcoming. Of the other Injuid *Shahnama*s, TS H. 1479 (731/1330) contains ninety-two text illustrations plus one double-page painting that serves as a frontispiece; Simpson has located 104 text illustrations belonging to the dispersed *Shahnama* of 741/1341, as well as a double-page figurative-frontispiece, a preface illustration depicting "Firdawsi and the Poets of Ghazna," and an enthronement scene that accompanies the colophon; however, she believes the manuscript may once have comprised as many as 140 illustrations; Simpson 2000, pp. 225–26. .

95. See note 75 above.

96. Sims 1992a, p. 49; Sims makes this statement with respect specifically to the *Shahnama* manuscripts produced for Ibrahim, Baysunghur, and their brother, Muhammad Juki (RAS no. 239).

97. Davis, however, refers to the second period as the "legendary"; see Davis 1992, p. xxi. "Heroic" is instead used here mainly to avoid any possible confusion between the first two periods. Although myth and legend of course differ, they are at times confused. (Generally speaking, myths of any specific culture or region may have their own internal chronology, but they are usually less time-based than are legends, and even though the latter do not relate actual historical events, they may be elaborations of them. Moreover, myths usually involve accounts of natural phenomena, social customs, and other such matters concerning the ori-

gin of the world and its inhabitants—as in the first section of the *Shahnama*—and therefore a sacred or religious element, at least in the broadest sense, may often be involved. Legends rarely have a scared or religious basis, although those involved are usually seen to be blessed with superhuman abilities of some sort—as is Rustam, the main hero of the second section of the *Shahnama*—or at least they are considered to be, in some respect, superior to the majority of people.

98. Davis 1992, pp. 35–36.

99. The fourteenth-century *Shahnama* manuscripts included were all made in Shiraz; however, the fifteenth- and sixteenth-century manuscripts are a somewhat random selection of manuscripts produced both in Shiraz and in other production centers. The three Small *Shahnamas* and the Great Mongol *Shahnama*, though included in the discussion of stepped formats, have been excluded from this portion of the study because it was felt that the degree of speculation required, regarding not only the number of lost paintings but also their precise content, would invalidate the conclusions. It should also be noted that, as with the calculations for the tables in the previous chapter, percentages have been rounded off, so the total of the three percentages listed for each manuscript does not always equal exactly 100 percent.

100. Davis 1992, pp. 78–79.

101. Davis 1992, pp. 15–16, partially in reference to Nodushan 2536, pp. 251–52; also see Shahbazi 1991, pp. 109–17. Illustration of the historical section tends to focus on the stories of Iskandar and Bahram Gur.

102. By comparison, Adamova and Gyuzal'yan have suggested that the illustrative emphasis on the heroic era in the 733/1333 *Shahnama* (StP-RNL Dorn 329) may be a reflection of "the attitude of the time and the milieu in which the manuscript was produced"; see Adamova and Gyuzal'yan 1985, p. 160.

103. Such a theory assumes that the decision as to which scenes were to be illustrated was made by the calligrapher; see, for example, Simpson 1979, pp. 251–52, who suggests that, in the case of the three so-called Small *Shahnamas*, the calligrapher and artist might have been one and the same individual.

104. For example, both TS H. 1479 (731/1330) and StP-RNL Dorn 329 (733/1333) have sections in which four to five consecutive pages are each illustrated with two paintings; see appendix 3.

105. This does not necessarily imply manuscript models.

106. With the exception of Sotheby's, 18 October 1995, lot 65 (878/1473), for which illustration folio numbers are not known.

107. Many other paintings could be interpreted as pertaining

indirectly to Rustam. One such example is the scene of Bizhan hunting wild boars, which could be understood as a buildup to Rustam's heroic deed of rescuing Bizhan from the pit. Also, the omission of couplets in the scene of "The King of Mazandaran Changes Himself into a Rock" (referred to earlier in this chapter, in the section "The *Shahnama* Manuscripts of Baysunghur and Ibrahim Sultan") can perhaps be understood as intended to highlight the role of Rustam over that of all other heroes in the battle with the army of the div-king.

108. According to the Norgren and Davis, "Preliminary Index of Shah-Nameh Illustrations" (1969), "Jamshid Teaches the Crafts" appears in only four other manuscripts, all of which date to the fifteenth century and one of which is Baysunghur's manuscript. "Faridun and the Sisters of Jamshid" is illustrated in three other manuscripts, only one of which dates to the fifteenth century, the other two being products of the sixteenth century. "The King of Mazandaran Changes Himself into a Rock" is illustrated in five other manuscripts, including the 731/1331 *Shahnama* (TS H. 1479) and a manuscript in the Metropolitan Museum of Art datable to about 1436 (no. 20.120.244); the others date to the sixteenth century. It must be remembered, however, that the index is only a preliminary listing of manuscripts.

109. This does not imply that the artists of the later manuscript necessarily had access to Ibrahim's manuscript itself; they may, instead, have been familiar with an intermediary model.

110. Maguire 1974, pp. 37–47.

111. Sims 1990–91, p. 175.

112. Sims 1973, pp. 235–353, but especially 347 and 353.

113. Sims 1992b, p. 55.

114. Sims 1992b, pp. 44–45. Sims sees this interpretation of the overall theme of the illustrations as substantiated by the inclusion in the manuscript of an illuminated double-page table on which are inscribed the names of the early kings of Iran, from Gayumars to Yazdigird, the kings whose exploits are detailed in the *Shahnama*. Similar genealogical tables, though not illuminated, are included in Ibrahim's manuscript also (see note 58 above).

115. Sims 1992b, p. 46.

116. Sims 1992b, p. 48.

117. Sims 1992b, p. 56. Sims makes this statement also in reference to the undated *Shahnama* manuscript of Ibrahim and Baysunghur's brother Muhammad Juki (RAS no. 239). Her analysis of Ibrahim's manuscript is apparently based on all forty-seven of its paintings treated as a single group, and thus differs from that presented here, which treats the text illustrations and double-page

paintings as two separate, yet related, entities. As discussed earlier, both the style and subject matter of the double-page paintings differ from those of most of the text illustrations. Moreover, the subject matter of each frontispiece is known from earlier manuscripts and therefore, as noted above, can be classified as traditional frontispiece iconography; thus the choice of scenes would have been more or less automatic (even though the battle scene appears to depict a specific event), as opposed to the more careful and conscious decision-making process involved in the selection of scenes to illustrate the text. Although Sims's interpretation would seem to rely heavily on the themes of the double-page frontispieces, the exclusion of these paintings (which, as discussed, were in fact likely a later addition to the manuscript) from the analysis presented here is to a certain extent a point of principle, for even when all paintings are included, the heavy emphasis on Rustam in Ibrahim's manuscript, in comparison with other manuscripts, remains. For Sims's views more generally on the topic of the intent or meaning of the programs of illustrations in Ibrahim Sultan's manuscripts, see Sims 2000, pp. 123–24.

4. CALLIGRAPHY

1. Portions of this chapter have previously been published in Wright 2003.

2. For the contributions of both Ibn Muqla and Ibn al-Bawwab, see Tabbaa 1991.

3. Qadi Ahmad 1959, pp. 57–60.

4. Qadi Ahmad 1959, p. 116. Sultan 'Ali's treatise constitutes a section of Qadi Ahmad's own treatise.

5. Both Qadi Ahmad and Sultan 'Ali Mashhadi state that a calligrapher by the name of Khwaja Mir 'Ali Tabrizi was the "inventor" of nasta'liq. This claim has led to some confusion, as there exists another scribe of the late fourteenth–early fifteenth centuries to whom this could refer, namely, Mir 'Ali ibn Ilyas, scribe of the British Library's copy of the Masnavis of Khwaju Kirmani (BL Add. 18113), dated 798/1396. However, Soucek has clarified this situation; as she notes, a manuscript published by M. Bayani contains a colophon stating "written by . . . Ja'far al-Katib in the style of the inventor of the archetype 'Ali ibn Hasan al-Sultani"; see Soucek 1979, p. 18; and Bayani 1967, p. 442.

6. Soucek 1979, p. 8; and also see Tabbaa 1991, p. 122; Abbott 1939, pp. 70–83; and Robertson 1920, pp. 57–83. No record of an actual canon of proportions for nasta'liq has survived.

7. For example, Qadi Ahmad states that the "inventor" of ta'liq was Khwaja Taj-i Salmani of Isfahan, although in this case he states

that Khwaja 'Abd al-Hayy then established a canon of proportions for the script; see Qadi Ahmad 1959, p. 84.

8. For an example of ta'liq, see a Jalayirid document (BN Supp. pers. 1630), reproduced in Soucek 1979, fig. 6.

9. For example, linking the letters dal and re generally contributes more to an overall sensation of a hanging script than does the linking of alif and lam.

10. Moritz 1913, pp. 390–91. In evidence of this last point, he refers to an inscription at Persepolis that states that when the Buyid ruler 'Adud al-Dawla visited the site in 344/955–56 the ancient Pahlavi inscriptions were read to him by two men. He also notes that in the ninth century, in his Fihrist, Ibn al-Nadim described the ancient Pahlavi script, the name of which was written as qiramuz, although he suggests it was possibly pronounced piramuz. Also see Alparslan 1978, pp. 1123–24.

11. Richard 1989, pp. 89–93, and p. 89 in particular for the Jalayirid document, for an illustration of which see note 8 above. For the early history of ta'liq, also see Moritz 1913, pp. 390–91; Qadi Ahmad 1959, pp. 84–85; Alparslan 1978, p. 1124; and Soucek 1979, p. 18.

12. Qadi Ahmad 1959, p. 116.

13. For Sultan 'Ali Mashhadi's description of nasta'liq, see Qadi Ahmad 1959, pp. 119–21.

14. All samples of naskh script are derived from CBL Per 111.5a, one of the few surviving (original) full folios of text from the Great Mongol Shahnama, probably produced in Tabriz in about 1335. The samples of nasta'liq are all from page 52 of Freer F1931.29, the copy of Nizami's Khusraw va shirin that was written by 'Ali ibn Hasan al-Tabrizi in about 1405–10.

15. Khan 1992, p. 40, but more generally pp. 27–46 for his analysis of the script of the Arabic papyri and for specific examples of cursive tendencies in the script. Also, he notes (on pp. 45–46) that, although many scholars have described the script used in the Arabic papyri as naskh, the first mention (and description) in the literary sources of naskh occurs in the Subh al-a'sha fi sina'at al-insha of al-Qalqashandi (d. 821/1418).

16. Khan 1992, p. 40.

17. Blochet (1928) recognized that some Persian manuscripts in the collection of the Bibliothèque Nationale employ naskh scripts that display cursive or specifically nasta'liq tendencies; the script of others, such as BN Supp. pers. 1817 (Blochet 1928, cat. no. 1247), he described as being intermediate between naskh and ta'liq. His comments were taken into consideration in the script analysis, but several of the manuscripts that he described in these terms and which would seem to be relevant to this study have in fact not

been included, usually because Blochet's analysis of the script has not been accepted or because his dating of the manuscript can be shown to be incorrect.

18. If the place of production is not stated in a manuscript, the attribution has usually been made on the basis of illustration or illumination style. (All but one manuscript is undecorated.) The group of Shiraz manuscripts includes the *Mu'nis al-ahrar* manuscript (Kuwait LNS 9 MS, 741/1341), although made in Isfahan, and BN Pers. 276, a manuscript illuminated in the blue-and-gold floral style but copied in Kirman; as Kirman, like Isfahan, was at various times under the control of members of the Injuid and Muzaffarid families, it can be considered as part of the cultural sphere of Shiraz. Two of the five manuscripts of uncertain provenance are the thirteenth-century copies of the *Shahnama*: one is illuminated in a style that cannot be associated with any specific center (Florence Cl.III.24), and the other is undecorated (BL Add. 21103). The other three manuscripts of uncertain origin are the so-called Small *Shahnama*s, the date and provenance of which are a matter of continuing dispute among scholars, although, as noted previously, they are generally attributed to Baghdad in about 1300.

19. For the provenance of five of these manuscripts, see note 18 above. The sixth manuscript is a collection of *divan*s (BL-IOL Ethé 903, etc.) that can be attributed to the Il-Khanid domains of western Iran on the basis of its illustration style, which relates to that of the early fourteenth-century copies of the *Jami' al-tavarikh* of Rashid al-Din.

20. This is equally apparent in other manuscripts that include both prose and poetry texts, such the Injuid *Shahnama* of 731/1330 (TS H. 1479).

21. Soudavar 1992, p. 24, and he notes that this "loosened *naskh*" foreshadows the appearance of *nasta'liq*. However, the term applies less well to the script of the collection of *divan*s, dated 713–14/1314–15 (BL-IOL Ethé 903, etc.; no. 3 in table 12a), which has also been given a score of 2/9.

22. Soudavar has suggested that the Great Mongol *Shahnama* is in fact the *Abu Sa'idnama* that Dust Muhammad, in his preface to the Bahram Mirza album (TS H. 2154), notes as having been copied by the renowned calligrapher 'Abd Allah Sayrafi. He notes that the fact that a calligrapher of such great repute had been commissioned to copy a secular manuscript "constituted a major shift in manuscript production at the Persian courts." He adds that the script usually used for Persian (i.e., non-Qur'anic manuscripts) was "the regular quick-hand *naskh*, legible but hardly elaborate"; see Soudavar 1996, pp. 159–60.

23. IUL FY 496/1–2, dated 759/1358, probably also belongs in this group, but the manuscript has not been examined at firsthand and the only published sample of script is not clear enough to allow the script to be judged accurately.

24. It should be noted, however, that nos. 26 and 29 in table 12c (BN Supp. pers. 1817 and BOD Ouseley 274–75) are copied by the same calligrapher, Ahmad ibn al-Husayn ibn Sana. A fourth copy of the *Khamsa* of Nizami also belongs to this group of Shiraz manuscripts but is rated just 4/9 (Berlin-SB Minutoli 35; no. 27 in table 12c).

25. See note 24 above.

26. And often resulted in multiple scores being assigned for one trait, as noted previously.

27. For the history of the further development of *nasta'liq* in the fifteenth century, see Soucek 1979, pp. 24–32.

28. The possible impact of other types of script on the development of *nasta'liq* was explored, but no such impact was discerned. In particular, unusual ligatures, a defining feature of *ta'liq*, do appear in the script of a very few Muzaffarid manuscripts, most notably BN Supp. pers. 580, dated 767/1366, but they are not a standard feature of these manuscripts and are used sparingly when they are used, especially in comparison with their use in *ta'liq*. Their presence therefore in no way alters the thesis presented here.

29. Most of the manuscripts included in the script analysis contain the name of the calligrapher. Each manuscript is copied by a different calligrapher, with the exception of BN Supp. pers. 1817 and BOD Ouseley 274–75 (see note 24 above) and two Injuid manuscripts, TS H. 1479 and BL Add. 7622, both copied by al-Husayn ibn 'Ali ibn al-Husayn al-Bahmani. For the names of the other calligraphers, see app. 5.

30. For example, BN Supp. pers. 580 and BOD Ouseley 274–75 were both copied in the 1360s and are illuminated in such similar styles that they could well have been produced in the same atelier. Both exhibit strong *nasta'liq* tendencies: BN Supp. pers. 580 was given a final score of 6/9 and BOD Ouseley 274–75 a final score of 7/9, yet their individual scores for each of the twelve distinguishing traits were often very different.

31. For example, the scribe of BOD Marsh 491 could vary the form of the *re*, *ze*, *zhe*, and *vav* so much (often even on a single page) that it was necessary to rate this trait (point 4 on the script analysis tables) as both 1 and 4.

32. Although BN Supp. pers. 1817 and BOD Ouseley 274–75 were copied by the same scribe and both manuscripts were given

a final score of 7/9, the individual scores for each of the twelve distinguishing traits were often surprisingly different.

33. Khan 1992, pp. 39–40, in his study of the script used in Arabic papyri. He notes that "script competence" (and "script performance," referred to in the following paragraph) is a term borrowed from linguistic theory, as in Chomsky 1965, pp. 3–4.

34. In the undated but late Injuid Stephens *Shahnama*, there are none of the *nasta'liq* tendencies evident in the three other Injuid *Shahnama*s. As previously discussed, the illuminations of this manuscript exhibit Il-Khanid influence. Therefore, a script lacking in the *nasta'liq* tendencies characteristic of other roughly contemporary copies of the same text, produced in the same city, is not too surprising, for its calligrapher may well have migrated to Shiraz from the capital and therefore may have been trained in a tradition somewhat different from that of earlier Injuid calligraphers.

35. Other adjustments such as reducing the overall size of the script while maintaining its correct proportions and the ideal form of the letters.

36. Soudavar 1992, p. 37, who makes this statement while commenting on the "loosened *naskh*" script of the Small *Shahnama* manuscripts.

37. It has been suggested that in the copying of early *Shahnama* manuscripts, the calligrapher may have followed an oral recitation of the poem; alternatively, the calligrapher (assuming he was literate) would presumably have read the text quietly to himself as he wrote. Whatever the case, it would probably be difficult to copy only words without being aware of the actual content and tone of the text.

38. Francis Richard offers a rather different view of the development of *nasta'liq*, one that is more in line with traditional opinion. He sees it as first appearing in Tabriz and Baghdad in about 1375 and as having originated from within the chancery through a combining of *naskh* and the chancery script *ta'liq*. The script of the group of manuscripts produced in Shiraz in the 1360s (on which rests the thesis of the development of *nasta'liq* presented here), and also the script of later fourteenth-century and some early fifteenth-century Shiraz manuscripts, he considers a distinct type of script, derived from *naskh* and peculiar to Shiraz. That the script of some of these Muzaffarid manuscripts employs distinctive features found only in manuscripts produced in Shiraz is not in dispute. What is in dispute is how these features are to be interpreted, for while I see them, generally, as increasingly cursive tendencies that lead to the development of the new script, *nasta'liq*,

he clearly sees them as having no bearing on the eventual appearance of *nasta'liq*. See Richard 1997b, pp. 61–62; and also note 54 below.

39. Thackston 1989, p. 341, translated from TS H. 2154, f. 12b.

40. Others who credit Mir 'Ali Tabrizi as the inventor of *nasta'liq* include: (1) Mir 'Ali Haravi in his *Midad al-khutut* (The Model of Scripts) of 1519–20, see Roxburgh 2001, p. 131; (2) Majnun Rafiqi in his treatise *Adab al-mashq* (The Good Manners of Practice), of c. 1533–34, see Roxburgh 2001, pp. 131–32; (3) Mirza Muhammad Haydar Dughlat in his *Tarikh-i rashidi* of about 1541, see Thackston 1989, p. 359; (4) Malik Daylami in his preface to the Amir Husayn Beg album (TS H. 2151), complied in 958/1560–61, see Thackston 1989, pp. 351–52; (5) Mahmud ibn Muhammad in his treatise *Qavanin al-khutut* (Canons of Scripts), of c. 1561–62, see Roxburgh 2001, pp. 132–33; (6) Mir Sayyid Ahmad in his preface to the Amir Ghayb Beg album (TS H. 2161) of 972/1564–65, see Thackston 1989, p. 353; (7) Shams al-Din Muhammad al-Vasifi in the preface to Shah Isma'il II's album (TS H. 2138), begun in 976/1568–69 and completed 984/1576–77, see Roxburgh 2001, pp. 99–100 and 136; (8) Muhammad Muhsin in the preface to the album TS H. 2157, preface dated 990/1582–83, see Roxburgh 2001, pp. 136 and 224; and (9) Qadi Ahmad in his *Gulistan-i hunar* (which includes Sultan 'Ali Mashhadi's treatise) of c. 1015/1606, see Qadi Ahmad 1959, p. 100.

41. This may refer to the point made previously, namely, that the *kaf* in which the "upright" is parallel to the base stroke is commonly used in *naskh* but not in *nasta'liq*.

42. Probably a reference to the fact that in *naskh* the bottom curve of these letters is flattened in an attempt to adhere as closely as possible to the baseline; in *nasta'liq* the bottom curve of these letters is much more rounded.

43. "Stretched forms" likely refers to the increased use of elongated letter forms, one of the *nasta'liq* tendencies noted as part of the script analysis. Elongated letter forms are commonly used in *kufic* script.

44. Soudavar 1992, p. 37 and p. 53 n. 50, quoted and translated from Faza'eli 2536, p. 265. Soudavar notes that the original document (no. 1632) is in the Sena Library, Tehran, and that Faza'eli based his dating of the document on the immature style of its *nasta'liq* script. As for the attribution of the document to Ja'far, it has not been possible to view either the original Persian document or Faza'eli's complete book. However, I would like to express my gratitude to Abolala Soudavar for kindly providing me with a photocopy of the page from Faza'eli's book on which the document is

quoted. It begins merely with the statement, "In a treatise on his own script, Kamal al-Din Ja'far al-Baysunghuri says . . ."

45. Of the thirty-seven Mamluk Qur'ans, dated between 1304 and 1374, that James discusses or illustrates in his study of Qur'anic illumination and calligraphy, only five are signed by the illuminator; see James 1988. A rare signature of an illuminator from later in the century is that of Lutf Allah al-Tabrizi, who signs himself as both calligrapher and illuminator of the *Khamsa* of Nizami section of TS H. 1510, copied in Shiraz in 776/1374; see Soucek and Çağman 1995, p. 182.

46. Earlier signatures are that of: (1) 'Abd al-Mumin ibn Muhammad al-Khuyyi in TS H. 841, *Varqa va gulshah*, n.d, but probably thirteenth century, see Ettinghausen and Grabar 1987, p. 360, fig. 381; and Rogers et al. 1986, p. 50; (2) Yahya al-Wasiti in BN Arabe 5847, *Maqamat* of al-Hariri, 634/1237, see Ettinghausen 1977, p. 104; and (3) Ghazi ibn 'Abd al-Rahman of Damascus in BL Or. 9718, *Maqamat* of al-Hariri, n.d., but c. 1300, see Ettinghausen 1977, p. 147.

47. The very few examples of signatures from the first half of the fifteenth century include: (1) BOD Ouseley Add. 176, for Ibrahim Sultan, n.d., but late 1420s or early 1430s, with illumination signed by Nasr al-Sultani (f. 17a), who also signed ff. 1b–2a of TIEM 1979, also made for Ibrahim Sultan; the former is reproduced in Abdullaeva and Melville 2008, fig. 29; for the latter, see Richard 2001, pp. 93–100; (2) TS H. 781, 849/1445–46, with the name of Khwaja 'Ali al-Tabrizi, who signs himself as both the illustrator and illuminator, see Stchoukine 1968, p. 45; and (3) TS H. 786, dated 850/1446–47, signed by Sultan 'Ali al-Bavarchi, also as both illustrator and illuminator, see Stchoukine 1967, p. 402.

48. For Ruzbihan, see James 1992a, pp. 144–49. There are also two manuscripts in the Bodleian Library signed by the illuminator Darvish 'Ali: (1) BOD Pers. d. 97, a selection of the poems of Amir Khusraw Dihlavi, dated 879/1475; and (2) BOD Elliott 325, a *Shahnama*, dated 899/1494.

49. However, with the exception of the illuminators of Shiraz in the early sixteenth century, it is mainly figural painters who sign their work. For early sixteenth-century illuminators, see Robinson 1979.

50. Earlier albums—collections of calligraphies signed or attributed to past and even present masters—did exist, but there appears to have been a definite flourishing of interest in collecting such works at this time. For example, album H. 2310 in the Topkapi Saray Library is a collection of the work of the famed calligrapher Yaqut and six of his students, compiled in the early fifteenth century for Baysunghur. Dated works in the album span the years 690/1291 to 737/1337. Album B. 411, in the same collection, was compiled for an unknown patron and can be dated to about 1425 to 1447. It includes work by the same calligraphers as H. 2310 and also works more or less contemporary with its assumed period of compilation. See Roxburgh 1996, a study of these two albums and also albums TS H. 2152 and TS H. 2154, in particular pp. 2–4 and p. 24 n. 8 for references to collecting in earlier periods.

51. Sultan 'Ali's treatise deals specifically with the practice of calligraphy, and although he does name a few calligraphers, it is not the same genre of writing as Dust Muhammad's treatise or Mir Sayyid Ahmad's preface to the Amir Ghayb Beg album referred to in note 40 above.

52. For the history of *tazkira* writing and an examination of the *tazkira*s written in the late fifteenth and sixteenth centuries, see Subtelny 1979, especially pp. 16–38; and also Roxburgh 2001, pp. 122–30.

53. Considering Sultan 'Ali's statements, such as, "he who knows the soul, knows that purity of writing proceeds from purity of heart" and "writing is the distinction of the pure," it may have been that, in his eyes, the importance of the act of "bringing the script to perfection" so outweighed all other aspects of the script's development that nothing else warranted mention; for these quotations, see Qadi Ahmad 1959, p. 122. The fact that Sultan 'Ali worked in Herat for Husayn Bayqara for many years (approximately from 1470 to 1507) and that, as a calligrapher, he himself followed the tradition of Herat, tracing his calligraphic lineage back to 'Ali ibn Hasan al-Tabrizi, may also have encouraged him to overlook the contribution of the Shiraz scribes. For Sultan 'Ali's life and calligraphy, see Soucek 1979, pp. 30–31; and see Roxburgh 2001, pp. 230–40, for diagrams detailing master-student relationships as recorded by sixteenth-century authors.

54. At a late stage of preparing the present work for publication, I became aware of another, apparently little-known treatise on calligraphy, *Tuhfat al-muhibbin*, the text of which was published in 1997, by Iraj Afshar and Karamat Ra'na Hoseyni (in *Miras-e maktub*, no. 17). Unfortunately, it has not been possible to obtain a copy of this publication or to examine the only surviving copy of the treatise (BN Supp. pers. 386), which was produced in India in the late fifteenth or early sixteenth century. Richard, who has discussed the treatise in two recent studies, has identified the author of the treatise, Abu al-Da'i Ya'qub ibn Hasan ibn Shaykh, called Seraj al-Husayni al-Shirazi, as the calligrapher responsible for two almost contemporary copies of the *Zafarnama*: the well-known

dispersed copy, dated 839/1436, generally assumed to have been begun by command of Ibrahim Sultan; and one dated 840/1436 (Majlis 36782). Apparently, after completing the pilgrimage to Mecca, the author traveled to India, settled in Bidar, and wrote his treatise there, in 858/1454. According to Richard, the treatise states that nasta'liq is to be written following the rules of naskh and the principles of ta'liq, and it also distinguishes between Tabrizi and Shirazi versions of nasta'liq, stating that the former is the work of Mir 'Ali Tabrizi, though it was brought to perfection by Ja'far Baysunghuri. These statements in no way invalidate the thesis presented here, for, first, the "principles" of ta'liq may be said to be observed through the inherent hanging quality of nasta'liq, and, second, the existence of two distinct variations of the developed script does not deny the possibility of a single origin in Shiraz, and, in fact, the treatise associates Mir 'Ali specifically and only with the Tabrizi version. (Although the matter of variations or distinct styles of nasta'liq has not otherwise been dealt with here, a peculiarly Shirazi version of the script indeed can be identified in many Shiraz manuscripts of the late fourteenth and early fifteenth centuries. Richard refers to this script as "Muzaffarid" and considers it, not a version of nasta'liq, but a completely separate script that appears in the last two decades of the fourteenth century; see note 38 above.) It is not known if Ya'qub Seraj remained in India, and if so, if his treatise would have been known to Sultan 'Ali and others writing in Iran in the sixteenth century. Even if it were, it remains that it is a single named and known individual whom Sultan 'Ali and others associate with the development of nasta'liq, ignoring mention of any contribution by a collective group of Shirazi scribes. See Richard 2003; and Richard 2001, pp. 92–93. I would like to express my sincere gratitude to Francis Richard for providing me with a copy of his article (2001) and with a preconference copy of his lecture on the appearance of nasta'liq, presented at the Third International Conference on the Codicology and Paleography of Middle-Eastern Manuscripts in Bologna, in October 2000.

55. Ja'far's account actually does not even award 'Ali ibn Hasan credit for devising a canon of proportion for the script, because he states that the "Tabrizi scribes" defined its canons and that then, finally, Mir 'Ali brought this script to "perfection."

5. BOOKBINDING

1. Repairs such as these have most often been carried out in the West in the nineteenth century or later.

2. The number of bifolios per gathering is not always consistent throughout a manuscript; for example, there often are a few gatherings to which a single folio has been added or "tipped in."

3. The early Injuid examples are: (1) BN Supp. pers. 95, 717/1317; (2) BL Or. 3623, 729/1329; (3) TS H. 1479, 731/1330; (4) BL Or. 2676, 732/1332; and (5) BOD Ouseley 379-81, n.d., but c. 1340.

4. The late Injuid example is TS H. 231, 744/1344; two other late Injuid manuscripts have gatherings of two bifolios each (Khalili QUR181–82 and QUR242), while another has gatherings of four bifolios (Khalili QUR159).

5. The two early Muzaffarid examples are: (1) BN Supp. pers. 1817, 763/1362; and (2) BOD Pers. d. 31, 766/1365. BOD Marsh 491, 769/1367, has gatherings of just four bifolios.

6. The late Muzaffarid/early Timurid examples are: (1) TS H. 1511, 772/1371; (2) TIEM 1950, 801/1398; and (3) BL Or. 2833, 807/1405.

7. One of the rare occurrences of the use of gatherings of five bifolios in a non-Shiraz manuscript is TS B. 282, copied in Herat, in 818–19/1415–16, for Shah Rukh, but some of the illuminations in this manuscript are in the blue-and-gold floral style of Shiraz, suggesting that some of the artists, and perhaps other craftsmen, working on the manuscript may have been among those taken from Shiraz by Shah Rukh after the downfall of Iskandar Sultan. Raby and Tanındı (1993, p. 215) note that gatherings of three bifolios are employed in two of the fifty-nine manuscripts dedicated to the Ottoman sultan Mehmed II that they examined; as both manuscripts are signed by the Iranian scribe Muhammad al-Munshi al-Sultani, they conclude that although émigré craftsmen "might adapt their decorative styles to the latest fashions, they often betrayed themselves in the less regarded areas, such as the routine procedures of manufacture." Indeed, the influence of Shiraz craftsmen surely explains the fact that just over 70 percent or forty-two of those fifty-nine manuscripts employ gatherings of five bifolios, while only eleven manuscripts have gatherings of four bifolios.

8. In resewing a manuscript, the single central stitch was often replaced by two central stitches, presumably with the hope of holding the folios more securely in place. Whenever this has occurred, the original stitching holes are always clearly visible beneath the new thread.

9. See Jacobs and Rodgers 1990, p. 117, who note that green thread was used in texts recounting the life of the Prophet and red thread was used in works on Islamic law. However, no such correlation between text type and thread color exits for the corpus of manuscripts examined for this study (or, indeed, for any other manuscripts the author has ever examined). (In addition to the

white or cream silk thread, a faded and now rose-colored thread was also commonly used.)

10. In discussing the types of paste used in bookbinding, al-Ishbili states that it is best to use wheat flour or starch cooked in absinthe (wormwood), the roots of colocynth, or aloe, as each of the latter is a strong purgative and thus the paste would serve as a protection against worms. However, he notes that an added defense against worms was to fumigate the book with the feathers of a hoopoe or to add the inscription *ya kaykataj*. Al-Ishbili, whose skills, it is said, "were greatly appreciated at the Almohad court," wrote his treatise in the late sixth/late twelfth century; see Gacek 1990–91, pp. 106–07 and p. 11 n. 18, where Gacek refers the reader to further studies on the use of the phrase *ya kaykataj* and notes that it is a corruption of *kabikaj*. One of the meanings of *kabikaj* given by Steingass is "king of the cockroaches," noting that "in India [this word is] frequently inscribed on the first page of a book, under the superstitious belief that, out of respect for the name of their king, the cockroaches will spare it"; see Steingass 1992, p. 1013.

11. This small piece of leather is thought to have been added to prevent the thread from cutting through the paper of the gatherings. It was, however, often omitted, and a common feature of many manuscripts today is paper patches at either end of the center fold of each gathering where the thread used for these short stitches has cut through the paper.

12. For further details on sewing technique, see Bosch, Carswell, and Petherbridge 1981, pp. 46–48 and 53–55; and Jacobs and Rodgers 1990, pp. 117–19. The latter is a discussion of the conservation of Islamic manuscripts that provides useful diagrams and actual photographs of various aspects of bookbinding.

13. Bosch, Carswell, and Petherbridge 1981, pp. 53–55.

14. For a discussion of possible patterns and stitching methods, see Jacobs and Rodgers 1990, pp. 119–22 and figs. 8–12; and Bosch, Carswell, and Petherbridge 1981, pp. 53–55 and figs. 9–10. Al-Ishbili also describes various endband patterns; see Gacek 1990-91, p. 109. For a general discussion of endbands in both Western and Islamic manuscripts, see Gast 1983, who notes (p. 56) that Islamic endbands served no real pragmatic function but rather were primarily decorative.

15. For a more detailed discussion of the basic weaknesses of Persian bookbindings, see Rose 2007, especially pp. 80–82. I would like to thank Kristine Rose, formerly of the conservation department of the Chester Beatty Library, for providing me with a copy of her article and for kindly discussing with me this and various others issues concerning Islamic bindings, including correct end-band terminology. The "problems" inherent to Islamic bindings is a matter still under research, as is the subject of regional differences in binding practices.

16. The manuscript now has a modern binding, and the whereabouts of the original binding, that reproduced here as figure 124, are not known. I am grateful to Sue Kaoukji of the Dar al-Athar al-Islamiyya, Kuwait, for her assistance in trying to locate the missing binding.

17. Use of a pointed-oval medallion or mandorla (*lawzah*) as the main decorative motif on bindings of "small format" manuscripts is recommended by al-Ishbili; however, he gives no clear indication of the precise form of the motif or of the actual size of manuscript intended by his use of the term "small format"; see Gacek 1990–91, p. 110. The *Haft paykar* binding has a doublure of paper; but no information exists for the doublure of the *Mu'nis al-ahrar* binding.

18. See Raby and Tanındı 1993, pp. 26–28, and also figs. 20–21, for reproductions of fifteenth-century Ottoman examples; for fourteenth- and fifteenth-century Mamluk examples, see Bosch, Carswell, and Petherbridge 1981, cat. nos. 75–76. As noted by Raby and Tanındı (p. 26), one of the earliest examples of this type of decoration is the cover of the late thirteenth-century *Manafi'i hayavan* manuscript, produced in Maragha and now in the Pierpont Morgan Library in New York (no. M500). The binding is reproduced in Ettinghausen 1954, fig. 344; Brend 1989, p. 234, fig. 4; and Schmitz 1997, fig. 1. The date of the manuscript is not clear but is 694/1294–95, 697/1297–98, or 699/1299–1300. Schmitz (p. 10) has suggested that the binding is not original to the manuscript but that it is instead either an eighteenth-century copy of the manuscript's original thirteenth-century binding or a thirteenth-century binding that was cut down in the eighteenth century to fit the manuscript and serve as a replacement for its lost or badly damaged original binding. A slightly earlier manuscript (*Zij-i ilkhani* of Nasir al-Din Tusi, also produced in Maragha, in 687/1288–89) with the same type of binding is described but not reproduced by Gray 1985, p. 142, who notes it was sold at Sotheby's, 25 February 1968, lot 232.

19. Raby and Tanındı 1993, pp. 26–27, who have also identified a second type of generic binding, one that consists of a central knotwork rhomb with pendants that likewise take the form of (smaller) knotwork rhombs. An early Injuid manuscript dated 717/1317 (BN Supp. pers. 95) has covers of this type.

20. The doublures of Khalili QUR159 are plain leather; those of Khalili QUR181 and QUR182 are plain paper.

21. Although by the first years of the fifteenth century this type

of binding decoration would have been considered archaic if used on a fine Persian manuscript, it was still commonly used on Mamluk manuscripts of the fifteenth century. See Ettinghausen 1954, pp. 461–74, for a discussion of several other fourteenth-century bindings of this type.

22. Bindings with larger and more compositionally integrated cornerpieces, usually sections of the central, circular medallion, are most often considered to be of fourteenth- or fifteenth-century Mamluk (not Persian) origin, but much work remains to be done on bindings of almost all reigns and periods. See Bosch, Carswell, and Petherbridge 1981, cat. nos. 55–56, 65, and 70–71; and James 1980, cat. nos. 33 and 104.

23. For reproductions of the wall painting, see chapter 1, note 140; and see Raby and Tanındı 1993, pp. 37–45, for further references to the cloud-collar motif in fifteenth-century Persian art and to its use on Ottoman bindings.

24. Reproduced in Gray 1979, pl. XXXIV.

25. Sakisian has published a binding with a central pointed-oval medallion and cloud-collar cornerpieces that he assumes to be contemporary with the date of its manuscript, which is 1334 (TIEM, formerly Evkaf 2485). However, the proportions of the binding composition, with the central medallion occupying a large percentage of the overall space of the composition, suggests a fifteenth-century date for the binding, as does the wide band of tooling that surrounds the composition. (The central medallion and cornerpieces are filled not with florals but with what appears to be an all-over geometric, punched motif.) A second binding published by Sakisian (TIEM 1999) has different front and back covers, each also consisting of a central pointed-oval medallion and cloud-collar cornerpieces, and protecting a manuscript dated 781/1379 that was made for Hushang Shah of Shirvan (r. 1372–82). The binding, with its wide borders, is also surely a product of the fifteenth century. See Sakisian 1934a, pp. 83–84 and figs. 3–5; and for the latter manuscript, also Ölçer et al. 2002, pp. 198–2001. Ettinghausen also refers to these same bindings, noting that he in fact did not examine the bindings himself and, although he accepts Sakisian's dates "for the time being," he does so "with some hesitation"; see Ettinghausen 1954, pp. 467–68, figs. 355 and 357. Mention must also be made of the cover of the binding of the Chester Beatty Library's portion of the Collection of Epics, dated 800/1397 (CBL Per 114), which surely is not original to the manuscript. It employs a center-and-corner composition, of which the central medallion is a full cloud-collar motif and the cornerpieces are sections of a cloud collar. However, the floral motifs that fill the central medallion and the cornerpieces are

"shaded" with small, teardrop-shaped impressions in a manner typical of both Turcoman bookbinding and illumination of the second half of the fifteenth century; the binding is reproduced by Brend (1989, p. 235, fig. 5), who accepts it as original to the manuscript.

26. Also, the illuminated frontispiece of an Il-Khanid Qur'an, dated 739/1338–39 (TIEM 430), is dominated by a large pointed-oval medallion; see chapter 1, note 20. A very similar frontispiece introduces a copy of *Tuhfat al-khaqan*, dated 751/1350–51 and bearing a dedication to Jani Beg of the Golden Horde (TS R. 325).

27. As Rawson (1984, pp. 173–82) has shown, this oak-leaf-type form is in fact a derivation of the lotus leaf. In Khalili QUR242 it is, for example, used in the upper and lower panels of the frontispiece on ff. 1b–2a, in the heading and in the marginal that extends from it on f. 38b, and in the marginal on f. 61b; f. 38b is reproduced in James 1992b, cat. no. 31.

28. Ff. 1b–2a of the *Divan* of Sultan Ahmad (TIEM 2046); the same type of rosette, but placed on a plain-colored ground, is also used on ff. 118a–19a of this manuscript.

29. The closest parallel in Khalili QUR182 is set among the green blossoms and leaves that encircle the text on ff. 26b–27a.

30. For tooling implements in general, see Diehl 1946, pp. 321–24; and for al-Ishbili's list of tools used by Arab bookbinders in the late sixth/late twelfth century, see Gacek 1990–91, pp. 107–09.

31. Raby and Tanındı have identified a group of fifteenth-century Ottoman bindings, the decoration of which they have termed the "Fatih-style" (because many are on manuscripts made for Mehmed II). Certain of these bindings might initially seem to call into question the proposed fourteenth-century date of the binding of the 1371 *Shahnama* (TS H. 1511). However, close comparison reveals an overwhelming number of differences that far outweigh the broad similarities between the latter binding and those of the Fatih-style. In fact, the later bindings surely are based ultimately on the earlier Persian binding and other now-lost examples of the type. Some of the many differences are: the pointed-oval medallions of Fatih-style bindings are slimmer and more elongated, yet much larger in relation to the cloud-collar cornerpieces, than on the 1371 *Shahnama* binding; the blossoms, springing from an arabesque vine, that fill the central medallions are typically arranged in an asymmetrical composition on the Fatih-style bindings, while on the *Shahnama* binding, though not strictly symmetrical, the arrangement of blossoms is nearly so; the arrangement of blossoms on the 1371 binding is much less dense than on most Fatih-style bindings, allowing the more boldly stippled ground to play a greater role in the overall composition and resulting in a quite different aesthetic; the blos-

soms (and cloud scrolls) on Fatih-style bindings are highly elaborate versions of those on the *Shahnama* binding, and the flattened rosette, also used in the illuminations of Sultan Ahmad's *Divan* of 1407, is not used in the later group of bindings; on the Fatih-style bindings, the blossoms are "shaded" by the use of dense parallel strokes, while there is no attempt at shading on the *Shahnama* binding; the pendants emerging from the central medallions are, on the *Shahnama* binding, larger in relation to the size of the central medallions, more restrained, and more pendulous than those of the Fatih-style bindings, which tend to emerge directly from the tips of the oval medallions and which also tend to have extended lateral "arms"; the knotted-heart contour of the central medallion and cornerpieces—a defining trait of Fatih-style bindings—is not found on the *Shahnama* binding; nor does the *Shahnama* binding have filigree doublures, another characteristic feature of Fatih-style bindings. The two main examples of Fatih-style bindings used for this comparison are TS A.III 3213 (manuscript dated 872/1467) and TS A.III 2208 (undated but, like the former manuscript, made for the Ottoman sultan Mehmed II). See also Bayezit Feyzullah 1983 and TS A.III 2177, reproduced in Raby and Tanındı 1993, pp. 142–43 and 149, respectively, and pp. 47–79 for a discussion of Fatih-style bindings.

32. Reproduced in Brend 1989, p. 236, fig. 8.

33. For reproductions of several panel stamps of the eighteenth to nineteenth centuries in the Chester Beatty Library, see Bosch, Carswell, and Petherbridge 1981, figs. 11 and 13, and also pp. 68–71, for the techniques of tooling and pressure-molding.

34. Throughout the centuries, the bindings of unillustrated and unilluminated texts that served a primarily pragmatic rather than prestigious function continued to be decorated using the "older" techniques of tooling and single-motif stamps; see the comments made above on the first two groups of fourteenth-century Shiraz bindings.

35. Brend 1989, p. 237, who in fact suggests the manuscripts might also have been bound in Shiraz or Isfahan, where Iskandar Sultan eventually resided. Iskandar had been in control of Yazd, though at the time the Anthology was copied, the city was being governed by one of his amirs; see chapter 1, note 162.

36. Bindings decorated with filigree work were in fact known from a much earlier era: a fragment of a probably Manichaean manuscript of the eighth or ninth century was found in Turfan, the cover of which is described as "reddish brown goatskin, with a design cut out with a knife from thin, peeled leather and behind this another piece of peeled leather, gilded"; see Gratzl 1939, pp. 1975–76

and pl. 951B. Also, Raby and Tanındı (1993, p. 13) have pointed out that the credit usually accorded the Baghdadi bookbinder Qivam al-Din for "inventing" filigree work has been wrongly bestowed because of a probable misinterpretation of the term *munabbatkari*. They suggest that the term, which Dust Muhammad uses in his sixteenth-century account, would seem rather to refer to the invention of panel stamps to create designs by means of the technique of pressure-molding.

37. The filigree pattern of the doublure of the envelope flap is in the form of a half cloud-collar motif, and two small medallions decorate the inside flap spine; reproduced in Aslanapa 1979, fig. 32. The *Divan* binding has no flap.

38. As mentioned previously, the binding of the Chester Beatty Library portion of the Collection of Epics of 800/1397 (CBL Per 114) is not original to the manuscript, so its filigree doublures cannot be considered a fourteenth-century example of this technique.

39. See Aga-Oğlu 1935, page facing pl. xv, for the Yazd provenance of TIEM 2009. On the doublures of TIEM 2046 and on the front doublure of TIEM 2009, the cornerpieces are gently indented sections of a cloud-collar motif, but on the back doublure of TIEM 2009 they are triangular. The two sets of doublures also use different compositions for their fore-edge flaps, and TIEM 2009 does not use black as a ground for the filigree, as does TIEM 2046. See Brend 1989, p. 236 and fig. 7, for a reproduction of the doublures of TIEM 2009; the doublures are also reproduced in Sakisian 1934a, fig. 8, where they are incorrectly identified as "Baghdad 1407."

40. Two details of comparison with other manuscripts should be mentioned: (1) the hexagonal cartouches that form the borders of the covers of both manuscripts are also used in an illuminated frontispiece in the British Library's portion of the Collection of Epics of 800/1397 (Or. 2780), but they are also used on the covers of another of Shiraz manuscript, a *Shahnama* dated 842/1439 (TS R. 1547), and reproduced here as fig. 135; and (2) the rather unusual triangular cornerpieces on the doublures of TIEM 2009 are also used on the back doublure of a *Khamsa* of Nizami manuscript from Shiraz, the colophons of which are dated 844/1440 and 846–47/1442–43 (TS R. 862). The 1397 frontispiece is reproduced in Brend 1989, p. 235, fig. 6.

41. Sakisian 1934b, p. 88, believed that the two bindings were the work of a single binder, but, unaware of the date of the second manuscript, he assumed both to have been produced by a Jalayirid craftsman. Brend (1989, p. 236) has suggested that the binding of TIEM 2009 is a copy of that on TIEM 2046.

42. For manuscripts made for Sultan Ahmad Jalayir or else attributed to Baghdad during his reign, none of which has a contemporary binding, see chapter 1, note 155. An additional manuscript is BN Arabe 3365, 793/1391, with no decoration other than titles in colored ink and with a red velvet cover that Richard suggests dates to about 1470–80; see Richard 1997b, p. 72, cat. no. 34.

43. For example, the cover of a copy of the *Sitta* of ʿAttar, produced in Herat for Shah Rukh, in 841/1438 (TS A.III 3059). The landscape depicted on the cover of a *Khamsa* of Nizami manuscript, presumably copied in Shiraz and dated 844/1440 and 846–47/1442–43 (TS R. 862), includes both animals and a human figure; the same design is used on a copy of Rumi's *Mathnawi* made in Shiraz, in 849/1445–46 (TIEM 1906); for all three bindings, see Aslanapa 1979, figs. 39 and 42–43, respectively.

44. The front cover is reproduced in Sakisian 1934a, fig. 9; and Sakisian 1934b, fig. 1.

45. Harrison actually says that a Swedish binder, to whom F. R. Martin once showed the binding, suggested that it would have taken at least two to three years to complete, but, taking into consideration necessary periods of rest, five years would be a closer estimate of the total time required. The same Swedish binder also estimated that the cover consists of well over 550,000 stamped impressions; see Harrison 1924, p. 35. Gratzl, building on Harrison's information, later estimated that in addition to 550,000 blind-tooled stamps, 43,000 gold ones were also used; see Gratzl 1939, p. 1978. The illuminations of the manuscript are typical of Shiraz in this period; see chapter 1, note 228.

46. The binding of the Chester Beatty manuscript is now attached back to front, but it is discussed here as though attached correctly; in other words, "the back cover" refers to what was *originally* the back cover (but is now the front cover). That the front cover of each of these two *hadith* manuscripts has been completely covered in tooled decoration, but not the back covers, is surely not coincidental; instead of the covers merely being incomplete, as they may initially seem to be, this contrast between the front and back covers is more likely a deliberate feature and one that suggests further that the manuscripts were produced in the same workshop, namely that of Ibrahim Sultan.

47. The very lovely and well-preserved binding of an earlier Baysunghur manuscript—a small (19.8 x 10.8 cm) copy of *Nasaʾih iskandar* (Counsels of Alexander), dated 829/1425–26 (CBL Ar 4183)—has covers decorated with a central, long and slender pointed-oval medallion and elaborate cloud-collar cornerpieces. The motifs of the palmette-arabesque that fill each form are small, delicate, and densely tooled in a very low relief. The overall aesthetic is quite different from that of the shallow-tooled covers of Shiraz (even when the motifs of the latter are very fine, the decoration is much bolder and more exuberant), and likewise is it different (being much finer) than that of the other Baysunghur manuscripts discussed here. The leather doublures are each decorated with a small, central whorl motif only, and facing each doublure is a sheet of paper covered with green silk of the type frequently used in Ottoman manuscripts. All this suggests that the binding may be later than the manuscript itself, but as no exact parallels for it are known, it is difficult to be certain.

48. For example, the binding of a copy of *Jamiʿ al-sahih*, dated 863/1459 (CBL Ar 4248).

49. See Raby and Tanındı 1993, pp. 37–45 and figs. 44 and 74, for the impact of these tooled Shiraz bindings on Ottoman production and for reproductions of other Shiraz examples.

6. A CHRONOLOGICAL OVERVIEW

1. For an account of the poets (Hafiz, in particular) living in Shiraz and of the literary atmosphere of the city more generally, see Rypka 1968, pp. 263–73; and Schimmel 1986, pp. 929–47.

2. However, as far as I am aware, the earliest copies of the poems of Hafiz date to the early fifteenth century, and it is not until the second half of the century that they become common. Five copies of his *divan* are included in the corpus of manuscripts examined for this study: (1) TS R. 947, 822/1419; (2) BOD Ouseley 148, 843/1439; (3) BL Add. 7759, 855/1451; (4) Vienna N. F. 442, 855/1455; and (5) TS H. 1015, 870/1465–66.

3. Or, more specifically, the poet creates in the reader's mind the (not necessarily true) impression that it is his own personal experiences he is relating.

4. See Roemer 1986, pp. 14–15, who notes that Shah Shujaʿ's "constant squabbles" with his brothers made conditions in Shiraz "even worse" than under the Injuids.

5. Meisami 1987, pp. 272–73 and especially n. 48, for references to Rypka (1968) and Hodgson (1974) on their opposing views of the importance of the middle class and the literary culture of the time.

6. BOD Marsh 491.

7. O'Kane comments that the Muzaffarids "had been thoroughly Iranicised by the time of their independent rule in Fars," noting in particular that "Shah Shujaʿ was an able Persian poet"; see O'Kane 2006, p. 178 n. 35, and also pp. 177–78. Of the four Injuid *Shahnama*s, the dispersed manuscript of 741/1341 was copied for a vizier, and it has been suggested here that the Stephens manu-

script was made for Abu Ishaq. However, the Injuids were native Iranians, who claimed descent from the mystic 'Abd Allah Ansari of Herat (d. 481/1089), in which case their production of copies of the *Shahnama* could be explained as an assertion of their true Iranian heritage, perhaps in opposition to the attempted usurpation of that same heritage by the "foreign" Il-Khanids under whose auspices the Great Mongol *Shahnama* was produced.

8. Meisami 1987, p. 201.

9. Meisami 1987, p. 205; and also p. 232, where she notes that Bahram Gur however "succeeds, where Nizami's earlier heroes failed, in achieving self-knowledge, the prerequisite to justice"; for a complete analysis of the *Haft paykar*, see pp. 180–236, but especially pp. 204, 213, and 226–27.

10. Meisami 1987, p .80, and p. 77, where she notes that "with Fakhr al-Din Gurgani's *Vis u ramin*, composed around 1050 . . . the courtly verse romance emerged as a full-fledged genre with distinctive conventions of its own."

11. Meisami 1987, p. 80.

12. Meisami 1987, p. 80.

13. Meisami 1987, p. 80. Considering the more or less simultaneous emergence of the genre of romance poetry and Persian as the standard language of the Ghaznavid court, it is interesting that the most critical stage in the development of the purely Persian script *nasta'liq* is associated with the burgeoning interest in manuscript copies of the romantic epic.

14. Little is known of the personal interests of his brother Shah Mahmud, who ruled Shiraz for two years in the 1360s.

15. The Il-Khanid Abu Sa'id likewise is characterized as highly talented and cultured, for according to the fifteenth-century Egyptian scholar Taghribirdi, he wrote a fine hand, composed both poems and songs, and also played the lute. The Jalayirid Sultan Ahmad, too, was a calligrapher, artist, and poet. For Abu Sa'id, see Howorth 1970, p. 624; for Ahmad as a painter, see Dust Muhammad in Thackston 1989, p. 345.

16. See Kutubi 1913, p. 177; Browne 1928, 3:278; and Rypka 1968, pp. 264–65. Schimmel (1986, p. 934) reports that he was, however, considered to be a mediocre poet.

17. As discussed, the development of the floral/palmette-arabesque illumination style, with its incorporation of what are ultimately Jalayirid elements, cannot be credited to the influence of Iskandar's manuscripts of some decade and a half earlier, but rather appears to have been the result of contemporary influence from Herat.

18. Akimushkin and Ivanov 1979, p. 50, citing Budaq Qazvini in *Javahir al-akhbar* (StP-RNL Dorn 288, f. 109a–b); an indication of the level of production is provided by Qazvini's comment that "should anyone be desirous of procuring a thousand illuminated books, they could all be produced in Shiraz within a year." He also notes that "they all follow the same pattern, so that there is nothing to distinguish them by."

Abbott 1939 Abbott, Nabia. "The Contribution of Ibn Muqla to the North Arabian Script." *American Journal of Semitic Languages* 56 (1939): 70–83.

Abdullaeva and Melville 2008 Abdullaeva, Firuza, and Charles Melville. *The Persian Book of Kings: Ibrahim Sultan's* Shahnama. Oxford: Bodleian Library, University of Oxford, 2008.

Adahl 1981 Adahl, Karin. *A Khamsa of Nizami of 1439, Origin of the Miniatures: A Presentation and Analysis.* Acta Universitatis Upsaliensis, Figura, Uppsala Studies in the History of Art, new series 20. Stockholm: Almquist and Wiksell International, 1981.

Adamova 1992 Adamova, A. T. "Repetition of Compositions in Manuscripts: The *Khamsa* of Nizami in Leningrad." In *Timurid Art and Culture: Iran and Central Asia in the Fifteenth Century*, edited by Lisa Golombek and Maria Subtelny, 67–75. Leiden and New York: E. J. Brill, 1992.

Adamova 2001 Adamova, A. T. "The Hermitage Manuscript of Nizami's *Khamsa* Dated 835/1431." *Islamic Art* 5 (2001): 53–132.

Adamova and Gyuzal'yan 1985 Adamova, A. T., and L. T. Gyuzal'yan. *Miniatyury rukopisi poemy "Shakhname" 1333 goda.* Leningrad: Iskusstvo, Leningradskoe Otdelenie, 1985.

Afshar 1992 Afshar, Iraj. "Persian Manuscripts with Special Reference to Iran." In *The Significance of Islamic Manuscripts: Proceedings of the Inaugural Conference of Al-Furqan Islamic Heritage Foundation*, edited by John Cooper, 12–29. London: Al-Furqan Islamic Heritage Foundation, 1992.

Afshar 1995 Afshar, Iraj. "The Use of Paper in Islamic Manuscripts as Documented in Classical Persian Texts." In *The Codicology of Islamic Manuscripts: Proceedings of the Second Conference of Al-Furqan Islamic Heritage Foundation*, edited by Yasin Dutton, 77–91. London: Al-Furqan Islamic Heritage Foundation, 1995.

Aga-Oğlu 1935 Aga-Oğlu, M. *Persian Bookbindings of the Fifteenth Century.* Ann Arbor: University of Michigan Press, 1935.

Akimushkin and Ivanov 1979 Akimushkin, Oleg F., and Anatol A. Ivanov. "The Art of Illumination." In *The Arts of the Book in Central Asia, 14th–16th Centuries*, edited by Basil Gray, 35–57. London: UNESCO and Serinda Publications, 1979.

Album 1974 Album, Stephen. "Power and Legitimacy: The Coinage of Mubariz al-Din Muhammad ibn al-Muzaffar at Yazd and Kirman." *Le monde iranien et l'Islam* 2 (1974): 157–71.

Allan 1982 Allan, James. *Islamic Metalwork: The Nuhad Es-Said Collection.* London: Sotheby's, 1982.

Allan 1987 Allan, James. "Islamic Metalwork." *Louisiana Revy* 27, no. 3 (March 1987): 24–25 and 100.

Alparslan 1978 Alparslan, Ali. "Khatt." In *Encyclopaedia of Islam.* New series. Vol. 6, edited by E. Van Donzel et al., 1122–25. Leiden: E. J. Brill, 1978.

Ansari n.d. Ansari, Zoe, ed. *Life, Times and Works of Amir Khusrau Dehlavi.* New Dehli: National Amir Khusrau Society, n.d.

Arberry 1960 Arberry, A. J. *Shiraz: Persian City of Saints and Poets.* Norman: University of Oklahoma Press, 1960.

Arberry 1967 Arberry, A. J. *The Koran Illuminated, A Handlist of the Korans in the Chester Beatty Library.* Dublin: Hodges, Figgis and Co., 1967.

Arberry, Minovi, and Blochet 1959 Arberry, A. J., M. Minovi, and E. Blochet. *The Chester Beatty Library: A Catalogue of the Persian Manuscripts and Miniatures.* Vol. 1, edited by J.V.S. Wilkinson. Dublin: Hodges Figgis and Co., 1959.

Aslanapa 1979 Aslanapa, Oktay. "The Art of Bookbinding." In *The Arts of the Book in Central Asia, 14th–16th Centuries*, edited by Basil Gray, 58–90. London: UNESCO and Serinda Publications, 1979.

Ateş 1968 Ateş, Ahmad. *Istanbul kütüphanelerinde farsça manzum eseler.* Vol. 1. Istanbul, 1968.

Atil 1978 Atil, Esin. *The Brush of the Masters: Drawings from Iran and India.* Washington, D.C.: Freer Gallery of Art, Smithsonian Institution, 1978.

Atil, Chase, and Jett 1985 Atil, Esin, W. T. Chase, and Paul Jett. *Islamic Metalwork in the Freer Gallery of Art.* Washington, D.C.: Freer Gallery of Art, Smithsonian Institution, 1985.

Baer 1968 Baer, Eva. "Fish Pond Ornaments on Persian and Mamluk Metal Vessels." *Bulletin of the School of Oriental and African Studies* 21 (1968): 14–27.

Baer 1973–74 Baer, Eva. "The Nisan Tasi: A Study in Persian-Mongol Metalware." *Kunst des Orients* 9, nos. 1–2 (1973–74): 1–46.

Baker 1989 Baker, Don. "A Note on the Expression ' . . . a Manuscript on Oriental Paper.'" *Manuscripts of the Middle East* 4 (1989): 67–68.

Baker 1991a Baker, Don. "Arab Papermaking." *Paper Conservator* 15 (1991): 28–35.

Baker 1991b Baker, Don. "The Conservation of *Jami' al-Tawarikh* by Rashid al-Din (1313)." *Arts and the Islamic World* 20 (Spring 1991): 32–33.

Barthold 1958 Barthold, V. V. "Ulugh Beg." In *Four Studies on the History of Central Asia*. Vol. 2, translated by V. Minorsky and T. Minorsky. Leiden: E. J. Brill, 1958.

Bayani 1967 Bayani, Mahdi. *Ahval va asar khushnevisan: Nasta'liq nevisan.* Tehran, 1967.

Beach 1981 Beach, Milo Cleveland. *The Imperial Image: Paintings for the Mughal Court.* Washington, D.C.: Freer Gallery of Art, Smithsonian Institution, 1981.

Binyon, Wilkinson, and Gray 1971 Binyon, Laurence, J.V.S. Wilkinson, and Basil Gray. *Persian Miniature Painting.* 1933. Reprint, New York: Dover Publications, 1971.

Black and Saidi 2000 Black, Crofton, and Nabil Saidi. *Islamic Manuscripts: Catalogue 22.* London: Sam Fogg Rare Books and Manuscripts, 2000.

Blair 1989 Blair, Sheila S. "On the Track of the 'Demotte' *Shahnama* Manuscript." In *Les manuscrits du Moyen-Orient: Essais de codicologie et de paléographie,* edited by François Déroche, 125–31. Actes de Colloque d'Istanbul. Istanbul and Paris: L'Institut Français d'études Anatoliennes d'Istanbul and Bibliothèque Nationale, 1989.

Blair 1995 Blair, Sheila S. *A Compendium of Chronicles.* The Nasser D. Khalili Collection of Islamic Art, vol. 27. London and Oxford: Nour Foundation, Azimuth Editions, and Oxford University Press, 1995.

Blair 2000 Blair, Sheila S. "Color and Gold: The Decorated Papers Used in Later Islamic Times." *Muqarnas* 17 (2000): 24–36.

Blochet 1928 Blochet, Edgard. *Catalogue des manuscrits persans de la Bibliothèque Nationale.* Vol. 3. Paris: Reunion des Bibliothèques Nationales, 1928.

Bosch, Carswell, and Petherbridge 1981 Bosch, Gulnar, John Carswell, and Guy Petherbridge. *Islamic Bindings and Bookmaking.* Chicago: Oriental Institute, University of Chicago, 1981.

Bosworth 1968 Bosworth, C. E. "The Development of Persian Culture under the Early Ghaznavids." *Iran* 6 (1968): 33–44.

Boyle 1971 Boyle, J. A. "Indju." In *Encyclopaedia of Islam.* New series, edited by Bernard Lewis et al., 1208. Leiden: E. J. Brill, 1971.

Brend 1989 Brend, Barbara. "The Arts of the Book." In *The Arts of Persia,* edited by R. W. Ferrier, 232–42. New Haven and London: Yale University Press, 1989.

Brend 2001 Brend, Barbara. "A 14th-Century *Khamseh* of Nizami from Western Iran with Early Ottoman Illustrations." *Islamic Art* 5 (2001): 133–66.

Brend 2003 Brend, Barbara. *Perspectives on Persian Painting: Illustrations to Amir Khusrau's* Khamsah. London: Routledge, 2003.

Browne 1928 Browne, E. G. *A Literary History of Persia.* 4 vols. Cambridge: Cambridge University Press, 1928.

Burgel 1988 Burgel, J. C. "The Romance." In *Persian Literature,* edited by Ehsan Yarshater, 161–78. Columbia Lectures on Iranian Studies 3. New York: Bibliotheca Persica, 1988.

Cahill 1960 Cahill, James. *Chinese Paintings.* Geneva: Éditions d'Art Albert Skira, 1960.

Cammann 1951 Cammann, Schuyler. "The Symbolism of the Cloud Collar Motif." *Art Bulletin* 33, no. 1 (1951): 1–9.

Canby 1993 Canby, Sheila R. *Persian Painting.* London: Trustees of the British Museum and British Museum Press, 1993.

Chabbouh 1995 Chabbouh, Ibrahim. "Two New Sources on the Art of Mixing Ink." In *The Codicology of Islamic Manuscripts: Proceedings of the Second Conference of Al-Furqan Islamic Heritage Foundation,* edited by Yasin Dutton, 59–76. London: Al-Furqan, Islamic Heritage Foundation, 1995.

Chomsky 1965 Chomsky, Noam. *Aspects of the Theory of Syntax.* Cambridge: Massachusetts Institute of Technology, 1965.

Christie's, 24 April 1990 Christie's. *Islamic Art, Indian Miniatures, Rugs and Carpets.* London, 24 April 1990.

Christie's, 13 October 1998 Christie's. *Islamic Art and Manuscripts.* London, 13 October 1998.

Clifford 1992 Clifford, Derek. *Chinese Carved Lacquer.* London: Bamboo Publishing, 1992.

Crowe 1991 Crowe, Yolande. "Late Thirteenth-Century Persian Tilework and Chinese Textiles." *Bulletin of the Asia Institute* 5 (1991): 153–61.

Crowe 1992 Crowe, Yolande. "Some Timurid Designs and Their Far Eastern Connections." In *Timurid Art and Culture: Iran and Central Asia in the Fifteenth Century*, edited by Lisa Golombek and Maria Subtelny, 168–78. Leiden and New York: E. J. Brill, 1992.

Curatola 1993 Curatola, Giovanni, ed. *Eredità dell'Islam: Arte islamica in Italia*. Venice: Silvana, 1993.

Da-Sheng 1992 Da-Sheng, Chen. "Sources from Fujian on Trade between China and Hurmuz in the Fifteenth Century." In *Timurid Art and Culture: Iran and Central Asia in the Fifteenth Century*, edited by Lisa Golombek and Maria Subtelny, 191–94. Leiden and New York: E. J. Brill, 1992.

Davis 1992 Davis, Dick. *Epic and Sedition: The Case of Firdowsi's "Shahnameh."* Fayetteville: University of Arkansas Press, 1992.

Diehl 1946 Diehl, Edith. *Bookbinding: Its Background and Technique*. New York: Rinehart and Company, 1946.

Duda 1983 Duda, Dorothea. *Islamische Handschriften*. Vol. 1, *Persische Handschriften: Die Illuminierten Handschriften und Inkunabeln der Österreichischen Nationalbibliothek*. Vienna: Verlag der Österreichischen Akademie der Wissenschaften, 1983.

Enderlein 1991 Enderlein, Volkmar. *Die Miniaturen der Berliner Baisonqur-Handschrift*. Berlin: Bilderhefte der Staatlichen Museen zu Berlin, 1991.

Ethé and Sachau 1889 Ethé, Hermann, and E. Sachau. *Catalogue of the Persian, Turkish, Hindustani and Pushtu Manuscripts in the Bodleian Library*. Pt. 1, *The Persian Manuscripts*. Oxford: Clarendon Press, 1889.

Ettinghausen 1939 Ettinghausen, Richard. "Manuscript Illumination." In *A Survey of Persian Art*. Vol. 3, edited by A. U. Pope and Phyllis Ackerman, 1937–74. London and New York: Oxford University Press, 1939.

Ettinghausen 1954 Ettinghausen, Richard. "The Covers of the Morgan *Manafi'* Manuscript and Other Early Persian Bookbindings." In *Studies in Art and Literature for Belle da Costa Greene*, edited by Dorothy Miner, 459–73. Princeton: Princeton University Press, 1954.

Ettinghausen 1955 Ettinghausen, Richard. "An Illuminated Manuscript of Hafiz-i Abru in Istanbul, Part I." *Kunst des Orients* 2 (1955): 30–44.

Ettinghausen 1977 Ettinghausen, Richard. *Arab Painting*. 1962. Reprint, Geneva: Éditions d'Art Albert Skira, 1977.

Ettinghausen 1981 Ettinghausen, Richard. "The Categorization of Persian Painting." In *Studies in Judaism and Islam in Honour of Shelomo D. Goitein*, edited by Shelomo Morag et al., 55–62. Jerusalem: Magnes Press, 1981.

Ettinghausen and Grabar 1987 Ettinghausen, Richard, and Oleg Grabar. *The Art and Architecture of Islam, 650–1250*. Harmondsworth, Middlesex: Penguin Books, 1987.

Farès 1953 Farès, Bishr. *Le livre de la Thériaque: Art islamique*. Vol. 2. Cairo: L'Institut Français d'Archéologie Orientale, 1953.

Faza'eli 2536 Faza'eli, H. *Ta'lim-i khatt*. Tehran: Sorush Publications, 2536.

Fehervari 1976 Fehervari, Geza. *Islamic Metalwork of the Eighth to the Fifteenth Century in the Keir Collection*. London: Faber and Faber, 1976.

Figgess 1964–66 Figgess, John. "A Group of Decorated Lacquer Caskets of the Yuan Dynasty." *Transactions of the Oriental Ceramic Society* 36 (1964–66): 39–42.

Fitzherbert 1991 Fitzherbert, Teresa. "Khwaju Kirmani (689–753/1290–1352): An Éminence Grise of Fourteenth Century Persian Painting." *Iran* 29 (1991): 137–51.

Fong 1973 Fong, Wen. *Sung and Yuan Paintings*. New York: Metropolitan Museum of Art, 1973.

Fraad and Ettinghausen 1971 Fraad, Irma L. and Richard Ettinghausen. "Sultanate Painting in Persian Style, Primarily from the First Half of the Fifteenth Century: Preliminary Study." In *Chhavi: Golden Jubilee Volume of the Bharat Kala Bhavan*, edited by Anand Krishna, 48–66. Varanesi: Bharat Kala Bhavan and Barnaras Hindu University, 1971.

Gacek 1990–91 Gacek, Adam. "Arabic Bookmaking and Terminology as Portrayed by Bakr al-Ishbili in His *Kitab al-taysir fi sina'at al-tasfir*." *Manuscripts of the Middle East* 5 (1990–91): 106–13.

Galdieri 1982 Galdieri, Eugenio. "Un exemple curieux de restauration ancienne: La xoda-xane de Chiraz." In *Art et société dans le monde iranien*, edited by C. Adle, 297–309. Paris: Éditions Recherches sur les Civilisation, 1982.

Garner 1971–72 Garner, Sir Harry. "The Export of Chinese Lacquer to Japan in the Yuan and Early Ming Dynasties." *Archives of Asian Art* 25 (1971–72): 6–28.

Garner 1979 Garner, Sir Harry. *Chinese Lacquer*. London: Faber and Faber, 1979.

Gast 1983 Gast, Monika. "A History of Endbands, Based on a Study by Karl Jackel." *New Bookbinder* 3 (1983): 42–58.

Goitein 1968 Goitein, S. D. "A Plea for the Periodization of Islamic History." *Journal of the American Oriental Society* 68 (1968): 224–28.

Golombek 1972 Golombek, Lisa. "Toward a Classification of Islamic Painting." In *Islamic Art in the Metropolitan Museum of Art*, edited by Richard Ettinghausen, 23–34. New York: Metropolitan Museum, 1972.

Grabar 1970 Grabar, Oleg. "The Illustrated *Maqamat* of the Thirteenth Century: The Bourgeoisie and the Arts." In *The Islamic City: A Colloquium*, edited by Albert Hourani and S. M. Stern, 207–22. Philadelphia: University of Pennsylvania Press, 1970.

Grabar and Blair 1980 Grabar, Oleg, and Sheila Blair. *Epic Images and Contemporary History: The Illustrations of the Great Mongol Shahnama*. Chicago and London: University of Chicago Press, 1980.

Gratzl 1939 Gratzl, Emil. "Book Covers." In *A Survey of Persian Art*. Vol. 3, edited by A. U. Pope and Phyllis Ackerman, 1975–94. London and New York: Oxford University Press, 1939.

Gray 1940 Gray, Basil. "Fourteenth-Century Illustrations of the *Kalila wa Dimna*." *Ars Islamica* 7 (1940): 134–40.

Gray 1971 Gray, Basil. *An Album of Miniatures and Illuminations from the Baysonghori Manuscript of the "Shahnameh" of Ferdowsi, Completed in 833 A.H./A.D. 1430 and Preserved in the Imperial Library, Tehran*. Tehran: Central Council of the Celebration of the 2500th Anniversary of the Founding of the Persian Empire by Cyrus the Great and Franklin Book Programs, 1971.

Gray 1977 Gray, Basil. *Persian Painting*. 1961. Geneva: Éditions d'Art Albert Skira, 1977.

Gray 1978 Gray, Basil. *The World History of Rashid al-Din: A Study of the Royal Asiatic Society Manuscript*. London: Faber and Faber, 1978.

Gray 1979 Gray, Basil. "The School of Shiraz from 1392 to 1453." In *The Arts of the Book in Central Asia, 14th–16th Centuries*, edited by Basil Gray, 121–46. London: UNESCO and Serinda Publications, 1979.

Gray 1985 Gray, Basil. "The Monumental Qur'ans of the Il-Khanid and Mamluk Ateliers of the First Quarter of the Fourteenth Century (Eighth Century A.H.)." *Rivista degli studi orientali* 59, nos. 1–4 (1985): 135–46.

Gray 1987 Gray, Basil. "An Unknown Fragment of the *Jami'*

al-Tawarikh* in the Asiatic Society of Bengal." In *Studies in Chinese and Islamic Art*. Vol. 2, *Islamic Art*, edited by Basil Gray, 219–55. London: Pindar Press, 1987. Originally printed in *Ars Orientalis* 1 (1954).

Gray and Kühnel 1963 Gray, Basil, and Ernst Kühnel. *Oriental Islamic Art: Collection of the Calouste Gulbenkian Foundation*. Lisbon: Museu Nacional de Arte Antiga, 1963.

Grube 1981 Grube, Ernst. "The Problem of the Istanbul Album Paintings." *Islamic Art* 1 (1981): 1–30.

Grube 1991 Grube, Ernst. "The Early Illustrated *Kalila wa Dimna* Manuscripts." *Marg* 45, no. 2 (1991): 32–51.

Grube 2000 Grube, Ernst. "Ibrahim-Sultan's 'Anthology of Prose Texts.'" In *Persian Painting: From the Mongols to the Qajars*, edited by Robert Hillenbrand, 101–17. London: I. B. Taurus Publishers and the Centre of Middle Eastern Studies, University of Cambridge, 2000.

Grube n.d. Grube, Ernst. *Islamic Paintings from the 11th–18th Century in the Collection of Hans P. Krauss*. New York: H. P. Krauss, n.d.

Gyuzal'yan 1960 Gyuzal'yan, L. T. "Three Injuid Bronze Vessels." In *XXV International Congress of Orientalists: Papers Presented by the USSR Delegation*, 1–10. Moscow, 1960.

Hammer-Purgstall 1845 Hammer-Purgstall, J.F.V. *Narrative of Travels of Evilya Effendi*. Vol. 1, Pt. 2. London, 1845.

Harrison 1924 Harrison, T. "A Persian Binding of the Fifteenth Century." *Burlington Magazine* 250, no. 44 (January 1924): 31–35.

Hecker 1993 Hecker, Felicia J. "A Fifteenth-Century Chinese Diplomat in Herat." *Journal of the Royal Asiatic Society* 3, no. 1 (April 1993): 85–98.

Hodgson 1974 Hodgson, Marshall G. S. *Venture of Islam: Conscience and History in a World Civilization*. Chicago: University of Chicago Press, 1974.

Hodnett 1982 Hodnett, Edward. *Image and Text: Studies in the Illustration of English Literature*. London: Scolar Press, 1982.

Howorth 1970 Howorth, Henry H. *History of the Mongols: From the 9th to the 19th Century*. Pt. 3, *The Mongols of Persia*. 1888. Taipei: Ch'eng Wen Publishing Co., 1970.

Hunter 1947 Hunter, Dard. *Papermaking: The History and Technique of an Ancient Craft*. London: Pleiades Books, 1947.

Ibn Battutah 1958–71 Ibn Battutah. *The Travels of Ibn Battutah*, translated and edited by H.A.R. Gibb. London: Hakluyt Society, 1958–71.

Inal 1992 Inal, Güner. "Miniatures in Historical Manuscripts from the Time of Shahrukh in the Topkapi Palace Museum." In *Timurid Art and Culture: Iran and Central Asia in the Fifteenth Century*, edited by Lisa Golombek and Maria Subtelny, 103–15. Leiden and New York: E. J. Brill, 1992.

İpşiroğlu 1964 İpşiroğlu, M. S. *Saray-Alben*. Wiesbaden: Franz Steiner Verlag, 1964.

İpşiroğlu 1965 İpşiroğlu, M. S. *Painting and Culture of the Mongols*. London: Thames and Hudson, 1965.

Iranian Masterpieces 2005 *Iranian Masterpieces of Persian Painting*. Tehran: Tehran Museum of Contemporary Art, in association with the Institute for the Promotion of Visual Arts, 2005.

Ismailova 1980 Ismailova, E. M. *Oriental Miniatures of Abu Raihon Beruni Institute of Orientology of the UzSSR Academy of Sciences*. Tashkent: Gafur Gulyam Literature and Art Publishing House, 1980.

Ivanov 1990 Ivanov, Anatoly A. *Masterpieces of Islamic Art in the Hermitage Museum*. Kuwait: Dar al-Athar al-Islamiyyah, 1990.

Jacobs and Rodgers 1990 Jacobs, David, and Barbara Rodgers. "Developments in the Conservation of Oriental (Islamic) Manuscripts at the India Office Library, London." *Restaurator* 11 (1990): 110–37.

James 1980 James, David. *Qur'ans and Bindings from the Chester Beatty Library: A Facsimile Exhibition*. London: World of Islam Festival Trust, 1980.

James 1988 James, David. *Qur'ans of the Mamluks*. London: Alexandria Press and Thames and Hudson, 1988.

James 1992a James, David. *After Timur*. Nasser D. Khalili Collection of Islamic Art, vol. 3. London and Oxford: Nour Foundation, Azimuth Editions, and Oxford University Press, 1992.

James 1992b James, David. *The Master Scribes: Qu'ans of the 10th to 14th Centuries A.D.* Nasser D. Khalili Collection of Islamic Art, vol. 2. London and Oxford: Nour Foundation, Azimuth Editions, and Oxford University Press, 1992.

Kağıtçı 1976 Kağıtçı, M. A. *Historical Study of Paper Industry in Turkey*. Istanbul, 1976.

Keshavarz 1984 Keshavarz, Fateme. "The Horoscope of Iskandar Sultan." *Journal of the Royal Asiatic Society* 2 (1984): 197–208.

Keshavarz 1986 Keshavarz, Fateme. *A Descriptive and Analytical Catalogue of Persian Manuscripts in the Library of the Wellcome Institute for the History of Medicine*. London: Wellcome Institute for the History of Medicine, 1986.

Khalili, Robinson, and Stanley 1996 Khalili, Nasser D., B. W. Robinson, and Tim Stanley. *Lacquer of the Islamic Lands*. Nasser D. Khalili Collection of Islamic Art, vol. 22, pt. 1. London and Oxford: Nour Foundation, Azimuth Editions, and Oxford University Press, 1996.

Khan 1992 Khan, Geoffrey. *Arabic Papyri: Selected Material from the Khalili Collection*. London and Oxford: Nour Foundation, Azimuth Editions, and Oxford University Press, 1992.

Khwandamir 1994 Khwandamir, Ghiyas al-Din. *Habibu's-siyar*. Vol. 3, *The Reign of the Mongol and the Turk*. Sources of Oriental Languages and Literatures 24, translated and edited by W. M. Thackston. Boston: Department of Near Eastern Languages and Civilizations, Harvard University, 1994.

Komaroff 1994 Komaroff, Linda. "Paintings in Silver and Gold: The Decoration of Persian Metalwork and Its Relationship to Manuscript Illustration." *Decorative Arts* 2, no. 2 (Fall 1994): 2–34.

Komaroff 2006 Komaroff, Linda, ed. *Beyond the Legacy of Genghis Khan*. Leiden and Boston: Koninklijke Brill, 2006.

Komaroff and Carboni 2002 Komaroff, Linda, and Stefano Carboni, eds. *The Legacy of Genghis Khan: Courtly Art and Culture in Western Asia, 1256–1353*. New York: Metropolitan Museum of Art; New Haven and London: Yale University Press, 2002.

Kühnel 1931 Kühnel, Ernst. "Die Baysonghur-Handschrift der Islamischen Kunstabteilung." *Jahrbuch der Preuszischen Kunstsammlungen* 52 (1931): 133–52.

Kutubi 1913 Kutubi, Mahmud. "Account of the Muzaffari Dynasty." In *Ta'rikh-i guzida of Hamdu'llah Mustawfi-i Qazwini . . . Reproduced in Facsimile Form from a Manuscript Dated A.H. 857 (A.D. 1453)*. Gibb Memorial Series, vol. 14, no. 1, edited by Edward G. Browne and translated by R. A. Nicholson, 9–207. London: Luzac and Co., 1913.

Lee and Ho 1968 Lee, Sherman, and Wai-Kam Ho. *Chinese Art under the Mongols: The Yuan Dynasty (1279–1368)*. Cleveland: Cleveland Museum of Art, 1968.

Lentz 1985 Lentz, Thomas W. "Painting at Herat under Baysunghur ibn Shah Rukh." PhD diss., Harvard University, 1985.

Lentz and Lowry 1989 Lentz, Thomas W., and Glenn D. Lowry. *Timur and the Princely Vision: Persian Art and Culture in*

the Fifteenth Century. Los Angeles and Washington D.C.: Los Angeles County Museum of Art, Arthur M. Sackler Gallery, and Smithsonian Institution Press, 1989.

Levey 1962 Levey, Martin. "Mediaeval Arabic Bookmaking and Its Relation to Early Chemistry and Pharmacology." *Transactions of the American Philosophical Society* 52, no. 4 (1962): 1–79.

Limbert 2004 Limbert, John. *Shiraz in the Age of Hafiz: The Glory of a Medieval Persian City*. Seattle and London: University of Washington Press, 2004.

Lings 1976 Lings, Martin. *The Qu'anic Art of Calligraphy and Illumination*. London: World of Islam Festival Trust, 1976.

Losty 1982 Losty, Jeremiah. *The Art of the Book in India*. London: British Library Board, 1982.

Loukonine and Ivanov 1995 Loukonine, Vladimir, and Anatoli Ivanov. *L'Art Persan*. Bournemouth: Parkstone Editions, 1995.

Loveday 2001 Loveday, Helen. *Islamic Paper: A Study of the Ancient Craft*. London: Don Baker Memorial Fund, 2001.

Lowry and Beach 1988 Lowry, Glenn D., and Milo Beach. *An Annotated and Illustrated Checklist of the Vever Collection*. Washington, D.C.: Arthur M. Sackler Gallery, 1988.

Lowry and Nemazee Lowry, Glenn D., and Susan Nemazee. *A Jeweler's Eye: Islamic Arts of the Book from the Vever Collection*. Washington, D.C., and Seattle: Smithsonian Institution and University of Washington Press, 1988.

Maguire 1974 Maguire, Marcia E. "The *Haft Khvan* of Rustam and Isfandiyar." In *Studies in Art and Literature in Honor of Richard Ettinghausen*, edited by Peter J. Chelkowski, 37–47. Salt Lake City and New York: Middle East Centre of the University of Utah and New York University Press, 1974.

Makariou et al. 2001 Makariou, Sophie, et al. *L'Orient de Saladin: L'Art des Ayyoubides*. Paris: Institut du monde arabe and Éditions Gallimard, 2001.

Marchand 1976 Marchand, Ernesta. "The Panorama of Wu-T'Ai Shen as an Example of Tenth Century Cartography." *Oriental Art*, n.s., vol. 22, no. 2 (Summer 1976): 158–73.

Masuya 2002 Masuya, Tomoko. "IlKhanid Courtly Life." In *The Legacy of Genghis Khan: Courtly Art and Culture in Western Asia, 1256–1353*, edited by Linda Komaroff and Stefano Carboni, 74–103. New York: Metropolitan Museum of Art; New Haven and London: Yale University Press, 2002.

McParland 1982 McParland, Maighread. "Book Conservation Workshop Manual. Part 2, The Nature and Chemistry of Paper, Its History, Analysis and Conservation." *New Bookbinder* 2 (1982): 17–28.

Medley 1976 Medley, Margaret. *The Chinese Potter: A Practical History of Chinese Ceramics*. Oxford: Phaidon Press, 1976.

Meisami 1987 Meisami, Julie Scott. *Medieval Persian Court Poetry*. Princeton: Princeton University Press, 1987.

Meisami 1995 Meisami, Julie Scott. *The Haft Paykar: A Medieval Persian Romance*. Oxford: Oxford University Press, 1995.

Melikian-Chirvani 1969 Melikian-Chirvani, A. S. "Bronzes et cuivres iraniens du Louvre I, L'École du Fars au XIVe siècle." *Journal asiatiques* 257 (1969): 19–36.

Melikian-Chirvani 1971 Melikian-Chirvani, A. S. "Le Royaume de Saloman, Les inscriptions persanes de sites achemeides." *Le monde iranien et l'Islam* 1, no. 4 (1971): 1–41.

Melikian-Chirvani 1982 Melikian-Chirvani, A. S. *Islamic Metalwork from the Iranian World, 8–18th Centuries*. London: Her Majesty's Stationery Office, 1982.

Mohl 1373/1994 Mohl, Jules, ed. *Shahnameh-i Firdausi*. 7 vols. Tehran, 1373/1994.

Montgomery-Wyaux 1978 Montgomery-Wyaux, Cornelia. *Métaux islamiques*. Brussels: Musées Royaux d'Art et d'Historie, 1978.

Moritz 1913 Moritz, B. "Arabic Writing." In *Encyclopaedia of Islam*, Vol. 1, edited by M. Th. Houtsma et al., 390–93. London: Luzac and Co., 1913.

Nodushan 2536 Nodushan, M. A. Eslami. *Dastan-e dastanha*. Tehran, 2536.

Norgren and Davis 1969 Norgren, Jill, and Edward Davis. "Preliminary Index of Shah-Nameh Illustrations." Typescript. University of Michigan Center for Near Eastern and North African Studies, Ann Arbor, 1969.

O'Kane 1987 O'Kane, Bernard. *Timurid Architecture in Khurasan*. Costa Mesa, Calif.: Mazda Publishers and Undena Publications, 1987.

O'Kane 1999–2000 O'Kane, Bernard. "The Bibihani Anthology and Its Antecedents." *Oriental Art* 45, no. 4 (1999–2000): 9–18.

O'Kane 2006 O'Kane, Bernard. "The Iconography of the *Shahnama*, Ms. Ta'rikh Farisi 73, Dar al-Kutub, Cairo (796/1393–94)." *Shahnama Studies*, vol. 1, edited by Charles Melville, pp. 171–88. Cambridge: Centre of Middle Eastern and Islamic Studies, University of Cambridge, 2006.

Ölçer et al. 2002 Ölçer, Nazan, et al. *Museum of Turkish and*

Islamic Art. Istanbul: Akbank Department of Culture and Art, 2002.

Olearius 1662 Olearius, A. *The Voyages and Travels of the Ambassadors from the Duke of Holstein to the Great Duke of Muscovy and the King of Persia*, translated by John Davies of Kidwelly. London, 1662.

Petrosyan et al. 1995 Petrosyan, Yuri A., Oleg F. Akimushkin, Anas B. Khalidov, and Efim A. Rezvan. *Pages of Perfection: Islamic Paintings and Calligraphy from the Russian Academy of Sciences, St. Petersburg.* Lugano: ARCH Foundation, 1995.

Piemontese 1980 Piemontese, Angelo Michele. "Nuova luce su Firdawsi: uno 'Sahnama' datato 614 H./1217 a Firenze." *Istituto Orientale di Napoli Annali*, n.s., vol. 30 (1980): 1–38.

Piotrovsky and Vrieze 1999 Piotrovsky, Mikhail B., and John Vrieze. *Earthly Beauty, Heavenly Art: Art of Islam.* Amsterdam: Lund Humphries Publishers, 1999.

Poliakova and Rakhimova 1987 Poliakova, E. A., and Z. I. Rakhimova. *L'art de la miniature et la littérature de l'orient.* Tashkent: Éditions de la littérature et des beaux-arts Gafour Gouliame, 1987.

Pope and Ackerman 1939 Pope, Arthur Upham, and Phyllis Ackerman, eds. *A Survey of Persian Art: From Prehistoric Times to the Present,* vol. 6, pls. 981–1482, *Textiles, Carpets, Metalwork, Minor Arts.* London and New York: Oxford University Press, 1939.

Porter 1985 Porter, Yves. "Un Traité de Simi Neysapuri (IXe/ XVe S.), artiste et polygraphie." *Studia iranica* 14, no. 2 (1985): 179–98.

Qadi Ahmad 1959 Qadi Ahmad. *Calligraphers and Painters: A Treatise by Qadi Ahmad, Son of Mir Munshi (circa A.H. 1015/1606)*, translated V. Minorsky. Washington, D.C.: Freer Gallery of Art, 1959.

al-Qalqashandi 1963 al-Qalqashandi, Ahmad ibn 'Abdallah. *Subh al-a'sha fi sina'at al-insha.* Cairo: Dar al-Kutub al-Khidiwiyya, 1913–20. Reprint, Cairo: Wazirat al-Thaqafa wa al-Irshad al-Qawmi, 1963.

Raby and Tanındı 1993 Raby, Julian, and Zeren Tanındı. *Turkish Bookbinding in the 15th Century.* London: Azimuth Editions and l'Association Internationale de Bibliophilie, 1993.

Rawson 1984 Rawson, Jessica. *Chinese Ornament: The Lotus and the Dragon.* London: Trustees of the British Museum, 1984.

Rice and Gray 1976 Rice, David Talbot, and Basil Gray. *The Illustrations to the World History of Rashid al-Din.* Edinburgh: Edinburgh University Press, 1976.

Richard 1989 Richard, Francis. "*Divani* ou *ta'liq*: Un calligraphe au service de Mehmet II, Sayyidi Muhammad Monsi." In *Les manuscrits du Moyen-Orient: Essais de codicologie et de paléographie.* edited by François Déroche, 89–93. Actes de Colloque d'Istanbul. Istanbul and Paris: L'Institut Français d'Études Anatoliennes d'Istanbul and Bibliothèque Nationale, 1989.

Richard 1996 Richard, Francis. "Un témoignage inexploité concernant le mécénat d'Eskandar Soltan à Esfahan." *Oriente Moderno* 26, no. 5 (1996): 1–22.

Richard 1997a Richard, Francis. "Une des peintures de manuscrit Supplement persan 1113 de l'histoire des Mongols de Rashid al-Din identifié." In *L'Iran Face á la Domination Mongol,* edited by Denise Aigle, 307–20. Tehran: Institut Français de Recherche en Iran, 1997.

Richard 1997b Richard, Francis. *Splendeurs persanes: Manuscrits du XII au XVII siècle.* Paris: Bibliothèque nationale de France, 1997.

Richard 2001 Richard, Francis. "Nasr al-Soltani, Nasir al-Din Mozahheb et la Bibliothèque d'Ebrahim Soltan." *Studia Iranica* 30, no. 1 (2001): 87–104.

Richard 2003 Richard, Francis. "Autour de la naissance de *nasta'liq* en Perse: Les écritures de chancellerie et le foisonnement des styles durant les années 1350–1400." *Manuscripta Orientalia* 9, no. 3 (September 2003): 8–15.

Rieu 1879–83 Rieu, Charles. *Catalogue of the Persian Manuscripts in the British Museum.* 3 vols. London: Trustees of the British Museum, 1879–83.

Robertson 1920 Robertson, Edward. "Muhammad ibn 'Abd al-Rahman on Calligraphy." In *Studia semitica et orientalia,* 57–83. Glasgow: MacLehose, Jackson and Co., 1920.

Robinson 1958 Robinson, B. W. *A Descriptive Catalogue of the Persian Paintings in the Bodleian Library.* Oxford: Oxford University Press, 1958.

Robinson 1979 Robinson, B. W. "Painter-Illuminators of Sixteenth-Century Shiraz." *Iran* 17 (1979): 105–15.

Robinson 1980 Robinson, B. W. *Persian Paintings in the John Rylands Library.* London: Sotheby Parke Bernet Publications for Philip Wilson Publishers, 1980.

Robinson 1990 Robinson, B. W. "Zenith of His Time: The Painter Pir Ahmad Baghshimali." *Persian Masters: Five Centuries of Painting*, edited by Sheila R. Canby, 1–20. Bombay: Marg Publications, 1990.

Robinson et al. 1976 Robinson, B. W., E. Grube, G. M. Meredith-Owens, and R. Skelton. *Islamic Paintings and the Arts of the Book*. London: Faber and Faber, 1976.

Roemer 1986 Roemer, H. R. "The Jalayrids, Muzaffarids and Sarbadars"; "Timur in Iran"; and "The Successors of Timur." In *The Cambridge History of Iran*, vol. 6, edited by Peter Jackson and Laurence Lockhart, 1–146. Cambridge and London: Cambridge University Press, 1986.

Rogers 1995 Rogers, J. M. *Empire of the Sultans: Ottoman Art from the Collection of Nasser D. Khalili*. London: Musée d'Art et d'Histoire, Nour Foundation, and Azimuth Editions, 1995.

Rogers et al. 1986 Rogers, J. M., trans. and ed., Filiz Çağman, and Zeren Tanındı. *The Topkapi Saray Museum: The Albums and Illustrated Manuscripts*. Boston: Little, Brown and Company, 1986.

Rose 2007 Rose, Kristine. "The Conservation of a Seventeenth-Century Persian *Shahnama*." In *Edinburgh Conference Papers 2006*, edited by Shulla Jaques, 79–86. London: Institute of Conservation, 2007.

Roxburgh 1996 Roxburgh, David. "'Our Works Point to Us': Album Making, Collecting, and Art (1427–1565) under the Timurids and Safavids." PhD diss., University of Pennsylvania, 1996.

Roxburgh 2001 Roxburgh, David. *Prefacing the Image: The Writing of Art History in Sixteenth-Century Iran*. Studies and Sources in Islamic Art and Architecture, Supplements to *Muqarnas* 9. Leiden: E. J. Brill, 2001.

Roxburgh 2005 Roxburgh, David. *The Persian Album, 1400–1600: From Dispersal to Collection*. New Haven and London: Yale University Press, 2005.

Rührdanz 1997 Rührdanz, Karin. "Illustrationen zu Rashid al-Dins Ta'rihk-i Mubarak Gazani in den Berliner Diez-Alben." In *L'Iran Face á la Domination Mongol*, edited by Denise Aigle, 295–306. Tehran: Institut Français de Recherche en Iran, 1997.

Rypka 1968 Rypka, Jan. *History of Iranian Literature*, translated by P. Van Popta-Hope. 1956. Dordrecht: D. Reidel Publishing Co., 1968.

Sakisian 1934a Sakisian, Armenag. "La reliure dans la Perse occidentale, sous les Mongols au XIV et au début du XV siècle." *Ars Islamica* 1 (1934): 80–91.

Sakisian 1934b Sakisian, Armenag. "La reliure persane au XV siècle sous les Timourides." *La révue de l'art ancien et moderne* 66 (1934): 145–68.

Samarqandi 1844 Samarqandi, Kamal al-Din 'Abd al-Razzaq. *Matla'-i sa'dayn*, edited and translated by Quatremère. Notices et extraits de la Bibliothèque du Roi XIV. Paris, 1844.

Schimmel 1986 Schimmel, Annemarie. "Hafiz and His Contemporaries." In *The Cambridge History of Iran*. Vol. 6, edited by Peter Jackson and Laurence Lockhart, 929–47. Cambridge and London: Cambridge University Press, 1986.

Schmitz 1997 Schmitz, Barbara. *Islamic and Indian Manuscripts and Paintings in the Pierpont Morgan Library*. New York: Pierpont Morgan Library, 1997.

Schroeder 1942 Schroeder, Eric. *Persian Miniatures in the Fogg Museum of Art*. Cambridge, Mass.: Harvard University Press, 1942.

Shahbazi 1991 Shahbazi, A. Shapur. *Ferdowsi: A Critical Biography*. Boston: Harvard University, Center for Middle Eastern Studies, 1991.

Simpson 1979 Simpson, Marianna Shreve. *The Illustration of an Epic: The Earliest "Shahnama" Manuscripts*. New York and London: Garland Publishing, 1979.

Simpson 1982 Simpson, Marianna Shreve. "The Role of Baghdad in the Formation of Persian Painting." In *Art et société dans le monde iranien*, edited by C. Adle, 91–116. Paris: Éditions Recherches sur les Civilisation, 1982.

Simpson 1997 Simpson, Marianna Shreve. *Sultan Ibrahim Mirza's* Haft Awrang: *A Princely Manuscript from Sixteenth-Century Iran*. Washington, D.C., and New Haven: Freer Gallery of Art and Yale University Press, 1997.

Simpson 2000 Simpson, Marianna Shreve. "A Reconstruction and Preliminary Account of the 1341 *Shahnama*: With Some Further Thoughts on Early *Shahnama* Illustration." In *Persian Painting: From the Mongols to the Qajars*, edited by Robert Hillenbrand, 217–47. London: I. B. Taurus Publishers and the Centre of Middle Eastern Studies, University of Cambridge, 2000.

Sims 1973 Sims, Eleanor. "The Garrett Manuscript of the Zafar-Name: A Study in Fifteenth-Century Patronage." PhD diss., Institute of Fine Arts, New York University, 1973.

Sims 1981 Sims, Eleanor. "The Relations between Early Timurid Painting and Some Pictures in the Istanbul Albums." *Islamic Art* 1 (1981): 56–61.

Sims 1990–91 Sims, Eleanor. "Ibrahim Sultan's Illustrated *Zafarnameh* of 839/1436." *Islamic Art* 4 (1990–91): 175–95.

Sims 1992a Sims, Eleanor. "Ibrahim-Sultan's Illustrated *Zafarnama* and Its Impact in the Muslim East." In *Timurid Art and Culture: Iran and Central Asia in the Fifteenth Century*,

edited by Lisa Golombek and Maria Subtelny, 132–43. Leiden and New York: E. J. Brill, 1992.

Sims 1992b Sims, Eleanor. "The Illustrated Manuscripts of Firdausi's *Shahnama* Commissioned by Princes of the House of Timur." *Ars Orientalis* 22 (1992): 43–68.

Sims 1996 Sims, Eleanor. "Towards a Study of Shirazi Illustrated Manuscripts of the 'Interim Period': The Leiden *Shahnama* of 840/1437." *Oriente Moderno*, n.s. 15, vol. 76, no. 2 (1996): 611–25.

Sims 2000 Sims, Eleanor. "The Hundred and One Paintings of Ibrahim-Sultan." In *Persian Painting: From the Mongols to the Qajars*, edited by Robert Hillenbrand, 119–27. London: I. B. Taurus Publishers and the Centre of Middle Eastern Studies, University of Cambridge, 2000.

Sims 2001 Sims, Eleanor. "The Art of Illumination in Islamic Manuscripts." *Halı* 114 (January–February 2001): 96–98.

Sims 2002 Sims, Eleanor. *Peerless Images: Persian Painting and Its Sources.* New Haven and London: Yale University Press, 2002.

Sims forthcoming. Sims, Eleanor. "The Stephens *Shahnama*: An Inju Manuscript of 753/1352–53." Forthcoming.

Sotheby's, 8 July 1980. *The Jami' al-Tawarikh of Rashid al-Din.* London, 8 July 1980.

Sotheby's, 27 April 1981. *Fine Oriental Manuscripts and Miniatures.* London, 27 April 1981.

Sotheby's, 19 April 1983. *Fine Oriental Manuscripts and Miniatures.* London, 19 April 1983.

Sotheby's, 20 April 1983. *Islamic Works of Art, Carpets and Textiles.* London, 20 April 1983.

Sotheby's, 15 October 1985. *Islamic Works of Art, Carpets and Textiles.* London, 15 October 1985.

Sotheby's, 14 October 1987. *Islamic Works of Art, Carpets and Textiles.* London, 14 October 1987.

Sotheby's, 14 December 1987. *Fine Oriental Manuscripts and Miniatures.* London, 14 December 1987.

Sotheby's, 26 April 1995. *Oriental Manuscripts and Miniatures.* London, 26 April 1995.

Sotheby's 18 October 1995. *Oriental Manuscripts and Miniatures.* London, 18 October 1995.

Sotheby's, 15 October 1998. *Arts of the Islamic World.* London, 15 October 1998.

Soucek 1971 Soucek, Priscilla. "Illustrated Manuscripts of Nizami's *Khamsa*: 1386–1482." PhD diss., Institute of Fine Arts, New York University, 1971.

Soucek 1979 Soucek, Priscilla. "The Arts of Calligraphy." In *The Arts of the Book in Central Asia, 14th–16th Centuries*, edited by Basil Gray, 7–34. London: UNESCO and Serinda Publications, 1979.

Soucek 1988 Soucek, Priscilla. "The New York Public Library *Makhzan al-Asrar* and Its Importance." *Ars Orientalis* 18 (1988): 1–37.

Soucek 1992 Soucek, Priscilla. "The Manuscripts of Iskandar Sultan: Structure and Content." In *Timurid Art and Culture: Iran and Central Asia in the Fifteenth Century*, edited by Lisa Golombek and Maria Subtelny, 116–31. Leiden and New York: E. J. Brill, 1992.

Soucek 1997 Soucek, Priscilla. "Ebrahim Soltan." In *Encyclopaedia Iranica*. Vol. 3, fasc. 1, pp. 76–78. Costa Mesa: Mazda Publishers, 1997.

Soucek 1998a Soucek, Priscilla. "Eskandar Soltan." In *Encyclopaedia Iranica*. Vol. 8, fasc. 6, pp. 603–04. Costa Mesa: Mazda Publishers, 1998.

Soucek 1998b Soucek, Priscilla. "Ibrahim Sultan's Military Career." In *Iran and Iranian Studies: Essays in Honor of Iraj Afshar*, edited by Kambiz Eslami, 24–41. Princeton: Zagros, 1998.

Soucek and Çağman 1995 Soucek, Priscilla, and Filiz Çağman. "A Royal Manuscript and Its Transformation: The Life History of a Book." In *The Book in the Islamic World: The Written Word and Communication in the Middle East*, edited by George N. Atiyeh, 179–209. Albany: State University of New York, 1995.

Soudavar 1992 Soudavar, Abolala. *Art of the Persian Court: Selections from the Art and History Trust Collection.* New York: Rizzoli, 1992.

Soudavar 1996 Soudavar, Abolala. "The Saga of Abu-Sa'id Bahadur Khan: The Abu-Sa'idname." In *The Court of the Il-Khans, 1290–1340*, edited by Julian Raby and Teresa Fitzherbert, 95–218. Oxford Studies in Islamic Art 12. Oxford: Oxford University Press, for the Board of the Faculty of Oriental Studies, 1996.

Soudavar 2003 Soudavar, Abolala. *The Aura of Kings: Legitimacy and Divine Sanction in Iranian Kingship.* Costa Mesa: Mazda Publishers, 2003.

Stchoukine 1936 Stchoukine, Ivan. *La peinture iranienne sous les derniers 'Abbasides et les Il-Khans.* Bruges: Imprimerie Sainte Catherine, 1936.

Stchoukine 1954 Stchoukine, Ivan. *Les peintures des manuscrits timurides.* Paris: P. Geuthner, 1954.

Stchoukine 1959 Stchoukine, Ivan. *Les peintures des manuscrits safavis de 1502–1587*. Paris: P. Geuthner, 1959.

Stchoukine 1964 Stchoukine, Ivan. *Les peintures des manuscrits de Shah 'Abbas I à la fin des Safavis*. Paris: P. Geuthner, 1964.

Stchoukine 1966 Stchoukine, Ivan. "La peinture à Yazd au début du XV siècle." *Syria* 42 (1966): 99–104.

Stchoukine 1967 Stchoukine, Ivan. "Sultan 'Ali al-Bavardi un peinture iranien inconnu de XVe siècle." *Syria* 44 (1967): 401–08.

Stchoukine 1968 Stchoukine, Ivan. "Une Khamseh de Nizami de la Fin du Règne de Shah Rokh." *Arts Asiatiques* 18 (1968): 45–58.

Steingass 1992 Steingass, F. *A Comprehensive Persian-English Dictionary*. New Dehli: Asian Educational Services, 1992.

Storey 1927–39 Storey, C. A. *Persian Literature: A Bio-Bibliographical Survey*. London: Luzac and Co., 1927–39.

Subtelny 1979 Subtelny, Maria E. "The Poetic Circle at the Court of the Timurid Sultan Husain Baiqara and Its Political Significance." PhD diss., Harvard University, 1979.

Suleiman and Suleimanova 1983 Suleiman, Hamid, and Fazila Suleimanova. *Miniatures Illuminations of Amir Hosrov Dehlevi's Works*. Tashkent: Fan Publishers, 1983.

Swietochowski and Carboni 1994 Swietochowski, Marie Lukens, and Stefano Carboni. *Illustrated Poetry and Epic Images: Persian Painting of the 1330s and 1340s*. New York: Metropolitan Museum of Art, 1994.

Tabbaa 1991 Tabbaa, Yasser. "The Transformation of Arabic Writing: Part I, Qur'anic Calligraphy." *Ars Orientalis* 21 (1991): 119–48.

Thackston 1989 Thackston, Wheeler M. *A Century of Princes: Sources on Timurid History and Art*. Cambridge, Mass.: Aga Khan Program for Islamic Architecture, 1989.

Thackston 1990 Thackston, Wheeler M. "Treatise on Calligraphic Arts: A Disquisition on Paper, Colors, Inks, and Pens by Simi of Nishapur." In *Intellectual Studies on Islam: Essays Written in Honor of Martin B. Dickson*, edited by Michel M. Mazzaoui and Vera B. Moreen, 219–28. Salt Lake City, Utah: University of Utah Press, 1990.

Thackston 1993 Thackston, Wheeler M. *An Introduction to Persian*. Bethesda, Md.: Iranbooks, 1993.

Thompson and Canby 2003 Thompson, Jon, and Sheila Canby, eds. *Hunt for Paradise: Court Arts of Safavid Iran, 1501–1576*. Milan: Skira Editore, 2003.

Titley 1972 Titley, Norah M. "A 14th-Century Nizami Manuscript in Tehran." *Kunst des Orients* 8, nos. 1–2 (1972): 120–25.

Titley 1983 Titley, Norah M. *Persian Miniature Painting and Its Influence on the Art of Turkey and India*. London: British Library, 1983.

Togan 1963 Togan, Zeki Velidi. *On the Miniatures in Istanbul Libraries*. Publications of the Faculty of Letters of the University of Istanbul 1304. Istanbul: Baha Matbaasi, 1963.

Türkische Kunst 1985 *Türkische Kunst und Kultur aus Ösmanischer Zeit*. Frankfurt: Verlag Aurel Bongers KG Recklinghausen, 1985.

Valls i Subira 1970 Valls i Subira, Oriol. *Paper and Watermarks in Catalonia*. Vols. 1 and 2. Monumenta Chartae Papuracea Historiam Illustrantia. Hilversum: Paper Society, 1970.

von Folsach 2001 von Folsach, Kjeld. *Art from the World of Islam in the David Collection*. Copenhagen, 2001.

Waley and Titley 1975 Waley, P., and Norah Titley. "An Illustrated Persian Text of *Kalila wa Dimna* dated 707/1307–08." *British Library Journal* 1 (1975): 42–61.

Walzer 1969 Walzer, Sofie. "The Topkapu Saray Manuscript of the Persian Kalila wa Dimna (dated A.D. 1413)." In *Paintings from Islamic Lands*, edited by R. Pinder-Wilson, 48–84. Oriental Studies 4. London: Bruno Cassirer, 1969.

Warner and Warner 1905–12 Warner, George A., and Edmond Warner. *The Shahnama of Firdausi*. London: Kegan Paul, Trench, Trubner and Co., 1905–12.

Watt and Wardell 1997 Watt, James C. Y., and Anne E. Wardell. *When Silk Was Gold: Central Asian and Chinese Textiles*. New York: Metropolitan Museum of Art and Cleveland Museum of Art, 1997.

Weir 1957 Weir, Thomas S. "Some Notes on the History of Papermaking in the Middle East." *Paper Geschichte* 7, no. 4 (July 1957): 43–48.

Welch 1972–78 Welch, Anthony. *Collection of Islamic Art: Prince Sadruddin Aga Khan*. Geneva: Chateau de Bellerive, 1972–78.

Wilber 1955 Wilber, Donald. *The Architecture of Islamic Iran: The Il-Khanid Period*. Princeton: Princeton University Press, 1955.

Wright 1991 Wright, Elaine. "The Origins and Development of the Shiraz-Style of Illuminations, 1365 to the Mid-15th

Century." MPhil thesis, Faculty of Oriental Studies, Oxford University, Oxford, 1991.

Wright 2003 Wright, Elaine. "The Calligraphers of Shiraz and the Development of *Nasta'liq* Script." *Manuscripta Orientalia* 9, no. 3 (September 2003): 16–26.

Wright 2004 Wright, Elaine. "Firdausi and More: A Timurid Anthology of Epic Tales." In *Shahnama: The Visual Language of the Persian Book of Kings*, edited by Robert Hillenbrand, 65–84. Edinburgh: Ashgate Publishing, 2004.

Wright 2006 Wright, Elaine. "Patronage of the Arts of the Book under the Injuids of Shiraz." In *Beyond the Legacy of Genghis Khan*, edited by Linda Komaroff, 248–68. Leiden and Boston: Koninklijke Brill NV, 2006.

Wright 2009 Wright, Elaine. *Islam: Faith, Art, Culture. Manuscripts of the Chester Beatty Library*. London: Scala Publishers and Chester Beatty Library, 2009.

Yazdi 1336/1957 Yazdi, Sharaf al-Din ʿAli. *Zafarnama*, edited by M. ʿAbbasi. Tehran, 1336/1957.

INDEX

Italic numerals indicate text in a caption or table.